Women of the World:
Laws and Policies Affecting Their Reproductive Lives

Latin America and the Caribbean

The Center for Reproductive Law and Policy
DEMUS, Estudio para la Defensa de los Derechos de la Mujer

Argentina Bolivia Brasil Colombia El Salvador
Guatemala Jamaica México Perú

**WOMEN OF THE WORLD: LAWS AND POLICIES
AFFECTING THEIR REPRODUCTIVE LIVES:
LATIN AMERICA AND THE CARIBBEAN**

Published by the Center for Reproductive Law and Policy
120 Wall Street
New York, NY 10005
USA

First edition, November 1997

Entire content copyright ©1997, The Center for Reproductive Law and Policy and DEMUS. All rights reserved. Reproduction or transmission in any form, by any means, (electronic, photocopying, recording, or otherwise), in whole or part, without the prior consent of the Center for Reproductive Law and Policy or DEMUS is expressly prohibited. This prohibition does not apply to the organizations listed in the Acknowledgments, for each of their corresponding country chapters.

ISBN 1-890671-00-2
ISBN 1-890671-03-7

Acknowledgments

This report was coordinated jointly by Gaby Oré Aguilar, International Program Staff Attorney for Latin America and the Caribbean of the Center for Reproductive Law and Policy, and Roxana Vásquez Sótelo, General Coordinator of DEMUS and Regional Coordinator for this report.

Research and preliminary drafting of the corresponding country chapters were undertaken by the following lawyers and organizations: Mariana García Jurado, Instituto Género Derecho y Desarollo (Argentina); Julieta Montaño, Director, Oficina Jurídica de la Mujer (Bolivia); Silvia Pimentel and Valéria Pandjirjian, Director and President, respectively, of the Board of Trustees, Instituto para la Promoción de la Equidad (Brazil); Isabel Agatón, member, Casa de la Mujer (Colombia); Alba América Guirola, Director, Instituto de Estudios para la Mujer "Norma Virginia Guirola de Herrera," CEMUJER (El Salvador); María Eugenia Mijangos, Regional Women's Rights Coordinator, Centro para la Acción Legal en Derechos Humanos, CALDH (Guatemala); Margarette May Macaulay, Coordinator, Association of Women's Organizations in Jamaica, AWOJA (Jamaica); Adriana Ortega Ortíz, Consultant, Grupo de Información en Reproducción Elegida GIRE (Mexico); and Kitty Trinidad, who drafted the Peru report for DEMUS, Estudio para la Defensa de los Derechos de la Mujer (Peru).

The final report was edited by Gaby Oré Aguilar for CRLP, in collaboration with Carmen Reinoso and Luisa Cabal. Lauren Gilbert, Professor of Law and Director of the Women and International Law Program at Washington College of Law at American University, was the peer reviewer for the report. Katherine Hall Martinez, Staff Attorney at CRLP, edited the English translation from the original Spanish. Cynthia Eyakuze, Program Associate of the International Program at CRLP, provided invaluable assistance in coordinating the editing of the English version of this report.

The following people at CRLP also contributed to the various steps in the coordination and production of this report: Anika Rahman partially edited the English versions of the chapters on Colombia, Jamaica, and Peru; Katherine Hall Martinez coordinated and edited the Jamaica chapter; Jeremy Telman, legal intern, edited the Jamaica chapter; Julieta Lemaitre partially drafted the El Salvador chapter and provided essential assistance in editing the translation of the various chapters from the original Spanish. Others who also provided invaluable assistance in the completion of this report were Janet Benshoof, Barbara Becker, Bonnie Kimmel, Alison-Maria Bartolone, and Katherine Tell.

Jorge Chocos and Paula Masías, members of the DEMUS team, were invaluable contributors in the various stages of coordination and production of this report. Pedro Morales and Julieta Herrera collaborated in the drafting of the Mexico chapter. Juanita León commented on the report.

CRLP and DEMUS would like to thank the following organizations for their generous financial support towards the completion of this report: the Gender, Population and Development Branch of the Technical and Evaluation Division of the United Nations Population Fund; The William and Flora Hewlett Foundation; the Compton Foundation; and the Erik E. and Edith Bergstrom Foundation.

Design and Production ©Emerson, Wajdowicz Studios, New York, N.Y.

MESA Computer Sytems, New York, N.Y.

Photography: ©TAFOS, Social Photography Workshop, Lima, Peru

Table of Contents

ACKNOWLEDGEMENTS **3**

GLOSSARY **7**

FOREWORD **7**

1. INTRODUCTION **9**

2. ARGENTINA **15**

 I. Setting the Stage: The Legal and Political Framework 17
 A. The Structure of National Government 17
 B. The Structure of Territorial Divisions 18
 C. Sources of Law 19

 II. Examining Health and Reproductive Rights 19
 A. Health Laws and Policies 19
 B. Population, Reproductive Health and Family Planning 19
 C. Contraception 23
 D. Abortion 24
 E. HIV/AIDS and Sexually Transmissible Infections (STIs) 24

 III. Understanding the Exercise of Reproductive Rights: Women's Legal Status 25
 A. Civil Rights Within Marriage 26
 B. Economic and Social Rights 26
 C. Right to Physical Integrity 26

 IV. Analyzing the Rights of a Special Group: Adolescents 28
 A. Reproductive Health and Adolescents 28
 B. Marriage and Adolescents 29
 C. Sexual Offenses Against Adolescents and Minors 29
 D. Sexual Education 29

3. BOLIVIA **34**

 I. Setting the Stage: The Legal and Political Framework 36
 A. The Structure of National Government 36
 B. The Structure of Territorial Divisions 37
 C. Sources of Law 37

 II. Examining Health and Reproductive Rights 38
 A. Health Laws and Policies 38
 B. Population, Reproductive Health and Family Planning 39
 C. Contraception 40
 D. Abortion 41
 E. HIV/AIDS and Sexually Transmissible Infections (STIs) 41

 III. Understanding the Exercise of Reproductive Rights: Women's Legal Status 42
 A. Civil Rights Within Marriage 43
 B. Economic and Social Rights 44
 C. Right to Physical Integrity 45

 IV. Analyzing the Rights of a Special Group: Adolescents 45
 A. Reproductive Health and Adolescents 45
 B. Marriage and Adolescents 45
 C. Sexual Offenses Against Adolescents and Minors 46
 D. Sexual Education 47

4. BRAZIL **51**

 I. Setting the Stage: The Legal and Political Framework 53
 A. The Structure of National Government 53
 B. The Structure of Territorial Divisions 54
 C. Sources of Law 55

 II. Examining Health and Reproductive Rights 55
 A. Health Laws and Policies 55
 B. Population, Reproductive Health and Family Planning 57
 C. Contraception 57
 D. Abortion 58
 E. HIV/AIDS and Sexually Transmissible Infections (STIs) 59

 III. Understanding the Exercise of Reproductive Rights: Women's Legal Status 60
 A. Civil Rights Within Marriage 60
 B. Economic and Social Rights 61
 C. Right to Physical Integrity 63

 IV. Analyzing the Rights of a Special Group: Adolescents 63
 A. Reproductive Health and Adolescents 64
 B. Marriage and Adolescents 64
 C. Sexual Offenses Against Adolescents and Minors 64
 D. Sexual Education 64

5. COLOMBIA **69**

 I. Setting the Stage: The Legal and Political Framework 71
 A. The Structure of National Government 71
 B. The Structure of Territorial Divisions 72
 C. Sources of Law 73

 II. Examining Health and Reproductive Rights 73
 A. Health Laws and Policies 73
 B. Population, Reproductive Health and Family Planning 75
 C. Contraception 76

D. Abortion	77
E. HIV/AIDS and Sexually Transmissible Infections (STIs)	77

III. Understanding the Exercise of Reproductive Rights: Women's Legal Status — 79
A. Civil Rights Within Marriage — 79
B. Economic and Social Rights — 80
C. Right to Physical Integrity — 82

IV. Analyzing the Rights of a Special Group: Adolescents — 83
A. Reproductive Health and Adolescents — 83
B. Marriage and Adolescents — 83
C. Sexual Offenses Against Adolescents and Minors — 83
D. Sexual Education — 84

6. EL SALVADOR — 91

I. Setting the Stage: The Legal and Political Framework — 93
A. The Structure of National Government — 93
B. The Structure of Territorial Divisions — 94
C. Sources of Law — 94

II. Examining Health and Reproductive Rights — 95
A. Health Laws and Policies — 95
B. Population, Reproductive Health and Family Planning — 96
C. Contraception — 97
D. Abortion — 98
E. HIV/AIDS and Sexually Transmissible Infections (STIs) — 987

III. Understanding the Exercise of Reproductive Rights: Women's Legal Status — 99
A. Civil Rights Within Marriage — 99
B. Economic and Social Rights — 99
C. Right to Physical Integrity — 101

IV. Analyzing the Rights of a Special Group: Adolescents — 102
A. Reproductive Health and Adolescents — 102
B. Marriage and Adolescents — 102
C. Sexual Offenses Against Adolescents and Minors — 103
D. Sexual Education — 103

7. GUATEMALA — 108

I. Setting the Stage: The Legal and Political Framework — 110
A. The Structure of National Government — 110
B. The Structure of Territorial Divisions — 111
C. Sources of Law — 111

II. Examining Health and Reproductive Rights — 112
A. Health Laws and Policies — 112
B. Population, Reproductive Health and Family Planning — 114
C. Contraception — 114
D. Abortion — 115
E. HIV/AIDS and Sexually Transmissible Infections (STIs) — 116

III. Understanding the Exercise of Reproductive Rights: Women's Legal Status — 116
A. Civil Rights Within Marriage — 117
B. Economic and Social Rights — 118
C. Right to Physical Integrity — 119

IV. Analyzing the Rights of a Special Group: Adolescents — 120
A. Reproductive Health and Adolescents — 120
B. Marriage and Adolescents — 120
C. Sexual Offenses Against Adolescents and Minors — 120
D. Sexual Education — 120

8. JAMAICA — 126

I. Setting the Stage: The Legal and Political Framework — 128
A. The Structure of National Government — 128
B. The Structure of Territorial Divisions — 129
C. Sources of Law — 130

II. Examining Health and Reproductive Rights — 131
A. Health Laws and Policies — 131
B. Population, Reproductive Health and Family Planning — 132
C. Contraception — 133
D. Abortion — 134
E. HIV/AIDS and Sexually Transmissible Infections (STIs) — 135

III. Understanding the Exercise of Reproductive Rights: Women's Legal Status — 136
A. Civil Rights Within Marriage — 136
B. Economic and Social Rights — 137
C. Right to Physical Integrity — 138

IV. Analyzing the Rights of a Special Group: Adolescents — 139
A. Reproductive Health and Adolescents — 139
B. Marriage and Adolescents — 101
C. Sexual Offenses Against Adolescents and Minors — 102
D. Sexual Education — 102

9. MEXICO — 145

I. Setting the Stage: The Legal and Political Framework — 147
A. The Structure of National Government — 147
B. The Structure of Territorial Divisions — 148
C. Sources of Law — 148

II. Examining Health and Reproductive Rights	**149**
A. Health Laws and Policies	149
B. Population, Reproductive Health and Family Planning	151
C. Contraception	152
D. Abortion	152
E. HIV/AIDS and Sexually Transmissible Infections (STIs)	153
III. Understanding the Exercise of Reproductive Rights: Women's Legal Status	**153**
A. Civil Rights Within Marriage	154
B. Economic and Social Rights	154
C. Right to Physical Integrity	155
IV. Analyzing the Rights of a Special Group: Adolescents	**157**
A. Reproductive Health and Adolescents	157
B. Marriage and Adolescents	157
C. Sexual Offenses Agains Minors	157
D. Education and Adolescents	158

10. PERU — 163

I. Setting the Stage: The Legal and Political Framework	**165**
A. The Structure of National Government	165
B. The Structure of Territorial Divisions	166
C. Sources of Law	166
II. Examining Health and Reproductive Rights	**167**
A. Health Laws and Policies	167
B. Population, Reproductive Health and Family Planning	169
C. Contraception	171
D. Abortion	172
E. HIV/AIDS and Sexually Transmissible Infections (STIs)	173
III. Understanding the Exercise of Reproductive Rights: Women's Legal Status	**174**
A. Civil Rights Within Marriage	174
B. Economic and Social Rights	175
C. Right to Physical Integrity	176
IV. Analyzing the Rights of a Special Group: Adolescents	**177**
A. Reproductive Health and Adolescents	177
B. Marriage and Adolescents	178
C. Sexual Offenses Against Adolescents and Minors	178
D. Sexual Education	179

11. CONCLUSION — 186

I. Setting the Stage: The Legal and Political Framework	**186**
A. The Structure of National Government	187
B. Sources of Law	188
II. Examining Health and Reproductive Rights	**189**
A. Health Laws and Policies	189
B. Population, Reproductive Health and Family Planning	192
C. Contraception	194
D. Abortion	195
E. HIV/AIDS and Sexually Transmissible Infections (STIs)	196
III. Understanding the Exercise of Reproductive Rights: Women's Legal Status	**197**
A. Civil Rights Within Marriage	198
B. Economic and Social Rights	200
C. Right to Physical Integrity	202
IV. Analyzing the Rights of a Special Group: Adolescents	**204**
A. Reproductive Health and Adolescents	204
B. Marriage and Adolescents	205
C. Sexual Offenses Against Adolescents and Minors	206
D. Sexual Education	206

Glossary

Frequently used abbreviations

HIV:
Human Immunodeficiency Virus

AIDS:
Acquired Immunodeficiency Syndrome

STI:
Sexually transmissible infection

NGO:
Nongovernmental organization

Frequently used terms

Aborto culposo (unintentional abortion):
Unintentional abortion is an abortion caused without the direct intention of doing so. An unintentional abortion is a crime if the abortion was the foreseeable result of a person's actions.

Civil law:
Civil law, which derives from Roman law, describes a legal system in which statutes provide the principal source of rights and obligations.

Common law:
Common law refers to a legal system deriving from early English law based on principles, customary norms, or court decisions. Today, it is the body of law that develops from judicial decisions, as distinguished from laws brought forth through legislative enactments.

Estupro (Statutory rape):
The Spanish word *estupro* comes from the Latin *stuprum*, meaning abominable behavior. It is a crime defined as having sexual relations with an underage girl with her consent. In some countries, there must also be an element of deceit for the sexual relations to be criminal; in others, the girl must be a virgin or be known for "decent" sexual conduct. Anyone who has sexual relations with a prepubescent girl is guilty not of *estupro* but of rape of a minor, which carries more severe penalties.

Imprudencia, impericia and negligencia (negligence):
In civil law systems, there are three different kinds of negligence: negligence proper, lack of skill (*impericia*), and recklessness (*imprudencia*). In this report, all three terms are collectively referred to by the English term negligence.

Jurisprudencia (jurisprudence):
Jurisprudencia is the accumulated body of court decisions on a given issue. In civil law systems, prior court decisions generally have no precedential value for courts.

Nonpenalized abortion:
In this report, nonpenalized abortions are those exceptional cases of abortion that are not punishable by law, even where abortion is illegal.

Rapto (abduction for sexual purposes):
Rapto is the crime of taking a person away for romantic or sexual purposes by means of fraud, violence, or threats. This crime incurs a smaller penalty than kidnapping. In some countries the crime is not punished if the victim consents to marriage with the aggressor.

Roman Law:
This term refers to the legal system codified and applied during the era of the Roman Empire. The diverse legal texts written during the Roman Empire are collectively called Corpus *Juris Civilis*, and constitute a body of law that is distinct from English common law and canon law. Roman law constitutes the framework for all of the civil legal systems.

Social Security:
Many Latin American countries have a social security system that includes insurance coverage for health services, disability benefits, retirement benefits, and death benefits for contributing employees or other eligible citizens and their families.

Sociedad Conyugal (Community property):
Community property is a property regime that, unless otherwise agreed in writing by both partners, determines property rights in marriage. Under this regime, all the property acquired by each spouse, as well as the interest and income from inherited property or property acquired before marriage, belongs to both in equal shares. This property is thus divided equally upon legal separation, death, divorce or by contractual agreement between the spouses.

Separación (separation):
Separation refers to the court-ordered dissolution of community property; it is an intermediate stage between marriage and divorce in which the marriage is still valid, but conjugal rights and duties are suspended. In separation proceedings, the court also assigns custody of the children, and establishes the child support and alimony obligations to be paid.

Uniones de Hecho (Domestic partnerships):
Domestic partnerships are stable unions between a man and a woman that resemble a marriage and that generate rights and obligations similar to those of marriage. The law in each country determines the necessary conditions to legally recognize the union as valid. Domestic partnerships are roughly similar to the concept of common law marriage in common law legal systems. Generally, in common law such marriages are contingent on an explicit mutual agreement between the couple, whereas *uniones de hecho* merely require that the couple cohabitates in fact.

Foreword

It is with great pleasure that I present *Women of the World: Laws and Policies Affecting Their Reproductive Lives, Latin America and the Caribbean*. This report is unique in many ways. It is the first publication on Latin America and the Caribbean that describes and analyzes the content of all formal laws and policies that affect women's reproductive lives. The book presents a panoramic view of the region's laws and policies so as to provide some guidance regarding the arenas in which changes beneficial to women's reproductive health can be wrought. The information contained in this report highlights regional trends while indicating the differences that exist among the nine nations discussed. Moreover, the report is the product of a successful collaboration between national-level women's rights nongovernmental organizations located all over the Americas. Both the Center for Reproductive Law & Policy and our regional coordinator for Latin America, DEMUS, Estudio para la Defensa de los Derechos de la Mujer, worked closely and intensely for more than a year to produce this book. Finally, we seek to inform the world outside Latin America and the Caribbean of the legal and policy trends of this region. This report is thus being produced in Spanish and English.

Women of the World: Laws and Policies Affecting Their Reproductive Lives, Latin America and the Caribbean is the second regional report in a global series being produced by the Center for Reproductive Law and Policy. Future reports will focus on East and Southeast Asia, Eastern and Central Europe, the Middle East and North Africa, South Asia and West and Central Africa. We are attempting to enhance knowledge of the vast range of formal laws and policies that govern the actions of billions of people, both women and men, around the world. While there are numerous problems associated with the content and selective implementation of such laws and policies, there remains little doubt that laws and policies are powerful government tools. By making such information available to international, regional and national audiences, we hope to promote worldwide legal and policy advocacy to advance reproductive health and the status of all women. Ultimately, we seek a world in which women and men can be equal participants.

Anika Rahman
Director
International Program
The Center for Reproductive Law and Policy
November 1997

Introduction

Reproductive rights are internationally recognized as critical both for advancing women's human rights and for promoting development. In recent years, governments from all over the world have acknowledged and pledged to advance reproductive rights to an unprecedented degree. Such governmental commitments — at major international conferences, such as the Fourth World Conference on Women (Beijing, 1995), the International Conference on Population and Development (Cairo, 1994), and the World Conference on Human Rights (Vienna, 1993) — have set the stage for moving from rhetoric to reality in the arena of women's rights. But for governments and nongovernmental organizations (NGOs) to work toward reforming laws and policies and implementing the mandates of these international conferences, they must be informed about the current state of laws and policies affecting reproductive rights at the national and regional levels.

Within the global human rights framework, reproductive rights encompass a broad range of internationally recognized political, economic, social, and cultural rights, at both the individual and collective levels. Hence, understanding the laws and policies that affect the reproductive lives of women requires knowledge of the legal and political situation of any given country, because this reality is a key factor affecting women's reproductive choices and their legal, economic, and social situations. All these facts are crucial to the efforts of advocates seeking to promote national and regional legislative reforms that would enhance protection of women's rights and their reproductive health. This knowledge may also assist in the formulation of effective government policies by providing information on the different aspects of women's reproductive lives as well as on their needs and general concerns. The objective of this report is to ensure that women's concerns are reflected in future legal and policy efforts.

Laws are essential tools by which to promote women's reproductive health, facilitate their access to health services, and protect their human rights as users of such services. However, laws can also restrict women's access to the full enjoyment of reproductive health. For example, laws may limit an individual's choice of contraceptive methods, impose penalties on health providers who treat women suffering from abortion complications, and discriminate against specific groups, such as adolescents, by denying them full access to reproductive health services. Laws that discriminate against women or that subordinate them to their spouses in marriage or to their partners in domestic partnerships (*uniones de hecho*), undermine the right to reproductive self-determination and serve to legitimize unequal relations between men and women. The absence of laws or procedures to enforce existing laws may also have a negative effect on the reproductive lives of women and men. For example, the absence of laws regulating the relationship between health providers and users of reproductive health services may contribute to arbitrary decision making, which may affect the rights and interests of both parties. At the same time, the absence of antidiscrimination laws and of laws promoting equality among diverse sectors of society undermines equal access to reproductive health services, affecting low-income women in particular.

Reproductive health policies are of special importance because they reflect a government's political positions and perspectives on health and women's rights. Some governments treat women as central actors in the promotion of reproductive health. Others view women as a means by which to implement demographic goals set by different economic and cultural imperatives. Public policies can either facilitate global access to reproductive well-being or exclude specific groups by establishing economic barriers to health services. In the latter situation, women who are the poorest, the least educated, and the least empowered are hurt the most. Furthermore, the absence of reproductive health and family planning policies in some countries demonstrates the need for greater effort to assure that governments live up to the commitments they assumed at the international conferences of Vienna, Cairo, and Beijing.

This report sets forth national laws and policies in key areas of reproductive health and women's empowerment in nine Latin American and Caribbean countries: Argentina, Bolivia, Brazil, Colombia, El Salvador, Guatemala, Jamaica, Mexico,

and Peru. This legal analysis examines constitutional provisions and laws and regulations enacted by each country's legislative and executive branches. Moreover, this report discusses ethical codes approved by professional associations whenever the country's legal system recognizes them as being equivalent to law. The government programs and activities examined include those that directly or indirectly involve reproductive health. In addition, this report describes the entities charged with implementing these policies and the mechanisms that enable people to participate in the monitoring of government reproductive programs and activities. This book also includes a description of the civil and socioeconomic rights of women and the status of adolescents in each country. It concludes with an analysis of the regional trends in population, reproductive health, and family planning policies and a description of the existing legal standards in reproductive rights.

This introduction seeks to provide a general background to the Latin American and Caribbean region, the nations profiled in this report, and the information presented on each country. The following section provides an overview of the regional context of Latin America and the Caribbean and places a special emphasis on the legal system and on the principal regional indicators of women's status and reproductive health. This description provides an overall perspective on the Latin American and Caribbean region in terms of the key issues covered in this report. A review of the characteristics shared by the nine countries profiled herein follows. Finally, this chapter includes a description of the content of each of the national-level profiles presented in this report.

I. An Overview of the Latin American and Caribbean Region

Latin America and the Caribbean — comprising South America, Central America, and the English, French and Spanish-speaking Caribbean — represent just over 8% of the world's population. Of the 40 million indigenous people living in the region, 59% are women. Latin America and the Caribbean are often considered a single region not only because of their geographical proximity but also because the nations within this region have experienced similar historic, economic, and structural processes.

A. A SHARED LEGAL TRADITION

Latin American legal systems generally derive from ancient Roman law, which some refer to as a civil legal system because of the common reliance on the important compilation of Roman laws, *Corpus Juris Civilis*. Spain and Portugal introduced this system into South America during their colonial rule. In this system, legislation is the principal source of the rule of law. It is also important to note that in Latin American countries the customary norms and authorities of indigenous populations exist alongside the formal legal systems. In several countries, the Constitution recognizes these customary laws and authorities. These laws primarily govern issues such as landholding in the indigenous communities, property inheritance, and marital life. They also establish the usage and customs that determine the status of women in the community.

The legal system of Jamaica derives from common law, which originated in England. This legal system's series of principles and rules derives solely from usage and long-held customs based primarily on unwritten law and has often been adopted by countries that were colonized by England. The primary difference between the common law system and the Roman legal system is the role of courts. In common law regimes, judicial decisions create binding legal norms. In the Roman legal system, legislation is the principal source of law, and judicial decisions establish legal norms only in the rare cases where legislative enactment or constitutional provisions so mandate.

B. REPRODUCTIVE HEALTH PROBLEMS: A COMMON AGENDA

During the 1980s and the early 1990s, structural adjustment policies throughout the region of Latin America and the Caribbean had a dramatic adverse impact on people's, especially women's, health and quality of life. As government expenditures in health and other social policies were drastically reduced, these adjustments caused economic recession and an increase in poverty throughout the region. Health system reforms in the region resulted in a sudden shift of the governmental role: the government went from being a key provider of health services to being a promoter of either private or public general health insurance. Adjustment programs forced governments to pursue strategies that would allow public health services to become self-financing by taking actions such as charging fees to service users and transferring the responsibility for health provision to private or mixed public and private health care systems. Recent evaluations of the implementation of such measures in the region have shown that they have had an adverse impact on the ability of low-income groups, especially rural and indigenous people, to gain access to health care services.

Latin America and the Caribbean face similar reproductive health problems. The United Nations Population Fund has established that the region requires US$1.79 billion to ensure universal access to reproductive health and population programs by the year 2000. The average rate of maternal mortality in the region is 194 for every 100,000 live births, the

fourth-highest rate in the world after Africa, Asia, and Oceania. Clandestine abortion is the principal cause of maternal death of Latin American women. In Latin America, approximately four million clandestine abortions are performed annually, of which 800,000 require hospitalization for subsequent complications. Six thousand women die every year from abortion-related complications in Latin America and the Caribbean. In the Caribbean, 30% of all maternal deaths are attributable to unsafe abortions. However, abortion-related hospitalizations are decreasing in the region, as the average rate of contraceptive prevalence among women has increased to about 60%. The governments of Barbados and Guyana have enacted laws that facilitate access to abortion services. However, the overall trend in Latin America is toward restrictive abortion laws. In some countries in the region, liberal policies that commit the government to provide services for women suffering from abortion-related complications coexist with harsh and restrictive laws against health care providers and patients. These contradictions have perpetuated high maternal mortality rates.

Teenage pregnancy in Latin America and the Caribbean now constitutes one of the region's most serious public health problems. Between 1990 and 1995, 15% of women in the region under the age of 20 had at least one child. The English-speaking countries of the Caribbean have higher average rates of teenage pregnancy than Latin America. In the former countries, nearly every female between the ages of 15 and 19 will have a child before turning 20. In Latin America, only 11% of that age group will do so. While some Caribbean countries provide reproductive health services to adolescents more consistently than those in Latin America, in both cases there are few sex education programs and specific policies aimed at adolescents' reproductive health. The average age of first sexual experience or marriage ranges from 18.4 to 23 in the Latin America and the Caribbean region. In the Caribbean, suicide is the principal cause of death among adolescent girls.

The following statistics indicate the status of women's reproductive health in Latin America and the Caribbean. The average number of children per woman is between 2.93 and 3.03 in the Caribbean and 3.13 in Latin America. In the Caribbean, 53% of women who live with their spouse or partner use some contraceptive method, while in Latin America the average is 56%. More specifically, in South America, the contraceptive prevalence rate is 63%, while in Central America it is 49%. The incidence of HIV/AIDS among women in the English-speaking Caribbean is 132 cases for every million women. In Latin America and the French- and Spanish-speaking Caribbean, it is 19.6 cases for every million women. Blood transfusions are the main means of HIV/AIDS transmission to women in Latin America. In the Caribbean, however, only 0.4% of those infected with the virus contracted it by a blood transfusion. Hence, in the Caribbean, HIV/AIDS is primarily sexually transmitted and the high rates of such transmission are attributable largely to the low social status of Caribbean women and their problems with assuring monogamous relationships with their partners and/or ensuring that their partners use condoms. Although information in the region about the prevalence of sexually transmissible infections (STIs) is very sketchy, there are some indications that STIs are increasingly prevalent in the Caribbean, particularly among adolescents. Recent statistics for Latin America and the Caribbean indicate that for every year of premature death and illness that a man suffers due to STIs, a woman suffers nine.

C. WOMEN'S LEGAL AND SOCIAL STATUS

In the early 1990s, the Inter-American Development Bank published a survey on women's legal status and conditions of equality in sixteen countries in the region, including the nine countries covered in this book. Based on an analysis of constitutional provisions and government commitment to implementing international treaties relating to equality, this report found that there is more inequality, both in legal and social terms, between men and women in the Caribbean than in the other Latin American countries. It is also not surprising that, with 35% of all households headed by women, the Caribbean has the highest percentage of women heads of household in the world. The figure for Latin America is 21%. When the poverty rate of households headed by men and those headed by women are compared, it has been shown that the latter are consistently poorer. These facts relate to the predominance of domestic partnerships (*uniones de hecho* or *concubinato*, concubinage), which are engaged in by 54% of women in the region. Throughout the Latin American and Caribbean region, domestic partnerships receive either less protection than marriage or no protection at all. In those legal systems where such partnerships receive legal recognition, women in general have fewer rights than they do in marriage. In Latin America, the trend is toward the gradual establishment of national laws that recognize and protect these unions.

The disadvantages of women in the labor market and salary discrimination exacerbate the problem of women heads of households. The unemployment rate among women in Latin America and the Caribbean was 13.45% in the first half of the 1990s — 30% higher than the rate for men. Employment is often segregated by sex. Of all Latin American and Caribbean women who work, 77% are employed in the service sector, 15% in the industrial sector, and 9% in the agricultural sector. The woman worker's average salary is equivalent to 67% of a man's. This difference is higher in Caribbean countries than in

Latin American countries. Latin American and Caribbean women spend an average of sixty and fifty-five hours per week, respectively, on unremunerated domestic work.

Other important indicators of women's status are their educational levels and their participation in government. While women in the Latin American and Caribbean region have higher educational levels than in many other regions of the world, in 1995, approximately 13% were illiterate. Rural women in the region are two to three times more likely than urban women to be illiterate. In 1994, women's participation in official positions of decision making was higher in Central American countries (7.7%) than in South America (4.9%) and the Caribbean (7.3%). However, even if women's participation in the executive and legislative branches of government is increasing, considerable inequality in these leadership positions continues.

II. Features of the Selected Nations

The nine countries analyzed in this report represent 50.2% of the population of Latin America and the Caribbean, of which 78% is women. Brazil is the largest and most populous country in the region, with 163 million inhabitants, while Bolivia and El Salvador are the least populated countries, with 8 million and 5.8 million people, respectively. Jamaica, with a population of 2.5 million, is one of the most densely populated countries in the Caribbean. Guatemala's population growth rate of 2.8% is the highest of all nations surveyed, while Jamaica has a growth rate of 0.9%. The eight Latin American countries profiled in this book are Christian, primarily Roman Catholic. Brazil has the highest number of Roman Catholics in the world. All the nations described in this report were categorized by the World Bank as low- to middle-level income countries. Bolivia has the third-lowest gross domestic product ("GDP") per capita in Latin America ($770), while Argentina has the highest per capita annual income in Latin America and the Caribbean ($8,629). Jamaica has a GDP per capita of $1,540, the second highest in the English-speaking Caribbean.

All nine countries that are the subject of this report currently have democratically elected governments. Argentina, Brazil, and Mexico are politically and administratively divided into provinces or states with their own constitutions and select representatives for their own executive, legislative, and judicial branches. Jamaica's legal, political, and economic tradition is similar to the majority of Caribbean countries that comprise the Caribbean Community ("CARICOM"), an association of Commonwealth Caribbean nations. The description of Jamaica's laws and policies in this report provides a crucial tool for comparative analysis. Moreover, official and statistical information on health issues, desegregated by sex, is available for Jamaica; such reliable information does not exist in other English-speaking Caribbean countries, and was an important factor in the decision to include Jamaica in this report.

The countries selected for this report reflect the features of the different subregions in which they are located. Their similarities and differences reflect their shared heritage as well as the diversity that characterizes the region. For the purposes of this report, the nine Latin American and Caribbean nations being discussed have three critical features in common: a shared legal tradition; similar reproductive health programs; and similar issues regarding the legal status of women, especially rural and indigenous women.

A. SHARED LEGAL TRADITION

All Latin American nations share the same legal tradition, because they derive from the ancient Roman law system. Jamaica, however, follows the English-derived common law system. In addition, in most Latin American countries, formal legal systems coexist with customary judicial systems that regulate native and indigenous communities. Only some countries recognize the juridical value of these norms and forms of administering justice. The Constitution of Bolivia, the country with the largest native population in the region, comprising about 55% of the population, establishes that the authorities of indigenous communities have the right to administer justice. They can do so according to their own norms, customs, and procedures, as a form of "alternative dispute resolution," as long as these norms are not contrary to the Constitution or to national laws. In Guatemala, through the Peace Accords, the government agreed to develop norms that permit the indigenous communities to rule themselves according to their customary laws. Peru recognizes the "customary law" of peasant and native populations, as well as the power of their authorities to apply it. In both cases, the law establishes that neither customary laws nor their application can be inconsistent with fundamental human rights recognized in national laws. Guatemalan law explicitly provides that customary law must not conflict with internationally recognized human rights. These legal limitations are important for the protection of native and indigenous women's rights, since customary laws are often based on gender stereotypes and roles that adversely affect women's human rights and relegate them to inferior social and economic status within the community. For example, in many cases, land-distribution and inheritance laws often benefit only men.

B. REPRODUCTIVE HEALTH PROBLEMS: A SHARED AGENDA

Although the average fertility rate of the nine countries described in this report is 3.4 children per woman, there are marked differences among nations. Bolivia and Guatemala have an overall fertility rate of 5 children per woman. However, Jamaica has an average fertility rate of 2.4, while Brazil's average is 2.5 children. On average, health professionals assist with 71% of all births. However, there are notable differences between countries. In Guatemala and Bolivia, health professionals assist only 35% and 46%, respectively, of all births, while the rate is 96% and 92%, respectively, in Argentina and Jamaica.

Maternal mortality is very high in all nine nations. It ranges from annual rates of 48 to 600 maternal deaths for every 100,000 live births. In South America, the highest maternal mortality rate is in Bolivia, with 600 maternal deaths per 100,000 live births. Peru has the second-highest rate of maternal mortality — 265 maternal deaths per 100,000 live births. In Central America, El Salvador, with 300 maternal deaths per 100,000 live births, has the highest rate of maternal mortality. The principal causes of maternal mortality in these countries are complications relating to pregnancy, childbirth, postpartum, and abortion. In Jamaica, the rate of maternal mortality has increased in the last few years to 115 per every 100,000 live births, 38% of which are related to abortions. Jamaica also has the highest rate of death from cervical cancer — 41.8 per 100,000 women — in the Caribbean. Eighty percent of all clandestine abortions in Latin America and the Caribbean occur in eight of the countries discussed in this report. Brazil and Mexico have the highest rates of clandestine abortions, which are estimated to be between 800,000 and two million annually.

The Latin American and Caribbean region shares other common reproductive health problems. Among the nine countries examined in this report, the countries with the highest prevalence of contraceptive use are Brazil (77%), Colombia (72%), and Jamaica (67%). Guatemala (35%) and Argentina (43%) have the lowest rates of contraceptive prevalence. Statistical information about HIV/AIDS and STIs is scarce in the region, and there are no consistent standards for collecting data. Brazil has one of the highest rates of HIV/AIDS infection in the world; at the end of 1996, among the 500,000 Brazilians infected with HIV/AIDS, approximately 146,000 are expected to develop AIDS. STI statistics also indicate that this is a problem urgently requiring attention. Official statistics reveal that in El Salvador in 1995, there were only 18,319 cases of STIs reported, while in Brazil between 1987 and 1995 the Ministry of Health reported 451,708 cases of STIs. Pregnancy rates among adolescents are high in most countries. In Jamaica, one-third of all births are to adolescent mothers, while in Peru, Colombia, and El Salvador, 13% or 14% of women between 15 and 19 are already mothers.

C. WOMEN'S LEGAL AND SOCIAL STATUS

To contextualize women's reproductive health and rights, it is critical to understand their social and legal status. Women's legal situations have a direct effect on their ability to exercise their reproductive rights. Spousal and familial relations, educational level, and access to economic resources and legal protection all determine a woman's ability to make choices about her reproductive health needs and her access to health services.

Violence against women is a serious problem in almost all the countries analyzed in this report. Yet it is also one of the least-documented women's problems. In the countries in which such information is available, the main forms of violence against women include sexual violence, domestic violence, and other forms of physical and psychological violence. In Bolivia, 76.3% of the acts of violence against women were physical acts of violence; 12% were sexual violence, most of which took place in the victim's home. In Peru, only 6,244 complaints of violence against women were brought before a special Lima-based police force; rape and other sexual assaults represent the third most commonly reported crime in the country. In Jamaica, 1,108 cases of rape were reported to the police in 1992. None of the countries examined in this report has specific legislation to protect women against sexual harassment. Argentina and Peru have minimal provisions against sexual harassment in the workplace. El Salvador and Mexico regulate sexual harassment through provisions incorporated within the sexual crime sections of their penal law.

Illiteracy rates in the nine countries examined in this report vary between 4% in Argentina and 50.3% in El Salvador. With the exception of Jamaicans and Argentines, women have higher illiteracy rates than men. Moreover, women who live in rural areas have higher illiteracy rates than those who live in urban areas. In Guatemala, for example, 13% of urban women, compared with 49% of rural women, are illiterate.

III. National-Level Information Discussed

This report presents an overview of the content of the laws and policies that relate to specific reproductive health issues as well as to women's rights more generally. It discusses each country separately, but organizes the information provided uniformly in four main sections to enable regional comparisons.

The first section of each chapter briefly lays out the basic legal and political structure of the country being analyzed, providing a critical framework within which to examine the laws and policies affecting women's reproductive rights. This background information seeks to explain how laws are enacted, by whom, and the manner in which they can be challenged, modified, or repealed. It also lays the foundation for understanding the manner in which countries adopt certain policies.

In the second part of each chapter, we detail the laws and policies affecting specific reproductive health and rights issues. This segment describes laws and policies regarding those major reproductive health issues that have been the concern of the international community and of governments. The report thus reviews governmental health and population policies, with an emphasis on general issues relating to women's status. It also examines laws and policies regarding contraception, abortion, sterilization, HIV/AIDS, and other STIs.

The next section of each chapter provides general insights into women's legal status in each country. To evaluate women's reproductive health and rights, it is essential to explore their status within the society in which they live. Therefore, this report describes laws and policies regarding marriage, divorce, custody of children, property rights, labor rights, access and rules regarding credit, access to education, and the right to physical integrity, including laws on rape, domestic violence, and sexual harassment.

The final section of each chapter focuses on the reproductive health and rights of adolescents. Discrimination against women often begins at a very early age and leaves women less empowered than men to control their sexual and reproductive lives. Women's unequal status in society may limit their ability to protect themselves against unwanted or coercive sexual relations and thus from unwanted pregnancies as well as from HIV/AIDS and STIs. The segment on adolescents focuses on laws and policies relating to reproductive health, marriage, sexual crimes, and sex education.

This report is the product of a collaborative process involving the following institutions: the Center for Reproductive Law and Policy, based in New York; DEMUS, Estudio para la Defensa de los Derechos de la Mujer (Office for the Defense of Women's Rights), based in Lima, Peru; and eight NGOs committed to advancing women's reproductive rights in Latin America and the Caribbean.

Argentina

Statistics

GENERAL

Population

- Argentina has a total population of 34.2 million,[1] of which 50.5% are women.[2] The growth rate is approximately 1.3% per year. 31% of the population is under 15 years old, and 9% is over 65.[3]
- In 1995, 87% of the population lived in urban areas and 13% lived in rural areas.[4]

Territory

- Argentina has an area of 2,767,000 square kilometers.[5]

Economy

- In 1996, the gross national product per capita was estimated at U.S.$8,629.[6]
- From 1990 to 1994, the gross domestic product grew at an estimated rate of 7.6%.[7]
- In 1996, public health expenditures were 3% of the total national budget.[8]

Employment

- From April to May 1996, the employment rate in urban areas was 34.1%.[9] In 1994, approximately 13 million people were employed in Argentina. Women represented 30% of the labor force.[10]

WOMEN'S STATUS

- The average life expectancy for women is 75 years, compared with 68 years for men.[11]
- 4% of citizens over 15 years of age are illiterate; this percentage is roughly the same for both men and women.[12]
- In October 1996, women made up 33% of the economically active population, 26.4% of the total employment rate, and 20.3% of the unemployment rate. Men made up 55.6%, 46.8%, and 15.7% respectively.[13]
- There is insufficient information on violence against women in Argentina. However, 1.3% of criminal acts in the country are categorized as "crimes against decency" — which includes rape.[14] In light of new "protection against domestic violence" legislation, it is hoped that data will be collected more systematically.[15]

ADOLESCENTS

- Approximately 31% of the population of Argentina is under 15 years old.[16]
- The median age of first marriage is 22.9 years.[17]
- From 1990 to 1995, the fertility rate in adolescents between the ages of 15 and 19 years old was 66 per 1,000 inhabitants.[18]

MATERNAL HEALTH

- From 1990 to 1995, the country's fertility rate was 2.77.[19]
- In 1991, the maternal mortality rate was 48 deaths per 100,000 live births.[20]
- In 1991, the reported causes for maternal mortality were as follows: 31.6% due to abortions, 60.3% due to direct causes, and 3.98% due to indirect causes.[21]
- In 1994, the infant mortality rate was estimated at 22 deaths per 1,000 live births.[22]
- In Argentina, 96% of births are attended by a health professional.[23]

CONTRACEPTION AND ABORTION

- In 1994, 68.9% of women in Argentina used some form of contraception.[24]
- Unofficial figures estimate that there are between 350,000 and 400,000 abortions per year in Argentina.[25]

HIV/AIDS AND STIs

- According to information from the AIDS Program (1997), 20% of all cases reported since the epidemic began were reported in 1996. In 1996, there was a rise of 19% from the previous year in the number of cases.[26]
- The number of women with AIDS grew 27% in 1995. The number of men with AIDS grew by 18%.[27]
- In 1990, there were 1,079 cases of sexually transmissible infections.[28]

ENDNOTES

1. UNITED NATIONS POPULATION FUND (UNFPA), THE STATE OF THE WORLD POPULATION 1997, at 72 (1996).
2. UNITED NATIONS, THE WORLD'S WOMEN 1995: TRENDS AND STATISTICS, at 25 (1995).
3. THE WORLD ALMANAC AND BOOK OF FACTS 1997, at 739 (1996).
4. THE WORLD'S WOMEN, *supra* note 2, at 62.
5. WORLD BANK, WORLD DEVELOPMENT REPORT 1996: FROM PLAN TO MARKET, at 188 (1996).
6. Presentation by the Argentine delegation before the 17th session of the Committee on the Elimination of Discrimination Against Women (CEDAW), annex, table 6 (July 22, 1997) (on file with CRLP).
7. WORLD DEVELOPMENT REPORT 1996, *supra* note 5, at 208.
8. THE STATE OF WORLD POPULATION 1997, *supra* note 1, at 72.
9. Gender and Development Institute, Draft Report on Argentina, at 11 (Rosario, Argentina, Jan. 1997) (on file with CRLP).
10. WORLD DEVELOPMENT REPORT 1996, *supra* note 5, at 195.
11. THE WORLD ALMANAC, *supra* note 3, at 740.
12. THE STATE OF WORLD POPULATION, *supra* note 1, at 69.
13. Presentation by the Argentine Delegation, *supra* note 6, at 44.
14. Report of the Government of Argentina before the 17th Session of the Committee on the Elimination of Discrimination Against Women (CEDAW), at 10 (July, 22 1997).
15. Draft Report on Argentina, *supra* note 9, at 7.
16. THE WORLD ALMANAC, *supra* note 3, at 739.
17. THE WORLD'S WOMEN 1995, *supra* note 3, at 35.
18. Id., at 86.
19. Draft Report on Argentina, *supra* note 9, at 8.
20. Presentation by the Argentine Delegation, *supra* note 6, at annex, graph 1.
21. Id., at tbl. 2.
22. National Statistics and Census Institute. <www.indec.mecon.ar>
23. THE STATE OF WORLD POPULATION, *supra* note 1, at 72.
24. UNITED NATIONS POPULATION FUND (UNFPA), RESOURCE REQUIREMENTS FOR POPULATION AND REPRODUCTIVE HEALTH PROGRAMS, at 154 (1996).
25. LAW LIBRARY, LIBRARY OF CONGRESS, REPORT FOR CONGRESS, at 31 (1996).
26. Report of Argentina before CEDAW 1997, *supra* note 14, at 46.
27. Id.
28. Draft Argentina Report, *supra* note 9, at 10.

The Republic of Argentina is located in the southern region of South America.[1] Chile borders it to the west, Bolivia and Paraguay to the north, and Brazil and Uruguay to the northeast.[2] The official language is Spanish, though other native languages — Quechua, Guaraní, Guaicurú, and Tehuelche — and some foreign languages, such as Italian, are also spoken in Argentina.[3] Roman Catholicism is the official religion[4], and 90% of the population is Catholic.[5] Argentina was a Spanish colony from 1515 to 1816,[6] when it won its independence. In the decades after 1880, there was massive immigration to Argentina from Italy, Germany, and Spain,[7] influencing the ethnic composition of the country. The country is predominantly white and of Spanish and Italian origin (85%). The next largest ethnic groups are mestizo and indigenous peoples.[8]

In 1976, a military junta overthrew Isabel Perón — the first woman to govern a country in the Western Hemisphere.[9] The military government ruled by a permanent "state of siege," fighting armed guerrillas and Argentine left-wing political parties. The military killed an estimated 5,000 people and imprisoned and tortured thousands of others.[10] In 1983, democracy returned to Argentina,[11] and in 1985, five members of the previous ruling military junta were found guilty of political murders and human rights abuses, though they were later pardoned.[12] In 1989, the state initiated structural and economic reform in Argentina to halt inflation and encourage efficiency and economic competitiveness.[13] In 1996, the government implemented a second economic reform that attempted to advance the 1989 initiative.[14] The current president of Argentina, reelected for a second term in 1995, is Carlos Saúl Menem.[15]

I. Setting the Stage: the Legal and Political Framework

To understand the various laws and policies affecting women's reproductive rights in Argentina, it is necessary to consider the legal and political systems of the country. By considering the bases and structure of these systems, it is possible to attain a better understanding of how laws are made, interpreted, modified, and implemented as well as the process by which governments enact reproductive health and population policies.

A. THE STRUCTURE OF NATIONAL GOVERNMENT

The Republic of Argentina has a representative, republican, and federal system of government.[16] The government is representative because the people govern through their representatives, who are empowered by national law.[17] The federal state is composed of the union of Argentine provinces that together form a federal government. The National Constitution (the "Constitution") establishes its functions and attributes.[18] The provinces "do not form a simple federal system" among independent entities. Rather, the federal state was created through an act of sovereign will by the Argentine nation.[19] The provinces retain all of the inherent powers of a duly qualified government, without limitations beyond those established in the Constitution.[20] The federal government provides the funds for the nation's expenditures from the National Treasury.[21] It also intervenes in the provincial territories under certain prescribed circumstances: to maintain the republican form of government; to defend against foreign invasions; and, when requested by the provincial authorities, to support or reestablish their sovereignty, if they are threatened by sedition or by the invasion of another province.[22] The federal government resides in Buenos Aires, Argentina's capital.[23] Separation of powers is one of the characteristics of the Argentine system of government.[24] The branches of the Republic of Argentina are the legislative, the executive, and the judicial.[25]

Executive Branch

The president of Argentina heads the executive branch.[26] He or she is the head of state, head of the government, and has political responsibility for the general administration of the country.[27] Although he or she does not posses legislative functions, in exceptional circumstances, he or she can issue decrees "of necessity and urgency", except on penal, fiscal and electoral matters or legislation regulating political parties.[28] According to the Constitution,[29] the president is directly elected by the people for a four-year term and can be reelected for an additional four years.[30] The president oversees the performance of the Minister who heads his or her cabinet (the "head of cabinet") and the other ministers.[31] The president can appoint and remove ministers from their posts.[32] Another of his or her functions is to negotiate and sign treaties.[33] He or she is the commander-in-chief of the armed forces of the nation and, as such, he or she oversees them.[34] The president can declare war and order defensive reprisals with the authorization of the Congress of the Republic.[35]

The head of cabinet and the remaining ministers are in charge of "overseeing the nation's business."[36] They authenticate and countersign presidential acts to give them legal effect.[37] The head of cabinet is responsible for the general administration of the country[38] and must meet with Congress at least once a month to inform it of the workings of the government.[39] Congressional appeals to resolve a "vote of no confidence"[40] are made to the head of cabinet. He or she can be removed by an absolute majority vote in each of the chambers of Congress.[41]

Legislative Branch

Legislative power is exercised by a bicameral Congress: a National Chamber of Deputies and a Senate, each composed of members from the provinces and from the Federal District of Buenos Aires.[42] The Chamber of Deputies is made up of representatives elected directly from the provinces and Buenos Aires.[43] There is one representative for every 33,000 inhabitants. For example, to calculate the number of representatives from a given province, the total population of this province is divided by 33,000, and the resulting quotient is the number of representatives. If the remainder is more than 16,500 inhabitants, the province has one more representative.[44] The Senate is made up of three senators from each province and three from Buenos Aires, who are elected simultaneously and by direct vote.[45]

The functions of Congress include the passage of the civil, commercial, penal, mining, employment, and social security legal codes applicable nationwide.[46] These codes do not affect local jurisdiction over certain matters. Both federal and provincial tribunals must apply these codes.[47] As authorized by the Constitution, Congress also enacts other general laws that are applicable nationwide.[48] Specifically, Congress must "legislate and promote affirmative measures to guarantee real equality of opportunity and treatment and the full exercise and enjoyment of those rights"[49] recognized by the Constitution and international human rights treaties,[50] "in particular with respect to children, women, the elderly, and disabled persons."[51] The Constitution also directs Congress to enact a "specific and comprehensive" social security regime for mothers during pregnancy and lactation.[52]

Under the Constitution, Congress also approves or rejects treaties with other nations, international bodies, or the Vatican;[53] creates courts lower than the Supreme Court; grants general amnesties;[54] and recognizes the ethnic and cultural preexistence of Argentine indigenous peoples, guaranteeing respect for their cultural identity, including bilingual and intercultural education and ownership of tribal lands.[55]

Judicial Branch

The Argentine legal system is a civil law system derived from Roman Law, as distinguished from English Common Law. Judicial power is conferred upon the Supreme Court of Justice and the lower courts created by Congress.[56] The principles of life tenure for judges and the responsibility of judicial functionaries form the basis of an independent federal judicial system.[57] These principles extend both to provincial and Buenos Aires justice systems.[58] Both the members of the Supreme Court and the lower court judges have life tenure contingent upon good conduct, but are still removable for cause.[59]

The President chooses Supreme Court judges, who then must be confirmed by the Senate.[60] A primary responsibility of the Supreme Court is to strengthen constitutional principles and precepts and to limit the scope of the powers of the other branches.[61] The Supreme Court and the lower courts decide all cases dealing with interpretation of the Constitution, the national laws, treaties, and foreign laws.[62]

The People's Defender Office ("Ombudsman"), created during the 1994 constitutional reform, is among the independent entities whose function is to control the Argentine government.[63] This office enjoys functional autonomy, as well as the privileges and immunities granted to legislators.[64] The function of the Ombudsman is to defend and protect human rights and other rights and interests established in the Constitution from acts or omissions committed by the government.[65] The Ombudsman also monitors the exercise of state power.[66] He or she is elected by Congress for a five-year period. Special laws regulate the operation and organization of the office.[67]

B. THE STRUCTURE OF TERRITORIAL DIVISIONS

Regional and local governments

The twenty-four provinces[68] and the federal capital[69] retain all powers not assigned to the Constitution by the federal government.[70] Each province has its own constitution under the republican system of government, in accordance with the principles, provisions, and guarantees of the Constitution.[71] The 1994 constitutional reform recognized the institutional autonomy of Buenos Aires, and as such, gives the city the prerogative to elect its own government and legislature.[72]

Without interference from the federal government, the provinces create their own local institutions and elect their governors, legislatures, and other provincial officials.[73] Each province must include within its constitution provisions affirming municipal autonomy and regulating the institutional, political, administrative, economic, and financial power of these municipalities.[74] The provinces can enter into international agreements as long as, in the view of the Argentine Congress, they are compatible with national foreign policy and do not affect the powers of the federal government.[75] Citizens of all the provinces share the same rights, privileges, and immunities.[76] In addition, public acts carried out and judicial decisions passed in one province must be recognized by the others.[77] Criminal extradition is mandatory between provinces.[78] Customs barriers exist only at the national level[79] and there is freedom of movement throughout the national territory for goods produced or made anywhere in the country.[80]

C. SOURCES OF LAW

Domestic sources of law

The Constitution, and some human rights treaties specifically mentioned in the Constitution, are the highest legal authorities in the Argentine legal system.[81] The Convention on the Elimination of All Forms of Discrimination Against Women is among those treaties that possess constitutional authority.[82] The Congress can incorporate other human rights instruments into the list of treaties having constitutional authority.[83] In general, treaties have superior authority over other laws.[84] Similarly, norms prescribed by Congress as a result of "treaties of integration that delegate responsibilities and jurisdiction to suprastate organizations" have superior authority over other domestic laws.[85]

Laws enacted by the federal government are mandatory nationwide,[86] whereas laws passed by a provincial government are binding only in that provincial territory.[87] To avoid conflicts that could arise from overlapping legislation at the federal and provincial levels, and to maintain the supremacy of the Constitution, of treaties with other countries, and of Federal law over provincial laws, the Constitution establishes that each of the above-mentioned sources constitutes "supreme law." Provincial authorities are obliged to conform to these laws.[88]

International sources of law

In Argentina, treaties entered into with other countries, international organizations, and the Vatican, are incorporated into domestic law. They have an authority superior to that of other national laws,[89] but not all of them have legal status equivalent to that of the Constitution. As described in the previous section, only certain human rights treaties have this legal authority.[90]

Argentina is a member of the United Nations and the Organization of American States. As such, Argentina has ratified a number of international treaties from the Universal System of Human Rights[91] and from the Inter-American System of Human Rights.[92] One of the most recently adopted conventions is the Inter-American Convention on the Prevention, Punishment and Eradication of Violence Against Women ("Convention of Belém do Pará").[93]

II. Examining Health and Reproductive Rights

In Argentina, women's health issues are dealt with within the context of the country's health and population policies. Thus, an understanding of reproductive rights in the country must be based on an analysis of health and population laws and policies.

A. HEALTH LAWS AND POLICIES

In examining national health legislation and policies in Argentina, reference will be made to the federal government's policies. However, in some cases, the focus will be on important aspects of provincial health policy, particularly reproductive health. As part of the Government Reform (1989–1994), the federal government transferred the provision of health and education services and assistance programs to the provinces.[94]

Objectives of the health policy

The Ministry of Health and Social Action ("MHSA"), which operates through the National Health Secretary, is the federal health authority.[95] In 1989, the Argentine government enacted legislation forming the current National Health Insurance System ("NHIS"),[96] which has the attributes of a national social security system, similar to those of other Latin American countries.[97] The Ministry of Health and Social Action enacts policies that constitute the framework for the functioning of the NHIS.[98] The National Health Secretary is the governmental authority that implements the NHIS.[99] The National Health Insurance Administration ("NHIA"), which is part of the National Health Secretary's office, is specifically in charge of the management and supervision of the NHIS.[100] When the NHIS was created, the government indicated that its objective was to bring a comprehensive approach to the provision of health care; to affirm the role of government leadership in the health sector; and to encourage participation from midsize organizations of civil society in the direct provision of health care.[101] The policy objective of the NHIS is the provision of "equal, comprehensive and humanized"[102] health services of the highest quality that promote and protect health and facilitate recuperation and rehabilitation, without discrimination.[103]

The National Health Secretary is responsible for promoting the progressive decentralization of the NHIS in the provincial jurisdictions, the City of Buenos Aires, and the national territory of Tierra del Fuego, Antarctica, and the South Atlantic Islands.[104] As such, the policies issued by MHSA must be aimed at "articulating and coordinating" health services, offered by all "health insurance agencies" — both in the public and private spheres — under a decentralized system and in accordance with the federal organization of the political system.[105]

Infrastructure of health services

The infrastructure of health services in Argentina is governed by NHIS regulations.[106] The provision of services by the NHIS must be in accordance with national health policies and must fully use the existing infrastructure to meet health needs.[107] The NHIS works through health insurance agents.[108] These agents are legally independent entities[109] that offer health services through a contractual system established by the

There is a National Register of Health Insurance Agents,[110] which accredits them.[111] "Social welfare associations" are the principal health insurance agents in the NHIS.[112] These associations are governed by a separate law[113] and are primarily composed of associations of workers affiliated with social security. These associations focus on funding health and social services.[114] Along with other entities under the NHIS, social welfare associations offer health care services either directly or through contracts with other institutions or individuals known as "health insurance providers."[115] The health insurance associations are expected to develop health service programs, some of which are established as obligatory by NHIA.[116] They also must ensure that their services provide the medicines required by such programs.[117]

The "health insurance providers" are the direct providers of health services.[118] They must be inscribed in the National Register of Health Care Providers.[119] All individuals, associations, or establishments, public or private, that assist with or provide health services; all associations that represent or contract services for their members; and those entities and private associations that offer direct medical services, must be included in the Register.[120]

Hospitals and other health care centers that depend on the government of Buenos Aires or the national territory of Tierra del Fuego, the Antarctic, and the South Atlantic Islands are also incorporated into NHIS as health care providers.[121] The provinces that form part of the NHIS do so through agreements with the National Health Secretary.[122] As such, the provinces are required to articulate their plans and programs according to NHIS guidelines and to comply with all technical and administrative requirements without ignoring adaptations in implementation that may render health services more appropriate for local circumstances.[123]

With regard to human resources, the average doctor-patient ratio in Argentina is one doctor per 376 inhabitants.[124] There is an average of one hospital bed per 227 patients.[125]

Cost of health services

National health care expenditure in 1996 was 3% of the total national budget.[126] The financing of health services offered by the NHIS comes from the following sources: (a) funds available to social welfare associations, which designate 80% of contributions to health services;[127] (b) the contributions reserved both in the provinces and in the National General Budget ("NGB") for the sector of the population lacking both financial resources and health coverage,[128] for which a special account was created known as the Common Redistribution Fund;[129] (c) the contribution by the National Treasury, determined by the NGB, to cover NHIS's additional financial needs;[130] and (d) contributions from the Solidarity and Redistribution Fund.[131]

Some provinces have established special rules to exempt certain sectors of the population from paying health care costs or contributing to social insurance. For example, in Rio Negro Province, there is a law providing that pregnant women who have no source of support or have only a partial source of support, have the right to free pre-and postnatal health care and to choose where they want to give birth. This assistance is provided by the Provincial Social Security Health Institute.[132]

Regulation of health care providers

The practice of medicine is primarily regulated by rules issued at the provincial level.[133] A law in existence since 1967, which is applicable in the federal capital and the national territory of Tierra del Fuego, Antarctica, and the South Atlantic Islands, regulates the practice of medicine, dentistry, and practices referred to as "activities collaborating in the practice of medicine."[134] This law delineates general professional obligations such as the obligation not to interrupt a patient's treatment until it is possible to send him or her to another professional or to a public facility;[135] the duty not to engage in medical procedures that have not been formally presented to or approved by the country's recognized institutions of medical science;[136] and the duty not to use secretly prepared products or products not authorized by competent authorities as part of medical treatment.[137] The Secretary of Public Health may impose sanctions against a health care provider if he or she violates this law.[138]

The Penal Code classifies the unauthorized practice of medicine as a crime against public health.[139] The relevant provisions penalize those who practice medical professions without a degree or a license and those who habitually exceed their authority in prescribing or applying medicine, solutions, electricity, hypnosis, or any other means used as treatment of persons with illnesses.[140] Additionally, those who are licensed and authorized to practice who promise to cure patients within a certain time frame or by secret or infallible means are also penalized[141] by fifteen days' to one year's imprisonment.[142] At the national level, the Medical Ethics Code,[143] approved by the Medical Conference of the Republic of Argentina, establishes ethical obligations for all medical professionals.[144] The Supreme Court of Justice has stated in its decisions that professional ethical codes carry great judicial weight and should not be limited in their application, since they serve to prevent the dehumanization of the healing arts.[145]

A 1991 law regulates health care in the capital city and in the areas under federal jurisdiction.[146] This law specifies the functions of health care providers as related to the prevention

of illnesses and to the promotion, recuperation, and rehabilitation of health.[147] The authority that administers this law is the Sub-Secretary of Health in the National Ministry of Health and Social Action.[148]

Patients' rights

In Argentine national legislation, a law enacted in 1967[149] and the medical ethics codes that regulate the medical profession determine the responsibilities of medical professionals toward patients.

According to the 1967 law, medical professionals are obligated to respect the will of their patients if they refuse medical treatment or to enter the hospital. The exceptions to this rule are cases of unconsciousness, psychological illness or grave wounds caused by accidents, suicide attempts, or crimes.[150] In "mutilating operations," the patient's written consent is required, except when the patient is unable to give consent and the operation is urgent, in which case, medical professionals must request the consent of the patient's representative.[151]

Both jurisprudence and scholarly studies have maintained the right of the patient to be informed about surgical procedures.[152] The patient should be fully aware of the nature and aims of the operation, the advantages and disadvantages, and the consequences to the patient if he or she decides not to have the surgery.[153] At a government level, patients' rights are protected by the MHSA, which is the highest national health authority under the National Health Secretary.[154] In each province there is a ministry and secretary of health that regulate the provision of health services.[155]

B. POPULATION, REPRODUCTIVE HEALTH, AND FAMILY PLANNING

Population laws and policies

Argentine governments have considered slow demographic growth to be a major geopolitical problem and thus have traditionally followed pronatalist policies.[156] In 1974, the government endorsed, "for the first time in an explicit manner, … a coercive approach to undermining the individual's right to regulate fertility."[157] In that year, the government enacted a decree that prohibited all activities related to voluntary birth control. The law provided for the monitoring of the commercialization and sale of contraceptives and established that they could be sold only with a medical prescription in triplicate.[158] Although the government campaign did not totally succeed and the prescription requirement was not fully implemented, sixty family planning centers were forced to close.[159]

In 1977, at the beginning of the last military dictatorship (1976–1983), the National Commission for Demographic Policies approved measures to combat any action appearing to support birth control.[160] The geopolitical issue of low population growth became the touchstone of the government's demographic policies.[161] At the end of the military dictatorship, the first democratic government (1983–1989) did not issue a population policy, but the limited statements it did make with respect to population issues were noteworthy because they did not refer to demographic trends as determining population policy.[162] At the end of 1986, the government issued a national decree, which is still in force, reinstating the individual's right to decide the timing and number of his or her children.[163] At the same time, it was established that MHSA, through the Secretaries of Health and Human and Family Development must take action to promote better maternal and infant health care, while also working to strengthen families.[164] In order to strengthen the ability of the population to exercise their right to decide about their reproductive lives, "with greater freedom and responsibility," the government began campaigns to disseminate information and counseling.[165] In the same year, the National Commission for Family and Population Policies was created within the Health Ministry. Two years later, the National Commission for Demographic Polices was dissolved and in its place the Inter-ministerial Commission for Population Policies was created and given a mandate to coordinate all governmental actions in this field.[166]

In the 1994 constitutional reform, the Constitution established as a responsibility of Congress, the provision of measures for human development and the harmonious growth of the population.[167]

Reproductive health and family planning laws and policies

National sphere

The current Argentine government issued reservations to the Platform for Action of the Fourth Women's World Conference held in Beijing in 1995 regarding the definition of "reproductive health." It was the government's view that the term as used in the platform includes abortion, illegal in Argentina, as a method of fertility regulation.[168] The government has also taken issue with "the link articulated between 'technology' and the reproductive roles of women [in that it] implies an acceptance of scientific developments that are not regulated in their ethical aspects."[169] The government has declared that, in Argentina, reproductive rights "are interpreted according to article 16 of the Convention on the Elimination of All Forms of Discrimination Against Women and paragraph 41 of the Vienna Declaration and Program of Action, endorsed at the World Conference on Human Rights (Vienna, 1993)."[170]

Considering that CEDAW has constitutional authority in Argentina and that the government interpreted article 16 of this Convention as governing its reproductive health policies, the government should ensure, equally for men and women,

"the same rights and responsibilities as parents"[171] and "the same rights to decide freely and responsibly on the number and spacing of their children and to have access to the information, education and means to exercise these rights."[172]

With respect to family planning, there is currently proposed legislation for a national law concerning responsible procreation.[173] It is pending passage by the National Congress and is "halfway there"[174] as it has been approved by the Chamber of Deputies.[175] The aim of this proposed legislation is to "contribute to the reduction in maternal and infant mortality and morbidity" and to "ensure that all citizens can freely and responsibly make procreative decisions."[176]

The objectives of national reproductive health policy are contained in a federal decree, issued in 1987, which establishes MHSA as the body responsible for the promotion of practices strengthening family development and improving maternal and children's health.[177] This decree guarantees the right of the population to make free and responsible decisions about reproduction.[178] The Coordinating Council for Public Policies on Women[179] is the body in charge of developing and promoting research and information to evaluate and improve health policies relating to women. The Council's principal mandate is to achieve compliance with the commitments made by Argentina when it ratified CEDAW.[180] The Council also develops projects and programs related to women's health.[181]

National programs related to women's reproductive health currently carried out in Argentina emphasize care and attention to mothers and pregnant women.[182] As such, in 1994, the Ministry of Health and National Social Action implemented the Maternal-Infant Nutrition Program.[183] The program's aim is to reduce maternal and infant mortality rates through "better focus, design, application and coordination" of programs and services relating to health, nutrition, complementary food, and infant development.[184] The execution of the program included the creation of various subprograms that specifically focus on the needs of women of reproductive age, adolescent mothers, care during pregnancy, and responsible procreation.[185] Also in 1994, the MHSA implemented the Women's Health and Development Program.[186] The aim of this program is to improve women's health through "making women more aware of culturally determined gender inequalities"; promoting and protecting the health of women and their families by disseminating basic information about health care; and better integrating women into development processes as a means to improve their health and quality of life.[187] This program involves carrying out training workshops throughout the country with different community organizations.[188] Through this program approximately 60,000 women have been trained as promoters of preventive health.[189]

Capital city and the provincial sphere

Buenos Aires and other provinces have their own reproductive health policies and legislation, as described below.

The Constitution of the City Buenos Aires[190] guarantees the right to comprehensive health care;[191] it establishes that health laws should promote responsible parenting;[192] and it ensures comprehensive health care for patients needing prenatal, maternal, and postnatal care services.[193] The Constitution also recognizes reproductive and sexual rights as basic human rights[194] and the right to be "free from coercion and violence" as a basic component of those rights. Particularly emphasized is the right "to responsibly decide about reproduction, the number of children and the interval between births."[195]

In 1996, the Chaco province created the Program on Responsible Human Procreation and Health Education.[196] The objective of the program is to train health professionals working in health institutions in areas such as sexuality and human reproduction.[197] The program also proposes to initiate campaigns on responsible parenting, responsible human reproduction, sexuality, and sexually transmissible infections ("STIs"). The program is designed to coordinate with public, private, and nongovernmental institutions.[198] All of this is to be done in accordance with existing national law.[199]

In 1995, the province of Entre Rios passed a law creating the Program on Responsible Procreation and Reproductive Health.[200] The aim of the program is to achieve a reduction in perinatal and maternal mortality rates and abortions; and to promote a sexuality that is "humane, loving and fulfilling and where neither partner fears unwanted pregnancy."[201] The program offers information and counseling on sex education, procreation, early detection of STIs, health consultations for the prescription of legal contraceptive methods, and training for community leaders and primary health workers.[202] It also proposes to reduce the disintegration of the family that results from "irresponsible and promiscuous relationships."[203]

The Provincial Reproductive Health Program was created by law in 1996, in the province of Mendoza.[204] Its specific objectives are the promotion of parental responsibility; the reduction of perinatal and maternal mortality rates; and the prevention of high-risk or unwanted pregnancies.[205] It also proposes to avoid abortions, to prevent STIs, and to improve the quality of life for parents and children.[206]

In province of Cordoba, a similar program to those described above was created by law, but it was vetoed by the provincial executive branch and was, therefore, returned to the provincial parliament for further discussion.[207] At the municipal level, some city councils have also created sexual and reproductive health programs, such as the Responsible Procreation Program in Rosario (Santa Fe province)[208] and the

Reproductive Health, Sexuality and Family Planning Program in the city of Cordoba (Cordoba province).[209]

Governmental delivery of family planning services

There is no national legislation regulating the provision and distribution of forms of contraception— with the exception of sterilization, which is prohibited under national law.[210] In 1986, the Argentine government committed itself to undertake "actions whose aim is to disseminate information and to make counseling services available in order that individuals can exercise their right to decide about reproduction with increased responsibility and freedom."[211] The provision of contraceptive methods was not included as part of this policy initiative, and there are no governmental programs[212] that offer information on contraceptives or contraceptive services.[213] In public health institutions and others supervised by the government, the provision of contraceptives as well as information about contraceptive methods continues to be restricted in practice.[214] When contraceptives are available from government-supported sources, their availability is irregular, sporadic, and dependent upon donations from foundations or pharmaceutical companies.[215]

Despite this situation, many municipal and provincial hospitals and health centers supply forms of contraception free of charge, particularly oral contraceptives.[216] These hospitals and centers provide family planning consultations or gynecological services that supply contraceptives, as well as information and advice about their use.[217]

In practice, in Argentina there is a double standard in the criteria regarding the provision of contraceptive services. In the public sector, political and legal restrictions and bans are "respected", whereas, in the private sector, contraceptives and related services are widely available,[218] but only to those who can pay.[219]

C. CONTRACEPTION

Prevalence of contraceptives

In Argentina, there are no recent official statistics measuring contraceptive prevalence. However, 1994 figures from the United Nations Populations Fund indicate that an average of 68.9% of Argentine women use some form of contraception.[220] According to a study by the National Statistics and Census Institute, carried out at the end of the 1980s, only 43.8% of Argentine women used some form of contraception. This figure was much lower among low-income women.[221]

Before contraception was banned in 1974, knowledge of methods of contraception in Buenos Aires was widespread: 97% of married women knew of at least one method of contraception, 78% declared that they had at some point used a method of contraception, and 63% were using contraception at the time of the interview.[222] The most commonly used methods in the 1960s were the condom and the withdrawal method,[223] but modern methods were coming into wider use by that time, as the pill was the third most commonly used form of contraception.[224] The data showed a correlation between women's socioeconomic status and their knowledge of contraceptive methods.[225] After this period, there is practically no official information on contraceptive prevalence or knowledge of contraception.

Recently, studies of small groups have been done. One such study was conducted with 123 working-class women, with two or three living children, who were primarily selected through general hospital registers in the northeast zone of greater Buenos Aires.[226] The study showed that up until the conception of the second or third child, 93 of the 121 women interviewed (77%) had used some form of contraception at least once.[227] The most commonly used contraceptive methods, in descending order, were the pill, the withdrawal method, injectable contraceptives, the condom, the rhythm method, intrauterine devices ("IUDs"), spermicides, and others.[228]

Legal status of contraceptives

Contraceptive methods are not explicitly regulated under Argentine law, except that sterilization is illegal as a method of family planning.[229] It is postulated by some that by not regulating contraception, the government is seeking to "avoid conflict with medical and church authorities opposing contraception."[230] As there is no express law allowing the distribution of contraceptives, hospitals must justify their acquisition of birth control pills as medicines necessary for the regulation of the menstrual cycle, and IUDs are placed under the heading of disposable items.[231]

Generally, the National Medicine Law[232] regulates the importation, exportation, production, manufacture, division, distribution, and marketing (both with respect to commerce in areas under federal jurisdiction and within or between provinces) of drugs, chemical products, medicines and any other product that is used as human medicine.[233] The MHSA oversees compliance with this law.[234]

Regulation of information on contraception

There are no laws that specifically prohibit the provision of information concerning methods of contraception and family planning.[235] However, the Argentine government has failed to implement activities related to the dissemination of information on and general support for family planning to which it committed itself in a 1986 presidential decree.[236]

Sterilization

Under Argentine law, sterilization is a crime. The Penal Code defines the infliction of both a "grave injury" resulting in permanent debilitation of a reproductive organ or limb[237] and a "very grave injury" resulting in the loss of the capacity to conceive or procreate as criminal.[238] The punishment for such acts is imprisonment for three to fifteen years.[239] However, sterilizations are performed on women whose lives are at risk, although this exception is not expressly provided for by law.[240] In such cases, in order to protect themselves from criminal liability,[241] doctors request the consent of the woman's spouse or partner before performing the surgery.[242] Even so, this procedure is left to the discretion of doctors or to judges when judicial authorization is sought. Recently, the Catholic Church and the Entre Rios provincial government opposed an authorization granted by the High Court of this province to a woman to have a tubal ligation performed after she gave birth. The High Court justified the permission because this woman had had her seventh child, suffered from diabetes and hypertension, and lived in extreme poverty.[243]

Recently passed provincial laws relating to reproductive health specifically prohibit sterilization as a contraceptive method, along with all forms of contraception considered abortifacients.[244] Furthermore, the proposed national law concerning "responsible procreation," which is under consideration by Congress,[245] provides that "methods of contraception must be reversible and transitory."[246]

D. ABORTION

Legal status of abortion

In Argentina, abortion is illegal and considered a crime against the person,[247] with two exceptions. These exceptions are, first, therapeutic abortion — an abortion carried out when the woman's life or health is in danger and when no other means can avoid such danger, and second, eugenic abortion — defined as when the pregnancy is the result of a rape, or of "indecent intercourse" with a mentally disabled woman.[248]

The Argentine government entered a reservation to Chapter II, Principle 1 of the Final Report of the Program for Action of the International Conference on Population and Development (Cairo, 1994). The government indicated that it would support the relevant provision, "taking into account that life begins at conception and from that moment the person…enjoys the right to life, that being the foundation of all other individual rights."[249] Referring to Paragraph 7.2 of Chapter VII of the Program of Action, the government declared that the Republic of Argentina would not accept "the inclusion of abortion as a health service or as a method of regulating fertility" as part of the concept of reproductive rights.[250]

The Civil Code of the Republic of Argentina provides that a person's existence begins at conception, enabling the unborn to acquire certain rights "as if they had already been born."[251]

Requirements for obtaining a legal abortion

Therapeutic abortion requires the woman's consent and eugenic abortion requires consent from the woman's legal representative.[252] A licensed doctor is the only person who can perform either procedure.[253] The Argentine government does not fund or subsidize abortion services and the large number of illegal abortions in Argentina are performed clandestinely.[254]

Penalties for abortion

A woman who induces her own abortion or agrees to let another perform it is subject to one to four years' imprisonment.[255] Anyone who provides an abortion without the consent of the woman is sentenced to three to ten years in prison; when the pregnant woman consents to the abortion, the penalty is reduced to one to four years. In both cases, if the woman dies, the prison terms increase to fifteen and six years, respectively.[256]

Doctors, surgeons, midwives, or pharmacists who use their professional skills to perform or induce an abortion or who receive payment to cooperate, are subject to the same terms of imprisonment, plus professional suspension for double the time of the prison sentence.[257]

Anyone who causes an abortion through violence, without intending to do so, when the pregnancy is either evident or the person knew of the pregnancy, is punishable by six months to two years in prison.[258]

E. HIV/AIDS AND SEXUALLY TRANSMISSIBLE INFECTIONS (STIs)

Examining HIV/AIDS issues within a reproductive health framework is essential insofar as both are closely related from the medical and public health standpoints. Furthermore, a complete evaluation of the laws and policies that affect reproductive health in Argentina must examine the status of HIV/AIDS and STIs, because of the dimension and implications of both diseases as reflected in the following statistics. In 1990, there were 1,079 cases of hospitalization for STIs: 778 cases of syphilis, 169 cases of gonorrhea, and 122 of other STIs.[259] Women represented 52%, 48%, and 64%, respectively, of those hospitalized.[260]

Through April 1994, 3,761 cases of HIV/AIDS were reported, pursuant to a law requiring such reporting, 15.3% of which (577 cases) were women.[261] AIDS cases are increasing in Argentina. In 1996, there were 19% more patients than the previous year, which represents 20% of the total number of cases reported since the beginning of the epidemic.[262] The male-female ratio of AIDS sufferers has varied. In the beginning it seemed to be an epidemic almost exclusively affecting men,

but the number of women affected is growing steadily. In 1988, the ratio of men to women was 12.6 to 1;[263] by 1996, it had dropped to 3.6 to 1.[264] Despite the fact that around 30% of all cases are not reported — it is estimated that between 100,000 and 150,000 people are infected with HIV/AIDS in Argentina[265] — existing data demonstrates that certain behaviors, such as unprotected heterosexual intercourse, are increasingly becoming the primary means of HIV transmission.[266]

Laws on HIV/AIDS and STIs

A federal law concerning the issue of HIV/AIDS[267] declares it to be in the national interest to research the cause of HIV/AIDS and its diagnosis and treatment as well as its prevention, treatment, and rehabilitation. It also specifies measures to prevent its transmission, giving priority to popular education.[268] The law also provides that the disease should not be allowed to affect the dignity of the person; anyone with the disease must not be discriminated against or degraded; breaches of patient confidentiality must not occur, except as mandated by law; the right to privacy must not be invaded, such as by identifying individuals in files or other stored information; and patient information should be coded.[269] The authority charged with implementing and enforcing this law is the MHSA, through the Health Sub-Secretary.[270]

The law provides that the government must develop programs aimed at achieving certain objectives, such as promoting training and research, educating the population about the characteristics of AIDS, its possible causes and means of transmission, and implementing measures to prevent infection and ensure appropriate treatment.[271] It is obligatory to screen for the virus and its antibodies in human blood given for transfusion or in plasma and other human blood derivatives used for medical treatment.[272] Health professionals who detect the HIV virus or have grounds to believe that an individual is carrying the virus are required to inform the carrier about the nature of the virus, the ways of transmitting it, and their right to receive appropriate treatment.[273] Those diagnosed with the virus must be notified within forty-eight hours of confirmation of such diagnosis.[274] The law establishes penalties for those that commit acts or omissions that violate the preventive norms or rules outlined in the law.[275]

There is a provision in the Penal Code that makes it a crime punishable by three to fifteen years of imprisonment for anyone to knowingly infect another person with a transmissible venereal disease.[276]

Policies on prevention and treatment of HIV/AIDS and STIs

The Argentine government has established the National Program to Combat HIV/AIDS.[277] MHSA manages the program and carries out its main objective — an intense prevention campaign carried out through television.[278] The program also seeks to incorporate the prevention of HIV/AIDS into the curricula at the primary, secondary and post-secondary levels of education.[279] To accomplish this, the Ministry of Culture and Education urges the governments of the provinces and the City of Buenos Aires to comply with this directive.[280]

Social welfare associations[281] and other affiliated agencies of the National Health System are required to provide medical, psychological, and drug treatment to people infected with the various human retro viruses, especially to those who suffer from AIDS. They are also required to implement AIDS prevention programs.[282] The program also provides that health care providers, along with the MHSA, must establish programs to cover certain requirements of the law. The national budget is supposed to set aside specific funds to meet these requirements.[283]

However, to date, the medical, psychological care, and drug treatment for people with AIDS who rely on the public sector is extremely deficient. This is especially true with respect to the supply of medication, given its high cost.[284] Despite the legal provisions in force, the coverage offered by social welfare associations and other health care providers is limited.[285]

III. Understanding the Exercise of Reproductive Rights: Women's Legal Status

Women's health and reproductive rights cannot be fully evaluated without analyzing women's legal and social status. Not only do laws relating to women's legal status reflect societal attitudes that will affect reproductive rights, but such laws often have a direct impact on women's ability to exercise reproductive rights. The specific characteristics of family life and couple relations, as well as women's educational level and their access to economic resources and legal protection, determine women's ability to make decisions about their reproductive health care needs and to exercise their right to obtain health care services.

The 1994 constitutional reform incorporated provisions intended to implement the principle of equality for "all the nation's inhabitants."[286] The Constitution provides that "real equality of opportunity for men and women for elected and party posts will be guaranteed through affirmative action measures in political parties and in the electoral regime."[287] Even before the constitutional reform, a quota law existed,[288] which resulted in an increase of women in the National Chamber of Deputies from 5.8% of the total in 1991 to more than 28% in

March 1997.[289] The law is still in force and now has constitutional backing.[290]

A. CIVIL RIGHTS WITHIN MARRIAGE

Marriage law

The provisions concerning marriage contained in the Civil Code of the Republic of Argentina ("Civil Code")[291] have been partially amended during recent years, principally to eliminate provisions that discriminate against women. However, some discriminatory laws remain that govern relations between partners.

Spouses must be mutually faithful and must support and assist each other.[292] They must live together in the same house in a mutually agreed upon location.[293] Each partner retains free management and disposition of his or her own property and earnings acquired through his or her work.[294] The consent of both partners is required in order to dispose of or encumber joint property acquired during marriage, real estate or registered personal property, or other property or tenure rights on real estate or registered personal property.[295] The consent of both spouses is also required for the disposal of real estate belonging to one of the partners, when young or disabled children reside therein as the family residence.[296] Married women may add their husbands' last name to their own if they wish to do so.[297]

On the other hand, the law gives the husband control of property whose ownership is uncertain or impossible to determine.[298] The law does not permit a woman to dispute the presumption of her husband's paternity of her children.[299] In addition, the Civil Code still has a provision assuming women feel "reverential fear" of their husband.[300]

Regulation of domestic partnerships

There are no specific laws governing domestic partnerships. These "concubines" or partners[301] have almost no legal protection in Argentina. Couples who live together in such a partnership do not have the same rights as men and women who are legally married.[302]

However, there are two cases where Argentine law grants domestic partners certain rights. Labor legislation[303] recognizes the right of such partners to receive a pension if their partner dies, provided the deceased was single, widowed, or legally separated or divorced, and the couple has lived together for a minimum of five years or has a child acknowledged as the product of their union.[304] In 1989, a law was passed that institutes a monthly, nonattachable, lifetime pension for mothers of seven or more children, whatever their age or marital status.[305]

Divorce and custody law

The Civil Code regulates separations — in which the marriage is not dissolved — and binding divorces.[306] The reasons for separation are adultery; grave slander; voluntary and malicious abandonment; an attack on the life of one of the spouses or the children by the other spouse (whether as the principal author, accomplice, or abettor); and when one of the spouses encourages the other to commit a crime.[307] The Civil Code considers a generic case for separation to be established if, after two years of marriage, the partners appear before a judge to jointly request a separation, stating significant reasons that make life together morally impossible.[308] In 1987, the Civil Code incorporated divorce following a joint petition or through mutual agreement.[309]

The law provides that the spouse who caused the separation or divorce must give assistance or alimony to the other.[310] When no one is declared responsible, the partner who does not have sufficient personal funds or the possibility of acquiring funds has the right to alimony when the other partner can afford it.[311] Mothers obtain maintenance for their children who are under 5 years old, except when it would be contrary to the interests of the child. Where the parents cannot agree on custody, the children over that age live with the parent whom the judge considers most suitable.[312] The parent who has legal custody of the children exercises parental authority, but without prejudice to the other parent's right to have sufficient contact with the children and to supervise their education.[313]

B. ECONOMIC AND SOCIAL RIGHTS

Property rights

Women can hold, manage, transfer, and inherit property without any legal restriction, except the restriction on the disposal and encumbrance of joint property when it is real estate, rights related thereto, or registered assets. In such cases, the law requires the consent of both partners.[314]

Labor rights

The Constitution provides that all citizens enjoy the right to work[315] and establishes the principle granting "equal remuneration for equal work."[316] The Argentine government has also ratified, among others, the International Labor Organization's conventions relating to equality of remuneration for men and women for work of equal value (No. 100);[317] to employment discrimination (No. 111);[318] and to workers with family responsibilities (No. 156).[319]

In 1995, the government created the Special Procedure to Promote Employment, whose purpose was to encourage employers to contract those who have the most difficulty entering the labor market, including women, by granting

employers incentives such as 50% exemptions from social security contributions.[320]

The Labor Contract Law[321] prohibits any type of discrimination against workers on account of sex, race, nationality, religion, age, and political or professional association.[322] The law codifies the prohibition on establishing differences based on sex in remuneration for work of equal value,[323] and prohibits dismissal due to marriage.[324] The law bans women from performing difficult, dangerous, or unhealthy work.[325]

Pregnant women workers are specially protected by labor legislation that prohibits women from working forty-five days before and forty-five days after giving birth.[326] The law establishes a legal presumption that the dismissal of pregnant women during the seven and one-half months before and after a pregnancy considers pregnancy to be the cause of the dismissal.[327] In such a case, the law orders special indemnity payments to the woman equivalent to one year's remuneration.[328] In order for this presumption to apply, the law requires that a woman formally advise her employer that she is pregnant.[329] Following maternity leave, the woman can opt to return to work, rescind her employment contract, or take a leave of absence for a term of no less than three months and no more than six.[330] Where a woman elects to take a leave of absence, the employer must hold the post open during this period.[331] A working mother has the right to two half-hour breaks per day, in order to breast-feed her child.[332] To facilitate this, the employer must provide maternity rooms and nurseries in good condition for children until they reach an appropriate age.[333] The labor law grants the father two days off work for the birth of a child.[334]

Access to credit

Legally, men and women have equal access to bank loans, mortgages, and other forms of credit. In practice, the requirements established by the banking system result in sex-based differences.[335] To combat this, nongovernmental organizations of business women as part of the Global Credit Program for Micro and Small Businesses, organize courses in business management for women under the auspices of the Secretary of Industry and the National Women's Council.[336]

Through December 1996, the Credit and Technical Support Program for Small Agricultural Producers of Northeast Argentina had given 1,040 credits to women in rural areas, who represented 14.6% of those provided loans under the program.[337]

Access to education

In 1991, statistics on access to and attendance in the school system revealed that 4.7% of eligible students did not attend school.[338] Divided by gender, 4.5% of boys and 4.9% of girls did not attend school.[339] In 1997, the National Ministry for Culture and Education initiated a Long Distance Program for Adults to Finish Primary School. The aim is to enable all Argentine citizens to become literate.[340]

At the national level, the government is developing the National Program for Equal Opportunities for Women in the Education Sector.[341] In its first stage, the program has focused on eliminating discriminatory stereotypes in teaching materials and using nonsexist language in the Federal Education Law.[342] Currently, a women's section has been formed in the Ministry of Education to secure and strengthen equality of men and women in all areas of the educational system.[343]

Women's bureaus

Governmental institutions have been formed to implement gender policies and to promote women's status. In 1992, the National Women's Council ("NWC")[344] was formed to implement the Convention on the Elimination of all Forms of Discrimination Against Women and to facilitate women's participation as much as possible in all spheres of life.[345] NWC has its own budget.[346] Within the Ministry of Foreign Relations, International Business and Culture, the Office of Human and Women's Rights is in charge of international relations regarding women's issues.[347] In the Ministry of Labor and Social Security, there is a separate Women's Department that is under the National Employment Office.[348]

An office on women exists in sixteen of the provinces, each of which seeks to develop public policies on the status of women.[349] There is a council on women operating within the government of the Buenos Aires municipality. Political and economic changes in the provinces have particularly affected the continuity and institutionalization of women's bureaus.[350] Women's institutions in the various provinces develop differently, as evidenced by the distinct formulations and applications among the provinces of public policies for women.[351] For example, in the Misiones province, the office on women has ministerial rank; in Mendoza, the Women's Institute has engendered significant development and change for women; in Tucumán, the office on women ranks equally with the Secretary of State and is dedicated specifically to women's issues without also having responsibility for other areas such as family and disability issues, among others, which is the situation in the majority of the provincial offices on women.[352]

C. RIGHT TO PHYSICAL INTEGRITY

Rape

The crime of rape, together with statutory rape and other sexual offenses committed against adolescents and minors, is regulated under the title "Crimes against Decency" in the Argentine Penal Code.[353] The punishment for rape is six to fifteen years of imprisonment.[354] This punishment also applies to

those who have carnal intercourse using force or intimidation with a person of either sex, or for whomever has carnal intercourse with a person of either sex who is mentally disabled, unconscious, or who, because of illness or for any other reason, could not resist.[355] The punishment is increased when the health of the victim is severely impaired, when the crime is committed by a parent, grandparent, child, grandchild, sibling, other relative, priest, teacher, or guardian of the victim; or if the victim is raped by two or more people.[356] In these cases, the punishment increases to eight to ten years of imprisonment.[357] If the victim dies as a result of the rape, the punishment is between fifteen and twenty-five years' imprisonment.[358]

The Penal Code provides that a person convicted of rape, statutory rape, abduction for sexual purposes, or indecent assault of a single woman will be exempt from punishment if he marries the victim, with her consent.[359]

Sexual harassment

The only legal norm relating to sexual harassment is a decree in force in the field of public administration. It defines sexual harassment as "an act by an official who, in carrying out his or her duties, takes advantage of a superior relationship and compels the other party to agree to sexual requests, whether or not carnal access results."[360] Sexual harassment complaints and accusations can be made in accordance with general procedures in force for labor-related complaints or before the person responsible for this issue in the human resources department of the respective institution.[361] The above-mentioned decree only applies to those in paid employment in offices of the national executive branch or its legally decentralized entities. However, a long list of officials is immune from this rule: ministers and secretaries of the national executive branch; secretaries under the presidency; subsecretaries and other persons who have an equivalent rank to the posts mentioned; active diplomatic personnel; active security force and police personnel; official clergy; teaching staff covered by special statutes; and those in high-level positions in decentralized institutions.[362] Therefore, the scope of coverage of this regulation is very limited.

Within the Labor Contract Law, there are generic rules that protect workers' psychological and physical integrity and dignity.[363]

Domestic violence

The National Law for Protection against Family Violence, promulgated in December 1994,[364] regulates acts of domestic violence, defining them as "physical or psychological abuse or injury" committed by one member of the family against another.[365] The victim can denounce acts of violence to a family law judge, verbally or in writing, and request protective measures.[366] Once the judge has heard the facts of the complaint, he or she may order that the author of the violence be removed from the family home; ban the perpetrator from entering the home and the place of work or study of the victim; order the return to the home of those who may have had to leave for personal security reasons, except for the perpetrator; decree provisional maintenance, custody, and communication rights with the children.[367] The law requires that within forty-eight hours of the adoption of such precautionary measures the judge convoke a mediation hearing with the parties and the district attorney, urging the parties and the family group to participate in educational and therapy programs.[368] In this way, the victim of domestic violence is forced to participate in a mediation hearing with the aggressor.[369]

Domestic violence complaints must be reported to the National Council for the Family and Minors so that private and public services may be coordinated to overcome and prevent further mistreatment, abuse, and other types of violence within the family.[370] In March 1996, the government signed a decree implementing the aforementioned law, providing for the creation of information and counseling centers for physical and psychological violence. The aim of these centers is to provide consultation and guidance to those who present complaints under the existing law concerning the resources available for the prevention of and attention to family violence.[371]

IV. Focusing on the Rights of a Special Group: Adolescents

The needs of adolescents are frequently ignored or neglected. Given that 31% of the Argentine population is below the age of 15,[372] it is particularly important to meet the reproductive health needs of this group. The effort to address issues of adolescent rights, including those related to reproductive health, are important for the right to self-determination and health of women in general.

A. REPRODUCTIVE HEALTH AND ADOLESCENTS

Laws and polices relating to the reproductive health of adolescents are scarce and insufficient. Therefore, health workers find it very difficult to offer reproductive health services to adolescents. Because of the lack of statistics defining the scope of the issue, as well as laws or policies that explicitly regulate the provision by reproductive health services to adolescents, health care providers do not consider it legitimate to offer such services without the consent or authorization of the parents.[373] It is even more difficult for them to provide adolescents with information on and access to contraceptives. There are no specific programs aimed at adolescents on issues of reproductive health, STIs, HIV/AIDS or unwanted pregnancies. Messages concerning these themes have been repressive and lacking in information.[374]

Some provinces have made efforts to address the needs of pregnant adolescents. For example, in 1992, the legislature of Catamarca province passed a law offering free medical attention to pregnant adolescents who are not covered by health insurance.[375] The executive branch in this province provides prenatal care, including nutritional supplements and vitamins to the mother and covers the costs of normal delivery or cesarean operation.[376]

B. MARRIAGE AND ADOLESCENTS

The average age of marriage in 1980 was 22.7 years.[377] The minimum legal age for marriage is 16 for women and 18 for men.[378] Marriage can be validated at an earlier age with judicial permission if there are exceptional circumstances and only if it is considered to be in the interest of the minors.[379] In order to obtain permission a hearing is required with those that intend to marry and the parents or legal guardians of the minor.[380] As the age of majority in Argentina is 21, women between 16 and 21 and men between 18 and 21 who wish to marry, even though they are of age under the marriage laws, must have either parental consent, or consent from the person exercising parental authority or, failing that, from a judge.[381]

C. SEXUAL OFFENSES AGAINST ADOLESCENTS AND MINORS

Rape of a girl under 12 years of age is punishable under the Penal Code by six to fifteen years of imprisonment.[382] "Statutory rape" is the crime that occurs when a "'decent' or 'chaste' girl between 12 and 15 years" has sexual relations with someone, even if she has consented.[383] Thus, statutory rape applies to voluntary sexual relationships with young women between 12 and 15 and is punishable by three to six years' imprisonment,[384] provided the young women is considered decent. Jurisprudence has indicated, in some contexts, that "decency" is synonymous with virginity.[385] Other legal opinions hold that decency requires appropriate conduct, and, as such, those who go out at night, those who behave improperly with a number of men, those who abandon their parental home, and who spend considerable amounts of time or sleep over either at a male friend's home or in places of ill-repute should be considered "indecent."[386]

D. SEXUAL EDUCATION

There are no national-level laws or policies related to sexual education. The current government has assumed a conservative position on this issue. This is evidenced by its express reservations regarding the Platform for Action of the Fourth Women's World Conference on Women in Beijing, stating that references to mandatory sex education contained in the plan do not alter the primary responsibility of parents to educate their children, in accordance with Article 5 of the Convention on the Rights of the Child.[387]

ENDNOTES

1. THE WORLD ALMANAC AND BOOK OF FACTS 1997, at 739 (1996).
2. Id.
3. Id.
4. National Constitution of Argentina, Santa Fe, Paraná. Approved by the General Constitutional Congress, May 1, 1853, reformed 1860, 1866, 1898, 1957, and 1994. Published in the Official National Bulletin (B.O.), Year CII, No. 29,759, Aug. 23, 1994, art. 2. (hereinafter ARG. CONST.).
5. THE WORLD ALMANAC, supra note 1, at 739.
6. Id., at 741.
7. Id.
8. Id., at 739.
9. Id., at 740.
10. Id.
11. Id.
12. Id.
13. Report of the Government of Argentina before the Committee on the Elimination of Discrimination Against Women ("CEDAW"), Third Periodic Report by States Parties to the Convention on the Elimination of All Forms of Discrimination against Women, Oct. 8, 1996, U.N. Doc. CEDAW/C/ARG/3, Spanish original (hereinafter Report of Argentina before CEDAW 1996) at 4.
14. Id., at 5.
15. THE WORLD ALMANAC, supra note 1, at 740.
16. ARG. CONST., art. 1.
17. Report of the Government of Argentina before the Committee on the Elimination of Discrimination Against Women ("CEDAW"), Second Periodic Reports of States Parties, U.N. Doc.CEDAW/C/ARG/2/Add.2, Aug. 18, 1994, Spanish original, at 10 [hereinafter Report of Argentina before CEDAW 1994].
18. See footnote 4.
19. Report of Argentina before CEDAW 1994, supra note 17, at 10.
20. ARG. CONST, art. 121. See also, Report of Argentina before CEDAW 1996, supra note 13, at 2.
21. ARG. CONST., art. 4.
22. Id., art. 6.
23. Id., art. 3.
24. Report of Argentina before CEDAW 1994, supra note 17, at 10.
25. Id.
26. ARG. CONST., art. 100.
27. Id., art. 99, cl. 1.
28. Id., cl. 3.
29. Id., art. 94.
30. Id., art. 90.
31. Id., art. 99, cls. 10 and 17.
32. Id., cl. 7.
33. Id., cl. 11.
34. Id., cls. 12 and 14.
35. Id., cl. 15.
36. Id., art. 100.
37. Id.
38. Id., art. 100, cl. 1.
39. Id., art. 101.
40. Id.
41. Id.
42. ARG. CONST, art. 44.
43. Id., art. 45.
44. Id.
45. Id., art. 54.
46. Id., art. 75, cl. 12.
47. Id.
48. Id., cls. 1, 2, 3, 6, 12, 19 and 23.
49. Id., cl. 23, first ¶.
50. Id.
51. Id.
52. Id., second ¶.
53. Id., art. 75, cl. 22, first ¶.
54. Id., cl. 20.
55. Id., art. 17.
56. Id., art. 108.
57. Id.

58. *Id.*
59. *Id.*, art. 110.
60. *Id.*, art. 99, cl. 4.
61. *Id.*, art. 112.
62. *Id.*, art. 116.
63. *Report of Argentina before CEDAW 1994*, at 8.
64. ARG. CONST, art. 86.
65. *Id.*
66. *Id.*
67. *Id.* Laws No. 24.284 and 24.379 (n.d.) regulate the operation and organization of the Ombudsman.
68. *Id.* The Argentine Constitution recognizes the institutional autonomy of the city of Buenos Aires which is the capital of the Republic.
69. ARG. CONST, art. 121.
70. *Report of the Government of Argentina before the Committee on the Elimination of Discrimination against Women ("CEDAW")*, U.N. Doc. A/52/38/Rev. 1, Jul. 22, 1997 (hereinafter *Report of Argentina before CEDAW 1997*) at 2.
71. *Id.*, art. 5.
72. *Report of Argentina before CEDAW 1996*, supra note 13, at 8.
73. ARG. CONST, art. 122.
74. *Id.*, art. 123.
75. *Id.*, art. 124.
76. *Id.*, art. 8.
77. *Id.*, art. 7.
78. *Id.*, art. 8.
79. *Id.*, art. 9.
80. *Id.*, art. 10.
81. *Id.*, art. 75, cl. 22. The Argentine Constitution recognizes the constitutional authority of the following human rights treaties: The American Declaration of the Rights and Duties of Man, *adopted* 1948, OEA/SER.L.V/II.92 Doc. 31 rev.3 May 3, 1996; The Universal Declaration of Human Rights, *adopted* Dec. 10, 1948; The American Convention on Human Rights, *signed* Nov. 22, 1969, 9 I.L.M. 101 (entry into force Jul. 18, 1978); The International Covenant on Economic, Social and Cultural Rights, *adopted* Dec. 16, 1966, 993 U.N.T.S. 3 (*entry into force* Sept. 3, 1976); The International Covenant on Civil and Political Rights, *adopted* Dec. 16, 1966, 999 U.N.T.S.171 (*entry into force* Mar. 23, 1976) and Optional Protocol to the International Covenant on Civil and Political Rights, *adopted* and *opened for signature* Dec. 16, 1966, 6 I.L.M. 383 (1967) (*entry into force* Mar. 23, 1976); The Convention on the Prevention and Punishment of the Crime of Genocide, *approved and proposed for signature* Dec. 9, 1948, 28 I.L.M. 761 (1989) (entry into force Jan. 12, 1951); The International Convention for the Elimination of All Forms of Racial Discrimination, *opened for signature* Mar. 7, 1966, 660 U.N.T.S. 195 (*entry into force* Jan. 4, 1969); The Convention on the Elimination of All Forms of Discrimination Against Women, *opened for signature* Mar. 1, 1980, 1249 U.N.T.S. 13 (*entry into force* Sep. 3, 1981); The Convention Against Torture and Other Cruel, Inhuman or Degrading Treatment or Punishment, *concluded* Dec. 10, 1984, S. Treaty Doc. 100–20, 23 I.L.M. 1027(1984), *as modified* 24 I.L.M. 535 (*entry into force* Jun. 26, 1987); The Convention on the Rights of the Child, *opened for signature* Nov. 20, 1989, 28 I.L.M. 1448 (*entry into force* Sept. 2, 1990). *See also Report of Argentina before CEDAW 1997*, supra note 68, at 19.
82. ARG. CONST, art. 75, cl. 22.
83. *Report of Argentina before CEDAW 1997*, supra note 68, at 19.
84. ARG. CONST, art. 75, cl. 22.
85. *Id.*, cl. 24.
86. Instituto Género y Desarollo [Gender and Development Institute], Rosario, Argentina, Draft chapter on Argentina, at 5 (1997) (on file with CRLP).
87. *Id.*
88. ARG. CONST, art. 31.
89. *Id.*, art. 75, cl. 22.
90. *Report of Argentina before CEDAW 1997*, supra note 68, at 19.
91. Among other treaties, the Argentine government has signed and ratified the following international conventions for the protection of human rights: The International Convenant on Civil and Political Rights (ratified by Argentina on Aug. 8, 1986), supra note 81; The International Convenant on Economic, Social and Cultural Rights (ratified by Argentina on Aug. 8, 1986), *supra* note 81; The International Convention for the Elimination of All Forms of Racial Discrimination (ratified by Argentina on Oct. 2, 1968), *supra* note 81.
92. The Argentine government has signed and ratified the following regional conventions: The American Convention on Human Rights (ratified by Argentina on Sep. 5, 1984), *supra* note 81; The Inter-American Convention to Prevent and Punish Torture, *adopted* Feb. 28, 1987 OEA/SER.L.V/II.92 doc. 31 rev. 3 May 3, 1996 (ratified by Argentina on Mar. 31, 1989); The Inter-American Convention on the Forced Disappearance of Persons, *adopted* Mar. 28, 1996 OEA/SER.L.V/II.92 doc. 31 rev. 3 May 3, 1996 (ratified by Argentina on Feb. 28, 1996).
93. Approved by Law No. 24,632 (B.O. Apr. 9, 1996).
94. *Report of Argentina before CEDAW 1996*, supra note 13, at 4.
95. Ley de Creación del Sistema Nacional de Seguro de Salud [Law for the Creation of a National Health Security System], Law No. 23,661, B.O. Jan. 20, 1989 (hereinafter Health Security Law).
96. *Id.*
97. *Id.*, art. 1.
98. *Id.*, art. 3.
99. *Id.*, art. 7.
100. *Id.*, art. 9.
101. *Id.*, art. 1.
102. *Id.*, art. 2.
103. *Id.*
104. *Id.*, art .4.
105. *Id.*, arts. 3 and 4.
106. *Id.*, chapters IV and VI.
107. Health Security Law, supra note 95, art. 25,.
108. *Id.*, art. 2, second ¶ and chapter IV.
109. *Id.*, art. 2, second ¶. *See also* Ley de Obras Sociales [Social Welfare Agency Law], Law No. 23,660 (B.O. Jan. 20, 1989), arts. 2, 3 and 4.
110. Social Welfare Agency Law, supra note 109, art. 7 and 27,.
111. Health Security Law, supra note 95, art. 17.
112. *Id.*, art. 15.
113. Social Welfare Agency Law, supra note 109, art. 3.
114. *Id.*
115. Health Security Law, supra note 95, arts. 26, 27 and 29.
116. *Id.*, art. 28.
117. *Id.*
118. *Id.*, art. 29, cl. e. "Those persons or entities that offer services through third parties, cannot be included in the Register of Health Insurance Agents nor receive payment for services rendered."
119. *Id.*, art. 29.
120. *Id.*
121. *Id.*, art. 30.
122. *Id.*, art. 48.
123. *Id.*
124. THE WORLD ALMANAC, supra note 1, at 740.
125. *Id.*
126. UNITED NATIONS POPULATIONS FUND (UNFPA), THE STATE OF THE WORLD POPULATION 1997, at 72 (1996).
127. Health Security Law, supra note 95, art. 21, cl. a.
128. *Id.*, cl. b.
129. *Id.*, art. 22.
130. *Id.*, art. 21, cl. c.
131. *Id.*, cl. d. This Fund is composed of: (a) 10%–15% of contributions from social welfare associations, according to whether or not the members of the association are management personnel; (b) 50% of social welfare association resources designated for services other than health; (c) amounts reassigned from financial contributions and their interest; (d) amounts from fines for infringements of NHIS law; (e) income from investments made with assets from the Fund; (f) subsidies, bequests and donations and other assets given to the Fund; (g) contributions from NGB; (h) 5% of the total income of the National Institute for Social Services for Retired Persons and Pensioners; (i) contributions agreed upon with social welfare agencies and other provincial associations which support the NHIS; (j) the balance from the liquidation of the Redistribution Fund, created by Law No. 22,269, as well as credits assigned to it. Health Security Law, supra note 95, art. 22, cls. a–k.
132. Law No. 1860 of Río Negro Province, B.O. Aug. 27, 1994.
133. Draft chapter on Argentina, supra note 86, at 36.
134. Law No. 17.132, B.O. Jan. 31, 1967. This law also regulates duties and restrictions on the following professionals: obstetricians; kinesiologists; physical therapists; occupational therapists; opticians; dietitians; radiology assistants; psychiatric assistants; laboratory assistants; anesthesiology assistants; and speech therapists, among others.
135. *Id.*, art. 19, cl. 2.
136. *Id.*, art. 30, cl. 7.
137. *Id.*, art. 20, cl. 8.

138. Draft chapter on Argentina, *supra* note 86, at 37.
139. The Republic of Argentina Penal Code, Law No. 11,719, text codified by Decree No. 3992, Dec. 21, 1984 (B.O. Jan. 16, 1985), art. 208. (hereinafter PENAL CODE).
140. *Id.*
141. *Id.*
142. *Id.*
143. The Medical Ethics Code was passed on April 17, 1955, by the Medical Conference of the Republic of Argentina.
144. *Id.*
145. SUSANA ALBANESE, CASOS MÉDICOS: RELACIONES JURÍDICAS EMERGENTES DEL EJERCICIO DE LA MEDICINA [MEDICAL CASES: EMERGING JUDICIAL RELATIONS IN THE PRACTICE OF MEDICINE] 64 (1994).
146. Law No. 24.004, B.O. Oct. 28, 1991.
147. *Id.*
148. *Id.*
149. Law No. 17.132, B.O. Jan. 31, 1967.
150. *Id.*, art. 19, cl. 3.
151. *Id.*
152. MEDICAL CASES, *supra* note 145, at 55–56.
153. *Id.*
154. Draft chapter on Argentina, *supra* note 86, at 69.
155. *Id.*
156. *Id.*, at 38.
157. SUSANA TORRADO, PROCREACIÓN EN LA ARGENTINA: HECHOS E IDEAS [PROCREATION IN ARGENTINA: FACTS AND IDEAS] 274 (1993).
158. Decree No. 659/74 (n.d.).
159. MARIA CHRISTINA GRANERO, MÉTODOS ANTICONCEPTIVOS. MITOS Y REALIDADES EN DERECHOS O DEBERES REPRODUCTIVOS [FORMS OF CONTRACEPTION, MYTHS AND REALITIES IN REPRODUCTIVE RIGHTS AND OBLIGATIONS] 10 (CLADEM, n.d.).
160. Decree No. 3.938/77 (n.d.).
161. Juan Jose Llovet and Silvina Ramos, *La Planificación Familiar en la Argentina: Salud Pública y Derechos Humanos* [Family Planning in Argentina: Public Health and Human Rights] 38 J. SOC. MED. OF THE CENTER FOR HEALTH STUDIES 27 (Dec. 1986).
162. REPRODUCTION IN ARGENTINA, *supra* note 157, at 276.
163. Decree No. 2.274 (B.O. Mar. 27, 1987).
164. *Id.*, art. 1. This decree revokes Decree No. 659/74 promulgated during the military dictatorship.
165. *Id.*, art. 2.
166. Draft chapter on Argentina, *supra* note 86, at 40.
167. ARG. CONST, art. 75, cl. 19.
168. Draft chapter on Argentina, *supra* note 86, at 42.
169. *Id.*
170. *Id.*
171. The Convention on the Elimination of All Forms of Discrimination Against Women, *supra* note 81, art. 16, cl. 1, ¶ d.
172. *Id.*, ¶ e.
173. Proposal for National Law on Responsible Reproduction. No. 20.014/95 (n.d.). This proposal relates to the creation of the National Program for Responsible Reproduction, which would be the responsibility of the National Ministry of Health and Social Action.
174. This means that the proposal must still be considered and passed by the National Senate.
175. *Report of Argentina before CEDAW 1996*, *supra* note 13, at 39.
176. Proposal for National Law on Responsible Reproduction, art. 1.
177. Decree No. 2274, B.O. Mar. 27, 1987, art. 2.
178. *Id.*
179. Decree No. 378/91, Mar. 1991. More detail about its function in Women's Bureaus section.
180. *Id.*
181. *Report of Argentine before CEDAW 1994*, *supra* note 17, at 16 and 17. In 1994, the council reported on two projects "aimed at obtaining technical and financial assistance from international organizations." The first is the Girl-Woman–Girl-Mother program. The objective of this program was to develop the National Plan for the Prevention of Adolescent Pregnancy and to protect homeless adolescent mothers. The second is the Women and AIDS Program which was formed to organize women's organizations to actively "study and contribute to" the design of public policies for the prevention of AIDS.
182. NATIONAL WOMEN'S COUNCIL, WOMEN'S HEALTH IN ARGENTINA, ch. 6, point 6.1 (1994) (Graciela Di Marco, consultant and Graciela Fabi, collaborator).
183. *Report of Argentine before CEDAW, 1997*, *supra* note 68, at 11. The Maternal-Infant Nutrition Program, initiated in 1994, is to run for six years in the provinces and municipalities, using funding from the World Bank.
184. *Id.*
185. *Id.*
186. *Id.*.
187. *Id.*
188. *Id.*
189. *Id.*
190. Constitution of the City of Buenos Aires, enacted on Oct. 1, 1996, Ch. II, Tit. II, art. 20.
191. *Id.*
192. *Id.* art. 21, cls. 4 and 5.
193. *Id.*
194. *Id.*, art. 37.
195. *Id.*
196. Law No. 4.726 of Chaco province, Apr. 10, 1996.
197. *Id.*, art. 2, cl. a and b.
198. *Id.*, cls. c and d.
199. *Id.*, art. 1.
200. Law in Entre Rios province, Nov. 21, 1995.
201. *Id.*, art. 2.
202. *Id.*, art. 4.
203. *Id.*, art. 2.
204. Law No. 6.433, Oct. 22, 1996.
205. *Id.*, art. 2, cl. a, b and c.
206. *Id.*, art. 2, cls. d, e, f and g.
207. Project for Law in Cordoba province, CLADEM, Argentina Bulletin, Year 6, No. 7/8, at 21.
208. Municipal Order No. 6244, Sept. 12, 1996, arts. 1 and 2. This order established the Responsible Procreation Program, under the authority of the Public Health Secretary in the Municipality of Rosario.
209. Cordoba Municipal Order No. 9479, art. 2. This order creates the Reproductive Health, Sexuality and Family Planning Program under the scope of Municipal Public Health Secretary, whose aim is promoting responsible procreation.
210. See section on Sterilization below.
211. Decree No. 2.274, B.O. Mar. 27, 1987.
212. SUSANA CHECA AND MARTHA ROSENBURG, ABORTO HOSPITALIZADO: UNA CUESTIÓN DE DERECHOS REPRODUCTIVOS, UN PROBLEMA DE SALUD PÚBLICA [HOSPITALIZED ABORTION: A QUESTION OF REPRODUCTIVE RIGHTS, A PROBLEM OF PUBLIC HEALTH] 73 (1996).
213. Draft chapter on Argentina, *supra* note 86, at 49.
214. *Id.*
215. HOSPITALIZED ABORTION, *supra* note 212, at 74.
216. *Id.*
217. *Id.*
218. Family Planning Association of Argentina, *Comunicaciones*, 2 POBLACIÓN Y DESAROLLO [*Communications*, POPULATION AND DEVELOPMENT] 8 (No. 3, 1995).
219. *Id.*
220. UNITED NATIONS POPULATION FUND (UNFPA), RESOURCE REQUIREMENTS FOR POPULATION AND REPRODUCTIVE HEALTH PROGRAMS, at 154 (1996).
221. I.N.D.E.C., LA POBREZA URBANA EN LA ARGENTINA [URBAN POVERTY IN ARGENTINA] (1990).
222. *Family Planning in Argentina*, *supra* note 161, at 31 (citing data taken from CELADE, FECUNDIDAD EN BUENOS AIRES. INFORME SOBRE LOS RESULTADOS DE LA ENCUESTA DE FECUNDIDAD EN EL ÁREA DEL CAPITAL Y GRAN BUENOS AIRES [FERTILITY IN BUENOS AIRES: REPORT ON THE RESULTS OF FERTILITY INVESTIGATION IN THE CAPITAL AND GREATER BUENOS AIRES], Series A, No. 132 (1964).
223. *Id.*
224. *Id.*
225. *Id.*
226. *Family Planning in Argentina*, *supra* note 161, at 31 (citing data taken from CEDES, LA INSTITUCIÓN MEDICO HOSPITALARIO Y EL CONTROL SOCIAL DE LA REPRODUCCIÓN: UN ESTUDIO DE LOS SECTORES POPULARES DE BUENOS AIRES [THE MEDICAL HOSPITAL INSTITUTE AND THE SOCIAL CONTROL OF REPRODUCTION: A STUDY OF WORKING CLASS AREAS OF BUENOS AIRES], (n.d.) .
227. *Id.*
228. *Id.*
229. For a detailed analysis of the legal regime regulating sterilization, see the section on this

issue below.

230. HOSPITALIZATION FOR ABORTION, *supra* note 212, at 74.
231. Draft chapter on Argentina, *supra* note 86, at 49.
232. National Medicine Law, Law No. 16.463, B.O. Aug. 8, 1964.
233. *Id.*
234. *Id.*, arts. 1 and 2.
235. Draft chapter on Argentina, *supra* note 86, at 56.
236. *See* Presidential Decree No. 2.274, B.O. Mar. 27 1987.
237. PENAL CODE, art. 90.
238. *Id.*, art. 91.
239. *Id.*, art. 92.
240. Draft chapter on Argentina, *supra* note 86, at 56.
241. *Id.*
242. *Id.*
243. "Página 12" Newspaper, on Dec. 12, 1996.
244. Law No. 4.276, *supra* note 110, art. 6.
245. The proposed law is half way to approval by Congress.
246. *Id.*, art. 5.
247. PENAL CODE, Bk. II., Tit. II, Ch. I.
248. *Id.*, art. 86, second ¶.
249. Written declarations to the *Programme of Action of the International Conference on Population and Development, Cairo, Egypt, 5–13 Sept. 1994, in* REPORT OF THE INTERNATIONAL CONFERENCE ON POPULATION AND DEVELOPMENT, at 21, U.N. Doc.A/CONF.171/13/Rev.1, U.N. Sales No. 95.XIII.18 (1995).
250. *Id.*
251. Civil Code of the Republic of Argentina, Law No. 340, Sept. 25, 1969, art. 70.
252. *Id.*
253. *Id.*
254. Draft chapter on Argentina, *supra* note 86, at 59.
255. PENAL CODE, art. 88.
256. *Id.*, art. 85.
257. *Id.*, art. 86, first ¶.
258. *Id.*, art. 87.
259. NATIONAL WOMEN'S COUNCIL, supra note 182, ch. 1, point 1.2.2.2.
260. *Id.*
261. *Id.*, point 1.4.
262. *Report of Argentina before CEDAW 1997*, *supra* note 68, at 46.
263. NATIONAL WOMEN'S COUNCIL, *supra* note 182, point 1.4.
264. *Report of Argentina before CEDAW 1997*, *supra* note 68, at 46.
265. NATIONAL WOMEN'S COUNCIL, *supra* note 182, point 1.4.
266. *Id.*
267. Law to Combat AIDS, Law No. 23.798 (B.O. Sept. 20, 1990).
268. *Id.*, art. 1.
269. *Id.*, art. 2.
270. *Id.*, art. 3.
271. *Id.*, art. 4.
272. *Id.*, art. 7.
273. *Id.*, art. 8.
274. *Id.*, art. 10.
275. *Id.*, art. 13.
276. Law No. 12.331, codified at PENAL CODE, art. 18.
277. *Report of Argentina before CEDAW 1997*, *supra* note 68, at 46.
278. *Id.*
279. Decree No. 1.244/91 (B.O. Jul. 8, 1991).
280. *Id.*
281. For more detail about this institution, see section on "Infrastructure of Health Services".
282. Law No. 24.455 (B.O. Mar. 8, 1995), art. 1.
283. *Id.*, art. 4.
284. Draft chapter on Argentina, *supra* note 86, at 46.
285. *Id.*
286. ARG. CONST., art. 16.
287. *Id.*, art. 37.
288. Law No. 24.012, 1991.
289. *Report of Argentina before CEDAW 1997*, *supra* note 68, at 28.
290. *Id.*
291. See note 150. It is important to note that the Civil Code of the Republic of Argentina has undergone isolated and fragmented reforms since its original adoption. The most important was in 1968 (Law No. 17.711), through which women's juridical status was made almost equal to that of men, especially in the administration and disposition of community property. In 1987, parental authority was modified, giving equal weight to the authority of the mother and father over their children (Law No. 23.264). In the same year, the last Civil Code reform was passed introducing divorce and giving equal rights and obligations to both partners, substantially modifying personal rights within family relations (Law No. 23.515).
292. CIVIL CODE, art. 198.
293. *Id.*, arts. 199 and 200.
294. *Id.*, art. 1276.
295. *Id.*, art. 1277, first ¶.
296. *Id.*, second ¶.
297. *Report of Argentina before CEDAW 1994*, *supra* note 17, at 102.
298. *Id.*, art. 1276. A proposed law pending in the National Parliament would repeal this provision in the Civil Code. *Report of Argentina before CEDAW 1997*, *supra* note 68, at 13.
299. CIVIL CODE, art. 259.
300. *Id.*, art. 940.
301. The term "concubines" is used in Argentine legislation to refer to men and women who cohabitate in a domestic partnership.
302. *Report of Argentina before CEDAW 1997*, *supra* note 68, at 51.
303. Law No. 23.226 (B.O. Oct. 2, 1985).
304. *Id.*
305. Law No. 23.746 (B.O. Oct. 24, 1989).
306. *Report of Argentina before CEDAW 1994*, *supra* note 17, at 102. Divorce was incorporated into the Civil Code in 1987 by Law No. 23.515.
307. CIVIL CODE, art. 206.
308. *Id.*, art. 205.
309. *Report of Argentina before CEDAW 1994*, *supra* note 17, at 103.
310. CIVIL CODE, art. 207.
311. *Id.*, art. 209.
312. *Id.*, art. 206.
313. *Id.*, art. 264, cl. 2.
314. CIVIL CODE, art. 1277.
315. ARG. CONST., art. 14.
316. *Id.*
317. Convention No. 100 of the International Labor Organization, Convention Concerning Equal Remuneration for Men and Women Workers for Work of Equal Value, *adopted* Jun. 29, 1951 (visited Dec 8, 1997) <http://ilolex.ilo.ch:1567/public/english/50normes/ infleg/ilo-eng/conve.htm> (*entry into force* May 23) (ratified by Argentina on Sept. 24, 1956).
318. Convention No. 111 of the International Labor Organization, Convention Concerning Discrimination in Respect of Employment and Occupation, *adopted* Jun. 25, 1958 (visited Dec. 8, 1997) <http://ilolex.ilo.ch:1567/public/english/50normes/infleg/iloeng/conve.htm> (*entry into force* Jun. 15, 1960) (ratified by Argentina on Jun. 18, 1968).
319. Convention No. 156 of the International Labor Organization, Workers with Family Responsibilities, *adopted* Jun. 23, 1981 (visited Dec. 8, 1997) <http://ilolex.ilo.ch:1567/public/english/50normes/infleg/iloeng/conve.htm> (*entry into force* Aug. 11, 1983) (ratified by Argentina on Mar. 17, 1988).
320. *Report of Argentina before CEDAW 1997*, *supra* note 68, at 43.
321. The Labor Contract Law and Modifications, Law No. 20.744. Text codified by Decree No. 390/76 (B.O. May 21, 1976).
322. *Id.*, art. 17.
323. *Id.*, art. 172
324. *Id.*, art. 181.
325. *Id.*, art. 176.
326. *Id.*, art. 177.
327. *Id.*, art. 178.
328. *Id.*, art. 182.
329. This requirement was introduced by an amendment to the Labor Contract Law, passed during the military dictatorship (1976), which substantially restricts legal protection for maternity and lactation. Prior to this amendment, formal notification was not required and the woman enjoyed rights to job stability from the moment of conception.
330. Labor Contract Law, art. 177.
331. *Id.*, arts. 183 and 184.
332. *Id.*, art. 179.
333. *Id.*
334. *Id.*, art. 158, cl. a.
335. Draft Chapter on Argentina, *supra* note 86, at 48.

336. *Report of Argentina before CEDAW 1994, supra* note 17, at 12. For more detail about the National Women's Council, see the section on Women's Bureaus.
337. *Report of Argentina before CEDAW 1997, supra* note 68, at 12.
338. *Id.*, at 40.
339. *Id.*
340. *Id.*
341. *Id.*, at 26.
342. *Id.*, at 39.
343. *Id.*
344. Decree No. 1426/92 (B.O. Aug. 13, 1992).
345. *Report of Argentina before CEDAW 1994, supra* note 17, at 21.
346. *Id.*
347. *Report of Argentina before CEDAW 1994, supra* note 17, at 16.
348. *Id.*, at 20.
349. NATIONAL COORDINATING CENTER FOR PREPARATION FOR THE FOURTH WORLD CONFERENCE ON WOMEN AND THE NATIONAL WOMEN'S COUNCIL, INFORME NACIONAL. SITUACIÓN DE LA MUJER EN LA ÚLTIMA DÉCADA EN LA REPÚBLICA ARGENTINA [NATIONAL REPORT ON THE STATUS OF WOMEN IN ARGENTINA IN THE LAST DECADE], at 28, 29 and 30 (Sept. 23, 1994).
350. *Id.*
351. *Id.*
352. *Id.*
353. PENAL CODE, Bk. II, Tit. 3. For more detail about sexual offenses against adolescents and minors, see the section under that title below.
354. *Id.*, art. 119.
355. *Id.*
356. *Id.*, art. 122.
357. *Id.*
358. *Id.*, art. 124.
359. *Id.*, art. 132.
360. Decree No. 2385/93 (B.O. Jan. 23, 1993), art. 1.
361. *Id.*
362. Law No. 22.140. Basic Juridical Regime of public functions, B.O. Jan. 25, 1980 and errata, B.O. Nov. 13, 1980 and Nov. 27, 1980, arts. 1, 2 and 3.
363. Labor Contract Law, art. 75.
364. Law for Protection Against Family Violence, Law No. # 24.417, Dec. 7, 1994 (B.O. Jan. 3, 1995).
365. *Id.*, art. 1.
366. *Id.*
367. *Id.*, art. 4.
368. *Id.*, art. 5.
369. *Id.*
370. *Id.*
371. Decree No. 235, B.O. Mar. 7, 1996, art. 1.
372. The World Almanac, *supra* note 1, at 739.
373. Draft chapter on Argentina, *supra* note 86, at 70.
374. Family Planning Association of Argentina, "*Comunicaciones: Cómo vives tu sexualidad hoy? Declaración sobre anitconceptivos para adolescentes* [Communications: How Do You Live Your Sexuality? Declaration About Contraceptives for Adolescents], YOUTH JOURNAL 1994, at 23. (Year 1, 1994).
375. Law No. 4713 of Catamarca province (B.O. Nov. 6, 1992).
376. *Id.*
377. REPRODUCTION IN ARGENTINA, *supra* note 157, at 129.
378. Law No. 23.515. Civil Code Modification, art. 166, cl. 5.
379. CIVIL CODE, art. 167.
380. *Id.*
381. *Id.*, art. 168.
382. PENAL CODE, art. 119.
383. *Id.*, art. 120.
384. *Id.*
385. SEBASTIAN SOLER, III PENAL LAW IN ARGENTINA 356 (Second Edition, 1953).
386. *Id.*
387. "The State Parties shall respect the responsibilities, rights, and duties of parents or, where applicable, the members of the extended family or community… to provide, in a manner consistent with the evolving capacities of the child, appropriate direction and guidance in the exercise by the child of the rights recognized by the present Convention." The Convention on the Rights of the Child, *supra* note 81, at art. 5.

Bolivia

Statistics

GENERAL

Population

- Bolivia has a total population of 8 million, of which 50.4% are women.[1] The growth rate is approximately 2.3% per year.[2] 41% of the population is under 15 years old and 4% is over 65.[3]
- In 1995, 54% of the population lived in urban areas and 46% in rural areas.[4]

Territory

- Bolivia has a surface area of 1,098,581 square kilometers.[5]

Economy

- In 1994, the World Bank estimated the gross national product per capita in Bolivia at U.S.$770.[6]
- From 1990 to 1994, the gross domestic product grew at an estimated rate of 3.8%.[7]
- In 1992, the Bolivian government spent U.S.$97 million on health.[8]

Employment

- In 1994, approximately 3 million people were employed in Bolivia, of which 37% were women.[9]

WOMEN'S STATUS

- The average life expectancy for women is 63 years, compared with 57 years for men.[10]
- The illiteracy rate for women is 24%, while it is only 10% for men.[11]
- For the period from 1991 to 1992, women represented 7.8% of the total unemployed compared with 6.9% for men.[12]
- In 1994, women represented 37% of the economically active population.[13] In the period from 1989 to 1990, women represented 8.6% of the unemployed in urban areas.[14]
- Of the cases of violence against women in Bolivia, 76.3% were acts of physical violence, 12.2% were rapes, 6.4% were attempted murders, and 3.3% were attempted rapes. Most cases of physical aggression, rape, and murder took place within the home.[15]

ADOLESCENTS

- Approximately 41% of the population of Bolivia is under 15 years old.[16]
- The median age of first marriage is 22 years.[17]
- During the period from 1990 to 1995, the fertility rate in adolescents between the ages of 15 and 19 years old was 83 per 1,000.[18]

MATERNAL HEALTH

- The fertility rate is 5 children per woman.[19]
- The maternal mortality rate is 600 deaths per 100,000 live births.[20]
- Three-quarters of maternal deaths occur during pregnancy or childbirth, the principal causes being hemorrhaging, induced abortion, and hypertension. Infections and toxemia are also significant factors in the maternal mortality rate.[21]
- From 1990 to 1995, the infant mortality rate was estimated at 85 deaths per 1,000 live births.[22]
- In Bolivia, 46% of births are attended by a health professional.[23]

CONTRACEPTION AND ABORTION

- 45% of women of childbearing age in Bolivia use some form of contraception. Within this group, 18% employ modern family planning methods.[24] Of those that practice traditional methods, 14.7% use the rhythm method.[25]

- According to 1995 calculations, it is estimated that 115 abortions are carried out per day and between 40,000 and 50,000 per year in Bolivia.[26]

- One-third of maternal deaths are due to induced abortions, which means that there are approximately 60 deaths per 10,000 abortions.[27]

HIV/AIDS AND STIs

- There is very little information about sexually transmissible infections in women who do not work in the sex industry, as the majority of studies done have been carried out on prostitutes. One study done in La Paz revealed that approximately 30% of the women participating had syphillis, 17% had gonorrhea and 17% had chlamydia.[28]

- The reported prevalence of AIDS in women is 0 per 100,000, compared with 1.9 per 100,000 men. Since 1985, 161 cases of HIV have been reported, and 95 of those have developed into AIDS.[29]

ENDNOTES

1. United Nations, The World's Women 1995: Trends and Statistics, at 25 (1995).
2. United Nations Population Fund (UNFPA), The State of World Population 1997, at 72 (1996).
3. World Almanac Books, The World Almanac and Book of Facts 1997, at 745 (1996).
4. The World's Women 1995, *supra* note 1, at 62.
5. Ministry of Human Development, National Health Secretary, Diagnóstico Cualitativo de la Atención en Salud Reproductiva en Bolivia [Qualitative Diagnosis of Attention to Reproductive Health in Bolivia], at 112 (Bibliographic Revision, 1996).
6. World Bank, World Development Report 1996: From Plan to Market, at 188 (1996).
7. *Id.*, at 208.
8. Qualitative Diagnosis, *supra* note 5, at 43.
9. World Development Report 1996, *supra* note 6, at 194.
10. The World Almanac, *supra* note 3, at 745.
11. The State of World Population 1997, *supra* note 2, at 69.
12. The World's Women 1995, *supra* note 1, at 122.
13. World Development Report 1996, *supra* note 6, at 194.
14. The World's Women 1995, *supra* note 1, at 12.
15. Ministry of Foreign Relations, Ministry of Human Development, Informe Acerca del Avance de la Mujer en Bolivia, Cuarta Conferencia Mundial sobre la Mujer [Report on the advancement of women in Bolivia for the Fourth World Conference on Women], at 54 (1994).
16. The World Almanac, *supra* note 3, at 745.
17. The World's Women 1995, *supra* note 1, at 35.
18. *Id.*, at 86.
19. Qualitative Diagnosis, *supra* note 5, at 111.
20. The World's Women 1995, *supra* note 1, at 86.
21. Qualitative Diagnosis, *supra* note 5, at 8.
22. *Id.*
23. The State of World Population 1997, *supra* note 2, at 72.
24. *Id.*, at 69.
25. Julieta Montano and Florinda Corrales, The Women's Legal Office, Draft Bolivia chapter, at 8 (1996).
26. Qualitative Diagnosis, *supra* note 5, at 11.
27. *Id.*, at 12.
28. *Id.*
29. *Id.*, at 13

Bolivia is located in the central region of South America.[1] Argentina and Paraguay border it to the south, Brazil to the north and east, and Peru and Chile to the west.[2] There are three official languages in Bolivia: Spanish, Aymara, and Quechua.[3] The official and most widely practiced religion is Roman Catholicism.[4] The predominant ethnic groups are the Quechua (30%), Aymara (25%), Mestizo (25–30%), and European (5–15%).[5] Bolivia was a Spanish colony from 1530 until August 6, 1825, when it gained its independence from Spain.[6]

Bolivia has had a long history of political instability accompanied by an "endemic" economic crisis.[7] In 1981, after a long succession of military and civilian governments, the military government transferred power to the Congress of the Republic, democratically elected a year before. Congress then called for presidential elections that ended eighteen years of military dictatorships.[8] Hugo Bánzer Suárez was elected president of the republic on August 6, 1997.[9] Currently, the government is in a process of transition to a market economy, undertaking privatization programs, encouraging exports and foreign investment, reducing the budget deficit, and strengthening the financial system.[10]

I. Setting the Stage: the Legal and Political Framework

To understand the various laws and policies affecting women's reproductive rights in Bolivia, it is necessary to consider the legal and political systems of the country. By considering the bases and structure of these systems, it is possible to attain a better understanding of how laws are made, interpreted, modified, and implemented, as well as the process by which governments enact reproductive health and population policies.

A. THE STRUCTURE OF NATIONAL GOVERNMENT

The Republic of Bolivia is centralist and has a "representative democratic" government.[11] The Political Constitution of the State ("Constitution")[12] establishes that sovereignty resides with the people, who then delegate that power to the three branches of government: the executive, the legislative, and the judicial.[13]

Executive branch

Executive power lies with the president of the republic and his ministers of state.[14] The president and vice president are elected by direct suffrage.[15] The presidential term is five years and immediate reelection is not permitted.[16] The president can be reelected for an additional term, but the terms must be nonconsecutive — at least one presidential term must have passed since his or her first presidency.[17] Among the functions of the president are to execute and implement laws; to negotiate and to enter into international treaties, and to exchange instruments of ratification after congressional ratification; to manage national funds and "to decree expenditures" through the appropriate ministries; and to present the legislative branch with national and departmental budgets for approval.[18]

The ministers of state are in charge of public administration.[19] Each is responsible for administering his or her own ministry in conjunction with the president of the republic.[20] They are also jointly responsible for governmental acts agreed to by the Council of Ministers.[21] Ministers of state must countersign presidential decrees and other legal acts enacted by the president relating to their areas of responsibility.[22]

Legislative branch

Legislative power resides in the National Congress,[23] which is composed of two chambers: the Chamber of Deputies and the Senate.[24] The Senate is composed of twenty-seven senators — three from each department.[25] The Chamber of Deputies has 130 deputies.[26] Senators and deputies are elected by universal, direct, and secret vote.[27] However, departments elect half the members of the Chamber of Deputies.[28] The distribution of seats is by proportional representation.[29] The other half of its members are elected through direct vote,[30] by a simple majority[31] in single electoral districts, which are constituted for electoral purposes.[32]

Among other tasks, the legislative branch is responsible for enacting, repealing, derogating, modifying, and interpreting laws; imposing contributions and taxes of any kind upon the executive branch's proposal; abolishing existing taxes and contributions; determining the national, regional, or university-related nature of the law; and decreeing fiscal expenditures.[33] The legislative branch also determines the national budget following its proposal by the executive branch and annually approves the income and expenditures account that the executive presents in the first session of each legislature. It ratifies international treaties and conventions, decrees amnesties for political crimes, and grants pardons after receiving a report from the Supreme Court of Justice. The legislative branch appoints the justices of the Supreme Court of Justice, the magistrates in the Constitutional Court, the attorney general, and the people's defender ("ombudsman").[34]

Senators, deputies, the vice president, and the executive branch may propose legislation.[35] The relevant minister must defend executive branch proposals before Congress.[36] Once Congress has passed a law, it sends it to the president for promulgation.[37] The president has ten days from the date of its receipt to review the proposed legislation.[38] If the president does not either return the law to Congress with his or her

suggestions for revision or promulgate it, the president of the National Congress can order its promulgation.[39] Laws are effective from the day after their publication, except where the law itself provides otherwise.[40]

Judicial branch

The Bolivian legal system is a civil law system derived from Roman Law, as distinguished from English Common Law. The judicial branch is composed of the Supreme Court of Justice, the superior district courts, tribunals and courts of first instance, and other courts as established by law. The Judicial Council and the Constitutional Court also form part of the judicial branch.[41] The Supreme Court is composed of twelve justices, elected by two-thirds of Congress following nominations made by the Judicial Council.[42] The Supreme Court is responsible for: leading and representing the judicial branch; proposing candidates for superior district courts to the Senate; electing ordinary judges; hearing appeals of judgments; and rendering final judgment in actions involving the president, vice president, or ministers of state, for crimes committed in office.[43]

The justice system in Bolivia is regulated by certain constitutional principles such as exclusive jurisdiction, meaning the exclusive power of one court to hear an action to the exclusion of other courts;[44] administrative and economic independence of the judicial branch;[45] the right of access to the justice system free of charge;[46] and fair, prompt, and public trials.[47]

The attorney general and other officials appointed as prescribed by law are responsible for defending the law, including the interests of the state and society as a whole.[48] The ombudsman is responsible for defending people's rights from unlawful state action and for the defense and promotion of human rights.[49]

As an alternative form of dispute resolution, the Constitution recognizes the authority of peasant and indigenous leaders to administer justice in their communities according to their customs, rules, and procedures, provided these do not conflict with the Constitution or other national laws.[50]

B. THE STRUCTURE OF TERRITORIAL DIVISIONS

Regional and local governments

Bolivia is politically divided into nine departments, each of which has its own provinces, provincial subdivisions, and towns.[51]

A prefect, appointed by the president, governs and administers each department.[52] The prefect is the general commander of the department and must appoint subprefects and mayors for each province and town within the department.[53] He or she also appoints all other departmental administrative functionaries not named by other officials.[54]

The law known as the Regime of Administrative Decentralization of the Executive Branch[55] transfers and delegates technical and administrative responsibilities not reserved for the executive branch to the subprefects in each department. These include the administration, supervision, and control of human resources and of budgetary matters related to the operation of health, education, and social assistance services. The subprefects must act within the framework of applicable laws and policies that regulate the provision of these services.[56]

In each departmental capital, there is a municipal council and a mayor.[57] In the provinces, the provincial subdivisions, and the ports there are municipal boards.[58] In the towns there are municipal agents.[59] Local government is independent[60] and is run by municipal councils or boards, which are elected by popular vote for a two-year term.[61] These entities are responsible for enacting municipal ordinances to ensure quality services to the population; annually approving the municipal budget; and establishing and eliminating municipal taxes, following Senate approval.[62] Municipal councils or boards elect mayors, who oversee the administration of local governments[63] for a two-year term.[64]

C. SOURCES OF LAW

Domestic sources of law

The Constitution is the supreme law of the land.[65] All authorities are required to uphold the Constitution, laws and regulations. The Constitution prevails over laws, and laws take precedence over all types of regulatory measures.[66]

International sources of law

Numerous international human rights treaties recognize and promote specific reproductive rights. Governments that adhere to such treaties are legally obligated to protect and promote these rights. International treaties must be ratified by the legislative branch by an ordinary law, and it can be inferred that such treaties are equivalent in authority to ordinary law.[67] The executive branch negotiates and signs treaties with foreign nations and, after Congressional ratification, it arranges for the exchange of instruments of ratification.[68]

Bolivia is a member state of the United Nations and the Organization of American States. As such, Bolivia has signed and ratified the majority of relevant treaties of the Universal and the Inter-American Systems for the Protection of Human Rights.[69] In particular, Bolivia has ratified treaties relating to women's human rights, such as the Convention on the Elimination of All Forms of Discrimination Against Women[70] and the Inter-American Convention on the Prevention, Punishment and Eradication of Violence Against Women ("Convention of Belém do Pará").[71]

II. Examining Health and Reproductive Rights

Issues of reproductive health are dealt with in Bolivia within the context of the country's national health and population policies. Thus, an understanding of reproductive rights in Bolivia must be based on analysis of the laws and policies related to health and population.

A. HEALTH LAWS AND POLICIES

Objectives of the health policy

One of the fundamental rights recognized by the Constitution is the right to health,[72] which is understood to be in the public interest.[73] The state is obligated to safeguard the health of the individual, the family, and the general population.[74] Public health policy is defined by the Ministry of Human Development, through the National Health Secretary.[75] One of the Health Secretary's functions is to "formulate, implement and oversee health policies and programs, including prevention, protection and recuperation, as well as nutrition, sanitation and hygiene."[76] The present Bolivian government is reforming the health sector by devising a national decentralized health system that more efficiently links together the public sectors, the social security system and private entities, including non-governmental organizations.[77] Following these principles, the Public Health System ("PHS")[78] has been created. Its aim is "to achieve high levels of equity, quality and efficiency in health service provision, and provide universal access and coverage for the population."[79] The PHS, as a new model for health policy, seeks to define the priorities governing the health system, organize health services and define both sectoral and shared management structures with local participation.[80] The organizational structure of PHS is divided into three levels of management: the national level, represented by the National Health Secretary,[81] whose function is to control, regulate, and lead the PHS;[82] the prefecture level, represented by the Departmental Health Office which is in charge of implementing general strategies, plans, national programs, and special departmental projects;[84] and the municipal level, consisting of Local Health Directorates,[85] which shares its functions with the community. Municipal governments provide the infrastructure, equipment, and funds generated from municipal sources and from taxation.[86]

Infrastructure of health services

The health institutions and establishments that constitute the PHS are divided into three levels: (a) the health district level, composed of health stations, local clinics, local health centers, and district hospitals; (b) the Regional Health Secretary level, consisting of regional hospitals, maternity hospitals, and pediatric hospitals; and (c) the National Health Secretary level, composed of medical research institutes.[87] The health system has 33 regional hospitals, 54 district hospitals, 191 health stations with beds, and 1,373 health clinics with outpatient services.[88] With respect to the private sector, there are approximately 100 private clinics in the country.[89] In the rural areas and in the outlying impoverished areas of La Paz, Cochabamba, and Santa Cruz, medical services offered by nongovernmental organizations ("NGOs") are particularly important.[90] There are approximately 500 NGOs offering services in rural areas.[91]

In terms of human resources, doctors work in hospitals and health centers, while in the itinerant rural health stations, patients are attended to by nurses and physicians' assistants. In Bolivia, the average doctor-patient ratio is 3.4 doctors per 10,000 inhabitants, and the nurse-patient ratio is 1.4 nurses per 10,000 inhabitants.[92]

Cost of health services

Bolivia depends substantially on international aid to finance the national budget, especially social development programs.[93] As evidenced by the outcome of the health sector reorganization, international donors have begun to favor policies that build the capacity of national actors and develop a more efficient management of financial resources.[94] The Local Health Directorates develop projects according to the needs and priorities of each region. These projects are then sent to the System of Public Investment and Foreign Financing,[95] which carries out the authorization of funding or seeks other funding sources according to the particulars of each project.[96] The entity in charge of seeking funds and negotiating the terms of projects is the International Relations Office of the National Health Secretary.[97]

Health care services are not free of charge.[98] The prevailing philosophy of health administration is "without money, no treatment."[99] Funds obtained from payments for health services are mainly used to purchase medicines and to cover other operating costs, though they are also used to supplement doctors' salaries.[100]

Regulation of health care providers

The practice of health professionals in medicine, dentistry, nursing, nutrition, and other fields, is regulated by the Health Code and special regulations.[101] None of the professionals mentioned above can perform medical procedures without being registered in their respective profession before the Health Authority.[102] The Health Authority verifies compliance with appropriate requirements, such as completion of university studies and the registration of the degree in the relevant professional

association.[103] The Health Authority develops the necessary measures to monitor health professionals' performance.[104] The Penal Code[105] punishes anyone who, without authorization or a license, practices a medical, health, or related profession.[106] The penalty for violation of this criminal law is three months' to two years' imprisonment or a fine of 30 to 100 days' wages.[107]

Traditional medicine plays an important role in the health sector. It is estimated that each traditional healer in Bolivia attends to about 500 people a year. However, traditional healers are not legally regulated.[108]

Patients' rights

The Health Code recognizes a patient's right to comprehensive health services; to be attended in any public or private medical facility in an emergency; and to be informed by the Health Authority of the medical or surgical procedure be performed on him or her.[109] Furthermore, all patients have the right "not to be compelled to undergo unnecessary tests, surgery, or treatment, or to participate in clinical or scientific experiments without their consent and without receiving information about the risks."[110] However, there are no procedural rules to guarantee that medical facilities comply with these rights.[111] The Penal Code protects patients from negligence. A penalty of three months' to two years' imprisonment or a fine of 30 to 100 days' wages is imposed on any health professional that performs unnecessary surgery or treatment.[112]

B. POPULATION, REPRODUCTIVE HEALTH, AND FAMILY PLANNING

Population laws and policies

In 1992, the National Development Strategy[113] stated that a general objective of Bolivian population policy would be "to encourage a symmetrical relationship between the dynamic of population growth and the country's economic and social development in order to satisfy the basic needs of the diverse population groups while preserving sustainable development and the environment."[114] Furthermore, it articulated specific objectives such as encouraging a more rapid decrease in maternal and infant morbidity and mortality; promoting a more balanced distribution of the population throughout the national territory; supporting the growth of intermediate cities to achieve territorial, economic, and social integration; and controlling the negative effects of population growth and urbanization on the environment.[115]

The Bolivian government, in its Declaration of Principles on Population and Sustainable Development,[116] reaffirms the principles mentioned above. It also states that development should be understood from a global perspective that combines four fundamental factors: economic growth, social equity, the rational use of natural resources, and governability.[117] It points out that population policies should not be understood solely as instruments for demographic control but should be incorporated into a wider strategy of "sustainable development at whose core are population issues."[118] The Declaration of Principles also specifies the Bolivian government's obligation to achieve "comprehensive development of the potential of the Bolivian people"[119] through increasing the number and quality of available jobs; education for sustainable development; the strengthening of primary health care services; and respect for cultural diversity.[120]

Reproductive rights and family planning laws and policies

The Bolivian government has declared that health is a crucial factor in development and that it is the government's obligation to protect everyone's health, particularly that of mothers and children.[121] The government considers reproductive health and family planning to be essential components of maternal and infant health.[122] Reproductive health, including its physical, psychological, and social aspects, is seen as an integral part of overall health.[123] Based on these principles, the government created the National Plan for Rapid Reduction of Maternal, Perinatal, and Infant Mortality ("Life Plan").[124]

The Life Plan, aimed at lowering the levels of illness and death, especially in the area of maternal and infant mortality, was conceived as an instrument for social development and the "improvement of the quality of life of every Bolivian family."[125] The main objective of the Life Plan is "permitting free access to educational programs and maternal-infant health care services, maternal-infant nutritional services, and family planning services for all those who need them."[126] From 1994 to 1997, the goals of the Life Plan were to reduce maternal mortality by 50%;[127] to reduce perinatal mortality by 30%;[128] and to develop and establish effective and comprehensive local health care services for pregnant women, mothers, and children under five.[129]

As one of its strategies aimed at reducing maternal mortality rates and improving the status of women's health, the National Health Secretary created the Comprehensive Women's Health Services Program. This program features health assistance to pregnant women, including prenatal and postnatal care; care during delivery; care for obstetric and perinatal complications; and reproductive health education. It also includes services aimed at all women generally in several areas such as family planning, reproductive health education, gynecological care; detection and care of cervical, uterine, and breast cancer; and detection and care of sexually transmissible infections ("STIs"). A second strategy initiated by the government features Maternity and Infancy Insurance,[130] which seeks to reduce maternal mortality by 20% and infant mortality by 25%[131] and to increase the expansion of health services, prioritizing maternal and infant

care and generating a funding mechanism that "breaks economic barriers without falling back on subsidies."[132] This insurance, to be adopted by 311 municipal governments countrywide, strives to cover a population of approximately 3 million people, including women and children.[133]

The Bolivian government recognizes family planning as a component of reproductive health and as a fundamental human right of individuals and couples, who have the right to "freely and responsibly decide the number and timing of their children."[134] The National Health Secretary, through the Comprehensive Women's Health Services Program and particularly through the Sexual and Reproductive Health Strategy,[135] is in charge of ensuring that family planning services are offered in different health establishments countrywide. It must continuously coordinate with the prefects of each department and with municipal governments in order to do so.[136]

Government delivery of family planning services

The government does not provide free family planning services or free contraceptive methods, and there are no established official prices for these.[137] Among the programs comprising the Sexual and Reproductive Health Strategy are those aimed at providing information, education, and mass media campaigns on sexual and married life and the risks of reproduction.[138] There are also more standard family planning–related activities, such as treatment for infertility and information on the use of traditional and modern contraceptive techniques.[139]

C. CONTRACEPTION

Prevalence of contraceptives

Of all Bolivian women, 18.3% use traditional methods of contraception and 11.9% use modern methods.[140] Among the traditional methods of contraception, the rhythm method is used by 14.7% of women, and among the modern methods, the most prevalent ones are the intrauterine devise ("IUD") (5.21%) and sterilization (3.1%).[141] These statistics increase when only women in relationships are included, revealing that 45% of these women use some form of contraception.[142] Of these, 27.6% prefer traditional methods such as the rhythm method (22%), other methods (3.9%), and withdrawal (1.7%); 17.7% use modern methods of contraception — 8.1% use IUDs, 4.6% use sterilization, and 2.8% use the contraceptive pill.[143]

Legal status of contraceptives

The Bolivian government specifically establishes the distribution of information about reproductive health, the promotion of methods for the regulation of fertility, and support for family planning services as part of its population policy.[144] Although the government recognizes and respects each person's right to decide freely about his or her sexuality and fertility, abortion is strictly prohibited as a method of family planning.[145] In the regulation of the sale of contraceptives, the law distinguishes between medical devices, such as condoms and IUDs, and pharmaceutical items, such as the contraceptive pill, vaginal foaming tablets, and injectables.[146] Pharmaceutical contraceptives are regulated by the same laws as other drugs.[147] The National Health Secretary, through the National Department of Drugs, Pharmacies and Laboratories, performs the regulatory function.[148] Drugs such as contraceptive pills, injectables, and spermicides must have a drug license that authorizes their importation, distribution, and commercialization for a five-year period.[149] On the other hand, condoms and IUDs are considered medical devices rather than pharmaceutical products and, therefore, do not require a license and can be freely imported.[150]

Regulation of information on contraception

There is no law limiting information on contraception.[151] To the contrary, the government indicates that reproductive health services should include all necessary means to ensure that patients have "wide, objective, complete and accurate" information,[152] strengthening individuals' freedom of choice regarding their fertility.[153]

Some efforts undertaken by the government to disseminate information on a large scale about different methods of family planning and the use of the condom have met with strong opposition and pressure from the Catholic Church for their withdrawal.[154] Because of this pressure, government health authorities decided to end the information campaign that had been aimed at conveying the benefits of family planning and at preventing the transmission of STIs and HIV/AIDS.[155] As a result of information and educational efforts provided by the medical community, family planning is currently supported at different levels of civil society, because of the benefits to the health of women and to the population in general, and because it enables men and women to decide on the number of children they want and can support.[156]

Sterilization

Although sterilization is not specifically addressed in legislation, health regulations in Bolivia prohibit doctors from performing any procedure that affects the normal functioning of reproductive organs.[157] However, sterilization has become a routine procedure in health care facilities.[158] Although there are no regulations or directives on point, health service personnel require the male partner's written authorization to perform a woman's sterilization. They also take into consideration the number of children she has had[159] and the age of the woman before they will sterilize her. These issues are not considered in male sterilizations or vasectomies.[160]

D. ABORTION

Legal status of abortion

In Bolivia, the Penal Code classifies abortion as a crime, and punishes anyone who "causes the death of a fetus in the womb or provokes the premature expulsion of the fetus."[161] When a woman has an abortion because the pregnancy is the result of rape, abduction for sexual purposes not followed by marriage, statutory rape, incest,[162] or because the mother's life is in serious danger (therapeutic abortion), the act is not considered punishable.[163] The Penal Code punishes both the woman who "gives consent" to have an abortion[164] and the person who carries out the abortion procedure with or without the woman's approval.[165] A specific provision mandates an additional punishment for persons who habitually provide abortions.[166] The Penal Code punishes those who unintentionally induce a miscarriage[167] and those who through violence provoke a woman to miscarry, even though there was no intention to do so, if the pregnancy is obvious or the aggressor previously knew of the pregnancy.[168] Attempted abortion is not punishable.[169]

Despite the criminalization of abortion, it constitutes one of the country's most serious public health issues. This is both because of the maternal mortality caused by abortions and the hospital costs resulting from medical treatment following complications of unsafe abortions.[170] The Bolivian Gynecology and Obstetrics Society estimates that there is a rate of 60 deaths per 10,000 abortions.[171] This figure is influenced by the lack of training of those who perform the abortions (generally, nurses, medical students, and others); the high cost of obtaining an abortion; the low quality of services; economic problems; social pressures; and fears due to abortion's criminal status.[172]

Requirements for obtaining a legal abortion

In order for an abortion to be performed relying upon one of the two exceptional cases permitted by law, a doctor must perform the procedure and the woman must consent.[173] Therapeutic abortion is not punished only when the threat to the woman's life cannot be averted through any another means.[174] When the abortion is a result of rape, abduction for sexual purposes not followed by marriage, statutory rape, or incest, the law requires that the victim first file a criminal complaint against the aggressor[175] and only then may the judge authorize the performance of an abortion.[176]

Penalties for abortion

The person who performs an abortion without the woman's consent or on a woman under 16 years of age, is liable to two to six years of imprisonment.[177] When the abortion is performed with the woman's consent, the punishment is one to three years of imprisonment[178] both for the woman and for the person who performs the procedure.[179] When the woman induces her own abortion, or when another person performs the abortion with her consent with the aim of "saving her honor,"[180] a punishment of six months to two years is imposed,[181] increased by one-third if the woman dies as a result of the procedure.[182]

When an abortion to which the woman has consented results in injury, the punishment provided is one to four years of imprisonment.[183] The penalty is increased by half if the women dies as a result of the procedure.[184] If the woman does not give her consent and the abortion results in injury, the penalty is one to seven years of imprisonment[185] and two to nine years if the women dies as a consequence of the abortion.[186]

In the case of unintentional abortion or miscarriage, the Penal Code establishes obligatory community service for up to one year.[187] Whoever causes a miscarriage through violence, without intention, when the pregnancy is obvious or with previous knowledge of it, is given three months to three years in prison.[188] A person convicted of habitually performing abortion procedures is punished with one to six years of imprisonment.[189]

E. HIV/AIDS AND SEXUALLY TRANSMISSIBLE INFECTIONS (STIs)

Examining the problem of HIV/AIDS issues within the reproductive health framework is essential, as both are intimately related from a medical and public health standpoint. Hence, a full evaluation of laws and policies affecting reproductive rights in Bolivia must examine HIV/AIDS and STIs because of the dimensions and implications of these illnesses. Between 1991 and 1995, 160 cases of HIV/AIDS were reported in Bolivia, of which 78 had developed AIDS.[190] Of the reported cases, 75% were men and 25% women.[191] With respect to STIs, in the same period, 16,432 cases of gonorrhea and 19,427 cases of syphilis were reported.[192] In September 1996, the departmental registers in Cochabamba department showed 36 reported cases of HIV, but the departmental authority reported that within two months, 11 more cases were reported, putting the figure at 47.[193]

Laws on HIV/AIDS and STIs

Recently, the Bolivian government promulgated the Regulations for the Prevention and Care of HIV/AIDS in Bolivia ("HIV/AIDS Regulations").[194] These Regulations classify AIDS and infections caused by HIV as "diseases transmitted through sexual contact, blood, and blood derivatives."[195] Additionally, it states that an HIV test can be performed only when requested by an individual who has an epidemiological risk factor, when there is a clinical reason to suspect that the individual is carrying HIV, or for the purpose of epidemiological monitoring and epidemiological research.[196]

The HIV/AIDS Regulations also set out the rights and duties of healthy, infected, and sick persons. It establishes that the results of laboratory tests are strictly confidential[197] and that in all cases counseling and psychosocial services should be provided.[198] Test results that indicate the presence of the illness must be reported confidentially to the regional secretary responsible for epidemiological research.[199] Medical professionals cannot invoke patient confidentiality to avoid reporting such information to health authorities.[200] When the patient agrees, or when the doctor considers it necessary, the HIV status of the infected person and the risks of infection can be reported to the patient's spouse, domestic partner, or sexual partner(s), so that they can take preventive measures.[201] If the state of health of the AIDS patient is serious, family and those close to the patient must be informed, always maintaining strict confidentiality.[202]

The HIV/AIDS Regulations also state that surveys and interviews for research purposes may only be carried out with the prior consent of the person interviewed unless the health authority decides it is appropriate to conduct the research without consent for public safety reasons.[203] It is expressly prohibited to conduct such investigations for reasons of "discrimination or publicity."[204] Persons infected with HIV cannot be barred from public or private education, sports, or cultural facilities[205] or be subjected to any form of discrimination because of their condition as a carrier.[206] It is prohibited to require HIV/AIDS tests as an obligatory prerequisite in the following cases: for admission to education, sports, or cultural facilities; to gain entrance to the country for both foreigners or nationals; to enter or remain in the workplace; or to gain entrance into military institutions.[207] No health care worker in public, social security, or NGO or other private establishments can deny medical attention and in-patient services to a person who has AIDS or is HIV positive.[208] Furthermore, they have an obligation to provide guidance, information, and education to the Bolivian population about HIV/AIDS, without discrimination.[209] Anyone who works as a prostitute should receive information, education, and counseling about prevention and control of HIV/AIDS through his or her corresponding health center.[210] Managers of motels, brothels, and other such establishments have the duty to regularly provide condoms to clients and to those who work as prostitutes in these establishments.[211]

In the area of labor, HIV/AIDS Regulations also provide that the Ministry of Employment and Labor Development has the duty to offer legal and labor support services to carriers of HIV. These workers cannot be denied jobs or permanent status in their positions.[212] Employees are not required to inform their employers of their condition, thereby reinforcing their right to confidentiality and protection from discrimination.[213] Health care providers affiliated with the social security system are prohibited from reporting details of employees' health status to employers.[214]

In the criminal context, the Penal Code classifies the spreading of serious or contagious diseases as a crime against public health.[215] The crime is punished by imprisonment of whoever puts another in danger of infection through sexual relations or breast-feeding. The punishment is increased if the exposed person becomes infected.[216]

Policies on prevention and treatment of HIV/AIDS and STIs

The prevention of AIDS in Bolivia is regulated by the Program for the Prevention and Care of STIs and AIDS, which is run by the National Health Secretary.[217] The principal objective of this program is "to improve comprehensive services for health problems, as well as to offer information, education, support, and counseling to persons who are infected with HIV/AIDS, those who are at risk of being infected and to the general population, and, in so doing, assisting in the reduction of psychosocial, economic, political, and legal consequences generated by HIV/AIDS in Bolivia."[218] The National AIDS Program coordinates comprehensive health care for those infected with HIV or sick with AIDS[219] and offers programs of training in STIs and AIDS to health personnel involved in a system of comprehensive service provision.[220] Each region has access to this system, which consists of a multidisciplinary team of doctors, dentists, nurses, social workers, psychologists, psychiatrists, biochemists, lawyers, pastoral support groups, family support groups, and self-help groups.[221] These specialists carry out ongoing checkups and offer assistance to those infected with AIDS related to both their physical and mental health.[222]

The principal activities of the National STI/AIDS Program are documenting and updating confidential national and regional registers of those infected with HIV and suffering from AIDS, with their respective clinical histories;[223] offering health, counseling, and psychosocial services for patients with AIDS;[224] carrying out studies of HIV status in diverse groups of the population for epidemiological observations;[225] creating centers to detect cases of AIDS;[226] and conducting surveys of knowledge, attitudes, and practices in diverse groups of the population to facilitate epidemiological control of the disease.[227]

III. Understanding the Exercise of Women's Reproductive Rights: Women's Legal Status

Women's reproductive health and rights cannot be fully evaluated without analyzing women's legal and social status. Not

only do laws relating to women's legal status reflect societal attitudes that affect their reproductive health, but such laws often have a direct impact on women's ability to exercise reproductive rights. The legal context of couple relations and family life, educational level, and access to economic resources and legal protection determine women's ability to make choices about their reproductive health needs, as well as their ability to exercise their rights to obtain health care services.

The principle of equality recognized in the Bolivian Constitution establishes that all people enjoy rights, freedoms, and guarantees, without distinction by gender.[228] The Constitution also affirms equality between spouses to form a marital union "that rests on equality of rights and duties of both spouses."[229]

A. CIVIL RIGHTS WITHIN MARRIAGE

Marriage law

The Constitution provides that marriage, family, and maternity are protected by the state.[230] The Family Code[231] regulates all that concerns family and matrimonial relations and recognizes the constitutional principle of legal equality of spouses. The law provides that marriage, family relationships, and parental authority over children are subject to the principle of equal treatment before the law.[232]

For purposes of civil legislation, the age of majority is 21,[233] although political rights of citizenship are acquired at 18.[234] The Family Code establishes that the minimum age for marriage is 16 for boys, and 14 for girls.[235]

Although the Family Code maintains the principle of spousal equality, it also contains certain discriminatory provisions, including one that states "the husband can restrain or refuse to permit the wife from carrying out a profession or occupation, for reasons of morality or when her social function at home is seriously impeded."[236] Spouses have a mutual duty of fidelity, assistance, and support.[237] Both partners choose the marital residence,[238] and each contributes to their joint maintenance, according to the means of each spouse.[239] In cases where one spouse is unemployed or is unable to work, the other should provide for their maintenance.[240] According to the law, women carry out a useful social and economic function in the home, which receives specific legal protection.[241]

Both spouses manage joint property acquired during marriage.[242] Actions related to the administration of such property undertaken by only one of the spouses are presumed to have the consent of the other spouse and are legally binding on him or her as long as they are justified by joint expenses and obligations.[243] If the acts are not justifiable, they are the sole responsibility of the spouse who undertook them and they do not encumber the joint property, provided the creditor knew or should have known of the unjustifiable nature of these acts.[244]

As long as an act is not damaging to their joint ownership of property, each spouse can freely manage and spend earnings obtained from his or her work separately from the other spouse.[245] To dispose of or encumber joint property, consent from both spouses is essential, given either directly by the spouses or by a third party empowered with special authority to do so.[246] Bigamy is a crime under the Penal Code and is punished with two to four years of imprisonment.[247]

Regulation of domestic partnerships

Bolivian family law protects domestic partnerships (*uniones de hecho*), defining such partnerships as occurring "when a man and a woman voluntarily constitute a home and live together in a monogamous and stable way" for a minimum period of two years.[248] Their privileges and duties are the same as in a legal marriage both in terms of the relationship between the spouses and of property rights.[249] The requirements for legal recognition of a domestic partnership are that both partners must have legal majority, which is the same as for marriage; neither partner can be married to another person; and neither partner can have been convicted of the homicide of the spouse of the other partner.[250] The Civil Code recognizes inheritance rights between domestic partners[251] and provides that "the individuals in a domestic partnership recognized by the Constitution and the Family Code are treated similarly to persons who are married with respect to rights of succession to the property of their partner."[252]

Other forms of domestic partnership, such as the "*tantanacú*" and the "*sirvinacuy*" that exist in the Andean and other indigenous communities are legally recognized by Bolivian law. The legal effects of such unions are similar to those of marriage.[253]

Divorce and custody law

Divorce, as a means of dissolving a marriage, is permitted in the following circumstances: when either spouse engages in adultery or sexual relations with another; when either spouse commits acts of excessive cruelty; when one spouse gravely slanders the other; when verbal or physical ill treatment makes it intolerable for the spouses to live together; when one spouse attempts to kill or arranges for another to kill the other spouse; when one spouse is the protagonist, accomplice or instigator of a crime against the honor or property of the other; when one spouse attempts to "corrupt" the other or their children or when that spouse consents to the corruption or prostitution of the other spouse or children by another; when one spouse "maliciously" abandons the family home; and where one spouse, without reason, does not return to the home for six months after the other spouse has a judge order him or her to do so.[254] It is also legal cause for divorce when partners freely and mutually agree to separate and have lived apart for more than two years.[255]

Property acquired during the marriage becomes joint property. In cases of divorce, such property is divided equally between the two spouses, including profits made during marriage. This is not the case when the spouses have signed a contract providing that they are not subject to the joint property regime.[256]

In cases of separation, divorce, or termination of a domestic partnership, custody of children is granted by a judge, based on the best interests of the children, to the parent that will provide the best care and protect their material and moral interests.[257] The mother and father can make their own agreement regarding custody and child support, which can be accepted by the judge.[258] The noncustodial parent is obliged to contribute child support, "according to the parent's means" and the needs of the children.[259] Family maintenance (alimony and child support), once determined by a judge, is subject to modification in accordance with increases in the payer's income and the needs of the partner and children receiving alimony and child support. Since alimony and child support are considered to be of public interest, compliance with the obligation to pay may be enforced by filing a judicial action.[260]

B. ECONOMIC AND SOCIAL RIGHTS

Property rights

According to various legislative provisions, particularly in the Civil Code,[261] there are no legal obstacles to women acquiring, holding, transferring, and inheriting property.[262] In rural communities, where customary norms remain prevalent, women are limited in their ability to acquire or hold property if there is not a man from their household who will guarantee that the land will be used for production.[263] Rural women also are unable to inherit land when there are males in the family.[264]

Labor rights

Labor laws, contained in the General Labor Law,[265] recognize a pregnant woman's right to thirty days of prenatal and thirty days of postnatal leave.[266] Furthermore, a pregnant woman cannot be fired from her place of work during her pregnancy or for one year after the baby is born.[267] The Social Security Code[268] includes mandatory maternity insurance coverage for women workers and for wives or partners of workers.[269] This insurance covers prenatal, childbirth, and postnatal care.[270] In addition to providing health services, the Code also provides a maternity subsidy for the worker or beneficiary for seventeen months, beginning in the fourth month of pregnancy and continuing until one year after the birth.[271] The subsidy is equivalent to the national minimum salary and is payable in milk and iodized salt.[272] Maternity and lactation subsidies are regulated by the Social Security Code.[273]

Access to credit

There are no legal restrictions on access to credit, but women lack access to guarantees, which hinders their ability to obtain credit from financial institutions. This is especially the case when the credit sought is greater that the equivalent of one or two hundred U.S. dollars.[274]

Access to education

Access to education for girls between the ages of 15 and 19 is 52.8% compared with 55.3% for boys.[275] Levels of illiteracy are reported to be highest in rural areas for both sexes, but principally for women.[276] Fifty percent of rural women over 15 years do not know how to read or write, while 23% of men are illiterate.[277] In urban areas, the illiteracy rate is 15% for women and 4% for men.[278]

Women's inferior access to education and their premature departure from the school system are the result of socioeconomic and cultural factors present in the family, the government, and society in general.[279] There have been no government initiatives or policies implemented to, for example, make school calendars compatible with domestic or farming tasks or to improve the quality of education in order to increase its effectiveness or decrease its opportunity cost.[280]

Women's bureau's

Beginning in 1991, the Bolivian state began to incorporate a gender perspective into all of its policies.[281] The Bolivian Social Strategy and the National Development Strategy, approved in 1992, both incorporate gender issues within the framework of national development. As a primary objective, the strategies propose to widen women's participation in spite of social, labor, ethnic, and educational discrimination.[282] In 1992, the results of a study carried out by the Social Policy Analysis Unit made possible the creation of the National Women's Program, established as an instrument of social policy. The National Solidarity Committee was in charge of implementing the program and was provided with substantial initial funding to do so.[283]

During the restructuring of the executive branch,[284] the Gender Issues Subsecretary was established under the auspices of the National Secretary of Ethnic, Gender, and Generational Issues.[285] This specific "third level" entity was created "to institutionalize a gender perspective in development policies through a concrete integration process and to strengthen political, social, and family democracy; … to contribute to the eradication of poverty; to work for equality; and to eliminate all forms of discrimination, as defined in the Convention on the Elimination of all Forms of Discrimination Against Women."[286]

Within the departments of government, "fourth level" governmental entities were also created to implement the policies of the Gender Issues Subsecretary. These entities are called Departmental Gender Units.[287]

C. RIGHT TO PHYSICAL INTEGRITY

Rape

Rape, understood as a crime against good morals, is classified "as carnal access with a person of either sex, through violence or intimidation."[288] The punishment for this crime is four to ten years in prison.[289] The same punishment applies if rape is committed against someone who is mentally disabled or incapable of resisting. In these cases violence or threats are not required for the act to constitute rape.[290] If the victim dies as a result of the rape, the punishment is ten to twenty years in jail.[291] The punishment is increased by one-third in several circumstances: if the victim is severely injured as a result of the rape; if the perpetrator is a close relative of the victim, such as a father, a son, a brother, a half-brother, an adoptive parent, or someone involved in the education or guardianship of the victim; or if two or more people participate in the rape.[292]

The Penal Code also defines the crime of abduction for sexual purposes as occurring when someone "using violence, threats or deceit kidnaps or detains another person with the aim of entering into marriage."[293] The punishment in such cases is three to eighteen months in prison,[294] but the sentence is reduced by half if the abductor spontaneously returns the victim to freedom or places him or her in a safe place accessible to the family.[295] There is no prison term if the captor marries the victim before a sentence is imposed.[296]

Sexual harassment

Sexual harassment is neither a crime nor an administrative violation, and no standards exist that provide for punishment for acts of sexual harassment.[297]

Domestic violence

In 1995, the Bolivian government enacted the Law against Family or Domestic Violence.[298] Its principal objectives are to implement processes to modify sociocultural values; to sensitize society to issues of domestic violence; to promote values of respect and solidarity within families; to punish acts classified as intrafamily violence; and to apply alternative measures of conflict resolution, while at the same time adopting preventive measures to protect the victims.[299] The law defines family or domestic violence as "physical, psychological or sexual aggression committed by a spouse or partner; a close relative, including a father, a son, or a sibling; another relative, a close relation by marriage, or a guardian or custodian."[300] Acts of violence committed by a former spouse, a former partner or the parent of the victim's children are also classified as acts of domestic violence.[301]

The law confers jurisdiction on family law judges to deal with cases of domestic violence.[302] In rural and indigenous communities, community and indigenous authorities have jurisdiction to deal with acts of family violence, according to their own customs, as long as they are not in conflict with the Constitution or the spirit of the law.[303] Acts of violence classified as crimes in the Penal Code remain under the exclusive jurisdiction of penal judges.[304]

Some of the protective measures that a judge can order for victims of domestic violence are prohibiting or temporarily restricting the perpetrator from entering the family home; ordering the return of victims of violence to the home if they have fled because of the violence; authorizing the victim to leave the home and to have delivered to her or him all of her or his personal effects; ordering an inventory of all shared personal property and real estate; and prohibiting or limiting the perpetrator's access to the victim's place of work.[305]

IV. Analyzing the Rights of a Special Group: Adolescents

The needs of adolescents are often unrecognized or neglected. Considering that 41% of the Bolivian population is under the age of 15,[306] it is particularly important to meet the reproductive health needs of this group. The effort to address issues of adolescent rights, including those related to reproductive health, are important for women's right to self-determination as well as for their general health.

A. REPRODUCTIVE HEALTH AND ADOLESCENTS

In Bolivia, approximately 10% of births are to adolescent women.[307] Eighteen percent of girls between the ages of 15 and 19 are mothers;[308] 40% of 19-year-old girls are mothers or are pregnant; and 9% of 19-year-old girls have had two children.[309] The Minor's Code[310] states that the State has responsibility for guaranteeing pregnant minors special prenatal and postnatal care, and free childbirth services in state hospitals.[311] Within sexual and reproductive health services, which form part of the Women's Comprehensive Health Attention Program, care and services are provided to all those who seek them.[312] It is understood that adolescents have access to these services. However, the majority of children (both boys and girls) grow up in Bolivia without any sexual education or guidance.[313]

B. MARRIAGE AND ADOLESCENTS

The Family Code establishes the minimum age for marriage as 16 years for males and 14 years for females.[314] In exceptional cases, minors below these ages may marry with the approval of a family court judge "under serious or justifiable circumstances." Pregnancy is considered as such an exceptional circumstance.[315] The average age of women's first marriage is 20

years.[316] Marriage statistics reveal that approximately 95% of the population marry at least once in their lives.[317]

C. SEXUAL OFFENSES AGAINST ADOLESCENTS AND MINORS

The Penal Code defines rape as a crime committed when carnal intercourse occurs through physical violence or intimidation. When the victim is a "minor who has not reached puberty," the applicable punishment is nineteen to twenty years of imprisonment.[318] If the minor dies as a consequence of the rape, the punishment is equivalent to that for murder.[319] Statutory rape is defined as "carnal intercourse with an 'honest' girl who has reached puberty and who is under 17 years" through seduction or deceit.[320] This crime is punishable by a prison sentence of two to six years.[321] The punishments for both crimes described above are increased by one-third when the victim suffers serious injury; when the perpetrator is a close relative, such as a father, a grandfather, a sibling, or an adoptive parent; when the perpetrator is a guardian or custodian of the victim; or when the rape was committed by two or more people.[322]

The Penal Code also classifies crimes of unchaste abuse and abduction for sexual purposes. Unchaste abuse is understood to be all "lustful acts not constituting carnal penetration, committed with violence or intimidation,"[323] and the punishment imposed is one to three years' imprisonment.[324] Abduction for sexual purposes is divided into two subcategories. Abduction for sexual purposes "proper" is an act where someone, with lustful aims, and through violence or serious threats, kidnaps or detains a person who has not reached puberty.[325] Abduction for sexual purposes "improper" is committed when a man "with lustful aims" abducts an "honest girl" who has reached puberty or is under 17 years old, with her consent.[326] The criminal sanctions provided are, in the former case, one to five years and, in the latter, six months to two years of imprisonment.[327] All sanctions imposed for abduction are suspended if the aggressor marries the victim before the sentence has been carried out.[328] Finally, the crime of corruption of minors punishes those who "through lustful acts or by any other means, corrupts or contributes to the corruption of a person under 17 years." The punishment is imprisonment for one to five years.[329] The punishment may be reduced or the accused can be exempted from the punishment if the minor is considered a "corrupt person."[330]

D. SEXUAL EDUCATION

Sexual education is part of the Bolivian government's policies. The Law for Education Reform states that among the aims of education is "preparation for a biologically and ethically healthy sexuality."[331] The first steps toward implementation of this provision have recently begun — sex education training is being provided to teaching staff in educational establishments.[332] Also, the Regulations for the Prevention and Care of HIV/AIDS in Bolivia provide that the Education Secretary, in coordination with the National Health Secretary, must provide sex education classes in schools, after teaching staff have been trained in these issues.[333] This program is to be carried out at the primary, secondary, and higher educational levels.[334]

Some NGOs have initiated sexual education sessions with adolescents during the past several years. Although the impact on adolescents overall is still limited, these sessions are a useful base of experience which may be replicated in formal sex education instruction.[335]

ENDNOTES

1. WORLD ALMANAC BOOKS, THE WORLD ALMANAC AND BOOK OF FACTS 1997, at 745 (1996).
2. *Id.*
3. *Id.*
4. *Id.*
5. *Id.*
6. *Id.*
7. *Id.*, at 746.
8. *Id.*
9. Bolivia web page (viewed on Sept. 5, 1997) <http://www.boliviaweb.com>.
10. UNITED STATES DEPARTMENT OF STATE, COUNTRY REPORTS ON HUMAN RIGHTS PRACTICES FOR 1996, at 357 (1997).
11. Political Constitution of the State, art. 1 (Legal Collection Guttentag, 2nd edition, "Editorial los Amigos del Libro," 1996) (hereinafter BOL. CONST.)
12. *Id.*
13. BOL. CONST., art. 2.
14. *Id.*, art. 85.
15. *Id.*, art. 86.
16. *Id.*, art. 87.
17. *Id.*
18. *Id.*, art. 96.
19. *Id.*, art. 99.
20. *Id.*, art. 101.
21. *Id.*
22. *Id.*, art. 102.
23. *Id.*, art. 46.
24. *Id.*
25. *Id.*, art. 63.
26. *Id.*, art. 60.
27. *Id.*, arts. 60 and 63.
28. *Id.*, art. 60, cl. II.
29. *Id.*, art. 60, cl. V.
30. *Id.*, art. 60, cl. IV. The candidate with the majority of votes is elected as deputy.
31. *Id.*
32. *Id.*, art. 60, cl. III.
33. *Id.*, art. 59.
34. *Id.*
35. *Id.*, arts. 71–81.
36. *Id.*, art. 71.
37. *Id.*, art. 72.
38. *Id.*, art. 76.
39. *Id.*, art. 78.
40. *Id.*, art. 81.
41. *Id.*, art. 116.
42. *Id.*, art. 117.
43. *Id.*, art. 127.
44. *Id.*, art. 116, cl. III.
45. *Id.*, cl. VIII.
46. *Id.*, cl. X.
47. *Id.*
48. *Id.*, arts. 124 and 125.
49. *Id.*, art. 127.
50. BOL. CONST., art. 171, cl. III.
51. *Id.*, art. 108.
52. *Id.*, art. 109, cl. I.
53. *Id.*, cl. II.
54. *Id.*
55. Law No. 1654, July 28, 1995.
56. *Id.*
57. BOL. CONST., art. 200.
58. *Id.*
59. *Id.*
60. *Id.*
61. *Id.*
62. *Id.*, art. 201.
63. *Id.*, art. 205.
64. *Id.*, art. 200.
65. *Id.*, art. 228.
66. *Id.*
67. *Id.*, art. 59, cl. 12.
68. *Id.*, art. 96, cl. 2.
69. The Bolivian government has signed and ratified, among others, the following international instruments for the protection of human rights: The International Covenant on Civil and Political Rights, *adopted* Dec. 16, 1966, 999 U.N.T.S.171 (*entry into force* Mar. 23, 1976) (ratified by Bolivia on Aug. 12, 1982); The International Covenant on Economic, Social and Cultural Rights, *adopted* Dec. 16, 1966, 993 U.N.T.S. 3 (*entry into force* Sept. 3, 1976) (ratified by Bolivia on Aug. 12, 1982), The International Convention on the Elimination of all Forms of Racial Discrimination, *opened for signature* Mar. 7, 1966, 660 U.N.T.S. 195 (*entry into force* Jan. 4, 1969) (ratified by Bolivia on Sept. 22, 1970); and The American Convention on Human Rights, signed Nov. 22, 1969, 9 I.L.M. 101 (entry into force Jul. 18, 1978) (ratified by Bolivia on Jul. 19, 1979).
70. The Convention on the Elimination of All Forms of Discrimination Against Women, *opened for signature* Mar. 1, 1980, 1249 U.N.T.S. 13 (*entry into force* Sept. 3, 1981) (ratified by Bolivia on July 8, 1990).
71. Inter-American Convention on the Prevention, Punishment and Eradication of Violence Against Women, *adopted* Jun. 9, 1994, 33 I.L.M 1534 (*entry into force* Mar. 5, 1995) (ratified by Bolivia on Oct. 26, 1994).
72. BOL. CONST., art. 7, cl. a.
73. HEALTH CODE, Decree Law No. 15629, Jul. 18, 1978, art. 2.
74. *Id.*
75. MINISTRY OF HUMAN DEVELOPMENT, NATIONAL HEALTH SECRETARY, DIAGNÓSTICO CUALITATIVO DE LA ATENCIÓN EN SALUD REPRODUCTIVA EN BOLIVIA, REVISIÓN BIBLIOGRÁFICA [QUALITATIVE DIAGNOSIS OF ATTENTION TO REPRODUCTIVE HEALTH IN BOLIVIA, BIBLIOGRAPHIC REVISION], at 32 (1996).
76. Executive Branch Ministers' Law, Law No. 1495, Sept. 17, 1995, art. 19, cl. f.
77. MINISTRY OF HUMAN DEVELOPMENT, NATIONAL HEALTH SECRETARY, PLAN VIDA. PLAN NACIONAL PARA LA REDUCCIÓN ACELERADA DE LA MORTALIDAD MATERNA, PERINATAL Y DEL NIÑO. BOLIVIA 1994–1997 [LIFE PLAN: NATIONAL PLAN FOR THE RAPID REDUCTION IN MATERNAL, PERINATAL AND CHILD MORTALITY IN BOLIVIA 1994–1997], UNPF/USAID/UNICEF/OPS, at 20 (1994).
78. MINISTRY OF HUMAN DEVELOPMENT, NATIONAL HEALTH SECRETARY/OPS/OMS, INFANT AND COMMUNITY HEALTH PROJECT, NECESIDADES Y EXPECTATIVAS DE COOPERACIÓN INTERNACIONAL EN SALUD EN EL NIVEL NACIONAL, DEPARTAMENTAL Y MUNICIPAL [NEEDS AND EXPECTATIONS OF INTERNATIONAL AID IN HEALTH AT A NATIONAL, DEPARTMENTAL AND MUNICIPAL LEVEL], at 26 and 27 (1997). The Public Health System is an organizational model that incorporates municipal governments and departmental administration in the management of health services.
79. Supreme Decree No. 24237, art. 3.
80. NEEDS AND EXPECTATIONS, *supra* note 78, at 27.
81. NATIONAL HEALTH SECRETARY, REFERENCE TEXT ON SEXUAL AND REPRODUCTIVE HEALTH, at 25 (2nd edition, 1996). The National Health Secretary is the national entity that governs the Public and Decentralized Health System. It is part of the Ministry of Human Development, along with Secretaries of Popular Participation, Education, Ethic Issues, and Matters of Ethnic and Gender Differences.
82. NEEDS AND EXPECTATIONS, *supra* note 78, at 27.
83. REFERENCE TEXT ON SEXUAL AND REPRODUCTIVE HEALTH, *supra* note 81, at 25. The DHOs form part of the departmental human development secretaries for each prefect in the nine departments of Bolivia.
84. NEEDS AND EXPECTATIONS, *supra* note 78, at 27.
85. REFERENCE TEXT ON SEXUAL AND REPRODUCTIVE HEALTH, *supra* note 81, at 25. This entity consists of the municipal mayor or his or her representative in the name of the municipal government, the departmental health director or his or her representative, and a representative from the Surveillance Committee, elected by local territorial organizations.
86. NEEDS AND EXPECTATIONS, *supra* note 78, at 27.
87. LIFE PLAN, *supra* note 77, at 22.
88. QUALITATIVE DIAGNOSIS, *supra* note 75, at 32.
89. *Id.*, at 33.
90. *Id.*
91. *Id.*
92. NEEDS AND EXPECTATIONS, *supra* note 78, at 36.
93. UNITED NATIONS POPULATIONS FUND (UNFPA), PROGRAM REVIEW AND STRATEGY DEVELOPMENT REPORT, BOLIVIA, at 4 (1991).
94. *Id.*, at 33.
95. *Id.*

96. *Id.*
97. *Id.*
98. QUALITATIVE DIAGNOSIS, *supra* note 75, (a) at 49.
99. *Id.*
100. *Id.*
101. HEALTH CODE, Decree Law No. 15629, Julo 18, 1978, Bk. Five, Tit. I, Ch. I.
102. *Id.*, art. 3. The Health Code denominates Health Authority to the Ministry of Social Security and Public Health.
103. *Id.*, art. 125.
104. *Id.*, art. 126.
105. PENAL CODE, Decree No. 14426, Aug. 22, 1972.
106. *Id.*, art. 218, cl. 1.
107. *Id.*, art. 218, first ¶.
108. Julieta Montano and Florinda Corrales, The Women's Legal Office, Draft Bolivia chapter, at 23 (1996).
109. HEALTH CODE, art. 5.
110. *Id.*, cls. c and d.
111. Draft Bolivia chapter, *supra* note 108, at 23.
112. PENAL CODE, art. 218, cl. 4.
113. MINISTRY FOR PLANNING AND COORDINATION, POPULATION POLICY UNIT, ESTRATEGIA NACIONAL DE DESARROLLO. LINEAMIENTOS DE POLÍTICAS DE LA POBLACIÓN [NATIONAL DEVELOPMENT STRATEGY: OBJECTIVES OF POPULATION POLICIES] (1992).
114. *Id.*, at 13.
115. *Id.*, at 13-16.
116. MINISTRY OF HUMAN DEVELOPMENT, DECLARACIÓN DE PRINCIPIOS SOBRE POBLACIÓN Y DESARROLLO SOSTENIBLE [DECLARATION OF PRINCIPLES ON POPULATION AND SUSTAINABLE DEVELOPMENT] (1994). This document lays out the official Bolivian government policy on population issues and was presented by the Bolivian Delegation at the International Conference on Population and Development, Cairo, Sept. 1994.
117. *Id.*, at 3 and 4.
118. *Id.*, at 5.
119. *Id.*, at 13.
120. *Id.*, at 13 and 14.
121. *Id.*, at 6.
122. *Id.*
123. *Id.*, at 21.
124. LIFE PLAN, *supra* note 77.
125. *Id.*, at 7.
126. *Id.*, at 30 and 31.
127. *Id.*, at 29. The current maternal mortality rate in Bolivia is 600 per 100,000 live births. UNITED NATIONS, THE WORLD'S WOMEN 1995: TRENDS AND STATISTICS, at 86 (1995).
128. *Id.*
129. *Id.*
130. Supreme Decree No. 24227, May 28, 1996, which entered into force on Jul. 1, 1997.
131. NEEDS AND EXPECTATIONS, *supra* note 78, at 28.
132. *Id.*
133. *Id.*
134. DECLARATION OF PRINCIPLES ON POPULATION, *supra* note 116, at 21 and 22.
135. REFERENCE TEXT OF SEXUAL AND REPRODUCTIVE HEALTH, *supra* note 81, at 24.
136. *Id.*
137. QUALITATIVE DIAGNOSIS, *supra* note 75, at 49.
138. MINISTRY OF SOCIAL SECURITY AND PUBLIC HEALTH, PLAN NACIONAL DE SUPERVIVENCIA-DESARROLLO INFANTIL Y SALUD MATERNA. LIBRO DE NORMAS Y PROCEDIMIENTOS [NATIONAL PLAN FOR INFANT SURVIVAL-DEVELOPMENT AND MATERNAL HEALTH: BOOK OF RULES AND PROCEDURES], at 122 (1992).
139. *Id.*
140. MINISTRY FOR PLANNING AND COORDINATION, NATIONAL STATISTICS INSTITUTE 1993, CENSO NACIONAL DE POBLACIÓN Y VIVIENDA 1992 [NATIONAL POPULATION AND HOUSING CENSUS 1992], at 40.
141. *Id.*
142. *Id.*
143. *Id.*
144. DECLARATION OF PRICNIPLES ON POPULATION, *supra* note 116, at 18.
145. *Id.*
146. QUALITATIVE DIAGNOSIS, *supra* note 75, at 87.
147. *Id.*
148. *Id.*
149. *Id.*
150. *Id.*, at 90.
151. Julieta Montano and Florinda Corrales, The Women's Legal Office, Draft Bolivia chapter, at 32 (1996).
152. DECLARATION OF PRINCIPLES ON POPULATION, *supra* note 116, at 23.
153. *Id.*
154. QUALITATIVE DIAGNOSIS, *supra* note 75, at 21.
155. *Id.*
156. *Id.*, at 23.
157. PATRICIA E. BAILEY, LUIS LLANOS SAAVEDRA, LUIS KUSHNER, MICHAEL WELSH AND BARBARA JANOWITZ, BARBARA, A HOSPITAL STUDY OF ILLEGAL ABORTION IN BOLIVIA, PAHO Bulletin 2, at 27–41, in QUALITATIVE DIAGNOSIS, *supra* note 75, at 67.
158. QUALITATIVE DIAGNOSIS, *supra* note 75, at 67.
159. *Id.*, at 47.
160. *Id.*
161. PENAL CODE, art. 263.
162. *Id.*, art. 266.
163. *Id.*
164. *Id.*, art. 263, cl. 3.
165. *Id.*, cls. 1 and 2.
166. *Id.*, art. 269.
167. *Id.*, art. 268.
168. *Id.*, art. 267.
169. *Id.*, art. 266.
170. Julieta Montano and Florinda Corrales, The Women's Legal Office, Draft Bolivia chapter, at 34 (1996).
171. ZULEMA ALANEZ, MITOS Y REALIDADES. EL ABORTO EN BOLIVIA [MYTHS AND REALITIES: ABORTION IN BOLIVIA], at 9 (1995).
172. *Id.*
173. PENAL CODE, art. 266, third ¶.
174. *Id.*, second ¶.
175. *Id.*, first ¶.
176. *Id.*, third ¶.
177. *Id.*, art. 263, cl. 1.
178. *Id.*, cl. 2.
179. *Id.*, cl. 3.
180. *Id.*, art. 265. The code does not define what should be understood by "honor".
181. *Id.*
182. *Id.*
183. *Id.*, art. 264.
184. *Id.*
185. *Id.*, second ¶.
186. *Id.*
187. *Id.*, art. 268.
188. *Id.*, art. 267.
189. *Id.*, art. 269.
190. NEEDS AND EXPECTATIONS, *supra* note 78, at 24.
191. Julieta Montano and Florinda Corrales, The Women's Legal Office, Draft Bolivia chapter, at 11 (1996).
192. NEEDS AND EXPECTATIONS, *supra* note 78, at 24.
193. Los Tiempos, Nov. 14, 1996.
194. Resolución Secretarial No. 0660 para la Prevención y Vigilencia del VIH/SIDA en Bolivia [Secretarial Regulation No. 0660 for the Prevention and Care of HIV/AIDS in Bolivia], Dec., 1996.
195. *Id.*, art. 6.
196. *Id.*, art. 8.
197. *Id.*, arts. 9 and 11.
198. *Id.*
199. *Id.*, art. 10 and 12.
200. *Id.*, art. 40.
201. *Id.*, arts. 41 and 42.
202. *Id.*, art. 43.
203. *Id.*, art. 36.
204. *Id.*
205. *Id.*, art. 38.
206. *Id.*
207. *Id.*, art. 45.

208. *Id.*, art. 17.
209. *Id.*, art. 49.
210. *Id.*, art. 50.
211. *Id.*, art. 51.
212. *Id.*, art. 37.
213. *Id.*, art. 39.
214. *Id.*
215. PENAL CODE, Article 216, cl. 1.
216. *Id.*, art. 277.
217. Secretarial Resolution No. 0660 for the Prevention and Care of HIV/AIDS in Bolivia, *supra* note 194, art. 3.
218. Ministry of Human Development, National Health Secretary, Presentation on Secretarial Resolution No. 0660 for the Prevention and Care of HIV/AIDS in Bolivia, Dec. 1996.
219. *Id.*, art. 14.
220. *Id.*, art. 15.
221. *Id.*, art. 16.
222. *Id.*
223. *Id.*, art. 20, cl. a.
224. *Id.*, cl. b.
225. *Id.*, cl. c.
226. *Id.*, cl. d.
227. *Id.*, cl. e.
228. BOL. CONST., art. 6.
229. *Id.*, art. 194.
230. *Id.*, art. 193.
231. Family Code Decree, Aug. 23, 1972, elevated to the rank of law on Apr. 4, 1988 [hereinafter FAMILY CODE].
232. *Id.*, art. 3.
233. CIVIL CODE, Decree Law No. 12760, Aug. 6, 1975, art. 4.
234. BOL. CONST., art. 41.
235. FAMILY CODE, art. 44.
236. *Id.*, art. 99.
237. *Id.*, art. 97.
238. *Id.*
239. *Id.*, art. 98.
240. *Id.*
241. *Id.*
242. *Id.*, art. 114.
243. *Id.*
244. *Id.*
245. *Id.*, art. 115.
246. *Id.*, art. 116.
247. PENAL CODE, art. 240.
248. FAMILY CODE, art. 158.
249. FAMILY CODE, art. 159.
250. *Id.*, art. 172.
251. CIVIL CODE, art. 1083.
252. *Id.*, art. 1108.
253. FAMILY CODE, art. 160.
254. *Id.*, arts. 130 and 131.
255. *Id.*
256. *Id.*, art. 101.
257. *Id.*, art. 145.
258. *Id.*
259. *Id.*
260. *Id.*, art. 149.
261. Secretarial Resoulution No. 0660 for the Prevention and Care of HIV/AIDS in Bolivia, *supra* note 194, arts. 41 and 42.
262. Julieta Montano and Florinda Corrales, The Women's Legal Office, Draft Bolivia chapter, at 23 (1996).
263. *Id.*
264. *Id.*
265. General Labor Law, Decree Law, May 24, 1939, elevated to Law of the Republic on Dec. 9, 1942.
266. *Id.*, art. 61.
267. Law No. 975, May 2, 1988, art. 1.
268. SOCIAL SECURITY CODE, Law of December 14, 1956.
269. *Id.*, art. 23.
270. *Id.*
271. *Id.*
272. *Id.*
273. *Id.*, art. 45.
274. Julieta Montano and Florinda Corrales, The Women's Legal Office, Draft Bolivia chapter, at 15 and 16 (1996).
275. MINISTRY OF FOREIGN RELATIONS, MINISTRY OF HUMAN DEVELOPMENT, INFORME ACERCA DEL AVANCE DE LA MUJER EN BOLIVIA. CUARTA CONFERENCIA MUNDIAL SOBRE LA MUJER [REPORT ON THE ADVANCEMENT OF WOMEN IN BOLIVIA FOR THE FOURTH WORLD CONFERENCE ON WOMEN], at 29 (1994).
276. *Id.*
277. *Id.*
278. *Id.*
279. *Id.*, at 30.
280. *Id.*, at 31.
281. SONIA MONTANO (ED), INVERTIR EN LA EQUIDAD. BOLIVIA [INVEST IN EQUALITY. BOLIVIA] (1993).
282. *Id.*
283. *Id.*
284. Law No. 1493, Law of Executive Branch Ministers, Sept. 17, 1993.
285. National Secretary of Ethnic, Gender and Generational Issues, Subsecretary of Gender Issues, Resumen Ejecutivo [Executive Summary], at 3 (n.d.).
286. *Id.*
287. Law of Administrative Decentralization 1995, Law No. 1654, Jul. 28, 1995.
288. PENAL CODE, art. 308.
289. *Id.*
290. *Id.*
291. *Id.*, art. 310, second ¶.
292. *Id.*, art. 308.
293. *Id.*, art. 315.
294. *Id.*
295. *Id.*, art. 316.
296. *Id.*, art. 317.
297. JULIETA MONTANO, PROYECTO DE REFORMAS AL CÓDIGO PENAL Y DE FAMILIA [PROJECT FOR REFORMS OF THE PENAL AND FAMILY CODE], at 26 (1994).
298. Law against Family or Domestic Violence, Law No. 1674, Dec. 15, 1995.
299. *Id.*, art. 3.
300. *Id.*, art. 4.
301. *Id.*, art. 5.
302. *Id.*, art. 14.
303. *Id.*, art. 16.
304. *Id.*, art. 15.
305. *Id.*, art. 18.
306. THE WORLD ALMANAC, *supra* note 1, at 745.
307. Susana Rance, Planificación Familiar: Se Abre el Debate [Family Planning: The Debate Opens] National Population Council, 1990, in QUALITATIVE DIAGNOSIS, *supra* note 75, at 14.
308. *Id.*
309. *Id.*
310. MINOR'S CODE, Law No. 1403.
311. *Id.*, arts. 15 and 16.
312. REFERENCE TEXT OF SEXUAL AND REPRODUCTIVE HEALTH, *supra* note 81, at 25.
313. QUALITATIVE DIAGNOSIS, *supra* note 75, at 14.
314. FAMILY CODE, art. 44.
315. *Id.*
316. QUALITATIVE DIAGNOSIS, *supra* note 75, at 14.
317. *Id.*
318. PENAL CODE, art. 308, second ¶. There is no legal provision that defines the legal age of puberty. Evaluation of this is at the discretion of the judge.
319. *Id.* The punishment for murder is thirty years imprisonment.
320. *Id.*, art. 309. The code does not define "honest".
321. *Id.*
322. *Id.*, art. 310.
323. *Id.*, art. 312.
324. *Id.*
325. *Id.*, art. 313.
326. *Id.*, art. 314.

327. *Id.*, arts. 313 and 314.
328. *Id.*, art. 317.
329. *Id.*, art. 318.
330. *Id.*, second ¶
331. Education Reform Law, art. 2, cl. 3 (n.d.).
332. Julieta Montano and Florinda Corrales, The Women's Legal Office, Draft Bolivia chapter, at 30–31 (1996).
333. Secretarial Resolution No. 0660 for Prevention and Care of HIV/AIDS in Bolivia, *supra* note 194, art. 56.
334. *Id.*
335. Julieta Montano and Florinda Corrales, The Women's Legal Office, Draft Bolivia chapter, at 31 (1996).

Brazil

Statistics

GENERAL

Population

- Brazil has a total population of 163.1 million,[1] of which 50.9% are women.[2] The growth rate is approximately 1.2% per year.[3]
- 34% of the population is under 15 years old,[4] and 4% is over 60.[5]
- In 1996, 75.47% of the population lived in urban areas; 57.83% of the population of the northern region, 60.64% of the northeast region, 81.26% of the central-western region, 88.01% of the southeastern region, and 74.12% of the southern region lived in urban areas.[6]

Territory

- Brazil covers 8,580,444 square kilometers.[7]

Economy

- In 1994, the World Bank estimated the gross national product per capita at U.S.$2,970.[8]
- From 1990 to 1994, the gross domestic product ("GDP") grew at an estimated rate of 2.2%. This is a fall from the period from 1980 to 1990, when the rate was 2.7%.[9]
- In 1990, the government's budget for health, sanitation, and education was 5.5% of the GDP.[10]

Employment

- In 1994, approximately 71 million people were employed in Brazil, of which 47.9% were women.[11]

WOMEN'S STATUS

- The average life expectancy for women is 71.2 years, compared with 63.4 years for men.[12]
- The illiteracy rate for women and men is the same: 17%.[13]
- Women's representation in the economically active population grew in the last decade (1981 to 1990) from 31% to 35%.[14]
- Women represent 3.9% of the unemployment rate in urban areas and 1.4% in rural areas.[15]
- Violence against women is common in Brazil. Of all reported incidents of violence in 1991, 70% took place within the home, and, in nearly all cases, the aggressor was the woman's spouse or partner.[16]

ADOLESCENTS

- Approximately 34% of the population of Brazil is under 15 years old.[17]
- The median age of first marriage or domestic partnership for women is 22.6 years.[18]
- From 1990 to 1995, the fertility rate in adolescents between the ages of 15 and 19 was 41 per 1,000.[19]

MATERNAL HEALTH

- In the three years prior to 1996, the total fertility rate of women between the ages of 15 and 49 was 2.5 children per woman. In urban areas, the rate was 2.3, and in rural areas, 3.5.[20]
- The maternal mortality rate is 220 per 100,000 live births.[21]
- The most frequent cause of maternal deaths is toxemia, which is responsible for 30% of deaths.[22]
- The practice of surgical births has reached striking levels. In 1970, 15% of births were by cesarean section. In 1980 that figure rose to 31%, and in 1990 to 34%.[23] By 1996, 36.4% of births were registered as cesareans.[24]
- From 1995 to 2000, it is estimated that the infant mortality rate is 42 per 1,000 live births.[25]
- In Brazil, 73% of births are attended by a health professional.[26]

CONTRACEPTION AND ABORTION

- Currently, 76.6% of Brazilian women in a stable relationship use some form of contraception. Sterilization and the contraceptive pill are the most frequently used methods, with prevalence rates of 40.1% and 20.7%, respectively.[27] Together they represent about 87% of the modern contraceptive methods used and 80% of all methods employed by women in relationships.[28]

- In 1992, 7.5 million women were sterilized during cesarean operations.[29]

- Other methods used are condoms (4.4%), abstinence (3%), withdrawal (3.1%), male sterilization (2.6%), injectable contraceptives (1.2%), the intrauterine device (1.1%), and others (0.4%).[30]

- In 1991, estimates of the number of women who had induced abortions ranged from 866,003 to 2,020,674.[31] In the three years between 1989 and 1992, the number of women hospitalized because of abortion complications was between 290,965 and 327,157.[32]

- In 1995, the Single Health System registered 274,698 hospitalizations for abortions.[33]

HIV/AIDS AND STIs

- According to information given by the Ministry of Health, between 1987 and 1995, 451,708 cases of sexually transmitted infections were registered.[34]

- Brazil has one of the highest rates of AIDS in the world. It is estimated that at the end of 1996, 146,000 people had developed the disease of the total number of approximately 500,000 infected.[35] Officially, the country has only 94,997 cases registered.[36]

ENDNOTES

1. UNITED NATIONS POPULATION FUND (UNFPA), THE STATE OF WORLD POPULATION, 1997, at 72 (1996).
2. UNITED NATIONS, THE WORLD'S WOMEN 1995, TRENDS AND STATISTICS, at 25 (1995).
3. THE STATE OF WORLD POPULATION *supra* note 1, at 72.
4. WORLD ALMANAC BOOKS, THE WORLD ALMANAC AND BOOK OF FACTS, 1997, at 746 (1996).
5. *Id.*
6. MINISTRY OF HEALTH ATG/GM, SAÚDE NO BRAZIL [HEALTH IN BRAZIL]. INDICATORS: DEMOGRAPHIC, SOCIOECONOMIC, MORTALITY, DISEASE, FUNDS AVAILABLE FOR HEALTH SERVICES AND ACTIVITIES (1996).
7. THE WORLD ALMANAC, *supra* note 4, at 746.
8. WORLD BANK, WORLD DEVELOPMENT REPORT 1996: FROM PLAN TO MARKET, at 189 (1996).
9. *Id.*, at 208.
10. UNITED NATIONS DEVELOPMENT PROGRAM (UNDP), INSTITUTE FOR APPLIED ECONOMIC RESEARCH (IAER), REPORT ON HUMAN DEVELOPMENT IN BRAZIL 1996, at 182 (1996).
11. WORLD DEVELOPMENT REPORT 1996, *supra* note 8, at 195.
12. THE STATE OF WORLD POPULATION, *supra* note 1, at 69.
13. *Id.*
14. REPORT ON HUMAN DEVELOPMENT IN BRAZIL 1996, *supra* note 10, at 33.
15. THE WORLD'S WOMEN 1995, *supra* note 2, p 123.
16. HUMAN RIGHTS WATCH, CRIMINAL INJUSTICE: VIOLENCE AGAINST WOMEN IN BRAZIL. AN AMERICAS WATCH REPORT, at 14 (1991).
17. THE WORLD ALMANAC, *supra* note 4, at 746.
18. THE WORLD'S WOMEN 1995, *supra* note 2, at 35.
19. *Id.*, at 86.
20. CIVIL SOCIETY AND FAMILY WELL-BEING IN BRAZIL (BEMFAM), PROGRAM OF RESEARCH ON DEMOGRAPHY AND HEALTH, NATIONAL RESEARCH ON DEMOGRAPHY AND HEALTH 1996: PRELIMINARY REPORT (cited in Silvia Pimentel and Valeria Pandjiarjian, Institute for the Promotion of Equality, Draft Brazil chapter, at 5 (1997)).
21. THE STATE OF WORLD POPULATION, *supra* note 1, at 69.
22. REPORT ON HUMAN DEVELOPMENT IN BRAZIL 1996, *supra* note 10, at 43.
23. NATIONAL RESEARCH ON DEMOGRAPHY AND HEALTH 1996, *supra* note 20, at 5-6.
24. *Id.*
25. THE STATE OF WORLD POPULATION, *supra* note 1, at 69.
26. *Id.*, at 72.
27. NATIONAL RESEARCH ON DEMOGRAPHY AND HEALTH 1996, *supra* note 20, at 6.
28. *Id.*
29. Katrin Oliveira, *In Brazil: sterilization contributes to curbing demographic explosion; however, for some women, it is a prerequisite to obtaining work; for others, it is done out of ignorance*, THE GAZETTE, Feb. 6, 1992, (cited in THE CENTER FOR REPRODUCTIVE LAW AND POLICY (CRLP), WOMEN OF THE WORLD: FORMAL LAWS AFFECTING THEIR REPRODUCTIVE LIVES, at 2 (1995)).
30. NATIONAL RESEARCH ON DEMOGRAPHY AND HEALTH 1996, *supra* note 20, at 6-7.
31. SUSHEELA SINGH AND DEIDRE WULF, ESTIMATED LEVELS OF INDUCED ABORTION IN SIX LATIN AMERICAN COUNTRIES, (cited in WOMEN OF THE WORLD, *supra* note 29, at 2).
32. *Id.*
33. Data from the Ministry of Health, Office for Coordination of Women's Health, in Draft Brazil chapter, *supra* note 20, at 7.
34. Ministry of Health, *National Program for Sexually Transmitted Diseases: AIDS, STDs*, BOLETIM EPIDEMIOLOGICO [EPIDEMIOLOGICAL BULLETIN], Year IV, No. 4, Sept. 1995 — Feb. 1996, at 8.
35. Epidemiological Bulletin presented by the Ministry of Health at the close of the First National Conference for the Prevention of AIDS, Salvador, Dec. 1996. Draft Brazil chapter, *supra* note 20, at 8.
36. *Id.*

Brazil is located in the eastern central part of South America and is the largest country on the continent.[1] To the north, it is bordered by French Guyana, Suriname, Guyana and Venezuela; to the west by Colombia, Peru, Bolivia, Paraguay, and Argentina; to the south by Uruguay; and to the east by the Atlantic Ocean.[2] The official language in Brazil is Portuguese, and Roman Catholicism is the prevalent religion.[3] The ethnic composition of the country is Caucasian (58%), mulatto (38%), and African (6%).[4]

Brazil was a Portuguese colony from 1500, when Portuguese navigator Pedro Alvares Cabral arrived on the Brazilian coast,[5] until 1822, when Prince Pedro I declared Brazil independent of the Portuguese kingdom and proclaimed himself emperor of the new kingdom of Brazil.[6] In 1889, his successor, Emperor Pedro II, was overthrown, and the Republic of the United States of Brazil was formed.[7] In 1967, the country adopted the name the Federal Republic of Brazil.[8] From 1964 to 1985, Brazil was governed by successive military dictatorships. In 1985, the first democratic presidential elections were held.[9] Fernando Henrique Cardoso is currently Brazil's president. He was inaugurated on January 1, 1995.[10] Brazil is implementing economic reforms to open up the market through both privatization of state companies and elimination of laws and policies that restrict free market competition.[11]

I. Setting the Stage: the Legal and Political Framework

To understand the various laws and policies affecting women's reproductive rights in Brazil, it is necessary to consider the legal and political systems of the country. By considering the bases and structure of these systems, it is possible to attain a better understanding of how laws are enacted, interpreted, modified, and implemented as well as the process by which governments adopt reproductive health and population policies.

A. THE STRUCTURE OF NATIONAL GOVERNMENT

Brazil is a democratic state,[12] formed as a federal republic,[13] consisting of the Union of Federal Territories (the "Union"), the Federal District, states, and municipalities.[14] The federal territories constitute only a form of administrative-territorial decentralization of the Union,[15] whose creation is prescribed by the Constitution,[16] but presently there are no federal territories in Brazil.[17]

Power emanates from the people and is exercised through their representatives. These representatives are elected directly by the people according to terms established by constitutional norms.[18] The Constitution of the Federal Republic of Brazil (the "Federal Constitution")[19] is the supreme law of the Republic.[20] However, the states are also ruled by their own constitutions.[21] The state constitutions and all other laws of the Brazilian legal order must be compatible with the principles contained in the Federal Constitution.[22] The branches of power of the Federal Republic of Brazil are the executive, the legislative, and the judiciary, and they are "independent" and "coordinated."[23]

Executive Branch

Executive power is exercised by the president of the republic and the ministers of state.[24] The president is elected through universal, direct, and secret suffrage,[25] requiring a majority of the votes cast.[26] The president is elected for four years and can be reelected for another consecutive period.[27] The president, together with the ministers of state, administers the federal government.[28] The functions of the President are, among others, to appoint ministers of state;[29] propose and veto legislation; approve, enact, and have laws published; enter into international treaties, conventions, and agreements; appoint justices to the Federal Supreme Court; and appoint the territorial governors and magistrates.[30]

Relations between the executive and the legislative branches are regulated by the Federal Constitution. The Chamber of Deputies, the Federal Senate, or any of their standing commissions can convoke ministers of state or any official directly subordinate to the president of the republic to present reports about issues of national interest.[31] If a minister or official is not present to deliver the report or if he or she gives false information, he or she has committed a crime of responsibility[32] and is judged in accordance with the Federal Constitution.[33] The president of the republic commits a crime of responsibility if he or she undertakes any act contrary to the Federal Constitution, the internal security of the country, or the free exercise of power by the legislative and judicial branches of government or the constitutional powers of the states that make up the Federation.[34] The President is tried before the Federal Supreme Court for common crimes and by the Senate for crimes of responsibility.[35]

Legislative Branch

Legislative power is exercised through the National Congress,[36] which is composed of the Chamber of Deputies and the Chamber of the Federal Senate.[37] The Chamber of Deputies[38] is made up of representatives of the people elected for a four-year term[39] by a quota system[40] in each state, territory,[41] and the Federal District.[42] The Federal Senate[43] comprises three representatives from each state and the Federal District, elected by an absolute majority, for an eight-year term.[44] Decisions in both chambers are taken by an absolute majority of members.[45]

The National Congress's principal function is to address and to legislate on the issues under federal competency.[46] These issues include, among others the tax system; the financial and monetary system; national, regional, and sector development plans and programs; the incorporation, subdivision, or breakup of territorial areas in the republic; and the administrative and judicial organization of the Office of the Attorney General and the Public Defender.[47] Congressional legislation on these matters must have presidential approval to be valid.[48] However, Congress has exclusive competence[49] to ratify international treaties, accords, and other agreements that involve commitments of national resources; to suspend acts by the executive branch that exceed the executive's legislative capacity; to approve the annual budgets presented by the President; and to evaluate reports on the execution of governmental plans.[50] Congress oversees and exercises control over the executive branch directly or through either one of the chambers.[51]

The National Congress carries out the legislative process,[52] which encompasses drafting constitutional amendments, laws, and other legal norms of lesser authority.[53] Constitutional amendments may be introduced through a proposal by a minimum of a one-third of the members of the Chamber of Deputies or the Federal Senate, by the president, or by more than half of the state legislative assemblies.[54] Legislative proposals can be made by any member of the Chamber of Deputies, or the Federal Senate or by the entire National Congress, the President, the Federal Supreme Court, the High Courts, the Attorney General of the Republic, and any citizen, through the right to the "popular initiative."[55] Laws, once proposed and approved according to constitutional procedure, are sent to the president, who promulgates them.[56] If the president has observations to make about the law, they must be presented to the National Congress within fifteen days.[57] If the president does not present observations, the law is considered approved.[58]

The National Congress can delegate powers to the president of the republic to enact laws.[59] Likewise, the president can adopt provisional measures that have the force of law in cases of urgency and public necessity, but these must be immediately submitted to Congress for approval.[60] These executive measures cease to have legal effect if they are not converted into a law with congressional approval within thirty days of their publication.[61]

Judicial Branch

The judicial branch of Brazil consists of the following judicial bodies, in hierarchical order: the Federal Supreme Court and the higher courts of justice; the federal regional courts; the courts with jurisdiction over labor, electoral, and military matters; and courts with jurisdiction over the states, the Federal District, and the territories.[62]

The Federal Supreme Court and the higher courts are composed of judges appointed by the President after being approved by a majority of the members of the Federal Senate.[63] These courts have territorial jurisdiction throughout the national territory.[64] The subject matter jurisdiction of the Federal Supreme Court includes determining the constitutionality of federal laws and other legal norms; trying the president of the republic, the vice president, members of the National Congress, justices of the Supreme Court, and the attorney general of the republic when they are accused of common crimes; and trying crimes of responsibility allegedly committed by ministers of state, members of the higher courts, and heads of diplomatic missions.[65] To be a justice on the Federal Supreme Court, one must be a Brazilian over 35 and under 65 years old, who is a recognized specialist in law with an irreproachable reputation.[66]

The high courts have jurisdiction, in the first instance, to judge common crimes allegedly committed by state governors, Federal District governors, and judges of federal regional courts, regional electoral courts and labor courts. They are also responsible for resolving conflicts of jurisdiction between courts, hearing appeals, and hearing actions involving writs of habeas corpus.[67] To be a judge of a high court, the same requirements are necessary as those for justices of the Federal Supreme Court.[68] The courts and judges with jurisdiction over military matters are responsible for hearing and adjudicating military crimes defined as military crimes under the law.[69] Labor courts have jurisdiction to mediate and resolve individual and collective disputes between workers and employers.[70] The electoral courts and judges are regulated by a special law.[71]

The states' judicial systems follow principles established in the Federal Constitution.[72] The jurisdiction of the courts and tribunals is defined in each state's constitution and by a state law on judicial organization.[73] The states and the Federal District each constitute a separate judicial district based in the state capital.[74] There are also special tribunals responsible for judging civil cases of lesser complexity and minor penal crimes, and Justices of the Peace who are empowered to perform marriages and arbitrate disputes, among other functions.[75]

B. THE STRUCTURE OF THE TERRITORIAL DIVISIONS

Regional and local governments

The political-administrative organization of the Federal Republic of Brazil is constituted by the Union,[76] the states, the Federal District, and the municipalities.[77] It is the responsibility of the Union to maintain relations with foreign states and participate in international organizations; prepare and execute national and regional plans about territorial organization and

economic and social development; organize and maintain the judicial branch, the Attorney General's Office the Public Defender of the Federal District, and the federal territories; and legislate in civil, commercial, penal, procedural, electoral, agrarian, maritime, aeronautic, space, and labor matters.[78] Among other duties, the union prepares the framework of the national education system.[79]

The states are ruled by the constitutions and laws they adopt, following principles mandated in the Federal Constitution.[80] The union determines policies and programs for different sectors,[81] such as health, but the states are responsible for enacting the regulations for these programs so they can be applied at the regional and state levels.[82] There is a governor[83] and a state assembly,[84] which are in charge of the administration and management of internal state issues.[85] States are divided into municipalities,[86] or local governments, represented by a prefect who is elected by direct suffrage for a four-year term.[87] The Federal District is represented by a governor who has the same legislative and administrative responsibilities as those reserved to the states and municipalities.[88]

C. SOURCES OF LAW

Domestic sources of law

Laws determining women's legal status, including their reproductive rights, are derived from diverse sources. In the Brazilian legal system, formal sources of law are ranked in order of hierarchy, under the supremacy principle that establishes the superiority of the Federal Constitution; above all other laws.[89] The levels of Brazilian legislation, in hierarchical order, are the Federal Constitution, international treaties that do not deal with human rights;[90] state constitutions and complementary laws; ordinary laws; delegated laws; provisional measures; legislative decrees; and regulations.[91] No law can be contrary to the provisions of the Constitution.[92] International human rights treaties have the legal status of "constitutional norms."[93]

International sources of law

Multiple international human rights treaties specifically recognize and promote reproductive rights. These treaties legally commit governments to impose measures in order to advance and protect these rights. The Federal Constitution, in one of its articles,[94] provides that rights and guarantees laid out in the constitution do not exclude other rights and principles that are adopted through international treaties signed by Brazil.[95] Judicial decisions interpret this provision as a direct incorporation of human rights treaties into the internal legal order, giving such treaties a special status equivalent to that of constitutional provisions.[96]

International treaties that do not deal with human rights have subconstitutional[97] status and are approved and ratified in accordance with constitutional provisions dealing with international agreements.[98] Brazil is a member state of the United Nations and the Organization of American States. As such, Brazil has signed and ratified the majority of relevant treaties of the universal and Inter-American systems for the protection of human rights.[99] In particular, Brazil has ratified treaties related to women's rights, such as, the Convention on the Elimination of All Forms of Discrimination Against Women[100] and the Inter-American Convention on the Punishment, Prevention and Eradication of Violence against Women ("Convention of Belém do Pará").[101]

II. Examining Health and Reproductive Rights

In Brazil, issues related to the reproductive health of women fall within the scope of the country's national health and population policies. Thus, in order to understand reproductive rights in Brazil, it is necessary to analyze the laws and programs in both areas.

A. HEALTH LAWS AND POLICIES.

The Federal Constitution establishes that "everyone has the right to health and it is the duty of the State to guarantee it through social and economic policies aimed at reducing the risk of illness."[102] The Constitution also creates the Single Health System ("SHS"), whose purpose is to provide health care to all Brazilians through public services sponsored by the government.[103] The Fundamental Health Law[104] is the law that regulates standards for health promotion, protection, and recuperation and the organization and management of the corresponding services.[105] This law recognizes health as a fundamental human right and the state's obligation to create conditions that will ensure respect for this right.[106]

Objectives of the health policy

In Brazil, health policy is overseen by the Ministry of Health and the National Health Council,[107] in accordance with constitutional and other legal norms. The Ministry of Health establishes and regulates national programs,[108] and the states and municipalities are in charge of their implementation. The states and municipalities are free to determine health priorities in accordance with regional needs, provided they follow applicable federal norms.[109] The National Health Council was created in 1937 as a technical body of the Ministry of Health.[110] Today, it constitutes a forum for civil society to participate in the health system. The Council establishes guidelines to be observed in the development of health programs. It works in

conjunction with the Ministry of Health and with state and municipal health councils, which together are responsible for formulating strategies and overseeing the execution of health policies in each corresponding body.

The Single Health System is responsible for undertaking activities included in the national health policy. It encompasses health initiatives and services provided by federal public institutions, state and municipal institutions (directly or indirectly managed), and by public foundations.[111] The primary goals of the SHS are to identify and disseminate the most salient issues affecting the status of health in Brazil and to formulate health policies that ensure that all Brazilians have access to health assistance and preventive services.[112]

The Brazilian government pronounced 1997 to be the Year of Health.[113] Thus, for the period from 1997 to 1998, the government has established as essential goals the "coherent and joint" organization of activities to improve the population's health and the incorporation of federal, state, municipal, and private organizations in the attainment of this goal.[114] Strategies during this one-year period have been divided into three categories:[115] improving the quality of health services;[116] "pro health" social mobilization campaigns;[117] and prevention programs emphasizing primary care, which, among others, include community health promoters running family health projects around themes of basic medical care, women's and children's health, and sexually transmissible infections ("STIs"), among others.[118]

Infrastructure of health services

Public health services form a network divided both by region and by level of care provided in each establishment. This network functions as a unit. It is a system organized on the basis of principles of decentralization, coordination, and community participation.[119] Private entities can be incorporated into the SHS in a complementary way, through public rights contracts or agreements with the relevant health authority.[120] Charitable or nonprofit institutions are given preference in joining the SHS.[121]

According to statistics provided by the Brazilian Federation of Hospitals,[122] in 1996, there were 6,378 hospitals in the country, including 2,877 private, 107 federal, 731 state, 1,096 municipal, 1,419 charitable, and 148 university hospitals.[123]

In Brazil, human resources statistics show the average ratio of doctors to residents is 1 to 486.[124] Of the personnel employed in the health sector, a larger percentage work in administrative areas than in technical or medical areas,[125] revealing a distortion in the occupational structure of the health sector in Brazil.[126] The number of medical staff grew significantly during the last decade, increasing 5% from 1980 to 1987, and 8.3% from 1987 to 1992. However, this growth of employment took place principally within the private sector in the last few years, while the percentage of medical employees in the public sector dropped from 54% in 1987 to 48% in 1992.[127]

Cost of health services

The Single Health Service is financed by funds from the social security budget,[128] the federal government, the states, the Federal District, and the municipalities. Funds also come from other sources such as donations or the SHS's own income from payments for services. Charging for services cannot compromise the SHS's obligation to provide health care.[129] Since January 1997, and as a means to make up for the health sector budget deficit, the Brazilian government has instituted the collection of a Provisional Contribution on Financial Movement.[130] This means that, for thirteen months, all movements in bank accounts and financial and contractual obligations incurred by individuals and institutions are to be taxed 0.20%, which amounts are to be used to finance the health system.[131]

Regulation of health care providers

In Brazil, the exercise of the medical profession is regulated by the Federal Council of Medicine and the regional Councils of Medicine.[132] The Federal Council of Medicine, the body that supervises ethical medical practice nationally,[133] enacted the Medical Ethics Code,[134] which establishes that in order to practice medicine, it is mandatory for professionals to register with their respective state or, territory, or the Federal District's regional council.[135]

The provisions of the Medical Ethics Code are mandatory for all registered doctors. Physicians have the following general duties, among others, under the code: to respect human life; to always act for the benefit of the patient,[136] without any form of discrimination;[137] and to respect patients' confidentiality.[138] Doctors who fail to comply with the code will be tried by the respective regional Council of Medicine, which applies the applicable disciplinary measures, as provided by law.[139] Doctors are prohibited from carrying out any medical procedure without the express consent of the patient or his or her legal representative.[140] The Medical Ethics Code also contains rules about the doctor-patient relationship concerning reproductive health, such as the doctor's obligation to respect the patients' right to decide freely which contraception or conception methods they prefer and to explain to the patient the risks and consequences of each method.[141] The doctor is prohibited from carrying out artificial insemination without the patient's prior written consent.[142]

Patients' rights

In accordance with the Medical Ethics Code, a doctor will be sanctioned if he or she negligently causes harm to a patient

in the course of treatment[143] or if he or she does not comply with national legislation referring to organ or tissue transplant, sterilization, assisted fertility methods or abortion.[144] Patients are also protected from medical negligence under the Penal Code, which provides that in cases of negligent homicide[145] and injuries,[146] the sentence shall be increased by one-third when "the crime is the result of the nonobservance of technical regulations of a profession, art or occupation."[147]

With regard to patients' rights as consumers of health services, Law No. 8142[148] provides for community participation in the management of the SHS, through the health councils. These institutions are composed of government representatives, service providers, health professionals, and consumers.[149] The health councils are active in the formulation of health strategies and the execution of health policy in each state, municipality, and the Federal District.[150]

B. POPULATION, REPRODUCTIVE HEALTH, AND FAMILY PLANNING

Population laws and policies

A significant structural transformation that Brazilian society has undergone in the last decades of this century has been a change in its demographic profile. This is due to population growth, which has been accelerating since the end of the 1960s.[151] However, there is no specific government policy dealing with population issues in Brazil. Recently, the issue of the demographic transformation has been incorporated into development plans and programs and social projects and policies,[152] such as education and employment policy.[153] In 1996, a law was passed that prohibits forcing or requiring anyone to practice family planning as a means of demographic control.[154]

Reproductive health and family planning laws and policies

The Federal Constitution establishes that the state must provide the necessary educational and scientific resources in order that the right to family planning may be exercised.[155] It also prohibits any form of coercion with regard to this right by public or private institutions.[156]

The 1996 Family Planning Law defines family planning as "the totality of methods to control fertility that guarantee to the woman, the man, or the couple equality of constitutional rights regarding the decisions regarding the founding, limiting, or increasing of their descendants."[157] Experimentation with human beings in the field of fertility control is permitted only when prior authorization has been given, when it is managed and controlled by the National Directorship of the SHS, and when it corresponds to the World Health Organization's established criteria.[158] The above-mentioned law designates the SHS as the body responsible for providing reproductive health and family planning services. In issues of reproductive health, the law states that the SHS is responsible for prenatal, child birth, postnatal, and neonatal care, and is also in charge of the prevention of STIs and prevention and care of cervical, breast and prostate cancer.[159] With regard to family planning, the SHS is required to provide comprehensive women's, men's, and couple's health care in issues of fertility and contraception.[160]

The Single Health Service outlines governmental policy on family planning within the framework of the Family Planning Law.[161] Family planning measures and programs can be carried out by both public and private bodies.[162] With prior authorization from the National Directorship of the SHS, foreign organizations and funds can cooperate in research activities and programs on family planning carried out in Brazil. The SHS manages and oversees all activities.[163]

In 1983, the government implemented the Comprehensive Women's Health Care Program[164] with the aim of providing care to women in all stages of life,[165] but with particular emphasis on problems related to reproductive health.[166] In this regard, the program includes detection and treatment of STIs, cervical and breast cancer,[167] prenatal, childbirth, postnatal, and lactation care.[168] It has enlarged family planning services in the public sector to include services related to contraception, infertility, and sexuality.[169] However, due to various factors, including a lack of funds and lack of cooperation by local governments, implementation of the program has been incomplete.[170]

Government delivery of family planning services

The SHS, at all levels and through its network of health service establishments, is in charge of providing fertility and contraception services to women, men, and couples.[171] It is also responsible for promoting training for health sector employees, especially for technical personnel, in order to encourage the provision of information on methods and available techniques for controlling fertility.[172]

C. CONTRACEPTION

Prevalence of contraceptives

Currently, the percentage of Brazilian women in stable relationships who use contraception is 76.6%.[173] Sterilization and oral contraceptives are the most frequently used methods, representing 40.1% and 20.7%, respectively, of the total prevalence rate.[174] These two methods represent approximately 87% of the average of modern methods used and 80% of all methods used by women in stable relationships.[175] Other less widely used methods are the condom (4.4%), abstinence (3%), the withdrawal method (3.1%), male sterilization (2.6%), injectable contraception (1.2%), the intrauterine device ("IUD"; 1.1%) ,and others (0.4%).[176]

Legal status of contraceptives

The Family Planning Law states that to facilitate the exercise of the right to family planning, all fertility and contraceptive methods and techniques that are scientifically proved not to place people's health or lives at risk, are to be available, guaranteeing the freedom to choose.[177] Dispensation of contraceptives should always be accompanied by substantive information about risks, advantages, disadvantages, and effectiveness of the methods and techniques, as well as a clinical evaluation and follow-up visits.[178]

At the federal level, the National Secretary for Health Monitoring of the Ministry of Health ("NSHM") and the National Methodology, Standards and Industrial Quality Institute ("NMSIQI")[179] are responsible for guaranteeing the quality of contraceptives.[180] The NSHM must publish guidelines regarding the registration, and authorization for marketing and sale of contraceptive products as well as controls on the manufacture of these products.[181] The decision as to whether a product must be registered is the responsibility of a scientific commission, headed by the president of the Brazilian Society for Medical Monitoring and consisting of ten members, all leaders of the medical and pharmaceutical communities.[182] The NMSIQI, in conjunction with NSHM, is the federal governmental body responsible for condom quality control.[183]

At the state level, authorities responsible for implementation of product manufacturing regulations monitor adherence to health standards.[184] The states can establish more rigorous standards than those in effect at the federal level.[185]

Regulation of information on contraception

There are no restrictions on the dissemination of information about contraceptive methods. The Family Planning Law obliges the government to promote conditions and the necessary informational, educational, technical, and scientific resources to assure free exercise of the right to family planning.[186]

Sterilization

Female sterilization constitutes 57% of all modern contraceptive methods used by women in stable relationships, indicating an excessive reliance on this method.[187] In 1992, 7.5 million women were sterilized during cesarean operations.[188]

Until August 1997, there was heated debate about the legal status of sterilization. The Family Planning Law, promulgated in 1996, contained some provisions referring to sterilization[189] that were vetoed by the president. This provoked opposition from civil society, especially from the feminist movement. As a consequence, the president retracted his veto and officially asked Congress to reinstate the vetoed provisions. On August 12, 1997, Congress repealed President Fernando E. Cardoso's veto of the fourteen provisions on sterilization. The vetoed articles provided that voluntary sterilization be available to women and men who have full legal capacity and who are over 25 years old or have at least two living children. There must be a waiting period of sixty days between expressing the wish for sterilization and the surgery.[190] During this period, the party requesting sterilization will be provided access to fertility control services, including guidance by a multidisciplinary group whose objective is to discourage premature sterilization and avoid risking the life and health of the women and future fetuses. This process must be certified as completed by a written report signed by two doctors.[191] Second, the reinstated provisions also provide that conditions for sterilization must include recording the expressed desire by the interested party[192] and that surgical sterilization of a woman during delivery or miscarriage is prohibited, except in cases where it is proven necessary because of successive previous cesareans.[193] Also according to the Family Planning Law, the only forms of surgical sterilization that are permitted as contraception are tubal ligation, vasectomy, and other scientifically accepted methods. Hysterectomy and ovariectomy are prohibited.[194] Finally, the consent of both partners is required for sterilization during marriage.[195]

After congressional repeal of the presidential veto of the articles regulating the above-described situations, the revocation requires the approval of the president. A regulation that permits the application of the law must be enacted within the ninety days after the promulgation of the law.[196] Other articles of the Family Planning Law prohibit individual or collective incentives to promote surgical sterilization[197] and prohibit the demand of proof of sterilization or pregnancy for any purpose.[198]

D. ABORTION

Legal status of abortion

In Brazil, abortion is illegal and is defined in the Penal Code as a crime against life.[199] There are two exceptions to the illegality: abortion carried out by a medical professional when no other measures exist to save the life of the pregnant woman[200] and abortion to terminate a pregnancy that is the result of rape.[201] Outside of these circumstances, the Penal Code punishes the women who "induces her abortion" or "consents to another performing it."[202] Equally, the person who performs a woman's abortion, with or without the woman's consent, is punished.[203] The Penal Code, in the section of crimes of grave injury, also punishes a person who, through physical aggression, causes a woman to miscarry.[204]

Requirements for obtaining legal abortion

In order to perform an abortion in the two exceptional cases permitted by law, the person performing the abortion must be a doctor[205] and the pregnant woman or her legal representative must consent.[206]

Currently, the Brazilian judiciary permits the performance of abortion in cases where the fetus has grave and irreversible anomalies. This is not provided for in the law but is regularly authorized by the judiciary.[207] It is estimated that 350 such authorizations have been granted countrywide. The most common cases are anencephaly, gastroschisis, Turner syndrome, Arnold Chiari II syndrome, and achondrogenesis.[208]

There is proposed legislation in the final stages of approval that establishes the SHS's duty to provide abortion services in those circumstances permitted by the Penal Code.[209] The proposed law states that abortion, in legally permitted cases, can be carried out in any SHS public hospital.[210] It also sets out the different requirements for establishing each of the two exceptional cases of abortion that are not punishable.[211]

Penalties for abortion

The law provides that women who induce their own abortion or consent to another performing it are punished by imprisonment of no less than one year and no more than three.[212] Those who perform abortions with the consent of the pregnant woman receive a punishment of one to four years of imprisonment.[213] If an abortion is performed without the woman's consent, the punishment is three to ten years in prison.[214]

If the pregnant woman gives her consent for the abortion, but is under 14 years old or is mentally handicapped, the punishment for the person performing it is three to ten years in prison.[215] The same punishment is applied in cases where consent has been secured through fraud, threat, or physical violence.[216] In all cases, the punishment is extended by a third if as a consequence of the abortion or the measures employed to perform the abortion the pregnant women suffers serious injury.[217] If the woman dies, the sentence is doubled.[218]

E. HIV/AIDS AND SEXUALLY TRANSMISSIBLE INFECTIONS (STIs)

Examining the problem of HIV/AIDS issues within the reproductive health framework is essential, as the topics are interrelated from both a medical and a public health standpoint. Moreover, a full evaluation of laws and policies affecting reproductive rights in Brazil must examine the status of HIV/AIDS and STIs because of the extent and implications of both diseases, as reflected in the following statistics. In 1996, there were 500,000 people infected with AIDS in Brazil, of which 146,000 had already developed the disease.[219] Officially, there are only 94,997 registered cases. The number of Brazilian women infected with AIDS is growing significantly. In 1985, for every twenty-eight men with the disease there was one woman. In 1991, this ratio changed to five to one.[220]

Laws on HIV/AIDS and STIs

In spite of the dimension of the problem of HIV/AIDS in Brazil, legislation on this subject is scant. In 1978, the Ministry of Health declared, as a priority public interest, the need to eradicate STIs such as syphilis, gonorrhea, soft chancre, and lymphogranuloma venereum.[221] In 1986, the Ministry of Health added AIDS to the list of diseases whose notification by doctors and health centers is obligatory.[222] The legislation provides that all blood donations must be tested to screen for HIV and AIDS.[223] One of the most significant laws on this subject is one that assures social benefits for victims of AIDS who are forced to retire or temporarily leave their work for health reasons.[224]

The Brazilian Penal Code punishes anyone who places others in danger of infection of venereal disease through sexual relations or through any "lustful act," when the perpetrator knows or should have known that he or she was infected.[225] This crime is punishable by incarceration for no less than three months and no more than one year or by payment of a fine.[226] Those who commit such acts with the intention of transmitting the disease are punished with imprisonment for one to four years and the payment of a fine.[227] The Penal Code also declares it a crime to expose someone to a contagion of a serious disease like HIV/AIDS.[228] Moreover, anyone infected with a serious disease who engages in an act likely to transmit the disease with the intention of transmitting the disease will be punished with incarceration for one to four years and the payment of a fine.[229]

Policies on prevention and treatment of HIV/AIDS and STIs

Government action to prevent and treat HIV/AIDS in Brazil has been slow and has been limited by the severe national budget crisis that has coincided with the period of the fastest growth of the disease.[230] Currently, the prevention of AIDS in Brazil is overseen by the National STI/AIDS Program, implemented in 1985, under the Division of STIs and HIV/AIDS of the Ministry of Health.[231] This body carries out the program in close collaboration with various local government and nongovernmental organizations.[232] The National STI/AIDS Program gives priority to AIDS prevention, applying two strategies: the strengthening of activities related to the diagnosis and care of STIs and the coordination of information, education, and counseling campaigns.[233] These are directed at specific groups of the population, such as children, adolescents, women, workers, indigenous populations, and the armed forces.[234] There are also special programs for members of high-risk groups, such as homosexuals, prisoners, intravenous, drug users, and prostitutes.[235] The program has also appealed to the mass media to disseminate information

about HIV/AIDS and STIs.[236] One of the most important contributions of this program has been the increase in the supply of condoms and a corresponding increase in their use.[237] The program promotes free condom distribution within specific groups, principally the poor.[238]

In 1987, the government created the National Commission for the Control of AIDS. This commission advises the Ministry of Health in its formulation of AIDS policies in Brazil and is composed of doctors, scientists, public officials, and leaders of civil society groups and organizations.[239] Since 1988, the Ministry of Health has made efforts to decentralize the campaign to reduce STIs and AIDS, in order to benefit the largest segment of the population possible.[240] To achieve this goal, regional consultation centers have been established, which provide services according to the needs of the specific region.[241] Each state has its own AIDS committee, which is responsible for presenting monthly reports to the Ministry of Health.[242] Additionally, there are national consultation centers, universities, and hospitals that conduct research on AIDS and offer related training.[243] These institutions are financed by the federal government and/or national or international institutions.[244] The Ministry of Health has prepared training guides for health professionals who work in clinics where STIs and AIDS are treated.[245]

III. Understanding the Exercise of Reproductive Rights: Women's Legal Status

Women's health and reproductive rights cannot be fully evaluated without investigating women's legal and social conditions. Not only do laws relating to women's legal status reflect societal attitudes that affect their reproductive rights, but such laws often have a direct impact on women's ability to exercise their reproductive rights. The legal context of family life and couple relations, women's educational level, economic resources, and legal protection determine women's ability to make choices about their reproductive health care needs and their right to obtain health care services.

The Federal Constitution recognizes the principle of equality through a provision stating that all persons "are equal before the law, without any distinction of any nature."[246] The Federal Constitution also specifically recognizes equality of rights and duties between women and men.[247] Also, Law No. 9100,[248] a national law passed in 1995, provides that the lists of candidates in municipal elections for each party or political alliance must have a minimum of 20% women.[249]

Despite the rights to equality and nondiscrimination included in the Federal Constitution, the Civil Code contains provisions that discriminate against women and violate fundamental constitutional rights.

A. CIVIL RIGHTS WITHIN MARRIAGE

Marriage law

The Federal Constitution states that the family is the basis of society and as such has special state protection.[250] Men and women in a marriage have equal rights and duties.[251]

The Civil Code[252] establishes that the minimum age for marriage without parental consent is 21 years.[253] Sixteen-year-old girls and 18 year-old-boys can marry with the authorization of a responsible person.[254] The law provides that minors under the age of 16 are considered totally incapable of carrying out acts of civil life, such as entering into marriage.[255] Civil marriage may be contracted free of charge and has the same legal effect as a religious marriage.[256]

Contrary to the principle of equality established in the Federal Constitution, a provision of the Civil Code establishes that the husband has authority over jointly held property.[257] This status confers on him the right to legally represent the family[258] and exercise parental authority during the marriage.[259] The husband can request an annulment of the marriage up to ten days after it is celebrated, if he discovers that his wife is not a virgin.[260] Under the Civil Code, a married woman is designated as her husband's "companion," "consort," and "collaborator,"[261] and is charged with the "material and moral" direction of the family.[262] The wife must have received express authorization from her husband — consisting of either a publicly or privately duly authenticated legal document[263] — in order to sell or encumber real property; sell property rights she has in a third party's property; and acquire liabilities that may impair marital property.[264] A wife who works at a profession different from that of her husband has the right to practice said profession and the right to spend and save for herself the income she receives, as long as this principle does not undercut her duty to protect the well-being of the family.[265] The law presumes that a woman who occupies a public post or has a profession outside of the home for more than six months is authorized by the husband to carry out all of the acts mentioned above.[266]

The husband has the right to manage the jointly owned property and the wife's property that is under his care, according to the marital property regime agreed to in the prenuptial agreement.[267] The Civil Code specifies four kinds of marital property regimes: the universal community, partial community, separation, and endowment regimes. In the case of universal community, all present and future assets of the couple are jointly owned, including debts, save for certain exceptions

specified in the law.[268] The regime for partial community excludes from joint ownership those properties that each spouse owned at the time of marriage and those that one of them acquires during the marriage such as by gift or inheritance.[269] In the separation regime, each partner administers his or her own property.[270] In the endowment regime each piece of real or personal property is classified to determine whether it constitutes part of the dowry in the prenuptial agreement. The dowry can include all or part of the woman's present and future property.[271] When there is no prenuptial agreement that elects the property regime applicable to the marriage, the law provides that the partial community property regime is applicable.[272]

Polygamy is not permitted in Brazil. The Penal Code punishes with two to six years of imprisonment those who enter into a new marriage while legally married to another.[273] The same punishment applies to a single person who enters into marriage with someone who is married, knowing that person's marital status.[274] The Penal Code also punishes adultery with fifteen days to several months of detention.[275]

Regulation of domestic partnerships

Unlike the laws that regulate marriage, the laws that regulate domestic partnerships in Brazil respect the principles of equality and nondiscrimination against women. The Federal Constitution recognizes a domestic partnership as the "stable union of a woman and a man as a family entity" and obliges the state to protect it.[276] In 1996, Law No. 9278 [277] recognized as a family unit the permanent, public, and continual domestic partnership of a man and woman that has been established with the aim of constituting a family for a period longer than five years.[278] Both partners have equal rights and owe each other mutual respect, protection, consideration, moral assistance, and reciprocal financial support. Both should provide support and education to their children.[279] Real estate and other property acquired by one of the partners or by both during their relationship is considered to be jointly owned property and is to be shared, unless a written agreement between the partners provides otherwise.[280] If there is no agreement stating otherwise, the administration of the property is the joint responsibility of both partners.[281] If the relationship is dissolved, it is the duty of either of the partners to pay alimony to the other, if he or she is unable to provide for himself or herself.[282]

There is a specific law governing inheritance and alimony for domestic partnerships,[283] which provides that any woman who is "the verified companion" of a man who is either single, legally separated, divorced, or widowed for more than five years, or with whom she has had children, has the right to request alimony, as long as she does not enter into a new relationship and can prove she lacks economic resources.[284] The same rights are granted to a man who can show his situation meets the same conditions.[285] In cases where one partner dies, the surviving man or woman, without distinction, is entitled to one-fourth of the estate of the partner who has died, if they have children together.[286] If the partners did not have children, the surviving partner is entitled to half the estate of the partner who has died.[287] If the partner who has died has no living parents or descendants, the surviving partner is entitled to inherit the entire estate.[288]

Divorce and custody law

Divorce and legal separation are regulated by Law No. 6515 of 1977.[289] The law distinguishes between the termination of the joint property regime and conjugal rights, called separation, and the termination of the marriage. The former occurs when one of the spouses dies, the marriage is annulled, or there is a legal separation or divorce.[290] The marriage terminates only when one spouse dies or there is a divorce.[291] A legal separation can be requested by both spouses by mutual agreement, as long as the marriage has lasted at least two years.[292] One spouse may also seek legal separation for "dishonorable conduct" when the other is guilty of acts that seriously violate marital duties and make shared life intolerable, or when the couple in fact has been separated for more than a year and reconciliation is impossible.[293] A divorce terminates the marriage, including the civil effect of a religious marriage.[294] To obtain a divorce, there needs to be a previous and final decree of legal separation.[295] The request to have the decree changed from separation to divorce can be done by either of the spouses[296] one year or more after the separation decree has been issued.[297]

The civil effects of legal separation and divorce include the division of jointly owned property[298] and the right to alimony. Alimony is to be provided by the spouse who is "guilty" of causing the separation to the other if he or she needs it,[299] provided the other spouse does not remarry.[300] With regard to custody of the children, the law provides that, in an agreed separation, custody is to be determined by the couple.[301] When the separation is the fault of one of the spouses, that spouse is not entitled to custody of the children.[302] If both partners are responsible for the separation, the mother gets custody.[303] However, the court may conclude that neither of the parents is fit to assume custody of the children. In such a case, custody is granted to a suitable third person, preferably a relative of one of the spouses.[304]

B. ECONOMIC AND SOCIAL RIGHTS

Property rights

The Federal Constitution establishes the inviolability of the right to property, without discrimination.[305] Referring specifically to agrarian reform, the Constitution specifically

guarantees to both men and women the right to own and to use rural property, independent of their civil status.[306] Law No. 8629/93[307] implements the constitutional provisions relating to agrarian reform, assuring women the right to hold title to real property, independent of their civil status.[308]

However, as described in the previous section, the Civil Code establishes restrictions on married women in the exercise of this property right.[309] With respect to inheritance, the Civil Code states that the testator has the right to disinherit an "indecent" daughter who lives in the paternal home,[310] defining indecency specifically as related to her sexual behavior.[311]

Labor rights

The state protects employment, defining it as a social right.[312] The Constitution provides that the state must provide specific protection to women's right to employment.[313] The Federal Constitution also recognizes a pregnant woman's right to 120 days of paid maternity leave.[314]

The Brazilian government has ratified various international agreements adopted by the International Labor Organization ("ILO"), referring to the rights of women workers. Among them are the following: Convention No. 100 of the ILO, Convention Concerning Equal Remuneration for Men and Women Workers for Work of Equal Value,[315] and Convention No. 111 of the ILO Convention Concerning Discrimination in Respect of Employment and Occupation, which guarantees equality of opportunity and treatment for men and women.[316]

The Unified Labor Law ("ULL")[317] contains a chapter dedicated to women's employment.[318] It establishes that all legal norms that regulate male employment are applicable to women, as long as they do not contradict special protections granted to women workers.[319] However, labor laws do not extend to those cases where women work with relatives, their husband, father, mother, guardian, or children.[320]

The ULL states that the fact that a woman worker marries or becomes pregnant does not constitute just cause for dismissal.[321] The legislation prohibits women from working for four weeks before the birth of the child and eight weeks after.[322] If the birth is premature, the woman reserves the right, by law,[323] to twelve weeks of paid leave.[324] In cases of a miscarriage certified by a doctor, the woman has the right to two weeks' paid leave.[325] During lactation, women workers enjoy the right to two breaks during each workday to feed the child, until the child is six months old.[326] The ULL obliges the employer to provide a place for women workers to care for their children during this period.[327] This duty is only applicable if the workplace has more than 30 women workers over 16 years old.[328]

Other complementary labor rules regulate the maternity leave for urban, rural, and domestic women workers and the maternity benefits for small rural farmers and unemployed women workers.[329] It is prohibited for employers to request pregnancy or sterilization certificates, or similar discriminatory practices, in hiring women or in continuing their employment.[330]

Access to credit

There are no express legal restrictions on women's capacity to obtain credit, but certain provisions in the Civil Code relating to the property regime constitute a limitation on their exercise of this right.[331] Particularly discriminatory is the provision that prohibits women from contracting obligations that may impair the marital property,[332] because it constitutes a legally sanctioned presumption that women are incapable of entering into agreements regarding financial obligations or their inherited property.

Access to education

The Federal Constitution grants everyone the right to a free education[333] and establishes the duty of the state and the family to guarantee this right.[334] It also states that everyone who desires to study must be granted equal access to educational facilities for as long as he or she wishes to remain in school.[335] The government recognizes education as a basic requirement for human development and, as such, endeavors to develop education policies.[336] However, as the United Nations Development Program points out, in Brazil, women's education has always been secondary to men's.[337]

Confronting this situation, the Brazilian government has proposed not only to increase the number of people with access to formal education but also to improve the quality of teaching that is offered in schools.[338] In the last few decades, the participation of girls in the education system has improved considerably.[339] From 1980 to 1986 the number of girls in secondary school grew by 31% as compared with 10% for boys.[340]

Women's bureaus

The National Women's Rights Council ("NWRC") is the government entity involved in formulating national policies and programs that incorporate women's rights.[341] The NWRC played an important role in the constitutional reform process from 1986 to 1988, assuring that 80% of women's proposals were incorporated in the Constitution of 1988.[342]

Likewise, the National Human Rights Program,[343] founded by the Ministry of Justice in conjunction with organizations from civil society, has a women's section. In this section, concrete strategies are developed to benefit women, such as coordinating activities with the National Women's Rights Council to formulate and implement public policies for the defense of women's rights;[344] supporting state and municipal government

policies to prevent domestic and sexual violence;[345] encouraging the modification of the Penal Code relating to crimes of sexual violence against women;[346] and modification of the Civil Code in relevant respects relating to the family.[347]

C. RIGHT TO PHYSICAL INTEGRITY

The Federal Constitution guarantees the right to life and security without discrimination of any kind.[348] However, violence against women is common in Brazil. In 1991, of all incidents of violence reported to the justice system, 70% took place in the home and, in nearly all of those cases, the aggressor was the male spouse or partner of the victim.[349]

Rape

Rape is defined in articles 213 through 218 of the Penal Code as a crime "against sexual freedom."[350] Rape is committed when a man "forces a woman to engage in 'sexual intercourse' through violence or threat of violence."[351] The punishment for this crime is between six and ten years of imprisonment.[352] Indecent assault[353] is a crime committed when, through violence or serious threats, one person forces another to engage in "lustful acts" other than carnal intercourse.[354] This crime is punished with the same term of imprisonment as rape.[355]

In the Penal Code, a woman's "decency" is what determines whether she is entitled to legal protection. Sexual intercourse with a "decent" woman, without violence, but through deceit, is punishable with one to three years in jail.[356] The punishment is one to two years if the perpetrator induces a woman to engage in "lustful acts" other than intercourse.[357] The abduction of a "decent" woman through violence, serious threats, or deceit, for the purpose of engaging in lustful acts, is punishable by two to four years' imprisonment.[358] In all of the cases described above, if, as a consequence of the violence, the victim is seriously injured or dies, the punishment is increased to eight to twelve years in the former case and to twelve to twenty-five years in the latter case.[359] If the crime is committed by two or more persons, if the perpetrator is a relative, a relative through adoption, a stepparent, a sibling, a guardian, a health care provider, a teacher or an employer of the victim or exercises other authority over her, or if the perpetrator is married, the punishment is increased by one-fourth.[360] If the crime of abduction is committed with intent to enter into marriage or if the perpetrator returns the victim to a safe place or to her family, without having committed any lustful act, the punishment is reduced by a third.[361]

Law No. 8072, of 1990,[362] classifies rape and indecent assault as "sordid crimes" and provides that in such cases amnesty, forgiveness, pardon, and provisional release with or without bail are not applicable.[363]

Sexual harassment

Several legislative proposals on sexual harassment are currently pending in Congress. Among the proposals is one that regards sexual harassment as a crime and another that regulates sexual harassment only in cases of employment and teaching relations.[364]

Domestic violence

The Federal Constitution guarantees protection to the family and its members by setting out public policies to deter violence within the family.[365] Brazil does not have a specific law against domestic violence, though there is proposed legislation,[366] which is facing great resistance. The principal opposition comes from a group of jurists who argue that protection against this kind of violence already exists in the Penal Code, within the provisions that deal with assault. The jurists also argue that modern legal reform has tended toward decriminalizing conduct rather than penalizing additional conduct.[367]

In Brazil, among the institutions dedicated to women's defense and protection, are those known as Police Delegations for Women's Defense ("PDWD"), which have served as a means for Brazilian women to report cases of family violence to the police. However, the PDWD are created at a state level and do not have federal legal status. In São Paulo, there are 124 PDWDs.[368]

With regard to violence against women, the Brazilian government ratified the Inter-American Convention for the Prevention, Punishment and Eradication of Violence Against Women (Convention of Belém do Pará),[369] adopted by the Organization of American States in 1994.

IV. Analyzing the Rights of a Special Group: Adolescents

The needs of adolescents are often ignored or neglected. Considering that 34%[370] of the Brazilian population is under the age of 15, it is particularly important to attend to the reproductive health needs of this group. Efforts to address adolescent rights, including reproductive rights, are important for women's right to self-determination and health generally.

The Federal Constitution states that the family, society, and the state have a duty to guarantee the child and adolescent the right to life, health, and, in general, comprehensive personal development.[371] The Child and Adolescent Statute[372] defines children as all persons under 12 years old and adolescents as all persons between 12 and 18 years old.[373]

A. REPRODUCTIVE HEALTH AND ADOLESCENTS

The Federal Constitution guarantees health protection to the child and adolescent through the implementation of social policies that protect their birth and stable healthy development in dignified living conditions[374] without discrimination.[375] The Constitution guarantees pregnant adolescents prenatal and perinatal care within the SHS.[376]

In 1983, the Ministry of Health created a program aimed specifically at adolescent health, called the Program of Adolescent Health. The program is based on a comprehensive approach to health, emphasizing growth and development, sexuality, and mental and reproductive health.[377] It is in operation and offers services through municipal and state health service centers.[378] However, implementation of the planned program activities has been very limited.[379]

In 1993, the Brazilian government established the National Child and Adolescent Comprehensive Care Program ("NCACCP").[380] The principal objectives of NCACCP are to offer comprehensive health care to children from birth to age 6, to protect child and adolescent health, and to offer vocational counseling and education to adolescents.[381] The National STI/AIDS Program,[382] within the Ministry of Health, has intervention projects aimed at specific populations, one of which is for children and adolescents.[383] The objective of this program is to prevent transmission of AIDS or other STIs, unwanted pregnancies, clandestine abortions, prostitution, and drug abuse.[384]

B. MARRIAGE AND ADOLESCENTS

The minimum age to marry without authorization is 21 years,[385] which is the age of majority.[386] Girls over 16 and boys over 18 can marry, but only with permission from both parents.[387] If there is disagreement between the parents, the father's decision prevails.[388] If the parents are separated or divorced, the decision rests with the parent who has parental authority.[389]

C. SEXUAL OFFENSES AGAINST ADOLESCENTS AND MINORS

The Federal Constitution establishes that severe legal penalties are applicable in cases of abuse, violence, and exploitation of children and adolescents.[390] Despite legislative advances on these issues, the current situation is troubling, as sexual abuse of children and adolescents has grown, especially within the home.[391]

Rape is a crime punishable by no less than six and no more than ten years of incarceration.[392] Any incidence of sexual intercourse with a minor under 14 years old is considered rape. The consent of the minor does not exempt the perpetrator from criminal responsibility.[393] When, through deceit, a sexual act is practiced on a "decent" girl between 14 and 18, the prison sentence is two to six years.[394] Crimes against decency,[395] committed by deceiving a "decent" girl under 18 and over 14 years old, are punishable with two to four years in prison.[396]

The Brazilian Penal Code also criminalizes seduction and corruption of minors.[397] Anyone who seduces and has sexual intercourse with a girl who is a virgin under 18 and over 14, "by taking advantage of her inexperience or trust" will be punished by incarceration of one to four years.[398] The same punishment is applicable in cases where a minor, over 14 and under 18 is "corrupted" or the perpetrator facilitates his or her corruption.[399] The crime of abduction of adolescents involves the abduction of someone who is between 14 and 21 years old with his or her consent, and is punished by one to three years in prison.[400] This punishment is reduced by a third if the abductor, without having engaged in "lustful acts," returns the victim to a safe place or to her family.[401] The punishment is reduced by the same amount when the abductor intends to marry the victim.[402]

D. SEXUAL EDUCATION

The Child and Adolescent Statute provides that education should be oriented toward the comprehensive development of the person, preparing him or her to be a good citizen and training him or her for employment.[403]

Although there is no official program of sex education in the formal schooling system, the National STI/AIDS Program has recognized the need for sex education among young people[404] and is developing important educational strategies in coordination with the Ministry of Education, to incorporate these themes in the school curriculum.[405] As part of the preventive aspect of this program, training is provided to teachers, materials are developed on issues around AIDS, and informational courses are offered to the student population of Brazil.[406] Training is also being planned for adolescent community promoters, to develop educational programs outside of school[407] and among high-risk children and adolescents, such as children who live on the streets and those who use drugs.[408]

ENDNOTES

1. WORLD ALMANAC BOOKS, THE WORLD ALMANAC AND BOOK OF FACTS 1997, at 746 (1996).
2. *Id.*
3. *Id.*
4. *Id.*
5. *Id.*, at 747.
6. *Id.*
7. *Id.*
8. *Id.*
9. *Id.*
10. UNITED STATES DEPARTMENT OF STATE, COUNTRY REPORTS ON HUMAN RIGHTS PRACTICES FOR 1996, at 364 (1997).
11. *Id.*, at 365.
12. Constitution of the Federal Republic of Brazil, art. 1; promulgated Oct. 5, 1988, reformed by constitutional amendment No. 15, Sept. 12, 1996 [hereinafter BRAZ. CONST.].
13. *Id.*
14. *Id.*
15. JOSE ALFONSO DA SILVA, CURSO DE DERECHO CONSTITUCIONAL POSITIVO [DEFINITIVE CONSTITUTIONAL LAW COURSE], at 406 (5th ed., 1989).
16. BRAZ. CONST., art. 18, second ¶. The Brazilian Federal Constitution recognizes the feasibility of creating a territory, later transforming it into a state, or reintegrating it into the state of which it originally formed a part.
17. DEFINITIVE CONSTITUTIONAL LAW COURSE, *supra* note 15, at 406.
18. BRAZ. CONST., art. 1.
19. *Id.*
20. *Id.*, art. 25.
21. *Id.*
22. *Id.*, art. 18, 25, 29, and 32.
23. *Id.*, art. 2.
24. *Id.*, art. 76.
25. *Id.*, art. 14.
26. *Id.*, art. 77.
27. Constitutional amendment to art. 77 of the BRAZ. CONST..
28. BRAZ. CONST., art. 84.
29. *Id.*
30. *Id.*
31. *Id.*, art. 50.
32. DEFINITIVE CONSTITUTIONAL LAW COURSE, *supra* note 15, at 554: "Crimes of responsibility by ministers are: (I) when, without an adequate justification, a minister or official does not appear before the Chamber of Deputies, the Federal Senate or any of their commissions, when they have been summoned to present reports on previously determined issues. (FC, art. 50 and 58, III); (II) The practice, including by the President of the Republic, of acts defined as crimes of responsibility (art. 52, I, 85)."
33. BRAZ. CONST., art. 50.
34. *Id.*, art. 85.
35. *Id.*, art. 86.
36. *Id.* The total number of deputies per state and for the Federal District is proportionally determined according to the number of inhabitants. No state or the Federal District can have less that eight or more than seventy deputies.
37. *Id.*
38. *Id.*, art. 45.
39. *Id.*, art. 44.
40. *Id.*, art. 45, second ¶. Each territory elects four deputies.
41. *Id.*
42. *Id.*, art. 44.
43. *Id.*, art. 46.
44. *Id.*
45. *Id.*, art. 47.
46. *Id.*, art. 48.
47. *Id.*
48. *Id.*
49. *Id.*, art. 49.
50. *Id.*
51. *Id.*
52. *Id.*, Tit. IV, Ch. I, § VII.
53. *Id.*, art. 59.
54. *Id.*, art. 60.
55. *Id.*, art. 61. The popular initiative can be exercised through presentation of a proposed law to the Chamber of Deputies, if it is signed by a minimum of one percent of the national electorate after being circulated in at least five states.
56. *Id.*, art. 66.
57. *Id.*
58. *Id.*
59. *Id.*, art. 67.
60. *Id.*, art. 62.
61. *Id.*
62. *Id.*, art. 92.
63. *Id.*, art. 101 and 104.
64. *Id.*, art. 92.
65. *Id.*, art. 102.
66. *Id.*, art. 101 and 104.
67. *Id.*, art. 105.
68. *Id.*, art. 101 and 104.
69. *Id.*, art. 124.
70. *Id.*, art. 114.
71. *Id.*, art. 121.
72. *Id.*, art. 125.
73. *Id.*
74. *Id.*, art. 110.
75. *Id.*, art. 98.
76. For more detail about the definition of the Union, see section above on the Structure of National Government.
77. BRAZ. CONST., art. 18.
78. *Id.*, art. 21 and 22.
79. *Id.*
80. *Id.*, art. 25.
81. *Id.*, art. 48.
82. Single Health System ("SHS"), Basic Operational Norms of SHS, NOB-SUS-01/96, Official Daily Gazette of the Union, at 7 and 8 (Nov. 6, 1996).
83. BRAZ. CONST., art. 28.
84. *Id.*, art. 27.
85. *Id.*, art. 25.
86. *Id.*, third ¶.
87. *Id.*, art. 29.
88. *Id.*, art. 32.
89. *Id.*, art. 59, 97 and 102, I.
90. *Id.*, art. 102, III, b. See also the discussion on this subject in the next section.
91. *Id.*, art. 59.
92. *Id.*, art. 97 and 102, I.
93. DEFINITIVE CONSTITUTIONAL LAW COURSE, *supra* note 15, at 318.
94. BRAZ. CONST., art. 5, second ¶.
95. *Id.*
96. DEFINITIVE CONSTITUTIONAL LAW COURSE, *supra* note 15, at 317-319.
97. *Id.*, at 318.
98. See sections on legislative and executive branches, for a detailed description of the process of and those branches' role in the adoption of treaties.
99. The Federal Republic of Brazil has ratified, among others, the following instruments for the universal protection of human rights: The International Covenant on Civil and Political Rights, *adopted* Dec. 16, 1966, 999 U. N. T. S. 171 (*entry into force* Mar. 23, 1976) (ratified by Brazil on Jan. 24, 1992); The International Covenant on Economic, Social and Cultural Rights, *adopted* Dec. 16, 1966, 993 U. N. T. S. 3 (*entry into force* Sept. 3, 1976) (ratified by Brazil on Jan. 24, 1992); The International Convention for the Elimination of all Forms of Racial Discrimination, *opened for signature* Mar. 7, 1966, 660 U. N. T. S. 195 (*entry into force* Jan. 4, 1969) (ratified by Brazil on Mar. 27, 1968). Brazil has also signed Inter-American instruments, such as: The American Convention on Human Rights, signed Nov. 22, 1969, 9 I. L. M. 101 (entry into force Jul. 18, 1978) (ratified by Brazil on Sept. 25, 1992); The Inter-American Convention for the Prevention and Punishment of Torture, *adopted* Feb. 28, 1987 OEA/SER. L. V/II. 92 doc. 31 rev. 3 May 3, 1996 (ratified by Brazil on Jul. 20, 1989) and the Inter-American Convention on the Granting of Civil Rights to Women, *adopted* May 2, 1948, O. A. S. T. S. 23 (ratified by Brazil on Mar. 19, 1952).
100. The Convention on the Elimination of All Forms of Discrimination against Women, *opened for signature* Mar. 1, 1980, 1249 U. N. T. S. 13 (*entry into force* Sept. 3, 1981) (ratified by Brazil on Feb. 1, 1984).

101. Inter-American Convention on the Prevention, Punishment and Eradication of Violence Against Women (Convention of Belém do Pará), *adopted* Jun. 9, 1994, 33 I. L. M. 1534 (1994) (ratified by Brazil on Nov. 27, 1995).
102. BRAZ. CONST., art. 196.
103. *Id.*, art. 198.
104. Fundamental Health Law, Law No. 8080, Sept. 19, 1990.
105. *Id.*, art. 1.
106. *Id.*, art. 2.
107. Decree 99. 438/90; Fundamental Health Law, art. 37; Federal Law No. 8142, Dec. 28, 1990, art. 1.
108. Basic Operational Norm of SHS, *supra* note 82, at 7 and 8.
109. *Id.*, at 4 and 5.
110. Law No. 8142, Dec. 28, 1990.
111. Fundamental Health Law, art. 4.
112. *Id.*, art. 5.
113. FEDERAL REPUBLIC OF BRAZIL, MINISTRY OF HEALTH, O ANO DE SAÚDE NO BRASIL. AÇOES E METAS PRIORÍTARIAS [THE YEAR OF HEALTH IN BRAZIL. PRIORITY ACTIONS AND GOALS] (1997).
114. *Id.*, at 2.
115. *Id.*, at 5.
116. *Id.*, at 6.
117. *Id.*, at 8.
118. *Id.*, at 5 and 6.
119. BRAZ. CONST., art. 198. "Community participation" is carried out through health councils, at a state and municipal level. For more information, see section on Objectives of Health Policy.
120. *Id.*, art. 199.
121. *Id.*
122. Brazilian Federation of Hospitals (BFH), Census of Unified Health Service Hospitals, Brazil, 1996 (visited, Jul. 24, 1997) <http:/fbh. com. br/hospit. htm>. This federation groups together all private hospitals in Brazil and was founded in 1965.
123. *Id.*
124. UNITED NATIONS DEVELOPMENT PROGRAM (UNDP), INSTITUTE FOR APPLIED ECONOMIC RESEARCH (IAER), BRAZIL HUMAN DEVELOPMENT REPORT 1996, at 49 (1996).
125. *Id.*, p 48.
126. *Id.*
127. *Id.*, at 49.
128. BRAZ. CONST., art. 195. The Social Security budget is financed by funds from the central government, the states, the Federal District and the municipalities. It also comes from social contributions from employers' and employees' taxes, and taxes on gambling.
129. *Id.*, art. 198; Fundamental Health Law, art. 31 and 32.
130. Law No. 9311, Oct. 24, 1996.
131. *Id.*, Treasury Ministry No. 6, Jan. 10, 1997; Interview with Dr. Fernando Proenca de Gouvea, representative of the Ministry of Health in São Paulo (Dec. 22, 1996).
132. Created by Decree-Law No. 7955, Sept. 13, 1945.
133. Federal Council of Medicine (visited Jul. 24, 1997) <http://www. cfm. org. br>.
134. Medical Ethical Code, Resolution CFM No. 1246/88.
135. *Id.*, Preamble, cl. III.
136. *Id.*, art. 6.
137. *Id.*, art. 1.
138. *Id.*, art. 11.
139. *Id.*, Preamble, cls. IV and VI.
140. *Id.*, art. 46.
141. *Id.*, art. 67.
142. *Id.*, art. 68.
143. *Id.*, art. 29.
144. *Id.*, art. 43. For more detail, see sections on Abortion and Sterilization.
145. Penal Code, Decree Law No. 2848, Dec. 7, 1940. São Paulo, Revista do Tribunais Publishers, 1997; art. 121, cl. 4. [hereinafter PENAL CODE].
146. *Id.*, art. 129, cl. 7.
147. *Id.*, art. 121, cls. 4 and 129, cl. 7.
148. Law No. 2142, Dec. 28, 1990.
149. *Id.*, art. 1, cl. 1.
150. *Id.*, In the last National Health Councils Plenary that took place on Apr. 16, 1997, it was agreed to undertake lobbying efforts to support a constitutional amendment that would mandate an increased budget for the health sector. National Health Conference On Line, 2nd National Health Councils Plenary (visited Aug. 4, 1997) <http://datasus. gov. br/cns/plenaria/2plenar. htm>
151. BRAZIL HUMAN DEVELOPMENT REPORT, *supra* note 124, at 65.
152. *Id.*, p 69.
153. *Id.*, at 70, 71 and 73.
154. Law No. 9263 (Family Planning Law), promulgated Jan. 12, 1996, art. 2.
155. BRAZ. CONST., art. 226, seventh ¶.
156. *Id.*
157. Family Planning Law, art. 2.
158. *Id.*, art. 8.
159. *Id.*, art. 3.
160. *Id.*
161. *Id.*, art. 7.
162. *Id.*
163. *Id.*
164. THE CENTER FOR REPRODUCTIVE LAW AND POLICY (CRLP), WOMEN OF THE WORLD: FORMAL LAWS AND POLICIES AFFECTING THEIR REPRODUCTIVE LIVES, at 3 (1995).
165. *Id.*
166. *Id.*
167. *Id.*
168. *Id.*
169. *Id.*
170. *Id.*
171. Family Planning Law, art. 3.
172. *Id.*, art. 4 and 5.
173. BEFAM-PNDS 1996 and the Office of Women's Health Coordination, cited in Silvia Pimentel and Valeria Pandjiarjian, Institute for the Promotion of Equality (IPE), Draft Brazil chapter, at 6 (1997).
174. *Id.*
175. *Id.*
176. *Id.*, at 7.
177. Family Planning Law, art. 9.
178. *Id.*
179. UNITED NATIONS POPULATION FUND (UNFPA), CONTRACEPTIVE REQUIREMENTS AND LOGISTIC MANAGEMENT NEEDS IN BRAZIL, Technical Report No. 21, 7 (1995), in WOMEN OF THE WORLD, *supra* note 164, at 4.
180. *Id.*
181. *Id.*
182. *Id.*
183. *Id.*
184. *Id.*
185. *Id.*
186. Family Planning Law, art. 5.
187. BENFAM-PNDS 1996, *supra* note 173, at 7.
188. Katrin Oliveira, *In Brazil: sterilization contributes to curbing demographic explosion; however, for some women, it is a prerequisite to obtaining work; for others, it is done out of ignorance*, THE GAZETTE, Feb. 6, 1992, cited in WOMEN OF THE WORLD, *supra* note 164, at 2.
189. Family Planning Law, art. 12 and 14.
190. Message by the President of the Republic to the Federal Senate President, No. 66, Jan. 15, 1996, communicating the partial veto to the proposed legislation on family planning, referring to art. 10, 11 ¶ one of arts. 14, and 15, and presenting the alleged reasons by the Ministry of Health to justify the veto.
191. *Id.*
192. *Id.*
193. *Id.*
194. *Id.*
195. *Id.*
196. HOJA DE SÃO PAULO, Aug. 13, 1997, notebook 3, at 3.
197. Family Planning Law, art. 12.
198. *Id.*, art. 13.
199. PENAL CODE, Tit. I, Ch. I of Special Section.
200. *Id.*, art. 128.
201. *Id.*
202. *Id.*, art. 124.
203. *Id.*, art. 125 and 126.
204. *Id.*, art. 129, cl. 5.
205. *Id.*, art. 128.
206. *Id.*

207. Interview with Dr. Marcos Frigerio, (Nov. 1996). On file with the Institute for the Promotion of Equality (IPE).
208. *Id.*
209. Proposed Legislation No. 2021, art. 1.
210. *Id.*
211. *Id.*, art. 1-3.
212. PENAL CODE, art. 124.
213. *Id.*, art. 126.
214. *Id.*, art. 125.
215. *Id.*, art. 126.
216. *Id.*
217. *Id.*, art. 127.
218. *Id.*
219. VARGAS Y MUNOZ SAFFIOTI, MULHER BRASILEIRA É ASSIM [THE BRAZILIAN WOMAN IS LIKE THIS], at 118 (n. d.).
220. *Id.*
221. Ministry of Health, National Dermatological Health Division, Resolution No. 22, issued on Jul. 18, 1978.
222. Ministry of Health, Resolution No. 542, Dec. 22, 1986.
223. Executive Directorate issued in 1987 and the law passed by Congress and signed by President José Sarney in 1988. Barbara Misztal and David Moss (eds.), *Action on AIDS, National Policies in Comparative Perspective.* "Response in Brazil" in CONTRIBUTIONS IN MEDICAL STUDIES, No. 28, 66 (n. d.).
224. *Id.*
225. PENAL CODE, art. 130.
226. *Id.*
227. *Id.*
228. *Id.*, art. 131.
229. *Id.*
230. *Action on AIDS*, *supra* note 223, at 65.
231. Ministry of Health, Directive No. 236, May 2, 1985, which establishes the guidelines of the National STIs/AIDS Program, and gives the authority for the coordination of the program to the National Dermatological Health Division of the National Secretary for Special Health Programs.
232. National STI/AIDS Program Home Page (visited Aug. 6, 1997), <http//www. aids. gov. br/prevencao/link111. htm>
233. *Id.*
234. *Id.*
235. *Id.*
236. *Id.*
237. *Id.*
238. *Id.*
239. *Action on AIDS*, *supra* note 223, at 68.
240. WOMEN OF THE WORLD, *supra* note 164, at 5.
241. *Id.*
242. *Id.*
243. *Id.*
244. *Id.*
245. *Id.*
246. BRAZ. CONST., art. 5.
247. *Id.*, cl. I.
248. Law No. 9100/95 (Law of Quotas), Oct. 2, 1995.
249. *Id.*, art. 11, second ¶.
250. BRAZ. CONST., art. 226.
251. *Id.*, cl. 5.
252. Civil Code and Civil Legislation in Effect, Law No. 3071, Jan. 1, 1916 and modifications, São Paulo, Saraiva Publishers (1997). *See* art. 9 and 180, cl. I (hereinafter CIVIL CODE).
253. *Id.*, art. 9 and 180, cl. I.
254. *Id.*, art. 183, cl. XII.
255. *Id.*, art. 5, cl. I.
256. BRAZ. CONST., art. 226, cl. 2.
257. CIVIL CODE, art. 253.
258. *Id.*, cl. I.
259. *Id.*, art. 380.
260. *Id.*, art. 178, first ¶, and art. 219.
261. *Id.*, art. 240.
262. *Id.*
263. *Id.*, art. 243.
264. *Id.*, art. 242.
265. *Id.*, art. 246.
266. *Id.*, art. 247, first ¶.
267. *Id.*, art. 233, cl. II.
268. *Id.*, art. 262 and 268.
269. *Id.*, art. 269.
270. *Id.*, art. 276.
271. *Id.*, art. 278. This regime has nearly disappeared in practice, but it is still valid under national legislation. Draft Brazil chapter, *supra* note 173, at 13.
272. *Id.*, art. 258. There are cases where it is obligatory to adopt a specific regime. For example, the separation regime is mandatory when a man older than 60 enters into marriage with a woman over 50 (*Id.*, cl. II) or when the marriage is between two persons who require permission to marry. (*Id.*, cl. IV).
273. PENAL CODE, art. 235.
274. *Id.*, cl. 1.
275. *Id.*, art. 240.
276. BRAZ. CONST., art. 226, cl. 3.
277. Law No. 9278 (Law on Domestic Partnerships), May 10, 1996. Implements cl. 3 of art. 226 of the Federal Constitution.
278. *Id.*, art. 1.
279. *Id.*, art. 2.
280. *Id.*, art. 5.
281. *Id.*, cl. 2.
282. *Id.*, art. 7.
283. Law No. 8971 (Alimony Law and Inheritance Rights for Domestic Partners), Dec. 29, 1994.
284. *Id.*, art. 1.
285. *Id.*
286. *Id.*, art. 2, cl. I.
287. *Id.*, cl. II.
288. *Id.*, cl. III.
289. Law No. 6515 (Divorce Law), Dec. 26, 1977. This law regulates cases of dissolution of married life and marriage, its effects, related procedures, and other related issues.
290. *Id.*, art. 2.
291. *Id.*
292. *Id.*, art. 4.
293. *Id.*, art. 5.
294. *Id.*, art. 24.
295. *Id.*, art. 31.
296. *Id.*, art. 35.
297. *Id.*, art. 25.
298. *Id.*, art. 7.
299. *Id.*, art. 19.
300. *Id.*, art. 29.
301. *Id.*, art. 9.
302. *Id.* art. 10, introductory part.
303. *Id.*, first ¶.
304. *Id.*, second ¶.
305. BRAZ. CONST., art. 5.
306. *Id.*, art. 189.
307. Law No. 8629/93, promulgated on Feb. 25, 1993.
308. *Id.*, art. 1.
309. See previous section.
310. CIVIL CODE, art. 1744.
311. Draft Brazil chapter, *supra* note 173, at 11.
312. BRAZ. CONST., art. 6.
313. *Id.*, art. 7, cl. XX.
314. *Id.*, cl. XVII.
315. Convention No. 100 of the International Labor Organization, Convention Concerning Equal Remuneration for Men and Women Workers for Work of Equal Value, *adopted* Jun. 29, 1951 <http://ilolex. ilo. ch:1567/public/english/50normes/infleg/iloeng/conve. htm> (visited Dec. 8, 1997) (*entry into force* May 23, 1953) (ratified by Brazil on Apr. 25, 1957).
316. Convention No. 111 of the International Labor Organization, Convention Concerning Discrimination in Respect of Employment and Occupation, *adopted* Jun. 25, 1958 <http://ilolex. ilo. ch:1567/public/english/50normes/infleg/iloeng/conve. htm>(visited Dec. 8, 1997) (*entry into force* Jun. 15, 1960) (ratified by Brazil on Nov. 26, 1965).

317. The Unified Labor Law, Decree Law No. 5452, May 1, 1943.
318. *Id.*, tit. III, ch. III.
319. *Id.*, art. 372.
320. *Id.*
321. *Id.*, art. 391.
322. *Id.*, art. 392.
323. *Id.*, art. 393.
324. *Id.*, art. 392, third ¶.
325. *Id.*, art. 395.
326. *Id.*, art. 396.
327. *Id.*, art. 389, first ¶.
328. *Id.*
329. Law No. 8861/94, promulgated on Mar. 25, 1994.
330. Law No. 9029/95, promulgated on Apr. 13, 1995.
331. See also section on marriage.
332. CIVIL CODE, art. 242, cl. IV. See also section on marriage.
333. BRAZ. CONST., art. 206.
334. *Id.*, art. 205.
335. *Id.*
336. BRAZIL HUMAN DEVELOPMENT REPORT, *supra* note 124, at 109.
337. *Id.*, at 38.
338. *Id.*, at 109.
339. *Id.*, at 38.
340. *Id.*
341. Draft Brazil chapter, *supra* note 173, at 23.
342. *Id.*
343. National Human Rights Program (visited Aug. 6, 1997) <http://www.mj.gov.br/pndh/intro.htm>
344. *Id.* Women's Section.
345. *Id.*
346. *Id.*
347. *Id.*
348. BRAZ. CONST., art. 5.
349. HUMAN RIGHTS WATCH, CRIMINAL INJUSTICE: VIOLENCE AGAINST WOMEN IN BRAZIL. AN AMERICAS WATCH REPORT, at 14 (1991).
350. PENAL CODE, Tit. VI, Ch. I of Special Part.
351. *Id.*, art. 213.
352. *Id.*
353. *Id.*
354. *Id.*, art. 214.
355. *Id.*
356. *Id.*, art. 215. The Code does not define the term "honesty."
357. *Id.*, art. 216.
358. *Id.*, art. 219.
359. *Id.*, art. 223.
360. *Id.*, art. 226.
361. *Id.*, art. 221.
362. Law No. 8072/90 (Law on Sordid Crimes), Jul. 25, 1990.
363. *Id.*, art. 1 and 2.
364. Draft Brazil chapter, *supra* note 173, at 21.
365. BRAZ. CONST., art. 226, ¶8.
366. Proposed Legislation No. 132, of 1995.
367. Draft Brazil chapter, *supra* note 173, at 18.
368. SILVIA PIMENTEL AND VALERIA PANJIARJIAN, PERCEPÇÕES DAS MULHERES EM RELAÇAO AO DIREITO E À JUSTIÇA: LEGISLAÇAO, ACESSO E FUNCIONAMENTO [PERCEPTIONS OF WOMEN REGARDING LAW AND JUSTICE: LEGISLATION, ACCESS AND OPERATION], at 35 (1996).
369. Passed as Decree Legislation No. 107/95 on Sept. 1, 1995, The Convention of Belém do Pará was incorporated definitively into the internal legal order on Aug. 1, 1996, by Presidential Decree No. 1973, published in the Official Federal Daily Gazette on Aug. 2, 1996.
370. THE WORLD ALMANAC, *supra* note 1, at 746.
371. BRAZ. CONST., art. 227.
372. Law No. 8069/90 (Child and Adolescent Statute), Jul. 13, 1990.
373. *Id.*, art. 2.
374. *Id.*, art. 7.
375. *Id.*, art. 11.
376. *Id.*, art. 8.
377. WOMEN OF THE WORLD, *supra* note 164, at 3.
378. *Id.*
379. *Id.*
380. National Child and Adolescent Comprehensive Care Program, passed as Law No. 8642, Mar. 31, 1993 and its regulation; Decree No. 1056, Feb. 11, 1994.
381. *Id.*, art. 2.
382. *supra* notes 230-238 and accompanying text.
383. National STDs/AIDS Program, *supra* note 232.
384. *Id.*
385. CIVIL CODE, art. 9 and 180, cl. 1.
386. *Id.*, art. 9.
387. *Id.*, art. 183, cls. XII and 185.
388. *Id.*, art. 186.
389. *Id.*
390. BRAZ. CONST., art. 227, ¶4.
391. Draft Brazil chapter, *supra* note 173, at 19.
392. PENAL CODE, art. 213.
393. *Id.*, art. 224, literal a.
394. *Id.*, art. 215, only ¶.
395. *Id.*, art. 216, only ¶. For a definition of this crime, see section on rape.
396. *Id.*
397. *Id.*, Tit. I, Ch. II of Special Part.
398. *Id.*, art. 217.
399. *Id.*, art. 218.
400. *Id.*, art. 220.
401. *Id.*, art. 221.
402. *Id.*
403. Child and Adolescent Statute, art. 53.
404. National STDs/AIDS Program, *supra* note 232.
405. *Id.*
406. *Id.*
407. *Id.*
408. *Id.*

Colombia

Statistics

GENERAL

Population

- Colombia's total population is 36 million,[1] of which 52% are women.[2] The population growth rate is approximately 1.8% annually;[3] life expectancy at birth is 69.7 years.[4] The median age of the population is 21 years.[5]
- In 1995, 71% of the population lived in urban areas.

Territory

- Colombia's territory covers an area of 1,139,000 square kilometers.[6]

Economy

- In 1994, the World Bank estimated Colombia's gross national product ("GNP") per capita to be $1,670 for the period from 1985 to 1994.[7] From 1985 to 1994, the GNP grew at an estimated 2.4%.[8]
- From 1990 to 1994, the gross domestic product grew at an estimated 4.3%.[9]
- In 1990, the government implemented an economic reform program aimed at accelerating the opening of the economy.[10]

Employment

- Women make up approximately 42.6% of the work force.[11] In 1992, 62% of employed women worked in the informal sector.[12]
- In 1991, women's participation by economic sector was estimated to be 21.8% in agriculture; 31.4% in industry; and 43.9% in service.[13]
- The difference in wages paid to men and women varies from 10% to 30%.[14]
- Women constititute approximately 55.2% of the total unemployed population.[15]

WOMEN'S STATUS

- The average life expectancy at birth is estimated to be 70 years;[16] it is 72.26 years for women and 69.24 years for men.[17]
- The illiteracy rate for women in 1992 was 5.5%.[18]
- One-third of all women who live with their partners have been victims of verbal abuse.[19] One of every five women has been the victim of physical abuse,[20] while 6% have been victims of sexual violence.[21]

ADOLESCENTS

- In 1995, approximately 34% of the population was under the age of 15.[22]
- The median age at first marriage in 1995 was 21.4 years.[23]
- The median age at first childbirth was 22.1 years.[24]
- In 1995, only 11% of women between the ages of 14 and 19 used contraceptives.[25]
- Also in 1995, 14% of women between the ages of 14 and 19 were mothers.[26]
- In Colombia, violence particularly affects women between the ages of 15 and 24: In 1991, external injuries, accidents, homicides, etc., were the leading cause of death among women in this age group.[27]

MATERNAL HEALTH

- In 1994, the fertility rate was 2.6 children per woman.[28]
- From 1989 to 1994, the maternal mortality rate was 107 per every 100,000 live births.[29]
- In 1994, the infant mortality rate was 20 per 1,000 live births.[30]
- Of pregnant women, 82.6% receive prenatal care from a physician, nurse, physician's assistant, or other health care worker.[31]

- Of childbirths, 84.6% are attended by a physician, nurse, physician's assistant, or health care worker.[32]
- In 1991, 37% of female deaths were directly related to complications during pregancy, while 25% were due to toxemia during pregnancy.[33]

CONTRACEPTION AND ABORTION

- In 1995, 99.9% of women who lived with their partners were familiar with at least one modern method of contraception.[34] Of these, 72% presently use contraception.[35]
- Of women living with their partners who use contraception, 12.9% use the pill, 11.1% use the intrauterine device, 2.5% use injections, 1.4% use vaginal methods, 4.3% use condoms, and 25.7% use sterilization.[36]
- It is estimated that 450,000 abortions occur annually.[37] Complications resulting from the conditions in which abortions are performed was the second cause of maternal mortality from 1980 to 1990.[38]

HIV/AIDS AND STIs

- In 1994, the total number of individuals infected with HIV/AIDS or sexually transmitted infections in Colombia was 4.1 per million,[39] of whom 3.4 per million were women and 36.9 per million were men.[40]
- Of the total cases of AIDS reported in 1992, 2,855 were men, while 212 were women.[41]
- In 1993, 2,855 cases of HIV and 3,304 cases of AIDS were reported.[42]

ENDNOTES

1. PROFAMILIA, ENCUESTA NACIONAL DE DEMOGRAFÍA Y SALUD [NATIONAL DEMOGRAPHIC AND HEALTH SURVEY], at 6 (1995).
2. *Id.*, at xxvii.
3. *Id.*, at 7.
4. *Id.*
5. UNITED NATIONS POPULATION FUND, PROGRAMME REVIEW AND STRATEGY DEVELOPMENT REPORT-COLOMBIA, UN Doc. E/850/1993, at vi (1993).
6. THE WORLD BANK, WORLD DEVELOPMENT REPORT 1996: FROM PLAN TO MARKET, at 188 (1996).
7. *Id.*
8. *Id.*
9. *Id.*, at 208.
10. PRESIDENTIAL COUNCIL FOR SOCIAL POLICY (PNR), INFORME NACIONAL DE COLOMBIA [NATIONAL REPORT FROM COLOMBIA], PREPARED FOR THE FOURTH INTERNATIONAL CONFERENCE ON WOMEN, at 14 (1995).
11. *Id.*, at 30.
12. NATIONAL COUNCIL OF ECONOMIC AND SOCIAL POLICY-CONPES, EL SALTO SOCIAL, POLÍTICA DE PARTICIPACIÓN Y EQUIDAD PARA LA MUJER [THE SOCIAL GAP, PARTICIPATION AND EQUITY POLICY FOR WOMEN], at 2 (1994).
13. *Id.*
14. *Id.*, at 37.
15. *Presentación conjunto de los informes periódicos segundo y tercero, revisados, de los Estados-partes, Colombia* [Combined presentation of the revised versions of the second and third periodic reports of States Parties, Colombia], UN Doc.CEDAW/C/COL/2-3/Rev. 1; *supra* note 9, at 39.
16. WORLD DEVELOPMENT REPORT, *supra* note 6, at 188.
17. *Combined presentation, supra* note 13, at 5.
18. NATIONAL REPORT FROM COLOMBIA, *supra* note 9, at 23. In 1964, the illiteracy rate was 28.9%. *Id.*
19. DEMOGRAPHIC AND HEALTH SURVEY, *supra* note 1, at xxxi.
20. *Id.*
21. *Id.*
22. *Id.*, at xxvii.
23. *Id.*, at xxxiii.
24. *Id.*
25. *Id.*, at 47.
26. *Id.*, at 40.
27. PRESIDENCY OF THE REPUBLIC OF COLOMBIA, COLOMBIA PAGA SU DEUDA A LAS MUJERES. INFORME NACIONAL DEL GOBIERNO DE COLOMBIA. CUARTA CONFERENCIA MUNDIAL SOBRE LA MUJER. [COLOMBIA PAYS ITS DEBT TO WOMEN. NATIONAL REPORT OF THE COLOMBIAN GOVERNMENT. FOURTH INTERNATIONAL CONFERENCE ON WOMEN], at 24. (1995).
28. WORLD DEVELOPMENT REPORT, *supra* note 6, at 198.
29. *Id.*
30. *Id.*
31. DEMOGRAPHIC AND HEALTH SURVEY, *supra* note 1, at xxxiii.
32. *Id.*
33. PARTICIPATION AND EQUALITY POLICY, *supra* note 14, at 3.
34. *Id.*
35. *Id.*
36. *Id.*
37. *Combined presentation, supra* note 13, at 46.
38. *Id.*
39. NATIONAL REPORT FROM COLOMBIA, *supra* note 9, at 30.
40. *Id.*
41. *Combined presentation, supra* note 13, at 47.
42. *Id.*

Colombia is located in the northwest of the South American continent and has access to both the Atlantic and the Pacific oceans. The country's topography is highly diverse, consisting of coastal regions, island territories, the eastern plains, a section of the Andes Mountains and part of the Amazon jungle.[1] Approximately 58% of the population is mestizo, 20% is Caucasian and 14% is mulatto.[2] Although Spanish is the official language, the languages and dialects of the different ethnic groups are also official languages of their regions.[3] In the fifteenth century, Spain colonized what is now Colombia, and governed the region for nearly 300 years.[4] Colombia declared its independence from Spain on July 20, 1819.[5]

Colombia is one of the few countries in Latin America that has not been regularly governed by military dictatorships. However, the country's political history is marked by a legacy of violence, exacerbated by guerrilla warfare and drug trafficking.[6] Violence especially affects women.[7] The majority of victims of forced migrations caused by rural violence are female heads of household.[8]

In 1990, Colombia adopted an economic reform policy intended to accelerate the opening of the economy and to guarantee a self-sustaining process of economic growth.[9] The Colombian government is attempting to facilitate industrial modernization and to create new mechanisms to promote private investment by opening the economy and promoting competition. The Constitution of Colombia was reformed in 1991.

I. Setting the Stage: the Legal and Political Framework

The legal and political systems constitute the framework for exercising rights and designing policies that affect women's reproductive lives. In order to understand the process through which laws are made, interpreted, modified and implemented, as well as the process through which reproductive health and population policies are adopted, it is necessary to comprehend the basis and structure of this framework.

A. THE STRUCTURE OF NATIONAL GOVERNMENT

The current Constitution of Colombia (the "Constitution") establishes that "Colombia is a 'social democracy' based on the rule of law. It is organized as a unitary republic, is decentralized into autonomous territorial entities, and is democratic, participatory, and pluralist."[10] The fundamental objectives of the state are: "to serve the community, to promote the general welfare, to guarantee that the principles, rights and duties set forth in the Constitution are upheld, to facilitate the participation of all citizens in the decisions that affect their lives and the economic, political, administrative and cultural life of the nation."[11] Likewise, the state must guarantee peaceful coexistence and a just legal order.[12]

Governmental authorities have a constitutional mandate to protect the lives, honor, properties, beliefs, and other rights of all people, as well as to ensure the fulfillment of the social obligations of the state and of private citizens.[13] The people exercise sovereignty directly or through their representatives via certain mechanisms of democratic participation, specifically, the right to vote, the plebiscite, the referendum, the open forum, the legislative initiative, and impeachment.[14]

The Constitution recognizes and protects the ethnic and cultural diversity of Colombia.[15] To carry out this constitutional mandate, the government has developed policies and enacted legislation aimed at protecting and fostering the recognition of Afro-Colombian and indigenous communities.[16]

The Colombian government is divided into three branches: the executive branch, the legislative branch, and the judicial branch. Also part of the government are other "controlling authorities" that oversee the proper functioning of the government and electoral bodies that oversee elections.[17]

Executive Branch

The president of the republic is the head of the executive branch and is charged with approving, promulgating, obeying, and enforcing the law.[18] The president is the head of state, the head of the government, and the highest administrative authority.[19] The president exercises regulatory power by enacting regulations, decrees, and ordinances to implement laws. The president also oversees Colombia's foreign relations and is charged with maintaining peace and order throughout the country.[20] State and municipal governments are part of the executive branch.[21] The president is elected for a period of four years by direct universal suffrage.[22] The president appoints ministers and heads of administrative departments, who direct state policy within their specific sectors or ministries.[23] The Constitution regulates relations between the executive, legislative, and judicial branches.[24] The Congress may authorize the president to enact decrees that have the force of law for a period of up to six months.[25]

Legislative Branch

The legislative branch consists of the Congress of the Republic, whose principal functions are: "to amend the Constitution, to enact laws, and to exercise political control over the government and public administration."[26] Congress consists of two chambers, the Senate and the House of Representatives.[27] The Senate has one hundred members elected nationally, and two additional members elected from special electoral districts

formed by the country's indigenous communities.[28] The House of Representatives is elected from territorial and special electoral districts.[29] Senators and members of the House of Representatives are elected for a four-year period and directly represent the people.[30]

Congress interprets, amends, and repeals laws and codes within all legislative areas, and also approves the government's development and public investment plans.[31] Members of Congress, the executive branch, and some entities of the judicial branch and the Attorney General's Office may introduce legislative proposals.[32] Citizens also have the right to propose legislation or to propose constitutional amendments.[33] Once both chambers have passed legislation,[34] it must then be approved by the president.[35]

Judicial Branch

The Colombian judicial system is derived from Roman law.[36] In issuing their decisions, judges rely principally on statutory law.[37] The judicial branch consists of the Constitutional Court,[38] the Supreme Court of Justice,[39] the Council of State,[40] the Superior Council of the Judiciary,[41] the Attorney General's Office,[42] and the courts.[43] The Constitutional Court decides cases initiated by citizens that challenge the constitutionality of laws and decree-laws. It also decides the constitutionality of international treaties and related implementing legislation.[44] The Supreme Court is the highest court of civil and penal law. One of its most important functions is as a final court of cassation and appeal.[45] The Council of State is the highest court in the administrative law system; its jurisdiction consists of the review of administrative decisions. Some of the Council of State's most important functions are to consider challenges to the constitutionality of decrees promulgated by the government that do not fall under the Constitutional Court's jurisdiction and to act as the highest consultative body to the government in administrative matters.[46] The Superior Council of the Judiciary fulfills essentially administrative functions within the judicial branch. It is charged with overseeing the career advancement of judicial branch officials; proposing candidates to be appointed as judicial officials and remitting these proposals to the corresponding entities; evaluating and sanctioning cases of unprofessional conduct on the part of judicial branch officials and lawyers; and deciding cases of conflict of jurisdiction that occur between the different courts.[47]

The attorney general is responsible for investigating crimes and bringing charges against those accused of committing a crime; assuring the appearance of the defendant before the court; and protecting witnesses and victims during the legal process.[48] The Constitution also authorizes the creation of justices of the peace to promote the equitable resolution of conflicts.[49] Likewise, the authorities of indigenous communities can administer justice within their territorial jurisdiction according to their tradition and customary law.[50]

The "controlling authorities" are autonomous government entities and are independent from the other branches of government.[51] The Department of the Public Prosecutor and the National Comptroller's Office are the controlling authorities in Colombia.[52] The Department of the Public Prosecutor is composed of the following entities: the prosecutor general, the ombudsman, the assistant prosecutors and agents of the Department of the Public Prosecutor who appear before the judicial authorities, and the municipal prosecutors.[53] The main function of the Department of the Public Prosecutor is to protect and enforce human rights, to safeguard the public interest, to oversee the official conduct of public officials, and to intervene in actions before judicial or administrative bodies in defense of the law, the national patrimony, or human rights.[54] The ombudsman promotes human rights, makes recommendations to the authorities and to private individuals in cases of human rights violations, assists the prosecutor general in preparing a report on the human rights situation in Colombia, and files petitions before the Constitutional Court regarding all laws directly involving human rights.[55]

B. STRUCTURE OF TERRITORIAL DIVISIONS

Colombia is divided into 32 departments, which are subdivided into districts, municipalities, and indigenous territories.[56] These territorial entities are autonomous — they develop and manage their own interests,[57] and their officials are elected by popular vote.[58] They also enjoy autonomy in the administration of their finances and they receive a share of the national budget.[59] A popularly elected administrative agency, known as a departmental assembly,[60] exists in each department to direct the operations and services provided by the departmental government.[61] The governor, who is popularly elected, is the head of departmental administration.[62] The governor is charged with upholding national and departmental laws, coordinating the department's administrative activities, and promoting the development of the department.[63]

Municipalities are the basic entity of the government's political and administrative division.[64] The municipality provides certain public services as proscribed by law, builds public works projects necessary to foster local development, and promotes community participation and the social and cultural development of the community.[65] Each municipality has a popularly elected administrative body, known as the City Council, which is charged with regulating the municipality's operations and the services provided by the municipal government.[66] The mayor, who is popularly elected, is the head of the

municipal government.[67] The mayor must uphold the Constitution and the national laws at the municipal level, ensure peace and order, and oversee the services provided by the municipal government.[68]

C. SOURCES OF LAW

Domestic sources of law

The laws that affect the legal status of women, including their rights, derive from a variety of sources. In the Colombian legal system, the Constitution prevails over all other sources of law.[69] In the case of incompatibility between the Constitution and a law or other legal norm, the Constitution prevails.[70] Legislation is the principal source of law, and auxiliary sources include equity, "jurisprudence" (principles established by several prior court decisions on the same legal issue), the general principles of law, and the established opinion of well known and respected scholars.[71] No law can be retroactively applied except when it favors a defendant.[72]

International sources of law

Several international human rights treaties recognize and promote specific reproductive rights. Governments that adhere to such treaties are legally obligated to protect and promote these rights.

International treaties that have been ratified by Congress become part of national legislation in Colombia.[73] If a treaty so provides, the president may provisionally implement treaties dealing with economic and trade issues with international organizations.[74] Once these treaties become effective, they must be sent to Congress for ratification. If Congress does not ratify the treaty, its implementation must be suspended.[75] Once Congress ratifies a treaty, the government sends it to the Constitutional Court for approval. If approved, the government can exchange diplomatic notes confirming ratification; if the Constitutional Court does not approve, the treaty cannot be ratified.[76] The Constitution specifically provides that international treaties and conventions dealing with human rights that have been ratified by Congress prevail over all other laws.[77] It also states that the rights protected by the Constitution must be interpreted in accordance with the human rights treaties ratified by the Colombian government.[78]

Colombia is a member-state of the United Nations and of the Organization of American States. As such, it is a party to most international treaties dealing with the protection of human rights,[79] including those that protect the rights of women in the universal and Inter-American systems. Thus Colombia is a party to: the Convention on the Elimination of All Forms of Discrimination Against Women;[80] the Convention on the Political Rights of Women;[81] and the Inter-American Convention on the Prevention, Punishment and Eradication of Violence Against Women.[82]

II. Examining Reproductive Health and Rights

In Colombia, issues related to the reproductive health of women fall within the scope of the country's national health policies. To understand reproductive rights in Colombia, it is therefore necessary to analyze the nation's laws as well as its health programs.

A. HEALTH LAWS AND POLICIES

Objectives of the health policy

The situation of women's health in Colombia has improved substantially over the past decades.[83] Some of the factors that have produced these changes are improved living standards, increased educational levels, greater intervals between births, and improved health-care-service delivery.[84] For example, the life expectancy at birth for women increased from 52 years in the 1950s to 72 years in the 1990s.[85]

As of 1991, the Colombian Constitution recognized health as a public service and mandated that the government guarantee all individuals equal access to health services.[86] The government is also required to manage, direct, and regulate the provision of health services in accordance with the principles of efficiency, universality, and solidarity.[87] Health service delivery is decentralized by levels of treatment provided by national and local public and private health care entities. It also includes community involvement.[88]

The Ministry of Health directs the national health system. It formulates policies, plans, programs, and projects that define the activities and allocate the resources of the health system. It is also responsible for formulating scientific and administrative regulations.[89]

In Colombia, the government is required to provide social security (health insurance) to all its citizens "directed, coordinated and supervised by the government."[90] Based on this constitutional mandate, Congress passed Law No. 100 in 1993, which delineates the characteristics of the national social security system. It includes provisions that guarantee that by the year 2000, health care will be provided for all citizens, even those who cannot pay for it.[91] The social security system provides for health services, including disability benefits and retirement benefits. There are two systems affiliated with the social security system: the contributory system, to which salaried workers have access, and the subsidized system, which provides coverage to the poorest segment of the population.[92] Both public and private entities provide health care services.[93]

Government or private pension funds cover disability and retirement benefits, in accordance with the option chosen by the beneficiary.[94]

The social security system provides services through these programs: the Compulsory Health Plan (the "Compulsory Plan"),[95] the Primary Health Care Plan (the "Primary Plan"),[96] and the Compulsory Health Plan of the Subsidized Regime (the "Subsidized Plan").[97] The Compulsory Plan provides health services to all families, particularly maternal health care.[98] In addition to these services, pregnant women and mothers of children under one year covered by the Compulsory Plan also receive a food subsidy.[99] The Compulsory Plan also mandates the creation of educational programs for women dealing with comprehensive health and sex education, with special emphasis on women in rural areas and adolescents.[100] The Subsidized Plan provides health services for those individuals who cannot afford to pay for them and who need to be incorporated into the Compulsory Plan.[101] The Ministry of Health created the Primary Plan to complement the coverage provided by the Compulsory Plan.[102] It also provides coverage for family planning services and the treatment of transmissible diseases like AIDS.[103] Primary health care provision under this program is free of charge and mandatory.[104] The Subsidized Plan includes health care services for those who cannot pay for them and yet must be covered by the Compulsory Plan. It also includes programs promoting health for women of childbearing age through family planning services, reproductive health counseling, Pap smear testing, breast examinations, and programs to treat sexually transmissible infections ("STIs").[105]

The Maternal and Child Health Care Plan was created as part of the subsidized social security system to incorporate the most vulnerable groups of the population into the subsidized regime. The program, which treats pregnant women and children under the age of one year, includes, among other services, treatment during pregnancy, childbirth, and the postnatal period. It also includes family planning services, reproductive health counseling, and health care for children in their first year.[106]

Infrastructure of health services

According to 1996 statistics, 97% of the Colombian population has access to primary health care.[107] The coverage provided by the public health system was only 39% in 1992.[108] Between 1990 and 1995, 80% of pregnant women received prenatal care coverage from either public or mixed (private and public) health care establishments,[109] while 3% were attended by a nurse and 17% received no prenatal attention.[110] Seventy-seven percent of births were attended by medical personnel in 1995.[111] According to another source, 77% of births were attended by a physician, 10% by a nurse, 8.5% by a midwife, and 6.6% were not attended by any health care provider.[112] Despite the fact that the levels of coverage and of human resources in health care are relatively high, the quality of services remains poor. Moreover, resources continue to be concentrated in certain areas of the country, which means that a significant portion of the low-income population lacks access to these services.[113]

Cost of health services

In Colombia, public expenditures on health care have increased during the past few decades.[114] In 1996, health expenditures were 2.41% of the Gross Domestic Product (GDP), the highest percentage in the last sixteen years.[115]

In 1993, the law creating the new social security system[116] established sliding scales for subsidies, methods of payment by installments, health services packages for women, and other subsidized forms of payment, with preference given to primary health care services.[117] The paying affiliates of the social security system finance the services they receive through their health insurance fees.[118] The affiliates of the subsidized regime receive special treatment, as part of the strategy to offer the most disadvantaged sectors of the population social security system health coverage. In this way, Law No. 100 of 1993 provides that under the subsidized regime, the provision of services of the Primary Plan[119] will be mandatory, free of charge, and covered by the state.[120] The government will only partially subsidize the primary health care services not included in the Primary Plan. Those on the Subsidized Plan pay only 50% of the amount paid for these services in the contributory system. Higher level services will be incorporated gradually, with the support of the fees paid by contributors from 1993 on.[121]

Regulation of health care providers

The Code of Medical Ethics regulates the medical profession.[122] Specifically, this code establishes the principles governing the medical profession and the professional conduct of health care providers in Colombia.[123] It also regulates physician patient relations;[124] medical prescriptions, clinical histories, and patient confidentiality;[125] as well as relationships between physicians and medical institutions, society, and the government.[126]

In addition, the Code of Medical Ethics regulates supervising entities and the disciplinary regime applicable to the medical profession.[127] It recognizes the Medical Federation as a consultative body of the national government, and it was responsible for the creation of the National Tribunal of Medical Ethics.[128] The latter is empowered to deal with the ethical and professional complaints brought against individual medical providers.[129] These disciplinary processes may result in imposing of the penalties provided by the Code of Ethics.[130]

These penalties are private warnings, reprimands (including [i] written and private reprimands, [ii] written and public reprimands; [iii] verbal and public reprimands), suspension from the practice of medicine for up to six months; and suspension from the practice of medicine for up to five years.[131]

The Penal Code also establishes penalties for the following criminal acts committed by health care providers in the exercise of their profession: manslaughter,[132] injuries caused by negligence,[133] the performance of an abortion,[134] and the performance of an abortion without the patient's prior consent.[135]

Patients' rights

The Code of Medical Ethics establishes that the physician is obligated to maintain confidentiality regarding the patient's medical information and history,[136] as well as to obtain the patient's consent before administering any treatment or performing any procedure.[137] In addition, the code regulates the rights of patients in their relationship with the physician.[138] Furthermore, patients must give their informed and voluntary consent in advance of the performance of irreversible contraceptive procedures.[139] This regulation also mandates that any establishment that seeks to provide fertility regulation services is part of the medical profession and must therefore abide by the ethical norms established by that profession.[140]

Additional regulations establish the means through which members of the local community can participate in health service delivery. Such regulations seek to assist service users in the exercise of their rights and in their participation in the management of existing health plans and programs.[141] They mandate that healthcare establishments provide service-users with regular information and care.[142] They also propose the creation of associations of service users.[143] These associations report on the quality of the services provided, respond to the complaints of service users, and supervise and control the performance of health care establishments.[144] The law also provides for community control of health care provision through oversight committees,[145] comprising citizens and institutions at the community level, to oversee health service delivery.[146]

Health care institutions must also create hospital ethics committees.[147] These committees must develop prevention programs for individual and family health care; develop programs intended to build a culture of public service;[148] promote respect and awareness of health rights among service users;[149] receive and channel the observations of the oversight committees on the quality of and access to health services;[150] and channel concerns and complaints about health services to the proper authorities.[151] Patients are protected against medical negligence by criminal law, which establishes sanctions for negligent injuries caused by a physician. In some cases, the physician may be suspended from the practice of medicine.[152]

B. POPULATION AND FAMILY PLANNING

Population laws and policies

Colombian law recognizes the right of couples and/or individuals to make informed decisions about the number and timing of children.[153] The Ministry of Health and the Ministry of the Environment have the joint responsibility of formulating the National Population Policy ("NPP"),[154] promoting and coordinating programs aimed at population control,[155] and evaluating national demographic statistics.[156] The government prepared a policy guideline on sustainable population growth as part of its legal mandate.[157] This document serves to highlight the most important and strategic aspects of the interrelationship between population growth and the development process. In 1995, the government issued a diagnostic evaluation to serve as a basis for the formulation of the NPP.[158]

Given the rapid decrease in the birth rate and in population growth in Colombia, the government has never adopted a population policy per se.[159] Various social policies have, however, addressed population issues.[160] The National Planning Office[161] has played a significant role in incorporating population issues into the Colombian government's planning and development strategies.[162]

Reproductive health and family planning laws and policies

Over the past decade, the Colombian government has sought to promote the recognition of women as the principal beneficiaries of development plans and policies. This is part of an effort to go beyond previous programs, which were limited to promoting the participation of women primarily as a means to improving the living conditions of the family.[163]

In 1992, the Ministry of Health launched its policy initiative Health for Women, Women for Health,[164] which focuses on the role of women as central decision makers and the primary providers of health care.[165] The policy's objectives include improving women's quality of life; decreasing inequalities between men's and women's access to to health services; and strengthening the role of women in the health sector by promoting their participation in decision making.[166] The program seeks to foster autonomy and self-care for women in terms of their bodies, their sexuality, and their overall health.[167] Within the context of its National Development Plan for the period from 1994 to 1998, known as The Social Leap Forward,[168] the current government recently enacted the Participation and Equality Policy for Women.[169] The objectives of the Participation and Equality Policy for Women are to foster respect for the issue of the treatment of women's health issues; to promote comprehensive treatment of women's health through programs that respond to their specific needs; and to promote a greater role for women by encouraging their participation in the

design, implementation, and evaluation of health policies.[170] In this context, the Ministry of Health is committed to carrying out a series of reforms in the institutional,[171] legislative,[172] and cultural[173] arenas. The specific commitments of the Ministry of Health are to "strengthen, coordinate and supervise those policies that promote the comprehensive health and human development of women and girls; develop a program of prevention, detection and treatment of preventable STIs; and implement promotional and educational programs to foster greater male participation in issues of sexual and reproductive health."[174]

As a component of the Participation and Equality Policy for Women, the government established the Comprehensive Health Program for Women based on the earlier experience of the policy initiative, Health for Women, Women for Health.[175] One of the primary goals of the Comprehensive Health Program for Women is to link low-income women to the subsidized health system in an equitable manner. It also aims to encourage self-employed women workers and domestic employees to become contributors to the social security system.[176] Another goal of the Comprehensive Health Program for Women is to encourage contributors to take out family coverage within the social security system for their spouses, permanent partners, and children.[177] It also provides that the government must take the necessary steps to reduce unwanted pregnancies, abortions, maternal and perinatal mortality, morbidity and mortality due to breast and cervical cancer, and the transmission of STIs and HIV/AIDS.[178] The National Office for Women's Equality coordinates and supervises these policies and programs. The office also plans, coordinates, and oversees the general policy on women in Colombia.[179]

In terms of population and family planning policies, one of the main objectives of the Ministry of Health is to increase the prevalence of contraceptive methods and family planning counseling. Its specific goal in this regard is to increase the impact of state health care providers on the rate of total contraceptive prevalence: from 30% in 1994 to 60% by the year 2000. This would bring the total level of public and private impact on the rate of contraceptive prevalence to between 70 and 72% by the year 2000.[180]

Government delivery of family planning services

The Colombian government has provided family planning services for many years, and family planning is incorporated in its health policies.[181] In 1993, the government provided only 20% of all available family planning services.[182] The Ministry of Health provides 53% of IUDs, 25.2% of contraceptive pills, 25.2% of sterilizations, and 7% of condoms.[183] These services are offered in hospitals, health centers, and a network of health clinics in rural and urban areas.[184] Public family planning services provided in accordance with the Comprehensive Health Program for Women seek to make contraceptive methods available to both the male and female populations. Among its other goals are abortion prevention and management and the adjustment of fees for reproductive health care to the socioeconomic conditions of the service-users.[185] The policy reforms promoted by the Comprehensive Health Program for Women emphasize the legal obligation of service providers to inform service-users of their family planning options as part of the counseling process.[186] Family planning services are a component of the primary health care program,[187] and every health center and hospital must provide family planning services to low-income individuals.[188] In practice, the private sector, through organizations such as Profamilia, provides most family planning services.[189]

In addition, the subsidized regime of the social security system establishes that women of childbearing age have the right to receive family planning services, reproductive health counseling, Pap smear testing, and breast examinations.[190] The subsidized regime's Maternal and Infant Health Care Plan includes prenatal, birth, and postnatal care as well as family planning services.[191] It also mandates the creation of a reproductive health counseling center to implement the provision of these services.[192]

C. CONTRACEPTION

Prevalence of contraceptives

Nearly all Colombian women are knowledgeable about modern contraceptive methods.[193] In 1995, the fertility rate was 2.6 children per woman.[194] Sixty-nine percent of women of childbearing age have used family planning methods at least once in their lives.[195] The most widely known methods are: the birth control pill, the condom, female sterilization, and the intrauterine device ("IUD").[196] Sterilization is the most commonly used method among women in a stable relationship;[197] the pill and the IUD are also common methods, with average uses of 12% and 11%, respectively.[198] In 1995, 72% of women living with a partner stated they used some contraceptive method, a significant increase from previous estimates.[199] The contraceptive prevalence rate is greater among women with higher educational levels who reside in urban areas.[200] In Colombia, the private sector plays an important role in supplying contraceptive methods; nearly three-fourths of all women who use family planning services obtain them from private sector sources.[201] Pharmacies are the principal supply source for the pill, injections, condoms, and barrier methods.[202]

Legal status of contraception

The only legal prohibition against contraceptive methods in Colombian law is the prohibition against abortion as a method of family planning.[203] The National Food and Drug Administration ("NFDA") is charged with ensuring quality control over pharmaceutical products.[204] This entity implements policies formulated by the Ministry of Health that deal with the safety and quality control of drugs and contraceptive devices such as condoms and diaphragms.[205] Generally, the NFDA is charged with proposing, developing, disseminating, and updating scientific norms and standards that are applicable to inspection, safety, and control procedures.[206] It is also responsible for granting licenses and recording registrations for the operation of a health facility[207] of and for authorizing advertisements that promote specific pharmaceutical products.[208] The law that regulates the functions of the NFDA also outlines the conditions for the production, processing, bottling, sale, import, export, and marketing of these products, as well as the process of granting operating licenses for health product manufacturers.[209]

Regulation of information on contraception

Dissemination of information about condoms and diaphragms, whether it be for scientific or advertising purposes, is subject to the conditions established for obtaining a health license, as well as to other relevant technical regulations and laws. No express authorization is required, however, from the Ministry of Health or the NFDA before distributing such information.[210] Contraceptive methods considered drugs may only be advertised or promoted in scientific or technical publications directed at medical professionals.[211]

Sterilization

In Colombia, the Ministry of Health regulates surgical sterilization.[212] The ministry's regulations mandate that those who elect irreversible methods of contraception must provide clearly documented voluntary and informed consent.[213] The individual may consent only after a health professional gives a full explanation of the desired surgical procedure. This explanation must include the procedure's possible side-effects, the risks and benefits of the procedure, the availability of alternative contraceptive methods, the precise purpose of the operation and its irreversibility.[214] The median age of those seeking sterilization is 30.6.[215]

D. ABORTION

Legal status of abortion

Abortion is illegal in Colombia and is categorized by the Penal Code as a crime against life and personal integrity.[216] The Constitution recognizes the right to life as an inviolable fundamental right, but it does not specify at what point in the development of the fetus this right becomes applicable.[217] However, the Constitutional Court determined in a recent case before it that human life is protected from the moment of conception.[218]

Criminal law penalizes a woman who induces her own abortion as well as the person who performs the abortion with the woman's consent.[219] It also criminalizes the behavior of any person who performs an abortion without the woman's consent or on a woman younger than 14.[220] The penalty is less severe in cases of abortion when the pregnancy was the result of rape, incest, or nonconsensual artificial insemination.[221] The law also penalizes any person who causes injuries to a woman resulting in a miscarriage.[222]

Despite the illegality of abortion, there are approximately 450,000 induced abortions in Colombia each year.[223] In addition, statistics show that complications resulting from the conditions under which illegal abortions are performed was the second-leading cause of maternal mortality between 1980 and 1990.[224]

Penalties

A woman who induces her own abortion or who consents to its performance by another person is liable to imprisonment for one to three years.[225] The same penalty applies to any person who performs an abortion with the woman's consent.[226] Any person who performs an abortion without the woman's consent or on a minor under 14 years of age is liable for three to ten years of imprisonment.[227] A woman whose pregnancy was the result of rape, incest, or nonconsensual artificial insemination and who induces her own abortion is liable to imprisonment for four months to one year.[228] The same penalty is applicable to any person who performs an abortion on a woman who became pregnant under these circumstances.[229]

E. HIV/AIDS AND SEXUALLY TRANSMISSIBLE INFECTIONS (STIs)

It is essential to examine the issue of HIV/AIDS within the framework of reproductive rights insofar as the two areas are interrelated from both medical and public health standpoints. Furthermore, a comprehensive evaluation of laws and policies affecting reproductive health in Colombia must examine all the dimensions and implications of HIV/AIDS and STIs. As of 1994, there were 85 cases of HIV/AIDS for every one million inhabitants in Colombia.[230]

Laws on HIV/AIDS and STIs

The laws presently governing official HIV/AIDS[231] policies regulate health establishments, preventive treatments, research, and the rights and duties of persons infected with HIV/AIDS.[232] The law mandates that health establishments promote and implement activities aimed at providing public

health care personnel with information, training, and education to keep them abreast of scientific and technological advances, thus ensuring the proper treatment of HIV/AIDS.[233] The law also provides that these activities be directed at prevention as the most important means of controlling HIV infection.[234] The Ministry of Health is responsible for promoting HIV/AIDS research.[235] When such research involves human subjects, particularly AIDS patients, it must be consistent with the provisions of the Helsinki Declaration of the International Medical Association.[236] Colombian law also requires all government institutions, organizations, departments, areas, and ministries, especially the ministries of Communications, Health, and Education, to promote educational campaigns related to HIV/AIDS.[237]

With respect to the rights of HIV/AIDS victims, the law provides that public and private health establishments must provide comprehensive treatment to such persons as well as to any person at risk of contracting HIV/AIDS.[238] This treatment must be provided with respect for the dignity of the patient, without any discrimination and in accordance with the technical and administrative regulations and the standards of epidemiological control issued by the Ministry of Health.[239] The law also states that criminal charges may be brought against a person who, after having been informed that he or she is infected with HIV, deliberately engages in practices that might expose other persons to infection, or donates blood, semen, organs, or other body parts, for the crime of "propagating an epidemic" or for violating health regulations as established in the Penal Code.[240]

Employees are not required to inform their employers that they are HIV-positive.[241] Moreover, prisoners cannot be forced to have an HIV test except when such a test will serve as probative evidence in a criminal trial or by order of the competent health authorities.[242]

Policies on prevention and treatment of HIV/AIDS and STIs

In 1993, Colombia issued an interministerial policy on HIV/AIDS control and prevention based on strategies of health promotion, HIV/AIDS prevention, epidemiological monitoring, and the reduction of the social and economic impact of HIV/AIDS.[243]

The "Inter-ministerial Medium-Term Plan to Control and Prevent STIs and HIV/AIDS" (the "STI and HIV/AIDS Plan") is a government plan for the structuring and implementation of programs within the different ministries.[244] The National AIDS Council[245] and the National Executive Committee on the Control and Prevention of HIV/AIDS[246] are the principal government bodies charged with implementing the STIs and HIV/AIDS Plan.

The STIs and HIV/AIDS Plan was created pursuant to the constitutional mandate establishing the government's duty to provide comprehensive health care to the population, to preserve the health of each individual and of the population as a whole, and to strengthen the mechanisms of community participation and intervention.[247] The objective of the HIV/AIDS Plan is "to foster awareness among the individual, the family, and society at large regarding the different forms of transmission of HIV/AIDS and other sexually transmissible infections; to promote values, attitudes and conduct that will ensure the exercise of responsible sexual behavior; to strengthen and develop programs aimed at preventing and controlling HIV/AIDS and other STIs and reducing their social and economic impact."[248] The activities developed under this plan must be coordinated among the various ministries and follow the applicable criteria and policy governing such coordination,[249] particularly those related to decentralization.[250] The activities also must seek to promote regional and local autonomy in the design, implementation, and evaluation of the plans, programs, and projects related to STIs and HIV/AIDS.[251] The plan emphasizes the following strategies: the promotion of sexual health; the prevention of transmission of infection through sexual contact, pregnancy, transfusions of blood and blood derivatives, and organ transplants or other invasive procedures. It also emphasizes the following: the prevention of transmission through syringes and needles, epidemiological control and research on STIs/HIV/AIDS, and the reduction of the social and economic impact of the illness through the monitoring and evaluation of its development.[252]

In keeping with the above strategies, the STI and HIV/AIDS Plan includes the following subprograms: sexual health promotion,[253] the provision of materials and infrastructure for regional blood banks and laboratories,[254] epidemiological control and research,[255] and the reduction of the economic impact of HIV/AIDS infection.[256]

The subprogram on sexual health promotion seeks to develop intervention strategies, such as regional and local programs designed to prevent STIs/HIV/AIDS. These are directed at specific groups of the population, including men and women of childbearing age, adolescents who attend school as well as those who do not, teachers, and health care personnel. These intervention strategies seek to improve the quality of information, educational, and training services.[257] The objective of the subprogram on the provision of materials and infrastructure for regional blood banks and laboratories is to improve the infrastructure of the regional referral laboratories and the blood banks in the departments' capital cities. The six state laboratories that act as referral laboratories for the regional networks of epidemiological control have priority.[258] The

subprogram on epidemiological control and research seeks to strengthen, at the regional level, the notification process and the active identification of cases and to improve the flow of information about how the HIV virus behaves.[259] Finally, the subprogram on the economic impact of the disease aims to make the appropriate adjustments in those health services that respond to the HIV/AIDS epidemic, with special emphasis on the comprehensive care of HIV/AIDS victims. It also seeks to prioritize the needs of individuals from the poorest sectors of society, including those who receive benefits from the subsidized social security regime.[260]

III. Understanding the Exercise Of Reproductive Rights:

Women's legal status

Women's health and reproductive rights cannot be fully evaluated without investigating women's legal and social status. Not only do laws relating to women's legal status reflect societal attitudes that affect reproductive rights, but such laws often have a direct impact on women's ability to exercise their reproductive rights. The legal context of family and couple relations, a woman's educational level, and access to economic resources and protection from the legal system determine women's ability to make choices about their reproductive health care needs and to exercise their right to obtain health care services. While the situation of Colombian women has improved significantly over the past 40 years,[261] they — especially rural women — continue to predominate in the poorest segment of the population.[262] Moreover, women have been the most affected by the internal displacements generated by political violence in Colombia.[263]

The constitutionally recognized principle of equality establishes equal rights, freedoms, and opportunities for all people, without discrimination based on sex, race, national or family origin, language, religion, or political or philosophical opinion.[264] The government is responsible for creating the conditions that make such equality realizable and effective. It must also adopt affirmative measures that favor groups that are excluded and discriminated against.[265] Similarly, the government must ensure equal participation in the political process and the public's right to exercise and control political power[266] and the elimination of all forms of discrimination against women.[267] Moreover, the government must protect and support women during pregnancy and after childbirth, as well as women heads of household.[268] The following section describes the laws and policies regulating those areas of women's lives that directly affect their health.

A. RIGHTS WITHIN MARRIAGE

Marriage law

The Constitution states that the basic unit of society is the family. The family is formed by the free decision of a man and a woman to marry or by the responsible decision of a man and a woman to establish a family.[269] The Constitution provides that family relations are based on the equal rights and duties of both spouses, who have the right to make voluntary and informed decisions regarding the number of children to have.[270] It also establishes that civil law regulates marriage, its forms, the minimum age and capacity required for marriage, the rights and duties of spouses, and laws regarding separation and the dissolution of marriages.[271] Colombian civil law gives legal effect to marriages performed by religious authorities,[272] and it recognizes the cessation of the legal rights and duties of such a religious marriage by divorce.[273]

Civil law[274] provides that marriage is a solemn contract in which a man and a woman unite with the objective of living together, procreating, and giving each other aid.[275] A marriage becomes legal when the two persons express their mutual and voluntary consent to marry before a competent authority.[276] The minimum age required for marriage is 18.[277] A woman may decide whether or not to adopt her husband's surname.[278] Spouses are obligated to be faithful and to aid and assist one another.[279]

Both spouses have the joint right to administer the household,[280] the authority to choose their place of residence, and the duty of contributing to the household economy according to their abilities.[281] The mother and father share parental authority[282] over their children,[283] and either parent can act as the legal representative of his or her children.[284]

Civil law establishes equality between spouses, and the full legal capacity of a married woman to manage her property and the couple's jointly owned property, to enter into contracts, and to access the courts.[285] In 1996, Congress passed a law that requires the signature of both spouses when transferring immovable property pertaining to the family domicile.[286]

Colombia prohibits polygamy. The Penal Code defines bigamy[287] as a crime against the family, punishable by one to four years' imprisonment.[288]

Regulation of domestic partnerships

Law No. 54 of 1990 formally recognized a form of legal union, *union de hecho* or domestic partnership, which it defines as a stable union between an unmarried man and an unmarried woman who form a permanent household together.[289] The law states that, for legal purposes, the man and woman who form part of a domestic partnership are "permanent companions."[290] A domestic partnership exists once the two

unmarried individuals have lived together for more than two years and as long as no impediment exists that would prevent either of the companions from marrying.[291] Any property or capital derived from work belongs jointly to both permanent companions.[292] The joint ownership of property by permanent companions may be dissolved for the following reasons: the death of one or both companions, marriage by one or both companions to a third person, a notarized document affirming the mutual consent of both companions to dissolve the union, or judicial decree.[293] Labor laws provide that a permanent companion has the right to the retirement or disability pension of the other as well as to death benefits payable upon an employee's death, provided the permanent companions lived together for at least two years or had one or more children together.[294] At the same time, the permanent companion of the employee or pensioner is also entitled to health care benefits from whichever entity is the provider, provided the permanent companions have lived together at least two years.[295] The liquidation of joint property in domestic partnership is governed by the Civil Code provisions applicable to marriage.[296] In 1992, the Constitutional Court recognized domestic work as a contribution to the joint property in domestic partnerships.[297]

Divorce and custody law

Civil marriage in Colombia terminates upon the death of one of the spouses or by a judicial decree of divorce.[298] The legal rights and duties of a religious marriage also cease upon legal divorce.[299] Grounds for divorce include adultery; failure to fulfill one's duty as a spouse or as a mother or father; cruel treatment; the habitual and unjustified use of alcohol or drugs; a grave and incurable illness that endangers the physical or mental well-being of the other spouse; conduct on the part of a spouse that corrupts or perverts the other spouse or one of their children; physical separation of the spouses for more than two years; and the mutual consent of both spouses before an authorized judge.[300] The divorce decree determines alimony and child support, the former spouses' residence arrangements, custody of their children, and visitation rights.[301] Once the divorce has been granted, the marriage is dissolved as is any joint ownership of property which then must be liquidated according to the law.[302] Each spouse receives one-half of any remaining property.[303] The "innocent" spouse may repossess any gifts made during their marriage to the "guilty" spouse.[304]

A judge grants custody and parental authority over the children.[305] The judge also determines the amount of child support[306] and alimony.[307] The Penal Code establishes penalties for parents who fail to pay alimony or child support.[308] Colombian law includes several provisions regarding the amount of child support and the type of civil legal procedures that must be followed to enforce this obligation.[309]

B. ECONOMIC AND SOCIAL RIGHTS

Property rights

The Colombian Constitution establishes that all persons enjoy the same rights, which must be respected without any discrimination whatsoever.[310] It recognizes the right to private property for all.[311] Colombian civil law provides that a woman does not require her spouse's authorization or permission from a judge to administer and dispose of her personal belongings and of those jointly owned with her husband.[312] However, only 37.5% of women heads of household own property, in contrast with 53% of households headed by men.[313]

No legal restrictions or discriminatory provisions against women exist in Colombia's inheritance and succession laws.[314] In general, the grounds for disinheriting descendants include serious injury against the testator and, in the case of a minor descendant, when he or she marries without the testator's consent.[315]

Labor rights

Unemployment in Colombia is higher for women than for men.[316] While the average unemployment rate in 1992 was 8.4% for men, it was 13.5% for women.[317] Of all those who were unemployed in 1992, 58% were women, of which 84% were from low-income sectors.[318] Women also receive lower pay than men: women's pay was 32.7% less than men's pay in 1984, and 29.5% less in 1992.[319] Moreover, while women have increasingly joined the work force in Colombia — currently women are 43% of the economically active population — the formal sector employs a relatively small proportion of the female work force. Thus, women, particularly low-income women, tend to be more active in the informal sector than in the formal sector.[320] The Colombian Constitution provides that work is a right and a social duty that enjoys government protection.[321] At the same time, one of the fundamental principles of labor law is the special protection bestowed on women and maternity.[322] The Constitution guarantees the right of all persons to social security, with preference granted to women heads of household, pregnant women and women who are breast-feeding.[323] Colombia is a party to several international treaties that protect women in the workplace, such as Convention No. 100 of the International Labor Organization, the Convention Concerning Equal Remuneration for Men and Women Workers for Work of Equal Value;[324] and Convention No. 111 of the International Labor Organization, the Convention Concerning Discrimination in Respect of Employment and Occupation.[325]

Colombian law protects pregnant women. No employee can be terminated for being pregnant or for breast-feeding.[326] The law presumes that an employee was terminated because of pregnancy or breast-feeding when this dismissal occurs without official authorization during the woman's pregnancy or in the three months following childbirth.[327] If such a termination occurs, it is null and void, and the woman must be reinstated to her employment following the maternity leave to which she is entitled.[328] Since 1994, the practice of forcing women to submit to a pregnancy test before being hired has been prohibited, except when the work to be undertaken is categorized as involving high-risk activities.[329] An employer is obligated to relocate an employee who becomes pregnant to a position that will not expose her to substances that present a risk for her pregnancy.[330]

A pregnant employee also has the right to a postnatal maternity leave of twelve weeks, during which she receives the same salary as at the time her leave began.[331] A woman who adopts a child under the age of 7 also receives a maternity leave under the same conditions, and the date of adoption is equivalent to the date of birth.[332] An employee who uses her maternity leave before childbirth may reduce her leave to eleven weeks and give the remaining week to her husband or permanent companion so that he may accompany her at the moment of childbirth and immediately after delivery.[333] During the first six months, the employer must allow a woman who has returned from her maternity leave to take two thirty-minute breaks during the workday to breast-feed her child, without discounting any pay from her salary.[334]

An employee who miscarries or whose baby dies during or after premature delivery has the right to a two- to four-week leave of absence, to be paid at the salary she was receiving at the time her leave began.[335] If a premature delivery occurs and the infant survives, the same provisions on maternity leave described above apply.[336]

Colombian labor law prohibits the employment of minors and women of any age in activities that involve contact with substances that are potentially harmful to their health. It also prohibits assigning pregnant women to shifts longer than five hours.[337]

Access to credit

There are no laws in Colombia that restrict women's access to credit. However, some government programs promoting access to credit have noted that the fact that only 26.4% of women have been granted loans suggests the existence of discriminatory practices against women.[338] To counteract these practices, the Colombian government passed a law aimed specifically at making credit more accessible to women heads of household and to their families.[339] This law mandates that government credit agencies, as well as credit agencies in which the government participates, create special programs providing credit and technical assistance with the objective of assisting women heads of household.[340]

Access to education

The illiteracy rate among women in Colombia has declined from 29% in 1964 to 11.6% in 1993.[341] School enrollment is evenly distributed by sex at almost all levels. The percentage of women in higher education (post-secondary school) has increased dramatically, from 18.4% in 1960[342] to 51.7% today.[343] For the period between 1989 and 1991, women represented 50% of primary school enrollment and 49.2% of high school enrollment.[344] For the population above age 24, on average, men and women have completed almost the same number of school years: 5.8 years for women and 6.0 years for men.[345] Rural women have less access to education than urban women.[346]

Women were first granted access to higher education in Colombia in 1933.[347] The Constitution establishes that education is a right and a public service designed to provide access to knowledge, science, technology, and other cultural goods and values.[348] The government, society, and family are responsible for education, which is compulsory for children between the ages of 5 and 15. Education is free of charge in public schools.[349]

The Colombian government is currently implementing a project entitled Education for Equality whose main objective is to modify the educational system so that it does not foster socialization patterns that reinforce inequity between the sexes and gender stereotypes.[350] It also seeks to promote equal access to education for boys and girls, and to identify the factors that limit girls' access to education.[351]

Women's bureaus

During the past decade, the government has designed and carried out several programs aimed at issuing policies and establishing governmental entities that promote women's rights.[352] The National Office for Women's Equality[353] ("NOWE") was created in 1995 to oversee the planning, monitoring, and permanent coordination of government activities promoting equality and participation for women.[354] NOWE is a permanent body under the control of the Presidency of the Republic. It has administrative autonomy and an independent budget.[355] NOWE has assumed responsibility for the Presidential Program for Youth, Women and the Family (PPYWF), which implemented women's policies from 1990 to 1994.

Another entity created to implement the mandate of the Equality and Participation Policy for Women (EPPW) is the Ministerial Network, which brings together women working at different managerial levels of ministries, other administrative

agencies, and the vice-presidency.[356] The Ministerial Network evaluates the extent to which women working in the public sector are being promoted to managerial positions.[357] The Colombian government is planning the creation of a consultative group comprised of nongovernmental organizations ("NGOs") and women's organizations. It is also planning a Congressional Network to promote the passage of laws favoring women.[358]

The Territorial Network, comprising women's bureaus in the departmental and municipal governments, was created with the aim of implementing the EPPW at the territorial level. As of 1995, women's bureaus were created in seven departmental governments and twelve municipal governments.[359] Departmental and local women's bureaus come under the control of their respective governors and mayors.[360]

C. RIGHT TO PHYSICAL INTEGRITY

Rape

In Colombia, 5.3% of women of childbearing age have stated that they have been forced to have sexual relations.[361] Of this percentage, 3.1% are adolescents; 3.2% are women who have separated from their husbands; 5.4% are married women; and 3.0% are single.[362] In the majority of cases, the victim knew the offender: Forty-four percent of women say the offender was her husband or current partner; 20% say the offender was a neighbor or friend; 14% say the offender was a stranger; 14% say he was a relative; 2% say it was an employer or coworker; and 7% were categorized as "others."[363] The median age at which a woman is first raped is 18.7 years.[364] Rape statistics vary only slightly by area: six percent of women in urban and 4% in rural areas report having been raped.[365] In 1995, the Institute for Legal Medicine collected evidence for 11,970 sexual crimes.[366]

Colombian law was recently modified[367] to increase the penalties for rape and to change the classification of crimes considered attacks against "sexual freedom and human dignity."[368] Penal law classifies these crimes in three categories: rape,[369] abusive "sexual acts,"[370] and "statutory rape."[371] The law divides rape into three subcategories. These are "violent carnal access" (which carries a penalty of eight to twenty years' imprisonment);[372] a "violent sexual act" (which carries a penalty of four to eight years imprisonment);[373] and a sexual act with a person who is incapable of resisting (which carries a penalty of four to ten years' imprisonment).[374] An "abusive sex act" includes abusive "carnal access" with a person who is incapable of resisting and carries a penalty of three to ten years of imprisonment.[375] The offender is liable for harsher penalties for these crimes if one of the following aggravating circumstances is present: more than one person participated in the crime;[376] the offender has some degree of authority over the victim;[377] the victim becomes pregnant as a result of the rape;[378] the victim contracts a venereal disease; or the victim is under the age of 10.[379] The section on adolescents will further examine the crimes of "violent carnal access" with a minor under 14 years of age and statutory rape, which is, by definition, committed against adolescents and minors.

Law No. 360 of 1997 repealed the provision in the Penal Code establishing that an offender could be exculpated from liability for such crimes if he married the victim.[380] Another positive legislation development is that in 1996, rape within marriage became a criminal offense.[381]

Domestic violence

Statistics from 1995 reveal that 33% of women living with a partner were the victims of verbal abuse by their partners; 19% were physically abused;[382] and 6% were sexually abused.[383] While many women said they were aware of the existence of institutions where they could file a complaint against their partners, only 27% had reported domestic abuse to the authorities.[384] In 1995, the Institute of Legal Medicine handled 42,963 cases of injury caused by domestic violence.[385]

The Colombian Constitution provides that domestic violence in any form is destructive of family harmony and unity and will be punished according to the law.[386] Following this constitutional mandate, Congress enacted Law No. 294 in 1996, whose objective is to penalize and provide a remedy for domestic violence. Congress also ratified the Inter-American Convention on the Prevention, Sanction and Eradication of Violence Against Women, which is now incorporated into Colombian domestic law.[387]

The law described above, which implements the constitutional mandate to provide comprehensive treatment for different types of domestic violence,[388] provides that physical, psychological, or sexual abuse against a family member is a crime.[389] A person who inflicts physical or psychological injury on a family member is punished in accordance with the penalty established in the Penal Code for personal injury, plus an additional one-third of half the penalty because the situation involves domestic violence.[390] This law also establishes the penalties applicable to a person who uses unjustified force to restrain the freedom of movement of an adult family member.[391] In addition, the legislation establishes mechanisms for the provisional and permanent protection of abused persons with the objective of ending the abuse and preventing and punishing domestic violence.[392] This law empowers the Colombian Institute of Family Welfare[393] to develop programs to prevent and remedy domestic violence.[394] It also provides resources to state and city governments to establish Family Violence Prevention Councils to study the problem of domestic

violence and to promote activities designed to prevent and treat domestic violence.[395] The National Development Plan establishes that the government must improve the training of law-enforcement personnel who deal with domestic issues and of the justices of the peace in dealing with the problem of violence against women.[396]

Sexual harassment

In Colombia there are no laws or regulations that specifically deal with the issue of sexual harassment.

IV. Focusing on the Rights of a Special Group: Adolescents

The needs of adolescents are often unrecognized or neglected. Given that 34% of Colombia's population is under 15 years of age,[397] it is particularly important to meet the reproductive health needs of this group. The effort to address adolescent rights, including reproductive health, is important for women's right to self-determination, as well as for their general health.

The rights of adolescents are contained in the Constitution in the section dealing with social, economic, and cultural rights.[398] The Constitution states that young people have the right to protection and comprehensive education[399] and mandates that the government must promote the participation of young people in public and private institutions charged with their protection, education, and advancement of youth.[400] General laws on children's rights also protect the rights of adolescents.[401] The Constitution provides that children have the following fundamental rights: the rights to life; physical integrity; health, education, and culture; recreation; and the right to freely express their opinions.[402] Constitutional protection exists for children who have been abandoned, physically or psychologically abused, sexually abused, or exploited for their labor.[403] Colombia has passed legislation specifically aimed at protecting minor children, and it has ratified the Convention on the Rights of the Child.[404] Despite these legal protections, however, statistics reveal that violence particularly affects adolescents, especially young women between the ages of 15 and 24.[405]

A. REPRODUCTIVE HEALTH

Approximately one of every ten women in Colombia states that her first sexual relationship took place before the age of 15.[406] One-third of women state that it took place before the age of 18, and slightly more than half say it took place before the age of 20.[407] Only 11% of women between the ages of 14 and 19 currently use a contraceptive method.[408] In Colombia, 14% of women between the ages of 14 and 19 are mothers.[409] The median age of women at first childbirth is directly related to their educational level.[410] Women who have no education have their first child at a median age of 19, while women with a high school education have their first child at a median age of 23.[411] Early pregnancy is part of a cultural pattern in some regions in Colombia. In large cities, however, early pregnancies are generally unwanted, and they often involve single mothers abandoned by their partner.[412] Many of these pregnancies are terminated by expensive illegal abortions practiced in unsanitary conditions.[413]

The Health for Women, Women for Health Program targets in particular women between the ages of 15 and 49, especially adolescent women.[414] As part of the Participation and Equality Policy for Women, the government has proposed including the prevention of abortion and unwanted pregnancies through the design and implementation of appropriate family planning programs.[415]

B. MARRIAGE AND ADOLESCENTS

The median age at first marriage for Colombian women in 1995 was 21.4 years.[416] This median age differs considerably, however, according to educational levels. More-educated women between the ages of 30 and 34 married ten years later on average than less-educated women of the same age group.[417] A woman's place of residence is another factor affecting the median age at first marriage. The median age of marriage for urban women is 22, while it is 20 for rural women.[418]

The legal minimum age for marriage is 18.[419] However, men over the age of 14 and women over the age of 12 may marry with the consent of their parents.[420] Marriages in which either partner is under these respective ages are null and void,[421] unless its validity has not been questioned within three months after the minors reach puberty, or when the woman, even if she is underage, is pregnant.[42]

C. SEXUAL OFFENSES AGAINST MINORS

Of Colombian women between the ages of 14 and 19, 3.1% have been raped; of those the average age is 14.[423] Within this age group, 3.1% have been raped.[424] The rapists in such cases are principally: boyfriends, friends, or neighbors (39%); relatives (26%); strangers (16%); and others (10%).[425] The median age of adolescents who are raped is lower for those with lower levels of education. The median age for women who have no education is 13, while it is 17 for women who have completed some higher education.[426]

The penal law for crimes against "freedom and human dignity"[427] provides that a person convicted of "carnal access" with a person under the age of 14 is liable to four to ten years' imprisonment.[428] An offender who uses violence to obtain "carnal access" to a person under the age of 12 is liable to twenty to

forty years of imprisonment.[429] An offender who carries out a "sex act" other than intercourse with a person under the age of 14 is liable to two to five years of imprisonment.[430] The Penal Code also classifies statutory rape, which is the use of deception to obtain "carnal access" or another sex act with a person between the ages of 14 and 18, as a crime:[431] an offender who uses deception to obtain "carnal access" is liable to one to five years of imprisonment;[432] an offender who uses deception to carry out a "sex act" is liable to six months to two years' imprisonment.[433] Also, Colombian penal law considers incest to be a crime against the family.[434] Incest consists of "carnal access" or any other sex act with a direct descendant or ascendant, adoptive parent or adopted child, or brother or sister.[435] The penalty for perpetrating such a crime is six months' to four years' imprisonment.[436] Other sexual crimes under Colombian penal law include "fostering the prostitution of minors"[437] and "fostering the use of minors in pornography."[438] Offenders are liable to two to six years' imprisonment and four to ten years' imprisonment, respectively.[439]

D. SEXUAL EDUCATION AND ADOLESCENTS

The Ministry of Education has enacted a regulation regarding the compulsory nature of sex education.[440] This regulation provides that, with the beginning of the academic year in 1994, establishments throughout the country that offer programs of preschool, primary, high school, and vocational education must incorporate mandatory sex education programs as essential components of public education.[441] Pursuant to this mandate, the Ministry of Education designed the National Plan on Sex Education ("NPSE"), whose objectives include fostering changes in the values and behavior relating to sexuality;[442] reformulating the traditional definition of gender roles;[443] encouraging changes in the traditional family structure with the aim of promoting greater equality in the relationships between parents and children and between spouses;[444] and ensuring that men and women make voluntary and informed decisions about when they want to have children and that they know how to use birth control methods properly.[445]

The NPSE's further goals are that, by the end of high school, students understand their own sexual behavior and that of others;[446] that they recognize that they are endowed with sexual rights and duties and that they must respect others' similar rights on an equal basis;[447] that they assume responsibility for procreation;[448] that they are able to recognize the difficulties presented by unwanted pregnancy at any age;[449] and that they have basic knowledge about how to prevent the transmission of HIV/AIDS and other STIs.[450]

With the aim of providing methodological tools to the National Program on Sex Education, the Ministry of Education has published a series of eleven texts to be incorporated into the curriculum at the preschool, primary, and high school levels.[451] These texts include themes relating to personal identity, recognition of others, tolerance, reciprocity, life, tenderness, dialogue, love and sex, responsibility, and creativity. All these issues then form part of the curriculum starting from the first through the eleventh grades.[452]

ENDNOTES

1. Profamilia, Encuesta Nacional de Demografía y Salud [National Demographic and Health Survey], at 6 (1995).
2. The World Almanac and Book of Facts 1997, at 754 (1996).
3. Colombia Constitution, in force as of July 4, 1991, art. 10. (hereinafter Colom. Const.)
4. The World Almanac, *supra* note 2, at 754.
5. *Id.*
6. *Presentación conjunto de los informes periódicos segundo y tercero, revisados, de los Estados-partes, Colombia* [Combined presentation of the revised versions of the second and third periodic reports of States Parties, Colombia], U.N. Doc.CEDAW/C/COL/2-3/Rev. 1, at 6. The homicide rate, which was at 4.3 per 1,000 inhabitants in 1985, rose to 7.3 per 1,000 in 1990. The total number of homicides and other violent crimes went from 77,064 in 1985 to 86,153 in 1990. In addition, politically motivated crimes affected 83,531 people between 1988 and September 1991. *Id.*
7. Presidency of the Republic of Colombia, Colombia Paga Su Deuda a Las Mujeres. Informe Nacional del Gobierno de Colombia. Cuarta Conferencia Mundial Sobre la Mujer [National Report from Colombia. National Report of the Colombian Government. Fourth World Conference on Women], at 23-24 (1995).
8. *Consejería Presidencial para la Política Social- PNR- Informe nacional del Gobierno de Colombia-preparado para la IV Conferencia Mundial sobre la Mujer en Beijing, China* [Presidential Council for Social Policy- PNR- National Report of the Colombian Government- prepared for the IV Conference on Women in Beijing, China] at 14 (1995).
9. *Id.*
10. Colom. Const., *supra* note 3 art. 1.
11. *Id.*, art. 2.
12. *Id.*
13. *Id.* Article 100 establishes that foreigners and Colombian citizens enjoy the same civil rights and guarantees, which may only be limited in cases specified by law. Political rights, however, are reserved for Colombian citizens.
14. *Id.*, arts. 3 and 103.
15. *Id.*, art. 7.
16. These legal initiatives include, among others: Law No. 70, 1993, which establishes a general framework for the recognition of the right to collective property of Afro-Colombian communities and the protection of the cultural identity and social and economic development of these communities. Other mechanisms designed to protect these communities include, Decree No. 555, 1992, which created the Special Commission for Afro-Colombian Communities; Decree No. 1386, 1994, which set up a fund for indigenous reservations; and Law No. 715, 1992, which created the National Committee on Indigenous Rights.
17. Colom. Const., *supra* note 3, art. 113.
18. *Id.*, art. 189.
19. *Id.*, art. 115.
20. *Id.*
21. *Id.*, art. 115.
22. *Id.*, art. 190.
23. *Id.*, art. 189.
24. *Id.*, arts. 200 and 201.
25. *Id.*, art. 150, §10. These are known as decree-laws. This power must be expressly requested by the executive and its authorization approved by an absolute majority of votes in both houses. This power may not be granted to enact codes, statutory laws, or organic laws or to create taxes.
26. *Id.*, art. 114. The specific functions of Congress are described in arts. 150 to 152 of the Constitution.
27. *Id.*
28. *Id.*, art. 171.
29. *Id.*, art. 176.
30. *Id.*, arts. 132 and 133.
31. *Id.*, art. 150. The development plan is that which sets out the aims and objectives of the government's policies. The public investment plan sets out the budgets for the principal public investment programs and projects.
32. *Id.*, arts. 154 and 156. Some entities of the judicial branch and the Attorney General's Office have the power to propose legislation on subjects related to their functions. They are the Constitutional Court, the Council of State, the Prosecutor General, and the National Comptroller.
33. *Id.*, art. 155.
34. *Id.*, art. 145. Congress, whether in plenary session or either chamber, may not hold sessions or deliberate with less than a quarter of its members present. Decisions require a majority of votes of the House or Senate, except where the Constitution provides otherwise.
35. *Id.*, art. 165.
36. Continental European law is drawn directly from Roman law. This system was codified during the time of the Roman Empire. The *Compilation of Justinian* and his other works, such as *the Institutes, Codex, Digestas, and Novellae*, etc., are collectively referred to as *Corpus Juris Civilis*, to distinguish the civil system from English Common Law and Canon Law. *See* Black's Law Dictionary, at 168 (6th ed. 1991).
37. Colom. Const., *supra* note 3 art. 230.
38. *Id.*, arts. 239-245.
39. *Id.*, arts. 234-235.
40. *Id.*, arts. 236-238.
41. *Id.*, arts. 254-257.
42. *Id.*, arts. 249-253.
43. *Id.*, art. 116. Other entities exercising judicial functions include the military court system; the Congress in certain cases; and some administrative authorities. In addition, private citizens may be temporarily invested with the power of administering justice as conciliators or arbiters.
44. *Id.*, arts. 239-245.
45. *Id.*, arts. 234-235. "*Cassation* is the power given to the highest court of a country […] to decide on challenges against final judgments of lower courts by either affirming or reversing them." Pedro Flores Polo, Dictionary of Legal Terms, at 411 (2nd ed. 1987).
46. *Id.*, arts. 236-238.
47. *Id.*, arts. 254-257.
48. *Id.*, arts. 249 and 253.
49. *Id.*, art. 247. Such officials are intended to enable local communities to administer justice. They primarily deal with minor infractions and family law matters. Law 23, passed in 1991, regulates "Conciliation with Equity," which implements these objectives.
50. *Id.*, art. 246.
51. *Id.*, art. 113.
52. *Id.*, art. 117.
53. *See Id.*, arts. 275-282.
54. *Id.*, art. 277.
55. Law No. 24, 1993, art. 9. This law defines the organization and functions of the Ombudsman's Office.
56. Colom. Const., *supra* note 3 art. 286.
57. *Id.*, art. 287.
58. *Id. See also Id.*, art. 303.
59. *Id*, art. 287.
60. *Id.*, art. 299.
61. *Id.*, art. 300. The departmental assembly also enacts laws related to planning and to economic and social development; creates departmental taxes; determines the structure of the state's civil service; and establishes rules governing the police. *Id.*
62. *Id.*, art. 305.
63. *Id.*
64. *Id.*, art. 311.
65. *Id.*
66. *Id.*, art. 312.
67. *Id.*, art. 314.
68. *Id.*
69. *Id.*, art. 4.
70. *Id.*
71. *Id.*, art. 230. In effect, the nature of auxiliary sources of law, including jurisprudence and the principles of law and judicial doctrine, are reflected in the judgments of the highest courts of the Colombian judicial system. To see how these sources are employed, see the judgment of the Constitutional Court C-013, 1997, p. 9, in which the court cites principles of previous judgments in order to justify a decision.
72. *Id.*, art. 29.
73. *Id.*, art. 224.
74. *Id.*
75. *Id.*
76. *Id.* art. 241, no. 10.
77. *Id.*, art. 93. These rights cannot be altered even when states of emergency are in force. The state of emergency is a mechanism that gives the president exceptional powers in the case of an external threat (state of foreign war), disturbances of peace and order (state of internal unrest), and disturbances of the economic order (state of economic emergency). Colombian governments have systematically used this mechanism (known as a state of siege under the 1886 Constitution) in order to restrict and suspend constitutional rights.
78. *Id.*

79. Colombia is a party to the following universal treaties: International Covenant on Economic, Social and Cultural Rights, *adopted* Dec. 16, 1966, 993 U.N.T.S._ 3 (*entry into force* Sept. 3, 1976) (ratified by Colombia on Oct. 29, 1969)**;** International Covenant on Civil and Political Rights, *adopted* Dec. 16, 1966, 999 U.N.T.S. 171 (*entry into force* Mar. 23, 1976) (ratified by Colombia on Oct. 29, 1969); International Convention on the Elimination of All Forms of Racial Discrimination, *opened for signature* Mar. 7, 1966, 660 U.N.T.S. 195 (*entry into force* Jan. 4, 1969) (ratified by Colombia on Sept. 2, 1981); Convention against Torture and Other Cruel, Inhuman or Degrading Treatment or Punishment, *concluded* Dec. 10, 1984, S. Treaty Doc. 100-20, 23 I.L.M. 1027(1984), *as modified* 24 I.L.M. 535 (*entry into force* June 26, 1987) (ratified by Colombia on Dec. 8, 1987); Convention on the Rights of the Child, *opened for signature* Nov. 20, 1989, 28 I.L.M. 1448 (*entry into force* Sept. 2, 1990) (ratified by Colombia on Jan. 28, 1991).
80. Convention on the Elimination of All Forms of Discrimination Against Women, *opened for signature* Mar. 1, 1980, 1249 U.N.T.S. 13 (*entry into force* Sept. 3, 1981) (ratified by Colombia on Jan. 19, 1982).
81. Convention on the Political Rights of Women, *opened for signature* Dec. 20, 1952, G.A. Res. 640(VII) U.N. GAOR (*entry into force* Jul. 7, 1954) (ratified by Colombia on Aug. 5, 1986).
82. Inter-American Convention on the Prevention, Punishment and Eradication of Violence Against Women, *adopted* Jun. 9, 1994, 33 I.L.M 1534 (*entry into force* Mar. 5, 1995) (incorporated into Colombian legislation via Law No. 248, 1995).
83. MINISTRY OF HEALTH, SALUD PARA LAS MUJERES, MUJERES PARA LA SALUD [HEALTH FOR WOMEN, WOMEN FOR HEALTH] (1992).
84. *Id*.
85. NATIONAL REPORT FROM COLOMBIA, *supra* note 8, at 22.
86. COLOM. CONST., *supra* note 3 art. 49.
87. *Id*.
88. *Id*. The regulations relating to territorial health entities provide that the state assemblies and the municipal councils must regulate the operations and the provision of services by such entities within their respective jurisdictions. Law No. 60,1993.
89. Decree Law No. 1292 of 1994 (restructuring the Ministry of Health).
90. *Id*., art. 48. The same article provides that the provision of these services should be based on the principles of efficiency, universality, and solidarity.
91. NATIONAL REPORT OF COLOMBIA, *supra* note 8, at 55. The choice between the government and private health system is voluntary.
92. *Id*.
93. Law No. 100 of 1993, bk. II, art. 162, 1.
94. *Id*.
95. *Id*., art. 162.
96. *Id*., art. 165.
97. *Id*. *See also* Decree Nos. 1298 and 1895, of 1994, which regulate the subsidized regime of the social security system in health matters.
98. *Id*., arts. 162 and 166.
99. *Id*., art. 166.
100. *Id*., at ¶ 2.
101. *Id*., art 162. The regulations for the Subsidized Plan can be found in Decree No. 1895, 1994, arts. 1-3.
102. *Id*., art. 166
103. *Id*., art. 165
104. *Id*.
105. *Id*., art. 11.
106. *Id*., art. 12.
107. UNITED NATIONS POPULATION FUND, RESOURCE REQUIREMENTS FOR POPULATION AND REPRODUCTIVE HEALTH PROGRAMS: COUNTRY PROFILES FOR POPULATION ASSISTANCE, U.N. Doc.E/500/1996, at 158 (1996). This indicator is consistent with the goals established by the United Nations Population Fund.
108. *Id*., at 22.
109. DEMOGRAPHIC AND HEALTH SURVEY, *supra* note 1, at 101.
110. *Id*.
111. *Id*., at xxx.
112. Profamilia, *Porque se mueren las Mujeres en Colombia* [*Why Women Die in Colombia*], 14(28) PROFAMILIA, PLANIFICACION, POBLACION Y DESARROLLO [PLANNING, POPULATION AND DEVELOPMENT] 18-19 (1996).
113. *Combined presentation*, *supra* note 6, at 48-49.
114. Departamento Público de Planeación [Department of Public Planning], source DNP-UDS-DIOGS, based in Office of the Controller, Ministry of the Interior, "Gasto Público Central en Salud," (visited July 20, 1997), <http://dnp.gov.co/sisd-0202.htm>.
115. *Id*
116. For further information on the functioning of the health system in Colombia, and of the provisions of Law No. 100 of 1993, see the section on Objectives of the Health Policy, above.
117. "The National Board of Social Security for Health will design a program such that its beneficiaries shall enter the Compulsory Plan of the contributory system in a progressive manner before the year 2001." Law No. 100 of 1993, art. 162.
118. *Id*.
119. See the description of the Primary Plan in the section on Objectives of the Health Policy, above.
120. Law No. 100 of 1993, art. 165.
121. *Id*., art. 162.
122. Law No. 23, 1981. *See also* Res. 711, June 30, 1982, which establishes the Tribunal of Medical Ethics.
123. Law No. 23, 1981, art. 1.
124. *Id*., arts. 3-26.
125. *Id*., arts. 33-41.
126. *Id*., arts. 42-54.
127. *Id*., arts. 62-94.
128. *Id*., arts. 62-73.
129. *Id*., art. 74.
130. *Id*., art. 83.
131. *Id*.
132. COLOMBIA PENAL CODE, *supra* note 132 Decree No.100, art. 329 (1991)[hereinafter PENAL CODE].
133. *Id*., art. 340; *supra* note 123, art. 1. According to Colombian penal law, there are two kinds injuries caused by negligence: *lesiones culposas* and *lesiones preterintencionales*, which are distinguished by the degree of negligence involved.
134. PENAL CODE, *supra* note 132 art. 343.
135. *Id*., art. 344.
136. Law No.23, *supra* note 123, art. 1.
137. *Id*., art. 5.
138. *Id*., arts. 4-26.
139. MINISTRY OF HEALTH, Res. No. 08514, 1984, art. 2, § 4.
140. *Id*., art. 2, § 2.
141. Decree No. 1757, 1994, art. 1.
142. *Id*., arts. 3-6 and 9-14.
143. *Id*.
144. *Id*., art. 14.
145. In Colombia, *veedurias* are organizations, in this case of citizens, charged with supervising public-health-service delivery and the performance of health care officials.
146. Decree No. 1757, *supra* note 142, art. 20.
147. *Id*., art. 15.
148. *Id*., art. 16, § 1.
149. *Id*., at §§ 2 and 3.
150. *Id*., at § 5.
151. *Id*., at § 6.
152. *Id*., art. 340, partially modified by Law No. 23, 1991.
153. COLOM. CONST., *supra* note 3 art. 42; MINISTRY OF HEALTH, Res. No. 08514, 1984. *See* the preamble of this regulation.
154. Law No. 99, 1993, art. 5.
155. *Id*.
156. *Id*.
157. NATIONAL PLANNING DEPARTMENT, NATIONAL ENVIRONMENTAL POLICY: SOCIAL LEAP TOWARD SUSTAINABLE DEVELOPMENT, Doc. CONPES 2750, at 17 (Dec. 21, 1994).
158. THE WOMEN'S HOUSE CORPORATION, DERECHOS SEXUALES Y REPRODUCTIVOS. LEYES Y POLITICAS, COLOMBIA [SEXUAL AND REPRODUCTIVE RIGHTS. LAWS AND POLICIES, COLOMBIA], at 46 (1996).
159. COUNTRY PROFILES, *supra* note 115, at 158.
160. *Id*.
161. The National Planning Office is the governmental entity under the President's direction charged with producing all plans and programs related to Colombia's development. Among its objectives are to promote decentralization and the modernization of the government and to support governmental entities in the formulation and evaluation of their development programs. National Planning Office, *Mission and Objectives of the NPO* (visited July 28, 1997), <http://dnp.dnp.gov.co/perfil/fundac.htm>
162. *Id*.
163. HEALTH FOR WOMEN, *supra* note 80; *See also*, COLOM. CONST., *supra* note 3 arts. 42 and 43.
164. The Ministry of Health oversees the National Health System. This mandate is found in

Decree No. 1292, 1994, which restructures the Ministry of Health.
165. HEALTH FOR WOMEN, *supra* note 80, at 30.
166. *Id.*
167. *Id.* This program seeks to reorient previous policies directed at women with the aim of institutionalizing them and improving the quality and coverage of the health system as well as strengthening women's role in promoting and understanding her health. In addition, the program outlines policies and programs aimed at promoting women's health and addressing the need for improved preventive measures and attention related to women's health. The target population of this program is women heads of family, women aged 15-49, working women, and older women;
168. NATIONAL DEVELOPMENT PLAN, THE SOCIAL LEAP FORWARD (1994), Law No.188, 1995.
169. NATIONAL DEVELOPMENT PLAN, *The Social Leap Forward, Political Participation and Equality for Women*, Decree No. 2726 (Aug. 30, 1994).
170. MINISTRY OF THE ENVIRONMENT, APOYO INSTITUCIONAL A LA POLÍTICA DE EQUIDAD Y PARTICIPACIÓN DE LA MUJER-EPAM [INSTITUTIONAL SUPPORT OF THE POLICY OF EQUITY AND PARTICIPATION FOR WOMEN], at 28.
171. PERMANENT MISSION OF COLOMBIA TO THE UNITED NATIONS, REVISIÓN DESPÚES DE LA CONFERENCIA DE BEIJING. IMPLEMENTANDO EL CONTRATO CON LAS MUJERES DEL MUNDO: DE LAS PALABRAS A LA ACCIÓN [REVIEW AFTER THE BEIJING CONFERENCE. IMPLEMENTING THE CONTRACT WITH THE WOMEN OF THE WORLD: FROM WORDS TO ACTION], at 4 (1996).
172. *Id.* I
173. *Id.* In terms of educational and cultural arenas, the Ministry of Health is committed to developing programs to promote value changes that will foster more equitable gender relations; creating and financing organizations of support services for battered women and children; organizing educational and training campaigns; designing strategies to foster self-esteem and autonomy among women and female children; and incorporating the theme of gender equity in the health sciences curriculum at both the undergraduate and postgraduate level.
174. *Id.*
175. NATIONAL COUNCIL OF ECONOMIC AND SOCIAL POLICY-CONPES, POLÍTICA DE PARTICIPACIÓN Y EQUIDAD PARA LA MUJER [PARTICIPATION AND EQUITY POLICY FOR WOMEN], Doc. No. 2726, at 5 (1994); *See also* GENDER UNIT-CA, MINISTRY OF THE ENVIRONMENT, APOYO INSTITUCIONAL DE LA POLÍTICA DE EQUIDAD Y PARTICIPACIÓN DE LA MUJER-EPAM [INSTITUTIONAL SUPPORT OF THE POLICY OF EQUITY AND PARTICIPATION FOR WOMEN], at 28 (1995).
176. *Id.*
177. *Id.*
178. *Id.*, at 5. The same document indicates that in carrying out these steps, the government must undertake aggressive health education campaigns, improve service provision, and design programs created especially for women, including family planning services, reproductive health, and the early detection of illnesses that primarily affect women.
179. Regulatory Decree No. 1440, 1995. This office does not, however, implement policies. Its role is to promote, coordinate and provide assistance and technical support to national and territorial entities. It is a permanent institution that has administrative autonomy and its own assets. For more information on this office, see the section on Women's Bureaus below.
180. United Nations Population Fund, Programme Review and Strategy Development Report-Colombia, *supra* note 187 at 23 (1993).
181. *Id.*
182. *Id.*
183. *Id.*, at 23.
184. *Id.*, at 22.
185. HEALTH FOR WOMEN, *supra* note 80, at 45.
186. *Id.*
187. UNITED NATIONS POPULATION FUND, PROGRAM REVIEW AND STRATEGY DEVELOPMENT REPORT, *supra* note , at 23.
188. *Id.*
189. *Id.*, at 22-23. Profamilia is a private institution created in 1965 with the objective of informing people about available contraceptive methods and making them easily available. It has 47 clinics for women, 8 for men, and 11 youth centers located in 35 Colombian cities. *See* DEMOGRAPHIC AND HEALTH SURVEY, *supra* note 1, at 7.
190. Decree No. 1895, 1995, art. 11.
191. *Id.*, art. 12.
192. *Id.*
193. DEMOGRAPHIC AND HEALTH SURVEY, *supra* note 1, at xxvii.
194. COUNTRY PROFILES, *supra* note 115, at 158.
195. Demographic and Health Survey, *supra* note 1 at 45. Sixty-two percent of women have used some modern method of contraception, while 44% have used a traditional method.
196. *Id.*
197. *Id.*, at 46.
198. *Id.*
199. *Id.*, at xxix. The contraceptive prevalence was 64% in 1986 and 66% in 1990.
200. *Id.*
201. *Id.*
202. *Id.*
203. *See* PENAL CODE, *supra* note 132 art. 343.
204. Decree No. 1290, 1994. In addition, Decree No. 677, 1995, partially regulates registrations and licenses, quality control, and the safety of drugs, pharmaceutical products made of natural ingredients, and other products, including condoms and diaphragms.
205. Decree No. 1290, 1994, art. 4.
206. *Id.*, art. 2.
207. *Id.*, art. 4.
208. *Id.*
209. *Id.*; *See also* Decree No. 677, 1995, art. 6.
210. Decree No. 677, 1995, art. 88.
211. *Id.*, at art. 79.
212. MINISTRY OF HEALTH, Res. 08514, 1984.
213. *Id.*, art. 2, § 4.
214. *Id.*
215. DEMOGRAPHIC AND HEALTH SURVEY, *supra* note 1, at 52.
216. PENAL CODE, *supra* note 132 art. 343.
217. COLOM. CONST., *supra* note 3 art 11.
218. Judgement No. C-013/97, Constitutional Court (Jan. 23, 1997).
219. PENAL CODE, *supra* note 132 art. 343.
220. *Id.*, art. 344.
221. *Id.*, art. 345.
222. *Id.*, art. 338. In January 1997, the Constitutional Court of Colombia found this law to be constitutional and declared that life is protected from the moment of conception. *See* Judgment No. C-013/97, Constitutional Court (Jan. 23, 1997).
223. Joint Statement, *supra* note 6, at 46.
224. *Id.*
225. PENAL CODE, *supra* note 132 art. 343.
226. *Id.*
227. *Id.*, art. 344.
228. *Id.*, art. 345.
229. *Id.*
230. MINISTRY OF HEALTH, PROGRAMA NACIONAL DE PREVENCIÓN Y CONTROL DE LAS ETS-VIH/SIDA [NATIONAL PROGRAM TO PREVENT STIs AND HIV/AIDS], at 25 (1995).
231. Decree No. 559, 1991.
232. *Id.*
233. *Id.*, art. 9.
234. *Id.*, art. 11.
235. *Id.*, art. 30.
236. *Id.*, art. 29.
237. *Id.*, arts. 13, 16-18.
238. *Id.*, art. 31. In addition, art. 8 establishes that health professional and health establishments cannot deny services to persons infected with HIV/AIDS. If this occurs, the law provides that a penalty will be imposed.
239. *Id.*
240. *Id.*, art. 53. Any person convicted of such a crime must be held in an institution that can assure his or her proper health, psychological, and psychiatric care. Any institution that fails to observe this law will be subject to penalties ranging from the imposition of fines to the suspension or loss of the institution's license to provide health services.
241. *Id.*, art. 35.
242. *Id.*, art. 38.
243. NATIONAL PROGRAM TO PREVENT STIs AND HIV/AIDS, *supra* note 216, at 1.
244. *Id.*, at 1.
245. Decree Law No. 559, 1991, art. 41.
246. *Id.*, at 46.
247. NATIONAL PROGRAM TO PREVENT STIs AND HIV/AIDS, *supra* note 216, at 1.
248. *Id.*, at 3. The specific objectives of the STI and HIV/AIDS Plan include: promoting greater awareness among the population of issues related to STIs and HIV/AIDS; reducing morbidity and mortality due to STIs and HIV/AIDS; decreasing the risk of infection of HIV and other STIs; guaranteeing respect for persons who are infected with HIV/AIDS or

other STIs and protecting their rights; and strengthening services such as treatment and counseling for persons infected with STIs and HIV/AIDS. *Id.*

249. *Id.*, at 4. In this respect, the Inter-ministerial Plan must seek to minimize the duplication of efforts, optimize the use of financial resources, and foster coordination and unification of the operational criteria of the programs carried out by the different ministries, by public or private establishments, and by churches.

250. *Id.* The decentralization process seeks to promote regional and local autonomy in the design, implementation, and evaluation of the plans, programs, and projects related to the problem of STIs/HIV/AIDS. It also seeks to promote maximum efficiency in the use of technical, human, and financial resources according to the needs and priorities of the activities to be carried out by the public sector, the private sector, and the churches at the national, regional, and local level. The decentralization process in Colombia is in accordance with the model of self-management*).*

251. *Id.*
252. *Id.*, at 7.
253. *Id.*, at 8.
254. *Id.*, at 28.
255. *Id.*
256. *Id.*, at 29.
257. *Id.*, at 8.
258. *Id.*, at 28.
259. *Id.*
260. *Id.*, at 29.

261. Participation and Equity Policy, *supra* note 110, at 1. See especially the indicators on life expectancy and access to education, health services, and the labor market. *Id.*

262. *See Combined presentation, supra* note 6, at 2 and 62. Rural women predominate at the lowest levels of income. According to the indicators measuring poverty through basic unmet needs, 35.7% households in the rural sector live in extreme poverty, of which 15.2% are female-headed households. Of the total rural communities, 3.9% have piped water, 58% have access to transportation routes, 38% have electricity, and 4.5% have access to health clinics.

263. Presidential Council for Social Policy (PNR), Informe Nacional de Colombia [National Report from Colombia], Prepared for the Fourth International Conference on Women, at 32 (1995). According to conservative estimates, the number of internal refugees in 1989 was 300,000, of which 70% were women. Displacement affects women in the following ways: the majority of displaced families are headed by women; women are the most affected psychologically by displacement; women become responsible for the economic survival of the family; displaced women have greater difficulty organizing; and they are more vulnerable to sexual assault. *Id.*

264. Colom. Const., *supra* note 3 art. 13. *See* also art. 5.
265. *Id.*
266. *Id.*, at art 40. In this Article, the Constitution also states: "The authorities must guarantee the adequate and effective participation of women at the decision-making levels of public administration." Despite this constitutional mandate, women's access to political power remains very limited. *See* National Report from Colombia, *supra* note 8, at 25-26.
267. Colom. Const., *supra* note 3 art. 42.
268. *Id.*, arts. 42 and 43.
269. *Id.*, at art 42.
270. *Id.*
271. *Id.*
272. Law No.25, 1992, art. 1. The religious denomination under which a marriage is celebrated must have entered into a formal agreement or international treaty with the Colombian government. Such denomination must attain juridicial personality and be registered as a religious entity with the Ministry of Government.
273. *Id.*, at art 5.
274. Civil Code, bk. I, tit. IV.
275. *Id.*, art. 113.
276. *Id.*, art. 115.
277. *Id.*, art. 116.
278. Decree Law No. 999, 1988, eliminated the legal requirement that a woman use her husband's surname, preceded by the word *de* (of) on her citizenship documents.
279. Civil Code, art. 176.
280. Civil Code, art. 177.
281. *Id.*, art. 179.
282. Parental authority denotes the series of rights recognized by law that parents have over their minor children. *See Id.*, art. 288.
283. *Id.*

284. *Id.*, art. 306.
285. Law No.28, 1932, and Decree No.2820, 1974.
286. Law No.258, 1996.
287. Penal Code, *supra* note 132 art. 260. Bigamy is defined as a crime committed by a person who, being already legally married, marries another person or by a single person who knowingly marries a person who is legally married.
288. *Id.*
289. Law No.54, 1990, art. 1.
290. *Id.*
291. *Id.*, art. 3.
292. *Id.*
293. *Id.*, art. 5.
294. Law No. 100 of 1993, art. 47. *See* also Dirreccion Nacional de Equidad para las mujeres, Los Derechos de la Mujer en Colombia [The Rights of Women in Colombia] 134 (Mar. 1997).
295. Law No. 100 of 1993, art. 236.
296. *Id.*, art. 8. These provisions are contained in Book 4, Title XXII, chapters 1 to 4 of the Civil Code.
297. *Combined presentation, supra* note 6, at 68.
298. Law No.25, 1992, art. 5.
299. *Id.*
300. Civil Code, art. 154, modified by Law No.25, 1992, art. 6.
301. Law No.25 1992, art. 9.
302. The regulations on the dissolution of joint ownership of property of spouses is found in Civil Code, bk. 4, tit. XXII, chs. I-IV.
303. Civil Code, art. 1830.
304. *Id.*, art. 162.
305. *Id.*, arts. 161 and 151.
306. *Id.*, art. 151 and 411. Child support is considered to be the minimum amount required for the sustenance, shelter, clothing, medical assistance, recreation, and comprehensive education of an individual. Alimony is granted in some cases using similar guidelines.
307. *Id.*, art. 161 and 411.
308. Penal Code, *supra* note 132 art. 263. In other words, when a person is required to pay alimony or child support but fails to pay it without just cause.
309. Decree No. 2727, 1989.
310. Colom. Const., *supra* note 3 art.13.
311. *Id.*, at art. 58.
312. Civil Code, art. 181. Law No. 258 of 1996 contains certain exceptions related to property intended for the family's home.
313. Participation and Equity Policy, *supra* note 110, at 2.
314. *See* Civil Code, bk. 3, especially ch. III.
315. Civil Code, art. 1266.
316. Participation and Equity Policy, *supra* note 110, at 2.
317. *Id.*
318. *Id.*
319. *Id.*
320. Ministry of Health, La Dirección Sexual y Reproductiva de la Mujer en el Marco del Desarrollo Humano [The Sexual and Reproductive Status of Women within the Framework of Human Development], at 3 (1996).
321. Colom. Const., *supra* note 3 art. 25.
322. *Id.*, art. 53.
323. *Id.*, art. 48; Law No. 100, 1993.
324. Convention No. 100 of the International Labor Organization, Convention Concerning Equal Remuneration for Men and Women Workers for Work of Equal Value, *adopted* Jun. 29, 1951, (visited Dec. 8, 1997) <http://ilolex.ilo.ch:1567/public/english/50normes/infleg/iloeng/conve.htm>, (*entry into force* May 23) (Incorporated into Colombian law through Law No. 54, 1962).
325. Convention No. 111 of the International Labor Organization, Convention Concerning Discrimination in Respect of Employment and Occupation, *adopted* Jun. 25, 1958, (visited Dec. 8, 1997) <http://ilolex.ilo.ch:1567/public/english/50normes/infleg/iloeng/conve.htm>, (*entry into force* Jun. 15, 1960) (incorporated into Colombian law through Law No. 22, 1967). Colombia has also ratified Convention No. 3 of the International Labor Organization, Convention Concerning the Employment of Women before and after Childbirth, *adopted* Nov. 28, 1919, (visited Dec. 8, 1997) <http://ilolex.ilo.ch:1567/public/english/50normes/infleg/iloeng/conve.htm>, (*entry into force* Jun. 13, 1921) (incorporated into Colombian law through Law No. 129, 1931); and Convention No. 4 of the International Labor Organization, Convention Concerning Employment of Women during the Night,

adopted Nov. 28, 1919, (visited Dec. 8, 1997) <http://ilolex.ilo.ch:1567/public/english/50normes/infleg/iloeng/conve.htm> (*entry into force*, Jun. 13, 1921) (incorporated into Colombian law through Law No.129, 1931).

326. LABOR CODE (Law No. 50 of 1990), art. 239.

327. *Id.* In order to terminate a woman during pregnancy or in the three months following childbirth, the employer must receive authorization from the labor inspector or the mayor. *See also* arts. 240 and 241.

328. *Id.*, arts. 240 and 241.

329. Res. No. 4050, 1994, art. 2.

330. *Id.*, art. 3.

331. LABOR CODE, art. 236.

332. *Id.*

333. *Id.*

334. *Id.*, art. 238.

335. *Id.*, art. 237.

336. *Id.*

337. Res. No. 02400, May 1979.

338. A study carried out by the Comprehensive Rural Development Fund (DRI), a rural development organization, found that only 26.4% of women affiliated with DRI have taken out a loan. Rural women's access to loans has been limited because they often lack property titles or long-term lease agreements that are required as guarantees for a loan. *See supra note 6*, at 61.

339. Law No. 82, 1993. Article 43 of the Colombian Constitution mandates special protection to women heads of household.

340. Id., art. 15. In addition to providing credit, this law seeks to facilitate the access of women heads of household to education, social security, and housing. Within the Colombian legal system, this law is considered to be analogous to an affirmative action program. NATIONAL REPORT FROM COLOMBIA, *supra* note 8, at 45.

341. NATIONAL REPORT FROM COLOMBIA, *supra* note 8, at 21.

342. *Combined presentation*, *supra* note 6, at 26.

343. *Id.*

344. *Id.*

345. NATIONAL REPORT FROM COLOMBIA, *supra* note 8, at 21.

346. *See Combined presentation*, *supra* note 6, at 61. Rural women completed an average of 3.2 years of education in 1990, while urban women completed an average of 5.8 years. Comparing the educational levels of rural and urban women reveals the following differences: 13.9% of rural women have no education (6.3% of urban women have no education); 40.2% have completed some primary school (compared with 60% of urban women); 12.9% have completed at least one year of high school (compared with 35% of urban women); and 0.5% have completed some higher education (compared with 7.5% of urban women).

347. NATIONAL REPORT FROM COLOMBIA, *supra* note 8, at 11.

348. COLOM. CONST., *supra* note 3 art. 67.

349. *Id.*

350. INSTITUTIONAL SUPPORT, *supra* note 106, at 27.

351. *Id.*

352. *Id.*, at 14. These policies are Política para la Mujer Rural [Rural Women's Policy], (1984); Política Integral Para las Mujeres Colombianas [Comprehensive Policy for Colombian Women], (1992); Salud para las Mujeres, Mujeres para la Salud [Health for Women, Women for Health], (1992); Política para el Desarrollo de la Mujer [Development Policy for Women], (1992); and Política de Equidad y Participación de la Mujer-EPAM [Equality and Participation Policy for Women], (1994).

353. The National Office for Women's Equity was created by Law No. 188, 1995, and Regulating Decree No. 1440, 1995.

354. NATIONAL REPORT FROM COLOMBIA, *supra* note 8, at 10.

355. *Id.*

356. NATIONAL REPORT FROM COLOMBIA, *supra* note 8, at 39.

357. *Id.*

358. NATIONAL REPORT FROM COLOMBIA, *supra* note 8. The "Congressional Network" is composed of congresswomen interested in enacting laws and policies favoring women.

359. *Id. See also* NATIONAL REPORT FROM COLOMBIA, *supra* note 244, at 56.

360. *Id.*

361. Profamilia, *Violacion a las Mujeres en Colombia* [*The Rape of Women in Colombia*], 14(27) PROFAMILIA, PLANIFICACION, POBLACION Y DESARROLLO [PLANNING, POPULATION AND DEVELOPMENT] 45 (1996).

362. *Id.*, at 46.

363. *Id.* "Others" include the woman's prior husband or partner, the father of her child, her godfather, a tenant, and other persons known to her. *Id.*

364. *Id.*

365. *Id.*, at 49.

366. DIRRECIÓN NACIÓNAL DE EQUIDAD PARA LAS MUJERES, LOS DERECHOS DE LA MUJER EN COLOMBIA [RIGHTS OF WOMEN IN COLOMBIA], *supra* note 294 at 47.

367. On February 7, 1997, the Colombian Congress passed Law No. 360, 1997.

368. Previously, such crimes were classified as crimes "against freedom and sexual decency." *See* PENAL CODE, *supra* note 132 bk. II, tit. XI.

369. PENAL CODE, *supra* note 132 arts. 298-300, modified by Law No. 360, 1997, arts. 2-4.

370. *Id.*, arts. 303-305, modified by Law No. 360, 1997, art. 204.

371. *Id.*, arts. 301 and 302. Statutory rape is classified as a crime involving carnal access or other sexual acts with a person under the age of 18 through the use of deceit. For a more detailed description, see the section on adolescents below.

372. Law No. 360, 1997, art. 2. In penal law, "carnal access" is a sexual act that includes the realization of coitus.

373. *Id.*, art. 3. A sexual act is defined as all acts of a sexual nature other than carnal access.

374. *Id.*, art. 4.

375. *Id.*, art. 6. Abusive carnal access is the rape of an individual who is unconscious, who suffers from a psychological impediment, or who is otherwise incapable of resisting.

376. PENAL CODE, *supra* note 132 art. 306.

377. *Id.*

378. *Id.*

379. *Id.*

380. *Id.*, art. 8.

381. Law No. 294, 1996, art. 25. The penalty for this crime is six months to one year of imprisonment. A criminal trial takes place only when the victim brings a lawsuit against the offender.

382. DEMOGRAPHIC AND HEALTH SURVEY, *supra* note 1, at 157.

383. *Id.*, at xxxi.

384. *Id. See also Id.*, at 157. This percentage is higher than in 1990, when only 11% of women reported that they had been physically abused.

385. DIRRECIÓN NACIÓNAL DE EQUIDAD PARA LAS MUJERES, LOS DERECHOS DE LA MUJER EN COLOMBIA [RIGHTS OF WOMEN IN COLOMBIA], *supra* note 294, at 47.

386. COLOM. CONST., *supra* note 3 art. 42.

387. Law No. 248, 1995.

388. *See* Law No.294, 1996, art. 1.

389. *Id.*, art. 22.

390. *Id.*, art. 23; Articles 331-341 of the Penal Code define different types of injuries as crimes and establish penalties according to the degree of severity of the injuries inflicted.

391. This crime is called "abuse through the restriction of physical freedom," and is classified in Law No. 294, 1996, art. 24.

392. *Id.*, arts. 4-5.

393. The Colombian Institute of Family Wellfare is the entity charged with protecting the family. Specifically, it devises programs aimed at abused children and abused mothers with limited economic means. It also provides foster care for children under five. *See* NATIONAL REPORT FROM COLOMBIA, *supra* note 8, at 34.

394. *Id.*, arts. 28-29.

395. *Id.*, art. 28.

396. NATIONAL DEVELOPMENT PLAN, EL SALTO SOCIAL [THE SOCIAL LEAP FORWARD] (1994).

397. PROFAMILIA, National Inquiry on Population and Health 1995, at xxxi.

398. COLOM. CONST., *supra* note 3 ch. II.

399. *Id.*, art. 45.

400. *Id.*

401. *See* COLOM. CONST., *supra* note 3 art. 44; Law No. 12, 1991; and the Code of Minors, Special Decree No. 2737, 1989.

402. COLOM. CONST., *supra* note 3 art 44. The Constitution also states that children born both in and out of wedlock, and those conceived naturally or by artificial means have equal rights and duties. *Id.*, art. 42.

403. *Id.*

404. Law No. 12 of 1991 incorporates the Convention on the Rights of the Child into Colombian law. *See id.*, arts. 17, 24, and 26.

405. NATIONAL REPORT FROM COLOMBIA, *supra* note 8, at 6.

406. DEMOGRAPHIC AND HEALTH SURVEY, *supra* note 1, at 68.

407. *Id.* Notably, of the 80% of women of childbearing age who have had sexual relations at some point in their lives, 30% are under the age of 20. *Id.*, at 73.

408. *Id.*, at 47.

409. *Id.*, at 40.

410. *Id.* Thirty percent of women under the age of 20 who have no education or who only finished primary school already have at least one child, compared with only 7% among women with higher education. *Id.*
411. *Id.*, at 39.
412. *Id.*
413. Id.
414. HEALTH FOR WOMEN, *supra* note 80, at 35.
415. PARTICIPATION AND EQUITY POLICY, *supra* note 110, at 6.
416. DEMOGRAPHIC AND HEALTH SURVEY, *supra* note 1, at 70.
417. *Id.*
418. *Id.*, at 71.
419. CIVIL CODE, art. 116, modified by Decree No. 2820, 1974, art. 2.
420. *Id.*, art. 117.
421. *Id.*, art. 140.
422. *Id.*, art. 143.
423. *The Rape of Women in Colombia, supra* note 340, at 46.
424. *Id.*
425. *Id.*
426. *Id.*, at 49.
427. PENAL CODE, *supra* note 132 tit. XI.
428. PENAL CODE, *supra* note 132 art. 303, modified by Law No. 360, 1997, art. 5.
429. *Id.*, art. 290, modified by Law No. 360, 1997, art. 2.
430. *Id.*, art. 305, modified by Law No. 360, 1997, art. 7.
431. *Id.*, arts. 301 and 302.
432. *Id.*, art. 301.
433. *Id.*, art. 302.
434. *Id.*, tit. IX.
435. *Id.*, art. 259.
436. *Id.*
437. *Id.*, art. 312, modified by Law No. 360, 1997, art. 12.
438. *Id.*, art. 312 A, modified by Law No. 360, 1997, Art. 13.
439. Id., arts. 312 and 312 bis.
440. Res. No. 03353, July 2, 1993, which establishes the creation of institutionalized sex education programs in the national educational curriculum.
441. *Id.*
442. MINISTRY OF EDUCATION, PROYECTO NACIONAL DE EDUCACIÓN SEXUAL [NATIONAL PROJECT ON SEX EDUCATION], at 1 (1993).
443. *Id.*
444. *Id.*
445. *Id.*
446. Res. No. 03353, 1993, art. 2.
447. *Id.*
448. *Id.*
449. *Id.*
450. *Id.*
451. NATIONAL PROJECT ON SEX EDUCATION, *supra* note 418, at 4–5.
452. *Id.*

El Salvador

Statistics

GENERAL

Population

- El Salvador has a total population of 5.8 million,[1] of which 51% are women.[2] The growth rate is approximately 2.2% per year.[3]
- In 1996, 40% of the population was under 15 years old[4] and 4% was over 65.[5]
- In 1995, 47% of the population lived in urban areas while 53% lived in rural areas.[6] There are more women in the urban areas: 114 women per 100 men live in urban areas, while 97 women per 100 men live in rural areas.[7]

Territory

- El Salvador has a surface area of 21,122 square kilometers.[8]

Economy

- In 1994, the World Bank estimated the gross national product per capita at U.S.$1,360.[9]
- From 1990 to 1994, the gross domestic product (GDP) grew at an estimated rate of 6.2%, as compared with the period from 1980 to 1990, when the GDP grew at a rate of 0.2%.[10]
- In 1996, government investment in the health sector was 7.3% of the total national budget.[11]

Employment

- In 1994, approximately 2 million people were employed in El Salvador,[12] of which 33% were women.[13]

WOMEN'S STATUS

- The average life expectancy for women is 72.5 years, compared with 66.5 years for men.[14]
- Illiteracy continues to be a problem that affects women more than it does men. In 1990, the illiteracy rate for women over 25 years old was 56.1% of the total population, compared with male illiteracy, which was 44.5%.[15]
- In 1992, 41.4% of women in urban areas were unemployed.[16]
- In 1994, women represented 33% of the national labor force.[17] Participation of female labor in agriculture was 5%; in the industrial sector, 18%; and in the service sector, 77%.[18]
- Violence against women is a serious problem in El Salvador. Between 1992 and 1996, the Legal Medical Institute attended to 3,695 victims of rape.[19] In 1996, of 906 cases that were attended to, 824 of the victims were women and 82 were men.[20]

ADOLESCENTS

- Approximately 40% of the population of El Salvador is under 15 years old.[21]
- The median age at first marriage is 18.5 years.[22]
- In 1995, 13% of adolescents between the ages of 15 and 19 were mothers.[23]
- Between March and December 1996, the Salvadoran National Civil Police registered 14 cases of mistreatment of minors, 8 cases of sexual violence against minors, and 41 cases of violence within the family.[24]

MATERNAL HEALTH

- The total fertility rate is 3.09 children per woman.[25]
- For 1996, the maternal mortality ratio was estimated at 300 deaths per 100,000 live births.[26]
- The infant mortality rate is 42 deaths per 1,000 live births.[27]
- In 1995, only 66% of births were attended to by a health professional;[28] only 60% of pregnant women had prenatal care;[29] and 43% of pregnant women suffered from some degree of anemia.[30]

CONTRACEPTION AND ABORTION

■ 53% of Salvadoran women use some form of contraception.[31] 48% employ modern family planning methods.[32]

■ The most frequently used modern contraceptive methods are female sterilization (20.8%); oral contraceptives (5%); injectable contraceptives (2.2%); intrauterine devices (1.3%); condoms (1.3%); and male sterilization (0.2%).[33]

■ Between January and June 1996, the number of women treated for complications from abortion procedures in hospitals and clinics throughout the country was 3,738.[34]

HIV/AIDS AND STIs

■ Prior to 1997, 3,470 cases of HIV had been reported in El Salvador, of which 1,875 had developed AIDS.[35] Of all of the cases reported, 720 were women.[36]

■ In 1995, 18,319 cases of sexually transmissible infections were registered with health authorities, including 3,118 cases of gonorrhea, 1,055 cases of syphilis, 24 cases of congenital syphilis, 175 cases of lymphogranuloma venereum, 887 cases of herpes, and 13,060 cases of trichomoniasis.[37]

ENDNOTES

1. WORLD ALMANAC BOOKS, THE WORLD ALMANAC AND BOOK OF FACTS 1997, at 761 (1996).
2. UNITED NATIONS, THE WORLD'S WOMEN 1995: TRENDS AND STATISTICS, at 27 (1995).
3. UNITED NATIONS POPULATION FUND ("UNFPA"), THE STATE OF WORLD POPULATION 1997, at 72 (1996).
4. THE WORLD ALMANAC, supra note 1, at 761.
5. Id.
6. THE WORLD'S WOMEN 1995, supra note 2, at 65.
7. Id.
8. THE WORLD ALMANAC, supra note 1, at 761.
9. WORLD BANK, WORLD DEVELOPMENT REPORT 1996: FROM PLAN TO MARKET, at 188 (1996).
10. Id., at 208.
11. THE STATE OF WORLD POPULATION 1997, supra note 3, at 72.
12. WORLD DEVELOPMENT REPORT 1996, supra note 9, at 194.
13. Id.
14. THE STATE OF WORLD POPULATION 1997, supra note 3, at 69.
15. THE WORLD'S WOMEN 1995, supra note 2, at 110.
16. THE GOVERNMENT OF EL SALVADOR, INFORME NACIONAL PARA LA CONFERENCIA REGIONAL PREPARATORIA SOBRE LA MUJER A CELEBRARSE EN ARGENTINA. SEPTIEMBRE 1994 [NATIONAL REPORT FOR THE PREPARATORY REGIONAL CONFERENCE FOR WOMEN IN THE REPUBLIC OF ARGENTINA, SEPT. 1994], [DOCUMENTO CONSULTORIO PRELIMINAR Y PREPARATORIO PARA LA CUARTA CONFERENCIA SOBRE LA MUJER, BEIJING, CHINA] PRELIMINARY AND PREPARATORY CONSULTATIVE DOCUMENT FOR THE FOURTH WORLD CONFERENCE ON WOMEN, BEIJING, CHINA, at 36 (1994).
17. WORLD DEVELOPMENT REPORT 1996, supra note 9, at 194.
18. THE WORLD'S WOMEN 1995, supra note 2, at 158.
19. Information collected by the Norma Virginia Guirola de Herrera Women's Studies Institute ("CEMUJER"), from statistics sources by the Dr. Roberto Masferrer Legal Medical Institute (1996) (on file with the Center for Reproductive Law and Policy ("CRLP")).
20. Id.
21. THE WORLD ALMANAC, supra note 1, at 761.
22. SALVADORIAN DEMOGRAPHIC ASSOCIATION, WITH THE PARTICIPATION OF THE CONSULTATIVE COMMITTEE CONSISTING OF THE MINISTRY OF PUBLIC HEALTH AND SOCIAL ASSISTANCE, THE MINISTRY OF PLANNING AND COORDINATION OF ECONOMIC AND SOCIAL DEVELOPMENT, THE STATISTICS AND CENSUS DIRECTIVE, THE ISS AND THE UNITED STATES AGENCY FOR INTERNATIONAL DEVELOPMENT (USAID/EL SALVADOR), NATIONAL FAMILY HEALTH SURVEY (NFHS-93), at 65 (1994).
23. THE WORLD'S WOMEN 1995, supra note 2, at 32.
24. Information collected by CEMUJER, from statistical sources by the Dr. Roberto Masferrer Legal Medical Institute (1996) (on file with the Center for Reproductive Law and Policy ("CRLP")).
25. THE STATE OF WORLD POPULATION 1997, supra note 3, at 72.
26. Id., at 69.
27. Id.
28. THE WORLD'S WOMEN 1995, supra note 2, at 93.
29. NATIONAL REPORT, supra note 16, at 7.
30. Id., at 15.
31. THE WORLD'S WOMEN 1995, supra note 2, at 69.
32. Id.
33. Information collected from the CEMUJER (on file with CRLP).
34. Id.
35. LA PRENSA GRAFICA, Jun. 18, 1997, at 12.
36. Id.
37. Information collected from the Ministry of Health by CEMUJER (on file with CRLP).

The Republic of El Salvador is located in Central America, bordered on the north and east by Honduras, on the west by Guatemala, and on the south by the Pacific Ocean.[1] Spanish is the official language.[2] Ninety-four percent of the population is mestizo, 5% is indigenous, and 1% is white.[3] Roman Catholicism is the predominant religion, although there are also numerous Protestant denominations.[4]

El Salvador declared independence from Spain in 1821, and from the Central American Federation in 1839.[5] Its recent history is characterized by twelve years of civil war in which the leftist guerrilla movement known as the Farabundo Marti National Liberation Front[6] fought the national government.[7] More than 75,000 Salvadorans were killed during the war.[8] In 1992, with the support of the United Nations, the war ended and both parties to the conflict signed the Peace Accords.[9] These Accords have promoted the incorporation of guerrilla groups into the political system, the reform and reduction of the armed forces, and the implementation of a program of agrarian land reform.[10]

The present government of El Salvador is led by President Armando Calderón Sol, a member of the conservative political party ARENA. He was democratically elected in June 1994.[11] His government is committed to privatizing government-owned enterprises and opening up the economy, which is based principally on agriculture and light industry, in order to strengthen it.[12]

I. Setting the Stage: the Legal and Political Framework

To understand the various laws and policies affecting women's reproductive rights in El Salvador, it is necessary to consider the legal and political systems of the country. By considering the bases and structure of these systems, it is possible to attain a better understanding of how laws are made, interpreted, modified, and implemented as well as the process by which governments adopt reproductive health and population policies.

A. THE STRUCTURE OF NATIONAL GOVERNMENT

The Political Constitution of El Salvador (the "Constitution"),[13] establishes that the government is republican, democratic, and representative.[14] The political system is "pluralistic"[15] and political parties are the only organizations that represent the people.[16] Power emanates from the people[17] and is delegated to three branches of government.[18] Political power is exercised in accordance with principles contained in the Constitution and laws.[19] The branches of government are the executive, the legislative, and the judicial.[20]

Executive Branch

The president of the republic, together with the vice president, the ministers and vice ministers of state, and the officials under them, form the executive branch of public power.[21] The president, elected every five years by universal suffrage,[22] is responsible for obeying and enforcing the Constitution and laws, directing foreign relations, signing treaties, commanding the armed forces, and issuing regulations to facilitate the application of laws.[23] The president is the commander in chief of the armed forces and of the National Civil Police.[24]

The Constitution provides that the ministers of state oversee public administration.[25] Each of them is in charge of a ministry that he or she governs in collaboration with the viceminister.[26] The president, the vice president, and the ministers form the Council of Ministers,[27] which is the body in charge of drafting the General Government Plan and the National Budget.[28] The Legislative Assembly[29] can recommend to the president that ministers be dismissed when it deems appropriate,[30] either after investigation or an interrogation process of the ministers known as *interpelación ministerial*.[31] The Legislative Assembly's recommendation regarding dismissal is binding when related to serious human rights violations by the heads of the state public security or intelligence agencies.[32]

Legislative Branch

The legislative branch consists of a unicameral legislative body, elected by the people, called the Legislative Assembly (the "Assembly").[33] The Assembly is composed of 168 representatives, 84 "proprietor representatives", or acting representatives, and 84 deputy representatives. All representatives are elected to serve for a three-year term, and can be reelected.[34] The representatives represent the people and are "inviolable,"[35] that is to say, they cannot be tried for common crimes during their term in office.[36] In the event that a representative is alleged to commit a serious crime,[37] he or she can be tried before a criminal court, as long as the Legislative Assembly has previously declared there is a basis for initiating such action.[38] In such cases, the representative is suspended from carrying out his or her functions.[39]

The main function of the Assembly is to enact, revise, and repeal laws.[40] It is also responsible for approving the National Budget proposed by the executive, and for electing, through a public vote, the main officials in the judicial branch, the Attorney General's Office, and other public administrative bodies.[41] The following individuals and entities have the right to propose legislation: representatives, the president through his ministers, the Supreme Court on subjects relating to the administration of the judicial branch, and the Municipal Councils on the subject of municipal taxes.[42]

An absolute majority of all representatives in the Assembly is required in order to pass a bill.[43] The Assembly must forward any bill it passes to the president within ten days for his or her approval.[44] The president then orders the official publication of the bill.[45] Alternatively, the president may opt to veto a bill and return it to the legislature, explaining the reasons for the veto.[46] The Assembly may vote to override the president's veto, with a two-thirds majority of the total votes cast. The president then must sign the bill into law and order its publication.[47] Presidential approval is not needed when the Assembly carries out internal administrative functions, when it nominates officials or administers oaths, or when it carries out functions to control the executive.[48]

Judicial Branch

The legal system in El Salvador derives from Roman law.[49] The judicial branch consists of the Supreme Court of Justice,[50] the Appeals Chambers,[51] the courts of first instance,[52] the justices of the peace,[53] and "the other courts as provided for by law."[54] The Supreme Court of Justice is the highest court, and its duties consist of resolving conflicts that arise between courts; nominating magistrates of Appeals Chambers, judges of first instance, and justices of the peace; and deciding cases that are not under the jurisdiction of another authority.[55] The Appeals Chambers each have two magistrates[56] and have jurisdiction over matters on appeal on diverse subjects and in different regions, according to what the Organic Law of Judicial Authority assigns them.[57] The judges of first instance hear and decide the matters that the Appeals Chambers hear on appeal. The judges of first instance also oversee the administrative matters of the judicial branch.[58] The justices of the peace are citizens elected by the Supreme Court of Justice for a two-year term.[59] They must be lawyers or graduates of juridical science faculties.[60] Justices of the peace resolve civil and commercial cases where the amount of money in question is small,[61] and they try certain penal matters as specifically designated by the law.[62]

The judicial branch is independent from the other branches of government and the judges and magistrates issue judgments according to their interpretation of the Constitution and the law.[63] Only the judicial branch can impose punishment,[64] with the exception of military courts.[65] Laws may not have retroactive effect, except in matters of public order and criminal matters when they favor the defendant.[66] Everyone has access to the justice system, free of charge.[67]

In El Salvador, the Attorney General's Office is charged with controlling the exercise of public power and with defending society's interests.[68] This body consists of the attorney general, the public defender, and the human rights ombudsman,[69] all of whom are appointed by the Legislative Assembly.[70] The attorney general defends the interests of the state and society in the courts. He or she brings legal actions on his or her own initiative or when a complaint is filed by a party in defense of legality, represents the state in contracts involving acquisition of property, and assures that state concessions of property are legal.[71] The human rights ombudsman promotes respect for human rights through the following means: investigations of human rights violations throughout the country; assistance to victims of human rights violations; oversight of the conduct of public administration; the performance of inspections; the issuance of opinions about proposed legislation; and the drafting and publication of reports.[72] The Public Defender provides assistance and legal representation to poor people, and protects the well-being of minors, the disabled, and the family.[73]

B. THE STRUCTURE OF REGIONAL GOVERNMENT

Regional and local governments

El Salvador is divided into departments, whose number and borders are established by law.[74] Each department has a governor, nominated by the executive branch,[75] whose function is political administration.[76] The departments are divided into municipalities, which are governed by Municipal Councils and elected through universal suffrage.[77] The Municipal Councils consist of a mayor, an administrative official named as trustee and two or more councilmembers, the number of which is proportional with the population represented.[78] The municipalities are independent in administrative and budgetary matters.[79] Within the limits established by law, they can create, modify and abolish public taxes and contributions to carry out municipal works, enact their own budget; appoint and remove municipal officials, and manage municipal properties.[80]

C. SOURCES OF LAW

Domestic sources of law

Laws that shape women's legal status, including their reproductive rights, derive from various sources. In the legal system of El Salvador the formal sources of law are hierarchically ordered in the following way: the Constitution, international treaties, laws, and regulations.[81] Any citizen can petition the Supreme Court to assess the constitutionality of a law, decree, or regulation.[82] Jurisprudence is not a source of law. The law states that there can be no laws that establish general rules and regulations to regulate the application or interpretation of the laws.[83] However, custom constitutes a source of national law in cases where the law gives it such status.[84]

International sources of law

Numerous international human rights treaties recognize and promote women's rights. These treaties legally commit

governments to impose measures to advance and protect these rights. The international treaties ratified by El Salvador are a source of law, and take precedence over other laws, but are subject to the Constitution.[85] The government cannot enter into treaties that restrict or affect the Constitution.[86] The Assembly must ratify all treaties in order for them to have legal effect.[87] Once the Assembly ratifies the treaty, it becomes a law of the Republic.[88] The Courts have the authority to declare a treaty unconstitutional, following the same procedure used for declaring laws unconstitutional.[89]

El Salvador is a member state of the United Nations and the Organization of American States and, as such, it has signed and ratified the majority of relevant treaties of the universal[90] and the Inter-American systems for the protection of human rights.[91] Specifically, it has ratified treaties related to women's rights, such as the International Convention on the Elimination of All Forms of Discrimination Against Women[92] and the Inter-American Convention for the Prevention, Punishment and Eradication of Violence Against Women ("Convention of Belém do Pará").[93]

II. Examining Health and Reproductive Rights

In El Salvador, women's reproductive health issues are part of the country's national health and population policies. Thus, an understanding of reproductive rights in El Salvador must be based on analysis of these laws and policies.

A. HEALTH LAWS AND POLICIES

Objectives of the health policy

The Constitution establishes as a state duty the protection of the health of El Salvador's inhabitants.[94] However, statistics reveal that the public health situation there is alarming: 45% of the population does not have access to potable water.[95] Of this number, 85% are from rural areas and 13% live in cities.[96] Twenty-five percent of the population does not have access to latrines.[97] Concerning women's health, in 1994, only 60% of pregnant women received prenatal care[98] and 43% of pregnant women suffered some degree of anemia.[99]

For the period from 1994 to 1999, the government of El Salvador has declared it a national health priority to secure the population's access to a "basic basket" of health services and access to a "larger basket" of essential clinical services.[100] The Ministry of Public Health and Social Assistance ("MPHSA") has also proposed the creation of a mandatory medical insurance program for all of the population as well as private medical insurance.[101] Finally, it has proposed the reorganization of the institutional and legal frameworks of the health sector to achieve greater efficiency in the provision of health services.[102]

Infrastructure of health services

The MPHSA is the sector within the executive branch in charge of directing and coordinating all aspects of public health countrywide.[103] It offers medical assistance and sociomedical services to the population through its technical sections and its regional, departmental, and local health agencies.[104] It is the duty of the MPHSA to develop a national program designed to provide general and specialized medical services to the population.[105] It is also responsible for coordinating and standardizing the procedures of all medical facilities.[106]

The Salvadoran Social Security Institute ("SSSI")[107] is in charge of managing the country's social security system.[108] The objective of the system is to cover health risks that contributing workers may be exposed to because of sickness, accidents, maternity, disability, old age, death, and involuntary unemployment.[109] It offers medical, surgical, pharmaceutical, dental, hospital, and laboratory services[110] to insured workers, their spouses and registered partners, widows, their children, and unemployed or disabled workers.[111]

Cost of health services

The state provides funds to finance the health services provided by MPHSA,[112] through an annual allocation that comes from the national budget.[113] For 1996, public health expenditure was 7.3% of the total central government's expenditures.[114] The services provided by SSSI are primarily funded through contributions that the law requires from employers, workers, and the state.[115]

The Constitution establishes that the state has a duty to offer free care to the sick who cannot afford to pay.[116] Free health services are offered to the entire population when there is an effort to combat the spread of a transmissible disease or an epidemic.[117]

Regulation of health care providers

The Health Code[118] and the Penal Code[119] are the main regulators of the practice of health care professionals. The Health Code contains provisions dealing with the supervision and control of all professionals working directly with the people,[120] through the Superior Public Health Council (the "Council")[121] and the Professional Supervision Board (the "Supervision Board").[122] These bodies are charged with authorizing individuals to practice a health profession.[123]

The Health Code contains norms of binding character for professionals, technicians, auxiliaries, hygienists, and assistants who work in the health sector.[124] These provisions require them to provide appropriate care to all persons who request it without discrimination of any kind and to attend immediately to emergency cases when their professional collaboration is

requested.[125] The Health Code also prohibits the deception of patients with "nonscientific or doubtful" treatments; practicing hypnosis with nonmedical aims; and issuing false medical certificates, among others.[126] The following acts are considered serious infractions against health:[127] causing a person's death; causing temporary or permanent harm or impairment through error, negligence, inexcusable abandonment, or malice during professional practice;[128] breach of patient confidentiality;[129] failing to provide appropriate medical treatment;[130] suggesting or proceeding with surgery when the patient could be treated by medication;[131] and refusing to offer medical, technical or auxiliary services when they are required and the refusal results in harm to the health of an individual or the community.[132] It is classified as a minor infraction[133] to fail to conduct a serological examination for syphilis in any pregnant woman.[134] Other minor infractions are principally related to care and hygiene in the use and handling of medical instruments in health establishments.[135]

Medical professionals who violate any regulation, prohibition, or duty established in the Medical Code are sanctioned by the Council and the respective Supervision Boards.[136] The disciplinary sanctions that may be imposed on health professionals are a private verbal warning;[137] a written warning;[138] a fine, the amount of which shall depend on the seriousness of the infraction;[139] suspension from professional practice for up to five years;[140] and the temporary or permanent closing of the health establishment.[141] The Penal Code regulates punishments in cases of perpetration of crimes derived from practicing the profession. Performing an abortion,[142] injuring a patient,[143] or causing a patient's death[144] are considered crimes that imply the participation of health professionals.

Patients' rights

The law also influences the quality of health services by protecting patients' rights. In El Salvador, the Constitution considers health as a public good,[145] and it is the duty of the state and the general public to watch over its preservation and restoration.[146]

Although there is no specific law protecting health service users and patients in general, all the duties contained in the Health Code mentioned in the previous section imply a correlative right of patients to demand appropriate conduct from health professionals as well as the duty of the supervising bodies to protect that right. The Health Code establishes that a person who feels his or her rights have been violated or who witnesses a health professional's infraction of the norms contained in the code has the right to denounce the perpetrator before the supervising boards set up for such matters.[147] The government is responsible for controlling the quality of chemical, pharmaceutical, and veterinary products,[148] and must establish supervisory bodies to ensure quality.[149]

B. POPULATION, REPRODUCTIVE HEALTH, AND FAMILY PLANNING

The Government of El Salvador has declared that the country is facing a serious problem of overpopulation due to the high fertility rate, which is estimated at 4.5 children per woman,[150] and the low prevalence of contraception.[151] The population growth rate was 2.5% for the period 1990 to 1995,[152] which is one of the highest rates in Latin America.[153] Furthermore, the civil war and related political violence increased migration to the cities and resulted in large numbers of internally displaced people.[154] Growth is disorderly, and more than 1 million Salvadorans have emigrated in the last decade,[155] 50% of which were women.[156]

Population laws and policies

The Constitution provides that the state must guarantee its inhabitants enjoyment of health, culture, economic well-being, and social justice.[157] The Constitution contains a specific provision stating that the state should adopt population policies with the goal of "assuring the maximum well-being of the inhabitants of the republic."[158]

The National Population Policy ("NPP"),[159] devised by the government in 1993, is contained within the Plan for Economic and Social Development,[160] which seeks economic growth and improvement of quality of life for the population, especially for the poorest people.[161] The general objective of the NPP is to establish a compatible and satisfactory relationship between development and growth, and the size and territorial distribution of the population, in such a way as to contribute to an improvement in quality of life for Salvadorans.[162] Among the specific objectives that refer to women's status are to improve conditions in order to better enable the incorporation of women into development and to recognize more fully their dignity as free persons with rights and duties equal to those of men.[163] To achieve these objectives, the principle courses of action are to provide education, information, and communication on population matters,[164] to improve health and nutrition,[165] to provide family planning,[166] and to seek a better distribution of displaced populations.[167]

The coordination and implementation of the NPP is the responsibility of the National Population Commission ("NPC") and the Technical Population Committee ("TPC"). The former is a decision-making body, and the latter an advisory body.[168] The NPC consists of representatives from the various ministries involved in population-related issues, while the TPC is made up of one member of the NPC as well as representatives from other governmental institutions.[169]

Reproductive health and family planning laws and policies

Laws and policies related to reproductive health and family planning are found principally in the NPP and, in a more limited way, in the National Women's Policy ("NWP").[170] The specific objectives of the NPP in matters of reproductive health are to protect pregnant women and nursing women[171] and to supply them with nutritional supplements.[172] It establishes measures aimed at enlarging the scope of health services and emphasizes maternal-infant care.[173] It also proposes to increase the efficiency and effectiveness of health care services, with emphasis on maternal-infant care.[174] In family planning matters, the NPP establishes the need to enlarge the reach and improve the quality of family planning services offered by institutions in the public sector.[175] It also emphasizes the need to increase the availability of family planning services in rural areas, marginal-urban areas, and among "vulnerable groups," taking into account the demands, living conditions and sociocultural patterns of each group.[176] It promotes the use of additional family planning methods and strategies in urban areas.[177] Finally, it establishes that public health sector institutions should support family planning activities carried out by nongovernmental and private bodies, as long as they are in line with the objectives and aims of the NPP.[178]

The NWP, adopted by the government in 1996, is a policy instrument whose purpose is to improve Salvadoran women's status. The Salvadoran Institute for Women's Development ("SIWD") is charged with carrying it out.[179] The strategic objectives of the NWP in reproductive health matters are to promote women's reproductive health by preventing practices that present a health risk, to facilitate women's access to health services for pregnancy, childbirth, and postnatal care, and to detect breast cancer as well as psychological, physical, and sexual violence against women.[180] In family planning matters, the NWP seeks to improve women's access to services.[181] Another general strategic objective of the NWP is to train health workers to ensure efficient services and to respect women's human rights within the health care system.[182]

Government delivery of family planning services

Family planning services are provided principally by three entities: two from the public health sector (the MPHSA and the SSSI) and one private entity (the Salvadoran Demographic Association, "SDA").[183] These entities are charged with carrying out the National Family Planning Program.[184] The MPHSA covers 48.9% of demand for family planning services, the SDA covers 15.3%, and the SSSI 14.5%. In urban areas, the SSSI and pharmacies are the main sources of contraception, while in rural areas it is the SDA.[185] The forms of contraception provided by these institutions are sterilization, oral contraceptives, injectable contraceptives, condoms, intrauterine devices, and others that are less frequently used, such as male sterilization, vaginal methods, and Norplant.[186]

C. CONTRACEPTION

Prevalence of contraceptives

In 1993, 97.8% of Salvadorans between the ages of 15 and 44 years old were familiar with at least one form of contraception.[187] These figures were higher among married, separated, widowed, or divorced women (99.5%) and lower (94.4%) among single women.[188] The better known forms were sterilization (93%), oral contraceptives (90.8%), and condoms (88.2%).[189] In 1993, 53.3% of married or cohabiting women of reproductive age used some form of contraception.[190] However, only 2.5% of single women and 27.9% of separated, divorced, or widowed women use contraceptives.[191] Women who work outside the home (20% more than housewives),[192] those with some higher education,[193] those with more children,[194] and those who live in urban areas[195] have the highest prevalence rates of contraceptive use. Of all women that use some form of contraception, 31.5% were sterilized, 8.7% use oral contraceptives, 2.1% use the IUD, 2.1% use condoms, 3.6% use injectable contraceptives, 3% use natural methods (rhythm/billings), and 2.4% use other methods.[196]

A study of prevalence rates of various forms of contraception in El Salvador reveals that the proportional increase in the use of contraceptives through 1985 was attributable mostly to increased reliance on permanent forms of contraception (female sterilization),[197] while the increase from 47.1% in 1988 to 53.3% in 1993 was due to increased prevalence of temporary methods.[198]

Legal status of contraceptives

In El Salvador contraception is legal and is promoted by the MPHSA as a strategic activity of the National Population Policy.[199] There are no legal restrictions on the use of contraceptives. The Constitution and the Health Code[200] regulate the quality and the commercialization of contraceptives.

The Constitution establishes the state's duty to provide the resources necessary to control the quality of chemical, pharmaceutical, veterinary, and cosmetic products as well as therapeutic devices. This control is exercised by the MPHSA[201] through the Quality Control Laboratory.[202] In cases where a product or device does not comply with legal requirements, the Superior Public Health Council[203] will deny authorization for its distribution.[204] Only pharmacies and authorized trade establishments can sell or dispense the above-mentioned products.[205]

Regulation of information on contraception

There are no restrictions on access to information relating to methods or techniques of contraception. One of the

fundamental courses of action of the National Population Policy is the dissemination of information on topics relating to reproductive health and population through media or social communication.[206]

Sterilization

Female sterilization represents 31.5% of all forms of contraception used by women in El Salvador.[207] Female sterilization is the most widely used method regardless of where the woman lives. It is most prevalent in rural areas, where it represents two-thirds of contraceptive prevalence.[208] Sterilization was widespread, especially before 1985.[209] Among married, widowed, and divorced women, sterilization is the most prevalent form of contraception (84.6%).[210] Despite its popularity as a method of family planning, there are no laws or policies establishing procedures or requirements for obtaining surgical sterilization.

D. ABORTION

Although no systematized statistics on the prevalence of abortion in the country exist, during the period of January to June 1996, approximately 3,738 cases of abortions and related complications were treated by hospitals and provincial clinics countrywide.[211]

Legal status of abortion

In accordance with the Penal Code passed in April 1997, which entered into effect on January 20, 1998 (the "Penal Code"),[212] abortion is classified under "Crimes Relating to the Life of a Human Being in Formation."[213] The Penal Code's revised provisions on abortion have eliminated all exceptional circumstances in which abortion was not punishable and has increased penalties for abortion.[214] Thus, the Penal Code penalizes the "woman who induces her own abortion or consents to its performance by another person."[215] It also penalizes "those who perform an abortion with the woman's consent[216] or without it"[217] and those who obtain consent through violence or deception.[218] In addition, a doctor, pharmacist, or assistant in those professions who performs an abortion is also punished.[219] The Penal Code also punishes those who persuade a woman to undergo an abortion,[220] or facilitate the performance of an abortion by economic or any other means. Attempted abortion and unintentional abortion are not punishable, provided no third-party participants were involved.[221]

Penalties for abortion

The Penal Code that took effect in January 1998 increased the penalties for abortion than those in the previous code. The woman who induces her own abortion or consents to its performance by another person is punished with two to eight years in prison.[222] The same penalty applies for the person who performed the abortion with the woman's consent.[223] When the woman does not give her consent, or consent is obtained through violence or deceit, the punishment is four to ten years in prison.[224] In cases where the abortion is carried out by a doctor, pharmacist, or assistant of these professions, the punishment is six to twelve years in prison.[225]

Anyone who persuades a woman to undergo an abortion[226] or who facilitates the abortion through economic or any other means, is liable for two to five years in prison.[227] If the person who encourages or provides assistance to the woman is the father of the fetus, the punishment is increased by a one-third.[228] Unintentional abortion[229] is also penalized by six months to two years imprisonment for the person who caused the abortion.[230]

The revised Penal Code now contains new crimes called "illegal sale of abortifacents"[231] and "advertisement of means to obtain an abortion."[232] Those that are convicted of these crimes receive punishments of detention for fifteen to twenty-five weekends and a fine of ten to thirty days' wages for the former,[233] and a fine of ten to thirty days' wages for the latter.[234]

E. HIV/AIDS AND SEXUALLY TRANSMISSIBLE INFECTIONS (STIs)

Examining HIV/AIDS issues within the framework of reproductive rights is essential, as the two areas are interrelated from both medical and public health standpoints. Hence, a comprehensive evaluation of laws and policies affecting reproductive health in El Salvador must examine HIV/AIDS and sexually transmissible infections ("STIs") because of the dimension and implications of these diseases as reflected in the following statistics. Approximately 30,000 people in El Salvador are infected with the AIDS virus,[235] but only 694 cases have been officially reported,[236] of which 23% are women.[237]

Laws on HIV/AIDS and STIs

The MPHSA is the body in charge of issuing standards for the prevention of STIs, as well as the treatment, care, and rehabilitation of those infected.[238] The regulations and other measures decreed by the MPHSA must be complied with by all public and private health establishments.[239] In El Salvador, the Health Code is the only legal instrument that contains norms regulating AIDS and STIs. Both diseases are considered "diseases of mandatory reporting,"[240] which means that they are subject to a mandatory reporting system established by the MPHSA.[241] All of the following are required to report cases of HIV and STIs: (a) the doctor who cares for the patient; (b) the professional responsible for the public or private health establishment where the case was presented or attended to; (c) the legal representative, family member, or responsible person caring for the infected person, (d) the owner of the house or

establishment where one of these cases is presented; (e) the professional responsible for the laboratory that confirms the diagnosis of the infected person; and (f) any person who knows or suspects of the existence of a case.[242]

The Health Code authorizes the quarantine, observation, and supervision of sick persons and those who may have been exposed to infection, "for the time and in the form that the ministry [MPHSA] deems fit."[243] It also provides that "places and objects" with which the sick person could have had contact or relation will be submitted to disinfecting procedures as necessary.[244] Specifically, "patients with venereal diseases and those with whom they have had contact" are required to submit to orders of observation, supervision, and treatment as determined by the Health Code.[245] Treatment and prevention services for transmissible diseases are generally provided free of charge to the entire population.[246]

Policies on prevention and treatment of HIV/AIDS and STIs

In El Salvador there is no policy related to the prevention and treatment of HIV/AIDS. The NWP[247] declares one of its strategic aims to be the revision of laws and regulations that relate to STIs and HIV/AIDS.[248] It also proposes to massively promote prevention of these diseases with emphasis on the eradication of high-risk behaviors.[249]

The Health Code declares that actions by MPHSA to eradicate transmissible diseases, including AIDS and STIs, are in the public interest. The eradication efforts that have been undertaken in El Salvador are carried out unilaterally or are coordinated by governmental institutions, such as the MPHSA, the SSSI, and the Ministry of Education, or by non governmental organizations such as the National Foundation for the Prevention, Education, and Control of HIV/AIDS Patients, the Salvadoran Demographic Association ; the Collective of Women Workers in the Sex Industry, "Flor de Piedra," (Stone Flower); and organizations within the homosexual community.[250]

III. Understanding the Exercise of Reproductive Rights: Women's Legal Status

Women's reproductive health and rights cannot be fully understood without first analyzing women's legal and social conditions. Not only do laws relating to women's legal status reflect societal attitudes that affect their reproductive rights, but such laws often have a direct impact on women's ability to exercise reproductive rights. The legal context of family life and couple relations, women's educational level, and access to economic resources and legal protection determine women's ability to make choices about their reproductive health care needs and to exercise their right to obtain health care services.

The Constitution of El Salvador recognizes the principle of equality and establishes the equality of all persons before the law.[251] No one may restrict an individual's enjoyment of his or her rights based on nationality, race, sex, or religion.[252] Furthermore, the Salvadoran government has signed various international agreements related to women's civil rights, in which the principles of equality of rights between men and women and nondiscrimination against women are established.[253] In El Salvador, however, violence against women and other violations of their human rights as well as high illiteracy continue to be a serious problem.[254]

A. RIGHTS WITHIN MARRIAGE

Marriage law

The Constitution defines the family as the fundamental basis of society, and marriage as the foundation of the family.[255] The state has a duty to encourage marriage.[256] The Constitution recognizes the equality of the spouses by providing that marriage "rests on the legal equality of the spouses."[257] The Family Code,[258] enacted in 1993, extended the principle of equality by revoking certain provisions that discriminated against women, particularly against married women.[259]

The Family Code defines matrimony as the legal union of a man and woman who come together in a "permanent community."[260] In accordance with the Constitution, the Family Code establishes equality of rights and duties of the spouses: to live together, to remain faithful to each other, to assist each other in all circumstances, and to treat each other with respect, tolerance, and consideration.[261] The spouses should jointly decide all issues related to their domestic affairs.[262] Both contribute to the family in proportion to their economic resources. If one spouse does not have resources, the maintenance of the home and care of the children is considered as an equal contribution to that of the other spouse.[263] Neither of the spouses can limit the right of the other to undertake legal economic activities, to study, or to improve his or her knowledge.[264] Spouses should also cooperate and be mutually supportive.[265] The housework and the care of the children are the responsibility of both spouses.[266]

The spouses can opt for one of the following property regimes: separation of property, sharing of earnings, or deferred community property.[267] Alternately, they can create their own property regime as long as the rules they establish are not contrary to the Family Code provisions.[268] In the separation of property regime, each spouse reserves the right to freely manage and dispose of any property that he or she

brought into the marriage and any property that he or she acquires during the marriage as well as the profits generated by such.[269] In the sharing of earnings regime, each of the spouses acquires the right to share in the earnings of the other, during the time that the regime is in effect.[270] However, each spouse retains the management, the use, and the free disposition of his or her own property, both that which he or she brought into the marriage and that which he or she acquired after the marriage.[271] In the deferred community property regime, property acquired by purchase as well as the profits, income, and interest obtained by either of the spouses while the regime is in effect, belongs to both spouses and is divided in half if the marriage dissolves.[272] The applicable property regime must be chosen before the celebration of marriage.[273] If a regime is not chosen, the deferred community property regime is applied.[274] The property that serves as the family home cannot be transferred and may not be otherwise encumbered without the consent of both spouses, under penalty of the relevant transaction being voided, regardless of the applicable property regime.[275] Bigamy is a crime punishable by six months to two years in prison.[276]

Regulation of domestic partnerships

The Constitution indicates that "the absence of matrimony" does not affect the enjoyment of rights established in favor of the family.[277] It also provides that the law should regulate the family relations that result from a stable union of a man and woman.[278] The Family Code defines a domestic partnership as a nonmatrimonial union between a man and woman who, without any legal impediment to marriage, make a life together in a "singular, continuous, stable and public manner for more than three years."[279] These couples are denominated "cohabitants" or "life companions."[280] The property of the couple is governed by a sharing of earnings regime and they are equally responsible for family expenses.[281] Furthermore, among other rights, the domestic partnership enjoys the same right to protection of the family home as that established for a married couple[282] as well as the same right to inherit from one another.[283] To enjoy these rights, a prior judicial finding of the existence of the domestic partnership is required.[284] This judicial finding is obtained when one of the partners dies or when the union is dissolved.[285] The opportunity to request legal recognition of the union expires one year after the union is dissolved or when one of the partners dies.[286]

Divorce and custody law

Divorce is the dissolution of the matrimonial bond decreed by a judge.[287] Divorce can be granted with the consent of each spouse, after a separation for one or more consecutive years, or when the spouses' life together has become intolerable.[288] The court may find life together is intolerable when there is serious or continuing noncompliance with matrimonial duties or evident deplorable conduct by either of the spouses.[289] The application of this cause for divorce to particular circumstances is left to the discretion of the judge.[290] Only a spouse who was not at fault in the events that made life together intolerable may file for divorce.[291]

In divorce by mutual consent, the spouses determine by agreement who will exercise paternal authority over the children, the visitation regime, child support payments, who retains possession of the home and family furniture, the basis for liquidation of the marital property, and whether or not alimony will be payable to one of the spouses.[292] Alimony is payable to protect the spouse for whom the divorce causes an appreciable loss in his or her economic status, in comparison with what he or she had in the marriage.[293] In the case of a contested divorce, if there is no agreement between the spouses, the judge will establish the conditions of separation.[294] If the applicable property regime is separation of property or deferred community property, and the liquidation of the marital property produces a negative balance, the spouse whose situation is less favorable has the right to receive a compensatory pension.[295] The purpose of the divorce decree is to dissolve the matrimonial bond and the marital property regime, and to determine who will exercise parental authority, whether or not alimony is payable, and visitation rights.[296]

B. ECONOMIC AND SOCIAL RIGHTS

Property rights

The Constitution of El Salvador guarantees the right to private property[297] and economic freedom of all persons,[298] as long as the exercise of those rights does not conflict with societal interests.[299] Despite the lack of *de jure* discrimination against women, in practice they do not have equal access to land.[300] In 1994, only 10.7% of rural lands designated for former guerrilla combatants[301] was registered under women's names,[302] even though 26.23% of Salvadoran heads of families were women.[303]

Labor rights

Work is a social function protected by the State.[304] The Constitution establishes the principal of equality in remuneration for equal work[305] and prohibits employment discrimination on the basis of sex, race, creed, or nationality.[306] It also establishes the right of the female worker to enjoy paid leave before and after a birth[307] and to keep her job.[308] Furthermore, it establishes the employer's duty to establish and maintain nurseries and child-care facilities.[309]

The Labor Code[310] prohibits the employer from discriminating in employment on account of race, color, or sex.[311] It also establishes the right of women to twelve weeks' maternity

leave, six of which are mandatory after childbirth.[312] During the period of leave, the woman receives remuneration equal to 75% of her regular salary.[313] During breast-feeding, the working mother has the right to one hour of paid leave per day to feed her child.[314] The Labor Code prohibits employers from assigning pregnant workers to tasks that require physical exertion not compatible with their pregnancy.[315] Pregnancy is not a justifiable cause to dismiss a worker.[316] During the pregnancy and the postnatal leave, even a justifiable dismissal of a woman worker will not result in the termination of the employment contract.[317] Such termination is effective only after the pre- and postnatal leaves have been completed.[318]

Access to credit

There are no legal restrictions on women's access to credit. However, the practical limitations on women's access to property[319] directly affect their ability to get credit because, in the formal financial system, access to credit requires a mortgage on real property as collateral or a similar guarantee. In 1990, to address this problem, the government created Community and Microbusiness Banks in El Salvador to respond to the credit needs of women.[320] In 1994, these programs granted credit to 6,372 Salvadoran women.[321]

Access to education

The Constitution establishes that all inhabitants of the republic have the right and duty to receive primary and basic education[322] and that public education is free.[323] However, illiteracy is a more serious problem among women than men. Twenty-four and one-tenth percent of the Salvadoran population is illiterate.[324] Of those who are illiterate, 14.3% are women and 9.8% are men.[325] There have been signs of improvement in educational opportunities for women in the last few years. In 1993, 53,970 boys and 60,172 girls were registered for secondary school education.[326] In the same year, in primary schools, 532,172 boys and 519,304 girls registered.[327] In 1993, 48.7% of those receiving higher education were women.[328]

Women's bureaus

The governmental body in charge of formulating gender policies and encouraging women's advancement in El Salvador is the Salvadoran Institute for Women's Development ("SIWD").[329] The SIWD was created in 1996 as an independent entity with its own legal status and assets.[330] Its aim is to create public policies to improve women's conditions and promote gender equality in the country.[331] Specifically, it is in charge of drafting and implementing the NWP,[332] which became effective in December 1996. It principal objective is to improve the conditions of Salvadoran women and to obtain their share in national development through equality of opportunity with respect to men.[333] Among the NWP's strategies for 1997, 1998, and 1999 are the following: to propose legislative reforms aimed at eliminating provisions that discriminate against women[334] and to train members of the legislative and judicial branches, the Public Defenders Office, and the Ministry of Public Security to eradicate discrimination against women.[335] Also, the NWP proposes to strengthen the focus on gender in formal education,[336] to promote health and reproductive rights,[337] and to propose reforms to the Constitution and the Labor Code to bring them into compliance with International Labor Organization agreements ratified by El Salvador.[338] Finally, the promotion of women's participation in designing national and municipal public policies is an additional strategic objective of the NWP to improve Salvadoran women's status.[339]

C. RIGHT TO PHYSICAL INTEGRITY

Rape

Between 1992 and 1996, 3,695 cases of sexual crimes were reported to law enforcement authorities in the San Salvador metropolitan area.[340] In 1996, 906 cases of sexual crimes were reported in the same area, in which 824 victims were female and 82 were male.[341] One governmental organization reported 71 rape cases in 1996.[342]

The Penal Code, which took effect in January 1998, classifies rape as a crime "against sexual freedom,"[343] that is committed by those who, "through violence, have vaginal or anal intercourse with another person."[344] The punishment for this crime is six to ten years in prison.[345] The Penal Code also penalizes, with three to six years in prison,[346] those who carry out any sexual aggression, "not constituting rape."[347] The punishment is increased to six to ten years if the sexual aggression consisted of "oral carnal access" or "the introduction of objects into the vagina or anus."[348] In crimes of rape and sexual aggression, the maximum sentences described above are increased by one-third when the aggressor is an ascendant, descendant, brother, adoptive parent, adopted child, or the spouse or partner of the victim's mother or father.[349] The sentence is also increased by one-third when the rapist or aggressor represents public authority or has the victim in custody;[350] when the crime is carried out by two or more persons;[351] or when it is committed using "especially brutal, degrading or humiliating means, measures, or instruments."[352]

The Penal Code requires that an indemnity payment be made by perpetrators of the aforementioned crimes, including the medical, psychiatric, and psychological fees that the victim incurs, as well as full maintenance throughout the period of medical incapacity.[353] The Penal Code that was repealed in January 1998 included the crime denominated "rape of a prostitute."[354] It was penalized by three months to two years in prison, a much lighter sentence than that imposed for rape of any other person.[355]

Sexual harassment

In the Penal Code, sexual harassment is penalized with a sentence of six months to one year in prison. Sexual harassment is defined as "sexual conduct that is not desired by those who receive it, which implies touching or other conduct which is unequivocally of a sexual nature."[356] If sexual harassment is committed by someone who is taking advantage of a "superior" position within "any relationship," a fine of thirty to fifty days' salary will also be imposed.[357]

Domestic violence

In El Salvador, violence within the family is regulated by the Law Against Violence Within the Family and by the Penal Code.[358] The former establishes the state's duty to prevent, punish and eradicate violence within the family.[359] To this end, a special division was created in the National Civil Police to investigate and process complaints of violence within the family.[360] The law defines violence within the family as direct or indirect acts or omissions "that cause harm, physical, sexual, or psychological suffering, or death to persons within a family."[361] Three types of family violence are distinguished: psychological violence,[362] physical violence,[363] and sexual violence.[364] The law also sets out the procedures for police intervention and establishes the jurisdiction of certain courts to adjudicate cases of violence within the family as well as protective measures that the court may order to protect the person who has been harmed.[365] Among the protective measures that can be ordered by a judge are ordering the termination of acts of harassment and mistreatment; prohibiting the aggressor from consuming alcohol or drugs or from carrying weapons; ordering the aggressor to leave the shared home and prohibiting him or her access to the home of the injured party; granting the injured party an order of protection and police assistance; decreeing a loss of parental authority and/or custody of the children; and decreeing maintenance for the injured party.[366] The aggressor is required to undergo specialized psychological and psychiatric treatment relating to violence within families.[367] In cases where there is any violation of the measures ordered by the judge, a fine of five to twenty days' wages will be imposed.[368] Any person who has knowledge of an act of violence within the family can file a complaint.[369] The family courts and the justices of the peace are legally competent to hear complaints of violence within the family.[370]

In addition, the Penal Code penalizes crimes of violence within the family and defines them as crimes committed by anyone who uses "violence on his or her spouse or the partner with whom he or she lives, or on his or her children, or his or her partner's children in his or her custody, a minor or disabled person under his or her guardianship, or his or her parents."[371] The applicable sentence is six months to one year in prison.[372] A punishment of detention for five to ten weekends and a fine of five to ten days' wages may also be applied to cases of violence within the family when injuries are caused to another person.[373] Although jurisdictional conflicts between the procedures established by the Law Against Violence within the Family and those of the Penal Code are not addressed in the laws themselves, the fact that the former law is exclusively handled by family judges and justices of the peace excludes the possibility of a conflict with the criminal process, in which more severe sanctions are applicable.

IV. Focusing on the Rights of a Special Group: Adolescents

The needs of adolescents are often unrecognized or neglected. Considering that 41% of the Salvadoran population is under the age of 15,[374] it is particularly important to meet the reproductive health needs of this group. The effort to address adolescent rights, including those related to reproduction, are important for the right to self-determination and to the health of all women.

A. REPRODUCTIVE HEALTH AND ADOLESCENTS

In El Salvador, girls from ages 15 to 19 contribute 16% to the total fertility rate.[375] According to figures from the National Population Council, in 1992, there were approximately 503,459 adolescent mothers out of a total of 1,866,121 mothers.[376] Despite these statistics, in 1993, a demographic and health study revealed that only 2.5% of single women between 15 and 44 years old used contraception.[377] In El Salvador there are no policies or legislation that specifically address adolescent health, in spite of the fact that the average woman's first sexual experience occurs during adolescence. The statistics on fertility and contraception do not take into account the population between 12 and 16, thus making it difficult to study the reproductive health of women in this age group.

B. MARRIAGE AND ADOLESCENTS

The average age of a woman at the time of her first marriage is 18.5 years.[378] Those under 18 years of age are legally permitted to marry if they already have a child together or if the woman is pregnant.[379] In such cases, the express consent of the parents is required.[380] If one parent is absent, it is sufficient to have the consent of the other. If both are absent, the consent of the closest relatives is requested.[381] In case of a difference of opinion, the parent who favors the marriage prevails.[382] Denial of consent is justified only if one of the impediments or

prohibitions for marriage exists, such as if one of the two leads an immoral life, has a "passion for illegal games," habitually gets drunk or consumes illicit drugs, or if either one suffers from an illness that puts the health or life of the other or their child in danger.[383] Consent can also be denied if neither of the two seeking to marry has economic means sufficient to carry out the responsibilities of marriage.[384] When the denial is unjustified, the judge can authorize the marriage of the minors upon their request.[385]

C. SEXUAL OFFENSES AGAINST ADOLESCENTS AND MINORS

Sexual crimes against minors and adolescents that are prohibited by the Penal Code are rape, sexual aggression distinct from rape, statutory rape, and other attacks against sexual freedom.[386] Rape, whether vaginal or anal, of a minor less than 12 years old is punished by ten to fourteen years' imprisonment.[387] The punishment is increased by one-third in the following cases: if the crime is carried out by the parents, siblings, or adoptive parents; if the aggressor is a government authority or anyone who had the victim under his or her custody; when the crime involved is an abuse of "domestic relationships"; when it is committed by two or more persons; and when "brutal, degrading, or humiliating" means, methods, or instruments have been used.[388] "Other sexual aggressions" include those acts carried out with violence but without actual intercourse, for example, oral carnal access or the introduction of objects into the anus or vagina, the latter two carrying longer sentences.[389] The above-described acts carry sentences of six to eight years in prison, or ten to fourteen years.[390]

Engaging in carnal access with a minor between 14 and 16 years of age through deceit is known as statutory rape.[391] The punishment is one to three years of imprisonment.[392] If the victim is between 12 and 14 years old, the punishment is two to four years in prison, even if consent was given for carnal access.[393] Other attacks on the sexual freedom of an adolescent that constitute crimes are sexual harassment, sexual acts different from carnal access, corruption of minors, inducement, promotion and favoring of prostitution, indecent exposure, pornography, and using minors for pornography. Sexual harassment of a minor under 12 years old is punished with six months to two years in prison.[394] Sexual acts other than carnal access that are committed through deception on a person between 14 and 16 years[395] are punished by a sentence of six months to two years in prison.[396] If the victim is between 12 and 14 years of age, the sanction is one to three years in prison, even where the act is consensual.[397]

Corruption of minors less than 18 years old "through acts other than carnal access," even though the victim consents to participate in such acts,[398] is penalized by imprisonment for two to six years.[399] The punishment is increased to four to eigth years if the victim is under 12; if it is carried out for profit; if it is performed through deception, violence, abuse of authority or trust, or any other means of intimidation; or if it is committed by an older relative, an adoptive parent, a biological or adopted sibling, or someone charged with guardianship or custody of the victim.[400]

D. SEXUAL EDUCATION

In El Salvador, the principle objective of education is to achieve the comprehensive development of the human being and contribute to the "building of a more prosperous, fair and humane society."[401] The Ministry of Education, in its curriculum for secondary education, incorporates the subject of sexuality into the curriculum for students at this level.[402] The principal aspects of sexuality included in the education program are: the psychobiology of an adolescent's sexuality, identity and sexual roles, personal and social responsibility in sexuality, consequences of sexual activities, and sexuality and culture.[403]

ENDNOTES

1. Political Constitution of the Republic of El Salvador, with all its reforms, entry into effect Dec. 20, 1983, art. 84. Publishers, Lis San Salvador, 1996. [hereinafter EL SAL. CONST.].
2. *Id.*, art. 62: "The official language is Castilian. The government has a duty to ensure its conservation and teaching. The indigenous languages spoken within the national territory are part of the cultural heritage and will be preserved, disseminated and respected."
3. WORLD ALMANAC BOOKS, THE WORLD ALMANAC AND BOOK OF FACTS 1997, at 761 (1996).
4. *Id.*
5. *Id.*, at 762.
6. *Id.*
7. *Id.*
8. *Id.*
9. *Id.*
10. UNITED STATES DEPARTMENT OF STATE, COUNTRY REPORTS ON HUMAN RIGHTS PRACTICES FOR 1996, at 442 (1997).
11. *Id.*
12. *Id.*
13. EL SAL. CONST., *supra* note 1.
14. *Id.*, art. 85.
15. *Id.*
16. *Id.*
17. *Id.*, art. 86.
18. *Id.*, the Constitution denominates the branches of Public Power of the State "bodies."
19. *Id.*
20. *Id.*
21. *Id.*, art. 150.
22. *Id.*, art. 154.
23. *Id.*, art. 168.
24. *Id.*, arts. 157, 159, and 168.
25. *Id.*, art. 159.
26. *Id.*
27. *Id.*, art. 166.
28. *Id.*, 29 and 167.
29. For a definition of this institution, see section on Legislative Branch.
30. EL SAL. CONST., art. 131, cl. 37.
31. *Id.*
32. *Id.*
33. *Id.*, art. 121.
34. *Id.*
35. *Id.*, art. 125.
36. *Id.*, art. 238.
37. *Id.* The Legislative Assembly is responsible for establishing and defining what constitute "serious" crimes committed by representatives and for declaring the initiation of the respective criminal proceeding. *Id.*, arts. 236 and 238.
38. *Id.*, art. 238.
39. *Id.*, art. 237.
40. *Id.*, art. 131.
41. *Id.*, cl. 19. Justices of the Supreme Court of Justice, the Supreme Electoral Tribunal, the Attorney General of the Republic, the Public Defender, the Human Rights Ombudsman, and Members of the National Judiciary Council.
42. *Id.*, arts. 133.
43. *Id.*, art. 134.
44. *Id.*, art. 135.
45. *Id.*, arts. 135 and 136.
46. *Id.*, art. 137.
47. *Id.*
48. *Id.*, art. 135.
49. This system was codified during the time of the Roman Empire. *The Compilation of Justinian* and his other works such as *Institutions, Codex, Digestas, Novellaes*, etc., are collectively referred to as *Corpus Juris Civilis*, to distinguish the civil system from English common law and Canon Law. See BLACK'S LAW DICTIONARY, at 168 (6th ed. 1991).
50. EL SAL. CONST., art. 172 and Organic Judicial Law, Decree No. 123, Jun. 6, 1984, art. 1.
51. *Id.*, and Organic Judicial Law, art. 1.
52. Organic Judicial Law, art. 15.
53. *Id.*, art. 22.
54. EL SAL. CONST., art. 172.
55. *Id.*, art. 182.
56. Organic Judicial Law, art. 5.
57. *Id.*, art. 57. There are 11 Chambers in the capital (San Salvador), 4 in the City of Santa Ana, 5 in the City of San Miguel and 1 in each of the following cities: Usulatan, Cojutepeque, San Vicente, and Nueva San Salvador. *Id.*, arts. 6-10.
58. *Id.*, see also arts. 35-42.
59. *Id.*, see also art. 43.
60. *Id.*
61. *Id.*, art. 64. The amount in controversy must not exceed 10,000 colones.
62. *Id.*
63. EL SAL. CONST., art. 172.
64. *Id.*, art. 14 and Organic Judicial Law, art. 24.
65. *Id.*, art. 216.
66. *Id.*, art. 21.
67. *Id.*, art. 181.
68. *Id.*, arts. 193 and 194.
69. *Id.*, art. 191.
70. *Id.*
71. *Id.*, art. 193.
72. *Id.*, art. 194.
73. *Id.*
74. *Id.*, art. 200. El Salvador is divided into fourteen departments. THE WORLD ALMANAC, *supra* note 3, at 761.
75. *Id.*, art. 200.
76. *Id.*
77. *Id.*, art. 80.
78. *Id.*, art. 202.
79. *Id.*, art. 203.
80. *Id.*, art. 204.
81. *Id.*, arts. 246 and 144.
82. *Id.*, art. 183.
83. Organic Judicial Law, art. 24.
84. For example, civil laws, through the Civil Code, make reference to custom as a source of law, in different articles related to contracts, purchases and sale, leasing and powers of attorney. *See* arts. 2, 1417, 1626, 1728, 1732, 1774, and 1877.
85. EL SAL. CONST., art. 144.
86. *Id.*, art. 146.
87. *Id.*, art. 131, cl. 7.
88. *Id.*, art. 144.
89. *Id.*, art. 149.
90. El Salvador has signed and ratified among others the following: International Covenant on Economic, Social and Cultural Rights, *adopted* Dec. 16, 1966, 993 U.N.T.S. 3 (*entry into force* Sept. 3, 1976) (ratified by El Salvador on Nov. 30, 1979); International Covenant on Civil and Political Rights, *adopted* Dec. 16, 1966, 999 U.N.T.S. 171 (*entry into force* Mar. 23, 1976) (ratified by El Salvador on Nov. 30, 1979); Convention on the Rights of the Child, *opened for signature* Nov. 20, 1989, 28 I.L.M. 1448 (*entry into force* Sept. 2, 1990) (ratified by El Salvador on Jun. 10, 1990). UNITED NATIONS, MULTILATERAL TREATIES DEPOSITED WITH THE SECRETARY GENERAL: STATUS AS AT DEC. 31, 1995, ST/LEG/SER.E/14, at 95, 111, 121 and 198.
91. Among the treaties from the Inter-American system signed and ratified by the government of El Salvador are: American Convention on Human Rights, signed Nov. 22, 1969, 9 I.L.M. 101 (*entry into force* Jul. 18, 1978) (ratified by El Salvador on Jun. 23, 1978); Additional Protocol to the American Convention on Human Rights in the Area of Economic, Social and Cultural Rights - "Protocol of San Salvador", *signed* Nov. 17, 1988 O.A.S.T.S. 69 (1988) (ratified by El Salvador on Jun. 6, 1995); Inter-American Convention for the Prevention and Punishment of Torture, *adopted* Feb. 28, 1987 OEA/SER.L.V/II.92 doc. 31 rev. 3 May 3, 1996 (ratified by El Salvador on Dec. 5, 1994).
92. Convention on the Elimination of All Forms of Discrimination Against Women, *opened for signature* Mar. 1, 1980, 1249 U.N.T.S. 13 (*entry into force* Sep. 3, 1981) (signed by El Salvador on Nov. 14, 1980 and ratified on Aug. 19, 1981). Multilateral Treaties, *supra* note 90, at 95, 111, 121 and 198.
93. Inter-American Convention on the Prevention, Punishment and Eradication of Violence Against Women, adopted June 9, 1994, 33 ILM 1534 (*entry into force* Mar. 5, 1995) (signed by El Salvador on Aug. 14, 1995 and ratified on Nov. 13, 1995).
94. EL SAL. CONST., art. 65.
95. THE GOVERNMENT OF EL SALVADOR, INFORME NACIONAL PARA LA CONFERENCIA REGIONAL PREPARATORIA SOBRE LA MUJER A CELEBRARSE EN ARGENTINA. SEPTIEMBRE 1994 [NATIONAL REPORT FOR THE PREPARATORY REGIONAL CONFERENCE FOR WOMEN IN

THE REPUBLIC OF ARGENTINA, SEPT. 1994], PRELIMINARY AND PREPARATORY CONSULTATIVE DOCUMENT FOR THE FOURTH WORLD CONFERENCE ON WOMEN, BEIJING, CHINA, at 8 (1994).
96. UNITED NATIONS, THE WORLD'S WOMEN 1995: TRENDS AND STATISTICS, at 53 (1995).
97. NATIONAL REPORT, supra note 95, at 8.
98. Id., at 7.
99. Id., at 15.
100. ELSA CABELLERO, NATIONAL DEVELOPMENT FOUNDATION, LA REFORMA DE SALUD: ENTRE LA DESCENTRALIZACIÓN Y LA PRIVATIZACIÓN [HEALTH REFORM: BETWEEN DECENTRALIZATION AND PRIVATIZATION], at 71 (1995).
101. Id., at 71.
102. Id., at 71.
103. HEALTH CODE, Decree No. 955, May 11, 1988 (updated until Mar. 27, 1996), art. 193.
104. Id., art. 193.
105. Id., art. 194.
106. Id., art. 196.
107. Social Security Law, Decree No. 1263, Dec. 3, 1953, art. 4.
108. EL SAL. CONST., art. 50.
109. Social Security Law, art. 2.
110. Id., art. 48.
111. Regulation for the Application of the Social Security Regime, Decree No. 37, Sep. 25, 1968, art. 41.
112. HEALTH CODE, arts. 14, cl. p, and 18 cl. a.
113. EL SAL. CONST., art. 167, cl. 3.
114. UNITED NATIONS POPULATION FUND (UNFPA), THE STATE OF THE WORLD POPULATION 1997, at 72 (1997).
115. Social Security Law, art. 25.
116. EL SAL. CONST., art. 65.
117. Id., art. 66.
118. Approved by Decree No. 955, published in the Official Bulletin (Vol. 299 (86)), May 11, 1988.
119. PENAL CODE, Decree No. 1030, Apr. 26, 1997. This Code entered into effect Jan. 20, 1998. Id., art. 409. [hereinafter Revised penal code].
120. HEALTH CODE, art. 5.
121. Id., arts. 7, 8, 10, and 11. It is a "public law corporation" and, like the Supervision Boards, enjoys independence in its functions and decisions. It is linked to other bodies through the MPHSA and consists of fourteen members, two elected by the executive branch and three representatives from each of the following professional associations: medical, dentistry, chemical-pharmaceutical, and veterinary. Each member is elected for two years by his or her association's general assembly convoked for that purpose.
122. Id., arts. 5, 9, 10, and 11. Legal bodies that control the work of diverse health professionals are denominated as such. There is one for every professional branch. For example, a Supervision Board for the Medical Profession and one for the Nursing Profession. They are composed of five scholars from the profession that is being regulated and are elected in a general assembly of professionals from each association formed for this purpose by the Superior Public Health Council for a period of two years.
123. Id., arts. 23 and 30.
124. Id., art. 33.
125. Id.
126. Id.
127. Id., art. 279.
128. Id., art. 284, cl. 1.
129. Id., cl. 2.
130. Id., cl. 3.
131. Id., cl. 4.
132. Id., cl. 15.
133. Id., art. 279.
134. Id., art. 284, cl. 30.
135. Id., art. 286.
136. Id., arts. 279, 289, 290, 291, and 292.
137. Id., arts. 280 and 287, cl. a.
138. Id., cl. b.
139. Id., arts. 281 and 287, cl. c.
140. Id., arts. 282 and 287, cl. ch.
141. Id., arts. 283 and 287, cl. d.
142. Revised PENAL CODE, art. 135. For more detail about punishment for abortion, see section on abortion.
143. Id., art. 146. In such cases, a sentence of two to six years is imposed on the professional, as is a special disqualification from practicing the profession for a similar period of time.
144. Id., art. 132. The punishment is two to four years in prison and professional disqualification for the same period.
145. EL SAL. CONST., art. 65.
146. Id.
147. HEALTH CODE, art. 294. Also see a more detailed description of supervisory bodies in the previous section and the respective footnotes.
148. EL SAL. CONST., art. 69.
149. Id. For a more detailed discussion of bodies responsible for quality control of medicines and contraceptives, see the section on legal status of contraception.
150. NATIONAL POPULATION COMMISSION, POLÍTICA NACIONAL DE POBLACIÓN DE EL SALVADOR [NATIONAL POPULATION POLICY OF EL SALVADOR], at 11 (1993).
151. Id.
152. Id.
153. Id., at 12.
154. Id., at 11.
155. Id.
156. THE WORLD'S WOMEN 1995, supra note 96, at 65.
157. EL SAL. CONST., art. 1.
158. Id., art. 118.
159. See footnote 149.
160. NATIONAL POPULATION POLICY, supra note 150, at 7.
161. Id., p 10.
162. Id., at 20.
163. Id., at 21.
164. Id., at 25.
165. Id., at 26.
166. Id., at 27.
167. Id., at 28.
168. Id., at 15.
169. Id., at 9 and 10.
170. SALVADORAN INSTITUTE FOR WOMEN'S DEVELOPMENT (SIWD), NATIONAL WOMEN'S POLICY (1996).
171. NATIONAL POPULATION POLICY, supra note 150, at 21.
172. Id.
173. Id., at 26.
174. Id.
175. Id., at 27.
176. Id. The law does not define the term "vulnerable groups."
177. Id.
178. Id.
179. Legislative Decree No. 644, February 1996, arts. 1-3. SIWD was created in 1996 as an independent body, with its own legal status and assets, with the aim of designing public policies to improve women's conditions and establish gender equality in the country,
180. NATIONAL WOMEN'S POLICY, supra note 170, at 29.
181. Id.
182. Id., at 30.
183. SALVADORAN DEMOGRAPHIC ASSOCIATION (SDA), 35 ANIVERSARIO. MAYO 1962-1977 [35TH ANNIVERSARY. MAY 1962-1997], at 1 (1997). The SDA is a private service organization, founded in 1962, dedicated to educating and informing the population on responsible parenthood. It also designs and implements programs that offer sexual and reproductive health and family planning services.
184. SALVADORAN DEMOGRAPHIC ASSOCIATION (SDA), with the participation of the Consultative Committee consisting of: MPHSA, THE MINISTRY FOR PLANNING AND COORDINATION OF ECONOMIC AND SOCIAL DEVELOPMENT, (MIPLAN), STATISTICS AND CENSUS DIRECTIVE, (SCD), SALVADORAN SOCIAL SECURITY INSTITUTE (SSSI), THE UNITED STATES AGENCY FOR INTERNATIONAL DEVELOPMENT (USAID/EL SALVADOR), ENCUESTA NACIONAL DE SALUD FAMILIAR [NATIONAL FAMILY HEALTH SURVEY], at 80 (1994).
185. Id.
186. Id., arts. 73 and 74.
187. Id., at 53.
188. Id.
189. Id.
190. Id., at 54.
191. THE WORLD'S WOMEN 1995, supra note 96, at 91.
192. NATIONAL FAMILY HEALTH SURVEY, supra note 184, at 62.

193. *Id.*, at 75.
194. *Id.*, at 62.
195. *Id.*, at 75.
196. *Id.*, at 79.
197. *Id.*, at 71.
198. *Id.*, at 75.
199. National Population Policy, *supra* note 150, at 27.
200. Approved by Decree No. 955, May 11, 1988.
201. Health Code, art. 249.
202. *Id.*, art. 243.
203. See nature and functions of this entity in the section on Patients Rights.
204. Health Code, art. 14.
205. *Id.*
206. National Population Policy, *supra* note 150, at 25.
207. National Family Health Survey, *supra* note 184, at 79.
208. *Id.*, at 54.
209. *Id.*, at 71.
210. *Id.*, at 54.
211. Statistics collected from the Ministry of Health by CEMUJER, El Salvador, July 1997 (on file with CRLP).
212. Revised penal code, art. 409.
213. *Id.*, Bk. II, Ch. II in Special Part.
214. Superseded penal code, art. 169. According to the Penal Code that was recently replaced, abortion was not punishable when performed under the following circumstances: (a) when the abortion was the result of an accident, not caused by the pregnant woman; (b) to protect the pregnant woman's life when there was no other alternative; (c) when the pregnancy was the result of rape; and (d) to avoid an inevitable abnormality in the fetus.
215. Revised penal code, art. 133.
216. *Id.*
217. *Id.*
218. *Id.*
219. *Id.* Also see section on Regulation of Health Professionals.
220. *Id.*, art. 136.
221. *Id.*, art. 137.
222. *Id.*, art. 133.
223. *Id.*
224. *Id.*, art. 134.
225. *Id.*, see also section on "Regulation of Health Professionals."
226. *Id.*, art. 136.
227. *Id.*
228. *Id.*
229. *Id.*, art. 137.
230. *Id.*
231. *Id.*, art. 373.
232. *Id.*, art. 374.
233. *Id.*, art. 373.
234. *Id.*, art. 374.
235. National Report, *supra* note 95, at 57.
236. *Id.*
237. *Id.*, p 58.
238. Health Code, art. 154.
239. *Id.*
240. *Id.*, art. 131.
241. *Id.*, art. 134.
242. *Id.*, art. 135.
243. *Id.*, art. 136.
244. *Id.*, art. 137.
245. *Id.*, art. 153.
246. El Sal. Const., art. 66.
247. For a discussion about the nature and functions of the NWP, see section on women's bureaus.
248. National Women's Policy, *supra* note 170, at 32.
249. *Id.*, at 131.
250. Norma Virginia Guirola de Herrera Institute for Women's Studies ("CEMUJER"), at 1-2 (inter-institutional communiqué, Aug. 22, 1997, on file with CRLP).
251. El Sal. Const., art. 3.
252. *Id.*
253. Andean Commission of Jurists and Manuela Ramos Movement, Instrumentos Internacionales de Protección de los Derechos de la Mujer [International Instruments for the Protection of Women's Rights], at 105 and 108 (1997). El Salvador is a party to, among others: The Inter-American Convention on the Nationality of Women, *adopted* Dec. 26, 1933, O.A.S.T.S. 4 (*entry into force* Aug. 29, 1934) (ratified by El Salvador on June 14, 1936) and the Inter-American Convention on the Granting of Civil Rights to Women, *adopted* May 2, 1948, O.A.S.T.S. 23 (ratified by El Salvador on Mar. 27, 1951).
254. CEMUJER, *supra* note 250, at 3.
255. El Sal. Const., art. 32.
256. *Id.*
257. *Id.*
258. Family Code, Decree No. 677, Nov. 22, 1993.
259. Country Reports on Human Rights, *supra* note 10, at 447.
260. Family Code, art. 11.
261. *Id.*, art. 36.
262. *Id.*, art. 37.
263. *Id.*, art. 38.
264. *Id.*, art. 39.
265. *Id.*
266. *Id.*
267. *Id.*, art. 42.
268. *Id.*
269. *Id.*, art. 48.
270. *Id.*, art. 51.
271. *Id.*, art. 52.
272. *Id.*, art. 62.
273. *Id.*, art. 42.
274. *Id.*
275. *Id.*, art. 48.
276. Revised penal code, art. 193.
277. El Sal. Const., art. 32.
278. *Id.*, art. 32.
279. Family Code, art. 118.
280. *Id.*
281. *Id.*, art. 119.
282. *Id.*, art. 120.
283. *Id.*, art. 121.
284. *Id.*, art. 123.
285. *Id.*
286. *Id.*, art. 125.
287. *Id.*, art. 105.
288. *Id.*, art. 106.
289. *Id.*
290. *Id.*
291. *Id.*
292. *Id.*, art. 108.
293. *Id.*, art. 113.
294. *Id.*, art. 111.
295. *Id.*, art. 113.
296. *Id.*, art. 115.
297. El Sal. Const., art. 103.
298. *Id.*, art. 102.
299. *Id.*
300. Country Reports on Human Rights, *supra* note 10, at 447.
301. National Report, *supra* note 95, at 40.
302. *Id.*, at 39.
303. *Id.*, at 58.
304. El Sal. Const., art. 37.
305. *Id.*, art. 38, cl. 1.
306. *Id.*
307. *Id.*, art. 42.
308. *Id.*
309. *Id.*, arts. 172 and 190.
310. Labor Code, Decree No. 15, Jun. 23, 1972.
311. *Id.*, art. 123.
312. *Id.*, art. 309.
313. *Id.*

314. *Id.*, art. 312.
315. *Id.*, art. 110.
316. *Id.*, art. 50.
317. *Id.*, art. 113.
318. *Id.*
319. See section on Property Rights.
320. NATIONAL REPORT, *supra* note 95, at 38.
321. *Id.*
322. EL SAL. CONST., art. 56.
323. *Id.*
324. NATIONAL REPORT, *supra* note 95, at 43.
325. *Id.*, at 44.
326. *Id.*, at 48.
327. *Id.*, at 47.
328. *Id.*, at 37.
329. Legislative Decree No. 644, Feb., 1996.
330. *Id.*, art. 1.
331. *Id.*
332. *Id.*, art. 3.
333. NATIONAL WOMEN'S POLICY, *supra* note 170, at 6.
334. *Id.*, at 16.
335. *Id.*, at 18.
336. *Id.*, at 24.
337. *Id.*, at 31.
338. *Id.*, at 35.
339. *Id.*, at 43.
340. Dr. Robert Mansferrer Legal Medical Institute (on file with CRLP).
341. *Id.*
342. Complaints presented to the "Casa Morada de la Mujer," CEMUJER, located in the San Salvador metropolitan area (on file with CRLP).
343. Revised penal code, Tit. IV, Ch. I of Special Part, arts. 158 and 162.
344. *Id.*, art. 158.
345. *Id.*
346. *Id.*, art. 160
347. *Id.*
348. *Id.*, second ¶.
349. *Id.*, art. 162, cl. 1.
350. *Id.*, cl. 2.
351. *Id.*, cl. 5.
352. *Id.*, cl. 6.
353. *Id.*, art. 174.
354. Superseded PENAL CODE, art. 196.
355. *Id.*
356. Revised PENAL CODE, art. 165.
357. *Id.*, third ¶.
358. Law Against Violence Within the Family, Decree No. 902, Nov. 28, 1996.
359. *Id.*, art. 6.
360. *Id.* The division created is called "The Division of Public Security in the Family Department."
361. *Id.*, art. 3.
362. *Id.* Psychological violence is defined as all actions or omissions whose purpose is to "control or degrade the actions, behavior, beliefs and decisions of other people, through intimidation, manipulation, direct or indirect threat, humiliation, isolation or any other conduct or omission that causes damage to mental health, self-determination, comprehensive development and personal opportunities."
363. *Id.* Physical violence is defined as "actions, behavior or omissions that threaten or wound the physical integrity of a person."
364. *Id.* Sexual violence is defined as "actions that force a person to engage in physical or verbal sexual contact, or to participate in such acts, through force, intimidation, coercion, blackmail, bribes, manipulation, threat or other mechanisms that nullify or limit personal free will. It is also considered sexual violence when a person is forced to carry out these acts with third persons."
365. *Id.*, art. 7.
366. *Id.*
367. *Id.*, art. 8.
368. *Id.*
369. *Id.*, art. 13.
370. *Id.*, art. 20.
371. Revised PENAL CODE, art. 200.
372. *Id.*
373. *Id.*, art. 375.
374. THE WORLD'S WOMEN 1995, *supra* note 156, at 27.
375. *Id.*, at 32.
376. NAPOCO, Statistics and Census 1992 (on file with CRLP).
377. NATIONAL FAMILY HEALTH SURVEY, *supra* note 184, at 54.
378. *Id.*, at 65.
379. FAMILY CODE, art. 14.
380. *Id.*, art. 18.
381. *Id.*
382. *Id.*
383. *Id.*, art. 19.
384. *Id.*
385. *Id.*
386. Revised PENAL CODE, Tit. IV, Chs. I-IV.
387. *Id.*, art. 159.
388. *Id.*, art. 12.
389. *Id.*, art. 160.
390. *Id.*
391. *Id.*, art. 163.
392. *Id.*
393. *Id.*
394. *Id.*, art. 165.
395. *Id.*, art. 166.
396. *Id.*
397. *Id.*, art. 164, second ¶.
398. *Id.*, art. 167.
399. *Id.*
400. *Id.*, art. 168.
401. EL SAL. CONST., art. 55.
402. MINISTRY OF EDUCATION, NATIONAL EDUCATION DIRECTION, REFORMA EDUCATIVA EN MARCHA. EDUCACIÓN MEDIA [EDUCATION REFORM IN PROCESS. MEDIA EDUCATION] (1996).
403. *Id.*, at 239.

Guatemala

Statistics

GENERAL

Population

- Guatemala has a total population of 11.2 million, of which 49.5 % are women.[1] The growth rate is approximately 2.8% per year.[2]

- In 1996, 44.7% of the population was under 15 years old[3] and 5.3% was over 60.[4]

- In 1997, 41%[5] of the population lived in urban areas and 52% in rural areas.[6]

Territory

- Guatemala has a surface area of 105,105 square kilometers.[7]

Economy

- In 1994, the World Bank estimated the gross national product per capita at U.S.$1,200.[8]

- From 1990 to 1994, the gross domestic product grew at an estimated rate of 4.1%, compared with the period from 1980 to 1990, when the growth rate was 0.8%.[9]

- In 1990, the Guatemalan government invested U.S.$9.2 million in health.[10]

Employment

- In 1994, approximately 3.2 million people were employed in Guatemala.[11] Women comprised 25% of the labor force.[12]

WOMEN'S STATUS

- The average life expectancy for women is 68 years, compared with 63 years for men.[13]

- Illiteracy continues to be a problem that affects primarily women. The illiteracy rate for women in urban areas is 12.63%; in rural areas it is 49.42%.[14]

- The unemployment rate for the economically active population in Guatemala is 6.4%[15]. Women make up 3.8% of that population in urban areas and 2.5% in rural areas.[16]

- In 1994, women made up 8% of the agricultural labor force, 17% of the labor force in the industrial sector, and 74% of the service sector.[17]

- Violence against women, especially within the family, is a significant problem. In 1991, a study conducted in thirteen health departments revealed that a large number of women who have been assaulted seek help in health centers. However, the help they receive is restricted to medical care, such as treatment for bruises, abrasions, miscarriages, and other injuries.[18]

ADOLESCENTS

- Approximately 46% of the population of Guatemala is under 15 years of age.[19]

- The median age at first marriage is 20 years.[20]

- According to figures from the Ministry of Public Health and Social Assistance, 87% of pregnancies occur in women between the ages of 20 and 35 years.[21]

MATERNAL HEALTH

- The total fertility rate is 5.4 children per woman.[22] This figure decreases in urban areas to 3.6 children per woman[23] but grows considerably in rural areas,[24] to 6.6 children per woman.[25]

- The maternal mortality rate is 200 deaths per 100,000 live births.[26]

- From 1995 to 2000, it is estimated that the infant mortality rate will be 40 deaths per 1,000 live births.[27]

- In Guatemala, 35% of births are attended by a health professional.[28]

CONTRACEPTION AND ABORTION

- 32% of Guatemalans of reproductive age use some form of contraception.[29] Within this group, 27% use modern methods of family planning.[30]

- From May to November 1995, 1,644 packets of birth control pills and 407 packets of condoms were distributed;[31] there were 2,281 operations to place intrauterine devices; and 11,688 voluntary surgical sterilizations took place.[32]

- There are no figures on the overall incidence of abortion. However, the Ministry of Public Health and Social Assistance (MPHSA) indicates that 76% of women who suffer complications from abortion procedures have had at least one previous abortion.[33]

HIV/AIDS AND STIS

- In 1996, 936 cases of AIDS were reported.[34] The pattern of infection by sex is three men to every one woman.[35]

- Those between the ages of 20 and 50 years make up the highest percentage of HIV/AIDS sufferers.[36]

- In 1994, the most common sexually transmissible infections found in the Guatemalan population were gonorrhea (16.7 cases per 1,000 inhabitants) and syphilis (2.98 cases per 1,000 inhabitants).[37]

ENDNOTES

1. PRO-FAMILY ASSOCIATION (APROFAM), CALENDARIO DEMOGRÁFICA 1997 ["DEMOGRAPHIC CALENDAR" 1997], annex B, at 3 (1996).
2. UNITED NATIONS POPULATION FUND, THE STATE OF WORLD POPULATION 1997, at 72 (1996).
3. DEMOGRAPHIC CALENDAR, supra note 1.
4. Id.
5. Id.
6. Id.
7. THE WORLD ALMANAC AND BOOK OF FACTS 1997, at 769 (1996).
8. WORLD DEVELOPMENT REPORT 1996: FROM PLAN TO MARKET, at 188 (1996).
9. Id.
10. Statistics and Quantitative Analysis, Guatemala (visited on July 14, 1997)<http://iadb6000.iadb.org/~http/guatemala/gubsed.html>.
11. Id.
12. WORLD DEVELOPMENT REPORT, supra note 8, at 194.
13. THE WORLD ALMANAC, supra note 7, at 770.
14. SECRETARY GENERAL FOR ECONOMIC PLANNING, PLAN DE DESARROLLO SOCIAL 1996–2000 (PLADES 1996-2000) [SOCIAL DEVELOPMENT ACTION PLAN 1996–2000 (PLADES 1996–2000)], at 3 (1996).
15. Statistics and Quantitative Analysis, supra note 10.
16. UNITED NATIONS, THE WORLD'S WOMEN 1995: TRENDS AND STATISTICS, U.N. Doc. ST/ESA/STAT/SER.K/12, at 133 (1995).
17. Id., at #158.
18. REPORT OF THE REPUBLIC OF GUATEMALA TO THE FOURTH WORLD CONFERENCE ON WOMEN: ACTION FOR EQUALITY, DEVELOPMENT AND PEACE, THE FUTURE APPLICATION OF THE STRATEGIES OF NAIROBI FOR THE ADVANCEMENT OF WOMEN, at 178 (1994).
19. DEMOGRAPHIC CALENDAR, supra note 1, at 4.
20. THE WORLD'S WOMEN, supra note 16, at 38.
21. THE MINISTRY FOR PUBLIC HEALTH AND SOCIAL ASSISTANCE (MPHSA), REPRODUCTIVE HEALTH UNIT, PLAN OPERATIVA 1996 [OPERATIVE PLAN 1996], at 2 (1996).
22. THE WORLD'S WOMEN, supra note 16, at 32.
23. DEMOGRAPHIC CALENDAR, supra note 1, at 7.
24. Id., Jutiapa Province.
25. Id.
26. THE STATE OF WORLD POPULATION, supra note 2, at 69.
27. Id.
28. Id.
29. Id.
30. Id.
31. OPERATIVE PLAN, supra note 21, at 6.
32. Id.
33. Id.
34. MPHSA, GENERAL OFFICE OF HEALTH SERVICES, NATIONAL PROGRAM TO PREVENT AND CONTROL HIV/AIDS, MANUAL DE CONSEJERIA EN VIH/SIDA/ETS PARA PROFESIONALES DE SALUD [GUIDELINES ON HIV/AIDS/STIS FOR HEALTH PROFESSIONALS], at 1 (1996).
35. Id.
36. Id.
37. MPHSA, NATIONAL PROGRAM FOR THE PREVENTION AND CONTROL OF HIV/AIDS. A SYMPTOMATIC FOCUS ON SEXUALLY TRANSMISSIBLE INFECTIONS, at 1 (1996).

Guatemala, which was part of the ancient Maya empire,[1] is located in Central America. Mexico borders it to the north, El Salvador to the south, and Honduras and Belize to the east.[2] The official language is Spanish, although several Maya dialects predominate in some regions of the country.[3] The predominant religion is Roman Catholicism.[4] In terms of ethnic composition, 56% of the country's inhabitants are mestizo, and 44% are indigenous.[5] Guatemala was a Spanish colony from 1524 until 1821, when it obtained independence.[6]

Guatemala has had a series of civilian and military governments and violent periods of civil war.[7] As a result of this political violence, more than 100,000 people have been killed since 1961, another 40,000 have been reported as "disappeared," and thousands have sought refuge in Mexico and other neighboring countries.[8] Alvaro Arzú Irigoyen, the current democratically elected president of Guatemala, took office on January 14, 1996.[9] The peace negotiations between the Guatemalan government and the armed rebel group[10] ended with the signing of the Peace Accords on December 29, 1996, after nine years of arduous negotiation, ending 36 years of civil war.[11]

I. Setting the Stage: the Legal and Political Framework

The legal and political systems of a country determine the framework for women to exercise their reproductive rights, and for governments to enact the policies that affect women's reproductive lives. To understand how laws are made, interpreted, modified, and implemented, as well as the process through which policies regarding women's reproductive health and population issues are enacted, it is necessary to understand the foundation and structure of the legal and political systems.

A. THE STRUCTURE OF THE NATIONAL GOVERNMENT

The Guatemalan government is republican, presidential, democratic, and representative, as established by the Guatemalan Constitution.[12] Sovereignty is rooted in the people, who delegate this authority to the three branches[13] of government that represent them: the legislative, the executive, and the judicial.[14] None of these branches is subordinate to any other.[15] However, the Constitution establishes mechanisms of checks and balances between the three branches, as a means of ensuring the proper administration of the country's affairs and respect for rights and freedoms.[16] Such mechanisms include the right of Congress to question[17] a minister of state,[18] the right of the president of the republic to veto any law passed by Congress,[19] and the right to prior review of dismissal[20] for magistrates and judges of the republic.[21]

Executive Branch

The executive branch is comprised of the president of the republic, the cabinet ministers, and all officials working within the ministries.[22] The president is elected for a period of four years by secret universal suffrage.[23] The president is the head of the Guatemalan state, and is charged with: upholding and implementing the Constitution and the law, approving and promulgating laws and decrees when he is authorized to do so, leading the armed forces, directing international affairs, and performing other functions as established by the Constitution.[24]

The ministries are responsible for implementing government policies;[25] each ministry is the responsibility of a minister of state.[26] Ministers design and develop policies for their ministry, or sector.[27] Ministers must approve the decrees, resolutions, and regulations issued by the president relating to their sector in order for them to be valid.[28]

Legislative Branch

The legislative power resides with the Congress of the Republic ("Congress"),[29] which is composed of ninety-eight deputies elected for a period of four years by secret universal suffrage.[30] Congressional deputies represent the people and they are considered high officers of the nation.[31] They enjoy a special privilege that protects them from being arrested or tried without a prior resolution of the Supreme Court of Justice establishing the lawfulness of criminal proceedings.[32] Congress has the power to pass, amend, and repeal laws.[33] The following entities have the power to introduce legislation:[34] congressional deputies, the executive branch, the Supreme Court of Justice, the University of San Carlos of Guatemala, and the Supreme Electoral Council.[35]

Once a bill is passed, Congress sends it to the president for approval, promulgation, and publication.[36] The president has fifteen days to return the bill to Congress if he or she has any modifications or reservations.[37] If the president does not return or promulgate the law within this fifteen-day period, Congress must promulgate it by the eighth day after the end of the fifteen-day period[38] with the approval of two-thirds of its members.[39]

Judicial Branch

The Supreme Court of Justice and other courts exercise the judicial function exclusively as established by law.[40]

The judicial branch[41] is composed of the Supreme Court of Justice;[42] the Court of Appeals and the collegiate tribunals (courts composed of several judges);[43] the courts of first instance;[44] and the lower courts.[45] The Supreme Court of Justice is the highest appeals court in Guatemala.[46] Its president presides over both the Supreme Court of Justice and the

judicial branch.[47] The Supreme Court is composed of nine judges, four of which are directly elected by Congress and five of which are selected from among thirty candidates nominated by the Nomination Commission.[48] Supreme Court judges are elected for a six-year period.[49] The Supreme Court of Justice established the Court of Appeals and the collegiate tribunals, the courts of first instance, and the lower courts or justices of the peace.[50] It determines their territorial jurisdiction and the number of tribunals or courts in Guatemala.[51]

The Guatemalan justice system is regulated by a series of principles established by the Constitution, such as functional and economic independence,[52] and the right to contest a decision through the process of judicial review.[53] The Law of the Judicial Branch establishes that access to the judicial system is free of charge.[54] With the exception of the military courts, only entities pertaining to the judicial branch administer justice.[55] The death penalty may be applied as provided by the Constitution,[56] with certain exceptions.[57] The death penalty cannot be imposed on women, persons over the age of 60, or persons convicted of political crimes.[58]

The Attorney General's Office, an auxiliary institution of the civil service,[59] is charged with upholding the law in Guatemala.[60] The Attorney General is the head of the Attorney General's Office, and is responsible for bringing judicial actions on behalf of the public.[61]

B. THE STRUCTURE OF THE NATIONAL GOVERNMENT

Regional and local governments

The system of government in Guatemala is decentralized.[62] The country is politically divided into departments, or states, which are in turn divided into municipalities.[63] A governor named by the President of the Republic heads the departmental governments.[64] This governor is head of the Departmental Council,[65] which comprises the mayors of the municipalities and representatives of organized groups within the public and private sectors.[66] The objective of the Departmental Council is the promotion and development of the department.[67] Municipalities are autonomous institutions of local government.[68] The Municipal Council[69] governs the municipality. It is elected by universal popular vote for a period of four years.[70]

With the aim of fostering the country's development, the Constitution provides for the possibility of creating development regions,[71] which may be established according to certain economic, social, and cultural criteria.[72] These regions may comprise one or more departments.[73] The National Council of Urban and Rural Development[74] is charged with formulating national policies relating to urban and rural development as well as territorial organization. It is under the supervision of the president of the republic.[75] Each region has a Regional Development Council,[76] composed of a representative of the president of the republic, the governors of the departments who belong to the region, a representative of the municipalities of each of the departments, and representatives of public and private entities as established by law.[77]

C. SOURCES OF LAW

Domestic sources of law

The laws that determine the legal status of women and their reproductive rights come from different sources. In the Guatemalan legal system, the formal sources of legislation are hierarchically organized into different levels, at the apex of which is the Constitution, which takes primacy over all other sources of law.[78] Next come international treaties that do not involve human rights issues; followed by laws and other governmental or regulatory decrees.[79] No law may violate the dispositions established in the Constitution.[80] In the case of incompatibility between the Constitution and a given law, judges must decide in favor of the former,[81] except where human rights issues are involved, in which case international treaties prevail over domestic law.[82] Laws are applicable throughout the national territory eight days after their publication in the official Daily Gazette.[83]

"Jurisprudence"[84]—or a series of court decisions deciding the same legal issue — is a complementary source of law in accordance with the Constitution.[85] Custom and usage is recognized as a source of law, but only when an applicable law is defective or when expressly permitted by law.[86] Upon signing the Peace Accords, the Guatemalan government committed itself to enacting laws that recognize the right of the country's indigenous communities to follow their own legal customs, "as long as such customs are not incompatible with the fundamental rights defined by the domestic legal system or with internationally recognized human rights."[87]

International sources of legislation

Several international human rights treaties recognize and promote specific reproductive rights. Governments that adhere to such treaties are legally obligated to protect and promote these rights. International treaties constitute the principal international source of legislation in Guatemala, and treaties ratified by the Guatemalan government form part of domestic law. When international treaties involve human rights issues, they prevail over domestic law, including the Constitution.[88] When the courts in Guatemala apply the law, they must observe the principle of the supremacy of international human rights treaties that have been signed and ratified by the government.[89]

The president may sign, ratify, or withdraw from treaties or conventions without prior authorization from Congress.[90]

The exception is when they modify existing laws, affect real property under the control of the government, commit the state to financial expenditures, contain general clauses of arbitration, or obligate the state to submit any issue to international judicial decision or arbitration.[91] In such cases, the president must submit these treaties to Congress, which must approve the treaty before its ratification.[92]

Guatemala is a member state of the United Nations and the Organization of American States. As such, it has signed and ratified most of the international treaties dealing with the universal system of protection of human rights.[93] In particular, Guatemala has ratified several treaties related to the protection of women's human rights in the universal and the Inter-American systems,[94] such as the Convention on the Elimination of All Forms of Discrimination Against Women[95] and the Inter-American Convention on the Prevention, Punishment and Eradication of Violence Against Women (Convention of Belem do Pará).[96]

II. Examining Health and Reproductive Rights

In Guatemala, issues referring to the reproductive health of women are subsumed under national health and population policies. In order to understand reproductive rights in Guatemala, it is therefore necessary to analyze both the laws and the government's programs in population and health.

A. HEALTH LAWS AND POLICIES

Objectives of the health policy

As part of its national development and planning programs,[97] the Guatemalan government has prioritized the war against poverty by creating greater opportunities for the population to access education, health, and other basic services.[98] For the period from 1996 to 2000, the Ministry of Public Health and Social Assistance ("MPHSA") defines the specific objectives of the health care sector as the modernization;[99] increasing the coverage and improving the quality of the health care services provided;[100] improving hospital administration;[101] and improving infrastructure.[102] Other goals for the health care sector during the same period include: the reduction of infant mortality;[103] the reduction of maternal mortality;[104] and the increase in the number of births attended by health professionals.[105]

The MPHSA will seek to achieve these objectives and goals through the following strategies: administrative modernization, decentralizing services, and developing health programs for the neediest groups.[106]

Infrastructure of health services

The infrastructure of the health care sector consists of public entities and establishments ("public health subsector"),[107] private institutions, nongovernmental organizations ("NGOs"), and groups and institutions that practice the traditional medicine of the various ethnic groups throughout the country.[108] In terms of the provision of services, the public health subsector-comprises health establishments that are classified as follows ,according to their capacity for treatment and their resources:[109] health stations, which provide minimal, basic treatment;[110] type "B" health centers and type "A" health centers, which provide intermediate treatment;[111] district and area hospitals, which provide comprehensive treatment;[112] and regional and national hospitals,[113] which treat the most complex illnesses and pathologies, and whose headquarters are in the capital city (Guatemala City).[114] As of 1996, there were 860 health stations, 131 type "A" health centers, 217 type "B" health centers, and 60 hospitals.[115]

Existing private health establishments primarily offer health services in urban areas. These establishments include 71 medical centers, services offered by private companies, and 2,526 private clinics.[116] NGOs that specialize in health services operate four hospitals and 637 private health centers throughout the country.[117]

In terms of human resources, there are approximately 51,500 health care professionals, staffing the network of services offered by the health sector of which 57% work in institutions pertaining to the public health subsector.[118] The MPHSA operates twelve technical schools, seven of which train personnel as comprehensive health care providers.[119] Training for the medical and nursing professions is carried out largely through exposure to treatment methods in hospitals, as opposed to more preventive forms of treatment.[120] While only 20% of the total population resides in the capital, more than 80% of medical professionals within the public health subsector work in Guatemala City, and 46% of the total hospital beds of the health sector are located there.[121] The Guatemalan government has recognized that there are serious deficiencies in both quantity and quality in the provision of health services.[122] The government has also noted that more than 64% of all deaths in Guatemala are related to the low prevalence of health services, the limited infrastructure of sewage systems and indoor plumbing, and poor nutrition.[123]

Cost of health services

The central government provides the funds required to carry out the public health sector's programs through an annual allocation within the national budget.[124] In 1996, public health expenditures have not surpassed 2.2% of Guatemala's gross domestic product.[125] Financial resources have primarily been spent on curative measures performed in hospitals rather than

on the development of preventive health programs and infrastructure projects like sewage systems and indoor plumbing.[126] Only 20 to 25% of public health expenditures over the last two years were directed at preventive programs.[127]

Regarding the cost of health services for patients, the Health Code[128] provides that preventive treatment and medical assistance in public health establishments be free of charge, with the exception of those that have an established fee prescribed by law.[129] Fees are charged for health licenses, and analyses and sales of biological products sold by the MPHSA.[130] The income generated by these services is expected to increase the amount of the national budget allocated by the government to the health sector.[131]

Regulation of health care providers

Who may legally provide health services, and of what kind? Are there meaningful guarantees of quality control within existing health services? Because the Guatemalan government regulates such matters, it is important to review the most relevant legal provisions. The conduct of health professionals as providers of health services is regulated primarily by the Ethics Code.[132] The Penal Code[133] regulates the punishment for criminal acts committed while exercising the medical profession. By constitutional mandate, medical professionals are required to become members of their professional association ("Guatemalan Association of Physicians and Surgeons") in order to exercise their profession.[134] The Ethics Code contains obligatory regulations for all affiliated physicians and surgeons. The general duties of physicians include the obligations to respect the life and dignity of all persons, protecting their health without discrimination,[135] and to maintain patient confidentiality.[136] Physicians must respect the beliefs and customs of their patients as long as these do not endanger their health.[137] They must also set their fees according to the time spent treating the person, the distance traveled, and the quality of the services provided.[138]

The Ethics Code contains certain regulations regarding the physician-patient relationship that are particularly relevant to reproductive health issues. It provides that physicians must abstain from examining the genitalia of minor females without the presence of their parents or legal guardians, except when requested by a judge or when an obstetric-gynecological emergency requires such an examination.[139] Physicians must maintain the confidentiality of the patient when testing for pregnancy and when assisting in childbirth if so requested by the patient, except when the patient is a minor.[140] In cases of "criminal abortion," the physician is exempt from maintaining professional confidentiality.[141] It is important to note that the Ethics Code prohibits sterilization except when medically necessary to prevent imminent danger to the life of the patient and after all other treatment methods have been exhausted.[142] This regulation conflicts with the policy of the MPHSA, which offers voluntary surgical sterilization as a method of family planning.[143] The Ethics Code also ratifies the prohibition against abortion,[144] and stipulates that only medical professionals may perform therapeutic abortions, in accordance with the Penal Code.[145] The Penal Code penalizes crimes that involve the participation of health professionals, such as performing an abortion,[146] and the illegal prescription of drugs.[147]

Patients' rights

Laws also seek to ensure quality health services by protecting the rights of patients. The rights of patients are protected by the Constitution, the bylaws of the Guatemalan Association of Physicians and Surgeons,[148] and the Ethics Code. The Constitution provides that it is the government's duty to defend the health, security, and economic interests of consumers and service users generally.[149] The government, therefore, is charged with overseeing the quality of foodstuffs, pharmaceutical and chemical products, and all other products that could affect the health and well being of the population.[150]

The Ethics Code mandates the review of any professional who violates its standards by the Tribunal of Honor of the Medical Association,[151] which acts as an ex-officio court for the profession.[152] Any person who contends that a physician or surgeon "has made an ethical breach or has violated the honor or prestige of his or her profession"[153] may present a complaint to the professional association.[154] The Tribunal of Honor then may impose any of the following penalties,[155] depending on the seriousness of the violation: a private warning, a public warning, a fine, temporary suspension from exercising the profession, and permanent suspension from exercising the profession.[156]

The Penal Code also provides protection to patients in cases of medical negligence. Negligence, which is categorized in the Code as a crime of "injury", is punished with three months, to twelve years, imprisonment, depending upon the gravity of the injury.[157] In terms of the rights of patients as consumers, the Regulations on Medicines, Narcotics, Psychotropic Drugs, and Beauty and Personal Hygiene Products for the Home and Pharmaceutical Establishments[158] regulate the sale of pharmaceutical products.[159] These regulations establish that the Department of Medicine Control, a department of the General Office of Health Services,[160] oversees the regulation of medicine, beauty and personal hygiene products, foodstuffs for medical use, therapeutic devices, and household pesticides.[161] It also regulates pharmaceutical establishments.[162]

B. POPULATION, REPRODUCTIVE HEALTH AND FAMILY PLANNING

The population, reproductive health, and family planning policies currently in force in Guatemala are outlined in the Government Program,[163] the Plan of Action for Social Development ("PLADES 1996-2000"), the Women, Health and Development Program ("WHD"), and the Operative Plan of the Reproductive Health Unit of the MPHSA ("Operative Plan").[164]

Laws and policies on population

While there is no specific population policy in Guatemala, the Government Program proposes that demographic policies be developed that "respect the right to life from the moment of conception,"[165] and that programs be implemented that promote family unity.[166] PLADES 1996-2000 mandates that the government give particular attention to satisfying the basic material and spiritual needs of the family.[167] Specifically, it requires the implementation of strategies such as training and orientation programs on family-related issues.[168]

Regarding population distribution, the government seeks to promote a more equitable distribution throughout the country of sources of employment and income, in order to help satisfy basic needs nationwide.[169]

Laws and policies on reproductive health and family planning

The Constitution includes several provisions related to sexual and reproductive rights. It mandates that the government promote responsible parenting and the right of all persons to choose freely the number and spacing of their children.[170] It also states that the government must provide special protection to mothers.[171] Guatemala has an annual population growth rate of 2.9%.[172] One of the goals of the health sector for the period from 1996 to 2000 established by the MPHSA is to achieve a minimum increase of 10% in contraceptive prevalence among married or cohabiting women.[173]

The WHD Program was created in 1989 as part of the MPHSA.[174] Its objectives include developing programs to treat health problems specific to women; incorporating a gender perspective in the proposal and development of different health initiatives; and training the health personnel of the public health subsector using this new perspective.[175] In a study carried out in 1994, the WHD has identified the existence of gender discrimination within the health sector. The WHD has also undertaken a study of domestic violence and its impact on women's health.[176]

In order to implement the government's reproductive health programs, the MPHSA created the Reproductive Health Unit ("RH Unit") to organize and coordinate these programs within the public health subsector.[177] The Operative Plan of the RH Unit states that the MPHSA seeks to improve the health of Guatemalan women and children by strengthening the provision of reproductive health services, with special emphasis on rural communities.[178] Its specific objectives include expanding the population's access to information about reproductive health[179] and coordinating the development of the RH Unit's reproductive health programs with local NGOs.[180]

The RH Unit, which is the only government agency that directly addresses the issue of reproductive health, is currently at risk of being eliminated. This is primarily due to the lack of support on the part of the MPHSA and to the fact that its importance to the country's social and economic development has not been widely recognized.[181]

Government delivery of family planning services

The RH Unit is responsible for providing family planning services in public health subsector establishments.[182] The RH Unit operates in eight of the twenty-four existing "health areas" in Guatemala.[183] Its activities include: providing training workshops on the use of contraceptive methods to health care personnel;[184] providing medical and surgical supplies;[185] and providing contraception to those who request it.[186] In an effort to develop a comprehensive approach to service provision, the RH Unit's activities are carried out in coordination with other public and private entities that deal with reproductive health.[187]

While there is no specific law or regulation requiring that the government provide family planning services free of charge, the Health Code states that in government-run establishments, preventive treatment and medical care must be provided to all Guatemalan citizens free of charge. Certain services are exempted from this provision by law.[188] The RH Unit is responsible for the distribution of contraceptives.[189]

C. CONTRACEPTION

Prevalence of contraceptives

According to recent statistics, the current prevalence of contraceptive methods among married or cohabiting women in Guatemala is 31.4%,[190] compared to 23% between 1986 and 1993.[191] The modern contraceptive methods most commonly used by married or cohabiting women are: female sterilization (14.3%), the birth control pill (3.8%), the intrauterine device (IUD); (2.6%), injectable hormonal contraceptives (2.5%), and the condom (2.2%).[192] The traditional rhythm method—periodic abstinence—is currently used by 3.6% of married or cohabiting women in Guatemala.[193]

During the period from May to November 1995, the RH Unit of the MPHSA distributed 1,644 packages of birth control pills and 407 packages of condoms.[194] The RH Unit also carried out 2,281 IUD insertions and performed 11,688 voluntary surgical sterilizations during this period.[195]

Legal status of contraceptives

Guatemalan law does not restrict women's right to obtain and use contraceptive methods. However, the Ethics Code of the Guatemalan Association of Physicians and Surgeons expressly prohibits the practice of sterilization as a method of contraception,[196] despite the fact that it is a family planning method offered by the MPHSA.[197]

The Department of Medicine Control, supervised by the General Office of Health Services, is responsible for regulating the sale of contraceptive methods in pharmacies or other establishments selling pharmaceutical products.[198] This department authorizes, inspects, and exercises general control over the entities that produce, store, or distribute such products.[199] Pharmaceutical products of any kind may be sold only in laboratories, drug stores, and pharmacies[200] that have been licensed by the Department of Medicine Control,[201] which regulates these establishments.[202] The sale of such products by street vendors, whether in vehicles, streets, plazas, markets, or other public places, is strictly prohibited.[203]

Regulation of information on contraception

There are no regulations restricting information about contraceptive methods or technologies. One of the responsibilities of the RH Unit is to carry out informational campaigns on reproductive health to patients and the public in general in the waiting rooms of public health establishments.[204]

PLADES 1996-2000 calls for the development of educational programs regarding the family, women's status, respect for women, and children's rights.[205] The government has proposed to carry out this mandate through a mass media campaign. This campaign aims at reaching 50% of the population with messages that promote respect for and the recognition of the rights of women and children[206] and offer advice to parents on family issues.[207] PLADES 1996-2000 does not specify the content of these programs, which are to be supervised by the appropriate governmental agency.[208]

Sterilization

Voluntary surgical sterilization is one of the family planning methods provided by the establishments of the RH Unit of the MPHSA,[209] despite the fact that the Ethics Code applicable to doctors permits sterilization only when medically required.[210] In such cases, written authorization of the patient's free and voluntary acceptance of this procedure is required before performing the operation. In addition, two physicians must concur that sterilization is medically indicated.[211]

There is no law or administrative regulation that requires health establishments to obtain the authorization of the patient and/or the spouse in cases of sterilization. In public hospitals, however, the authorization of the spouse is required for surgical sterilization.[212] Most private health establishments do not solicit the authorization of the spouse for this operation.[213] The Penal Code penalizes a person who intentionally "castrates or sterilizes" another person without his or her consent.[214]

D. ABORTION

Legal status of abortion

The state guarantees and protects human life from the moment of conception.[215] This constitutionally sanctioned principal is the basis for considering abortion a criminal act in Guatemalan domestic law.[216] Guatemala's Penal Code lists abortion among the crimes "against the life and integrity of the person."[217] "Therapeutic abortion" is an exception specifically authorized by law when abortion is necessary to save the mother's life.[218] The Penal Code penalizes "a woman who induces her own abortion or who permits another person to perform an abortion on her,"[219] as well as "any person who intentionally causes a woman to abort"[220] and any person "whose use of violence against a pregnant woman causes her to abort."[221]

Despite the fact that abortion is illegal in Guatemala, the MPHSA has recognized that abortion is of the principal and most serious health problems among the country's female population,[222] and that the MPHSA has a responsibility to develop programs through the RH Unit to combat this situation.[223] Statistics from the ministry's Maternal and Infant Department reveal that a high percentage of women have received hospital assistance for abortion-related complications and that 76% of those women had had at least one previous abortion.[224]

Requirements for obtaining a legal abortion

The Penal Code establishes essential requirements for obtaining a therapeutic abortion: "the woman's consent"[225] and a "previous diagnosis by at least one other physician concurring with this course of action."[226] The Penal Code also provides that the abortion procedure must be carried out "without the intention of directly causing the death of the fetus,"[227] with the sole intention of avoiding imminent danger to the life of the mother; and only after all other scientific and technical methods have been exhausted.[228]

Penalties

A woman who induces her own abortion, or who allows another person to perform her abortion, is liable to imprisonment for one to three years.[229] However, the law recognizes mitigating circumstances in which case the penalty is reduced. When the woman who obtains an abortion was "compelled by motives that are the product of undeniable psychological disturbance that is directly related to the pregnancy,"[230] the penalty is six months to two years of imprisonment.[231] A person who performs an abortion with the pregnant woman's

consent is subject to one to three years of imprisonment.[232] A person who performs an abortion without the woman's consent is subject to three to six years' imprisonment.[233] In the latter case, if the person used violence, threats, or deceit, the penalty is four to eight years' imprisonment.[234]

If a women who has consented to an abortion dies because of the procedure, the person performing it is liable to three to eight years' imprisonment.[235] If an abortion followed by death was performed without the woman's consent, the person performing it is liable to four to twelve years' imprisonment.[236]

When the person performing the abortion is a medical professional who "abuses his or her profession by performing an abortion or cooperating in the performance of such procedure,"[237] the above-mentioned penalties are applied, plus the additional penalties of a fine of 3,000 *quetzales* and suspension from the practice of medicine for a period of two to five years.[238] The same penalties apply when the performer is a medical intern or a person with another type of health degree.[239] The Penal Code expressly states that attempted abortion[240] and "unintentional" abortion[241] are not criminally sanctioned.[242]

E. HIV/AIDS AND SEXUALLY TRANSMISSIBLE INFECTIONS (STIs)

Examining the issue of HIV/AIDS within a reproductive rights framework is essential insofar as the two issues are interrelated from the medical and public health standpoints. Moreover, a comprehensive evaluation of the laws and policies affecting reproductive health in Guatemala must examine HIV/AIDS and STIs given the dimensions and implications of both diseases. Between 1984 and June 1996, 936 cases of HIV/AIDS were reported in Guatemala.[243] The pattern of infection by sex is three men to every one woman.[244] The highest incidence of infection is among people between the ages of 20 and 50.[245] Statistics on STIs show that for 1994, the rate of incidence was 16.7 cases of gonorrhea per 1,000 inhabitants[246] and 2.98 cases of syphilis per 1,000 inhabitants.[247]

Laws affecting HIV/AIDS and STIs

The laws governing HIV/AIDS and STIs regulate the rights and duties of persons infected with HIV/AIDS and of health establishments. The law states that blood tests may not be required to obtain goods or services, or to access educational establishments or to obtain medical attention.[248] It protects the right of all people to dignified and respectful treatment, and it prohibits discrimination against people due to their status as carriers of the HIV/AIDS virus.[249] It also establishes that the results of all blood tests are strictly confidential.[250] However, health professionals are required to notify the nearest health authority when a case of AIDS or HIV infection is diagnosed.[251] Health institutions pertaining to the MPHSA are required to provide counseling and psychological assistance to all persons who are notified that they are HIV-positive.[252]

In Guatemalan criminal law, a person who is aware that he or she has a "venereal disease" and knowingly exposes another person to infection is penalized with a fine of 50 to 300 *quetzales*.[253] If infection occurs, in addition to the fine, the offender is penalized with a prison term of two months to one year.[254]

Policies affecting prevention and treatment of HIV/AIDS and STIs

In 1987, the Guatemalan government created an advisory body, the National Commission to Prevent and Control AIDS ("the AIDS Commission"),[255] to coordinate all programs nationwide dealing with the prevention and control of the disease.[256] The AIDS Commission has a representative from each of the following institutions: the MPHSA, the Medical Association, universities, the ministries of Education and Government, social service organizations, religious institutions, and the media.[257] The main function of the AIDS Commission is to systematize the control and prevention of AIDS and to propose national policies and laws to reach its goals.[258]

For the period from 1996 to 2000, the MPHSA established the National Plan to Prevent and Control HIV/AIDS.[259] The principal objective of this program is to diminish the incidence of HIV infection and, thereby, of AIDS, through health promotion programs directed at the population at large and at high-risk groups in particular.[260] To obtain these ends, the MPHSA has organized its activities along three lines of action: epidemiological control of HIV/AIDS infection;[261] the promotion of health and counseling for the prevention of HIV infection;[262] and the treatment and monitoring of persons with AIDS.[263] In addition, through the National Office of Health Services, the ministry has published a series of informative pamphlets on HIV/AIDS and STIs for health personnel and the public in general.[264]

III. Understanding the Exercise of Reproductive Rights: Women's Legal Status

Women's health and reproductive rights cannot be fully evaluated without investigating women's legal and social status. Not only do laws relating to women's legal status reflect societal attitudes that will affect reproductive rights, but such laws often have a direct impact on women's ability to exercise reproductive rights. The legal context of family life and couple relations, a woman's access to education, her economic status, and the legal protection available to her determine a woman's ability to

make decisions concerning her reproductive health needs and to exercise her right to obtain health care services.

The Constitution recognizes the principle of equality, and provides that all human beings are free and equal in their dignity and their rights.[265] The Constitution acknowledges equal opportunities and responsibilities for men and women regardless of their marital status.[266] In addition, Guatemala is a party to several international treaties regarding women's civil rights, which recognize the equal rights of men and women and enshrine the principle of nondiscrimination against women.[267] However, as the following section suggests, Guatemalan domestic law includes provisions that are contrary to the principles of equality and nondiscrimination.

A. RIGHTS WITHIN MARRIAGE

Marriage law

The Constitution mandates that the government guarantee the social, economic, and legal protection of the family and promote its establishment on the legal basis of marriage.[268] It also provides that the government should promote equality between spouses as well as responsible fatherhood.[269] This principle is also recognized in the Civil Code, which provides that both spouses should enjoy equal rights and obligations within marriage.[270] However, the Civil Code, which has been in effect since 1963, stipulates that only the husband may legally represent the married couple—a violation of the principle of equal rights and obligations between spouses.[271] During marriage, a woman has the right to add her husband's surname to her own and to retain his name unless the marriage is dissolved through annulment or divorce.[272]

Both spouses have the right to decide jointly their place of residency, to make decisions regarding the education and rearing of their children, and to administer the household financial affairs.[273] The Civil Code provides that it is the husband's duty to protect and support his wife, and that he is required to provide all the resources necessary to maintain the household.[274] The wife has the "special" right and duty of caring for and rearing their minor children and of overseeing domestic tasks.[275] The Civil Code also provides that a woman may seek employment, exercise a profession or trade or engage in a commercial enterprise, as long as these activities do not interfere with the interests and well-being of the children and her other household responsibilities.[276] The husband may object to the wife's working outside the home at any time as long as he provides the necessary resources to sustain the household.[277]

Property rights within marriage are regulated by a "marriage contract,"[278] which is entered into by the man and woman before or during the celebration of the marriage.[279] The spouses may choose one of the following property regimes: absolute community property,[280] absolute separation of property,[281] and joint community property.[282] If no marriage contract regarding marital property rights has been agreed upon, the law provides that the regime of joint community property applies.[283] Women may not enter marriage until 300 days after the dissolution of a prior marriage. This provision was enacted to avoid uncertainty regarding paternity in case of pregnancy.[284]

The minimum age required to enter marriage without parental consent is 18.[285] Polygamy is not permitted in Guatemala. The Penal Code penalizes any person who enters a second marriage without having legally dissolved the previous marriage.[286] The same penalty is applicable to a single person who enters marriage with a married person, knowing that that person is already legally married.[287]

Until March 1996,[288] the Penal Code had defined the crime of "adultery" as the crime committed by a "married woman" who "lays with" a man who is not her husband, or by the man who "lays with" such woman "knowing that she is married."[289] The penalty for this crime was six months, to three years, imprisonment.[290] However, with respect to male adulterers, the crime, known as "concubinage" (*concubinato*) was defined to have occurred only when the man brought his lover into the conjugal home, the penalty for which was one year of imprisonment.[291] Guatemalan women's organizations successfully fought for the repeal of these criminal provisions by bringing a lawsuit seeking a declaration of unconstitutionality before the Guatemalan Constitutional Court.[292]

Regulation of "domestic partnerships"

The Constitution recognizes the legality of domestic partnerships *(uniones de hecho)*.[293] The Civil Code defines a domestic partnership as a stable union between a man and a woman who have the legal capacity to enter into marriage,[294] provided that they share a permanent and single household, have lived together continuously for more than three years as witnessed by their family members and friends, and are committed to procreating, feeding, and educating their children and mutually supporting each other.[295] Domestic partnerships are legally recognized when the couple declares their relationship before a local governmental authority.[296] This declaration is inscribed in the Civil Register,[297] and has the same legal effect as a marriage certificate.[298]

The inscription of a domestic partnership in the Civil Register has the following legal effects: the children born during the duration of the partnership are presumed to be the children of the mother's partner and[299] the property acquired during the domestic partnership is considered joint property of the couple.[300] Either partner may request the liquidation of the

couple's jointly owned property and the distribution of the property that belongs to him or her.[301] Finally, a man and woman in a domestic partnership are subject to the same rights and duties as spouses during marriage.[302] A domestic partnership may be dissolved by the mutual agreement of the partners or based on any of the grounds for divorce established in the Civil Code.[303] Reciprocal inheritance rights are recognized between a man and woman whose domestic partnership has been duly registered.[304] The prohibition against a woman remarrying during the 300 days following the death of her spouse or the dissolution of her marriage also prohibits her from entering a domestic partnership during that period. [305]

Divorce and custody law

The Civil Code establishes the categories of *separation*, which modifies a marriage, and *divorce*, which dissolves a marriage.[306] Both separation and divorce may be declared by an agreement between the spouses[307] or when one of the spouses invokes one of the legal grounds for divorce.[308] Legal grounds for separation or divorce include adultery, mistreatment, excessive slander, any behavior that makes living together impossible,[309] an attack against the life of the spouse, having conceived a child prior to the marriage without the husband's prior knowledge of the pregnancy, serious, incurable, and contagious illness that may endanger the life of the other spouse or their children, and absolute or relative inability to procreate, as long as it is incurable and was made known only after entering into the marriage.[310]

After a separation or divorce, the marital property is legally liquidated.[311] In a separation or divorce in which the husband is the party at fault, the wife has a right to alimony[312] as long as she maintains good conduct and does not remarry.[313] In addition, one of the spouses receives custody of the children. The spouse who is the party at fault in the separation or divorce is suspended from or loses parental authority over the children if the "innocent" spouse expressly requests it.[314] The Civil Code also provides that from the moment the petition for separation or divorce is filed, the woman and the children are under government protection to ensure their personal integrity and to safeguard their property until the final decree is handed down.[315] A judge determines whether provisional custody of the children is granted to the father, the mother, or a legal guardian until the divorce proceedings are settled.[316]

B. SOCIAL AND ECONOMIC RIGHTS

Property rights

The Guatemalan Constitution guarantees the fundamental right of all persons to private property and states that all persons may freely dispose of their property.[317]

However, the Guatemalan Civil Code provides specific legal restrictions on the rights of women regarding the joint ownership of property of a married couple. The husband is responsible for administering jointly owned property,[318] and the wife may legally challenge her husband's decisions only when they endanger their jointly owned property.[319] A woman may represent the married couple and administer their jointly owned property only when an injunction has been granted against the husband, when the husband abandons the household or his abandonment has been legally declared, or, when the husband is condemned to imprisonment, for the duration of his incarceration.[320]

The Civil Code provides that the disposition of or encumbrance on jointly owned real estate requires the consent of both spouses, otherwise such actions are considered null and void.[321] No laws exist that restrict women's right to inherit property. The Civil Code states that in cases in which there is no will, inheritances are regulated by law, which stipulates that only family relationships and not the sex of the persons involved are to be considered.[322]

Labor rights

Employment is protected by the Constitution as an inherent right of all persons and is declared a social obligation.[323] The Constitution provides that the protection of working women and the regulation of women's working conditions are basic social rights that must be guaranteed by labor legislation.[324] The Constitution specifically states that women must receive equal pay for equal work under equal conditions, and prohibits discrimination between single and married women.[325]

The Guatemalan government is a party to several international conventions adopted by the International Labor Organization (ILO) that protect women in the workplace, such as Convention No. 100, the Convention Concerning Equal Remuneration for Men and Women Workers for Work of Equal Value; [326] Convention No. 111, the Convention Concerning Discrimination in Respect of Employment and Occupation;[327] and Convention No. 156, the Convention concerning Workers with Family Responsibilities.[328]

The Labor Code[329] regulates nondiscrimination based on sex, family responsibility, civil status, and pregnancy.[330] It also protects working women who become pregnant, providing that they must not be subjected to work that might endanger a pregnancy.[331] It also establishes that women must be given a required rest period of thirty days prior to childbirth and forty-five days after, paid at 100% of the woman's salary.[332] Women who adopt a minor child enjoy the same benefits.[333] Working women who are breast-feeding have the right to two rest periods during the workday to breastfeed their child.[334]

Access to credit

While no laws in Guatemala exist that specifically restrict women's access to credit, this right is restricted in practice by certain civil laws that provide that the husband legally represents the married couple and administers their affairs.[335] This has been interpreted to mean that the husband alone is capable of carrying out commercial transactions. In practice, widows, abandoned women and single mothers must seek out the support of a male family member to act as their legal representative and to appear as the "head of the household" for purposes of credit applications before the government or private entities.[336]

Access to education

The Constitution provides that the government is responsible for providing and facilitating access to education for all Guatemalan citizens without discrimination.[337] Public education is provided free of charge.[338] However, illiteracy remains high and primarily affects rural women.[339] In 1994, 62% of all illiterate persons were women.[340] 20.35% of all illiterate women lived in urban areas, and 79.65% lived in rural areas.[341]

Following the Constitution, the government must provide and promote scholarships and educational loans.[342] The Constitution also establishes that education must be bilingual in areas where the population is predominantly indigenous.[343] PLADES 1996-2000 mandates that the government develop special educational programs for repatriated, refugee, and displaced women and children during the period,[344] and that it ensure that educational services are appropriate to the activities and needs of the families of each region.[345]

Women's bureaus

The National Office for Women (NOW),[346] which is part of the Ministry of Labor, is the entity of the Guatemalan government responsible for formulating policies relating to gender and the promotion of women.[347] However, NOW's budget is minuscule and it has a low status in the administrative hierarchy of government,[348] making it impossible for it to achieve its objectives in a satisfactory manner.[349] A bill currently awaiting congressional approval proposes the creation of another entity,[350] the National Institute for Women (NIW).[351]

The Ombudsman for Women of the Office of the Procurator General for Human Rights[352] is responsible for organizing workshops on women's human rights with local authorities in the country's interior, carrying out statistical studies of the situation of women in Guatemala, and providing direct services to women who have been victimized by violence.[353] Regarding criminal laws, the Attorney General's Office on Women[354] is charged with investigating and prosecuting crimes involving one or more women that are related to their being women.[355] The crimes under the purview of this office include abortion; crimes against sexual freedom, safety, and decency; and crimes related to the integrity of the family or one's marital status.[356]

C. RIGHT TO PHYSICAL INTEGRITY

The Guatemalan Constitution guarantees and protects human life and the integrity and security of all persons.[357]

Rape

Rape is categorized in articles 173 to 175 of the Penal Code as a crime "against sexual freedom and security and against decency."[358] Criminal law defines the crime of rape as the act of "laying with a woman" by the use of sufficient force to obtain this end or by taking advantage of circumstances in which the woman is unconscious or lacks the capacity to understand her actions or is otherwise incapable of resisting.[359] If the female victim is under the age of 12, the law states that a rape has occurred "in all cases" in which the aggressor had sexual relations with the victim.[360] The penalty for this crime is six to twelve years of imprisonment.[361] Under certain circumstances, the penalty for rape is more severe. The penalty is eight to twenty years[362] when two or more persons carry out the crime;[363] if the perpetrator is a relative of the victim, or if she is under his guardianship or he is responsible for the victim's education or custody;[364] or when the rape results in serious injury to the victim.[365] In cases in which the rape results in the death of the victim, the penalty is thirty to fifty years' imprisonment.[366] If the victim who dies is under the age of ten, the offender is punished with death.[367]

Abducting, kidnapping, or holding a woman against her will with sexual intentions, and by using violence or deception,[368] is penalized with two to five years' imprisonment.[369] The Penal Code also penalizes "crimes against decency",[370] by establishing fines ranging from 300 to 5,000 *quetzales*.[371] Under Guatemalan law, if the offender of any of the above-mentioned crimes marries the victim, the offender is exonerated from criminal responsibility or any other penalties. However, the offender is exonerated only as long as the woman is over the age of 12 and the marriage is authorized by the Attorney General's office.[372]

Sexual harassment

There are no specific laws in the Guatemalan legal system that addresses the problem of sexual harassment. However, a bill on sexual harassment, which would provide legal protection to women in cases of sexual harassment in the workplace and in educational establishments, was approved by the House of Representatives.[373] The bill is currently awaiting full congressional approval.[374]

Domestic violence

In 1996, the Guatemalan Congress promulgated the Law to Prevent, Punish and Eradicate Domestic Violence.[375] The law defines domestic violence as those acts or omissions that directly or indirectly cause harm or suffering of a physical, sexual or psychological nature or damage to property of a family member.[376] In such cases, the offender may be any relative, a live-in partner or former live-in partner, a spouse or former spouse, or the person with whom the victim has a child.[377]

The law provides for protection mechanisms in such cases, including imposing a court order to force the offender to abandon the common residence, the suspension of guardianship and custody of minor children, sequestration of the offender's property, and civil reparations to the victim for damages caused, among others.[378] The victim, the victim's relatives, or a physician who is in contact with the victim, or any other person who is a witness to domestic violence may request these remedies.[379] The law establishes the role of the national police[380] and justices of the peace[381] in the process of receiving complaints of domestic violence or in the filing of requests for protection in such cases.[382]

IV. Focusing on the Rights of a Special Group: Adolescents

The needs of adolescents are often unrecognized or neglected. Given that in Guatemala 46% of the total population is under the age of 15,[383] it is particularly important to meet the reproductive health needs of this group. Efforts to address issues of adolescent rights, including those related to reproductive health, are important in terms of women's health as well as their right to self-determination.

A. REPRODUCTIVE HEALTH

One of the main objectives of PLADES 1996-2000 is to provide special protection to children and adolescents.[384] Following this aim, the program seeks to promote the design and implementation of public policies and programs to protect their rights.[385] In particular, the government has proposed developing massive educational campaigns[386] to prevent and eradicate prostitution[387] and the mistreatment and sexual abuse of children and adolescents.[388] With respect to the relationship between physicians and adolescent patients, the Ethics Code notes that physicians are prohibited from examining the genital organs of women under the age of 18 without the presence one of the minor's parents or legal guardians, unless a judge requests the examination or there is an obstetric-gynecological emergency.[389]

To address the problem of AIDS among adolescents, PLADES 1996-2000 mandates the implementation of AIDS prevention campaigns that promote abstention and monogamy to young people.[390] The Guatemalan government ratified the Convention on the Rights of the Child in 1990.[391] A bill, the Code of Children and Adolescents, was drafted in order to bring Guatemala into compliance with the international standards of protection for children and adolescents. The proposed law is currently awaiting approval by Congress.[392]

B. MARRIAGE AND ADOLESCENTS

The minimum age required to marry without parental consent in Guatemala is 18,[393] the age at which one is considered an adult and at which one may fully exercise his or her civil rights.[394] Men over the age of 16 and women over the age of 14 may marry[395] with the express consent of both parents or of only one parent if he or she exercises sole legal parental authority.[396] If it is impossible to obtain the authorization of both parents due to the absence of one parent, illness, or for any other reason, the authorization of one parent is sufficient. If these factors prevent both parents from granting their authorization, a civil judge may authorize the marriage.[397] If the parents disagree over whether to approve the marriage, a judge may authorize it if the grounds for refusal are deemed unreasonable.[398]

C. SEXUAL OFFENSES AGAINST MINORS

The Penal Code provides that any person who has sexual relations with a person under the age of 12 has committed the crime of rape,[399] whether or not violence was involved or the victim was unconscious or unable to resist.[400] The penalty for such a crime ranges from six to twelve years' imprisonment.[401] If the offender is a relative of the victim, involved in the victim's education, or is the victim's legal guardian, the penalty is more severe,[402] ranging from eight to twenty years' imprisonment. When the victim is under the age of 10, and the rape results in the victim's death, the offender is to be sentenced to the death penalty.[403]

When an adolescent is between the ages of 12 and 14, and a sexual act occurs by exploiting their "inexperience," or through deception or "false promises" of marriage, the crime is known as "statutory rape" and is penalized with one to two years' imprisonment.[404] For punishment to be imposed in such a crime (and unlike the crime of statutory rape in, for example, many common law legal systems), Guatemalan law specifically stipulates that the victim must be an "honest woman."[405] If the author of the crime is a relative of the victim, responsible for the victim's education, or the victim's legal guardian, the penalty imposed increases by one-third.[406] The penalty is reduced to six months to one year of imprisonment when the victim is between the ages of 14 and 18.[407] Under Guatemalan law, if the offender of any of the above-mentioned crimes

enters into legal marriage with the victim, the offender is exonerated from criminal responsibility or any other penalties, as long as the woman is over the age of 12 and authorization is granted by the Attorney General's Office.[408]

The Penal Code also penalizes the crime of "corruption of minors."[409] Such a crime is committed when a person promotes, facilitates, or favors in any form the prostitution or sexual corruption of a minor,[410] and is penalized with two to six years' imprisonment, whether or not the minor consented to particular sexual acts.[411] The penalty is augmented by two-thirds in the following cases: if the victim is under the age of 12; if such acts are practiced for monetary gain; if these acts are committed with the use of violence, deception, or the abuse of authority; if the offender is the victim's parent, grandparent, brother, or guardian is otherwise responsible for the victim's education, custody, or guardianship; if the corruption occurs through "perverse, premature or excessive" acts; or when the acts involved are carried out "habitually."[412]

D. SEXUAL EDUCATION

The Guatemalan Constitution provides that the objective of education is to promote the comprehensive development of the human person.[413] It also states that parents have an obligation to educate their children, as well as the right to choose the type of education to impart to their children.[414] The educational objectives of the Government Program for the period 1996-2000 include affirming moral and cultural values that respect human rights, and avoiding the perpetuation of poverty and ethnic, sexual, social, and geographical discrimination.[415]

PLADES 1996-2000 is committed to improving the quality of education for children and adolescents.[416] It points out the need to educate children and adolescents about AIDS through educational campaigns emphasizing prevention through the eradication of promiscuity, which it considers to be the main cause of HIV/AIDS infection.[417]

ENDNOTES

1. THE WORLD ALMANAC AND BOOK OF FACTS 1997, at 770 (1996).
2. *Id.*
3. *Id.*, at 769.
4. *Id.*
5. *Id.*
6. *Id.*, at 770.
7. *Id.*
8. *Id.*
9. DEPARTMENT OF STATE OF THE UNITED STATES OF AMERICA, COUNTRY REPORTS ON HUMAN RIGHTS PRACTICES FOR 1996, at 454 (1997).
10. *Id*; This group, known as the Guatemalan National Revolutionary Union, is referred to by its Spanish acronym, URNG *(Unidad Revolucionaria Nacional Guatemalteca)*.
11. *Id.*
12. CONSTITUTION OF THE REPUBLIC OF GUATEMALA (decreed by the National Constituent Assembly, May 31, 1985, as amended by popular vote;. Legislative Agreement 18-93), art. 140 [hereinafter GUAT. CONST.].
13. *Id.*, art. 141. The Constitution denominates the three powers of government as "branches" *(organismos)*. *See id.*, tit. IV.
14. *Id.*
15. *Id.*
16. *Id.*, art. 140.
17. *Id.*, arts. 166-167. Known as *interpelación*, this process of questioning and investigation is designed to establish the political responsibility of the minister being questioned regarding issues related to the national interest. If the minister is found to be responsible of for the actions of which he or she stands accused, Congress emits a vote of no confidence, and the minister under investigation must immediately present his or her resignation.
18. *Id.*
19. *Id.*, art. 183 (h).
20. *Id.*, art. 206 Magistrates and judges who have been accused of a crime or of the inappropriate exercise of their functions have the right to have their case reviewed by Congress (if they are magistrates of the Supreme Court) or by the Supreme Court of Justice (in all other cases), so that these entities can determine whether the legal proceedings against them should continue. *See also* Law of the Judicial Branch, Decree No. 2-89, March 28, 1989, as amended by Legislative Decrees Nos. 64-90, 11-93, and by constitutional amendment in accordance with Legislative Agreement 18-93, art. 79 (c), § c).
21. *Id.*
22. *Id.*, art. 182.
23. *Id.*, art. 184.
24. *Id.*, art. 183.
25. *Id.*, art. 193.
26. *Id.*
27. *Id.*, art. 194 (d).
28. *Id.*, at art. 194 (c).
29. *Id.*, art. 157.
30. *Id.*
31. *Id.*, art. 161.
32. *Id.*
33. *Id.*, art. 171 (a).
34. Defined as the "authority to propose something. In politics, it means the right to present proposals and the exercise of certain related functions. For example, in public law, introducing legislation is, by general principle, a right of the legislative branch, the executive branch, and judicial entities such as the Supreme Court." PEDRO FLORES POLO, DICCIONARIO DE TÉRMINOS JURÍDICOS [DICTIONARY OF LEGAL TERMS] 587 (1987).
35. GUAT. CONST., arts. 174 and 183, (g).
36. *Id.*, arts. 177 and 183, (e).
37. *Id.*, art. 178, first ¶.
38. *Id.*, second ¶; modified by Legislative Agreement No. 18-93, Art. 13 (n.d).
39. *Id.*, art. 179.
40. *Id.*, arts. 203, 212 and 219.
41. *Id.* tit. IV- (Public Authority), ch. IV (Judicial Branch), arts. 203-222.
42. Law of the Judicial Branch, arts. 74-85.
43. *Id.*, arts. 86-93.
44. *Id.*, arts. 94-99.
45. *Id.*, arts. 101-107.
46. *Id.*, art. 74.
47. *Id.*, art. 75 , (a).

48. *Id.*, art. 76. The Nomination Commission is composed of the deans of Guatemala's law schools, representatives of the association of lawyers and notary publics, and a representative of the judicial branch.
49. *Id.*
50. *Id.*, art. 101. "The courts of minors are called justices of the peace except when, because of their special functions, the law or the Supreme Court gives them a different name."
51. *Id.*, arts. 86, 94 and 101. It also determines the subject matter jurisdiction of the courts as well as parameters on the amount and issue in controversy necessary for jurisdiction by particular courts. *Id.*
52. GUAT. CONST., art. 205, (a) and (b).
53. *Id.*, Art. 211.
54. Law of the Judicial Branch, *supra* note 42, art. 57, second ¶.
55. GUAT. CONST., arts. 203, 212 and 219.
56. *Id.*, art. 18.
57. *Id.*
58. *Id.*
59. *Id.*, art. 251.
60. *Id.*
61. *Id.*
62. *Id.*, art. 224.
63. *Id.*
64. *Id.*, art. 227.
65. *Id.*, art. 228.
66. *Id.*
67. *Id.*
68. *Id.*, art. 253.
69. *Id.*, art. 254. The Municipal Council is comprised of the mayor, the trustees, and the council members, who are elected by universal vote.
70. *Id.*, art. 254.
71. *Id.*, art. 224.
72. *Id.*
73. *Id.*
74. *Id.*, art. 225.
75. *Id.*
76. *Id.*, art. 226.
77. *Id.*
78. *Id.*, art. 175.
79. *Id.*; Law of Protection, Personal Liberty and Constitutionality, Decree No. 1-86, March 10, 1989, art. 115; Law of the Judicial Branch, art. 9.
80. GUAT. CONST., art. 175.
81. *Id.*, Art. 204.
82. *Id.*, art. 46; Law of Protection, Personal Liberty and Constitutionality, art. 114; Law of the Judicial Branch, art. 9.
83. GUAT. CONST., art. 180.
84. In the Roman system of civil law, the term "jurisprudence" refers to the "series of judgments decided by the courts related to the same legal issue and whose reiteration confers upon them the quality of interpretive sources of law, making them precedents that must necessarily be followed in future cases." DICTIONARY OF LEGAL TERMS, *supra* note 34, at 24.
85. Law of the Judicial Branch, art. 2.
86. *Id.*
87. OFICINA NACIONAL DE LA MUJER (ONAM) [NATIONAL OFFICE FOR WOMEN (NOW), WOMEN AND LEGAL REFORMS PROJECT] LAS OBLIGACIONES LEGISLATIVAS A FAVOR DE LAS MUJERES DERIVADAS DE LOS ACUERDOS DE PAZ [THE LEGISLATIVE OBLIGATIONS FAVORING WOMEN DERIVING FROM THE PEACE ACCORDS], at 41 (1997). Due to the initiatives of labor and grassroots women's organizations, other demands of the indigenous population were incorporated into the Peace Accords, including the right to land and housing; mechanisms to protect female-headed households, widows and orphans affected by the internal conflict; and the reintegration of displaced people and the development of resettlement areas.
88. Law of the Judicial Branch, art. 9.
89. Law of Protection, Personal Liberty and Constitutionality, art. 114.
90. GUAT. CONST., art. 183, (o).
91. *Id.*, arts. 183, (k) and 171.
92. *Id.*
93. The government of Guatemala has signed and ratified, among others, the following international treaties dealing with the protection of human rights: International Covenant on Civil and Political Rights, *adopted* Dec. 16, 1966, 999 U.N.T.S. 171 (*entry into force* Mar. 23, 1976) (ratified by Guatemala on May 5, 1992); International Covenant on Economic, Social and Cultural Rights, *adopted* Dec. 16, 1966, 993 U.N.T.S. 3 (*entry into force* Sept. 3, 1976) (ratified by Guatemala on May 19, 1988); International Convention on the Elimination of All Forms of Racial Discrimination, *opened for signature* Mar. 7, 1966, 660 U.N.T.S. 195 (*entry into force* Jan. 4, 1969) (ratified by Guatemala on Jan.18, 1983).
94. Convention on the Political Rights of Women, *opened for signature* Dec. 20, 1952, G.A. Res. 640(VII) U.N. GAOR (*entry into force* July 7, 1954) (ratified by Guatemala on Oct. 7, 1959); Inter-American Convention on the Nationality of Women, *adopted* Dec. 26, 1933, O.A.S.T.S. 4 (*entry into force* Aug. 29, 1934) (ratified by Guatemala on July 17, 1936); Inter-American Convention on the Granting of Civil Rights to Women, *adopted* May 2, 1948, O.A.S.T.S. 23 (ratified by Guatemala on Sept. 7, 1951).
95. Convention on the Elimination of All Forms of Discrimination Against Women, *opened for signature* Mar. 1, 1980, 1249 U.N.T.S. 13 (*entry into force* Sept. 3, 1981) (ratified by Guatemala on Aug. 12, 1982).
96. Inter-American Convention on the Prevention, Punishment and Eradication of Violence Against Women, adopted June 9, 1994, 33 I.L.M. 1534 (*entry into force* Mar. 5, 1995) (ratified by Guatemala on Apr. 4, 1995).
97. SECRETARY GENERAL OF PLANNING, GOVERNMENT PROGRAM 1996–2000 (1996) [hereinafter GOVERNMENT PROGRAM]; SECRETARY GENERAL FOR ECONOMIC PLANNING, SOCIAL DEVELOPMENT ACTION PLAN (PLADES 1996–2000) (1996) [hereinafter PLADES 1996–2000].
98. GOVERNMENT PROGRAM, at 72.
99. GOVERNMENT OF GUATEMALA, HEALTH POLICY 1996–2000, at 5 (1996).
100. *Id.*, at 8.
101. *Id.*, at 10.
102. *Id.*, at 11.
103. GOVERNMENT PROGRAM, at 71; PLADES 1996–2000, at 24. Currently, the infant mortality rate in Guatemala is 40 per 1,000 live births.
104. *Id.* Currently, the maternal mortality rate in Guatemala is 24.8 per 1,000 live births.
105. *Id.* Currently, 31% of childbirths are attended by health professionals.
106. GOVERNMENT PROGRAM, at 70.
107. *Id.*, at 67.
108. *Id.*
109. Regulations of the Ministry of Public Health and Social Assistance and its Departments, Governmental Accord No. 741-84, August 1984, art. 115.
110. *Id.*, art. 116.
111. *Id.*
112. *Id.*
113. *Id.*
114. *Id.*
115. GOVERNMENT PROGRAM, at 67.
116. *Id.*
117. *Id.*
118. *Id.*
119. *Id.*
120. *Id.*
121. PLADES 1996–2000, at 21.
122. GOVERNMENT PROGRAM, at 68.
123. *Id.*
124. HEALTH CODE, Decree No. 45-79, August 9, 1979, art. 16.
125. PLADES 1996–2000, at 21.
126. *Id.*
127. *Id.*
128. The Health Code is a legal document that outlines health and administrative regulations pertaining to health services in Guatemala.
129. Decree Law No. 132-85, promulgated on December 19, 1985, art. 1 (modifies article 104 of the Health Code).
130. HEALTH CODE, art. 16.
131. *Id.*
132. ETHICS CODE, Guatemalan Association of Physicians and Surgeons, approved by the General Assembly of the Guatemalan Association of Physicians and Surgeons, Mar. 18, 1991 [hereinafter ETHICS CODE].
133. PENAL CODE, approved by Decree No. 17-73.
134. GUAT. CONST. art. 90; Law of Obligatory Professional Association, Decree No.62-91, art. 1, published in the Diario de Centro América [Central American Newspaper], Oct. 1, 1991; HEALTH CODE, art. 134.
135. ETHICS CODE, art. 2.
136. *Id.*, art. 44.
137. *Id.*, art. 30.

138. *Id.*, art. 36.
139. *Id.*, art. 27.
140. *Id.*, art. 51. *See also* the section on the reproductive health of adolescents in this chapter.
141. *Id.*, art. (e).
142. *Id.*, art. 78. It specifically prohibits sterilization as a form of eugenics, as a punitive measure, as a contraceptive method, or as a method of population control. *See also* the section on sterilization in this chapter.
143. THE MINISTRY FOR PUBLIC HEALTH AND SOCIAL ASSISTANCE (MPHSA), REPRODUCTIVE HEALTH UNIT, OPERATIVE PLAN 1996, at 6 (1996) [hereinafter OPERATIVE PLAN].
144. ETHICS CODE, art. 81.
145. PENAL CODE, art. 137. *See also* the section on abortion in this chapter.
146. *Id.*, art. 140.
147. *Id.*, arts. 307-308, § (3).
148. Bylaws of the Guatemalan Association of Physicians and Surgeons, approved by the General Assembly of the Guatemalan Association of Physicians and Surgeons on Mar. 12, 1993.
149. GUAT. CONST. art. 119 (i).
150. *Id.*, art. 96.
151. Bylaws of the Guatemalan Association of Physicians and Surgeons, *Supra* note 148, art. 26; Rules of the Tribunal of Honor of the Guatemalan Association of Physicians and Surgeons, art. 2. The Tribunal is comprised of seven permanent members the president, vice-president, secretary and four members, plus two alternate members who are elected by the General Assembly by the majority of votes cast for the same period of time as the members of the Board of Directors of the Association.
152. ETHICS CODE, arts. 83-84.
153. Law of Obligatory Professional Association, art. 17; Bylaws of the Guatemalan Association of Physicians and Surgeons, *supra note* 148, art. 27.
154. Rules of the Tribunal of Honor of the Guatemalan Association of Physicians and Surgeons, art. 1.
15. *Id.*
156. Bylaws of the Guatemalan Association of Physicians and Surgeons, *supra* note 148, art. 38.
157. PENAL CODE, arts. 144-151.
158. Regulations on Medicine, Narcotics, Psychotropic Drugs, and Beauty and Personal Hygiene Products for the Home and Pharmaceutical Establishments, approved by Governmental Decree No. 106-85, Feb. 8, 1985, art. 1.
159. Id., art. 1.
160. *Id.*, art. 3.
161. *Id.*, art. 1.
162. *Id.*
163. GOVERNMENT PROGRAM, *supra* note 97.
164. OPERATIVE PLAN, *see supra* note 143.
165. GOVERNMENT PROGRAM, *supra* note 97, at 57.
166. *Id.*, at 56; PLADES 1996-2000, *supra* note 97, at 35.
167. *Id.*, at 35.
168. *Id.*, at 37.
169. GOVERNMENT PROGRAM, *supra* note 97, at 97.
170. GUAT. CONST. art. 47.
171. *Id.*, art. 52.
172. GOVERNMENT PROGRAM, *supra* note 97, at 46.
173. OPERATIVE PLAN, *supra* note 143, at 3.
174. REPORT OF THE REPUBLIC OF GUATEMALA TO THE FOURTH WORLD CONFERENCE ON WOMEN, *supra* note 166, at 139.
175. *Id.*
176. *Id.*
177. OPERATIVE PLAN, *supra* note 143, at 2.
178. *Id.*
179. *Id.*, at 11.
180. *Id.*, at 12.
181. MARÍA EUGENIA MIJANGOS, DERECHOS SEXUALES Y REPRODUCTIVOS DE LAS MUJERES [SEXUAL AND REPRODUCTIVE RIGHTS OF WOMEN] 61 (1996) (unpublished; on file with CRLP).
182. OPERATIVE PLAN, *supra* note 143, at 2.
183. Guatemala has twenty-four health areas corresponding to each of its twenty-four administrative departments (or states). Regulations on the Ministry of Public Health and Social Assistance, *supra* note 109, art. 117.
184. OPERATIVE PLAN, *supra* note 143, at 4.
185. *Id.*
186. *Id.*
187. *Id.*, at 2.
188. HEALTH CODE, art. 104, modified by Decree Law No. 132-85, December 19, 1985.
189. OPERATIVE PLAN, *supra* note 143, at 4.
190. *Guatemala 1995: Results from the Demographic and Health Survey*, 28(2) STUD. IN FAM. PLAN. 153 (1997).
191. OPERATIVE PLAN, *supra* note 143, at 1.
192. *Results from the Demographic and Health Survey, supra* note 194, at 153.
193. *Id.*
194. OPERATIVE PLAN, *supra* note 143, at 6.
195. *Id.*
196. ETHICS CODE, art. 78.
197. OPERATIVE PLAN, *supra* note 143, at 6.
198. Regulations of the Ministry of Public Health, *supra* note 109, art. 45.
199. *Id.*, art. 4.
200. *Id.*, art. 130.
201. *Id.*, art. 45.
202. *Id.*, art. 131.
203. *Id.*, art. 59.
204. OPERATIVE PLAN, *supra* note 143, at 12.
205. PLADES 1996-2000, *supra* note 97, at 37, 39-40.
206. *Id.*, at 40.
207. *Id.*, at 37.
208. *Id.*, at 13 and 17.
209. OPERATIVE PLAN, *supra* note 143, at 6.
210. ETHICS CODE, art. 78.
211. *Id.*, arts. 78 and 79.
212. *Id.*
213. SEXUAL AND REPRODUCTIVE RIGHTS OF WOMEN, *supra* note 185, at 69.
214. PENAL CODE, art. 145. "Anyone who intentionally castrates or sterilizes, blinds or mutilates another person, will be punished with five to twelve years' imprisonment."
215. GUAT. CONST. art 3.
216. The Constitution is the highest authority within Guatemala's hierarchical legal system. Therefore, no or inferior law may contradict the normative principles established in the Constitution. See the section on domestic sources of law.
217. PENAL CODE, art. 133 et.al. The code defines abortion as: "…the death of the product of conception at any moment of pregnancy." *Id.*, art 133.
218. *Id.*, art. 137.
219. *Id.*, art. 134.
220. *Id.*, art. 135.
221. *Id.*, art. 138.
222. OPERATIVE PLAN, *supra* note 143, at 1.
223. *Id.* (For general information about the programs and activities of the RH Unit, see the section on "Objectives of the Health Policy.")
224. *Id.*
225. PENAL CODE, art. 137.
226. *Id.*
227. *Id.*
228. *Id.*
229. *Id.*, art. 134.
230. *Id.* This mitigating factor refers to disturbances that a woman might suffer due to the pregnancy.
231. *Id.*
232. *Id.*, art. 135.
233. *Id.*, art. 135.
234. *Id.*, last ¶.
235. *Id.*, art. 136.
236. *Id.*
237. *Id.*, art. 140.
238. *Id.*
239. *Id.*
240. *Id.*, art. 14 "An attempt to commit a crime occurs when, with the intention of committing a crime, a person takes purposeful steps toward commission initiates an act, but the crime is not consummated for reasons independent of the will of the agent." *Id.*
241. *Id.*, art. 12 "A crime is negligent unintentional when lawful acts or omissions resulting from imprudence, negligence, or lack of skill result in harm or injury." *Id.*
242. *Id.*, art. 139.
243. MPHSA, GENERAL OFFICE OF HEALTH SERVICES, NATIONAL PROGRAM TO PREVENT

AND CONTROL HIV/AIDS, MANUAL DE CONSEJERÍA EN VIH/SIDA/ETS PARA PROFESIONALES DE SALUD [GUIDELINES ON HIV/AIDS/STIS FOR HEALTH PROFESSIONALS], at 3 (1996).
244. *Id.*
245. *Id.*
246. MPHSA, GENERAL OFFICE OF HEALTH SERVICES, NATIONAL PROGRAM TO PREVENT AND CONTROL HIV/AIDS, ENFOQUE SINDRÓMICO DE LAS ENFERMEDADES DE TRANSMISIÓN SEXUAL [A SYMPTOMATIC FOCUS ON SEXUALLY TRANSMISSIBLE INFECTIONS], at 1 (1996).
247. *Id.*
248. MPHSA, GENERAL OFFICE OF HEALTH SERVICES, NATIONAL PROGRAM TO PREVENT AND CONTROL HIV/AIDS, NORMAS, PRINCIPIOS Y RECOMENDACIONES PARA LA PREVENCIÓN Y CONTROL DE LA INFECCIÓN VIH/SIDA [REGULATIONS, PRINCIPLES AND RECOMMENDATIONS FOR THE PREVENTION AND CONTROL OF HIV/AIDS], at 17 (n.d.).
249. *Id.*, at 16.
250. *Id.*, at 17.
251. *Id.*, at 18.
252. *Id.*, at 17.
253. PENAL CODE, art. 151.
254. *Id.*
255. Governmental Decree No.119-87, Dec. 23, 1987, art. 1.
256. *Id.*, art. 2.
257. *Id.*, art. 3.
258. General Regulation of the National Commission to Prevent and Control AIDS, Agreement No.S/P-M-38-90 (October 10, 1990); National Program to Prevent and Control AIDS, art. 1.
259. MPHSA, GENERAL OFFICE OF HEALTH SERVICES, NATIONAL PROGRAM TO PREVENT AND CONTROL HIV/AIDS, PLAN NACIONAL DE ACCIÓN PARA LA PREVENCIÓN Y CONTROL DE VIH/SIDA [NATIONAL PLAN TO PREVENT AND CONTROL HIV/AIDS], art. 1 (1996).
260. *Id.*, at 2.
261. *Id.*, at 3.
262. *Id.*
263. *Id.*
264. This series includes the following pamphlets: MPHSA, GENERAL OFFICE OF HEALTH SERVICES, NATIONAL PROGRAM TO PREVENT AND CONTROL HIV/AIDS, NORMAS DE VIGILANCIA EPIDEMIOLÓGICA DE LAS ENFERMEDADES DE TRANSMISIÓN SEXUAL (STIs) [REGULATIONS ON EPIDEMIOLOGICAL CONTROL OF SEXUALLY TRANSMISSIBLE INFECTIONS] (1996); A SYMPTOMATIC FOCUS ON SEXUALLY TRANSMISSIBLE INFECTIONS, *supra* note 250; GUIDELINES ON HIV/AIDS/STIS FOR HEALTH PROFESSIONALS, *supra* note 247; REGULATIONS, PRINCIPLES AND RECOMMENDATIONS FOR THE PREVENTION AND CONTROL OF HIV/AIDS, *supra* note 252; MPHSA, GENERAL OFFICE OF HEALTH SERVICES, DIVISION OF MONITORING AND DISEASE CONTROL, DEPARTMENT OF TRANSMISSIBLE DISEASES, CONOZCA COMO SE TRANSMITEN LAS ENFERMEDADES VENÉREAS INCLUYENDO EL SIDA [LEARN HOW VENEREAL DISEASES, INCLUDING AIDS, ARE TRANSMITTED] (1996).
265. GUAT. CONST., art. 4.
266. *Id.*
267. Guatemala is a party to the following conventions dealing with civil and political rights: The Convention on the Political Rights of Women, *supra* note 94, and the Convention on the Elimination of All Forms of Discrimination Against Women, *supra* note 95. At the regional level, Guatemala is a party to: the Inter-American Convention on the Nationality of Women, *supra* note 94, and the Inter-American Convention on the Granting of Civil Rights to Women, *supra* note 94.
268. GUAT. CONST., art. 47.
269. *Id.*
270. CIVIL CODE, approved by Decree Law No. 106, Sept. 14, 1963, art. 79.
271. *Id.*, art. 109.
272. *Id.*, art. 108.
273. *Id.*, art. 109.
274. *Id.*, art. 110.
275. *Id.*
276. *Id.*, art. 113.
277. *Id.*, art. 114.
278. *Id.*, art. 117. Contracts or agreements entered into by both spouses that establish the property regime which regulates joint ownership of property by the married couple.
279. *Id.*, art. 116.
280. *Id.*, art. 122. "…All the goods brought by each spouse to the marriage or acquired during marriage are considered joint property; as such they shall be divided by half upon the dissolution of the marriage."
281. *Id.*, 123. "…Each spouse retains the property and the administration of such property that belonged to him or her and he or she shall be the exclusive owner of the fruits, products and profits therefrom. Each spouse shall remain the sole owner of his or her salary, wages, emoluments and earnings for personal services rendered, or through commercial or industrial enterprises."
282. *Id.*, art. 124. "The husband and wife retain ownership of all property that was theirs at the time of marriage and of that which was acquired during marriage, whether they were acquired by gift or by bequest or for value paid by either spouse; provided, however, that upon the dissolution of the marriage, the spouses shall each receive half of the income generated by the property owned by each spouse, including the value of anything that was purchased or invested from such income, whatever is sold or bought with these profits, and whatever income each spouse acquires through his or her work, employment, profession or trade."
283. *Id.*, art. 126.
284. *Id.*, art. 89, (3).
285. *Id.*, art. 81. For more information on this see the section on Marriage and Adolescents below.
286. PENAL CODE, art. 226.
287. *Id.*
288. Case No. 936-95, Constitutional Court of Guatemala (March 5, 1996), Center for Legal Action on Human Rights, DOCUMENTO INFORMATIVO, GUATEMALA [NEWSLETTER, GUATEMALA], at iii (1996)]
289. PENAL CODE, Art. 232 (repealed).
290. *Id.*
291. *Id.*, art. 235 (repealed).
292. Case No. 936-95, Constitutional Court of Guatemala, *supra* note 288.
293. GUAT. CONST., art. 48.
294. See the previous section for more information on the impediments to entering into marriage.
295. CIVIL CODE, art. 173.
296. *Id.* The relevant authorities are the district mayor or a notary public.
297. CIVIL CODE, art. 175.
298. *Id.* It is also possible to obtain legal recognition of domestic partnerships in Guatemala even if one of the partners opposes such recognition or after one of the partners is deceased.
299. CIVIL CODE, art. 182, (1). The children born 180 days after the date declared as the initiation of the domestic partnership and any children born within 300 days after the dissolution of the domestic partnership are also presumed to be the children of the mother's partner. Evidence that this is not the case may be presented.
300. *Id.*, at art. 182 (2). Property acquired by only one of the partners as a gift or in exchange for another item of property are excluded from this provision.
301. *Id.*, § 3.
302. *Id.*, § 5.
303. *Id.*, art. 183.
304. *Id.*, art., 184.
305. *Id.*, art. 89 (3).
306. *Id.*, art. 153.
307. *Id.*, art. 154, (1).
308. *Id.*, §2.
309. *Id.*, art. 155.
310. *Id.* Other grounds for separation or divorce include the destruction of the domestic household; the habitual use of drugs and a gambling habit or alcoholism that disrupt the family's stability; slanderous denunciations or accusations on the part of one spouse against the other; the conviction of a spouse to more than five years' imprisonment; incurable mental illness of one of the spouses that is severe enough to declare civil commitment; and a previous decree of legal separation for an indefinite period after the persons have been declared legally separated.
311. *Id.*, arts. 159, (1), 163 and 170.
312. *Id.*, arts. 159, (2).
313. *Id.*, art. 169. The man has the same right only when he is unable to work and does not remarry.
314. *Id.*, art. 159, (3).
315. *Id.*, art. 162.
316. *Id.*
317. GUAT. CONST., art. 39.
318. CIVIL CODE, art. 131.
319. *Id.*, art. 132.
320. *Id.*, arts. 115 and 133.

321. *Id.*, art. 131.
322. *Id.*, art. 1070.
323. GUAT. CONST., art. 101.
324. *Id.*, art. 102, § k).
325. *Id.*
326. Convention No. 100 of the International Labor Organization, Convention Concerning Equal Remuneration for Men and Women Workers for Work of Equal Value, *adopted* Jun. 29, 1951 (*entry into force* May 23, 1953) (ratified by Guatemala on Aug. 2, 1961) <http://ilolex.ilo.ch:1567/ public/english/50normes/infleg/iloeng/conve.htm>.
327. Convention No. 111 of the International Labor Organization, Convention Concerning Discrimination in Respect of Employment and Occupation, *adopted* Jun. 25, 1958 (*entry into force* Jun. 15, 1960) (ratified by Guatemala on Oct. 11, 1961), <http://ilolex.ilo.ch:1567/ public/english/50normes/infleg/iloeng/conve.htm> (visited Dec. 8, 1997).
328. Convention No. 156 of the International Labor Organization, Convention concerning Workers with Family Responsibilities, *adopted* Jun. 23, 1981, (*entry into force* Nov. 8, 1983) (ratified by Guatemala on Jan. 6, 1994), < http://ilolex.ilo.ch:1567/public/english/50normes/infleg/iloeng/conve.htm> (visited Dec. 8, 1997).
329. LABOR CODE, Decree No. 1441, Aug. 16, 1961.
330. *Id.*, art. 151, §§ a, b and c.
331. *Id.*, § e.
332. *Id.*, art. 152, first ¶.
333. *Id.*, art. 152, § f.
334. *Id.*, art. 153; GUAT. CONST., art. 120, § k.
335. CIVIL CODE, arts. 109 and 131.
336. SEXUAL AND REPRODUCTIVE RIGHTS OF WOMEN, *supra* note 185, at 50.
337. GUAT. CONST., art. 71.
338. *Id.*, art. 74.
339. PLADES 1996-2000, *supra* note 97, at 3.
340. *Id.*
341. *Id.*
342. GUAT. CONST., art. 74.
343. *Id.*, art. 76.
344. PLADES 1996-2000, *supra* note 97, at 33.
345. *Id.*, at 34.
346. SEXUAL AND REPRODUCTIVE RIGHTS OF WOMEN, *supra* note 185, at 56.
347. *Id.*
348. Proyecto de Ley Orgánica del Instituto Nacional de la Mujer—INAM [Proposed Law on the Establishment of the National Institute for Women—NIW], Statement of Purpose, at 4 (n.d.).
349. *Id.*
350. *Id.*, at 5 as of July 1997, this bill had not been passed by the Guatemalan Congress).
351. *Id.*, at 26. The main objectives of this entity are to foster women's participation in the country's development; to promote real equality and equity between men and women; and to strengthen the institutional and individual efforts of both the public and private sectors in all programs designed to improve the situation of women in society.
352. Created by Resolution No. 6-5-91, issued by the Office of the Procurator General for Human Rights, May 2, 1991.
353. *Id.*
354. Organic Law of the Ministry of Public Affairs, Decree No. 40-94.
355. Decree No. 69-96, arts. 7 and 17.
356. *Id.*, art. 7.
357. GUAT. CONST., art. 3.
358. PENAL CODE, bk. II, tit. III, ch. I.
359. *Id.*, art. 173.
360. *Id.*
361. *Id.*
362. *Id.*, art. 174.
363. *Id.*, § 1.
364. *Id.*, § 2.
365. *Id.*, § 3.
366. *Id.*, art. 175.
367. *Id.*, For more information about the rape of minors and adolescents, see the section on adolescents below.
368. *Id.*, art. 181.
369. *Id.*
370. *Id.*, arts. 191 and 192. The following are considered to be crimes against decency: *pimping* (promoting, facilitating, or favoring prostitution, without distinction on the basis of sex); *roguery* (living completely or in part at the expense of a person or persons who engage in prostitution); *trading in persons* (promoting, facilitating, or favoring the entry or exit of women from the country so that they may engage in prostitution); *obscene exhibitionism*; and *obscene publications and shows*.
371. *Id.*
372. *Id.*, art. 200.
373. LA HORA (THE HOUR; newspaper on-line) (visited July 20, 1997) <http://www/lahora.com.gt/80/10/1996/pgs/naci1.htm>
374. *Id.*
375. Ley para Prevenir, Sancionar y Erradicar la Violencia Intrafamiliar [Law to Prevent, Sanction and Eradicate Domestic Violence], promulgated by Decree No. 97-96, Oct. 24, 1996.
376. *Id.*, art. 1.
377. *Id.*
378. *Id.*, art. 7.
379. *Id.*, art. 2.
380. *Id.*, art. 10.
381. *Id.*, art. 6.
382. *Id.*, art. 13.
383. PRO-FAMILY ASSOCIATION (APROFAM), DEMOGRAPHIC CALENDAR 1997, GUATEMALA, at 4 (1996).
384. According to the U.N. Convention on the Rights of the Child, a child is any person under the age of 18. Convention on the Rights of the Child, *opened for signature* Nov. 20, 1989, 28 I.L.M. 1448 (*entry into force* Sept. 2, 1990) (ratified by Guatemala on June 6, 1990).
385. PLADES 1996-2000, *supra* note 97, at 41.
386. *Id.*, at 40. "The problem of prostitution has increased alarmingly over the last few years, particularly affecting girls under the age of 15."
387. *Id.*, at 42.
388. *Id.*
389. ETHICS CODE, art. 27.
390. PLADES 1996-2000, at 36.
391. *Id.*, at 40.
392. *Id.* As of July 1997, the proposed Code of Children and Adolescents had not been approved by Congress.
393. CIVIL CODE, art. 81.
394. *Id.*, art. 8.
395. *Id.*, art. 81.
396. *Id.*, art. 82.
397. *Id.*, art. 83.
398. *Id.*, art. 84.
399. PENAL CODE, art. 173, (3) This concept is similar to statutory rape in some countries' legal systems.
400. *Id.*
401. *Id.*, art. 173.
402., 403. *Id.*, art. 174, (3).
404. *Id.*, art. 175, last ¶.
405. *Id.*, arts. 176 and 177.
406. *Id.*
407. *Id.*, art. 178.
408. *Id.*, arts. 176 and 177.
409. *Id.*, art. 200.
410. *Id.*, bk. II, tit. III, ch. IV.
411. CIVIL CODE, art. 8.
412. *Id.*, art. 188.
413. *Id.*, art. 189.
414. GUAT. CONST., art. 72.
415. *Id.*, art. 73.
416. *Id.*
417. PLADES 1996-2000, *supra* note 97, at 32.
418. *Id.*, at 36-37.

Jamaica

Statistics

GENERAL

Population

- Jamaica's population is approximately 2.5 million,[1] with women accounting for slightly more than half the population.[2] The annual population growth rate is 0.9%.[3]
- Nearly one-third of the population is under the age of 15.[4]
- In 1994, approximately 55% of the population resided in urban areas, and the average annual rate of growth for the urban population from 1990 to 1994 was 2.1%.[5]

Territory

- Jamaica has a surface area of 4,244 square kilometers.[6]

Economy

- The World Bank estimates Jamaica's gross national product per capita in 1994 was U.S.$1,540.[7]
- From 1990 to 1994, gross domestic product ("GDP") grew at an estimated annual rate of 3.5%.[8]
- From 1992 to 1993, the government spent approximately 6% of its GDP on health,[9] compared with the U.S. which spent approximately 12.7% of its GDP on health in 1990.[10]

Employment

- In 1993, 1.3 million persons were employed in Jamaica.[11] Women account for 45% of the total labor force.[12]
- In 1992, the female unemployment rate in Jamaica was 22.8%, and the total unemployment rate was 15.7%.[13]

WOMEN'S STATUS

- The average life expectancy for women is 76.8 years, compared to 72.4 years for men.[14]
- The percentage of females attending secondary schools in Jamaica has been consistently higher than that of males. While adult illiteracy among males is 19%, it is only 11% for females.[15]
- 42% of Jamaican women are heads of households.[16]
- 1,108 rapes were reported to police in 1992, and the Women's Crisis Centre, established in 1985 in Kingston, recorded more than 2,000 telephone calls and office visits relating to incidents involving rape, incest, domestic violence, domestic crisis, or requests for shelter in 1991.[17]

ADOLESCENTS

- Although the median age at marriage for Jamaican women was most recently estimated at 29.7[18] years, a 1988 survey of Jamaican females aged 14 to 24 revealed an average age of sexual initiation of 16.9 years.[19]
- Nearly one-fourth of all births in Jamaica are to adolescent women.[20]

MATERNAL HEALTH

- The total fertility rate in Jamaica from 1990 to 1995 was 2.4 children per woman, down from 5 children per woman from 1970 to 1975.[21]
- The maternal mortality rate for Jamaica for 1990 was estimated to be 115 deaths per 100,000 live births.[22]
- The infant mortality rate is 12 per 1,000 live births.[23] In 1993, the under-five mortality rate was 17 per 1,000 live births.[24]
- In Jamaica, 92% of births are assisted by trained attendants.[25] While 75% of mothers accessed antenatal care in the 1980s, the proportion fell below 70% in 1990. But the proportion of women accessing postnatal service increased from 37% in 1981 to 67% in 1991.[26]

- In 1985, eighty-four percent of all births in Jamaica were to unmarried women.[27] Kingston's illegitimacy rate was 89% in 1981, and national out-of-wedlock birthrates have been higher than 60% for the entire 20th century.[28]

CONTRACEPTION AND ABORTION

- 67% of Jamaican women report using some method of birth control, and 64% report using a modern method of birth control.[29]

- Because abortion is illegal in most circumstances in Jamaica, it is difficult to get information about its prevalence there. It is estimated that there were from 10,000 to 20,000 illegal abortions in the 1970s and that 20% of all gynecological beds in Jamaican hospitals were occupied by patients suffering from the effects of illegal abortions. Seven and one-half percent of all maternal deaths were attributed to septic abortion.[30]

HIV/AIDS AND STIs

- Through 1996, there have been 2,060 reported cases of AIDS in Jamaica since 1982. Five hundred and twenty seven new cases were reported in 1996. Two hundred and six of those stricken were women.[31]

- Transmission of the HIV virus occurs mainly through heterosexual contact in Jamaica.[32]

- The incidence of sexually transmitted infections in Jamaica is high, with 5,125 cases of gonorrhea, 2,414 cases of syphilis, and 7,455 cases of chlamydia having been reported in 1995.[33]

ENDNOTES

1. United Nations Population Fund, The State of World Population: The Right to Choose: Reproductive Rights and Reproductive Health 72 (1997) [hereinafter State of World Population 1997].
2. Jamaica National Preparatory Commission, National Report on the Status of Women in Jamaica, Prepared for the Fourth World Conference on Women, Beijing: September, 1995, 15 (1994) [hereinafter National Report]. Statistics here are from 1992.
3. State of World Population 1997, *supra* note 1, at 72.
4. National Report, *supra* note 2, at 15, ¶1.3.
5. World Bank, World Development Report 1996: From Plan to Market 204 (1996) [hereinafter World Development Report 1996].
6. World Almanac Books, The World Almanac and Book of Facts 1997, at 787 (1996).
7. *Id.*, at 188.
8. *Id.*, at 208.
9. National Report, *supra* note 2, at 53, ¶6.4.18.
10. World Bank, World Development Report 1993: Investing in Health: World Development Indicators 211 (1993).
11. World Bank, World Tables, 379 (1995).
12. World Development Report 1996, *supra* note 5, at 194.
13. National Report, *supra* note 2, at 58, table 6.4.
14. State of World Population 1997, *supra* note 1, at 69.
15. World Development Report 1996, *supra* note 5, at 200.
16. National Report, *supra* note 2, at 6, ¶3.9a.
17. *Id.*, at 69.
18. United Nations, The World's Women 1995: Trends and Statistics 35 (1995) [hereinafter The World's Women 1995]. This statistic is from the early 1980s.
19. National Report, *supra* note 2, at 50, ¶6.4.8.
20. *Id.*
21. The World's Women 1995, *supra* note 17, at 30.
22. *Id.*, at 86.
23. State of World Population 1997, *supra* note 1, at 69.
24. World Bank, World Development Report 1995: Workers in an Integrating World 214 (1995).
25. State of World Population 1997, *supra* note 1, at 72.
26. National Report, *supra* note 2, at 50, ¶6.4.7.
27. The World's Women, *supra* note 17, at 19.
28. Suzanne LaFont, The Emergence of an Afro-Caribbean Legal Tradition: Gender Relations and Family Courts in Kingston, Jamaica 30 (1996).
29. The World's Women, *supra* note 17, at 86.
30. United Nations, Abortion Policies: A Global Review, Volume II, Gabon to Norway 78 (1993).
31. *AIDS costs JA $50m*, The Gleaner, February 7, 1997, at 1.
32. National Report, *supra* note 2, at 54, ¶6.5.3.
33. Planning Institute of Jamaica, Economic and Social Survey 22.8 (1985).

Jamaica is a Caribbean island with an area of 4,244 square miles[1] and a population of approximately 2.5 million.[2] Although it is a multiracial country, the majority (76%) of its people are of African descent. Fifteen percent are Afro-European, and there are small minorities originating from the United Kingdom, India, China, Syria, Portugal, and Germany.[3] Jamaica is a predominantly Christian country. While 56% of the population is Protestant,[4] there are churches of all denominations, as well as small Jewish, Muslim, and Hindu minorities.[5]

In 1962, after more than 300 years of British colonial rule, Jamaica attained independent status.[6] Jamaica is a monarchical constitutional parliamentary democracy and a member of the British Commonwealth of Nations. Queen Elizabeth II is the nominal head of state and is represented by Governor General Howard Cooke, who has held this office since 1991.[7] Since free elections were established under universal adult suffrage in 1944, two political parties have alternated in power; in 1995, a third major party was established.[8]

I. Setting the Stage: the Legal and Political Framework

To understand the various laws and policies affecting women's reproductive rights in Jamaica, it is necessary to consider the legal and political systems of the country. Without this background, it is difficult to determine the process by which laws are enacted, interpreted, modified, and challenged. The passage and enforcement of law often involves specific formal procedures. Policy enactments, on the other hand, are usually not subject to such a process.

A. THE STRUCTURE OF NATIONAL GOVERNMENT

Jamaica has a monarchical democratic parliamentary system of government. The head of state is Queen Elizabeth II, head of the British Commonwealth. Her representative in Jamaica is the governor general, whom the queen appoints and who holds office for as long as the queen determines.[9] The three arms of government are (1) the executive,[10] (2) the legislative,[11] and (3) the judiciary.[12]

Executive branch

Executive authority in Jamaica is formally vested in the queen and is to be exercised on her behalf by the governor general.[13] In practice, the prime minister and the cabinet exercise executive control over the administration.[14] The cabinet, which consists of the prime minister and no fewer than 11 other ministers, is the principal policy instrument of Jamaica. It is in charge of the general direction and control of the government and is collectively responsible to Parliament.[15]

The governor general selects the prime minister from the members of the House of Representatives, all of whom are popularly elected. Under Jamaican law, the governor general appoints the person who in his judgment is best able to command the confidence of a majority of the members of the House.[16] However, in practice, he is obliged to select the leader of the party that wins a majority of the seats in Parliament.[17] The governor general also appoints the other ministers of state on the advice of the prime minister.[18] The governor general, in consultation with the prime minister, appoints an attorney general, who is the principal legal advisor to the government of Jamaica.[19] The director of public prosecutions, who has power to institute and undertake criminal proceedings, is appointed by the governor general on the advice of the Public Service Commission.[20]

The governor general, in consultation with the prime minister, appoints the six-member Privy Council, whose primary function is to make recommendations to the governor general regarding his prerogative of mercy. This empowers the governor general to pardon persons convicted of criminal offenses, grant temporary or indefinite respites from criminal punishment, lessen the punishments imposed, or remit the whole or part of any punishment.[21] Members of the Privy Council serve for a term of up to three years.[22] The governor general summons the Privy Council[23] and, so far as is practicable, attends and presides over its meetings.[24]

Other than the aforementioned powers, the governor general has little executive power. The governor general's powers with respect to external affairs are exercisable only on the advice of the foreign minister.[25] While the governor general has the formal authority to dissolve Parliament and make appointments to tribunals of inquiry as well as ministerial and legislative positions, in practice his role is to lend formal approval to the decisions of the prime minister and other ministers of state.[26]

The prime minister controls the allocation of ministerial offices and has the power to advise the prorogation, or dissolution, of Parliament. As a result, the prime minister can control the timing of general elections.[27] Although the House of Representatives may resolve that the appointment of the prime minister be revoked, the prime minister can prevent the enactment of such a resolution by requesting that the governor general dissolve Parliament.[28] The prime minister, in consultation with the leader of the opposition, appoints the chief justice and the president of the Court of Appeal, as well as members of the Service Commissions, which oversee public servants and serve to insulate public service from political patronage and partisan

pressure.[29] The Defense Law of 1962 confers on the prime minister the right to issue orders to the Chief of Staff of the Jamaica Defense Force "for the purpose of maintaining and securing public safety and public order."[30]

Legislative branch

The Parliament of Jamaica consists of the governor general, representing the queen; the Senate; and the House of Representatives.[31] The governor general appoints 13 of the 21 members of the Senate, in accordance with the advice of the prime minister, and the remaining eight in accordance with the advice of the leader of the opposition.[32] The Constituencies (Boundaries) Order of 1959 divided Jamaica into 45 constituencies, each of which elects one member to the House of Representatives.[33] The Jamaica (Constitution) Order in Council of 1962 (the "Jamaican Constitution")[34] allows the governor general to increase the number of constituencies to a maximum of 60.[35]

Parliament makes laws "for the peace, order and good government of Jamaica."[36] Each Parliament sits for five years,[37] but the governor general may dissolve the Parliament at any time in accordance with the advice of the prime minister.[38] A Parliament's life can also be extended in time of war for an additional two years.[39] Members of both the House of Representatives and the Senate generally serve for the duration of the Parliament.[40] General election of members of the House of Representatives must be held within three months of the dissolution of Parliament.[41]

Judicial branch

In most common law legal systems, including Jamaica's, courts both create and interpret law. The judicial system can have a significant impact on legislation, including laws that affect reproductive rights, because it is able to enforce the law and rule on complaints from individuals challenging the constitutionality of specific laws. While the Jamaican Constitution does not explicitly embrace the doctrine of the separation of powers, following the common law tradition, it is a basic principle of Jamaican constitutional law that judicial bodies should not be subject to the control or directions of the other two branches of government.[42]

The Jamaican Constitution establishes two separate superior courts, the Court of Appeal and the Supreme Court of Judicature (the "Supreme Court").[43] It does not establish a system of inferior courts; independent statutes, such as the Judicature (Resident Magistrates) Act of 1928 (the "Resident Magistrates Act")[44] and the Judicature (Family Court) Act of 1975 (the "Family Court Act"),[45] established the inferior court system. The Jamaican Constitution empowers the Court of Appeal to hear civil and criminal appeals from the Supreme Court and from the Resident Magistrates Courts.[46] It also hears appeals from orders in contempt proceedings.[47]

The final court of appeal for Jamaica is Her Majesty in Council.[48] Appeals to Her Majesty in Council can be made from decisions of the Jamaican Court of Appeal as of right[49] or with leave of the Court of Appeal.[50] Appeals can be made from decisions of the Court of Appeal as of right when the matter in dispute involves a sum of at least J$1,000 (approximately U.S. $30);[51] claims or questions regarding property; or final decisions in any civil proceeding,[52] including those for dissolution of marriage[53] and those relating to the interpretation of the Constitution of Jamaica.[54] Appeals with the leave of either the Court of Appeal or of the queen arise in more limited circumstances. Where the Court of Appeal is of the opinion that although there is no constitutionally established right of appeal, the matter is of such great general or public importance that it ought to be submitted to the queen for determination, the Court of Appeal can submit the case to Her Majesty in Council.[55]

The Supreme Court, originally created in 1880, was declared to be "the Supreme Court for the purposes of the [Jamaican] Constitution."[56] Its jurisdiction in civil and criminal matters is unlimited, with the court's civil jurisdiction encompassing common law, equity, family law, bankruptcy, and admiralty matters.[57] Presiding over this court are the chief justice, a senior associate judge, and other associate judges (referred to as puisne judges).[58] Below the level of the Supreme Court are the Resident Magistrates Courts. The Resident Magistrates Courts were created by statute, and their jurisdiction is therefore derived entirely from statute, not from constitutional authority.[59] They are inferior courts of record with broad jurisdiction over common law actions, cases involving land, actions in equity, probate and administration, and bankruptcy.[60] There is one such court in each of the 14 parishes.[61] Within the Resident Magistrates Courts' jurisdiction are the Traffic and Family Courts. The Family Courts have concurrent jurisdiction with the Supreme Court in relation to paternity, maintenance, and custody of children. They also preside over cases involving the adoption of children.[62] The Domestic Violence Act of 1995 ("Domestic Violence Act")[63] has extended the jurisdiction of the Family Courts and Resident Magistrates Courts by granting to them sole jurisdiction to deal with all applications for protection, occupation, and ancillary orders obtainable under the act.[64]

B. THE STRUCTURE OF TERRITORIAL DIVISIONS

Jamaica is divided into 14 administrative districts called parishes. Each parish has its own individual Parish Council with elected members. The parishes of Kingston and St. Andrew are, however, constituted under one Parish Council, known as the

Kingston and St. Andrew Corporation.[65] The Parish Councils serve as local, administrative bodies, but the scope of their authority is limited.[66] Parish Councils are corporations and have the capacity to enter into contracts; sue and be sued; and acquire, hold, and dispose of real and personal property.[67] They are headed by a mayor and comprise parish councilors who are elected in a general election every three years.[68] The Parish Councils provide services in the areas of public health and sanitation; water supply; poor relief; maintenance of minor roads and of street lighting; regulation of markets and slaughterhouses; fire services; maintenance of cemeteries; and regulation of the development of private property.[69]

C. SOURCES OF LAW

Domestic sources of law

Laws that affect women's legal status — including their reproductive rights — derive from a variety of sources. As a former British colony, Jamaica's legal system is based in English common law. "Common law" is a body of law that develops and derives from judicial decisions, which have precedential value in future disputes, as distinguished from legislative enactments. The sources of law in Jamaica are the Jamaican Constitution, acts of Parliament, the common law, and subsidiary legislation made thereunder in the form of rules, regulations, proclamations, and orders.[70] The Constitution declares itself the supreme law of the land. Any law that is inconsistent with its provisions is void to the extent that it is in conflict.[71] The Constitution also provides, however, for its own amendment through act of Parliament.[72] Constitutional amendments generally require the approval of a two-thirds majority of both the House of Representatives and the Senate.[73] If the Senate twice rejects such an amendment, it may be submitted to the general electorate. Depending on the nature of the proposed amendment, the Constitution requires either a three-fifths or two-thirds majority of the electorate to override the Senate's rejection of the measure.[74]

The Constitution enumerates certain fundamental human rights and freedoms afforded protection without regard to "race, place of origin, political opinions, color, creed or sex, but subject to respect for the rights and freedoms of others and for the public interest."[75] The Constitution's antidiscrimination provision, however, defines as discriminatory any action "affording different treatment to different persons attributable wholly or mainly to their respective descriptions by race, place of origin, political opinions, color, or creed."[76] Discrimination based on gender is thus not explicitly prohibited. This nondiscrimination provision also specifically provides that its terms shall not apply to any law related to adoption, marriage, divorce, burial, devolution of property on death, or other matters of personal law.[77] Constitutional provisions relating to fundamental rights underlie and are applicable to all proceedings in every court.[78] However, relief on constitutional grounds will only be granted if all other processes for relief have been exhausted or there is no other form of relief available in law.[79]

Decisions made by the United Kingdom Privy Council on cases from other territories, as well as decisions of the British House of Lords, have highly persuasive authority in the courts of Jamaica. Decisions made by the Privy Council in relation to cases on appeal from Jamaica have binding authority.[80]

International sources of law

Because international instruments are legally binding, they create an obligation on the part of the government to undertake numerous actions, including those at the national level. Treaties are considered acts of state in Jamaica and, as such, may be entered into by the executive branch, which controls most aspects of foreign policy without parliamentary scrutiny. Subject to the exceptions noted below, treaties are immune from judicial review and do not require prior parliamentary approval for their negotiation, signature, or ratification.[81] Under common-law practice as applied in Jamaica, the executive branch must submit to Parliament those treaties that involve a reduction or alteration of the rights or legal obligations of Jamaican citizens, an extension of the powers of the executive, or the imposition of financial obligations on the state.[82] The government is bound under international law by any treaty that it enters into, whether or not parliamentary ratification has been secured.[83] If an international convention has been signed or ratified by Jamaica, the government must comply with its terms and, if necessary, enact local legislation implementing those terms.[84]

The Jamaican government is party to a number of international legal instruments, including, *inter alia*, the International Convention on the Elimination of All Forms of Racial Discrimination,[85] the International Covenant on Economic, Social and Cultural Rights,[86] the International Covenant on Civil and Political Rights,[87] the Convention on the Elimination of All Forms of Discrimination Against Women,[88] the Convention on the Rights of the Child,[89] and the American Convention on Human Rights.[90] Jamaica has not yet signed the recently concluded Inter-American Convention on the Prevention, Punishment and Eradication of Violence Against Women ("Convention of Belém do Pará").[91]

II. Examining Health and Reproductive Rights

In Jamaica, issues of reproductive health and rights are dealt with within the context of the country's health and population policies. Thus, an understanding of reproductive rights in Jamaica must be based on an examination of those policies.

A. HEALTH LAWS AND POLICIES

Objectives of the health policy

Although discussions for the elaboration of a new national health policy are taking place, there is currently no national health policy in effect.[92] The Jamaican Ministry of Health is the principle provider of health care and operates under principles outlined in three policy documents: the Population Policy and Primary Health Care Strategy of 1977; the National Health Policy of 1991; and the World Health Organization's ("WHO") Health for All by the Year 2000.[93]

Infrastructure of health services

The Public Health Act of 1985 (the "Public Health Act")[94] established one national Central Health Committee[95] and a local Board of Health in each parish.[96] The Central Health Committee advises the minister of health and the local boards on matters connected to public health.[97]

Health services are available to all persons in Jamaica at public hospitals, clinics, private hospitals, and private doctors' offices. As of 1995, there were about 350 government-operated health centers in Jamaica, which provide traditional primary health care and basic curative medical care.[98] The Ministry of Health also operates 19 acute-care hospitals and three specialized chronic-care facilities.[99] The implementing agencies for primary health care are the Ministry of Health, nongovernmental organizations ("NGOs"), the private sector, private doctors, and churches. In particular, approximately fifty NGOs participate in the provision of health care services and thus supplement the services that the Ministry of Health provides.[100] The University Hospital of the West Indies in Kingston, Jamaica, is a teaching hospital for doctors of all specialties.[101]

Cost of health services

Although WHO recommends a minimum allocation of 10% of a country's total budget to maintain its health system, Jamaica's governmental allocation for health has declined from 7.9% of the national budget for 1979 to 1980 to 6.0% for 1992 to 1993.[102] The government-allocated budget to the Ministry of Health for health care services for 1996 to 1997 is J$5,409,875,000 (or approximately U.S.$160 million).[103] The government has instituted a cost recovery program in all public hospitals and clinics. The program requires that patients pay 5% of the market rate for medical treatment and medication.[104] Patients are thus required to pay J$20 (U.S.$.60) for antenatal visits and J$10 (U.S.$.30) for medication at public institutions. Condoms are provided free of charge. All other contraceptives and reproductive health services are charged at 5% of their market price.[105]

In April 1997, the health minister, Dr. Peter Phillips, introduced a Green Paper in the House of Representatives proposing a national health insurance plan to cover essential medical services for all residents of Jamaica. The proposed insurance would cover specific hospital in-patient services, laboratory and diagnostic tests, and pharmaceuticals. The plan would make it mandatory for everyone to subscribe to the national insurance scheme.[106]

Problems in the financing of the health sector have hampered reform efforts. Because of low levels of remuneration, position vacancies persist among critical groups within the public health sector, despite the Ministry of Health's efforts to recruit and retain medical professionals.[107] For example, as of 1991, the doctor-patient ratio was 1 to 1,700; the Pan American Health Organization recommends a ratio of 1 to 910.[108] The proportion of vacant positions is also very high in other health-related professions. The vacancy rates are especially high among pharmacists (75.2%), midwives (52.9%), mental health officers (47.4%), enrolled assistant nurses (45.7%), public health nurses (31.7%), and registered nurses (29.4%).[109]

Regulation of health care providers

Critical questions regarding health care providers exist. Who is legally permitted to provide what types of care? Are there meaningful guarantees of quality control within health care services? Because the Jamaican government regulates these issues, reviewing relevant laws is important. Three statutes regulate health professionals in Jamaica: the Medical Act of 1976 (the "Medical Act");[110] the Nurses and Midwives Act of 1966 (the "Nurses and Midwives Act");[111] and the Pharmacy Act of 1975 (the "Pharmacy Act").[112]

The Medical Act establishes a Medical Council[113] that registers medical practitioners, appoints examiners to test persons applying for registration as medical practitioners, and ensures the maintenance of proper standards of professional conduct by registered medical practitioners.[114] Medical doctors must complete the required course of study and meet the requirements for registration to practice medicine in Jamaica.[115] The Ministry of Health recognizes twenty-three different categories of medical practitioners. The Medical Act also addresses the unauthorized practice of medicine. It is a criminal offense

for any person to practice medicine, make medical diagnoses, or prescribe or administer drugs if that person has not been registered as a medical practitioner under the Medical Act[116] or if his or her registration has been suspended.[117] The Medical Act does not require practitioners of alternative medicine to register.[118] The Medical Act establishes medical and ethical guidelines for registered medical practitioners.[119] The Medical Council hears complaints in relation to any acts or conduct in breach of these guidelines.[120]

The Medical Act empowers the Medical Council to suspend or revoke the license of any medical practitioner who (a) is suffering from any habit or mental or physical condition that renders him or her unfit to practice medicine; (b) procured his or her registration through the use of misleading, false, or fraudulent misrepresentation; (c) has been convicted of a criminal offense; or (d) engages in "conduct which is disgraceful in a professional respect."[121] The Medical Act also enumerates eight categories of behavior deemed "disgraceful in a professional respect," for which medical practitioners can be subject to disciplinary action by the Medical Council.[122]

A medical appeals tribunal hears appeals from the decisions of the Medical Council.[123] The tribunal may either allow or dismiss the appeal or send it back to the Medical Council to be reconsidered.[124] The tribunal may also set aside any punishment imposed by the Medical Council and substitute a milder sanction that is, in its view, more appropriate.[125]

The Nurses and Midwives Act establishes the Nursing Council[126] and empowers it to control the training and practice of nurses, midwives, and assistant nurses.[127] This council also has power to register nurses and midwives, to enroll assistant nurses,[128] and to discipline nurses and midwives by revoking or suspending their registration or enrollment.[129] It is an offense to practice midwifery or to act as or imply that one is a nurse or assistant nurse if one lacks a certificate of registration or enrollment or if that certificate has been suspended.[130]

The Pharmacy Act establishes the Pharmacy Council[131] and empowers it to serve a variety of regulatory functions.[132] This council registers pharmacists, pharmaceutical students, pharmacies, owners of pharmacies, and authorized sellers of poisons. It also establishes and maintains proper standards of conduct by persons registered under the Pharmacy Act and regulates the training of pharmaceutical students. The Pharmacy Council is additionally empowered to discipline those whom it registers through censure, suspension, or removal from the register.[133] It also publishes lists of drugs and poisons.[134] Only a registered pharmacist or a pharmaceutical student under the supervision of a registered pharmacist, working on premises registered as a pharmacy, may compound, dispense, and store for sale or retail the drugs listed.[135] Similarly, more restrictive regulations apply to the retailing, storing, selling, dispensing, and delivery of poisons.[136]

Patients' rights

Laws also seek to ensure quality health services by protecting the rights of patients. In practice, the consent of a patient or someone legally empowered to act on the patient's behalf is required before medical procedures can be carried out. The Ministry of Health encourages practitioners to have their patients sign consent forms before treatment, but there is no statutory requirement for such consent. In addition, there are no statutory provisions regarding either harm caused to a patient or medical malpractice. Common-law rules relating to assault and negligence, however, do apply.[137] A doctor who is found guilty of assault of a patient, could have his or her registration revoked or suspended for a maximum period of two years.[138]

The requirement of informed consent is an established principle of the English common law and is applicable in Jamaica.[139] To constitute valid consent, the person undergoing a medical procedure must both know of the risks involved and willingly consent to take these risks. By consenting to the procedure, the patient consents to the risks inherent in the procedure but does not consent to negligence on the part of the surgeon. A client who suffers injury due to the negligence of a medical practitioner may be able to allege a legal claim against the practitioner under tort principles of common law. To succeed in an action for negligence, the plaintiff must prove that the defendant was in breach of the duty of care owed by medical practitioners toward their clients, and that, as a result of the breach of that duty, the plaintiff suffered harm. Medical procedures that are performed without a client's consent may constitute an actionable tort — "trespass" to the client's person.[140]

B. POPULATION, REPRODUCTIVE HEALTH, AND FAMILY PLANNING

Population laws and policies

Jamaica's population policy provides the framework within which its family planning services are provided. The general objectives relating to population, as stated in the Revised Statement of National Population Policy of 1995 ("Revised Population Policy Statement"),[141] are to improve the satisfaction of basic human needs and the quality of life of Jamaican people in areas such as housing, health, nutrition, education, transportation, and the environment.[142] The government believes that the achievement of these objectives depends on ensuring that the population does not exceed the number of persons who can be satisfactorily supported by the nation. The population policy seeks specifically to restrict population growth to a maximum of 0.8% per annum over the next three decades.[143] The current average population growth rate is estimated at 0.9%.[144] The Revised Population

Policy Statement predicts that if that annual rate of decline continues, Jamaica should be able to achieve replacement level fertility (two children per woman) by the year 2000 or shortly thereafter.[145] Although the population policy aims at a population not to exceed three million by 2020,[146] the United Nations Population Fund ("UNFPA") projects that Jamaica's population will increase to around 3.4 million by 2025.[147]

The Planning Institute of Jamaica (the "PIOJ") has designed a National Plan of Action on Population and Development 1995 to 2015 (the "National Plan of Action on Population"),[148] to implement the Revised Population Policy Statement and the Cairo Programme of Action (the "Cairo Programme") [149] of the International Conference on Population and Development of 1994 (the "ICPD").[150] The National Plan of Action on Population is to guide the implementation of the national population policy and reflects the ICPD's theme of the interrelationship of population, sustained economic growth, and sustainable development.[151]

The agencies and institutions responsible for the process of monitoring the implementation and evaluation of the national population policy are the minister responsible for population; the Population Policy Coordinating Committee ("PPCC"), a multisectoral body appointed by the government in 1982; the PIOJ; and the Information, Education, and Communication Subcommittee of the PPCC. In addition, NGOs, other ministries of government, private sector organizations, and nonprofit private organizations also contribute to the implementation of the population policy.[152]

Reproductive health and family planning laws and policies

The National Family Planning Act of 1970 (the "National Family Planning Act")[153] established the National Family Planning Board ("the Family Planning Board") as the principal agency of government for the allocation of financial assistance and grants to bodies or persons engaged in family and population planning.[154] It coordinates or directs the work of those engaged in family and population planning to ensure an economical and effective national effort.[155] The National Family Planning Act empowers the Family Planning Board to promote research and disseminate information in relation to family planning;[156] to provide for sex education; and to arrange and participate in national and international courses, seminars, and conferences on family planning.[157] The National Family Planning Act requires the Family Planning Board to provide the minister of health with information on family and population planning upon request.[158] The minister may, after consulting with the chairman of the Family Planning Board, provide it with general directions that he or she believes to be in the public interest. In such instances, the Family Planning Board must follow the chairman's directions.[159]

Government delivery of family planning services

Family planning services are available throughout Jamaica in the public health system.[160] Family planning services are delivered through a network of health centers, hospitals, private physicians, and NGOs. In 1995, approximately 40,000 clients received services through the public family planning program.[161] The Family Planning Board is responsible for ensuring access to family planning services for those who want them; coordinating clinical services offered by public, private, and voluntary organizations; promoting outreach services, utilizing mobile units to distribute nonclinical methods of contraception; undertaking and promoting research and disseminating information relating to family planning and family-life education; monitoring the development of research in the areas of reproductive behavior and contraceptive health; and reviewing for adoption new or refined means of fertility regulation.[162]

The president of the Medical Association of Jamaica (the "MAJ") reports that doctors are seeing fewer patients in Jamaica generally because "many patients cannot afford it."[163] The Ministry of Health also reports a decline in the percentage of pregnant women receiving care from the public health system. While 73.8% of pregnant women received such care in 1994, only 68.2% did so in 1995.[164] The number of people visiting family planning clinics has declined from more than 370,000 in 1991 to slightly more than 170,000 in 1995.[165] During the first 16 weeks of pregnancy, however, the overall percentage of pregnant women in Jamaica seeking medical care has stayed relatively stable at just below 19%, and the average number of visits to public health services per pregnant woman has also remained stable at around four visits per pregnancy.[166] In recent years, the percentage of persons accepting contraception among those registered with the public family planning program declined from 22% in 1985 to 16.9% in 1992.[167]

C. CONTRACEPTION

Prevalence of contraceptives

Knowledge of at least one form of contraception is practically universal in Jamaica.[168] The most popular methods in the 1980s (by prevalence) were contraceptive pills, female sterilization, the condom, and Depo Provera®.[169] The rate of contraceptive use nationwide has increased steadily, from 38% in 1975 to 55% in 1989 to 67% in 1996.[170] All methods and types of contraceptives are readily available in hospitals, clinics, and Family Planning Board outlets. About 30% of the women of Jamaica, especially those whose male partners refuse to use condoms, use injections, contraceptive pills, IUDs, and diaphragms.[171] Of the 40,000 clients serviced by the family planning program in 1995, the pill was chosen by 47.8% as their method of contraception, while 28.8% chose condoms, and 21.7% chose

the Depo Provera® injection.[172] Although gender-specific statistics on contraception usage rate are unavailable, the Ministry of Health has acknowledged that the burden and responsibility for contraception in Jamaica falls largely on women. Most men hold the view that women must ensure their safety from pregnancy, and some actively oppose the use of any contraception by themselves or their partners. Public education programs seek to change the attitude of such persons.[173]

Legal status of contraceptives

Jamaican law does not restrict the use of contraceptives. The Ministry of Health and the Family Planning Board are the primary implementing agencies for the distribution of contraceptives. Sales and distribution of condoms reportedly have increased from approximately two million in 1985 to 10 million in 1996. The Ministry of Health aims to increase that number to 20 million in the next five years.[174] Various types of contraceptives are available in private clinics and retail outlets, primarily pharmacies.[175] Condoms are not distributed in schools, but a young person may obtain them from any government clinic or family planning center.[176]

Regulation of information on contraception

There are no laws in Jamaica specifically controlling the provision of information on contraceptive methods. As described above in the section Family Planning Laws and Policies, the National Family Planning Act empowers the Family Planning Board to disseminate information in relation to family planning and to provide for sex education.

Sterilization

Sterilization is legally available in Jamaica. Nearly 4,000 female sterilization procedures were carried out in 1995;[177] male vasectomies are extremely rare in Jamaica.[178] The procedures are performed at sixteen hospitals and four health centers. The government-operated Glen Vincent Fertility Unit performs tubal ligations, provided the woman has had more than two children, has received adequate counseling, and has signed a consent form.[179] Fees for the service at government facilities are set so as to cover the government's costs. The cost of the procedure in a private facility is unregulated. There is no specific legislation regulating those who provide sterilization services.[180]

D. ABORTION

Because abortion is illegal in most circumstances in Jamaica, it is difficult to obtain information about its prevalence. It is estimated that there were from 10,000 to 20,000 illegal abortions in the 1970s and that 20% of all gynecological beds in Jamaican hospitals were occupied by patients suffering from the effects of illegal abortions.[181] Complications brought on by illegal abortions are one of the leading causes of maternal deaths in Jamaica.[182]

Legal status of abortion

In Jamaica, abortion is *prima facie* illegal. It is a felony for anyone to perform an abortion or for a pregnant woman to attempt to abort her fetus by using any instrument, poison, or other means with the intention of causing herself to miscarry.[183] Where the abortion is performed by another person, the woman's consent to the abortion is no defense. A person may be guilty of an attempt to procure abortion even though the woman is not pregnant.[184] It is also a criminal offense to procure any poison or instrument for another person knowing that she or he intends to use it for the purpose of performing an abortion.[185]

Although the Penal Code provides no exceptions to its proscription against abortion, the common law has developed principles permitting specific exceptions. In the English case, *Rex v Bourne*, the House of Lords ruled that an abortion would not be unlawful when the operation was performed in good faith for the purpose of preserving the life of the mother.[186] The court stated that this did not merely mean saving the mother from death but included cases where the continuation of the pregnancy would cause her physical or emotional harm.[187] Since decisions of the House of Lords are of highly persuasive authority in Jamaica,[188] *Bourne* has been applied in Jamaica since 1975, when the Minister of Health embraced it in a policy paper, as described below.[189]

However, the *Bourne* principle merely provides a person performing an abortion with a defense to a criminal charge. The person performing the abortion remains technically subject to criminal prosecution, and she or he has the burden of establishing that the abortion was lawful according to the holding in *Bourne*. Some physicians are thus hesitant to perform abortions.[190] Neither the decision in *Bourne* nor any other provision of Jamaican law establishes any qualification necessary for the person who performs an abortion. Therefore an unqualified person, as well as a qualified one, may avail herself or himself of the *Bourne* defense. No statute establishes procedures for spousal or parental consent or for review or consultation among doctors. Jamaica's Medical Council allows for abortions, however, if continuing the pregnancy would involve "serious threat to the life or health (mental or physical) of the mother."[191]

Requirements for obtaining legal abortion

In 1975, Kenneth A. McNeill, then Jamaica's Minister of Health and Environmental Control, issued a Statement of Policy on abortion. The Ministry acknowledged the common-law position making it "lawful for a registered medical practitioner acting in good faith to take steps to terminate the pregnancy of any woman if . . . he forms the opinion that the continuation of the pregnancy would be likely to constitute a

threat to the life of the woman or inure to the detriment of her mental and physical health."[192] The Statement of Policy called for the amendment of the Offences Against the Person Act of 1864 (the "Offences Against the Person Act")[193] so as to "make clear when abortion would be lawful in Jamaica" and "to take steps to make rape, carnal abuse and incest a lawful ground for abortion."[194] Despite this statement, Jamaica has not amended the Offences Against the Person Act. The Medical Association of Jamaica supports the legalization of abortion and has lobbied for Jamaica's adoption of an abortion law modeled on Barbados's Medical Termination of Pregnancy Act, which allows for abortion before the twentieth week of pregnancy or in cases of rape or incest.[195]

Legal abortions are performed both at government clinics and by private doctors. The government finances the service at public health facilities.[196] Official government policy states that an abortion may be performed in a public facility when two doctors recommend it on the basis that the pregnant woman is physically or mentally at risk.[197] Public hospitals and the government-run Glen Vincent Fertility Unit provide abortions if certain conditions are met.[198] A pregnant teenager under the age of 17 can obtain an abortion if she is accompanied by a parent and provides documentation proving her age. A woman who has been the victim of rape or incest can also obtain an abortion, but she must provide documented evidence of the crime that caused her pregnancy. A pregnant woman referred by the police, the Family Court, or by a family planning clinic operated by the Ministry of Health can obtain an abortion if the referring public authority provides evidence documenting her need for an abortion. Women who require abortions because of medical or therapeutic reasons need not provide documentation to support the medical reason given. No woman can have more than one abortion, however, and every woman who obtains an abortion must be counseled on contraception prior to and immediately after the abortion.

Penalties for abortion

Persons performing abortions, as well as women who attempt to abort their fetuses, are subject to life imprisonment with or without hard labor.[199] The penalty for procuring any poison or instrument for another knowing that she or he intends to use it for the purpose of performing an abortion is three years with or without hard labor.[200]

Regulation of abortion information

There is no formal law or regulation restricting information about abortion. However, notwithstanding the government's policy permitting abortions in certain circumstances, there tends to be little information available relating to the availability of abortion services.[201]

E. HIV/AIDS AND SEXUALLY TRANSMISSIBLE INFECTIONS ("STIs")

Examining HIV/AIDS issues within a reproductive health framework is essential insofar as the two areas are interrelated from both medical and public health standpoints. Hence, a full evaluation of laws and policies affecting reproductive health and rights in Jamaica must examine HIV/AIDS and sexually transmissible infections ("STIs"). According to the Ministry of Health, since 1982, there have been 2,060 reported cases of AIDS in Jamaica. In 1996, 527 new cases were reported; 321 of those stricken were men and 206 were women. There have been a total of 154 cases of children with the virus. Of the reported cases, 55.7% of those who have developed AIDS have died.[202] The trend has been for the number of cases of AIDS to double every two years.[203] The incidence of STIs in Jamaica is high, with 5,125 cases of gonorrhea, 2,414 cases of syphilis, and 7,455 cases of chlamidya reported in 1995.[204]

Laws on HIV/AIDS and STIs

The Jamaican Parliament has passed no legislation to address HIV/AIDS, and no regulations address it. There is no law prohibiting discrimination against AIDS victims.[205] Several independent advocacy organizations have protested the Ministry of Health's delays in introducing legislation to protect people with AIDS. In 1995, the ethical subcommittee of Jamaica's National AIDS Committee ("NAC") submitted a position paper to the Ministry of Health in support of new legislation to protect people with AIDS.[206] The NAC position paper supports legislation to protect persons with AIDS from discrimination and would also protect their privacy rights by establishing policies on confidentiality and disclosure. The NAC also calls for criminal and civil liabilities against people with HIV/AIDS who willfully expose others to the disease.[207] The Jamaica Employers' Federation has also called for a standard policy to protect the rights of persons with AIDS and of other employees.[208] The Ministry of Health has cited a lack of public consensus as the cause for its delay in implementing an AIDS policy.[209]

Few laws in Jamaica specifically address STIs. The Public Health Act empowers the Ministry of Health to call upon the local boards of health to investigate any disease present in their parishes and to do "whatever is necessary for arresting the spread of that disease."[210]

Policies on prevention and treatment of HIV/AIDS and STIs

The government has issued a policy to deal with HIV/AIDS. The National HIV/STD Control Programme, Medium Term Plan 1997-2000 (the "Medium Term Plan"), identifies the policy priorities and critical issues. The Medium Term Plan intends to consolidate the response to the AIDS epidemic by coordinating

the efforts of government, private, community, religious, and civic sectors. The epidemiology unit of the Ministry of Health will act as the national coordinating body and as the resource for direct technical cooperation. On the local level, the Medium Term Plan supports parish leaders in their HIV/AIDS/STD interventions and activities. Specifically, the Medium Term Plan calls for the improvement of access to and use of condoms; the formulation of a prison health policy and a policy on HIV/AIDS in the workplace; and the integration of STD services into primary health care, especially in the maternal and child health program and in the school system.[211] The Association for the Control of Sexually Transmitted Diseases ("ACOSTRAD"), a nongovernmental organization, works with the epidemiology unit of the Ministry of Health to educate the public on AIDS and to encourage condom use. Employees of the Ministry of Health also place condoms in bars and low-rent hotel rooms.[212]

III. Understanding the Exercise of Reproductive Rights: Women's Legal Status

Women's reproductive health and rights cannot be fully evaluated without investigating women's status within the society in which they live. Not only do laws relating to women's legal status reflect societal attitudes that will affect reproductive rights, but such laws often have a direct impact on women's ability to exercise reproductive rights. The legal context of family life, a woman's access to education, and laws and policies affecting her economic status can contribute to the promotion or the prohibition of a woman's access to reproductive health care and her ability to make voluntary, informed decisions about such care. Laws regarding the age of first marriage can have a significant impact on a young woman's reproductive health. Furthermore, rape laws and other laws prohibiting sexual assault or domestic violence present significant rights issues and can also have direct consequences for women's health.

A. CIVIL RIGHTS WITHIN MARRIAGE

Marriage law

Marriages in Jamaica are governed by the Marriage Act of 1897 (the "Marriage Act")[213] the Hindu Marriage Act of 1957 (the "Hindu Marriage Act"),[214] and the Muslim Marriage Act of 1957 (the "Muslim Marriage Act"),[215] which prescribe the prerequisites for a valid marriage. The Muslim Marriage Act and the Hindu Marriage Act confer upon marriages performed in accordance with the customs of those faiths substantially the same status as marriages solemnized under the Marriage Act. To be valid, a marriage must be solemnized before two witnesses and before a person who is registered as a marriage officer.[216] Such a person may be either a minister of religion or a civil registrar.[217] The Marriage Act provides for the publishing of banns[218] (a public notice of the names of the parties intending to marry), the issuing of marriage licenses,[219] and the registration of marriages in a general registry.[220] It is an offense under the Marriage Act to falsify, destroy, injure, remove, or conceal a public register of marriage or any notice or document in relation to a marriage that a marriage officer has in his or her custody.[221] It is also an offense for a marriage officer to make any false certification of any document or for a person to pretend to be a marriage officer.[222] Bigamy is an offense, and the law requires the Registrar General to record any conviction for bigamy.[223]

Regulation of common-law marriage

In addition to legally recognized marriages, many couples form "visiting unions," in which the man visits the woman, often at the parental home, or common-law marriages, many of which develop out of visiting unions. Couples often live together for many years and raise several children together before entering a legal union.[224] However, a recent study of the Kingston Family Court found that in most Jamaican families women are at the core of the family unit, while men tend to be more transitory, although they still play an important financial role.[225]

Divorce and custody law

There is only one ground for divorce: an "irretrievable breakdown" of the marriage.[226] Pursuant to the Matrimonial Causes Act of 1989 (the "Matrimonial Causes Act"), the parties are able to establish that their marriage has broken down irretrievably only if they can prove that they have lived separate and apart for a continuous period of no less than twelve months immediately preceding the date of filing the divorce petition.[227] Persons may prove that they have been living apart even though they have been sharing the same house provided that they live in separate rooms and do not have conjugal relations.[228] The Supreme Court, which has jurisdiction in most divorce cases, will not hear divorce petitions without special leave, that is, a specific request by a party, unless the parties have been married for at least two years at the time when the petition is presented.[229] The judge may grant such leave if she or he is satisfied that the parties have attempted reconciliation with the assistance of a marriage counselor and there are special circumstances that justify the hearing of the petition.[230] Upon hearing any petition for divorce the Court may either grant or refuse a decree, or it may adjourn the case and refer the parties to an approved marriage counselor.[231] The Matrimonial Causes Act provides for custody and/or maintenance applications to be

entertained in proceedings preliminary to, at, or after a divorce proceeding.[232] It also provides for financial provisions to be made in respect of either spouse[233] and for protective orders to be issued with respect to a spouse or child of the marriage.[234]

The court may enforce an order for maintenance by attachment of the person's income or pension, seizure of assets, or, ultimately, imprisonment.[235] In general, a husband is not obliged to maintain a wife who has been guilty of adultery or unjustified desertion.[236] A man also does not have any legal responsibility to maintain his common-law wife. Although women in permanent, nonmarital relationships have no legal right to obtain support or maintenance, they may claim maintenance for their children. Under the Married Women's Property Act of 1887 (the "Married Women's Property Act"),[237] a woman has an obligation to support her husband if he is destitute and she has property.[238]

Spouses are financially responsible for each other and for their children. Pursuant to the Maintenance Act of 1881, a man is required to maintain his children and any of his wife's minor children who are living at the time of their marriage.[239] He is also required to maintain the children of any woman with whom he is cohabiting.[240] Although men have the principal responsibility for maintenance, women are also required to maintain their children and must do so if the father either fails or is unable to maintain them.[241]

Jamaican law enables women to obtain support for children from the fathers. Because 42% of Jamaican women are heads of households, more than 80% of Jamaican children are born out of wedlock.[242] The Affiliation Act of 1926[243] provides for procedures enabling single women to initiate legal proceedings against the putative fathers of their children and to obtain judgments ordering such fathers to make payments for the maintenance and education of their children.[244] Legislative reforms in the 1970s and 1980s aimed at preventing legal discrimination against children on the basis of their parents' marital status and encouraged men to take financial responsibility for their offspring.[245] For example, the Status of Children Act of 1976[246] eliminated the ceiling previously placed on child-support payments and linked such payments to the father's income.[247] When inflation is considered, however, actual child support awards have not significantly increased.[248] The Jamaican legislature has only recently begun to draft laws that grant to common-law spouses the same custody and inheritance rights as those enjoyed by spouses in marriages solemnized under the Marriage Act.[249]

B. ECONOMIC AND SOCIAL RIGHTS

Property rights

Jamaican women were first allowed to own and control individual property in 1887, when the Married Women's Property Act[250] was enacted. Later amendments to the act permitted married women to sign contracts, incur debts, and sue or be sued.[251] This statute also allows married women to bring criminal proceedings for the protection of their property.[252] The Married Women's Property Act is now mainly used in situations where the husband and wife own property jointly and wish a court to determine the extent of each of their interests or where even though the property is registered to only one of them, they are each claiming an interest in it.[253] The beneficial interest of married partners in jointly owned property is determined by examining the intention of the parties at the time of acquisition of the property, and their direct or indirect contribution to the purchase.[254] If a husband purchases property and transfers it into his wife's name, it is presumed to belong to her alone unless he can bring evidence to rebut that presumption.[255] Similarly, if he puts the property in both their names, there is a rebuttable presumption that he made a gift of one half-share to her. If both parties contributed to the purchase of the property, the presumption is usually that they each own an interest in proportion to their contribution.[256]

Inheritance rights are governed primarily by the Intestates' Estates and Property Charges Act of 1937.[257] Under the provisions of this act, beneficiaries of both sexes have equal rights to inheritance.[258] The rules of testamentary freedom permit a person to write a will that disinherits his or her spouse and children.[259] However, under the Inheritance (Provision for Family and Dependents) Act of 1993,[260] a spouse, child, or parent may apply to the Supreme Court for an order for maintenance out of a deceased's assets.[261] The court, in deciding whether to grant such an order, will consider all relevant circumstances including the size of the estate; the applicant's resources and needs; the deceased's reasons for not making provision for the applicant in his or her will; and the conduct of, and relationship between, the applicant and the deceased during the deceased's lifetime.[262] Pursuant to the Inheritance Act, a common-law spouse has the same rights as a legal spouse.[263]

Labor rights

Because the Jamaican Constitution does not prohibit discrimination on the basis of sex, it permits discriminatory legislation. For example, the Women (Employment of) Act of 1942 (the "Women's Employment Act")[264] provides, with certain exceptions, that "no woman shall be employed in night work"[265] and that the total permitted hours of employment per twenty-four hours is ten hours.[266] The statute provides no exception to the stated maximum hours of employment. Certain occupations are exempt from the prohibition on nighttime employment: nurses or healthcare workers; management; theater or cinema workers; workers in hotels, bars, restaurants,

and clubs; pharmacists; workers in fresh fruit preparation, packing, and shipment; and workers in certain specified unavoidable situations.[267] The Women's Employment Act further gives the Minister of Labor the power to restrict or prohibit, the employment of women in industrial undertakings[268] and to restrict, prohibit or regulate the employment of women before or after childbirth.[269]

Since the 1970s, legislation to prevent discrimination against women in the workplace has been in place. The Employment (Equal Pay for Men and Women) Act of 1975[270] makes it an offense for an employer to pay persons of different sexes at different rates for the same work where they have the same qualifications and are working under similar conditions.[271] This law sets out a mediation procedure, and the employer may only be prosecuted if no settlement is reached at the end of such mediation.[272] The employer must keep records in relation to rates of pay and any other matter that the Minister of Labor may by order prescribe, and ministry officials may examine these records.[273] A court has the power to order arrears of remuneration to be paid to an employee who has suffered from a discriminatory payment practice.[274] The agreement of the employee to a lower wage is no defense to prosecution pursuant to the statute.[275]

The Maternity Leave Act of 1979 (the "Maternity Leave Act")[276] allows women eight weeks of paid maternity leave during the time of their pregnancy[277] or after giving birth and another four weeks of unpaid leave if required due to pregnancy or confinement.[278] If the woman can provide evidence in the form of a medical certificate that she requires additional leave because either she or her child is ill, she may get another fourteen weeks of leave.[279] Another extension may be granted if her doctor indicates that it is necessary.[280] However, when an extended period of leave is recommended, the employer may require that the medical examination be carried out in consultation with, or in the presence of, a doctor named by the employer.[281] Two conditions apply to the maternity leave entitlement: the employee must advise the employer in advance of the expected time of her confinement,[282] and she must provide a medical certificate if her employer requests one.[283] To qualify for maternity leave, an employee must have been continuously employed with the employer for at least fifty-two weeks prior to the date of the leave.[284] Women under 18 years old and domestic workers do not qualify for maternity leave with pay.[285] A woman who has received paid maternity leave for three pregnancies is not entitled to more maternity leave from the same employer.[286]

The Maternity Leave Act requires employers to allow women to return to work when their leave is over.[287] When a woman returns from leave, she must be employed in the same place and capacity, to do the same type of work, on the same terms and conditions.[288] If the job has been eliminated during her absence, she should be offered a similar job if possible, and if it is not possible, unemployment payments must be made to her.[289]

Access to credit

Jamaican law provides men and women with equal access to credit. However, certain discriminatory practices persist. For example, where a husband and wife apply for a loan together, the wife is almost invariably required to get written confirmation from a lawyer that she has received legal advice as to her rights. This is done to rebut the legal presumption of undue influence of a husband over a wife.[290] The practice is controversial, as is the question of whether this requirement works against women or in their favor. Another discriminatory practice, which has no basis in law, is the practice by financial institutions of requiring married women to obtain their husbands' written consent prior to approval of a loan.[291]

Access to education

During the 1994–1995 academic year, 21,500 teachers were employed in public education at the early childhood, primary, and secondary levels, while 650 full-time lecturers served at the tertiary levels. Seven hundred thousand students were enrolled at all levels.[292] The allocation for the Ministry of Education, Youth and Culture accounted for 8.5% of the national budget, and additional funds were provided through the national cost-recovery program and through contributions to foundations and development and endowment funds at the tertiary level.[293]

Men and women in Jamaica have an equal right to education. In fact, girls outnumber boys in most of the school system.[294] While male students slightly outnumber female students at the primary-school level, female students outnumber male students at the secondary and university level.[295] Some students attend all-female or all-male schools; others attend coeducational schools.[296] Attendance at government schools is in principle free, but a recently introduced cost-sharing program has enabled the government to recover more than 5% of its budget in fees paid by students. A welfare fund assists students who are unable to pay their fees in full.[297] As of 1992, although women predominated among university students in the fields of education, the social sciences, medicine, dentistry, and law, they were underrepresented in the fields of agriculture, mathematics, architecture, theology, and engineering.[298] Women were also underrepresented among academic staff at the University of the West Indies in Kingston. However, women accounted for 63% of university enrollment in the year 1992-1993.[299]

Women's bureaus

The Bureau of Women's Affairs was formed in 1975 as an agency under the Ministry of Labor, Social Security and Sports to promote the full integration of women into the country's development process.[300] The Bureau seeks to address issues confronting women such as lack of economic opportunity; violence against women; and discriminatory laws, regulations, and policies.[301] This bureau, in collaboration with other government agencies and private organizations, trains community leaders and educators in gender sensitivity. The bureau also seeks to improve the health and nutritional status of low-income women through training in those areas, and to encourage women to participate in business through workshops and training in the areas of business management, marketing, and entrepreneurship.[302]

C. RIGHT TO PHYSICAL INTEGRITY

Rape

The law relating to rape is governed by the Offences Against the Person Act. Pursuant to this legislation, rape is punishable by life imprisonment.[303] While the crime of rape is not defined in the Offences Against the Person Act, it is clear from recent attempts to reform that act that only vaginal intercourse is considered rape.[304] An attempt to commit rape is punishable by seven years' imprisonment,[305] but if a weapon is used in the attempt, the sentence is a maximum of ten years' imprisonment.[306] The act also prescribes sentences for other sexual offenses, such as indecent assault, and offenses against minors, such as carnal abuse, which is defined as sexual intercourse with a girl under 16 years of age.[307]

There is currently a draft bill to amend the Offences Against the Person Act,[308] which seeks to change the law. The amendment would make the offense of rape gender-neutral;[309] prohibit the publication of a rape complainant's identity;[310] and specify that rape includes penetration of the vagina or anus by any object or part of a person's body.[311] In addition, the amendment would abolish the common-law presumption that a 14-year-old boy is incapable of rape[312] and allow wives to prosecute their husbands for rape in certain circumstances.[313]

The draft bill to amend the Offences Against the Person Act defines "rape" as "sexual intercourse with another person (a) without that other person's consent and (b) knowing that the other person does not consent to sexual intercourse or recklessly not caring whether that other person consents or not."[314] Consent is deemed not to exist where the "apparent agreement is (a) exhorted by threats or fear of bodily harm to the complainant or to a third person; or (b) obtained by false and fraudulent representations as to the nature of the act or the identity of the offender."[315]

The common law already recognizes that a wife is not deemed to have consented to have sexual intercourse with her husband in the following circumstances: during a separation, or when divorce proceedings are underway or there is a separation agreement or restraining order in place; when sex is accompanied by threat of, or actual, physical attack or injury; and when the husband has a sexually transmitted disease.[316] These common-law rules governing the circumstances under which a spouse can bring a charge of marital rape are incorporated into the bill to amend the Offences Against the Person Act.[317]

Sexual harassment

There is no specific law penalizing sexual harassment in Jamaica. None is being contemplated at this time, although there is a draft Caribbean Community ("CARICOM") Sexual Harassment Act that could serve as a model for future legislation in Jamaican.[318]

Domestic violence

In Jamaica, there are two statutes that protect spouses from domestic violence, the Domestic Violence Act and the Matrimonial Causes Act. Pursuant to these statutes, abused spouses may apply to the court for orders to exclude an abuser from the home in which both parties had been living or from going to or near to the workplace, school, or any other specified location where the abused spouse or child may be found.[319] The Domestic Violence Act applies equally to persons in marital and nonmarital relationships.[320] In the Domestic Violence Act, "'spouse' includes a woman who cohabits with a man as if she were his wife"[321] Applications under the Matrimonial Causes Act, however, which are brought in the Supreme Court, may only be brought by married persons.[322] Proceedings under the Domestic Violence Act are brought in the Resident Magistrates Court and are intended to be speedy and to require minimal legal assistance.[323] As a result, this process is expected to be inexpensive and to increase the access of poor women to the protection of the courts. The proceedings are not public,[324] and publication of the results is prohibited.[325]

The Domestic Violence Act also provides for occupation orders to be made, allowing an abused person to continue to occupy the home until other arrangements for accommodation can be made.[326] Usually a protection order excluding the abuser from the home will accompany an occupation order. Where an occupation order is entered, the court may also make an ancillary order for use of the household furniture and appliances.[327]

Sexual-offense-investigation units have recently been established within the police forces of six parishes, and female officers have been trained to encourage victims of sexual offenses to report those crimes.[328]

IV. Analyzing the Rights of a Special Group: Adolescents

The needs of adolescents are often unrecognized or neglected. Given that nearly one-third of Jamaica's population is under the age of 15, and given that nearly one-fourth of all births are to women aged 12 to 19,[329] it is especially important to meet the reproductive health needs of adolescents. The effort to address issues of adolescent rights, including those related to reproductive health, is important for women's rights to self-determination, as well as for their health.

A. REPRODUCTIVE HEALTH AND ADOLESCENTS

The government provides few reproductive health programs or services specifically geared towards adolescents. Neither the National Family Planning Act nor the Revised Population Policy Statement specifically targets adolescents or articulates a policy for promoting reproductive health and education among adolescents. Hence, the government does not provide contraceptives to schools, and contraceptives thus are not available in such locations. However, beginning at approximately age 15, a girl can get condoms free of charge from the Family Planning Board, the Ministry of Health, and clinics.[330] Although no information is available on unmet need for reproductive health services, there are indications that many adolescents who need contraception are unable to access it. A 1987 survey showed that 76% of all first births to young women aged 15 to 24 were unintended, and, of these, 15% were to mothers under 16 years of age.[331]

Independent women's organizations attempt to supplement the government's efforts in the areas of family planning and reproductive health, sometimes in coordination with the Ministry of Health. The Women's Center of Jamaica Foundation (the "Foundation") focuses on continued education for mothers under the age of 16; delaying or preventing teenage pregnancy; and improving job opportunities for young women.[332] The Foundation has also established a center for adolescent girls, operated by the Ministry of Health, which assists pregnant schoolgirls with continuing their education and learning parenting and vocational skills. This center also encourages "baby-fathers" to care for the children.[333] Since its creation in 1978, the Foundation's Adolescent Mothers Programme has assisted nearly 20,000 young mothers, and more than half of them have returned to the school system.[334]

B. MARRIAGE AND ADOLESCENTS

Marriages between persons under 16 years of age or within the prohibited degrees of consanguinity are void under English law.[335] Marriages between persons under 18 years of age are void unless the consent of the person's parent or legal guardian has first been obtained.[336]

C. SEXUAL OFFENSES AGAINST ADOLESCENTS AND MINORS

Jamaican law recognizes numerous sexual offenses against minors. These include incest;[337] procuring a girl under 18 years old "to have illicit carnal connection with any man";[338] "unlawful carnal knowledge" of a girl between the ages of 12 and 16;[339] inducing or encouraging "defilement" of a young girl on one's own premises;[340] and causing, encouraging, or favoring the "seduction" or prostitution of a girl under 16 years of age.[341] In addition, it is a criminal offense to procure any woman under 18 to have "unlawful carnal knowledge" within or outside of Jamaican territory; become a common prostitute; leave Jamaica to become a prostitute or an inmate of or to frequent a brothel; or leave her usual place of abode for the purposes of prostitution.[342] Abduction of a girl under 18 with intent to have "carnal knowledge"[343] and unlawful detention with intent to have carnal knowledge are also criminal offenses.[344]

Carnal abuse of a girl who is over 12 but under 16 years old is punishable by seven years' imprisonment,[345] while carnal abuse of a girl under 12 is punishable by life imprisonment.[346] Where the victim is over 12 but under 16, the Offenses Against the Person Act provides a special statutory defense for a man under 23 years of age who reasonably believed that the girl was over the age of 16.[347]

The Incest (Punishment) Act of 1948 (the "Incest Act")[348] prohibits sexual intercourse between a man and his granddaughter, daughter, sister, or mother.[349] A man who commits incest with a female under 12 years of age is liable to ten years' imprisonment at hard labor. Where the woman is over 12 years of age the maximum sentence is five years.[350] A female aged 16 years or over is guilty of incest if she "with consent permits" her grandfather, brother, father, or son to have sexual intercourse with her. On conviction she is liable to imprisonment for a maximum period of five years.[351] The Incest Act does not define the term *consent*. An amendment to the Incest Act has been proposed which would extend the prohibition to sexual intercourse between stepparents and their stepchildren, guardians and wards, as well as between uncles or aunts and their nieces or nephews.[352] The amendment would create a single, gender-neutral felony incest offense by persons over the age of 16[353] and would amend the definition of sexual intercourse to

conform to the new definition provided in the proposed amendment to the Offenses Against the Person Act.[354]

D. SEXUAL EDUCATION

There is as yet no formalized sex-education program in schools, but the Revised Population Policy Statement proposes that the Ministry of Education, Youth and Culture coordinate programs and projects in the formal education system in order to implement the population policy.[355] The Revised Population Policy Statement also stresses the importance of community involvement to the successful implementation of the policy.[356]

ENDNOTES

1. THE WORLD ALMANAC AND BOOK OF FACTS 1997, AT 787 (1996) [hereinafter WORLD ALMANAC].
2. UNITED NATIONS POPULATION FUND, THE STATE OF WORLD POPULATION: THE RIGHT TO CHOOSE: REPRODUCTIVE RIGHTS AND REPRODUCTIVE HEALTH 72 (1997) [hereinafter STATE OF WORLD POPULATION 1997].
3. WORLD ALMANAC, *supra* note 1, at 786; 29 ENCYCLOPEDIA BRITANNICA MACROPAEDIA, *West Indies: Jamaica* 750-751 (1997) [hereinafter ENCYCLOPEDIA BRITANNICA].
4. WORLD ALMANAC, *supra* note 1, at 786.
5. ENCYCLOPEDIA BRITANNICA, *supra* note 3, at 751.
6. WORLD ALMANAC, *supra* note 1, at 787.
7. *Id.*
8. U.S. DEPARTMENT OF STATE, COUNTRY REPORTS ON HUMAN RIGHTS PRACTICES FOR 1996, 490-491 (February 1997).
9. JAMAICA (CONSTITUTION) ORDER IN COUNCIL (1962), Ch. IV, §27 [hereinafter JAM. CONST.].
10. *Id.*, Ch. VI, §§68-96.
11. *Id.*, Ch. V, Pt. 1, §§34-67.
12. *Id.*, Ch. VII, Pt. 1, §97-113.
13. *Id.*, Ch. VI, §68.
14. LLOYD G. BARNETT, THE CONSTITUTIONAL LAW OF JAMAICA 37 (1977) [hereinafter BARNETT].
15. JAM. CONST., Ch. VI, §69(1-2).
16. *Id.*, Ch. VI, §70(1).
17. BARNETT, *supra* note 14, at 43.
18. JAM. CONST., Ch. VI, §70(1).
19. *Id.*, Ch. VI, §79.
20. *Id.*, Ch. VI, §90; BARNETT, *supra* note 14, at 142.
21. JAM. CONST., Ch. VI, §90.
22. *Id.*, Ch. VI, §83.
23. *Id.*, Ch. VI, §88(1).
24. *Id.*, Ch. VI, §87-88.
25. BARNETT, *supra* note 14, at 172.
26. *Id.*
27. *Id.*, at 63.
28. JAM. CONST., Ch. VI, §71(2),(3).
29. BARNETT, *supra* note 14, at 64, 113.
30. *Id.*, at 65.
31. JAM. CONST., Ch. V, Pt. 1, §34.
32. *Id.*, Ch. V, Pt. 1, §35.
33. *Id.*, Ch. V, Pt. 4, §66.
34. The Constitution of Jamaica is attached as the second schedule to the Jamaica (Constitution) Order in Council, laid before English Parliament on July 24, 1962.
35. JAM. CONST., Ch. V, Pt. 4, §67(1).
36. *Id.*, Ch. V, Pt. 2, §48(1).
37. *Id.*, Ch. V, Pt. 3, §64(2).
38. *Id.*, Ch. V, Pt. 3, §64(1,5).
39. *Id.*, Ch. V, Pt. 3, §64(3).
40. *Id.*, Ch. V, Pt. 1, §41(1)(a).
41. *Id.*, Ch. V, Pt. 3, §65(1).
42. BARNETT, *supra* note 14, at 337.
43. JAM. CONST., Ch. VII, §§97-110; BARNETT, *supra* note 14, at 301. The drafters of the Jamaican Constitution decided to vest the original and appellate jurisdictions of the former superior courts in these two separate courts with different personnel. *Id.*
44. Judicature (Resident Magistrates) Act (1928) [hereinafter Resident Magistrates Act, 1928].
45. Judicature (Family Court) Act (1975) [hereinafter Family Court Act, 1975].
46. JAM. CONST, Ch. VII, Pt. 2, §103.
47. Judicature (Appellate Jurisdiction) Act, 1962, Pt. II, §§ 3(c), 5 [hereinafter Judicature (Appellate Jurisdiction) Act, 1962].
48. JAM. CONST., Ch. VII, Pt. 3, §110.
49. *Id.*, Ch. VII, Pt. 3, §110(1).
50. *Id.*, Ch. VII, Pt. 3, §110(2); Judicature (Appellate Jurisdiction) Act, Pt. VIII, § 35 (1962).
51. Conversion rate is $J1=$U.S. .02937. OANDA, *164 Currencies Converter* (visited June 18, 1997) <http://www.oanda.com.cgi-bin/ncc>.
52. JAM. CONST., Ch. VII, Pt. 3, §110(1)(a).
53. *Id.*, Ch. VII, Pt. 3, §110(1)(b).
54. *Id.*, Ch. VII, Pt. 3, §110(1)(c).

55. *Id.*, Ch. VII, Pt. 3, §110(2).
56. JAMAICA (CONSTITUTION) ORDER IN COUNCIL, §13 (1962).
57. BARNETT, *supra* note 14, at 309.
58. JAM. CONST., Ch. VII, Pt. 1, §97(2).
59. Jurisdiction established in the Resident Magistrates Act, 1928.
60. BARNETT, *supra* note 14, at 304–305.
61. Resident Magistrates Act, 1928, §3.
62. Jurisdiction established in the Family Court Act, 1975, §4, schedule.
63. Domestic Violence Act (1995) [hereinafter Domestic Violence Act, 1995].
64. *Id.*, Pt. 1, §2.
65. BARNETT, *supra* note 14, at 130.
66. *Id.*, at 134.
67. Parish Councils Act, §3(2) (1901).
68. *Id.*, §8.
69. BARNETT, *supra* note 14, at 134.
70. *Id.*, at 25–26.
71. JAM. CONST., Ch. I, §2.
72. *Id.*, Ch. V, Pt. 2, §§49–50.
73. *Id.*, Ch. V, Pt. 2, §49(4),(7)(a).
74. *Id.*, Ch. V, Pt. 2, §49(5–6).
75. *Id.*, Ch. III, §13.
76. *Id.*, Ch. III, §24(3). The anti-discrimination provision states that "no law shall make any provision which is discriminatory either of itself or in its effect." *Id.*, Ch. III, §24(1).
77. *Id.*, Ch. III. §24(4)(b).
78. *Id.*, Ch. III, §25(1),(3),(4).
79. *Id.*, Ch. III, §25(2).
80. R. v. Howard, 16 West Indian Reports 67, 73 (Ct. of Appeal of Jamaica, 1970); *see generally*, Geoffrey Gilbert, *The Legal System of the British Commonwealth* in 3 MODERN LEGAL SYSTEMS CYCLOPEDIA 3.270, 3.270.9 (Kenneth Robert Redden, ed., 1994).
81. BARNETT, *supra* note 14, at 286–287.
82. *Id.*
83. *Id.*, at 287.
84. *Id.*
85. International Convention on the Elimination of All Forms of Racial Discrimination, *opened for signature* March 7, 1966, 660 U.N.T.S. 195 (*entry into force* Jan. 4, 1969) (ratified by Jamaica June 4, 1971).
86. International Covenant on Economic, Social and Cultural Rights, *adopted* Dec. 16, 1966, 993 U.N.T.S. 3 (*entry into force* Jan. 3, 1976) (ratified by Jamaica on Oct. 3, 1975).
87. International Covenant on Civil and Political Rights, *adopted* Dec. 16, 1966, 999 U.N.T.S. 171 (*entry into force* Jan. 3, 1976)(ratified by Jamaica on Oct. 3, 1975).
88. Convention on the Elimination of All Forms of Discrimination Against Women, *opened for signature* Mar. 1, 1980, 1249 U.N.T.S. 13 (*entry into force* Sept. 3, 1981) (ratified by Jamaica on Oct. 19, 1984).
89. Convention on the Rights of the Child, *opened for signature* Nov. 20, 1989, G.A. Res. 44/25, U.N.G.A.O.R., 44th Sess., Supp. No. 29, U.N. Doc. A/44/49, *reprinted in* 28 I.L.M. 1448 (*entry into force* Sept. 2, 1990) (ratified by Jamaica on May 14, 1991).
90. American Convention on Human Rights, *opened for signature* Nov. 22, 1969, OAS T.S., No. 36, OAS Off. Rec. OEA/Ser. L/VII.23 doc. 21, rev. 6 (1979) (*entry into force* 18 July 1978) (ratified by Jamaica on Aug. 7, 1978), *reprinted* in ORGANIZATION OF AMERICAN STATES, BASIC DOCUMENTS PERTAINING TO HUMAN RIGHTS IN THE INTER-AMERICAN SYSTEM OEA/Ser.L.V./II.92, doc. 31 rev. 3 (1996), at 25.
91. Inter-American Convention on the Prevention, Punishment and Eradication of Violence Against Women (Convention of Belém do Pará), *adopted by acclamation* June 9, 1994, General Assembly of the Organization of American States, 24th Sess.
92. Draft Report on Jamaica from Mrs. Margarette May Macaulay, Esq., coordinator of the Association of Women's Organizations in Jamaica ("AWOJA"), and Portia Nicholson Clarke, Esq., Chairperson of the Legal Committee, AWOJA, 18 (on file at the Center for Reproductive Law and Policy) [hereinafter AWOJA Draft Report], based on interview with Dr. Alafia Samuels, senior medical officer for the South-East Region, Jamaican Ministry of Health.
93. JAMAICA NATIONAL PREPARATORY COMMISSION, NATIONAL REPORT ON THE STATUS OF WOMEN IN JAMAICA, PREPARED FOR THE FOURTH WORLD CONFERENCE ON WOMEN, BEIJING: SEPTEMBER, 1995, 49, ¶6.4.1 (1994) [hereinafter NATIONAL REPORT].
94. The Public Health Act (1985) [hereinafter Public Health Act, 1985].
95. *Id.*, §3.
96. *Id.*, §5.
97. *Id.*, §4.
98. Pan-American Health Organization, *Country Health Profiles: Jamaica* (last updated Sept. 15, 1995) <http://www.paho.org/english/jamaica.htm>.
99. *Id.*
100. NATIONAL REPORT, *supra* note 93, at 49, ¶6.4.3.
101. PLANNING INSTITUTE OF JAMAICA, ECONOMIC AND SOCIAL SURVEY JAMAICA 22.6–22.7 (1995) [hereinafter ECONOMIC AND SOCIAL SURVEY 1995].
102. NATIONAL REPORT, *supra* note 93, at 53, ¶6.4.18.
103. AWOJA Draft Report, *supra* note 92, at 18, *citing* information provided by Dr. Alafia Samuels.
104. *Id.*, at 17, based on interview with Dr. Alafia Samuels.
105. *Id.*, at 18–19.
106. *Mandatory medical plan on stream*, THE GLEANER, Apr. 24, 1997 (on file at the Center for Reproductive Law and Policy).
107. ECONOMIC AND SOCIAL SURVEY 1995, *supra* note 101, at 22.1–22.2.
108. NATIONAL REPORT, *supra* note 93, at 53, ¶6.4.19.
109. ECONOMIC AND SOCIAL SURVEY 1995, *supra* note 101, at 22.1–22.2.
110. The Medical Act (1976) [hereinafter Medical Act, 1976].
111. The Nurses and Midwives Act (1966) [hereinafter Nurses and Midwives Act, 1966].
112. The Pharmacy Act (1975) [hereinafter Pharmacy Act, 1975].
113. Medical Act, 1976, §3.
114. *Id.*, §4(a–c).
115. *Id.*, §7.
116. *Id.*, §14(2).
117. *Id.*, §14(3).
118. AWOJA Draft Report, *supra* note 92, at 19, based on interview with Dr. Alafia Samuels. Such practitioners could be sanctioned for "practicing medicine" in contravention of Section 14 of the Medical Act.
119. Medical Act, 1976, §11(2).
120. *Id.*, §11.
121. *Id.*, §11(1)(a–d).
122. *Id.*, §11(2)(a–h).
123. *Id.*, §13.
124. *Id.*, §13(2)(b)(I–iii).
125. *Id.*, §13(2)(b)(iv).
126. Nurses and Midwives Act, 1966, §3.
127. *Id.*, §4.
128. *Id.*
129. *Id.*, §11.
130. *Id.*, §15.
131. Pharmacy Act, 1975, Pt. II, §3.
132. *Id.*, Pt. II, §4(a–e).
133. *Id.*, Pt. III, §14.
134. *Id.*, Pt. IV, §17.
135. *Id.*, Pt. IV, §18(1).
136. *Id.*, Pt. IV, §18(2–4).
137. AWOJA Draft Report, *supra* note 93, at 21.
138. Medical Act, 1976, §11(1)(c); §11(1)(d)(i–ii).
139. See discussion *supra* of sources of law.
140. Accuracy confirmed via e-mail correspondence with Portia Nicholson Clarke of AWOJA from July 7, 1997, on file at the Center for Reproductive Law and Policy.
141. PLANNING INSTITUTE OF JAMAICA, A STATEMENT OF NATIONAL POPULATION POLICY JAMAICA, REVISED 3 (1995) [hereinafter REVISED POPULATION POLICY STATEMENT]. The Revised Population Policy Statement was approved by the Jamaican Cabinet and adopted by Parliament in February 1996. *Id.* at 1.
142. *Id.*, at 3.
143. *Id.*
144. STATE OF WORLD POPULATION 1997, *supra* note 2, at 72.
145. REVISED POPULATION POLICY STATEMENT, *supra* note 141, at 4.
146. *Id.*, at 3.
147. STATE OF WORLD POPULATION 1997, *supra* note 2, at 72.
148. PLANNING INSTITUTE OF JAMAICA, NATIONAL PLAN OF ACTION ON POPULATION AND DEVELOPMENT JAMAICA 1995–2015 (1995) [hereinafter NATIONAL PLAN OF ACTION ON POPULATION].
149. *Programme of Action of the International Conference on Population and Development, Cairo, Egypt, 5–13 Sept. 1994*, in REPORT OF THE INTERNATIONAL CONFERENCE ON POPULATION AND DEVELOPMENT, U.N. Doc. A/CONF. 171/13/Rev.1, U.N. Sales No. 95, XIII.18 (1995).
150. NATIONAL PLAN OF ACTION ON POPULATION, *supra* note 148, at iv.

151. *Id.*, at v, ¶1.1.
152. REVISED POPULATION POLICY STATEMENT, *supra* note 141, at 9–13.
153. The National Family Planning Act (1970).
154. *Id.*, §3.
155. *Id.*, §4(3)(a).
156. *Id.*, §4(3)(b).
157. *Id.*, §4(3)(c–d).
158. *Id.*
159. *Id.*, §5.
160. NATIONAL REPORT, *supra* note 93, at 51, ¶6.4.8.
161. ECONOMIC AND SOCIAL SURVEY 1995, *supra* note 101, at 22.3.
162. REVISED POPULATION POLICY STATEMENT, *supra* note 141, at 11–12.
163. Carl Wint, *High-cost health care*, in The Jamaica Gleaner Online (June 17, 1997) <http://www.jamaica-gleaner.com/gleaner/19970617/cleisure/c2.html>.
164. ECONOMIC AND SOCIAL SURVEY 1995, *supra* note 101, at 22.4.
165. *Id.*, at 22.5.
166. *Id.*, at 22.4.
167. NATIONAL REPORT, *supra* note 93, at 50–51, ¶6.4.8.
168. According to UNFPA, 99% of Jamaicans have knowledge of a contraceptive method. STATE OF WORLD POPULATION 1997, *supra* note 2, at 69.
169. NATIONAL REPORT, *supra* note 93, at 51, ¶6.4.8.
170. REVISED POPULATION POLICY STATEMENT, *supra* note 141, at 16; THE WORLD'S WOMEN 1995: TRENDS AND STATISTICS 86 (1995).
171. AWOJA Draft Report, *supra* note 92, at 29, based on interview with Dr. Barry Chevannes, Chief Executive Officer of the Family Planning Board.
172. ECONOMIC AND SOCIAL SURVEY 1995, *supra* note 101, at 22.4.
173. AWOJA Draft Report, *supra* note 92, at 30, based on interview with Dr. Alafia Samuels, senior medical officer for the South-East Region, Jamaican Ministry of Health.
174. *Islandwide AIDS programmes to be strengthened*, in The Jamaica Gleaner Online (citing Dr. Peter Figueroa, head of the epidemiology unit within the Jamaican Ministry of Health) (Feb. 13, 1997) <http://www.jamaica-gleaner.com/gleaner/19970213/news.news10.html>.
175. AWOJA Draft Report, *supra* note 92, at 29, based on interview with Dr. Barry Chevannes, Chief Executive Officer of the Family Planning Board.
176. *Id.* at 27, based on interview with Dr. Barry Chevannes.
177. ECONOMIC AND SOCIAL SURVEY 1995, *supra* note 101, at 22.4.
178. AWOJA Draft Report, *supra* note 92, at 29, based on interview with Dr. Alafia Samuels.
179. Medical Association of Jamaica, *Position Paper on Termination of Pregnancy* 3 (1994) [hereinafter MAJ *Position Paper*] (on file at the Center for Reproductive Law and Policy).
180. AWOJA Draft Report, *supra* note 92, at 35, based on interview with Dr. Alafia Samuels.
181. *Abortion Policies: A Global Review*, U.N. Department for Economic and Social Information and Policy Analysis, Volume II, at 78, U.N. Doc. ST/ESA/SER.A/129/Add.1 (1993) [hereinafter *Abortion Policies*].
182. Ernest Pate, *Maternal and Child Health, in* PAN AMERICAN HEALTH ORGANIZATION, HEALTH CONDITIONS IN THE CARIBBEAN 171, 179 (1997).
183. Offences Against the Person Act (1864), §§72–73 [hereinafter Offences against the Person Act, 1864].
184. *Id.*, §§72–73.
185. *Id.*, §73.
186. Rex v. Bourne, 1 Law Reports 687, 691 (K.B. 1938).
187. *Id.*, at 692–694.
188. *See supra* note 80, and accompanying text.
189. *Abortion Policies*, *supra* note 181, at 78; Kenneth A. McNeill, Minister of Health and Environmental Control, Paper No. 1, "Abortion: Statement of Policy," Jan. 15, 1975 (M.P. No. HH 490/01) [hereinafter McNeill, Statement of Abortion Policy, 1975], *reprinted* in part in 2 ANNUAL REVIEW OF POPULATION LAW 44–45 (1975).
190. *Abortion Policies*, *supra* note 181, at 78.
191. Eulalee Thompson, *Call for legal abortions*, THE GLEANER, June 7, 1994, at 1, *quoting* the Ethics Guidelines of the Medical Council.
192. McNeill, Statement of Abortion Policy, 1975, *supra* note 189, at ¶4.
193. *See supra*, note 183.
194. McNeill, Statement of Abortion Policy, 1975, *supra* note 189, at ¶7.
195. Eulalee Thompson, *Call for legal abortion*, THE GLEANER, June 7, 1994, at 1; The Medical Termination of Pregnancy Act, 1983, §§4(2),5 (Barbados).
196. AWOJA Draft Report, *supra* note 92, at 32.
197. *Id.*, at 33.
198. The following information is provided in MAJ *Position Paper*, *supra* note 179, at 2–3.
199. Offences against the Person Act, §72.
200. *Id.*, §73.
201. MAJ *Position Paper*, *supra*, note 179, at 2.
202. *AIDS costs JA $50m*, THE GLEANER, February 7, 1997, at 1, *quoting* Peter Figueroa, head of the epidemiology unit of the Ministry of Health.
203. ECONOMIC AND SOCIAL SURVEY 1995, *supra* note 101, at 22.8.
204. *Id.*
205. Eulalee Thompson, *Slow pace of AIDS law worrying*, in The Jamaica Gleaner Online (May 22, 1997) <http://www.jamaica-gleaner.com/gleaner/19970522/news.n5.html>.
206. *Id.*
207. *NAC wants law to protect AIDS victims* in The Jamaica Gleaner Online (June 20, 1997) <http://www.jamaica-gleaner.com/gleaner/19970620/news.n3.html>.
208. Eulalee Thompson, *Workplace AIDS policy for 1997*, in The Jamaica Gleaner Online (Dec. 16, 1996) <http://www.jamaica-gleaner.com/gleaner/19961216/news1.html>.
209. *NAC wants law to protect AIDS victims*, in The Jamaica Gleaner Online (June 20, 1997) <http://www.jamaica-gleaner.com/gleaner/19970620/news.n3.html>.
210. Public Health Act, 1985, §8.
211. NATIONAL HIV/STD CONTROL PROGRAM, MEDIUM-TERM PLAN 1997–2000, 11–12 (n.d.) (on file at the Center for Reproductive Law and Policy).
212. AWOJA Draft Report, *supra* note 92, at 38, based on interview with Dr. Alafia Samuels.
213. The Marriage Act, (1897) [hereinafter Marriage Act, 1897].
214. The Hindu Marriage Act, (1957).
215. The Muslim Marriage Act (1957).
216. Marriage Act, 1897, §3(1).
217. *Id.*, §§5–7.
218. *Id.*, §20.
219. *Id.*, §§21–23.
220. *Id.*, §§31–34.
221. *Id.*, §64.
222. *Id.*, §§62–63.
223. *Id.*, §60.
224. *Id.*, at 14–15.
225. SUZANNE LAFONT, THE EMERGENCE OF AN AFRO-CARIBBEAN LEGAL TRADITION: GENDER RELATIONS AND FAMILY COURTS IN KINGSTON, JAMAICA 14 (1996) [hereinafter LAFONT, AFRO-CARIBBEAN LEGAL TRADITION].
226. The Matrimonial Causes Act, §5(1), (1989) [hereinafter Matrimonial Causes Act, 1989].
227. *Id.*, §5(2).
228. *Id.*, §6.
229. *Id.*, §§3,8(1).
230. *Id.*, §8(2).
231. *Id.*, §§11,16.
232. *Id.*, §23.
233. *Id.*, §20.
234. *Id.*, §10(1)(a).
235. The Maintenance Act, §§9, 20 (1881) [hereinafter Maintenance Act, 1881].
236. *Id.*, §12.
237. The Married Women's Property Act (1887) [hereinafter Married Women's Property Act, 1887].
238. *Id.*, §22.
239. Maintenance Act, 1881, §2(a).
240. *Id.*, §2(b).
241. *Id.*, §3.
242. Although there are no statistics on out-of-wedlock births for the 1990s, the proportion has been over 60% throughout the 20th century, and in 1985, 84% of all births were to unmarried women. In 1981, the proportion of births to unmarried women was 89%. NATIONAL REPORT, *supra* note 93, at 6, ¶3.9; LAFONT, AFRO-CARIBBEAN LEGAL TRADITION, *supra* note 225, at 30.
243. The Affiliation Act (1926).
244. *Id.*, §§3, 5(2).
245. LAFONT, AFRO-CARIBBEAN LEGAL TRADITION, *supra* note 225, at 58.
246. Status of Children Act (1976).
247. *Id.*, §16.
248. LAFONT, AFRO-CARIBBEAN LEGAL TRADITION, *supra* note 225, at 11, n.4, 82.
249. *See* The Inheritance (Provision for Family and Dependents) Act, §4(2)(e) (1993) [hereinafter Inheritance Act, 1993]; The Intestates' Estates and Property Charges Act, §2(d) (1937), as amended in 1988 [hereinafter Intestates' Estates and Property Charges Act, 1937]; The Status of Children Act, §3(1) (1976).
250. *See supra*, note 237.

251. Married Women's Property Act, 1887, §2.
252. Id., §13.
253. AWOJA Draft Report, supra note 92, at 42.
254. Pettitt v. Pettitt, 1970 App. Cas. 777 (appeal to the House of Lords taken from the Court of Appeal); Gordon v. Gordon, Supreme Court Civil Appeal #76 (Jamaica 1987).
255. Pettit v. Pettit, 1970 App. Cas. at 815.
256. Harris v. Harris, Supreme Court Civil Appeal #1 at 8 (Jamaica 1981).
257. See supra, note 249.
258. The operative word in the Intestates' Estates and Property Charges Act, 1937 is always the gender-neutral "spouse." See, e.g., §§2(d), 4(1).
259. The Wills Act, §4 (1840).
260. See supra, note 249.
261. Inheritance Act, 1993, Pt. II, §4.
262. Id., Pt. III, §7.
263. Id., Pt II, §4(2)(e)(I).
264. The Women (Employment of) Act (1942).
265. Id., §3(1).
266. Id., §3(2).
267. Id., §3(1)(a–h).
268. Id., §6(2)(a).
269. Id., §6(2)(b).
270. The Employment (Equal Pay for Men and Women) Act (1975).
271. Id., §§2(1), 3(1).
272. Id., §3(4) and Schedule.
273. Id., §8.
274. Id., §3(3).
275. Id., §6(2).
276. The Maternity Leave Act (1979).
277. Id., §5.
278. Id., §3(2).
279. Id., §3(3).
280. Id., §3(4)(a).
281. Id., §3(4)(b).
282. Id., §3(1)(a).
283. Id., §3(1)(c).
284. In the case of a seasonal worker the total period of employment over a five-year period must add up to at least 52 weeks. Id., §3(1)(b).
285. Id., §5(5).
286. Id., §5(2)(c).
287. Id., §4.
288. Id., §4(1)(b,c).
289. Id., §4(5–7).
290. For a discussion of the modern status of the legal doctrine of undue influence as it pertains to wives, see Barclays Bank PLC v. O'Brien, 4 All England Reports 417 (House of Lords, 1993).
291. AWOJA Draft Report, supra note 92, at 47–48.
292. Economic and Social Survey 1995, supra note 101, at 20.1.
293. Id.
294. State of the World Population 1997, supra note 2, at 69; National Report, supra, note 93, at 45.
295. National Report, supra note 93, at 45.
296. AWOJA Draft Report, supra note 92, at 56.
297. Economic and Social Survey 1995, supra note 101, at 20.10.
298. National Report, supra note 93, at 46, ¶6.2.5.
299. Id. at 46–47, ¶¶6.2.2, 6.2.6.
300. Id. at 24, § 2.1.1; Memorandum and attachments from Portia Nicholson Clarke of AWOJA to the Center for Reproductive Law and Policy regarding the Bureau of Women's Affairs (August 21, 1997) (on file with the Center for Reproductive Law and Policy).
301. Id.
302. Economic and Social Survey 1995, supra note 101, at 24.8.
303. Offences Against the Person Act, 1864, §44(1).
304. See the Bill Entitled An Act to Amend the Offences Against the Person Act, §2, published in The Jamaica Gazette supplement, Vol. CXVIII, No. 39 (October 10, 1995) [hereinafter Act to Amend the Offences Against the Person Act, 1995].
305. Id., §44(2)(b).
306. Id., §44(2)(a).
307. Id., §53.
308. See supra, note 303.
309. Id., passim.
310. Id., §4(44c).
311. Id., §2(43A(3)(b)).
312. Id., §2(43C).
313. Id., §2(43B).
314. Id., §2(43A(1)).
315. Id., §2(43A(2)).
316. R. v. R, 4 All England Reports 481 (House of Lords, 1991).
317. Act to Amend the Offences Against the Person Act, 1995, §2(43B(2)).
318. Commonwealth Secretariat, Caribbean Community Secretariat, Commonwealth Fund for Technical Cooperation, Model Legislation with regard to Sexual Harassment: An Act to Provide Remedies in Respect of Acts of Discrimination Involving Sexual Harassment (N.d) (on file at the Center for Reproductive Law and Policy).
319. Matrimonial Causes Act, 1989, §10(1)(b,c); Domestic Violence Act, 1995, §4(1).
320. Domestic Violence Act, 1995, §3(2).
321. Id., §2.
322. Matrimonial Causes Act, 1989, §10.
323. "In this Act . . . 'Court' means the Resident Magistrate's Court or the Family Court" Domestic Violence Act, 1995, §2.
324. Id., §14.
325. Id., §16.
326. Id., §7.
327. Id., §12.
328. National Report, supra note 93, at 8, ¶2.5.
329. Id., at 15, ¶1.3; 50, ¶6.4.8. These figures are from 1992.
330. AWOJA Draft Report, supra note 92, at 56.
331. Revised Population Policy Statement, supra note 141, at 19.
332. Economic and Social Survey 1995, supra note 101, at 24.8–24.9.
333. National Report, supra note 93, at 4, ¶2.10. "Baby-father" and "baby-mother" are the Jamaican terms for parents of children born out of wedlock.
334. Economic and Social Survey 1995, supra note 101, at 24.9.
335. Marriage Act, 1897, §3(2–3).
336. Id., §24.
337. The Incest (Punishment) Act, §2(1) (1948) [hereinafter Incest Act, 1948].
338. Offenses Against the Person Act, 1864, §45.
339. Id., §50.
340. Id., §51(b).
341. Id., §64.
342. Id., §58(1).
343. Id., §60.
344. Id., §61.
345. Id., §50. "Carnal abuse" is defined as sexual intercourse with a girl under 16 years of age. See supra note 307 and accompanying text.
346. Id., §48.
347. Id., §50.
348. See supra note 337.
349. Incest Act, 1948, §2(1).
350. Id., §2(1).
351. Id., §3.
352. An Act to Amend the Incest (Punishment) Act, §2(1), published in The Jamaica Gazette supplement, Vol. CXVIII, No. 39 (October 10, 1995).
353. Id., §§2(3), 5.
354. Id., §2(7).
355. Revised Population Policy Statement, supra note 141, at 12.

Mexico

Statistics

GENERAL

Population

- Mexico's total population is 92 million,[1] of which 46.5 million are women.[2] The population growth rate is approximately 2.05% annually.[3] The life expectancy of women at birth is 76 years.[4]
- In 1990, 71% of the population lived in urban areas.[5]

Territory

- Mexico has a surface area of 1,958 square kilometers.[6]

Economy

- The World Bank estimated that Mexico's gross national product ("GNP") grew by $41.80 per capita in 1994.[7]
- From 1985 to 1994, the GNP grew at an estimated 0.9%.[8]
- From 1990 to 1994, the gross domestic product grew at an estimated 2.5%.[9]
- In 1989, Mexico initiated a process of economic liberalization and privatization of state-owned enterprises.[10]

Employment

- In 1995, women made up 35% of the work force.[11]
- In 1995, women represented 50% of workers in the informal economy.[12]

WOMEN'S STATUS

- The average life expectancy is 72.6 years;[13] it is 76 years for women and 69.8 years for men.[14]
- The illiteracy rate for women was 15.2% in 1992.[15] Two of every three illiterate adults are women.[16]

ADOLESCENTS

- In 1995, approximately 16.3 million women in Mexico were under the age of 15.[17]
- The median age at first marriage is 18.4 years.[18]
- The median age at first childbirth is 21 years.[19]
- The fertility rate among women between the ages of 15 and 19 dropped from 132 births per 1,000 women in 1978 to 78 births per 1,000 women in 1994.[20]
- The prevalence of contraceptive use in women between the ages of 15 and 19 has increased from 14.2% in 1976 to 36.4% in 1992.[21]
- The contraceptive methods most commonly used by adolescent women include hormonal methods (40.3%), the intrauterine device ("IUD") (33.5%), and barrier methods (8.7%).[22]

MATERNAL HEALTH

- The total fertility rate in 1994 was 3 children per woman.[23]
- The maternal mortality rate in 1994 was 61 deaths per every 100,000 live births.[24]
- The infant mortality rate for 1990 to 1994 was 35 deaths per 1,000 live births.[25]
- In Mexico, 85.3% of births are attended by a physician, nurse, assistant, or other health care professional.[26]
- In 1991, 37% of maternal deaths were due directly to pregnancy-related complications, and 25% were due to toxemia during pregnancy.[27]

CONTRACEPTION AND ABORTION

- In 1995, 45% of women of childbearing age used a contraceptive method.[28]

- The most commonly used methods are the pill, feminine sterilization, the IUD, and traditional methods.[29] Sterilization is the most common method among women of childbearing age, with an average prevalence of 43.3%.[30] The pill and the IUD are also significant, averaging 15.3% and 17.7% prevalence, respectively.[31]

- Governmental institutions estimate that 220,000 induced and spontaneous abortions occur annually.[32] International groups and nongovernmental organizations ("NGOs") estimate that 500,000 to 1,500,000 abortions occur yearly.[33]

- Induced abortions represent the fifth most prevalent cause of maternal mortality in Mexico.[34]

HIV/AIDS AND STIs

- In 1994, 13.6% of those infected with HIV were women.[35]

- Blood transfusion is the most common means of transmission among women; 56.5% adult women were infected with AIDS through that means.[36]

- In 1993, 2,855 cases of HIV and 3,304 cases of AIDS were reported in Mexico.[37]

ENDNOTES

1. FEDERAL EXECUTIVE BRANCH, PROGRAMA NACIONAL DE LA MUJER 1995-2000 [NATIONAL WOMEN'S PROGRAM 1995-2000], at 11 (Mexico, 19956).
2. Id.
3. Id., at 1.
4. Id., at 19.
5. NATIONAL POPULATION COUNCIL (CONAPO), SITUACIÓN DE LA MUJER. DESAFÍOS PARA EL AÑO 2000 [THE STATUS OF WOMEN. CHALLENGES FOR THE YEAR 2000], at 59 (Mexico, Oct. 1995).
6. WORLD BANK, WORLD DEVELOPMENT REPORT 1996. FROM PLAN TO MARKET, at 189 (1996).
7. Id.
8. Id.
9. Id., at 209.
10. EUROPEAN YEARBOOK. MEXICO. INTRODUCTORY SURVEY (1994).
11. NATIONAL WOMEN'S PROGRAM, supra note 1, at 25.
12. THE STATUS OF WOMEN, supra note 5, at 19.
13. WORLD DEVELOPMENT REPORT, supra note 6, at 188.
14. NATIONAL WOMEN'S PROGRAM, supra note 1, at 19.
15. Id., at 13.
16. Id.
17. Id., at 11.
18. Id., at 40.
19. FEDERAL EXECUTIVE BRANCH, PROGRAMA DE SALUD REPRODUCTIVA Y PLANIFICACIÓN FAMILIAR [REPRODUCTIVE HEALTH AND FAMILY PLANNING PROGRAM], at 5 (Mexico, 1995).
20. Id.
21. FEDERAL EXECUTIVE BRANCH, PROGRAMA NACIONAL DE POBLACIÓN 1995-2000 (NATIONAL POPULATION PROGRAM 1995-2000), at 11 (Mexico, 1995).
22. REPRODUCTIVE HEALTH AND FAMILY PLANNING PROGRAM, supra note 19, at 5.
23. NATIONAL WOMEN'S PROGRAM, supra note 1, at 22.
24. Id., at 23.
25. UNITED NATIONS, THE WORLD'S WOMEN 1995: TRENDS AND STATISTICS, at 86 (1995).
26. REPRODUCTIVE HEALTH AND FAMILY PLANNING PROGRAM, supra note 19, at 23.
27. THE STATUS OF WOMEN, supra note 5, at 3.
28. THE WORLD'S WOMEN, supra note 25, at 86.
29. NATIONAL POPULATION COUNCIL (CONAPO), SITUACIÓN DE LA PLANIFICACIÓN FAMILIAR EN MÉXICO. INDICADORES DE ANTICONCEPCIÓN [STATUS OF FAMILY PLANNING IN MEXICO. STATISTICS ON CONTRACEPTIVE METHODS], at 3 (Mexico, 1994).
30. Id.
31. Id.
32. REPRODUCTIVE HEALTH AND FAMILY PLANNING PROGRAM, supra note 19, at 22.
33. Grupo de Informacion en Reproduccion Elegida (GIRE) [Free Choice Information Group], Aspectos del aborto en México [Feature of abortion in Mexico], 10 BOLETÍN TRIMESTRAL SOBRE REPRODUCCIÓN ELEGIDA [QUARTERLY BULLETIN ON FREE CHOICE], Sept. 1996, at 5.
34. REPRODUCTIVE HEALTH AND FAMILY PLANNING PROGRAM, supra note 19, at 25.
35. Id., at 24.
36. Id.
37. Id.

Mexico, one of the largest countries in the Americas, is bordered by the United States to the north and Guatemala and Belize to the south and has coasts on the Atlantic and Pacific Oceans.[1] Approximately 60% of Mexico's population is mestizo, 30% is indigenous, and 9% is white.[2] The official language is Spanish.[3] In the sixteenth century, Spain colonized the Mexican territory, which was inhabited principally by the Aztec and Mayan civilizations.[4] Mexico won its independence from Spain in 1821.[5] Since 1929, the country has been governed by the *Partido Revolucionario Institucional* (Institutional Revolutionary Party).[6] Over the past decade, the dominant feature of the political situation has been the gradual weakening of the governing party. This was made evident by the recent defeat of the PRI in the elections for governor of the Federal District held in July 1997.[7] The Mexican government must also deal with high levels of corruption within government institutions, the emergence of guerrilla movements, and an increase in drug trafficking.[8]

Since 1990, the Mexican government has adopted economic reforms aimed at opening the economy and privatizing state-owned enterprises.[9] Because of the economic crisis that hit the country in 1995, the government has implemented an austerity program.[10] As of 1995, Mexico was a party to the North American Free Trade Agreement, along with the United States and Canada.[11]

I. Setting the Stage: the Legal and Political Framework

To understand the various laws and policies affecting women's reproductive rights in Mexico, it is necessary to consider the legal and political systems of the country. By considering the bases and structure of these systems, it is possible to attain a better understanding of how laws are made, interpreted, modified, and implemented as well as the process by which governments enact reproductive health and population policies.

A. THE STRUCTURE OF THE NATIONAL GOVERNMENT

The Constitution of the United States of Mexico ("Federal Constitution"), in effect since 1917, has been amended approximately 200 times.[12] The Constitution establishes Mexico as a representative, democratic, and federal republic composed of free and sovereign states.[13] Sovereignty resides in the people and is exercised by the national government and by the states according to the Federal Constitution and the state constitutions.[14] In practice, the Mexican political system is presidential;[15] the exercise of executive power resides "in a single person," the president of the United States of Mexico.[16]

The Federal Constitution recognizes and protects the multicultural composition of the Mexican nation and mandates governmental safeguarding and promotion of the languages and customs of indigenous peoples as well as respect for their legal practices.[17] The Mexican federal government is divided into three branches: the executive branch, the legislative branch, and the judicial branch.[18]

Executive Branch

The president of the United States of Mexico is the head of the executive branch of government.[19] The president is elected by direct universal suffrage for a period of six years.[20] The president oversees foreign policy and enters into international treaties, which must be ratified by the Senate;[21] he is also charged with promulgating and implementing the laws enacted by Congress.[22] The president names the cabinet secretaries, officials akin to ministers in other countries, who direct state policy within their specific sectors.[23] He also nominates a list of candidates to be justices of the Supreme Court of Justice, who must then be approved by the Senate.[24] In order to become effective, all the regulations, agreements, decrees and orders approved by the president must be signed by the secretary of state or the head of the relevant administrative department that oversees the issues in question.[25]

The federal civil service is centralized and is an organ of the national government.[26] A law passed by Congress determines the administrative responsibilities of the federal ministries and of the administrative departments of the federal government.[27] The ministries are required to inform Congress periodically about the progress of the sector under their responsibility.[28]

Legislative Branch

The legislative branch is the Federal Congress,[29] which is a chamber of senators and a chamber of deputies.[30] The Senate is composed of 128 senators elected for a period of six years.[31] The House of Deputies is composed of 500 deputies elected for a three-year period.[32] The Senate and the House of Deputies meet independently; they meet in a joint session only when they must designate an interim president of the republic in the absence of the president,[33] at the inauguration of the president,[34] and at the opening of the ordinary sessions of Congress.[35]

The Congress is primarily responsible for enacting legislation.[36] In the process of enacting national laws, the following have the right to introduce legislation: deputies, senators, the president of the republic, and the state legislatures.[37] Once a bill is approved by both chambers of Congress, it is sent to the president, who proposes modifications or promulgates it if he

has no observations.[38] If the President does not return the bill within 10 working days, it is considered approved by the executive branch.[39]

When Congress holds a plenary session, it enacts laws related to national social and economic-development policies, federal crimes, nationality, and the imposition of taxes to cover the federal budget.[40] The Chamber of Deputies must approve the latter.[41] The Senate is responsible for ratifying international treaties signed by the president.[42] The Constitution provides that it is the duty of the Federal Congress and of the state legislatures to create entities to protect human rights within their respective jurisdictions.[43] These institutions are responsible for independently formulating public recommendations regarding human rights issues. They also make denunciations and file complaints regarding human rights violations before the respective authorities.[44] The National Commission on Human Rights was created following this constitutional mandate, and it has served as a model for the creation of state government entities.

Judicial Branch

The Mexican legal system derives from Roman law.[45] In Mexico, the function of judges is to interpret and apply the law but not to create it.[46] The federal judicial branch comprises the Supreme Court of Justice ("Supreme Court"),[47] the Council of the Federal Judiciary,[48] the Electoral Tribunal,[49] the Collegiate and Unitary Circuit Courts,[50] and the district courts.[51] The Supreme Court is comprised of 11 members nominated by the president and appointed by the Senate[52] for a period of 15 years.[53] The Council of the Federal Judiciary designates the district courts.[54] The same rules regarding nomination, appointment, nonremovability, and dismissal from office apply to all judges. The Electoral Tribunal is the highest jurisdictional authority in electoral issues, with the exception of the Supreme Court, which has the power to determine the constitutionality of electoral laws.[55] It is a specialized entity of the federal judicial branch.[56]

In 1994, the Mexican government proposed the adoption of constitutional amendments designed to increase the autonomy of the judicial branch.[57] These amendments gave the Supreme Court of Justice, among others, the power to emit general declarations of unconstitutionality[58] and to review, in specific cases, the legislation of different states.[59]

B. THE STRUCTURE OF TERRITORIAL DIVISIONS

The territory of Mexico is made up of 31 states and the Federal District.[60] Mexico City forms the Federal District, the site of the federal government.[61] Each state must adopt a form of republican, representative, and popular government, with the municipality as the basis of the territorial division and administrative organization.[62] The administration of the states is parallel to that of the federal government.[63] The federal government and the states may agree that the latter assume functions of federal administration, the implementation of public works, and the provision of public services for the benefit of national and social development.[64] The Federal Constitution, among other prohibitions on states, establishes that in no instance can the states enter treaties or alliances with another state or foreign power.[65] Neither can they issue currency; impose taxes on the transit of persons or merchandise through their territory or on national or foreign property; or contract obligations or loans with foreign governments, foreign corporations, or individuals.[66]

Public authority in the states is divided into the executive, legislative, and judicial branches.[67] Governors, who head the executive branch of the states, are directly elected for a period of no more than six years.[68] State governors are required to publish in an official source and to implement federal laws.[69] The state legislatures are composed of deputies elected by relative majority and proportional representation according to number of votes cast.[70] The states have the power to legislate in all matters that are not specifically reserved to federal competency.[71] The judicial branch of each state comprises courts established by each state's constitution.[72]

The municipalities are administered by a municipal government that is directly elected by the people.[73] Municipal governments autonomously manage municipal assets and are responsible for providing certain public services.[74] The municipal presidents and members of the city council are directly elected by the people.[75]

C. SOURCES OF LAW

Domestic sources of law

The laws that determine the legal situation of women and their reproductive rights come from different sources. In the Mexican legal system, the Federal Constitution, laws enacted pursuant to specific constitutional authority, and international treaties entered into by the president and ratified by the Senate, prevail over all other federal and state laws.[76] Federal law is not hierarchically superior to state law;[77] both are applied in accordance with the competencies conferred by the Federal Constitution and laws promulgated pursuant to specific constitutional authority to the federal and local legislatures.[78] When no law exists to govern a specific issue in a civil trial,[79] the source of law is the general principles of law.[80] No law can be applied retroactively, except when it benefits a defendant in a criminal matter.[81]

International Sources of Law

Several international human rights treaties recognize and promote specific reproductive rights. Governments that adhere to such treaties are legally obligated to protect and promote these rights. Once the president has signed an international treaty, the treaty must be submitted to the Senate for ratification.[82] Once it is ratified, it becomes part of domestic law and, together with the Constitution and laws enacted by Congress, becomes part of the supreme law of the land.[83]

Mexico is a member state of the United Nations and the Organization of American States. As such, it has ratified most of the international treaties that comprise the universal system of the protection of human rights.[84] In particular, Mexico has ratified most of the treaties referring to the protection of women's human rights in the universal and the Inter-American systems, including the Convention on the Elimination of All Forms of Discrimination Against Women[85] and the Inter-American Convention on the Prevention, Punishment and Eradication of Violence Against Women ("Convention of Belém do Pará").[86]

II. Examining Reproductive Health and Rights

The status of women's health in Mexico has improved over the past 30 years. This trend is reflected in the reduction in maternal mortality, an increase in life expectancy at birth, and the reduction of the population growth rate.[87]

A. HEALTH LAWS AND POLICIES

Objectives of the health policy

The Federal Constitution was amended in 1982 to provide that all persons shall have access to health services through the National Health System ("NHS").[88] The Constitution also establishes that all persons have the right to health care.[89] Mexican law specifies the responsibilities of both federal and state governments in this matter.[90] The Ministry of Health[91] is responsible for establishing and directing national health policy. Pursuant to the federal General Health Law, the duties of the Ministry of Health are to coordinate the health service programs of the departments and entities of the NHS that pertain to the federal civil service and to formulate recommendations to those departments responsible for allocating resources to health programs.[92]

The Federal Constitution also mandates that the social security system provide special protection to women during pregnancy and breast-feeding.[93] Mexican law provides that maternal and infant health care and family planning are basic health services,[94] and the former is a priority.[95]

The current government program for the health sector is the Reform Program of the Health Sector 1995–2000 ("RPHS"),[96] which sets forth national-level government strategies to reach the objectives outlined in the National Development Plan 1995–2000.[97] These objectives are to promote quality and efficiency in service provision by decentralizing services; to broaden the coverage provided by the social security system, facilitating the affiliation of the non-state-employed population; and to provide basic health services to the poorer sectors of the urban and rural population.[98]

The programs established to implement the health policy are the Program to Promote and Foster Health; the Program for Infants and School Children; the Reproductive Health and Family Planning Program 1995–2000 ("RHFPP"); the Health Program for Adults and the Elderly; Health Programs for the General Public; regional programs; and the Program to Promote Hygiene.[99]

Infrastructure of health services

The NHS is composed of private and public health establishments.[100] Public health providers are divided into the social security (or health) system for the employed population (the insured population) and the public health system for the uninsured population.[101] The largest providers of social security are the Mexican Institute of Social Security ("MISS") in the private sector[102] and the Institute for Social Security and Services for State Employees ("ISSSSE") for public employees.[103] Approximately 40% of the population is covered by the social security system.[104] The population that uses this system is primarily urban workers;[105] only 16.7% of the population in rural areas has access to the social security system.[106]

For the unemployed population, the health service providers are primarily the various government agencies, including the Ministry of Health, the Department of the Federal District, the Program for the Comprehensive Development of the Family, and the MISS. The latter provides services to the uninsured population independently of its role as a provider of social security.[107] The government provision of health services comprises approximately 70% of the beds registered in the census;[108] the remaining percentage corresponds to the services provided by the private sector.[109]

Public health services do not reach the most vulnerable groups of the population, which make up approximately ten million inhabitants.[110] In the period from 1991 to 1993, the percentage of women who lacked access to medical services increased from 54% to 59%.[111] In terms of human resources, there were approximately 100,000 physicians employed by the

state in 1992, of which 39% worked for the public health service and the remaining 56% worked in the MISS and the ISSSSE.[112] In 1995, there were 130.4 physicians for every 100,000 inhabitants.[113] The public health service employs 66% of the country's physicians and provides approximately 68% of all medical consultations.[114] The impact on women's reproductive health is reflected in the following statistics: approximately 87% of births are attended by physicians, 2% by nurses, 9% by midwives, and just 2% are not attended by trained personnel.[115]

Cost of health services

Since 1980, investment in the health sector has remained constant at approximately 2% of the gross national product.[116] The health services provided to the population that are not covered by the social security system are primarily funded by the federal government.[117] The public services provided by the Ministry of Health are funded through a fee paid by the patient that varies according to the individual's income and the type of service provided.[118] However, in 1992, less than 10% of the Ministry of Health's budget derived from fees charged,[119] which means that the federal government assumes almost all of the total cost of these services.[120] Only 2% of the Mexican population is covered by private health insurance companies.[121]

The funding of social security depends primarily on the contributions of employees and employers, plus contributions made by the federal government.[122] The budget of the social security system is financed by the employer (70%), the employee (25%), and the federal government (5%).[123] A deduction of 12.5% is taken from employees' salaries as a contribution to the social security system.[124] The health services offered by this system also cover the dependents of the insured person[125] and include medical visits as well as drugs and medications.[126]

Regulation of health care providers

The Federal Constitution establishes that states are competent to regulate those professions that require a professional degree and determine the qualifications needed and the entities authorized to give the degree. The General Health Law provides that the Ministry of Health and the state governments — within their respective jurisdictions — must oversee the performance of health professionals, technicians, and assistants.[127] These entities must also promote the establishment of professional associations and organizations for health professionals, technicians, and assistants,[128] which are to serve as ethical reference points for the exercise of the health profession and as consultants to government health authorities.[129] This law also mandates that the exercise of technical and auxiliary activities that require specific knowledge in the field of medicine and nursing also requires legally sanctioned diplomas.[130]

The regulations of the General Health Law dealing with the provision of medical treatment[131] contain specific requirements for reproductive health providers. They provide that those in charge of obstetric-gynecological hospitals must have a minimum of five years' experience in their specialty.[132] Nonprofessional personnel may provide obstetric and family planning services when they are trained and have received authorization from the Ministry of Health.[133] The state health ministries must maintain a registry of nonprofessional personnel who hold permits to provide obstetric services.[134]

Patients' rights

The General Health Law provides that patients have the right to "obtain timely health care of a suitable quality and to receive professionally and ethically responsible treatment, as well as respectful and dignified treatment from technical and auxiliary health professionals."[135] Health authorities and health establishments are required to regulate orientation and counseling procedures for health services users. They must also establish mechanisms for patients to communicate complaints, claims, and suggestions relating to the health services they receive.[136] The General Health Law encourages the participation of the community in health care prevention programs as well as in the provision of health care services. This participation is encouraged through mechanisms designed to inform the authorities about any failures or deficiencies encountered by health care services users.[137]

The government also regulates the physician-patient relationship. Conflicts can be brought before civil and criminal courts, among other entities.[138] A presidential decree[139] established the National Commission of Medical Arbitration ("NCMA").[140] While its decisions are not binding, this entity can resolve conflicts that arise among patients and providers of health services.[141] Its functions are to provide information to medical service users and providers about their rights and duties; to respond to complaints made by health service users; to intervene as an impartial mediator to reconcile conflicts deriving from service provision; and to award decisions to the parties that submit to its arbitration.[142] The NCMA expresses opinions about the complaints it hears[143] and must remit any documentation and reports solicited by the National Human Rights Commission that are related to complaints that are within the jurisdiction of this commission.[144]

Criminal laws in every state punish medical negligence. For the Federal District, the Penal Code establishes aggravated penalties for the crimes of homicide and assault[145] inflicted by health professionals during the exercise of their functions or as a result of them.[146]

B. POPULATION, REPRODUCTIVE HEALTH, AND FAMILY PLANNING

The Mexican government's current population policy is outlined in the General Population Law[147] and its regulations,[148] and in the National Population Program 1995–2000 ("NPP").[149] The family planning laws and policies are outlined in the Mexican Regulation on Family Planning Services[150] and in the Reproductive Health and Family Planning Program 1995–2000.[151]

Population laws and policies

The General Population Law provides that the fundamental objective of population policy is "to regulate those factors that affect the population in terms of its size, structure, dynamic, and distribution throughout the national territory, with the objective of ensuring that the population participates in a just and equitable manner in the benefits of economic and social development."[152] The population policy has the following specific objectives: to promote greater balance in the relationship between demographic phenomena and the process of economic and social development; to encourage the territorial distribution of the population so that it is in line with the region's development capacity; and to promote women's participation in the processes of economic, educational, social, cultural, and political development.[153] Through the Ministry of Government Administration, the federal government is responsible for emitting, promoting, and coordinating federal demographic policies.[154]

The National Population Council ("NPC")[155] is responsible for the demographic planning of the country.[156] One of its principle functions is to include population goals in social and economic development programs formulated by different government entities.[157] The demographic goals of the Mexican government are to attain a population growth rate of 1.75% by the year 2000 and 1.45% by the year 2005, compared with the current rate of 2.05%, and to attain a global fertility rate of 2.4 children per woman by 2000 and 2.1 per woman by 2005, compared with the current rate of 2.9 children per woman.[158]

Reproductive health and family planning laws and policies

The Federal Constitution recognizes the right to choose freely, and in a responsible and informed manner, the number and timing of one's children.[159] Reproductive health and family planning are considered by the Mexican government to be "strategic axes of the country's development."[160] The RHFPP 1995–2000 was created within the framework of the policy guidelines established by the NPP and the National Women's Program[161] as part of the RPHS.[162] The objective of the RHFPP is to integrate the following services: reproductive health, family planning, infant and maternal health care, sexually transmissible infections ("STIs"), cervical, uterine, and breast cancer, and prevention and monitoring of high-risk pregnancies.[163] In order to meet the needs of these services, six subprograms, one for each of the above-mentioned areas, were created within the RPHS.

The objectives of the family planning subprogram are to strengthen and broaden the coverage and quality of family planning information, education, and services, with special emphasis on rural areas; to contribute to a decrease in fertility; to reduce the number of unwanted, unplanned, and high-risk pregnancies; and to broaden activities designed to diversify the use of modern contraceptive methods.[164]

In respect to its reproductive health and family planning policies, some objectives of the federal government are to increase to 70% by the year 2000 the prevalence of contraception among women of childbearing age who live with their partner, compared to the current average of 64%; to increase the prevalence of contraception among women who have had children to 70%, compared with the current rate of 51%; to increase the number of vasectomies; and to reduce maternal mortality, currently 4.8 for every 10,000 live births, by half.[165]

Government delivery of family planning services

The General Health Law provides that family planning services are a priority within the general provision of health services.[166] The Regulation on Family Planning Services ("RFPS") establishes the principles, criteria of operation, and strategies for family planning service provision.[167] It also regulates activities aimed at promoting and disseminating family planning methods, information about family planning, counseling, and the prescription and application of contraceptive methods.[168] The RFPS also establishes the obligation of health providers to inform patients about the different contraceptive methods and to obtain their consent in the selection of any particular method.[169]

The family planning services provided by the government include information, orientation, counseling, selection, prescription, and application of contraceptive methods.[170] These services and the contraceptive methods are free of charge.[171] In particular, public services provide oral, injectable, and subdermal hormonal methods, intrauterine devices ("IUDs"), sterilization, vasectomy, barrier methods, and spermicides.[172]

The participation of the public sector in the provision of family planning services has increased in recent years. In 1979, just 51.5% of all users of modern contraceptive methods visited a public-sector institution to obtain family planning services;[173] by 1995, this number increased to 72%.[174] Within the public sector, the MISS and the Ministry of Health are the principal providers of contraceptives, at 44.1% and 16.5%,

respectively.[175] The private sector (pharmacies, private clinics, etc.) provides 28.9% of contraceptive methods.[176]

C. CONTRACEPTION

Prevalence of contraceptives

In 1995, 66.5% of women of childbearing age who lived with their partner used some method of family planning.[177] The best-known modern contraceptive methods are the birth control pill, female sterilization, the IUD, and traditional methods.[178] Sterilization is most common among women of childbearing age, with an average rate of 43.3%.[179] The pill and the IUD are also frequently used, with average rates of 15.3% and 17.7%, respectively.[180] The use of contraceptive methods is more frequent among women who have higher educational levels and who live in urban areas.[181] There is also greater spacing between pregnancies among women who live in urban areas.[182]

Legal status of contraceptives

The only legal prohibition related to contraceptive methods in Mexican law is the prohibition against abortion as a method of family planning.[183] The Ministry of Health is responsible for regulating all medicines and medical supplies, including contraceptives.[184] All contraceptive methods must be authorized by the proper health authorities, according to the procedures established in the General Health Law.[185] This law provides that the processes of production, preparation, preservation, bottling, handling, and distribution of all medicines and health products must take place in hygienic conditions, and prohibits any form of adulteration, contamination, or alteration.[186]

Regulation of information on contraception

The Ministry of Health is responsible for authorizing advertisements dealing with health issues[187] and for coordinating publicity on health matters issued by the public health sector establishments.[188] The General Health Law provides that advertising of medicine is classified according to the targeted audience: advertising directed to health professionals does not require authorization except when regulated in specific cases.[189] Mass advertising is allowed only for nonprescription medicines.[190] In such cases, advertisements must be limited to the general characteristics of the product in question and its properties and methods of usage, and they must point out the benefits of consulting a physician before using it.[191]

Sterilization

In Mexico, voluntary surgical sterilization is the most common family planning method and has a prevalence rate of 43.3% among women of childbearing age using contraceptives.[192] Surgical sterilization is legal in Mexico and regulated by the RFPS. This regulation establishes the following prerequisites prior to sterilization: the patient must be offered counseling services, and the patient must provide her free and voluntary consent to the operation, which must be documented in writing.[193]

D. ABORTION

According to government statistics, between 200,000 and 850,000 abortions occur annually in Mexico.[194] International agencies and nongovernmental organizations estimate that the number is much higher and that there are approximately 500,000 to 1,500,000 abortions performed in Mexico every year.[195]

Legal status of abortion

Abortion is illegal in Mexico, and its regulation falls under the jurisdiction of the states.[196] This section summarizes the criminal laws that regulate abortion in several Mexican states, highlighting the most significant features of the different state legislation on abortion. Such laws punish women who undergo abortion as well as any individual who performs the abortion with her consent.[197] Most Mexican state laws establish exceptional situations in which abortion is not penalized. Comparing the various state laws, the most frequent exceptions include unintentional abortion or abortion caused by the accidental negligence of the woman (in 29 states and the Federal District);[198] when pregnancy was the result of rape (in 30 states and the Federal District);[199] when it is necessary to save the life of the woman (in 28 states and the Federal District);[200] when the pregnancy was the result of nonconsensual artificial insemination (in two states);[201] abortion for eugenic purposes (in nine states);[202] and when the pregnancy could cause serious damage to the woman's health (in nine states).[203] Only one state provides that abortion is not punishable when there are serious and justifiable economic reasons, and only where the woman already has at least three children.[204] The requirements for obtaining an abortion based on these exceptional circumstances vary by state.[205]

Penalties

In the Federal District and the states, a woman who has an abortion, whether she induces it herself or has another person induce it, is liable to imprisonment for six months to five years.[206] Most states outline a series of mitigating factors that could reduce the penalty imposed against the woman who has had an abortion. Some of these circumstances are the fact that the woman does not have a "bad reputation," that she has been able to hide her pregnancy, that the pregnancy is the result of an illegitimate union, and that the abortion takes place in the first five months of the pregnancy.[207] In such circumstances, the penalty is six months to one year of imprisonment.[208] In the Federal District and the states, any person who performs

the abortion is liable to one to three years' imprisonment.[209] If a physician, surgeon, or midwife performs the abortion, he or she is suspended from the medical profession for a period of two to five years.[210] Any person who performs an abortion on a woman without her consent is liable to one to eight years' imprisonment.[211]

E. HIV/AIDS AND SEXUALLY TRANSMISSIBLE INFECTIONS

Examining HIV/AIDS within the framework of reproductive rights is essential insofar as the two areas are interrelated from both medical and public health standpoints. Hence, a comprehensive evaluation of laws and policies affecting reproductive health in Mexico must examine the conditions of HIV/AIDS given the dimensions and implications of these diseases. The number of reported AIDS cases in Mexico has increased from six cases in 1983 to more than 21,000 cases in 1994.[212] In 1994, 13 percent of HIV/AIDS cases were women.[213] Blood transfusions are the most common means of transmission for women, representing 56.5% of AIDS cases in adult women.[214] Sexual transmission was the means of infection in four out of every ten cases of women with AIDS.[215] In 1995, the prevalence of HIV in pregnant women was one of every 3,000 cases, and every year, 500 HIV-positive women become pregnant.[216]

Laws on HIV/AIDS and STIs

In 1995, the Mexican government enacted the Regulation for the Prevention and Control of HIV Infection ("HIV/AIDS Regulation").[217] The objective of this regulation is to standardize the guidelines and criteria governing the network of establishments comprising the National Health System[218] that are involved in HIV/AIDS control and prevention.[219] It notes the necessity of preventive measures directed at informing and educating the community and at encouraging participation in order to reduce the risk of infection.[220] The HIV/AIDS Regulation provides that all information regarding patients with HIV/AIDS is confidential[221] and indicates that all health institutions are required to provide emergency treatment to HIV/AIDS patients in a respectful manner.[222] The HIV/AIDS Regulation also includes recommendations and technical guidelines for health care providers on the treatment of HIV/AIDS patients.[223] The organizations charged with overseeing implementation of this regulation are the Ministry of Health and the state governments, according to their respective jurisdictions.[224]

Policies on prevention and treatment of HIV/AIDS and STIs

The government program directed toward the prevention and treatment of HIV/AIDS and sexually transmissible infections ("STIs") is a subprogram of the RHFPP.[225] The fundamental objective of the subprogram, Prevention and Control of Sexually Transmissible Infections and HIV/AIDS, is to reduce the morbidity and mortality rates of these infections.[226] It seeks to broaden the population's access to appropriate information and to quality services to prevent, diagnose, and control STIs and HIV/AIDS.[227] Three strategies promote these objectives. The first is the implementation of a permanent program of educational and social communication to promote safe sex. The second is the incorporation, at the primary health care level, of information and services on STIs. The third is the development of programs of prevention, early detection, referral, and notification of new cases of HIV/AIDS.

The subprogram's goals for the year 2000 include a 30% reduction of STI cases;[228] a 50% reduction in the number of children infected with HIV during pregnancy, childbirth, or breast-feeding by 50%; and detection and treatment of 80% of HIV-positive individuals in a timely manner.[229]

III. Understanding the Exercise of Reproductive Rights: Women's Legal Status

Women's health and reproductive rights cannot be fully evaluated without investigating women's legal and social conditions. Not only do laws relating to women's legal status reflect societal attitudes that will affect reproductive rights, but such laws often have a direct impact on women's ability to exercise reproductive rights. The legal context of family life and couple relations, a woman's educational level, and access to economic resources and legal protection determine women's ability to make choices about their reproductive health care needs and to exercise their right to obtain health care services. While the situation of women in Mexico has improved significantly over the past decades,[230] some sectors of the female population, such as indigenous women, female heads of household, and rural women, continue to live in greater poverty.[231]

The Constitution establishes the complete legal equality of men and women.[232] Similarly, the General Population Law and the National Development Plan 1995–2000 have established as one of their objectives the improvement of women's conditions and women's participation in the country's development.[233] Despite these provisions, however, the legal codes in many Mexican states contain discriminatory laws, as well as laws that subordinate women's legal rights to those of men. Provisions of some codes still require that women obtain the authorization of their husbands to work or to sign contracts,[234] and in some states, the penalty for rape is less than the penalty for stealing an

animal.[235] Many Mexican women bear all the responsibility for child-rearing and domestic work, yet their work is not recognized as a contribution to the family's maintenance.[236]

The following section describes laws regulating those areas of women's lives that directly affect their health. It analyzes the laws of the Federal District when discussing matters under local jurisdiction, and federal laws when discussing matters under federal jurisdiction as prescribed in the Constitution. In some cases, laws or regulations of some states that are particularly relevant to the issues discussed below are also mentioned.

A. RIGHTS WITHIN MARRIAGE

Marriage law

The Mexican Constitution states that the principal function of the law is to protect the organization and development of the family.[237] The states regulate marriage. Both for those living in the Federal District, and for the entire country in federal matters, the Federal District's Civil Code ("FD Civil Code") provides that marriage is a contract to be formalized before the competent authorities according to the requirements prescribed by law.[238] The minimum age to enter into marriage is 18 years.[239]

Husband and wife are obligated to contribute to the maintenance of the home and to support each other.[240] As long as both spouses are of age, they have the legal capacity to administer and dispose of their own property.[241] They have the right to decide, based on mutual agreement, on the number and timing of any children.[242] The rights and duties that arise as a result of marriage are the same for both spouses regardless of their contribution to the maintenance of the home.[243] The father and mother are jointly required to administer the household and to provide for the education and formation of their children.[244] In the Federal District, the penal code defines adultery as a crime punishable by a maximum of two years' imprisonment and suspension of one's civil rights for up to six years.[245]

Regulation of domestic partnerships

The regulation of *uniones de hecho*, or domestic partnerships, between a man and a woman is also under the jurisdiction of each state. The FD Civil Code regulates numerous aspects of domestic partnerships under the term "concubinage," though it does not explicitly regulate such partnerships. It establishes that the man and woman who cohabitate in a concubinage have the right to inherit each other's property according to the rules of succession applicable to spouses.[246] However, they have this right only when the concubinage has lasted five years or longer, unless they have a child together, and as long as neither of them has been married to another during the period of concubinage.[247] If one of the partners in a concubinage is survived by more than one domestic partner, none of the surviving partners has inheritance rights.[248] Similarly, the FD Civil Code provides that couples who are involved in a concubinage are required, as is the case for spouses, to provide for each other.[249] In addition, the civil code presumes paternity in a concubinage, to the benefit of the children.[250]

Divorce and custody law

A legal divorce terminates civil marriage in Mexico.[251] Grounds for divorce include adultery; the wife giving birth during the marriage to a child conceived prior to the marriage who is not the husband's child; the husband's proposal to prostitute his wife; failure to fulfill one's duty as a spouse or as a mother or father; cruel treatment toward one's spouse; conduct on the part of a spouse that corrupts their children; grave offense of one spouse to the other; drunkenness or the habitual use of drugs; and by mutual consent of both spouses.[252] The judgment decreeing the divorce establishes which spouse receives custody of their children and the amount of alimony and child support due.[253] Property is divided evenly between the spouses when marriage was contracted under a joint ownership or community property regime,[254] though measures may be imposed to assure that the spouses fulfill their obligations to each other and to their children.[255] The cost of maintaining the household and paying child support and alimony when the law so requires must be fulfilled by the other spouse as provided by law in case of separation and divorce.[256] The "guilty" spouse loses everything that the "innocent" spouse may have given or promised to him or her, while the innocent spouse may keep anything received from the other spouse and may demand any previously agreed upon item.[257]

B. SOCIAL AND ECONOMIC RIGHTS

Property rights

There are no limitations or discriminatory provisions applicable to women in the laws regulating inheritance and succession.[258] Generally, the law prohibits those individuals convicted of a crime against the deceased as well as a spouse legally declared an adulterer from acquiring testamentary property.[259]

Labor rights

The participation of women in the Mexican workforce has increased, and by 1995, women constituted 35% of the economically active population.[260] Women are employed primarily in salaried positions, are self-employed, or engage in unpaid family work in the home.[261] Women receive lower wages than men.[262] Seventy-four percent of women earned the equivalent of double the minimum wage or less in 1991, while only 54% of men earned this little.

Mexico is a party to several international treaties that protect women in the workplace, such as the International Labor

Organization's Convention No. 100 concerning equal remuneration[263] and Convention No. 111 concerning discrimination in employment.[264] The Constitution recognizes that all individuals have "the right to dignified and socially useful employment"[265] and establishes the principle of equal pay for equal work, prohibiting discrimination based on sex or nationality.[266] It also provides for special protection for pregnant women,[267] noting that a pregnant woman should not engage in labor that endangers her health.[268] The Constitution also provides that pregnant women workers have the right to pre- and postnatal leave of six weeks each. During these periods, they are entitled to be paid at the same salary as prior to their leave.[269]

The Federal Work Law[270] provides that women have the same rights and duties as men.[271] A woman has the right to extend prenatal or postnatal leave when she is unable to work due to pregnancy or childbirth. In this case, she is to be paid 50% of her salary for a period of no more than sixty days.[272] A woman has the right to return to work after her leave ends.[273] The employer is also required to allow the worker two thirty-minute breaks during the work day to breast-feed her child.[274]

Access to credit

No laws in Mexico exist that restrict women's access to credit. However, since in practice the access of rural women to credit is limited, the Mexican government has passed laws to provide special access to credit to rural women.[275] Some measures adopted to provide greater access to credit for rural women are the establishment of Agricultural Industrial Units for Rural Women,[276] and the Program to Support Productive Projects of Rural Women.[277]

Access to education

While the participation of women in secondary and postsecondary education has increased considerably in the last few decades,[278] the rate of illiteracy among women was still 15.2 % in 1995.[279] Approximately two out of every three illiterate adults are women.[280] Women with lower educational levels tend to live in rural areas.[281] There are no marked differences in the access of girls and boys to primary school, but by the age of fourteen, 32.5% of girls and 27.5% of boys stop attending school.[282]

The Constitution establishes the right of all individuals to an education.[283] The federal government, the states, and the municipalities are required to provide preschool, primary, and secondary education, which are all free of charge.[284]

Women's bureaus

The National Women's Program 1995–2000 ("NWP") is being developed by the Secretary of Government Administration of Mexico with the objective of eradicating discrimination against women.[285] The NWP calls for the creation of a Consulting Council to foster the participation of all entities and departments involved in the program's activities.[286] The Consulting Council identifies the entities responsible for different policies with the goal of encouraging the participation of these entities in the formulation and adoption of policies proposed by the NWP.[287] The government has also mandated the creation of a Social Comptroller's Office whose task is to disseminate, analyze, and update the registry of institutions that participate in the NWP, and to ensure that accurate data is available in order to facilitate the monitoring of the policies aimed at helping Mexican women.[288]

C. RIGHT TO PHYSICAL INTEGRITY

In Mexico, violence against women has not been systematically studied.[289] Nor is there accurate information about the incidence of violence against women, because few women report sexual crimes.[290] It is estimated, for example, that only one of every ten rapes is reported to the authorities.[291] A study carried out in the Federal District revealed that of the total number of complaints brought before the attorney general's office, 87% of the victims are women. Another study, also in the Federal District, revealed that one of the main factors triggering violence against women is to deny their refusal of unwanted sexual relations.[292] The incidence of violence against women by their partners is so high that it has been recommended that it be treated as a public health problem.[293]

Rape

The regulation of sex-related crimes falls within the jurisdiction of the states. Most states in Mexico legislate rape in conjunction with crimes against decency and abduction for sexual purposes. In addition, sex-related crimes that involve adolescents and minors are separately classified, such as statutory rape, incest, and the corruption of minors.[294] Some states categorize as sex crimes peculiar situations such as an individual who has sexual relations with a woman by pretending to be her spouse or domestic partner.[295]

In the Federal District, rape is a crime against "freedom and normal psychosexual development."[296] The crime of rape is committed when a person uses physical or psychological violence to engage in intercourse with another person of either sex.[297] The penalty in these cases is eight to fourteen years' imprisonment.[298] The Federal District Penal Code ("FD Penal Code") also categorizes as rape when an adult engages in intercourse, even without the use of violence, with a person under the age of 12. It also categorizes as rape when an adult, even without using violence, engages in intercourse with a person who does not understand the meaning of the sexual act or who is incapable of refusal.[299] These crimes are penalized with eight to fourteen years of imprisonment.[300]

Crimes against decency involve engaging in sexual acts other than intercourse with a person without his or her consent,[301] and are penalized with three months to two years' imprisonment.[302] When an individual engages in such sexual acts with a person who does not have the ability to understand the meaning of the sexual act, or who is incapable of refusal, or who is forced to engage in sexual acts against his or her will, the penalty is six months' to three years' imprisonment.[303] Higher penalties are imposed for this crime when the following aggravating circumstances are involved: if the crime is carried out in conjunction with other people;[304] if the author of the crime is a father, grandfather, brother, guardian, or stepfather of the victim;[305] if the crime is committed by a person who holds public office or who takes advantage of the exercise of his or her profession to engage in a sexual act; or if the author of the crime is the person who is charged with the care of the victim or who takes advantage of the victim's trust in him or her.[306]

In Mexico, *rapto,* or abduction for sexual purposes, is a sexual crime. Some states only consider this form of abduction as a crime against freedom and personal security.[307] In these states, abduction for sexual purposes is different from the more serious crime of kidnapping only when the woman is older than 18 and only when it involves the actual use or the threat of violence.[308] Few states even classify abduction for sexual purposes of a minor man by a woman.[309] The FD Penal Code classifies abduction for sexual purposes as the act of an individual who "takes control over a woman through the use of physical or psychological violence, seduction, or deceit to satisfy some erotic or sexual desire or to marry the woman." Such an act is penalized with six months' to six years' imprisonment and a fine of 50 to 500 *pesos*.[310]

Rape of spouses is not a crime under Mexican law. In June 1997, the Mexican Supreme Court of Justice decided a case in which it concluded that sexual relations between spouses that are the result of violence do not constitute a crime but the "undue exercise of a right."[311] This judgment affirms a prior decision of the Supreme Court on the same issue in 1994.[312] As of 1995, only the Penal Code of the state of Querétaro penalized rape between spouses.[313] Sexual crimes committed against adolescents and minors are analyzed in the chapter on adolescents, below.

Sexual harassment

The regulation of sexual harassment falls within the jurisdiction of the states. The FD Penal Code classifies the crime of sexual harassment as the conduct of a person who "with lustful intentions repeatedly harasses a person of any sex, taking advantage of his or her position of authority derived from an employment, teaching, or domestic relationship or any other relationship that implies some form of subordination."[314] The penalty for such conduct under the Penal Code is a fine.[315] When the perpetrator is a public employee who uses his or her position to engage in harassment, the law mandates that he or she be fired.[316] The criminal legislation provides that for sexual harassment to be a crime, it must have caused damage or detriment.[317] Only the victim may bring charges against the perpetrator.[318]

Domestic violence

No systematic data regarding the dimension of domestic violence in Mexico is available. However, existing information reveals that it is a serious problem that demands attention from the legal system and the health authorities.[319] A study carried out by the Ministry of Health of the Federal District among women between the ages of 14 and 57 who were beaten by their partners revealed that most victims were mothers between the ages of 22 and 29, and that 90% were beaten in front of their children.[320] Twenty-two percent of the battered women were illiterate or had not completed primary school; 44% had finished primary school and/or some secondary school; and the remaining 34% had some post–high school education or were professionals.[321] Other common forms of domestic violence in Mexico include verbal aggression, confinement to the home, prohibitions on seeing family members or working, and forced sexual relations.[322]

Domestic violence against children is legal. In 1995, eleven Mexican states permitted the corporal punishment of children by their parents or guardians. Injuries caused "while exercising the right to reprimand," are not punishable as long as the judge considers that this right is not abused by "reprimanding with cruelty or unnecessary frequency." The injuries are not punishable[323] if they do not endanger the victim's life, if they are healed within fifteen days, and if they involve no other consequences that are punishable by law.[324]

In 1996, the Federal District enacted the Assistance and Prevention of Domestic Violence Law.[325] The objective of this law is to establish nonjudicial procedures to protect the victims of domestic violence to develop the strategies and to determine the entities responsible for the prevention of domestic violence.[326] It defines violence as an "act of power or omission that is recurring, intentional, and cyclical, and is aimed at dominating, subordinating, controlling, or assaulting any member of the family through physical, verbal, psycho-emotional, or sexual violence."[327] The forms of sexual mistreatment mentioned include denying "sexual-affective" needs and inducing undesired or painful sexual practices.[328] This law "may only be used as a means to secure assistance and

prevention" when the provisions of the FD Penal Code are applicable, particularly those related to sexual crimes.[329] The procedures established for cases of domestic violence include conciliation,[330] friendly settlement, and arbitration.[331] The failure to respect the orders generated by this process is penalized with a fine of thirty to 180 days of the minimum salary in the Federal District or its equivalent in daily wages and with the administrative arrest of the offender for a period of no more than thirty-six hours without bail or parole.[332]

Only in a few states do the penal codes treat violent crimes or homicide committed against family members as aggravating circumstances.[333] In 1995, only one state treated an assault committed by one spouse or domestic partner against the other as an aggravating circumstance.[334] In the Federal District, domestic violence is penalized by the criminal law, specifically within the provisions on assault.[335] Assault includes wounds, bruises, fractures, burns, and, in general, any damage caused by an external force that leaves marks on the human body.[336] Penalties for such crimes range from three months' imprisonment for minor injuries to 10 years for serious injuries.[337]

IV. Analyzing the Rights of a Special Group: Adolescents

The needs of adolescents are often unrecognized or neglected. Given that in Mexico 36% of the total population is under the age of 15[338] and the adolescent population constitutes 23.2% of the country's total population,[339] it is particularly important to meet the reproductive health needs of this group. The effort to address issues of adolescent rights, including those related to reproductive health, are important for women's right to self-determination as well as for their general health.

The Federal Constitution establishes that "it is the duty of the parents to support the right of minors to have their basic needs met and to care for their physical and mental health."[340] It also mandates that there should be legally established mechanisms of protection for minors within the various public institutions.[341] However, domestic violence against minors and adolescents is still tolerated by the penal codes of some Mexican states.[342] Minors constitute 67% of the victims of psychological, physical, and sexual aggression in the Federal District.[343]

A. REPRODUCTIVE HEALTH

The fertility rate of Mexican women between the ages of 15 and 19 dropped from 132 births per 1,000 women in 1978, to 78 in 1994.[344] The prevalence of contraceptive use among women between the ages of 15 and 19 increased from 14.2% in 1976 to 36.4% in 1992.[345] In 1995, 36.1% of adolescents cohabiting with their partner used some form of contraception.[346] The most commonly used forms are hormonal methods (40.3%), the IUD (33.5%), and barrier methods (8.7%).[347] The median age of women at first birth is 21.[348] The maternal mortality rate for women under the age of 20 is 6% higher than that of those between 20 and 24.[349] Between 1990 and 1993, the number of cases of STIs among young adults between the ages of 15 and 24 increased 14%.[350]

One of the fundamental objectives of the RHFPP is to provide for the sexual and reproductive health of adolescents.[351] Its goals include broadening the coverage of information on sexual and reproductive health; increasing the age of adolescent women at first birth; preventing unwanted pregnancies, abortions, and STIs; and providing high-quality contraceptive information and services, as well as counseling.[352] In order to reach these objectives, the Ministry of Health has established 102 service modules, located in health centers and hospitals in all thirty-two states.[353]

B. MARRIAGE AND ADOLESCENTS

The average age at which Mexican women first marry was 19 in 1992.[354] In rural areas, women tend to establish their first union (marriage or cohabitation) at an earlier age — 17 — while women in urban areas do so at the age of 18.7.[355] Women enter into such unions an average of two years later than men.[356]

The minimum age required to marry in the Federal District is 18.[357] However, men over the age of 16 and women over the age of 14 may marry with the express consent of either their father or their mother.[358] In cases in which neither parent is available, the marriage may be authorized by the paternal grandparents or, if there are no paternal grandparents, by the maternal grandparents.[359] The authorities established by law may make an exception from the age requirement if serious and justified causes are involved, thereby authorizing the marriage of minors without the consent of the aforementioned persons.[360]

C. SEXUAL OFFENSES AGAINST MINORS

Approximately half of the rapes and other sexual crimes in Mexico are committed against girls and adolescent women.[361] In 60% of the cases of rape of minors that are reported, the aggressors are close relatives of the victim, including the victim's father.[362] In 90% of such cases, there was either implicit or explicit consent or tolerance by the mothers of the victims.[363]

The states regulate sexual crimes against adolescents and minors. The penal codes of most states classify rape of a person under the age of 13 or 14 as "improper rape."[364] Other sexual crimes against adolescents and minors that are classified by the

states include crimes against decency, statutory rape, kidnapping for sexual purposes, incest, and the corruption of minors. In cases of a crime against propriety, some states increase the penalty against the perpetrator when the victim is prepubescent or a virgin woman.[365] The FD Penal Code provides that the conduct of a person who engages in intercourse with a person under the age of 12 is committing the equivalent of rape and imposes a penalty of eight to fourteen years' imprisonment.[366] A crime against decency is committed when someone engages in a sexual act other than intercourse with a person under the age of 18. Some states gradate the penalty depending on whether the victim had reached puberty.[367] Different terminology is used for the same crime in some states, such as "lustful acts,"[368] while others call it "unchaste abuse."[369] In the Federal District, if crimes against decency are committed against a minor under the age of 12, the perpetrator of the crime is penalized with six months to three years of imprisonment.[370]

The Penal Code also includes the crime of statutory rape, which involves intercourse with a woman between the ages of 12 and 18 through seduction or deceit.[371] Some states identify this crime as one of many crimes "against sexual freedom and inexperience."[372] States define differently the characteristics of the woman who may be the victim of such crimes. While some establish that the woman's age range between 12 and 18, most also say that she must have reached puberty and that she also must be "chaste" and a virgin.[373] Some Mexican legal experts believe that statutory rape as it is currently defined by the country's criminal law has no valid purpose, as there is no object that the law should protect in this way. "Women do not require the legal protection that the laws defining statutory rape pretend to give them."[374] The FD Penal Code requires that the victim or her representatives report the perpetrator to the authorities.[375]

The crime of abduction for sexual purposes,[376] due to its sexual implications, is penalized in most Mexican penal codes as a sexual crime. Regarding the abduction for sexual purposes of adolescents and minors, only two states consider abduction of a male under the age of 18 by a woman to be a crime,[377] while the rest penalize such acts only when they are committed against females. The FD Penal Code establishes that the abduction for sexual purposes of a girl under the age of 16 is a crime even if the adolescent consented to the abduction. It presumes that the abductor used seduction to win the victim's consent.[378] If the abductor marries the victim, "he cannot be tried for the crime of abduction."[379] Criminal law also penalizes incest, which consists of sexual relations with one's offspring or sibling.[380] The penalty for incest is six months' to three years imprisonment.[381]

In the Federal District, the crime of corrupting minors is defined as the use of acts of "corporal, lustful or sexual exhibitionism" to corrupt or facilitate the corruption of minors under the age of 16.[382] The penalty for this crime is three to eight years' imprisonment and a fine of anywhere from fifty to 200 days of the person's wages.[383] The same penalty is imposed on a person who induces minors of this age group to practice homosexuality.[384] The penalty is five to ten years' imprisonment if, because of the repeated practices of the acts that constitute this crime, the minor becomes a regular practitioner of prostitution or homosexuality or develops alcoholism or drug dependency.[385]

D. EDUCATION AND ADOLESCENTS

There is no government-sponsored program of sexual education for adolescents in Mexico. The government's Program of Educational Development for the period 1995–2000 does not mention the inclusion of sexual education as part of the curricula of educational institutions.[386] Information and educational programs for reproductive health and family planning are part of the government's health policies and, more specifically, are an aspect of its policies on reproductive health and family planning.[387]

ENDNOTES

1. EUROPEAN YEARBOOK, MEXICO. INTRODUCTORY SURVEY: at 2, 1994.
2. THE WORLD ALMANAC AND BOOK OF FACTS 1997, at 798 (1996).
3. *Id.*
4. *Id.*
5. *Id.*
6. *Id.*
7. The Partido Revolución Democrática (PRD; Revolutionary Democratic Party) obtained 48.1% of the vote, while the PRI won 26.3%. Cuautémoc Cárdenas of the PRD was elected head of government of the Federal District. ELECTOR 97. *Democracia en Proceso. Resumen de los Resultados Electorales 1997 [Democracy in Process. Summary of the 1997 Election Results]* (visited Aug. 13, 1997), <http://www.elector.com.mx/resumen.htm>.
8. THE WORLD ALMANAC, *supra* note 2, at 798. *See* also EUROPEAN YEARBOOK, *supra* note 1, at 3–5.
9. EUROPEAN YEARBOOK, *supra* note 1.
10. THE WORLD ALMANAC, *supra* note 2, at 799.
11. THE ECONOMIST INTELLIGENCE UNIT, COUNTRY PROFILE: MEXICO (1996).
12. Guillermo Margadant, HISTORY, STRUCTURE AND CHARACTER OF MEXICAN LAW 3 (Mexico, Universidad Nacional Autónoma de México, Faculty of Law, n.d.) (on file with the Center for Reproductive Law and Policy).
13. CONSTITUTION OF THE UNITED STATES OF MEXICO (FEDERAL CONSTITUTION), art. 40 [hereinafter MEX. CONST.].
14. *Id.*, arts. 39 and 41.
15. *Liberalism and Democracy: Recent Judicial Reform in Mexico*, 108 HARV. L. REV. 566 (June 1995).
16. MEX. CONST., arts. 39 and 41.
17. *Id.*, art. 4.
18. *Id.*, art. 49.
19. *Id.*, art. 80.
20. *Id.*, art. 81.
21. *Id.*
22. *Id.*
23. *Id.*
24. *Id.*, § XVIII.
25. *Id.*, art. 92.
26. *Id.*, art. 92.
27. *Id.*
28. *Id.*, art. 93.
29. *Id.*, art. 50.
30. *Id.*
31. *Id.*, art. 156.
32. *Id.*, art 52.
33. *Id.*, arts. 84–85.
34. *Id.*, art. 87.
35. *Id.*, art. 69.
36. *Id.*, arts. 50 and 70.
37. *Id.*, art. 71.
38. *Id.*, art. 72.
39. *Id.*, ¶ B.
40. *Id.*, art. 73.
41. *Id.*, art. 74.
42. *Id.*, art. 76.
43. *Id.*, art. 102.
44. *Id.*
45. This system was codified during the time of the Roman Empire. *The Compilation of Justinian* and other legal documents and his other works, such as *Institutions, Codex, Digestas, Novellae*, etc., are collectively referred to as *Corpus Juris Civilis*, to distinguish the civil system from English Common Law and Canon Law. *See* BLACK'S LAW DICTIONARY, at 168 (6th ed., 1991).
46. J. Herget & J. Camil, *Mexican Civil Procedure*, MODERN LEGAL SYSTEMS ENCYCLOPEDIA, at 55 (1988).
47. MEX. CONST., arts. 94–99.
48. *Id.*, art. 94.
49. *Id.*, art. 99.
50. *Id.*, arts. 103–104.
51. *Id.*, art. 94.
52. *Id.*, arts. 94 and 96.
53. *Id.*, art. 94, § X.
54. *Id.*, art. 97.
55. *Id.*, arts. 99 and 105, § II.
56. *Id.*, art. 99.
57. *See Liberalism and Democracy, supra* note 15.
58. Prior to the 1994 reform, the declaration of unconstitutionality emitted by the Supreme Court of Justice was applicable exclusively to the person who requested this declaration.
59. *See Liberalism and Democracy, supra* note 15.
60. MEX. CONST., art. 43.
61. *Id.*
62. *Id.*, art. 115.
63. *Id.*, art. 90.
64. *Id.*, art. 116, § VI.
65. *Id.*, art. 117.
66. *Id.*, §§ I, III, IV, V, VI, and VIII.
67. *Id.*, art. 116.
68. *Id.*
69. *Id.*, art. 120.
70. *Id.*, art. 116.
71. *Id.*, art. 124.
72. *Id.*, art. 116.
73. *Id.*, art. 115.
74. *Id.* The municipality is responsible for providing the following public services: potable-water and sewage systems, public lighting, public restroom facilities, markets and central warehouses, cemeteries, public security, and public transportation.
75. *Id.*, § I.
76. *Id.*, art. 133. *See* also, Jorge Carpizo and Jorge Medrazo, DERECHO CONSTITUCIONAL [CONSTITUTIONAL LAW] 14 (1991).
77. MEX. CONST., art 14.
78. *Id.*
79. MEX. CONST., art. 14.
80. The general principles of law "are supplemental sources [of law] par excellence, to which the judge must refer when he or she finds significant omissions or deficiencies in the law [...] the concept is the equivalent to "judicial criteria" [...] some maintain that there must be a distinction between the principles of the domestic rule of law in effect in a given country and the general principles of universal law [...] giving preference to the former and referring to the latter only when the former is insufficient to resolve the problem at hand." Pedro Flores Polo, DICCIONARIO DE TÉRMINOS JURÍDICOS [DICTIONARY OF LEGAL TERMS], v.1, 432 (1987).
81. MEX. CONST., art. 14.
82. *Id.*, art. 89, § X.
83. *Id.*, art. 76, § I and art. 133.
84. The government of Mexico is a party to the following international treaties: the International Covenant on Economic, Social and Cultural Rights, *adopted* Dec. 16, 1966, 993 U.N.T.S. 3 (*entry into force* Sept. 3, 1976) (ratified by Mexico on Mar. 23, 1981); the International Covenant on Civil and Political Rights, *adopted* Dec. 16, 1966, 999 U.N.T.S. 171 (*entry into force* Mar. 23, 1976) (ratified by Mexico on Mar. 23, 1981); International Convention on the Elimination of All Forms of Racial Discrimination, *opened for signature* Mar. 7, 1966, 660 U.N.T.S. 195 (*entry into force* Jan. 4, 1969) (signed by Mexico on Jan. 11, 1966, and ratified on Feb. 20, 1975); the Convention against Torture and Other Cruel, Inhumane or Degrading Treatment or Punishment, *concluded* Dec. 10, 1984, S. Treaty Doc. 100–20, 23 I.L.M. 1027 (1984), *as modified* 24 I.L.M. 535 (*entry into force* June 26, 1987) (signed by Mexico on Mar. 18, 1985, and ratified on Jan. 23, 1986); and the Convention on the Rights of the Child, *opened for signature* Nov. 20, 1989, 28 I.L.M. 1448 (*entry into force* Sept. 2, 1990) (signed by Mexico on Jan. 26, 1990, and ratified on Sept. 21, 1990).
85. Convention on the Elimination of All Forms of Discrimination Against Women, *opened for signature* Mar. 1, 1980, 1249 U.N.T.S. 13 (*entry into force* Sept. 3, 1981) (signed by Mexico on July 17, 1980, and ratified on Mar. 23, 1981).
86. Inter-American Convention on the Prevention, Punishment and Eradication of Violence Against Women, adopted June 9, 1994, 33 I.L.M. 1534 (*entry into force* Mar. 5, 1995) (signed by Mexico on June 4, 1995).
87. NATIONAL POPULATION COUNCIL (CONAPO), LA DEMANDA DE ATENCIÓN DE SALUD EN MEXICO [THE DEMAND FOR HEALTH CARE IN MEXICO], at 15 (Mexico, 1995). Life expectancy at birth has increased over the past several decades, from 37 years in 1930 to 75 years in 1994. The mortality rate of girls under the age of one year dropped from 84 to 28 per 1,000. The fertility rate dropped from 6.8 children per women to 3 children per women in 1994. SITUACIÓN DE LA MUJER. DESAFÍOS PARA EL AÑO 2000 [THE STATUS OF WOMEN.

CHALLENGES FOR THE YEAR 2000], at 43–5 (Mexico, Oct. 1995).

88. THE DEMAND FOR HEALTH CARE, supra note 87, at 29. See also MEX. CONST., art. 4.

89. The right to health care was added in 1983, and was published in the Official Gazette of the federal government on Feb. 3, 1983.

90. MEX. CONST., art. 4.

91. In Mexico, the word secretaría (secretariat in English) is used to designate executive branch agencies. These agencies are analogous to ministries in other Latin American countries. The term "ministry" is used for secretaría herein.

92. General Health Law, published in the Official Gazette, Feb. 7, 1984, art. 7.

93. MEX. CONST., art. 123.

94. General Health Law, art. 27.

95. Id., art. 61.

96. This program was adopted by the federal government in accordance with MEX. CONST., arts. 4 and 26, Organizational Law of the Federal Civil Service, art. 9, and Planning Law, arts. 9, 17, 22, 23, 27, 28, 29, and 32. FEDERAL EXECUTIVE BRANCH. PROGRAMA DEL SECTOR SALUD 1995–2000 [REFORM PROGRAM OF THE HEALTH SECTOR 1995–2000], at i (Mexico, 1995).

97. Id.

98. Id., at 14.

99. Id., at 27–45.

100. THE DEMAND FOR HEALTH CARE, supra note 87, at 29.

101. Id.

102. Id.

103. Id.

104. Id.

105. Id.

106. Id., at 30.

107. Id., at 27.

108. REFORM PROGRAM, supra note 96, at 7.

109. Id.

110. Id.

111. FEDERAL EXECUTIVE BRANCH, PROGRAMA NACIONAL DE LA MUJER 1995–2000 [NATIONAL WOMEN'S PROGRAM 1995–2000], at 28 (Mexico, 1996).

112. THE DEMAND FOR HEALTH CARE, supra note 87, at 15.

113. Información Básica de los Estados Unidos Mexicanos [Basic Information about the United States of Mexico] (visited July 30, 1997) <http://cenids.ssa.gob.mx/>.

114. REFORM PROGRAM, supra note 96, at 7.

115. FEDERAL EXECUTIVE BRANCH, PROGRAMA DE SALUD REPRODUCTIVA Y PLANIFICACIÓN FAMILIAR 1995-2000 [REPRODUCTIVE HEALTH AND FAMILY PLANNING PROGRAM 1995–2000], at 7 (Mexico, 1995).

116. THE DEMAND FOR HEALTH CARE, supra note 87, at 32.

117. Id., at 30.

118. Id., at 32.

119. Id.

120. Id.

121. Id.

122. REFORM PROGRAM, supra note 96 at 6.

123. THE DEMAND FOR HEALTH CARE, supra note 87, at 31.

124. Id.

125. REFORM PROGRAM, supra note 96, at 6.

126. THE DEMAND FOR HEALTH CARE, supra note 87, at 31.

127. General Health Law, art. 48.

128. Id., art. 49.

129. Id.

130. Id., art. 79.

131. Regulations of the General Health Law, dealing with the Provision of Medical Treatment, published in the Daily Gazette, May 14, 1986.

132. Id., art. 102.

133. Id.

134. Id., art. 113.

135. General Health Law, art. 51.

136. Id., art. 54.

137. Id., arts. 57–58.

138. Grupo de Información en Reproducción Elegido [Information Group on Reproductive Choice]. Memorandum dated Aug. 13, 1997, at 2 (Interinstitutional communication on file with the Center for Reproductive Law and Policy).

139. The decree establishing the National Commission of Medical Arbitration was promulgated on June 3, 1996.

140. The NCMA is a decentralized entity of the Ministry of Health that has technical autonomy to emit its opinions, agreements, and judgments. Id., art. 1.

141. Id., art. 2.

142. Id., art. 4.

143. Id.

144. Id., art. 14.

145. The Penal Code Governing the Federal District and Other Areas of Law under Federal Jurisdiction, PENAL CODE OF THE FEDERAL DISTRICT, arts. 288–293 [hereinafter, PENAL CODE (DF)].

146. Id., art. 228.

147. General Population Law, promulgated on December 11, 1973.

148. Regulations of the Population Policy, entry into force in September 1993.

149. FEDERAL EXECUTIVE BRANCH, PROGRAMA NACIONAL DE POBLACIÓN 1995–2000 (NATIONAL POPULATION PROGRAM 1995–2000) (Mexico, 1995).

150. Daily Gazette of the Federation, May 30, 1994.

151. REPRODUCTIVE HEALTH PROGRAM, supra note 115.

152. General Population Law, art. 1.

153. NATIONAL POPULATION PROGRAM, supra note 149, at 56.

154. General Population Law, art. 3.

155. The National Population Council is an interinstitutional public entity created in 1974. It is responsible for the demographic planning of the country, and its primary objective is to incorporate the issues of volume, dynamic structure, and distribution throughout the national territory and the social, economic, and ethnic composition of the population in government programs of economic and social development" (visited July 16, 1997) <http://unam.mx.conapo/info/>.

156. General Population Law, art. 5.

157. Id.

158. NATIONAL POPULATION PROGRAM, supra note 149, at 1, 12, and 60.

159. MEX. CONST., art. 4.

160. REPRODUCTIVE HEALTH PROGRAM, supra note 115, at i.

161. Id., at ii.

162. REFORM PROGRAM, supra note 96, at 31.

163. Id., at 31–34.

164. REPRODUCTIVE HEALTH PROGRAM, supra note 115, at 14–15.

165. Id., at 2, 8, and 19–23.

166. General Health Law, art. 67.

167. The Regulation on Family Planning Services (RFPS), introductory section (n.d.).

168. Id., § 5.1.2.

169. Id., § 5.4

170. Id., § 5.1

171. Id., § 5.1.4; REPRODUCTIVE HEALTH PROGRAM, supra note 115, at 27.

172. RFPS, supra note 167, § 5.5.

173. MINISTRY OF HEALTH AND CONAPO, ANÁLISIS DE LA SITUACIÓN DEL PROGRAMA DE PLANIFICACIÓN FAMILIAR SEGÚN DATOS DE LA ENCUESTA NACIONAL DE PLANIFICACIÓN FAMILIAR [ANALYSIS OF THE FAMILY PLANNING PROGRAM BASED ON DATA FROM THE NATIONAL SURVEY OF FAMILY PLANNING] at 8-9 (Mexico, Oct. 1996).

174. Id.

175. Id., at 9.

176. Id.

177. Id., at 1.

178. CONAPO, SITUACIÓN DE LA PLANIFICACIÓN FAMILIAR EN MEXICO. INDICADORES DE ANTICONCEPCIÓN [STATUS OF FAMILY PLANNING IN MEXICO. CONTRACEPTIVE INDICATORS], at 3 (Mexico, 1994).

179. Id..

180. Id.

181. ANALYSIS OF THE FAMILY PLANNING PROGRAM, supra note 173, at 4–5.

182. STATUS OF FAMILY PLANNING, supra note 178, at 8.

183. The Penal Codes of the different states define abortion as a crime. Abortion is not penalized in specific limited circumstances, which vary among states.

184. General Health Law, art. 68, § 5, and arts. 144 and 204.

185. Id., art. 204.

186. Id., art. 205, in accordance with art. 194 bis.

187. Id., art. 300.

188. Id., art. 303.

189. Id., art. 310.

190. Id.

191. *Id.*
192. STATUS OF FAMILY PLANNING, *supra* note 178, at 3.
193. RFPS, *supra* note 167, ß 6.5.7.
194. Grupo de Información en Reproducción Elegida [Free Choice Information Group], *Aspectos del Aborto en México [Issues of abortion in Mexico]*, 10 Boletín Trimestral Sobre Reproducción Elegida [Trimestral Bulletin on Free Choice], Sept. 1996, at 5.
195. *Id.*
196. PENAL CODE (DF), arts. 329–334. *See also* the Penal Codes of Oaxaca, Chiapas, Nuevo León, Baja California Sur, Morelos, and Durango, among others.
197. The conduct of the woman and the person who performs the abortion are penalized in all states, and the Federal District.
198. José Luis Ibanez y Garcia Velasco, *Situación Legal del Aborto [Legal Status of Abortion]*, in NUEVAS ESTRATEGIAS PARA ABORDAR EL TEMA DE LOS DERECHOS REPRODUCTIVOS [NEW STRATEGIES TO ADDRESS THE ISSUE OF REPRODUCTIVE RIGHTS] 54 (GIRE ed., 1995).
199. *Id.*
200. *Id.*
201. This exceptional circumstance is recognized in the states of Guerrero and Chihuahua. *See* GIRE, CAUSALES SOBRE EL ABORTO NO PUNIBLES EN LOS CÓDIGOS PENALES DE LA REPÚBLICA MEXICANA [EXPLAINING NONCRIMINALIZED ABORTION IN THE PENAL CODES OF THE MEXICAN REPUBLIC]. Tabulations by Eugenia Martín Moreno. (Mexico, Oct. 1995).
202. NEW STRATEGIES, *supra* note 198, at 54.
203. *Id.*
204. *Id.* This exceptional circumstance is recognized only in the Penal Code of Yucatán.
205. PENAL CODE (DF), art. 334.
206. Comparative analysis of the Penal Codes of Chihuahua, the Federal District, Chiapas, Aguascalientes, Baja California Sur, and Campeche. Most states establish a penalty of one to three years' imprisonment.
207. *See* the PENAL CODE (DF), and the Penal Codes of the states of Yucatán, Jalisco, Nayarit and Zacatecas, among others.
208. *See* the PENAL CODE (DF) and the Penal Codes of the states of Yucatán, Jalisco, and Nayarit, among others.
209. *See* the PENAL CODE (DF) and the Penal Codes of the states of Aguascalientes, Baja California, Chihuahua, Chiapas, Baja California Sur, and Campeche.
210. *See* the PENAL CODE (DF), and the Penal Codes of the states of Yucatán, Zacatecas, Aguascalientes, and Baja California Sur, among others.
211. *See* the PENAL CODE (DF), and the Penal Codes of the states of Chihuahua, Chiapas, Aguascalientes, Baja California Sur, and Campeche.
212. REPRODUCTIVE HEALTH PROGRAM, *supra* note 115, at 10.
213. STATUS OF WOMEN, *supra* note 87, at 48.
214. *Id.*
215. *Id.*
216. REPRODUCTIVE HEALTH PROGRAM, *supra* note 115, at 6.
217. Published in the Daily Gazette, Jan. 17, 1995.
218. For more detail on the establishments that form the NHS, see the section on the Infrastructure of Health Services.
219. Mexican Regulation for the Prevention and Control of HIV Infection, ß 1, on the objectives and areas of application.
220. *Id.*, § 5, on prevention measures.
221. *Id.*, § 6, on control measures.
222. *Id.*, § 6.11.1.
223. *Id.*, §§ 6.8–6.15. It also provides that treatment of HIV patients must be carried out by trained personnel and that they must follow the recommendations outlined in the Outpatient and Inpatient Treatment Guide for Patients with HIV/AIDS. *Id.*, ß 6.11.
224. *Id.*, § 1.3.
225. REPRODUCTIVE HEALTH PROGRAM, *supra* note 115, at 22.
226. REFORM PROGRAM, *supra* note 96, at 34.
227. REPRODUCTIVE HEALTH PROGRAM, *supra* note 115, at 16.
228. *Id.*, at 23.
229. REFORM PROGRAM, *supra* note 96, at 34.
230. STATUS OF WOMEN, *supra* note 87, at 43–45.
231. NATIONAL WOMEN'S PROGRAM, *supra* note 111, at 30–38.
232. MEX. CONST., art. 4.
233. NATIONAL WOMEN'S PROGRAM, *supra* note 111, at 69.
234. Patricia Galeana, *La Violencia Intrafamiliar como Delito Tipificado [Domestic Violence As a Crime]* in NATIONAL HUMAN RIGHTS COMMISSION, MEMORIA DE LA REUNIÓN NACIONAL SOBRE DERECHOS HUMANOS DE LA MUJER [MINUTES OF THE NATIONAL MEETING ON WOMEN'S HUMAN RIGHTS] 19 (1st ed., Mexico City, Nov. 1995).
235. *Id.*
236. *Id.*
237. MEX. CONST., art. 4.
238. CIVIL CODE of the Federal District, arts. 146 and 178. [hereinafter CIVIL CODE (DF)].
239. *Id.*, art. 149.
240. *Id.*, arts. 162 and 164.
241. *Id.*, art. 172.
242. *Id.*, art. 162.
243. *Id.*, art. 164.
244. *Id.*, art. 168.
245. PENAL CODE (DF), art. 2733. Adultery is penalized when it is committed in the conjugal household or if it causes a scandal.
246. *Id.*, art. 1635.
247. *Id.*
248. *Id.*
249. *Id.*, art. 302. This includes "food, clothing, shelter, and assistance in the case of illness. Regarding minors, food also includes the cost of primary education." *Id.*, art. 308.
250. *Id.*, art. 383. This article states that the children who fulfill the following conditions are considered the children of the partners in a concubinage: "(I) Children born after 180 days, beginning with the first day of the cohabitation period and (II) Children born 300 days after the day that the concubinage was dissolved."
251. *Id.*, art. 266.
252. *Id.*, art. 267.
253. *Id.*, arts. 283–288.
254. *Id.*, arts. 178–218.
255. *Id.*, art. 287.
256. *Id.*, arts. 323 and 288.
257. *Id.*, art. 286.
258. CIVIL CODE (DF), art. 1602.
259. *Id.*, art. 1316.
260. NATIONAL WOMEN'S PROGRAM, *supra* note 111, at 25.
261. *Id.*, at 27.
262. STATUS OF WOMEN, *supra* note 87, at 20.
263. Convention No. 100 of the International Labor Organization, Convention Concerning Equal Remuneration For Men and Women Workers for Work of Equal Value, *adopted* June 29, 1951 (visited Dec. 8, 1997), <http://ilolex.ilo.ch:1567/public/english/50normes/infleg/iloeng/conve.htm>, (*entry into force* May 23) (ratified by Mexico on Oct. 2, 1962).
264. Convention No. 111 of the International Labor Organization, Convention Concerning Discrimination in Respect of Employment and Occupation, *adopted* June 25, 1958 (visited Dec. 8, 1997), http://ilolex.ilo.ch:1567/public/english/50normes/infleg/iloeng/conve.htm> (*entry into force* June 15, 1960), (ratified by Mexico in Sept. 1962).
265. MEX. CONST., art. 123.
266. *Id.*, fraction VII.
267. *Id.*, art. 123.
268. *Id.*, fraction V. *See also* arts. 166–167 of the Federal Work Law.
269. *Id.* See also art. 170 of the Federal Work Law.
270. Law published in the Daily Gazette, Apr. 1, 1970.
271. *Id.*, art. 164.
272. *Id.*, art. 170, fractions II and V.
273. MEX. CONST., art. 123. *See also* art. 170 of the Federal Work Law.
274. MEX. CONST., art. 123, fraction V. *See also* art. 170 of the Federal Work Law.
275. NATIONAL WOMEN'S PROGRAM, *supra* note 111, at 36.
276. The Agricultural Industrial Units for Rural Women (AIURW) were created in 1972. Their main goals include the incorporation of women into the economic activities of the *ejido*, a system of communal farming and to foster women's participation in rural development. There were 6,300 AIURW registered in the early 1990s.
277. NATIONAL WOMEN'S PROGRAM, *supra* note 111.
278. *Id.*, at 15. Between 1981 and 1994, the number of women with secondary education to every 100 men went from 89 to 95. The number of women with higher education to every 100 men went from 76 in 1991 to 82 in 1995.
279. *Id.*, at 13.
280. *Id.*
281. *Id.*, at 15–17.
282. *Id.* at 15.
283. MEX. CONST., art. 3.
284. *Id.*
285. NATIONAL WOMEN'S PROGRAM, *supra* note 111, at 6.

286. *Id.*, at 72.
287. *Id.*
288. *Id.*, at 73.
289. STATUS OF WOMEN, *supra* note 87, at 38.
290. *Id.*
291. *Id.*
292. *Domestic Violence as a Crime, supra* note 234, at 20.
293. *Id.*, at 19.
294. Marcela Martinez Roaro, DELITOS SEXUALES, SEXUALIDAD Y DERECHO [SEX CRIMES, SEXUALITY AND LAW], at 232 (4th ed., Mexico, Editorial Porrúa, n.d.).
295. *Id.*
296. *See* PENAL CODE (DF), tit. XV.
297. *Id.*, art. 265.
298. *Id.*
299. *Id.*, art. 266.
300. *Id.*
301. *Id.*, art. 260.
302. *Id.*
303. *Id.*, art. 261. If the sex act is carried out with physical or psychological violence, the penalty is two to seven years' imprisonment.
304. *Id.*, art. 306.
305. *Id.*
306. *Id.*
307. This is the case, for example, in the states of Mexico, Michoacán, and Zacatecas. SEX CRIMES, *supra* note 294, at 248.
308. *See* the Penal Codes of the states of Aguascalientes, Campeche, Puebla, and Yucatán.
309. *See* the Penal Codes of the states of Veracruz and Zacatecas.
310. PENAL CODE (DF), art. 267.
311. InterPress Service News Agency, 5 (103) IPS DAILY J, June 17, 1997, at 5.
312. Jurisprudence 10/94, 77 Gaceta 18 (First Chamber, 8th *Època* 1994).
313. As of 1995, only the state of Querétaro recognized, in art. 164, the crime of rape between spouses. *See Domestic Violence As a Crime, supra* note 234, at 21.
314. PENAL CODE (DF), art. 259b.
315. *Id.*
316. *Id.*
317. *Id.*
318. *Id.*
319. In 1995, only the state of Querétaro recognized, in art. 164, the crime of rape between spouses. *See Domestic Violence As a Crime, supra* note 234, at 21.
320. *Id.*, at 20.
321. *Id.*
322. STATUS OF WOMEN, *supra* note 87, at 39.
323. *Domestic Violence As a Crime, supra* note 234, at 19.
324. *Id.*
325. Decree of the Assembly of Representatives of the Federal District, promulgated Apr. 26, 1996, and published on Jul. 9, 1996, in the Daily Gazette.
326. *Id.*, art. 1.
327. *Id.*, art. 3, § III.
328. *Id.*, art. 3, § III, sub § c.
329. *Id.*
330. This is the responsibility of the police stations in the Federal District. The official designated as conciliator should seek the conciliation of the parties iby providing them with a series of alternatives and exhorting them to conciliate by informing them of the consequences of persisting in their conflict [...] If the parties reach an agreement a contract will be signed. *Id.*, art. 20.
331. This is the responsibility of the police stations in the Federal District. The official designated as friendly arbiter will listen to the parties, who will offer proof and arguments, after which the official will emit a resolution. *Id.*, art. 22.
332. *Id.*, art. 25.
333. Penal Code of the state of Hidalgo, art. 143. *Domestic Violence As a Crime, supra* note 234, at 19.
334. *Id.*
335. PENAL CODE (DF), tit. XIX, Crimes Against Life and Physical Integrity, arts. 288–301.
336. *Id.*, art. 288.
337. *Id.*, arts. 289–301.
338. NATIONAL POPULATION PROGRAM, *supra* note 149, at 2.
339. REPRODUCTIVE HEALTH PROGRAM, *supra* note 115, at 4.
340. MEX. CONST., art. 4.
341. *Id.*
342. See the detailed discussion of this issue in the section on Domestic Violence.
343. These statistics from the second half of 1992 were provided by the Centro de Terapia de Apoyo de la Procuraduría General de Justicia del Distrito Federal (Therapy Support Center of the Attorney General's Office of the Federal District). *Domestic Violence as a Crime, supra* note 234, at 19.
344. REPRODUCTIVE HEALTH PROGRAM, *supra* note 115, at 5.
345. NATIONAL POPULATION PROGRAM, *supra* note 149, at 3.
346. ANALYSIS OF THE FAMILY PLANNING PROGRAM, *supra* note 173, at 6.
347. REPRODUCTIVE HEALTH PROGRAM, *supra* note 115, at 5.
348. *Id.*
349. *Id.*
350. *Id.*
351. *Id.*, at 14–15.
352. *Id.*
353. ANALYSIS OF THE FAMILY PLANNING PROGRAM, *supra* note 173, at 6.
354. REPRODUCTIVE HEALTH PROGRAM, *supra* note 115, at 5.
355. STATUS OF WOMEN, *supra* note 87, at 66.
356. *Id.*
357. CIVIL CODE (DF), arts. 148–149.
358. *Id.*, art. 149.
359. *Id.*
360. *Id.*, art. 148.
361. STATUS OF WOMEN, *supra* note 87, at 38–39.
362. *Domestic Violence As a Crime, supra* note 234, at 22.
363. *Id.*
364. SEX CRIMES, *supra* note 294, at 232.
365. For example, the Penal Code of Puebla, art. 252, at 233.
366. PENAL CODE (DF), art. 266.
367. SEX CRIMES, *supra* note 294, at 212–213.
368. Penal Code of the state of Mexico, *Id.*, at 212.
369. Penal Codes of the states of Michoacán, Guerrero, Sonora, Tamaulipas, and Veracruz. *Id.*
370. PENAL CODE (DF), art. 261.
371. *Id.*, art. 262.
372. SEX CRIMES, *supra* note 294, at 221.
373. *Id.*
374. *Id.*, at 229.
375. PENAL CODE (DF), art. 263.
376. For a more detailed discussion of the concept of abduction for sexual purposes, see the section on Rape in part III of this report.
377. Penal Codes of Veracruz (art. 202) and Zacatecas (art. 300). SEX CRIMES, *supra* note 294, at 249.
378. PENAL CODE (DF), arts. 268–269.
379. *Id.*, art. 270.
380. *Id.*, art. 273.
381. *Id.*, art. 272.
382. *Id.*, art. 201.
383. *Id.*
384. *Id.*
385. *Id.*
386. FEDERAL EXECUTIVE BRANCH, PROGRAMA DE DESARROLLO EDUCATIVO, 1995–2000 [PROGRAM OF EDUCATIONAL DEVELOPMENT, 1995–2000] (Mexico, 1995).
387. REFORM PROGRAM, *supra* note 96, at 32.

Peru

Statistics

GENERAL

Population

- Peru has a total population of 23,950,000 inhabitants, of which 50.3% are women.[1] The annual growth rate is approximately 1.8%.[2] The average age of the rural population is 18 years while, in urban areas, it is 22 years.[3]
- In 1996, the proportion of the Peruvian population living in urban areas was estimated to be 67%.[4]

Territory

- Peru has a surface area of 1,285,215.6 square kilometers.[5]

Economy

- In 1993, the World Bank estimated the gross national product per capita to be U.S.$2,110.[6]
- During the period from 1990 to 1994, the gross domestic product ("GDP") grew by an estimated 4.1%, a highly significant increase over the period from 1980 to 1990, when the growth in the GDP was –0.2%.[7]
- In 1995, the government invested approximately U.S.$600 million in the health sector, an increase of 122.4% from 1994.[8]

Employment

- In 1996, approximately 8 million people were employed in Peru.[9] Women represented 28% of the workforce.[10]

WOMEN'S STATUS

- The average life expectancy for women is 71 years, compared with 67 years for men.[11]
- Illiteracy continues to be a problem that mainly affects women. The female illiteracy rate in Peru is 11.5%.[12]
- Unemployment in Peru is 8.4% of the total urban economically active population over the age of 14 years,[13] women and young people being the most affected. The unemployment rate for Peruvian women is 11.8%.[14]
- Violence against women is a serious social problem nationally. Statistics are difficult to obtain, as many incidents are not reported by the victims. However, according to reports of the Women's Police Delegation of Lima, 6,244 complaints were filed in 1996, while in 1995, the number was 4,181.[15]
- Despite the fact that many women do not report sexual attacks against them, rape and other sexual assaults hold third place among the most frequently committed crimes in the country.[16] According to some statistics, in 1995, the National Police of Peru registered 8,531 crimes against personal liberty at the national level, of which 48.6% were crimes of rape.[17]

ADOLESCENTS

- Approximately 38% of the population of Peru is under 15 years old.[18]
- The average age at first marriage for Peruvian women is 21 years.[19]
- 13% of women between the ages of 15 and 19 years are mothers,[20] 9% of adolescents have one child and 2% have two children.[21]

MATERNAL HEALTH

- The total fertility rate is 3.5 children per woman.[22] This figure is reduced to 2.8 children per woman in urban areas and considerably increased to 5.6 children in rural areas.[23]
- The maternal mortality rate is 265 deaths for every 100,000 live births.[24] It is estimated that 1,670 women, or 5 a day, died for reasons connected with pregnancy, delivery, or postnatal complications in 1993.[25]
- The infant mortality rate during the period from 1991 to 1996 has been estimated to be 43 deaths per 1,000 live births.[26] 67% of births between 1991 and 1996 were assisted by health care professionals.[27] Only 50% of births nationally took place within a health care facility.[28]

CONTRACEPTION AND ABORTION

- 64% of Peruvian women of reproductive age use some method of contraception.[29] Within this group, 41% use modern family planning methods and 23% use traditional methods.[30]

- Of the modern contraceptive methods, 12% of women in stable cohabitating relationships use the intrauterine device, 10% have been sterilized, and 8% rely on hormonal injections.[31] The pill, condoms, and vaginal spermicides are preferred by 6.2%, 4.4%, and 0.7%, respectively, of Peruvian women.[32]

- It is estimated that there are 270,000 abortions each year in Peru.[33]

HIV/AIDS AND STIs

- In 1996, there were 4,598 cases of AIDS, reported by the Ministry of Health's Program for the Control of STIs and AIDS.[34] Of these cases, 14.8% were women.[35]

- The highest percentage of people with AIDS were between the ages of 30 and 39 years (33.9%) and between 20 and 29 years (35.7%).[36]

- In 1995, the most common sexually transmissible infections among the Peruvian population were gonorrheal infections (6,178 cases) and late stages of syphilis (1,337 cases).[37]

ENDNOTES

1. NATIONAL INSTITUTE FOR STATISTICS AND INFORMATION (NISI), *Encuesta Demografica y de Salud Familiar* 1996 [Demographic Survey of Family Health 1996], at 15 (1997).
2. *Id.*, at 8.
3. *Id.*, at 15.
4. *Id.*, at 13.
5. *Id.*, at 6.
6. WORLD BANK, WORLD DEVELOPMENT REPORT 1996: FROM PLAN TO MARKET, at 189 (1996).
7. *Id.*, at 209.
8. MINISTRY OF HEALTH, GENERAL DIRECTORATE OF THE PEOPLE, DIRECTORATE OF SOCIAL PROGRAMS, *Programa de Salud Reproductiva y Planificación Familiar 1996–2000* [Program for Reproductive Health and Family Planning 1996–2000], at 24 (1996).
9. WORLD DEVELOPMENT REPORT 1996, *supra* note 6, at 194.
10. *Id.*, at 194.
11. WORLD ALMANAC BOOKS, THE WORLD ALMANAC AND BOOK OF FACTS 1997, at 808 (1996).
12. DEMOGRAPHIC SURVEY, *supra* note 1, at 19.
13. MANUELA RAMOS MOVEMENT, SITUACIÓN ACTUAL DE LA MUJER. CUÁNTOS SOMOS Y CÓMO ESTAMOS [CURRENT SITUATION OF WOMEN. HOW MANY AND HOW WE ARE], at 17 (1997).
14. *Id.*
15. *Id.*, at 12.
16. *Id.*, at 13.
17. CUANTO, S.A., PERÚ EN NÚMEROS 1996. ANUARIO ESTADÍSTICO [PERU IN NUMBERS 1996: STATISTICAL YEARBOOK], at 405 (1996).
18. DEMOGRAPHIC SURVEY, *supra* note 1, at 15.
19. *Id.*, at 89.
20. *Id.*, at 54.
21. *Id.*
22. *Id.*, at 44.
23. *Id.*
24. *Id.*, at 131.
25. CURRENT SITUATION OF WOMEN, *supra* note 13, at 16.
26. DEMOGRAPHIC SURVEY, *supra* note 1, at 118.
27. *Id.*, at 134.
28. *Id.*, at 139.
29. *Id.*, at 69.
30. *Id.*
31. *Id.*, at 63.
32. *Id.*
33. MINISTRY OF HEALTH, OFFICE FOR STATISTICS AND INFORMATION, PROGRAM FOR REPRODUCTIVE HEALTH AND FAMILY PLANNING (information on file with the Center for Reproductive Law and Policy (CRLP)).
34. *Id.* THE MINISTRY OF HEALTH, OFFICE FOR STATISTICS AND INFORMATION, PROGRAM FOR THE CONTROL OF SEXUALLY TRANSMISSIBLE INFECTIONS AND AIDS (information on file with CRLP).
35. *Id.*
36. *Id.*
37. *Id.*

The Republic of Peru is situated on the central Pacific coast of South America. Ecuador and Colombia border it to the north, Brazil and Bolivia to the east, and Chile to the south.[1] The official languages are Spanish and, in those areas where they are predominant, Quechua, Aymara, and other indigenous languages.[2] Roman Catholicism is the predominant religion. The population is racially diverse: while mestizo and indigenous ethnic groups are the majority, there is also a significant presence of other ethnic groups such as whites, mostly of Hispanic origin, blacks, and Asians.[3]

Peru was the political center of the Incan empire. In the fifteenth century, when the Spanish colonizers arrived, Incan territory included modern-day Bolivia, Argentina, Chile, Ecuador, and Colombia.[4] Its history as a republic began when it gained political independence from Spain on July 28, 1821. Democratic and dictatorial governments then alternated in power. At the end of the 1970s, General Juan Velasco Alvarado seized power by staging a coup.[5] In 1980, Peru returned to democracy with the election of President Fernando Belaunde Terry. In the same year, a long period of internal political violence began that gripped the country for more than thirteen years, aggravating the already acute problem of poverty, causing 27,000 deaths, and internally displacing 600,000 people.[6] President Alberto Fujimori was elected in 1990, and, for the first time in the country's history, in 1992, he dissolved the National Congress. Under Fujimori's government, an economic adjustment and restructuring program was implemented.[7] The end of a period of severe inflation and the capture of a leader of one of the armed opposition groups helped ensure his reelection as president for a second term (1995-2000).[8]

I. Setting the Stage: the Legal and Political Framework

The political and judicial systems constitute the framework for exercising rights and designing policies that affect women's reproductive lives. In order to understand the process by which laws are made, interpreted, modified, and implemented as well as the process by which governments enact reproductive health and population policies, it is necessary to consider the legal and political basis and structure of these systems.

A. THE STRUCTURE OF NATIONAL GOVERNMENT

The Political Constitution of Peru (the "Constitution") lays out the fundamental rights of its citizens, establishes sources of law and the hierarchy of legal norms, and determines the structure and organization of the state. The system of government in Peru is unitary and decentralized,[9] meaning that the country's laws and ministerial policies are executed in a decentralized way throughout the country. The branches of government are the executive, the legislative, and the judicial.

Executive Branch

Executive power is vested in the president of the Republic, who is the head of state and personifies the nation.[10] He or she is elected by universal and direct suffrage, by simple majority, for a period of five years.[11] The president is responsible for government policy and for implementing and enforcing the Constitution, laws, judgments, and other judicial decisions.[12] He or she has the power to propose legislation on his own initiative, and when the Congress of the Republic ("Congress") delegates such power to him.[13] He or she also may issue regulations implementing any law passed by Congress,[14] and can issue urgent decrees exclusively with respect to economic and financial matters, which have the same status as laws.[15] The president appoints ministers who are, in turn, responsible for sectorial policy via the ministries.[16] All presidential acts require the countersignature of one or more ministers in order to be valid.[17] The Council of Ministers, or any of its members, is accountable for its actions to Congress,[18] who can undertake votes of censure or of no confidence.[19] The president has the power to dissolve Congress if it censures or passes votes of no confidence against two consecutive Councils of Ministers,[20] and he or she must then call congressional elections within four months of the Congress' dissolution.[21]

Legislative Branch

Legislative power resides in the Congress of the Republic,[22] which consists of a single chamber of 120 members, elected for a period of five years.[23] The members of Congress represent the nation and cannot be prosecuted or imprisoned without prior congressional authorization.[24] The principal functions of Congress are to enact, approve, modify, repeal, and interpret laws as well as to ratify treaties, approve the national budget, and perform other functions specifically provided for by the Constitution.[25] Congress legislates by passing laws and legislative resolutions,[26] while the president does so through legislative decrees, when Congress has delegated such power to him or her during a fixed period.[27] Other bodies in which state power is vested, namely, autonomous public institutions, municipalities, and professional associations, may propose laws, but only concerning matters within their field or jurisdiction.[28] Citizens also have the right to propose legislation.[29] Once finalized and passed by Congress, bills are sent to the president for his or her approval; he or she must present observations to Congress within fifteen days,[30] or else the bill is deemed approved and is promulgated by Congress.[31] For a bill to be passed by Congress, it requires approval by a majority vote.[32]

Judicial Branch

By administering justice and ensuring that laws are complied with, the judicial system can have a significant impact on the general legal situation of women and, particularly, on their reproductive rights. The Peruvian judicial system is a civil law system derived from Roman law, as distinguished from English common law. The judiciary administers justice in accordance with the Constitution and laws[33] and is composed of the following bodies, each with its own jurisdiction: the Supreme Court of Justice ("the Supreme Court"), the higher courts of justice, the specialized and mixed courts, and the justices of the peace.[34]

The Supreme Court, when sitting in plenary session, is the judiciary's highest body and issues final judgments in certain cases specified by law.[35] Its president represents the judiciary.[36] The higher courts, established in various judicial districts,[37] decide cases on first and on final appeal — with certain exceptions specified by the law — in civil, criminal, labor, and agrarian matters.[38] The specialized and mixed courts are presided over by judges who have primary jurisdiction over civil, criminal, labor, agrarian, and juvenile cases and hear appeals from the justices of the peace.[39] Justices of the peace administer justice in districts or zones where there are no specialized judges, hearing cases on diverse subjects as long as the amount of money in dispute does not exceed a limit set by law.[40] The judges and prosecutors at all levels, including the Supreme Court, are elected by the National Council of the Judiciary[41] which must ratify its choices for these positions every seven years.[42] Only justices of the peace are elected by the general public.[43]

The authorities of rural and indigenous communities may administer justice within their territorial jurisdiction under customary law, "provided this does not violate the fundamental rights of the individual."[44] Legislation provides for coordinating this special jurisdiction with that of the national judiciary.[45]

The Office of the Public Prosecutor, the Public Defender's Office ("Ombudsman"), and the Constitutional Court are all autonomous mechanisms for protecting the rule of law in Peru. The Office of the Public Prosecutor is responsible for, among other functions, initiating cases before the judiciary to defend the legal order and the public interest[46] and representing society in legal proceedings.[47] The Ombudsman is obliged to defend individual and collective human rights and to supervise the administration and provision of services to the citizenry.[48] The Constitutional Court has a specialized jurisdiction empowering it to ensure respect for the Constitution by interpreting constitutional norms and issuing judicial decisions related to the Constitution.[49]

B. STRUCTURE OF TERRITORIAL DIVISIONS

Regional and local governments

The regional and municipal governments were created by the process of decentralization, which was intended to encourage the comprehensive development of the country.[50] Peru is divided into regions, departments, provinces, and districts.[51] These territorial divisions enjoy political, economic, and administrative autonomy over matters within their jurisdiction.[52] However, regional and local governments submit their budgets to the General Comptroller of the Republic and are subject to financial control in accordance with the law.[53] The regions are formed at the initiative and by the decision of the inhabitants of bordering departments, by a process of referendum.[54] The president of the region is elected by direct vote, for a period of five years,[55] and, together with the Regional Coordinating Council, forms the organs of government for the region.[56] The regions carry out and coordinate socioeconomic plans and programs, as well as other functions of government.[57] They must support local governments without substituting or duplicating their areas of responsibility.[58] The provincial and district municipalities are the instruments of local government and are represented by mayors elected by direct vote for a period of five years.[59]

C. SOURCES OF LAW

Domestic sources of law

The laws that determine the legal situation of women and their reproductive rights are derived from various sources. In Peru, the Constitution and legislation are the principal sources of law.[60] Laws follow a hierarchical principle that determines the supremacy of one norm over another where the two conflict.[61] Peru's sources of law in hierarchical order are as follows: the Constitution; the laws or norms with the force of law;[62] international treaties, decrees, and regulations. In exceptional cases, jurisprudence[63] is a source of law by express mandate of the law.[64] General legal principles[65] are specifically applicable in the area of health where there are omissions or deficiencies in the law.[66]

The Constitution prevails over all ordinary laws.[67] If a law conflicts with the Constitution, judges must give precedence to the Constitution.[68] A law can be repealed only by another law or a legal decision declaring its unconstitutionality.[69] No law may have retroactive effect, with the exception of criminal laws where they favor the defendant.[70] Laws enter into effect the day after they are published in the *Official Daily Gazette*, unless they expressly state otherwise.[71]

International sources of law

Numerous international human rights treaties recognize and promote specific reproductive rights. In Peru, treaties

become part of Peruvian national law once signed and ratified.[72] The president is responsible for concluding and ratifying treaties,[73] with the prior approval of Congress, where the treaty in question concerns such matters as human rights, sovereignty, national defense, or financial obligations of the state; or where it creates, modifies or abolishes taxes, among other matters.[74] If a treaty affects the Constitution, the latter must be amended before the treaty can be ratified.[75] The president has the power to withdraw from treaties, provided he informs Congress,[76] except where the treaty is subject to congressional approval, in which case withdrawal also requires congressional approval.[77]

Peru is a member state of the United Nations and the Organization of American States. As such, it has signed most of the relevant treaties that comprise the universal system for the protection of human rights[78] and, in particular, those that refer to the protection of women's rights in the universal and Inter-American system, such as the Convention on the Elimination of All Forms of Discrimination Against Women[79] and the Inter-American Convention on the Prevention, Punishment and Eradication of Violence Against Women (the Convention of Belém Do Pará).[80]

II. Examining Health and Reproductive Rights

In Peru, issues related to the reproductive health of women are subsumed under national policies on health and population. Therefore, in order to understand reproductive rights, it is necessary to analyze health and population programs as well as the laws related thereto. The Peruvian government has declared the 1990s the Decade of Family Planning.[81]

A. HEALTH LEGISLATION AND POLICY

The Constitution establishes that all the persons have the right to health care.[82] The General Law on Health (1997)[83] provides that health care is a matter of public interest and, as such, is regulated, overseen, and promoted by the state.[84] The state promotes progressive, universal health care for its citizens and guarantees freedom of choice regarding health care systems without favoring the state system that it is required to provide for the uninsured population.[85] The state determines and carries out its health policy at the national level through the Ministry of Health.[86] Any norm or regulation relating to health must be endorsed by this authority[87] and the public entities in charge of environmental or sanitary matters are also under its supervision, as are the various professional associations for health sciences, with respect to such associations' control over the professional activities of their members.[88]

Objectives of the health policy

The health policy for the five-year period from 1995 to 2000 seeks, among other objectives, to achieve greater coverage of health services for the population, to modernize the technological and institutional sectors, to promote greater institutional efficiency and efficacy in the provision of services, to better coordinate the private and state-supported health services, and to promote change in the institutional culture that exists within the Ministry.[89] In 1994, the government initiated the Program for Basic Health Care for All[90] to focus attention on these issues nationwide.[91] The Program for Strengthening Health Care Services[92] and Project 2000, currently being developed, are dedicated to improving health services.[93]

So far as programs specifically aimed at women's health are concerned, in 1995, the Ministry of Health reconceptualized and revitalized the Program for Women, Health and Development ("PWHD"),[94] which was created in 1990.[95] This program specifically incorporates gender-sensitive methodologies into health activities relating to women.[96] Its general objective is "to contribute, from within the health sector, to the elimination of the various forms of discrimination against women which contribute to the deterioration of women's health and that of their families."[97] It is proposed that the activities of the program be carried out at different levels and by various sectors.[98] In October 1996, the Ministry of Health announced the commencement of two programs within the framework of the PWHD: the Project on Violence Against Women and Girls and the Project for Investigation of Gender Equality in the Quality of Health Care from the Social and Emotional Perspective.[99] The former program relies on specialized non-governmental organizations ("NGOs") to carry out its activities and seeks to devise more coordinated responses and develop local strategies to deal with domestic violence.[100] The objective of the latter project is to seek new indicators to measure gender equality in the provision of medical services, exclusively from the "social and emotional perspective" of its users.[101] Both projects are under way in certain areas of the country that the Ministry of Health[102] considers to be a priority.

Infrastructure of health services

The General Law on Health establishes state responsibility for ensuring adequate coverage and quality of safe and accessible health care services for the public.[103] All types of health care establishments are subject to control by the national health authorities.[104] The infrastructure of the health sector comprises all the establishments owned and run by the Ministry of Health, the Social Security Institute of Peru, the Armed Forces, and the Police, as well as the private entities offering health services.[105] In 1992, there were 4,630 health care establishments in

Peru: 455 hospitals, 1,083 health care centers, and 3,079 health posts, not including private health establishments.[106] The health centers and posts provide the community with primary health care of a basic nature and are the core of the health care network, comprising the various entities of the Ministry of Health's system.[107] Hospitals are classified according to their capacity to handle complex cases, the number of beds, and geographical jurisdiction.[108] All health establishments are required, without exception, to attend to anyone needing emergency care.[109]

As far as human resources are concerned, in 1992, of a total of 19,969 general health care professionals, 12% were obstetricians and 6% were nurses.[110] In the same year there were 16,433 doctors nationwide, of which, 96% were obstetricians or gynecologists.[111] The geographic distribution of human resources, which the Ministry of Health has found to be inadequate, and the lack of training and motivation of health professionals are considered to be the principal problems in the field.[112] The most remote, rural communities are the most affected by the inadequate distribution: in 1992, there was one doctor for every 12,000 inhabitants in the most remote provinces, one for every 8,000 in the less remote provinces, and an average of one for every 800 inhabitants in Lima.[113] In 1994, only 32.6% of the population had medical insurance. 25% of the remaining 73.8% did not use any modern health care services, and dealt with their problems using alternative medicine, such as medicinal herbs and other remedies.[114]

Cost of health services

In 1995, the sector's budget was 1,272 million new soles (approximately U.S.$600 million), which was a 122.4% increase over the previous year's budget.[115] The General Law on Health of 1997 provides that the government's budget should be primarily geared towards wholly or partially funding health care activities for low-income individuals.[116]

Regarding the cost of health care, in 1981 the Ministry of Health created a fee system that is scaled according to the type of service and the economic status of certain vulnerable sectors, especially rural and low-income urban groups.[117] This ministerial decree provides that basic service, medicines, diagnostic tests, and treatment in health centers be free of charge.[118] It also covers all consultations, emergency services, hospitalization, medicines, and auxiliary examinations in local hospitals,[119] as well as treatment during pregnancy, childbirth, and postnatal care.[120] Finally, it also covers services and medicines in specialized[121] or highly specialized[122] hospitals, for qualifying low-income individuals.[123] In 1985, the Population Law provided that health care services for pregnancy, childbirth, and postnatal care should be provided with "a tendency towards their provision free of charge,"[124] modifying the previous 1981 decree that established that such services would be totally free.

In 1990, the Ministry of Health's establishments began to charge fees for clinical services in order to generate their own resources,[125] although there was no official modification of laws or policies on this subject. The total amounts generated and the fees that have been charged have not been made public. Evaluating the repercussions of the application of hospital fees, in 1995, the Ministry of Health stated that the partial change in health care funding, begun in 1990, had not brought about qualitative changes in health care services and "have probably had a negative impact on the population that traditionally relies on public establishments, making access more difficult for the poor and the homeless."[126] The demand on hospitals by the most destitute decreased between 1991 and 1994 from 30.1% to 28%, while the lowest-income middle classes[127] increased their demand from 34.8% to 45%.[128] The Ministry of Health stated that in certain cases hospitals were as much as 65% self-financing.[129]

The General Law on Health of 1997 does not expressly or implicitly abolish the 1981 standard establishing free health care[130] but does state that health establishments and medical staff are obliged to inform patients and their families "about the economic conditions for the provision of health care services as well as the other terms and conditions for the provision of this service."[131] The law does not establish what these "economic conditions" are. In the field of reproductive health, the only service guaranteed by law to be totally free of charge is the provision of the full range of contraceptive methods.[132]

The social security health care system, under the Institute for Social Security of Peru ("ISSP"), pays for the health care provided to those affiliated with ISSP through funds obtained from its compulsory contributors (9% of active workers' and 4% of retired workers' remuneration), funds obtained from voluntary contributors, and from investments and legally authorized funds.[133]

Regulation of health care providers

The General Law on Health currently in force contains a chapter on regulating the medical and related professions, including technical and auxiliary health care workers.[134] The law provides that in order to practice medicine, dentistry, pharmacology, or any other professional activity related to health care, a person must hold a professional degree, belong to a professional association if so required, and fulfill any specialist or other legal requirements.[135] The codes of ethics and other norms set by each professional association establish limits, penalties, and other prohibitions as provided by the General Law on Health.[136]

Information about "medical acts"[137] is confidential. Whoever divulges such information incurs civil or criminal responsibility, as well as any sanctions set out in the ethical

code of the relevant professional association.[138] Exceptions to the patient confidentiality rule are cases of illnesses or injuries that are required to be reported by law,[139] which include criminal violence and illegal abortion.[140] Only doctors can prescribe medication, and dentists and obstetricians may do so only in their own area of practice.[141] Experimental research is governed by the ethics set out in the Helsinki Declaration.[142] Medical professionals and technical and auxiliary staff are liable for damages or injuries caused to patients through negligence in their professional practices.[143] The General Health Law provides warnings and fines applicable to health care practitioners, without excluding other sanctions provided for in the applicable professional code of ethics.[144]

The Penal Code criminalizes certain acts that normally involve participation by health care professionals, such as causing injuries or death through negligence;[145] performing abortions;[146] fraud against the civil law;[147] breach of patient confidentiality;[148] crimes against public health;[149] illicit trafficking of drugs or toxic substances;[150] and crimes against public trust.[151]

In the case of traditional birth attendants without formal qualifications, commonly known as midwives (*comadronas*), there is a manual prescribing guidelines for their training in force since 1976.[152]

Patients' rights

The Constitution requires the state to defend the interests of consumers and service users.[153] The General Law on Health provides that those who use health care services are entitled to confidentiality; respect for their dignity; privacy; and to not be subjected, without their consent, to examination or treatment, to demonstrations for educational purposes, or to medication or treatment for experimental purposes.[154] Individuals also have the right to demand that health care services meet standards that are "acceptable by professional procedures and practices."[155] Everyone has the right to medical information without having to explain why he or she is requesting it.[156] Likewise, everyone has a right to receive emergency medical attention in any health establishment,[157] subject to the conditions regarding reimbursement of costs and other conditions of service provided by the General Law on Health.[158] The law prohibits discrimination based on the illness from which a person is suffering.[159] With the exception of emergency care, the consent of the patient or a legal representative or, alternatively, judicial authorization, is required before any treatment or surgery may be administered.[160]

Health establishments are jointly liable for any injury or damage caused to a patient due to the negligence of health professionals, technicians, or assistants who work for the establishment.[161] If the establishment has not provided its staff with adequate means for treating patients, then it is exclusively liable for any injury or damage caused.[162] The Penal Code provides that if a health provider causes minor injury to a patient, he or she shall be sentenced to a maximum of one year in prison or a fine of between 60 and 120 days' wages.[163] If the damage caused to the patient is serious, the sentence is for between one and two years' imprisonment and a fine of between 60 and 120 days' wages.[164] If the patient dies because the professional, technician, or assistant fails to observe the technical rules governing his or her professional activities, the penalty is two to six years' imprisonment and professional disqualification.[165]

The General Law on Health provides that breaches of its standards may be sanctioned by warnings, fines, or closure of the health establishment in question,[166] depending on the degree of damage caused to the patient's health, the gravity of the breach of the law, and whether the person responsible has committed other similar breaches.[167] Sanctions under this law do not exclude civil or criminal suits that could arise from such cases.

B. POPULATION, REPRODUCTIVE HEALTH, AND FAMILY PLANNING

The Constitution establishes that the objective of the National Policy on Population is to raise awareness concerning responsible parenthood and to protect the right of families and individuals to make their own decisions concerning reproduction.[168] To meet these aims, the state undertakes to provide adequate education and information services as well as access to those methods of family planning that do not adversely affect life or health.[169]

The population and family planning policies currently in force are contained within two main normative instruments: the National Population Law ("Population Law")[170] and the Program on Reproductive Health and Family Planning 1996-2000.[171] In 1995, the Population Law was modified to allow sterilization as a birth control method[172] and to integrate the objectives and strategies of the above-mentioned program.

Population laws and policies

Peru's national population policy, set out in its Population Law, has the following objectives: to promote a stable and harmonious equilibrium between the growth, structure, and territorial distribution of the inhabitants of the country; to encourage and ensure free, informed, and responsible choice by individuals and couples regarding the number and spacing of children; and to reduce the number of deaths caused by disease, particularly among mothers and children.[173] The Population Law gives the state a role as promoter in implementing family planning programs through educational and informational activities and services and provides that such programs must respect the individual's fundamental rights[174] and the dignity of

the family.[175] Peru's population policy treats mothers, children, adolescents, and the elderly as priority groups. The institution of marriage, the family, and responsible parenthood receive special protection under the terms of the law.[176]

The Population Law contains a special chapter on health aspects of Peru's population policy.[177] It establishes that maternity and infant health care services are a priority and a "tendency towards their provision free of charge."[178] It prohibits coercion, "manipulation," and conditioning by public or private institutions in the provision of family planning services.[179] Finally, the law promotes breast-feeding for its nutritional benefits to the child and its contribution to birth spacing.[180]

The responsibility for fulfilling the objectives of the national population policy is shared by various governmental entities.[181] The body in charge of formulating national programs and coordinating measures proposed by local and regional governments and mass communication programs on the theme of population[182] is the National Population Council ("NPC").[183] The NPC is a decentralized public institution and has legal status within internal public law. Its president represents it.[184]

Reproductive health and family planning laws and policies

Peru's laws and policies related to reproductive health face the second-highest maternal mortality rate in Latin America, after Bolivia.[185] The General Law on Health reaffirms the individual's constitutional right to freely choose his or her preferred method of contraception and to obtain adequate information about reproductive health and available family planning options prior to selecting a method.[186] The Ministry of Health has determined that its health policy for the period from 1996 to 2000 "shall be guided by the fundamental principle of guaranteeing public access to the highest level of quality information on the meaning and importance of reproductive health and family planning."[187]

In February 1996, the Ministry of Health approved the Program on Reproductive Health and Family Planning 1996-2000 ("Program on Reproductive Health and Family Planning"),[188] a policy instrument that contains the objectives, goals, activities, and government strategies concerning reproductive health and family planning. The program's mission is to provide services that promote reproductive health and to provide preventive, curative, and rehabilitative reproductive health services[189] and, in particular, "to attend to women's reproductive health in all stages of their lives."[190] It recognizes reproductive health as a fundamental human and social right.[191] The family planning component of the program is considered to be a central aspect of reproductive health, intended to ensure that men and women have the ability and freedom to decide on the number of children they wish to have and the right to obtain assistance with fertility problems.[192]

The language and orientation of the Program on Reproductive Health and Family Planning recognizes the fundamental importance of gender equality and it acknowledges that the reproductive health of women is dependent on their social and economic status.[193] Within the program's framework, the Ministry of Health has identified the following as priority problems in reproductive health: (a) the high maternal and perinatal mortality rate; (b) the high levels of unmet needs in family planning; (c) the increase in high-risk reproductive behavior among adolescents; (d) the increasing risk to pregnant women of sexually transmissable infections ("STIs") that especially affect women of fertile age, adolescents, and newborn babies; (e) the high morbidity and mortality rate among women caused by treatable gynecological illnesses that become life-threatening due to the lack of access to health services;[194] and (f) the inequity in the status of women.[195] The population most affected by the problems described above consists of women, infants of low-income families, adolescents, women living in rural areas, and women of certain ethnic and cultural groups.[196]

The goals of the Program on Reproductive Health and Family Planning are, among others, to achieve a total fertility rate of 2.5 children per woman;[197] to reach a total contraceptive prevalence rate of 50% of women of reproductive age, 70% of women in stable relationships, and 60% of all adolescent girls;[198] to reach a prenatal care coverage rate of 75% of probable pregnancies (the current rate is 67%);[199] to ensure that at least 75% of births are attended by a professional health care provider (the current rate is 56%);[200] to improve the screening for cervical cancer to reach 30% of women of reproductive age; to improve the screening of STIs to reach 60% of women of reproductive age, adolescents, and infants who are at risk; and to support educational programs so that 100% of school children receive sex education by the end of their secondary schooling.[201] To achieve these goals, the Ministry of Health has proposed strategies to initiate the democratization of information on reproductive health and family planning and to ensure universal access to such services.[202] The program also proposes that reproductive health and family planning services be decentralized with the coordinated participation of NGOs and both the public and private sectors and that these services become self-funding.[203]

With the objective of standardizing the existing regulations and procedures for family planning programs, the Ministry of Health published a manual of procedures and norms for health care providers in 1992 called the "Manual on Reproductive Health: Methods and Procedures" ("RH Manual").[204] The RH Manual complements the Program on Reproductive

Health and Family Planning, and its provisions on health care providers are binding.[205]

Government delivery of family planning services

Family planning services are provided by the state through all public health sector establishments.[206] In 1995, the Ministry of Health enacted a resolution requiring all such establishments to consider family planning a matter of priority and to strengthen their family planning programs, particularly those devoted to disseminating information on the subject.[207] Most important, the regulation requires the provision of the full range of contraception free of charge as a means to ensure freedom of choice.[208] In 1996, the program on Reproductive Health and Family Planning underscored that contraceptive services and methods provided by the program, including surgical sterilization, should be offered free of charge.[209] The Demographic and Family Health Survey[210] points out that the Ministry of Health and the Social Security Institute of Peru are the principle providers of modern contraceptive methods, with a coverage of 70% of users.[211] The remaining 30% obtain contraceptives from the private sector, principally pharmacies and drug stores (15.4%) and NGOs (3.3%).[212]

Obstetric professionals render the majority of reproductive health and family planning services.[213] In establishments that lack doctors and obstetricians, the nursing staff assumes responsibility for maternal health care.[214] It is estimated that 10% of nurses employed by the Ministry of Health perform some kind of services related to reproductive health.[215]

C. CONTRACEPTION

Prevalence of contraceptives

The demographic survey DFHS96 shows that between 1991 and 1996, the prevalence of modern contraceptive methods among cohabiting women increased from 57% to 64%.[216] Forty-one percent use modern methods and 23% use traditional methods.[217] The rate of prevalence of contraceptive methods is higher in sexually active women who are not cohabiting (76%).[218] The contraceptive methods most commonly used are the intrauterine device ("IUD"); (12%) and female sterilization (10%).[219] The public sector (the Ministry of Health and the ISSP) inserts 76.4% of IUDs and performs 78.3% of female sterilizations.[220] The use of modern methods such as the pill, the IUD, hormonal injections, condoms, and others, is more frequent among women living in urban areas who have a higher level of education.[221] The rhythm method or periodic abstinence is the most prevalent traditional method used by Peruvian women who cohabit (18%) as well as those who do not cohabit (24.6%), in urban and rural areas.[222]

During the period from January to August of 1996, the Ministry of Health performed 149,213 insertions of IUDs, 35,558 surgical sterilizations, and 3,376 vasectomies.[223] It provided 1,634,269 packets of pills, 786,269 hormonal injections, 8,369,386 condoms, and 4,267,413 vaginal suppositories.[224] It is estimated that 636,795 couples received family planning services during this period.[225]

The contraceptive methods currently provided by government-sponsored family planning programs include both modern and traditional methods:[226] barrier and hormonal contraceptives; IUDs; permanent (surgical) methods; and traditional methods such as periodic abstinence.

Legal status of contraceptives

The General Law on Health provides that a person has the right to choose freely his or her method of contraception.[227] The only legal prohibition in this regard in Peruvian legislation is the prohibition in the Population Law against abortion as a method of contraception.[228] The General Law on Health requires the client's prior consent before initiating any course of contraception, and, in the case of any permanent (surgical) method, the consent must be in writing.[229]

Emergency or postcoital contraception is regulated by the RH Manual,[230] which provides that this method may be used in cases of unprotected sexual relations, rape, or failure of barrier contraceptive methods.[231] According to the RH Manual, the morning-after pill should be used within seventy-two hours of unprotected intercourse.[232] Although emergency contraception is not specifically governed by any national legislative norm, the RH Manual itself is binding throughout the country.[233]

Contraceptives must be legally approved by and registered with the National Formulary of Medicines prior to being marketed nationally.[234] The formulary inscribes those medicines that the state deems necessary to the preservation, maintenance, improvement, or recovery of health and have been properly approved.[235] These medicines cannot be sold on the street.[236] The Directorate General for Medicines, Supplies and Drugs ("DIGEMSD") is the body within the Ministry of Health responsible for controlling, supervising, and regulating the quality, use, commercialization, registration, supply, and distribution of such products at the national level.[237] DIGEMSD can suspend or cancel the registration of the aforementioned products if they fail to meet the technical specifications by which they were approved and registered, or if the World Health Organization determines that the product is unsafe or ineffective.[238]

Regulation of information on contraception

The General Law on Health establishes the right of users of contraception to receive adequate information regarding "available methods, their risks, contraindications, precautions, warnings, and physical, physiological, or psychological effects which

their use or administration can cause," before any method is prescribed or administered.[239]

Contraceptives that are included in the health registry and are authorized to be sold without medical prescription may be advertised in the media.[240] The Ministry of Health may authorize publicity of pharmaceutical products sold by prescription only "as an exception and with due justification,"[241] in which case the advertisement must direct the consumer to read the instructions accompanying the product.[242] The body responsible for standardizing and controlling advertising and publicity regarding medicines, pharmaceutical ingredients, and drugs, is the Executive Office for Inspections and Inquiries of the DIGEMSD.[243]

Sterilization

Sterilization was the second-most commonly used contraceptive method in Peru in 1996.[244] Currently the percentage of sterilizations in women in a stable cohabiting relationship is 11.3% in urban areas and 5.4% in rural areas.[245] Until 1995, sterilization was prohibited as a method of family planning by the Population Law.[246] The recent General Law on Health now regulates sterilization.[247] This law provides that in the specific case of sterilization and other permanent methods preventing conception, the patient's prior consent must be given in writing.[248] Thus, it modifies the earlier provision in the RH Manual,[249] which provided that a woman needed her spouse's written consent before undergoing surgical sterilization.[250] The RH Manual continues to regulate the requirements, indications, contraindications, advantages, disadvantages, procedures, and surgical techniques for surgical sterilization. The following surgical methods are authorized: vasectomy, tubal ligation by minilaparatomy using local anesthetic, and laparoscopy for female sterilization.[251] Voluntary sterilization services must be provided by the state free of charge, through the various health sector facilities.[252]

The General Law on Health guarantees the right to seek fertility treatment through "assisted fertility treatments."[253] The law requires, however, that a woman who is impregnated must also be the genetic mother of the child she bears.[254] To use such treatments, the biological parents must give their prior written consent.[255]

D. ABORTION

Legal status of abortion

In Peru, abortion is illegal and is considered to be a crime against life, body, and health,[256] with the exception of therapeutic abortions, which may be performed to save a woman's life or to prevent serious and permanent damage to her health.[257] The Constitution provides that human life begins at conception and that the "conceived" is subject to the law insofar as this is in its favor.[258] Furthermore, the Population Law prohibits abortion as a method of family planning.[259]

Because abortion is illegal, the Population Law establishes the state's commitment to adopting "appropriate measures, coordinated by the Ministry of Health, to help women avoid having to undergo abortions."[260] Abortion is the second leading cause of maternal death (22%) in Peru.[261] It also establishes the state's commitment to "provide medical treatment and psychosocial help to those women who have undergone an abortion."[262] In 1994, it was estimated that 30% of available beds in facilities that provide obstetric and gynecological services were being used to care for women suffering from complications following abortion.[263] In 1996, the Family Planning and Reproductive Health Program decided that its immediate plan to reduce maternal mortality[264] "should confront the problem of reducing the number of deaths caused by complications following illegal abortions resulting from unwanted pregnancies."[265] However, the General Law on Health has recently stated that doctors must inform directors of health establishments of cases indicating that an illegal abortion was performed and that directors are required to report any such case to the competent authorities.[266] Where the police and District Attorney's Office require information concerning a case of abortion, the doctor is obliged to provide it[267] and, in such a case, is exempted from relying on patient confidentiality.[268]

The Penal Code provides that the following are guilty of criminal abortion: "a woman who induces her own abortion or consents to another performing it for her,"[269] "any person who performs an abortion with the patient's consent" and "any person who performs an abortion without the woman's consent."[270] It also penalizes "a person who causes a miscarriage through violence," whether or not that person intended to do so.[271]

Requirements for obtaining legal abortion

A therapeutic abortion may be performed legally, provided it is the only means of saving the pregnant woman's life or of avoiding serious and permanent damage to her health.[272] In addition, it is a prerequisite that the abortion be performed by a doctor and that the pregnant woman or her legal representative consent to the abortion.[273]

Penalties for abortions

Women who induce their own abortion or consent to another performing an abortion are sentenced to a prison term of not more than two years or to community service of between 52 and 104 days.[274] There are three cases in which it has been established that the prison sentence shall not exceed three months: where the pregnancy is either the result of extramarital rape or nonconsensual artificial insemination outside marriage or where it is likely that the fetus will be born with serious physical or mental defects and this has been diagnosed by a doctor.[275]

Persons who perform an abortion with the pregnant woman's consent receive prison sentences of between one and four years.[276] If the abortion was performed without the woman's consent, the sentence is three to five years.[277] In either case, if the woman dies and the person responsible could have foreseen such a result, the penalty is two to five years and five to ten years, for an abortion performed with and without her consent, respectively.[278] Doctors, obstetricians, pharmacists, or any other health care professionals who perform an abortion are, in addition to the above-mentioned criminal penalties, subject to between one and ten years' suspension from practice.[279] Any person who unintentionally causes a miscarriage with a violent act against a woman whom he or she knew to be pregnant is liable to receive a prison sentence of up to two years or between 52 and 104 days' community service.[280]

E. HIV/AIDS AND SEXUALLY TRANSMISSIBLE INFECTIONS (STIs)

Examining HIV/AIDS within the framework of reproductive rights is essential, insofar as the two areas are interrelated from both medical and public health standpoints. Moreover, a comprehensive evaluation of laws and policies affecting reproductive health in Peru must examine the situation of HIV/AIDS and STIs given the dimensions and the implications of both diseases as reflected in the following statistics. In Peru, between 1983 and 1996, there were 4,598 cases of AIDS.[281] Of this total number of cases, 678 were women (14.8%) and 3,902 were men (85.2%).[282]

Laws on HIV/AIDS and STIs

Legislation regarding HIV/AIDS and STIs in Peru has developed in conjunction with the evolving regulation of the handling of human blood. In 1988, on the basis of research conducted to assist in the formulation of the first program for the prevention and control of HIV/AIDS (1987),[283] the Ministry of Health passed a law requiring public and private institutions to conduct tests for AIDS, hepatitis B, and syphilis before performing transfusions of blood, components of blood, or blood derivatives.[284] In 1995, the acquisition, donation, and transfusion of blood was declared to be a matter of public interest and order.[285] The sale and marketing of human blood for transfusions and export is prohibited.[286] With respect to blood donations, written consent is required from the donor as well as a detailed evaluation of his or her medical history and clinical and laboratory examinations of the blood.[287] If an illness is detected in the donor's blood after performing the procedure, the health facility must inform and advise the person on possible treatments.[288]

In 1996, a law was passed sanctioning the formulation of a National Plan to Fight AIDS (known by its Spanish acronym, CONTRASIDA)[289] and establishing certain rights for people infected with HIV/AIDS. According to this law, tests for diagnosing HIV/AIDS require prior consent and are voluntary, except in the case of blood or organ donors and other cases for which testing is required by law.[290] HIV/AIDS test results and information as to the certain or probable cause of infection are confidential.[291] Only the Attorney General's Office and the judiciary may request such information for purposes of investigating a crime and only when the circumstances so require.[292] Health care professionals are required to notify the Ministry of Health of any AIDS diagnosis, even where the patient is deceased.[293]

The above-mentioned law also protects the labor rights of a person with HIV/AIDS for as long as that person is able to perform his or her duties.[294] The termination of a contract of employment is null and void if based on the the employee's HIV/AIDS status. In such a case, the employee is entitled to be reinstated.[295] Furthermore, any person who has HIV/AIDS has the right to comprehensive medical treatment and to any necessary state benefits.[296] The state must provide such treatment through the health facilities it administers, or those in which it has some direct or indirect participation. The right to comprehensive medical treatment and insurance coverage is enforceable in the private domain if it has been established pursuant to a contractual relationship.[297]

Policies on prevention and treatment of HIV/AIDS and STIs

In 1987, the Ministry of Health proclaimed the control, notification, and treatment of AIDS to be of public necessity and utility.[298] It also established the system of compulsory reporting of suspected cases by doctors as well as public and private health institutions throughout the country.[299] Such reports are deemed to be strictly anonymous and confidential, and in no circumstances may they be used as evidence or for publicity.[300] Ensuring compliance with these norms is the responsibility of the Technical Commission for the Certification, Assessment, and Registration of such cases, which is an entity within the Ministry of Health.[301] In 1987, the National Multisectorial Program for the Control of AIDS was approved[302] for the purpose of educating the population about the prevention of this disease and to detect, treat, and monitor cases. The program endeavors to exercise permanent oversight over AIDS cases and, in particular, to obtain a profile on prevailing causes of the disease through surveys.[303]

In 1996, a law was enacted, CONTRASIDA, that delegated to the Ministry of Health the task of formulating the National Plan to Fight HIV/AIDS and STIs.[304] This plan has the following objectives: (a) to coordinate and facilitate the implementation

of national strategies to control HIV/AIDS and STIs; (b) to promote national and international economic and technical cooperation to prevent, control, and treat these diseases; and (c) to propose legal reforms to facilitate and guarantee appropriate efforts to combat these diseases in Peru.[305] In 1996, a normative instrument was also approved to standardize the technical and administrative principles applicable to health care institutions with respect to the prevention and control of STIs and HIV/AIDS.[306] The document is called "Doctrine, Norms, and Procedures for Controlling STIs and AIDS in Peru" and is binding on all health care establishments in the country.[307]

III. Understanding the Exercise of Reproductive Rights: Women's Legal Status

Women's health and reproductive rights cannot be fully evaluated without analyzing their legal and social status. The legal status of women not only reflects societal attitudes that affect their reproductive rights but often has a direct impact on women's ability to exercise such rights. The legal context of relationships between couples and within families, women's educational level, and access to economic resources and legal protection generally determine women's ability to make choices about their reproductive health needs and to exercise their right to obtain such services. In Peru, recent governmental evaluations of women's reproductive health have shown a direct relationship between poverty, lack of education, social marginalization, discrimination, and lack of attention to women's reproductive rights and maternal mortality.[308] Sixty percent of Peruvian women are poor[309] and have limited understanding of their social and economic rights.[310] Domestic violence continues to have serious repercussions on their overall health and reproductive lives.[311] In 1996, 18% of Peruvian households were headed by a woman (19.2% in urban areas and 15.7% in rural areas).[312]

The Constitution recognizes the right to equality before the law and the right not to be discriminated against on grounds of origin, race, sex, language, religion, opinion, economic condition, or for any similar reason.[313] It recognizes the right not to be subjected to moral, psychological, or physical violence[314] and establishes the state's special obligation to protect mothers and children.

A. RIGHTS WITHIN MARRIAGE

Marriage law

The Constitution guarantees protection of the family and provides that the community and the state are responsible for promoting marriage, recognizing it as a natural and fundamental institution of society.[315] Regulation of the legal requirements to enter into marriage and of the causes of separation and dissolution is in the purview of the law.[316] The Peruvian Civil Code[317] provides that the minimum age for marriage, without parental consent, is 18 years.[318] Spouses have equal rights, obligations, and authority within the home.[319] During marriage, the woman has the right to adopt the husband's surname and to keep it even in the event of separation. Such right ceases upon divorce or the annulment of the marriage.[320] Both spouses participate in administering the household, jointly agreeing on where the matrimonial home will be located, whether to move, and decisions regarding the family's finances.[321] Both are obliged to contribute to the maintenance of the family according to their abilities and means, but if this responsibility falls on one spouse alone, the other must provide support.[322] Both may practice any profession or occupation permitted by law and may work outside the home with the express or tacit consent of the other. If one spouse is opposed, a judge can authorize the other to work if it is in the family's best interest.[323] Spouses must be faithful, assist one another, and cohabit in the matrimonial home.[324]

Legal representation of the married couple is jointly exercised by both spouses, especially with regard to disposing of or creating encumbrances on joint property; however, in the day-to-day administration of the home, either spouse may legally represent the couple.[325] Each spouse retains the right to freely administer, dispose of, or create encumbrances on his or her own property.[326] If a spouse does not contribute the income or proceeds of his or her own property towards the maintenance of the home, the other may request that the authority to administer such property be transferred to him or her, in whole or in part.[327] Married couples are obliged to maintain and educate their children.[328] Parental authority and legal representation of the children is exercised jointly by the spouses during their marriage. In the event of disagreement, a family court judge may resolve the conflict.[329]

Polygamy is not permitted in Peru. The Penal Code treats cases of bigamy as crimes against the family and applies a custodial sentence of between one and four years to a married person who marries again, and between one and three years to a single person who knowingly marries another who is already married.[330]

Regulation of domestic partnerships

A recent demographic survey shows that 24% of Peruvian women between the ages of 15 and 49 are living in domestic partnerships (*uniones de hecho*).[331] The Constitution defines and supports domestic partnerships by establishing that a stable relationship between a man and woman, neither of whom is married to another, gives rise to joint ownership of property,

similar to the regime governing matrimony.[332] The Civil Code adds that such a union must have goals and obligations similar to those of marriage and must have existed for at least two consecutive years.[333] Domestic partnerships are terminated by death, continuous absence, mutual agreement, or by a unilateral decision (abandonment).[334] In the case of an alleged domestic partnership that does not meet the legal prerequisites, a claimant is entitled to claim only unjust enrichment against the other party.[335]

Divorce and custody law

The Peruvian Civil Code provides for a preliminary stage prior to divorce, known as physical separation,[336] and for the dissolution of matrimony, or divorce.[337] The following are some of the grounds for separation or divorce: adultery, physical or psychological violence; attempted murder of or serious injury to the other spouse; unjustified abandonment of the matrimonial home for more than two years; dishonorable conduct that makes communal life untenable; the habitual and unjustified use of drugs or addictive substances; serious venereal disease contracted after the marriage; homosexuality arising during the marriage; being sentenced to a prison term exceeding two years for a crime involving deceit or fraud; and consensual separation for more than two years following the marriage ceremony.[338]

In regulating divorce, the Civil Code is concerned with three issues: the division of matrimonial property, alimony and child support, and custody of the children. Once the marriage has been liquidated, the matrimonial property[339] is divided equally between the spouses or their respective heirs.[340] The spouse who is "at fault" in a divorce loses his or her right to any benefits generated by the other spouse's own property.[341] The mutual obligation of spouses to support one another financially ends with divorce. A judge determines the amount of child support to be paid by either or both parents.[342] The parents are obliged to maintain their children for as long as they are minors; adults over 18 years are entitled to maintenance only if they are unable to support themselves because they are studying or if they are single women.[343] This latter provision establishes a difference based on gender that does not exist in the other provisions of the Civil Code.

Custody and parental authority are granted to the spouse who petitioned for the separation on a specific ground, unless the judge, taking into account the welfare of the children, decides that custody of one or more of the children should be granted to the other spouse or to some third party.[344] If both spouses are "at fault" in a separation, custody of any boys over the age of 7 is granted to the father, while that of the girls and any boys under 7 is granted to the mother.[345] The judge may order an alternative custody arrangement.[346]

B. ECONOMIC AND SOCIAL RIGHTS

Property rights

The Constitution establishes equal rights to enter into lawful contracts and to exercise property and inheritance rights, among others.[347] In Peru, there are no legal restrictions on women's property rights. The Civil Code does not permit contractual agreements that seek to circumvent the prohibition against transferring or encumbering property, except insofar as the law so permits.[348]

With respect to inheritance, spouses are obliged not to renounce an inheritance or legacy, or to decline a donation, without the consent of the other spouse.[349]

Labor rights

Peru is a party to various international instruments, adopted by the International Labor Organization, protecting women's work, equality of treatment within the workplace, and protection of maternity.[350] The Constitution establishes respect for equality and nondiscrimination in employment[351] and special protection for working mothers.[352] It also provides protection against discrimination in employment on grounds of pregnancy.[353] The Law for the Promotion of Employment[354] states that a dismissal on grounds of pregnancy within ninety days before or after birth is null and void.[355] If such a dismissal is carried out, it is considered null and the employee must be reinstated.[356]

The Law on Modernizing Social Security,[357] passed in 1997, regulates health care for female employees. Female workers and the spouses or domestic partners of male workers who are affiliated with the social security insurance system are entitled to medical services under the ISSP, including prenatal health care.[358] Housewives and mothers can become affiliated with health care and pension insurance systems if they wish to.[359] Minor children of employees affiliated with the social security system have the right to benefits from the time of their conception.[360] Pregnant employees are entitled to forty-five days' leave before and forty-five days after giving birth.[361] They may also claim a maternity subsidy for ninety days, provided they do not engage in any other paid employment.[362] A breast-feeding benefit used to be paid to breast-feeding workers or to the mother or person responsible for the insured worker's child.[363] In 1997, this benefit was restricted to women workers.[364] Women in certain jobs are entitled to breast-feeding leave so that they can take an hour each day to feed their child with natural milk during the child's first year. This leave is only available now to women teachers in the public and private sectors[365] and women working in public administration.[366]

Workers can choose whether to belong to the National Pension Scheme[367] or to the Private Pension Scheme.[368]

Currently, the retirement age under both schemes is 65 years.[369] Life insurance is the employer's responsibility and is compulsory once an employee has been working for said employer for four years. The employee's spouse or domestic partner is the beneficiary of this insurance.[370]

Access to credit

There are no legal provisions limiting or restricting women's access to credit. In practice, however, married women seeking to obtain credit must do so jointly with their husbands, even if they are not seeking to encumber or pledge joint property.[371] This is based on a presumption on the part of creditors that a woman requesting credit may be pledging matrimonial property or may use joint funds in order to pay the debt.[372]

Access to education

The Constitution establishes the state's duty to ensure that no one is prevented from receiving an adequate education for financial reasons or because of physical or mental limitations. Public education is provided free of charge.[373] In public universities, the state guarantees the right to a free education to those students who perform satisfactorily and do not have the necessary economic means to meet the costs of their education.[374] Notwithstanding these facts, illiteracy is still a serious problem among women. In Peru, the majority of illiterate people are women, principally from rural areas.[375] In 1993, of the total number of illiterate people (1,784,282), 72.70% were women.[376] Of this percentage, two-thirds lived in rural areas.[377]

Women's bureaus

Currently, the nation's governmental body responsible for formulating policies on gender and on promoting women is the Ministry for the Advancement of Women and Human Development ("MPWHD"), which was created in October 1996[378] with the mission of promoting the development of women and their families, overseeing activities that encourage the human development of the population and prioritizing services for minors at risk.[379]

Among the functions of the MPWHD are to ensure compliance with programs and platforms for action relating to human development, adhered to by Peru at world conferences, and to propose ratification of new international instruments.[380] From the outset, the Ministry has assumed control of a group of institutions and programs related to human development and population.[381] Among the organizations that have been transferred to the jurisdictional control of the MPWHD is the National Population Council.[382]

There are two other important bodies that are concerned with the promotion and defense of women's rights, which are under other state powers, namely, the Congressional Commission for Women[383] and the Specialized Defender for Women's Rights.[384] The latter, recently created, constitutes an auxiliary office of the Ombudsman.[385] It is aimed at protecting, promoting and defending women's rights[386] and has the power to introduce legislation and to promote the signing of human rights treaties.[387] There are other offices and units at a lower level within the ministries that are specifically or collaterally dedicated to women.[388]

C. RIGHT TO PHYSICAL INTEGRITY

The Constitution states that no person should be the victim of moral, psychological, or physical violence.[389] In Peru, 48.6% of crimes against personal freedom are cases of rape.[390] Reported cases of domestic violence increased by 50.53% in 1996 as compared with the previous year.[391]

Rape

Articles 170 and 178 of the Penal Code provide that rape is a criminal offense.[392] The Penal Code does not technically define the concept of rape and only classifies it as "a sexual or similar act," performed violently or in a manner that is seriously threatening to the victim.[393] In all rape cases, if the offense causes the victim's death and the aggressor could have foreseen such outcome, or if he proceeded with cruelty, the punishment is for between twenty and twenty-five years' imprisonment.[394] If the rape caused serious injury to the victim, the penalty is between ten and twenty years.[395] Aggravating circumstances are armed rape by two or more persons (which carries a prison sentence of between eight and fifteen years);[396] rape of a person suffering from a psychological abnormality or serious alteration of consciousness, or of a person who is mentally handicapped or unable to resist (imprisonment of between five and ten years);[397] taking advantage of a situation of dependency, authority, or supervision, where the victim is in a hospital, asylum, or other similar establishment; or if she is detained, imprisoned, or interned (imprisonment of between five and eight years and disqualification for two to four years).[398] A person convicted of rape must financially support any resulting child.[399] A person who is condemned for any of these crimes is referred for psychiatric treatment to facilitate his rehabilitation.[400] Submission to such treatment is mandatory.[401]

Until April 1997, the aggressor and any accomplices were exempt from punishment if one of them married the rape victim.[402] An amendment repealed this provision of the rape law, but the exemption for an offender convicted of seduction of an adolescent remains in force.[403] As a consequence, a person who, without violence, uses deception to engage in a sexual act with an adolescent between 14 and 18 years of age is exempt from prosecution if he marries the victim, with her consent.[404]

The Penal Code penalizes acts of indecency committed

using violence or with threat of serious harm and without intent to commit a sexual act, with up to three years' imprisonment.[405] Peruvian criminal law does not classify rape within marriage as a specific crime.

Sexual harassment

Sexual harassment is treated by labor legislation as an act of hostility by the employer comparable to dismissal without cause. A labor law also proscribes acts against morality and all dishonorable acts that affect the dignity of the worker.[406] The worker who is deemed to have been harassed for this reason may choose exclusively between either taking action to end the harassment or terminating her employment contract. In the latter case she is entitled to demand compensation for arbitrary dismissal as established by law, independently of the fine that is imposed on the employer.[407] The time limit for taking legal action for sexual harassment in the workplace is thirty days following the incident.[408] Legislation that seeks to prevent and punish sexual harassment in the workplace is under consideration by Congress.[409]

Domestic violence

In 1993, the Law Against Domestic Violence was enacted, setting out the policy of the state with regard to this form of violence.[410] The MPWHD is governmental body responsible for coordinating policy action on this issue.[411] The law defines domestic violence as "any action or omission which causes physical or psychological damage or abuse that does not cause physical injury, including serious threats and coercion" involving spouses, cohabitants, ascendants, descendants, other relatives, or those living in the same household.[412] The following stand out among the law's policy objectives: to strengthen the teaching of ethical values and respect for personal dignity; to establish effective legal procedures for victims of domestic violence; to reinforce existing law enforcement personnel with specialized staff; to promote the establishment of temporary shelters for victims of violence and to create institutions for the treatment of aggressors; and to train public and judicial functionaries.[413] The law specifies that the National Police may receive complaints of domestic violence and conduct preliminary investigations.[414] The provincial family prosecutor also receives direct complaints, verbally or in writing, from victims or their family members or from any person where the protection of a minor is involved; he or she acts ex officio once the complaint has been made. [415] The police report is remitted to the justice of the peace or to the provincial criminal prosecutor and to the family prosecutor,[416] who can issue the following immediate protective orders: removal of the aggressor from the family home, an injunction prohibiting harassment of the victim, the temporary suspension of visits, an inventory of the victim's personal property, and other measures that guarantee the physical, psychological, and moral integrity of the victim.[417] The procedures applicable to cases of domestic violence are not subject to appeal and are governed by the Law Against Domestic Violence and by the Children and Adolescents' Code.[418]

III. Analyzing the Rights of a Special Group: Adolescents

The needs of adolescents are frequently unrecognized or neglected. Given that in Peru, adolescents represent 22.5% of the population[419] and that minors under 15 years old constitute 38% of the population,[420] it is particularly important to meet the reproductive health requirements of this group. The effort to address issues of adolescent rights, including those related to reproductive health, are important for women's right to self-determination and for their health in general. In Peru, an adolescent is defined as a person between the ages of 12 and 18 years.[421]

A. REPRODUCTIVE HEALTH AND ADOLESCENTS

In Peru, 9% of women between the ages of 15 and 19 are mothers and 2% are pregnant for the first time. One in five teenagers has had between two and four pregnancies before reaching the age of 20.[422] In the Ministry of Health's hospitals, 20% of births are to teenage mothers.[423] In urban areas, teenage pregnancies are generally unwanted and occur between couples who do not live together.[424] Many teenage pregnancies end in illegal abortions, which are responsible for 15% of total maternal deaths.[425]

The Ministry of Health considers the risk of adolescent reproduction to be one of the primary public health problems[426] and proposes to develop strategies to reduce the following indexes: the frequency of teenage pregnancies; maternal mortality; the frequency and consequences of abortions; the frequency of STIs, including HIV/AIDS; and the increase in all forms of physical and sexual violence.[427] Legally, access by adolescents to reproductive health services and to contraceptive methods is not restricted. Twenty-nine percent of adolescents between 15 and 19 years old who are in a relationship use some method of contraception, but only 11% use modern methods. The traditional method of periodic abstinence (the rhythm or calendar method) is more commonly used by adolescents.[428] The Program on Reproductive Health and Family Planning 1996-2000 has as a goal that modern, safe, and effective contraceptive prevalence reach 60% of adolescent girls in a relationship.[429]

The Program for Comprehensive Health of Schoolchildren and Adolescents,[430] under the charge of the Ministry of Health, is aimed at the promotion of comprehensive health,

particularly the sexual and reproductive health of this sector of the population.[431] The comprehensive reproductive health care services for adolescents, provided pursuant to this program, are staffed by multidisciplinary teams in the facilities of the Ministry of Health and reach 40% of the population.[432] In 1992, the Technical Administrative Norms for Comprehensive Services for the Population Aged Between 5 and 19 Years were approved.[433] These norms set out guidelines for the development of promotional and preventive activities related to the health of children and adolescents. The preventive activities are aimed at controlling risk factors to avoid illnesses and to detect and treat any damage early on, as well as to identify groups at risk within the community.[434]

The Children and Adolescents' Code[435] provides that it is the state's responsibility to guarantee and society's responsibility to aid in the creation of adequate conditions for attending to teenage mothers during pregnancy, birth, and the postnatal period, by granting them special attention and facilitating breast-feeding and the introduction of day-care centers.[436] The state ensures that basic education for adolescents includes sexual guidance and family planning.[437]

B. MARRIAGE AND ADOLESCENTS

The average age of women who marry or enter into a relationship for the first time varies according to the area in which they live:[438] 21.9 years in urban areas and 19.1 years in rural areas.[439] The educational level of women is an important factor in determining when they begin the first relationship. Among uneducated women, the aforesaid average is 18.8 years, whereas it is 21.4 years for women with a secondary education.[440] Another differential factor is the region in which women live. The average age is lower in interior, jungle areas (19 years) and greater on the coast (20.8 years), not including the metropolitan area of Lima, where the average is 23.8 years. In mountain regions, the average is slightly lower than in coastal areas (20.1 years).[441]

In Peru, the right to fully exercise civil rights is attained at the age of 18.[442] Thus, this is the minimum age required for marriage without parental consent. Minors can marry if they have the express consent of their parents.[443] If one parent consents but the other refuses, that amounts to consent.[444] In the case of an absent or incapacitated parent, or a parent who has lost parental authority, the consent of the other parent will suffice. If there are no parents, grandparents may consent, and, failing these, a family judge.[445] A refusal by the parents or relatives to give their consent does not require a reason, and there is no appeal.[446]

A minor who marries without parental consent does not have rights of possession, administration, usufruct, or the right to encumber or dispose of his or her property until attaining legal majority.[447] In the exercise of civil rights, minors under the age of 16 are considered "absolutely" incompetent, while those between the ages of 16 and 18 are "relatively" incompetent. Those who are absolutely incompetent cannot marry, as a general rule. However, the judge may dispense with this impediment for serious reasons, provided, in the case of a boy, he has reached the age of 16 and, in the case of a girl, she has reached the age of 14.[448] The relatively incompetent, whether girls or boys, cease to be so if they marry or if they obtain a professional degree authorizing them to practice a profession or occupation. In the case of girls over the age of 14, incompetence also ceases upon marriage.[449]

C. SEXUAL OFFENSES AGAINST ADOLESCENTS AND MINORS

Legislation protecting minors against sexual violence is found in the Penal Code and in the Convention on the Rights of the Child, ratified by Peru in 1990.[450] The Penal Code establishes a sliding scale of punishment according to the age of the victim. If the child is under the age of 7, the penalty is for twenty to twenty-eight years in prison.[451] If the aggressor also had a position of responsibility or some family link that gave him or her particular authority or influence over the victim, this is considered an aggravating circumstance and the penalty is increased to twenty-five to thirty years.[452] When the child victim of sexual violence is aged 7 to 10 years, the established custodial sentence is for fifteen to twenty years. If there is the same aggravating circumstance involving a child aged 7 to 10 as that described for rape of a child under 7, the punishment is increased to between twenty and twenty-five years.[453] If the age of the minor ranges between 10 and 14 years, the sentence is ten to fifteen years of imprisonment. If the same aggravating circumstance occurs, the sentence is increased to fifteen to twenty years.[454] In the event of the minor's death in any of the situations described above, or if the aggressor acted with deliberate cruelty, the sentence is for life imprisonment. If, as a consequence of the aggression, the victim suffers serious injuries, the punishment is twenty-five to thirty years imprisonment.[455]

Rape of an adolescent between the ages of 10 and 14 years is punishable by ten to fifteen years' imprisonment.[456] The penalty is increased to between fifteen and twenty years' imprisonment if the rapist exploited his or her position of responsibility or his or her family or other link that gave him or her particular authority over the victim or led the victim to trust him or her.[457] If, as a result of the rape, the victim suffers serious injuries, the prison term is twenty-five to thirty years.[458] If the rape causes the adolescent's death, or if the aggressor could have foreseen such a result or proceeded with cruelty, the offense carries a life sentence.[459]

Seduction of persons between the ages of 14 and 18 years is a criminal offense when the sexual act occurs as a result of deceit.[460] It is punished with a prison term not exceeding three years or with community service for between thirty and seventy-eight days.[461] If, in such a case, the offense caused the death or serious injury to the victim or if the aggressor acted with cruelty, it is punishable with twenty to twenty-five years' imprisonment.[462] If the offense causes serious injury to the victim, the penalty is for ten to twenty years. If the rape produces a child, the aggressor is required to maintain such child.[463] In seduction cases, the aggressor is exempt from prosecution if he marries the victim.[464]

The Penal Code also provides for the protection of minors from acts "against decency."[465] Although it fails to define such acts, it does differentiate them from rape. As such, it penalizes a person who "without intending to perform a sexual or similar act commits an indecent act on a person under the age of 14 years,"[466] by a prison term of four to six years. If the offender had a position of responsibility or family link that gave him or her particular authority over the victim or led the victim to place trust in him or her, the punishment is for five to eight years in prison.[467]

D. SEXUAL EDUCATION

In 1996, 89% of school age children between 6 and 15 years old attended schools or learning centers.[468] However, only 52% of adolescents between the ages of 16 and 20 attended an educational institution and only 22.7% of young people between the ages of 21 and 24 attended educational institutions.[469]

The Constitution provides that the purpose of education is the comprehensive development of human beings and that parents have the duty to educate their children and are entitled to choose educational facilities and to participate in the educational process.[470] The state coordinates policies on education and formulates general guidelines for curricula.[471] In accordance with the Population Law, the Ministry of Education must design programs and supporting materials on sexuality, family life, the environment, and demographic dynamics for students and teachers.[472] In particular, it must facilitate education about population issues and the development of educational programs aimed at parents about the family and sexuality, so they can assist in the education of their children.[473] The Ministry of Education is required to supervise state publications and audiovisual programs that contain references to sex and family education in coordination with the various sectors and disciplines.[474]

At the beginning of 1996, the government announced that it would gradually include family planning and sex education materials in the secondary school curriculum.[475] It also announced that it would train 15,000 teachers in such matters and would print 1 million books that would include such themes and methodological guides for teachers.[476] To this end, the Ministry of Education has prepared and presented the *Guides for Family and Sex Education for Teachers and Parents*, as part of the National Program for Sex Education, which is in effect for the period from 1995 to 2001.[477] The general plan for training teachers proposes to educate children and young people in the following themes: basic aspects of family life and sexual development, moral values, self-esteem, gender roles, and equality. In secondary education, special emphasis is placed on sexual responsibility, the need to delay the commencement of sexual relations, and the prevention of STIs, AIDS, and unplanned pregnancies.[478]

Within the framework of the Program for Pupils and Adolescents' Health, *Comprehensive Health Promotion: Instruction for Parents* was recently published with the aim of achieving parents' participation in those educational responsibilities that they share with the state.[479]

ENDNOTES

1. WORLD ALMANAC BOOKS, THE WORLD ALMANAC AND BOOK OF FACTS 1997, at 808 (1996). [hereinafter THE WORLD ALMANAC]
2. Political Constitution of Perú, entry into force Dec. 31, 1993, art. 48. [hereinafter PERU CONST.]
3. *Id.*
4. CENTRO, INSTITUTE FOR SOCIOECONOMIC STUDIES AND PROMOTION FOR DEVELOPMENT, commissioned by ACDI, MUJERES PERUANAS. LA MITAD DE LA POBLACIÓN DEL PERÚ A COMIENZOS DE LOS 90 [PERUVIAN WOMEN. HALF THE POPULATION OF PERÚ IN THE EARLY '90S], at 18 (Amelia Fort (ed.), 1993).
5. THE WORLD ALMANAC, *supra* note 1, at 809.
6. ISABEL CORAL, VIOLENCIA CONTRA LA MUJER [VIOLENCE AGAINST WOMEN] (1996); Carlos Iván Degregori, *Las rondas campesinas y la derrota de Sendero Luminoso [Campesino Patrols and the Defeat of the ShiningPath]*, at 19 (1996) in MANUELA RAMOS MOVEMENT, LAS MUJERES, LA VIOLENCIA POLÍTICA Y LA CONSTRUCCIÓN DE LA DEMOCRACIA [WOMEN, POLITICAL VIOLENCE AND BUILDING DEMOCRACY], at 7 (1997).
7. SEBASTIAN EDWARDS, CRISIS AND REFORM IN LATIN AMERICA, FROM DESPAIR TO HOPE, at 6-7 (1995). See Table 1-3.
8. THE WORLD ALMANAC, *supra* note 1, at 809.
9. *Id.*, art. 189.
10. *Id.*, art. 110.
11. *Id.*, arts. 111 and 112.
12. *Id.*, art. 118, cls. 1-24.
13. *Id.*, art. 104.
14. *Id.*, art. 118, ¶ 8.
15. *Id.*, ¶ 19.
16. *Id.*, arts. 122 and 119.
17. *Id.*, art. 120.
18. *Id.*, art. 131.
19. *Id.*, art. 132.
20. *Id.*, art. 134.
21. *Id.*
22. *Id.*, art. 90.
23. *Id.*
24. *Id.*, art. 93.
25. *Id.*, art. 102.
26. *Id.*, ¶ 1.
27. *Id.*, art. 104.
28. *Id.*, art. 107.
29. *Id.* The right to propose or initiate legislation consists of "presenting proposals and exercising such power. For example, . . . the power to propose laws, as a general rule, comes from the legislative chambers or the executive branch and from judicial cases decided by the Supreme Court." PEDRO FLORES POLO, DICTIONARY OF LEGAL TERMS (1987).
30. *Id.*, art. 108.
31. *Id.*
32. *Id.*
33. PERU CONST., *supra* note 2, art. 138.
34. *Id.*, art. 143 and Organic Law on Judicial Power (OLJP), second §, Tit. 1, Ch. 1, arts. 25-27.
35. PERU CONST., *supra* note 2, art. 144 and OLJP, arts. 28-35.
36. PERU CONST., *supra* note 2, art. 140.
37. OLJP, art. 36.
38. *Id.*, arts. 39-43.
39. *Id.*, art. 46.
40. *Id.*, second §, Tit. I, Chs. VI and VII.
41. The National Council of the Judiciary is an independent organ of the judicial branch and is governed by its own organic law. It is made up of one member elected by each of the following institutions: the Supreme Court, the Senior Prosecutors' Committee, the Bar Association, other professional associations and deans of national and private universities. PERU CONST., *supra* note 2, arts. 150-155.
42. *Id.*, art. 154, ¶2.
43. *Id.*, arts. 150 and 152. The process of popular election of justices of the peace is governed by the Organic Law on Judicial Power.
44. *Id.*, art. 149.
45. *Id.*
46. *Id.*, art. 159.
47. *Id.*
48. *Id.*, art. 162.
49. *Id.*, arts. 201 and 203.
50. *Id.*, art. 188.
51. *Id.*, art. 189.
52. *Id.*, art. 191.
53. *Id.*, art. 199.
54. *Id.*, art. 190.
55. *Id.*, art. 198.
56. *Id.*, arts. 189, 191, 197, and 198.
57. *Id.*, art. 197.
58. *Id.*
59. *Id.*, art. 191.
60. *Id.*, art. 138.
61. MARCIAL RUBIO CORREA, EL SISTEMA JURÍDICA. INTRODUCCIÓN AL DERECHO [THE JUDICIAL SYSTEM. INTRODUCTION TO THE LAW], at 135 (1984).
62. There is a difference between a *law* and a *norm with the force of a law*. In addition to laws approved by Congress, "there are also other legislative norms which enjoy equal status: decree-laws, legislative decrees and certain decrees approved by the executive branch in the past…."*Id.*, at 140.
63. In the Roman civil judicial system, the term jurisprudence refers to the "… collection of decisions issued by courts relating to certain matters and their reiteration which confers the status of an interpretative source of law, constituting a legal precedent of a binding nature …." DICTIONARY OF LEGAL TERMS, *supra* note 29, at 24.
64. For example, in the case of an appeal seeking reversal, regulated by art. 400 of the Civil Procedures Code.
65. The general principles of law, "are an additional source [of law] par excellence, to which the judge should turn when there are gaps or deficiencies in the law … the concept is equivalent to 'judicial criteria' … there are some scholars who argue that there should be a distinction between national principles of law … and those of a universal nature, giving preference to the former and arriving at the latter only when the former are insufficient to enable the judge to reach a solution." DICTIONARY OF LEGAL TERMS, *supra* note 29, at 432.
66. General Law on Health No. 26842, promulgated Jul. 15, 1997 and published on Jul. 20, 1997, Preliminary Tit., art. XI.
67. PERU CONST., *supra* note 2, art. 138.
68. *Id.*
69. *Id.*, art. 103.
70. *Id.*
71. *Id.*, art. 109.
72. *Id.*, arts. 51 and 55.
73. *Id.*, art. 118, ¶ 11.
74. *Id.*, art. 56. Where the treaty does not require ratification, the president still must inform Congress of the executive act of adherence to the treaty.
75. *Id.*, ¶ 2.
76. *Id.*, ¶ 3.
77. *Id.*
78. Perú is a party to, among others, the following universal instruments: The International Covenant on Economic, Social and Cultural Rights, *adopted* Dec. 16, 1966, 993 U.N.T.S. 3 (*entry into force* Sept. 3, 1976) (signed by Peru on Aug. 11, 1977 and ratified on Apr. 28, 1978); The International Covenant on Civil and Political Rights, *adopted* Dec. 16, 1966, 999 U.N.T.S. 171 (*entry into force* Mar. 23, 1976) (signed by Peru on Aug. 11, 1977 and ratified on Apr. 28, 1978); The International Convention for the Elimination of all Forms of Racial Discrimination, *opened for signature* Mar. 7, 1966, 660 U.N.T.S. 195 (*entry into force* Jan. 4, 1969) (signed by Peru on Jul. 24, 1966 and ratified on Sep. 29, 1971); The Convention against Torture and other Cruel Inhuman or Degrading Treatment or Punishment, *concluded* Dec. 10, 1984 S. Treaty Doc. 100-20, 23 I.L.M. 1027(1984), *as modified* 24 I.L.M. 535 (*entry into force* June 26, 1987) (signed by Peru on May 29, 1985 and ratified on July 7, 1988); and the Convention on the Rights of the Child, *opened for signature* Nov. 20, 1989, 28 I.L.M. 1448 (*entry into force* Sept. 2, 1990) (signed by Peru on Jan. 26, 1990 and ratified on Sept. 4, 1990).
79. The Convention on the Elimination of all Forms of Discrimination against Women, *opened for signature* Mar. 1, 1980, 1249 U.N.T.S. 13 (*entry into force* Sep. 3, 1981) (signed by Peru on Jul. 23, 1981 and ratified on Sep. 13, 1982).
80. The Inter-American Convention on the Prevention, Punishment and Eradication of Violence Against Women (the Convention of Belem do Pará), *adopted* Jun. 9, 1994, 33 I.L.M 1534 (*entry into force* Mar. 5, 1995) (signed by Peru on Jul. 12, 1994 and ratified on Apr. 10, 1996).
81. This designation was approved by Ministerial Resolution No. 0738-92-SA/DM on Dec. 2, 1992. Although this program was devised to support the former National Program for Attention to the Reproductive Health of the Family 1992-1996, it remains in force. It replaced the Manual of Family Planning Rules and Procedures (R.M. No. 172-89-SA-DM).

See introductory paragraph [hereinafter referred to as the "Reproductive Health Manual".
82. PERU CONST., *supra* note 2, art. 7. The General Law on Health provides that "the conceived" also have rights in the field of health. General Law on Health, art. III.
83. PERU CONST., *supra* note 2, arts. 51 and 55.
84. General Law on Health, Preliminary Tit., art. II.
85. *Id.*, art. VII.
86. *Id.*, Fifth Tit.: On Health Authorities, arts. 122 and 123, in accordance with the PERU CONST., *supra* note 2, art. 9.
87. *Id.*, art. 126.
88. *Id.*, art. 127.
89. MINISTRY OF HEALTH, LINEAMIENTOS DE POLÍTICA DE SALUD 1995-2000. UN SECTOR SALUD CON EQUALIDAD, EFICIENCIA Y CALIDAD [GUIDELINES ON HEALTH POLICY 1995-2000. A FAIR, EFFICIENT AND HIGH-QUALITY HEALTH SERVICE], at 27. [Hereinafter GUIDELINES ON HEALTH POLICY]
90. Formerly known as the Program for Consolidation, it was initiated in 1994 with funding of U.S.$88 million. *Id.*, at 16.
91. *Id.*
92. Conducted under an agreement with the Inter-American Development Bank (IDB), with financing of U.S.$98 million. *Id.*, at 17.
93. Financed by the United States Agency for International Development (USAID), with a budget of U.S.$60 million.
94. MINISTRY OF HEALTH, GENERAL PLANNING OFFICE, PROGRAMA MUJER, SALUD Y DESARROLLO [PROGRAM FOR WOMEN, HEALTH AND DEVELOPMENT]. Document concerning the reformulation of policies, objectives, strategies and courses of action, approved by Ministerial Resolution No. 391-95-SA/DM, on May 26, 1995, at 5 (2d ed., 1996).
95. *Id.*
96. *Id.*, at 12–13.
97. *Id.*
98. *Id.*
99. Dr. Marino Costa Bauer, Minister for Health, Presentation to Congress' Special Commission for Women, at 41 and 42 (Oct. 15, 1996).
100. *Id.*
101. *Id.*
102. *Id.*
103. General Law on Health, Preliminary Tit., art. VI.
104. *Id.*, art. 37.
105. Law on National Population Policy (Legislative Decree No. 346), July 6, 1985, art. 24 [hereinafter Population Law].
106. Statistics taken from the health sector's 1992 Census on Sanitary Infrastructure, in GUIDELINES ON HEALTH POLICIES, supra note 89, at 22.
107. General Regulation of Health Sector Hospitals, D.S. No. 005-90-SA, May 25, 1990, introductory section.
108. *Id.*, art. 8.
109. General Law on Health, art. 39.
110. MINISTRY OF HEALTH, OFFICE FOR STATISTICS AND INFORMATION, CENSO DE INFRAESTRUCTURA SANITARIA Y RECURSOS HUMANOS 1992 [CENSUS OF HEALTH CARE INFRASTRUCTURE AND HUMAN RESOURCES 1992], at 19 (1993). *See also* MINISTRY OF HEALTH, GENERAL DIRECTORATE OF THE PEOPLE, DIRECTORATE OF SOCIAL PROGRAMS, PROGRAMA DE SALUD REPRODUCTIVA Y PLANIFICACIÓN FAMILIAR 1996-2000 [PROGRAM FOR REPRODUCTIVE HEALTH AND FAMILY PLANNING 1996-2000], approved by Ministerial Resolution No. 071-96-SA/DM, Feb. 6, 1996.
111. *Id.*
112. *Id.*
113. GUIDELINES ON HEALTH POLICY, *supra* note 89, at 21.
114. *Id.*, at 24.
115. *Id.*
116. General Law on Health, Preliminary Tit., art. VIII.
117. Supreme Decree No. 019-81-SA, Aug. 6, 1981, ¶ XX.
118. *Id.*, art. 1, ¶ a.
119. *Id.*, ¶ b.
120. *Id.*, ¶ d. The gratuity of these services was ratified in 1985 by the Population Law, *supra* note 105, art. 34.
121. This categorization of hospitals is regulated by the Ministry of Health in the General Regulations for Health Sector Hospitals, art. 8.
122. *Id.*
123. Supreme Decree No. 019-81-SA, art. 1, ¶ c.
124. Population Law, *supra* note 105, art. 34.
125. GUIDELINES OF HEALTH POLICY, *supra* note 89, at 18.
126. *Id.*, at 19.
127. *Id.*
128. *Id.*
129. *Id.*, at 18.
130. The General Law on Health, in its Fourth Complementary Set of Provisions, expressly repeals the following norms: Decree Law No. 17505 (Sanitary Code), Decree Law No. 19609 on emergency services, Law No. 2348 of 1916, Law on medical and pharmaceutical practice of 1888, Decree No. 25596 and the Third Complementary Set of Provisions of Decree Law No. 25988. It also tacitly repeals all norms which conflict with it. Given that the General Law on Health does not conflict with or replace the content of D.S. 019-81-SA, the latter continues in force.
131. General Law on Health, art. 40.
132. Ministerial Resolution No. 572-95-SA/DM, art. 2.
133. Law on Modernization of Health Social Security (Law No. 26790), passed on May 14, 1997 and published on May 1, 1997, arts. 2, 3 and 8.
134. General Law on Health, Tit. II, Ch. I.
135. *Id.*, art. 22.
136. *Id.*, art. 23.
137. The following are professional acts: the issuing of prescriptions, certificates, and reports regarding a patient's care; surgical intervention; and the trials of drugs, medications, controlled substances, or other products to aid diagnosis and the prevention or treatment of illnesses. *Id.*, art. 24.
138. *Id.*, art. 25.
139. *Id.*, cl. e.
140. *Id.*, art. 30.
141. *Id.*, art. 26.
142. *Id.*, art. 28.
143. *Id.*, art. 36.
144. *Id.*, art. 134.
145. Penal Code, promulgated by Legislative Decree No. 635, Apr. 3, 1991, arts. 111 and 124. [hereinafter PENAL CODE]
146. *Id.*, art. 117.
147. *Id.*, art. 144. "A doctor or obstetrician who cooperates with a woman who pretends to be pregnant or to have given birth in order to create rights for a supposed child is liable to be sentenced to a term of imprisonment for between one and five years and to be disqualified from medical practice."
148. *Id.*, art. 165.
149. *Id.*, arts. 291 and 294.
150. *Id.*, arts. 296 and 297 (as modified by Law No. 26233) and art. 300.
151. *Id.*, art. 431.
152. Directive Resolution No. 00061-SA-DG/INPROMI, issued on Oct. 26, 1976, approved a manual of standards for training traditional birth attendants.
153. PERU CONST., *supra* note 2, art. 65.
154. General Law on Health, art. 15, cls. a and d.
155. *Id.*, art. 2.
156. *Id.*, art. 5.
157. *Id.*, art. 3.
158. *Id.*
159. *Id.*, art. 15, cl. e.
160. *Id.*, cl. h and art. 4.
161. *Id.*, art. 48.
162. *Id.*
163. PENAL CODE, *supra* note 145, art. 124.
164. *Id.*
165. *Id.*, art. 111.
166. General Law on Health, art. 134.
167. *Id.*, art. 135. The legal regulations must categorize offenses, the scale of penalties and procedures. art. 137.
168. PERU CONST., *supra* note 2, art. 6.
169. *Id.*
170. Law approved by Legislative Decree No. 346, July 6, 1985.
171. Widely cited in the section Laws and Policies on Reproductive Health and Family Planning below.
172. Prior to the modifying law (Law No. 26530, Sep. 9, 1995) Art. IV of the Population Law expressly prohibited sterilization and abortion as contraceptive methods. Currently, only abortion is excluded as such.

173. Population Law, *supra* note 105, art. 1.
174. *Id.*, art. IV.
175. *Id.*, arts. 2 and 10.
176. *Id.*, art. V of the Preliminary Tit.
177. *Id.*, chapter VI.
178. *Id.*, arts. 22 and 34.
179. *Id.*, art. 28.
180. *Id.*, art. 32.
181. *Id.*, art. 45.
182. *Id.*, arts. 18 and 19.
183. In 1996, the NPC was transferred to the jurisdiction of the Ministry for Promotion of Women and Human Development (MPWHD). Legislative Decree No. 866, first complementary provision, cl. b.
184. Population Law, *supra* note 105, arts. 47 and 48.
185. NATIONAL INSTITUTE FOR STATISTICS AND INFORMATION (NISI), DEMOGRAPHIC AND FAMILY HEALTH SURVEY (DFHS) 1996, PERÚ, PRINCIPAL REPORT, General Summary, at xxx (1997). The maternal mortality rate in Perú during the period 1982-1996 was 247 deaths for every 100,000 live births.
186. General Law on Health, arts. 5 and 6, in accordance with art. 6 of the Constitution
187. Program on Reproductive Health and Family Planning, supra note 110, at 3.
188. The Program on Reproductive Health and Family Planning is in the process of functionally integrating certain existing activities and programs related to reproductive health, such as the Program for Maternal and Perinatal Health, the Program for the Comprehensive Health of Schoolchildren and Adolescents, and the Program for the Prevention of Cervical Cancer. It already has integrated the activities of the National Program on Family Planning and coordinates with the MSD Program and that for the Control of Sexually Transmissible Infections and AIDS. *Id.*, at 19-23.
189. *Id.*, at 3.
190. *Id.*, at 5.
191. *Id.*
192. *Id.*
193. *Id.*, at 18.
194. *Id.*, at 24 and 25.
195. *Id.*
196. *Id.*
197. *Id.*, at 26.
198. *Id.*
199. DEMOGRAPHIC AND HEALTH SURVEY, *supra* note 185, at 134.
200. *Id.*, at 141.
201. Program on Reproductive Health and Family Planning, *supra* note 110, at 26 and 27.
202. *Id.*, at 28 and 30.
203. *Id.*
204. General Law on Health, art. 127.
205. *Id.*, art. 1.
206. For greater detail on the infrastructure of the public health sector, see the section on Infrastructure of Health Services.
207. Ministerial Resolution No. 572-95-SA/DM, Aug. 17, 1995, art. 2.
208. *Id.*
209. Program on Reproductive Health and Family Planning, *supra* note 110, at 20 and 28.
210. DEMOGRAPHIC AND FAMILY HEALTH SURVEY, *supra* note 185, General Summary.
211. *Id.*, General Summary, at xxix.
212. *Id.*, at 72, tbl. 4.12.
213. Program on Reproductive Health and Family Planning, *supra* note 110, at 19.
214. *Id.*
215. *Id.*
216. DEMOGRAPHIC AND FAMILY HEALTH SURVEY, *supra* note 185, General Summary, at xxix.
217. *Id.*, at 62.
218. *Id.*, at 63.
219. *Id.*, at 64.
220. *Id.*, at 72.
221. National Population Council (NPC), *Población y Pobreza: Política y Dinámica Demográfica. 1996* [*Population and Poverty: Demographic Policy and Dynamics. 1996*] in NPC, THE UNIVERSAL DAY OF THE POPULATION, Jun. 11, 1996 (on file with CRLP).
222. *Id.*, at 63 and 66.
223. Statistics provided by the Ministry of Health, Office for Statistics and Information, Social Programs Office, Family Planning Office, Nov. 26, 1996. (on file with CRLP).
224. *Id.*
225. *Id.*
226. Reproductive Health Manual, *supra* note 81, at 84 and 85.
227. General Law on Health, art. 6.
228. Population Law, *supra* note 105, art. IV.
229. *Id.*
230. Reproductive Health Manual, *supra* note 81, at 119.
231. *Id.*
232. *Id.*
233. Ministerial Resolution No. 0738-92-SA/DM, ¶ 1.
234. General Law on Health, art. 51 and Ministerial Resolution No. 930-90-SA/DM, Sep. 11, 1990, ¶ 2.
235. Ministerial Resolution No. 930-90-SA/DM, Sep. 11, 1990, ¶ 2.
236. *Id.*, art. 65.
237. Regulation of the Organization and Functions of the Ministry of Health, DS. No. 002-92-SA, art. 85.
238. General Law on Health, art. 54.
239. *Id.*, art. 6.
240. *Id.*, art. 69.
241. *Id.*
242. *Id.*
243. Regulation of the Organization and Functions of the Ministry of Health, art. 90, cl. c.
244. DEMOGRAPHIC AND FAMILY HEALTH SURVEY, *supra* note 185, at 72.
245. *Id.*, at 66.
246. Law No. 26530, in force since Sept. 11, 1995, modifies art. VI of the Population Law *supra* note 105, (Legislative Decree No. 346), in force since 1985.
247. General Law on Health, art. 6.
248. *Id.*
249. Reproductive Health Manual, *supra* note 81, at 111.
250. *Id.*
251. *Id.*
252. For more details on the family planning and reproductive health services available in Peru, see the section on Government Delivery of Family Planning Services.
253. General Law on Health, art. 7.
254. *Id.*
255. *Id.*
256. PENAL CODE, *supra* note 145, arts. 114 and 120.
257. *Id.*, art. 119.
258. PERU CONST., *supra* note 2, art. 2, cl. 2. Other laws which reaffirm the rights of the conceived are: the Peruvian Civil Code (art. 1), the Population Law, *supra* note 105 (art. VI of the Preliminary Tit.) and Decree Law No. 26102 (CHILDREN AND ADOLESCENTS' CODE, art. 1 of the Preliminary Tit.).
259. Population Law, *supra* note 105, art. VI of the Preliminary Tit., modified by Law No. 26530.
260. *Id.*, art. 29.
261. Program on Reproductive Health and Family Planning, *supra* note 110, at 17.
262. Population Law, *supra* note 105, art. 29.
263. THE ALAN GUTTMACHER INSTITUTE, CLANDESTINE ABORTIONS: A LATIN AMERICAN REALITY, at 20 (1994).
264. Program on Reproductive Health and Family Planning, *supra* note 110, at 46.
265. *Id.*
266. General Law on Health, art. 43.
267. *Id.*, arts. 25, cl. g, and 30.
268. *Id.*
269. PENAL CODE, *supra* note 145, art. 114.
270. *Id.*, arts. 115 and 116.
271. *Id.*, art. 118.
272. *Id.*, art. 119.
273. *Id.*, art. 119.
274. *Id.*, art. 114.
275. *Id.*, art. 120.
276. *Id.*, art. 115.
277. *Id.*, art. 116.
278. *Id.*, arts. 115 and 116.
279. *Id.*, art. 117.
280. *Id.*, art. 118.
281. Information provided by the Ministry of Health, Office for Statistics and Information and the Program for the Control of Sexually Transmitted Diseases and AIDS

(PROCOSTDA) (on file with the CRLP).

282. *Id.*

283. National Multisectorial Program for the Prevention and Control of the Acquired Immune deficiency Syndrome, approved by Supreme Resolution No. 011-87-SA, Apr. 2, 1987. See introductory paragraph that refers to the situation of AIDS in Perú.

284. Supreme Decree No. 031-88-SA, promulgated on Nov. 21, 1988, Art. 1 and third ¶ of the preamble.

285. Law No. 26454, May 25, 1995, deemed the acquisition, donation, conservation, processing, transfusion, and supply of human blood, its components, and its derivatives to be a matter of public order and interest. Regulations were issued pursuant to this law by Supreme Decree No. 03-95-SA.

286. Regulation of Law No. 26454, approved by Supreme Decree No. 03-95-SA, art. 23.

287. *Id.*, art. 24.

288. *Id.*

289. Approved by Law No. 25526, passed on Jun. 15, 1996 and published on Jun. 20, 1996.

290. *Id.*, art. 4.

291. *Id.*, art. 5.

292. *Id.*

293. *Id.*

294. *Id.*, art. 6.

295. *Id.*

296. *Id.*, art. 7.

297. *Id.*, art. 7, cl. b and Ministerial Resolution No. 491-96-SA/DM.

298. Supreme Decree No. 013-87-SA, art. 1.

299. *Id.*, art. 2.

300. *Id.*, art. 3.

301. *Id.*, art. 5.

302. Created by Supreme Resolution No. 011-87-SA, Apr. 2, 1987.

303. See note 316 and Vice-Ministerial Resolution No. 0160-87-SA.

304. Law No. 26626.

305. *Id.*, art. 2. It provides that the Ministry of Health shall nominate, by Ministerial Resolution, the competent body to formulate the CONTRASIDA Program.

306. Ministerial Resolution No. 235-96-SA/DM, Apr. 11, 1996.

307. *Id.*, art. 1.

308. NPC/UNFPA, WORLD POPULATION DAY, Jul. 11, 1996.

309. UNICEF, ANALYSIS OF THE SITUATION OF WOMEN AND CHILDREN, (1995).

310. *Id.*

311. In 1996 alone, the Peruvian National Police Women's Delegation reported 6,294 complaints of mistreatment of women, which represents an increase of 2,113 cases compared with 1995. MANUELA RAMOS MOVEMENT, LA PAZ EMPIEZA POR CASA [PEACE BEGINS IN THE HOME] (1997) (on file with CRLP).

312. DEMOGRAPHIC AND FAMILY HEALTH SURVEY, *supra* note 185, at 16.

313. PERU CONST., *supra* note 2, art. 2, cl. 2.

314. *Id.*, art. 2, cl. 24, ¶ h.

315. *Id.*, art. 4.

316. *Id.*

317. CIVIL CODE, Approved by Legislative Decree No. 295, passed on Jul. 24, 1984. [Hereinafter CIVIL CODE]

318. *Id.*, art. 42.

319. *Id.*, art. 234, second ¶.

320. *Id.*, art. 24.

321. *Id.*, art. 290.

322. *Id.*, arts. 291 and 300.

323. *Id.*, art. 293.

324. *Id.*, arts. 288 and 289, respectively. Art. 289 also states that the judge may suspend the obligation to cohabit where this cohabitation seriously threatens either spouse's life, health, honor, or the performance of the economic activity on which the family depends.

325. *Id.*, arts. 292 and 315.

326. *Id.*, art. 287.

327. *Id.*, arts. 302 and 305.

328. *Id.*

329. *Id.*, art. 419.

330. PENAL CODE, *supra* note 145, arts. 139 and 140.

331. DEMOGRAPHIC AND FAMILY HEALTH SURVEY, *supra* note 185, at 25.

332. PERU CONST., *supra* note 2, art. 5 and CIVIL CODE, art. 326.

333. CIVIL CODE, *supra* note 317, art. 326.

334. *Id.*

335. *Id.*

336. Physical separation suspends the rights relating to cohabitation and sexual intercourse and terminates joint rights to income and proceeds generated by property while preserving the matrimonial bond. *Id.*, arts. 332 to 347.

337. *Id.*, arts. 348 and 360.

338. *Id.*, arts. 333 and 349.

339. Property considered as pertaining to the marriage is that which remains after liquidating the marriage partnership *Id.*, art. 324.

340. *Id.*

341. *Id.*, art. 352.

342. *Id.*, art. 473.

343. *Id.* and art. 425.

344. *Id.*, art. 340.

345. *Id.*, art. 420.

346. *Id.*

347. PERU CONST., *supra* note 2, art. 2, cl. 2.

348. CIVIL CODE, *supra* note 317, art. 882.

349. *Id.*, art. 304.

350. The International Labor Organization Conventions related to these issues and subscribed to by Peru are: Convention No. 4, Convention concerning Employment of Women during the Night, *adopted* Nov. 28, 1919, <http://ilolex.ilo.ch:1567/public/english/50normes/infleg/iloeng/conve.htm> (visited Feb. 3, 1998) (*entry into force* Jun. 6, 1921); Convention No. 41, Convention concerning Employment of Women during the Night, *adopted* Jun. 19, 1934, <http://ilolex.ilo.ch:1567/public/english/50normes/infleg/ilong/conve.htm>(visited Feb. 3, 1998) (*entry into force* Nov. 22, 1936); Convention No. 45, Convention concerning the Employment of Women on Underground Work in Mines of all Kinds, *adopted* Jun. 21, 1935, <http://ilolex.ilo.ch:1567/public/english/50normes/infleg/ilong/conve.htm>(visited Feb. 3, 1998) (*entry into force* May 30, 1937); Convention No. 100, Convention Concerning Equal Remuneration for Men and Women Workers for Work of Equal Value, *adopted* Jun. 29, 1951 <http://ilolex.ilo.ch:1567/public/english/50normes/infleg/iloeng/conve.htm> (visited Dec. 8, 1997) (*entry into force* May 23, 1953); Convention No. 111, Convention No. 111 of the International Labor Organization, Convention Concerning Discrimination in Respect of Employment and Occupation, *adopted* Jun. 25, 1958 <http://ilolex.ilo.ch:1567/public/english/50normes/infleg/iloeng/conve.htm>(visited Dec. 8, 1997) (*entry into force* Jun. 15, 1960); and Convention No. 156, Convention concerning Equal Opportunities and Equal Treatment for Men and Women Workers: Workers with Family Responsibilities, *adopted* Jun. 23, 1981, 1958 <http://ilolex.ilo.ch:1567/public/english/50normes/infleg/iloeng/conve.htm>(visited Dec. 8, 1997) (*entry into force* Aug. 11, 1983).

351. PERU CONST., *supra* note 2, art. 26.

352. *Id.*, art. 23.

353. *Id.*, art. 21, cl. 1.

354. Integrated Text of the Law for the Promotion of Employment, approved by Supreme Decree No. 05-95-TR of Aug. 18, 1995.

355. *Id.*, art. 62, cl. e.

356. Under Peruvian labor legislation, dismissals classified as "null" give rise to the employee's reinstatement to his or her job. *Id.*, arts. 63 and 67.

357. Law No. 26790, passed on May 1, 1997 and published on May 1, 1997.

358. *Id.*, art. 3.

359. Law No. 24705, arts. 1 and 4 and Law No. 26790, art. 3.

360. Law No. 26790, art. 3.

361. Law No. 26644, art. 1.

362. Law No. 26790, art. 12, cl. b.

363. Law Decree No. 22482, art. 30, modified by Law No. 25143, Dec. 20, 1989, repealed by Law No. 26790.

364. Law No. 26790, art. 12, cl. b, ¶¶ b.1 and b.3.

365. S.D. No. 19-90-ED, art. 65, ¶ a.

366. S.D. No. 005-90-PCM, art. 108.

367. Law No. 19990, which regulates the national pension scheme.

368. Regulated by Law No. 25897.

369. Law No. 26504, Jul. 18, 1995.

370. Legislative Decree No. 688.

371. Information obtained directly from credit institutions (Banco de Crédito, Banco Latino, Banco de Lima, Banco Wiese), and commercial credit companies (Carsa, Yompián, Casa Wensminster and others). DEMUS, Estudio para la defensa de los derechos de la mujer [Law Office for the Defense of Women's Rights], Draft Peru chapter (1997).

372. *Id.*

373. PERU CONST., *supra* note 2, art. 17.

374. *Id.*
375. Marino Costa Bauer, Minister of Health, Presentation before the Congress of the Republic's Special Commission on Women, at 11.
376. *Id.*
377. *Id.*
378. Law on Organization and Functions of the Ministry for the Advancement of Women and Human Development (MPWDH), approved by Legislative Decree No. 866, Oct. 25, 1996.
379. *Id.*, art. 2.
380. *Id.*, art. 4, cl. d.
381. *Id.*, First Complementary Provision.
382. *Id.*, cl. b. The National Population Council was created by the National Population Law *supra* note 105, (Art. 48). The NPC formulates the projects of the national population program and is responsible for following and evaluating their progress. For greater detail, see the section on Laws and Policies on Population.
383. This Commission began functioning during the Congress' First Ordinary Session of 1996; it has the character of a special congressional working commission, and, although it does not pass laws, it has the following aims: (a) to create awareness of gender inequality in leaders influencing public opinion and society's intermediary authorities, the media and the private and public sectors; (b) to promote cultural change and to reduce and eliminate the disadvantageous situation of women; (c) to publicize cases of discrimination and violence against women and to seek their prosecution; and (d) to propose and disseminate necessary legislation. Regulation of the Congress of the Republic, art. 35.
384. Created by Defense Resolution No. 017-96, Oct. 9, 1996.
385. Law No. 26520, Organic Law of the Ombudsman. This is an autonomous and independent governmental entity, dedicated to defending constitutional and fundamental individual and collective rights. The designation of auxiliary ombudsmen enables the Office of the Ombudsman to study, evaluate and adopt measures with respect to certain rights and/or sectors in the country that, due to their particular status, require special attention.
386. Lineamientos de acción de la Defensoría Adjunta de la Mujer [Guidelines for Action of the Auxiliary Ombudsman's Office for Women] (on file with the CRLP).
387. *Id.*, cls. 4 and 5.
388. At the executive level, there exist other bodies that prioritize women's issues within their activities, including the Foreign Ministry's Office for Women and Children's Matters, which exists as an official body supported by the United Nations, the Organization of American States and the Chancery on Inter-American Matters. INFORME NACIONAL DE LA MUJER [NATIONAL REPORT ON WOMEN], at 38. Other entities include the Network of Technical Cooperation and of Associations and Institutions of Support to Rural Women (Ministry of Agriculture); the Programs of the National Fund for Compensation and Social Development - FONCODES (Ministry of the President); and the Intersectoral Commission, responsible for reviewing the regulation of women's employment (Ministry of Labor), among others.
389. PERU CONST., *supra* note 2, art. 2, Clause 24, literal h.
390. CUANTO, S.A. PERÚ EN NÚMEROS 1996. ANUARIO ESTADÍSTICO [PERÚ IN NUMBERS 1996. STATISTICS YEARBOOK], at 405 (1996).
391. *Id.*
392. PENAL CODE, *supra* note 145, Vol. II, Tit. IV, Ch. IX, modified by Law No. 26293, Feb. 14, 1994, and Law No. 26357, Sept. 28, 1994.
393. *Id.*, art. 170.
394. *Id.*, art. 177.
395. *Id.*
396. *Id.*, art. 170, second ¶, modified by Law No. 26293, art. 1.
397. *Id.*, art. 172, modified by Law No. 26293, art. 1.
398. *Id.*, art. 174, modified by Law No. 26293, art. 1.
399. Law No. 26770, Apr. 7, 1997, art. 2.
400. PENAL CODE, *supra* note 145, art. 178-A.
401. *Id.*
402. *Id.*, art. 178, modified by Law No. 26770.
403. Law No. 26770, Apr. 7, 1997, art. 2, complementing art. 175 of the PENAL CODE, *supra* note 145.
404. *Id.*
405. *Id.*, art. 176.
406. Law on Promotion of Employment, art. 6, cl. g.
407. Supreme Decree No. 05-95-TR, art. 68.
408. *Id.*, art. 69.
409. Proposed Legislation No. 2842/96-CR, presented by the Congressional Commission for Women to the Employment Commission, Jul. 10, 1997.

410. Law No. 26260, Dec. 25, 1993.
411. Law on the Organization and Functions of the Ministry for the Promotion of Women and Human Development, Legislative Decree No. 866, Oct. 25, 1996, art. 4. See section on Women's Bureaus.
412. Law No. 26260, art. 2, modified by Law No. 26768, Mar. 11, 1997.
413. *Id.*, art. 3, modified by Law No. 26768, single art.
414. *Id.*, art. 5.
415. *Id.*, art. 7.
416. *Id.*, art. 5.
417. *Id.*, art. 7.
418. *Id.*, art. 9, ¶ b.
419. Program on Reproductive Health and Family Planning, *supra* note 110, at 13.
420. DEMOGRAPHIC AND FAMILY HEALTH SURVEY, *supra* note 185, at 15.
421. CHILDREN AND ADOLESCENTS' CODE, approved by Legislative Decree No. 26102, Dec. 23, 1992, art. I, Preliminary Tit..
422. Program on Reproductive Health and Family Planning, *supra* note 110, at 14.
423. *Id.*
424. *Id.*
425. *Id.*
426. *Id.*, at 24.
427. *Id.*
428. *Id.*, at 14.
429. *Id.*, at 26.
430. Program on Reproductive Health and Family Planning, *supra* note 110, at 23.
431. *Id.*
432. *Id.*
433. Approved by Ministerial Resolution No. 0023-92-SA/DM, Jan. 23, 1992.
434. In matters related to reproductive health, the provisions aim to "prevent unwanted and unplanned pregnancies and abortions, as well as STIs, especially AIDS, through sex education, guidance and counseling and the installation of support services to this end; to prevent cervical cancer, through performing Papanicolaou smears on sexually active teenagers in accordance with the norms of the Program for the Control of Cervical Cancer, and to prevent neonatal tetanus through the application of toxoid tetanus in adolescents." *Id.*, numeral 4,2.
435. Decree Law No. 26102, THE CHILDREN AND ADOLESCENT'S CODE, (n.d.).
436. *Id.*, art. 2.
437. *Id.*, art. 15, cl. f.
438. PERU IN NUMBERS, *supra* note 390, at 233.
439. *Id.*
440. *Id.*
441. *Id.*
442. CIVIL CODE, *supra* note 317, art. 42.
443. *Id.*, art. 244.
444. *Id.*
445. *Id.*, arts. 244, 245, 246, and 247; and the CHILDREN AND ADOLESCENTS' CODE, arts. 126 and 127.
446. *Id.*, art. 245.
447. *Id.*, art. 247.
448. *Id.*, art. 241.
449. *Id.*, art. 46.
450. The Convention on the Rights of the Child, *opened for signature* Nov. 20, 1989, 28 I.L.M. 1448 (*entry into force* Sept. 2, 1990) (approved by Perú by Legislative Resolution No. 25278 on Aug. 4, 1990, arts. 19 and 34). Its dissemination was declared to be of national interest by Law No. 25302, published on Jan. 4, 1991.
451. PENAL CODE, *supra* note 145, art. 173, ¶ 1, modified according to art. 2 of Law No. 26293.
452. *Id.*, final ¶.
453. *Id.*, art. 173, ¶ 2 and final.
454. *Id.*, ¶ 3 and final.
455. *Id.*, art. 173-A.
456. *Id.*, art. 173, text modified according to Law No. 26293, art. 1.
457. *Id.*
458. *Id.*
459. *Id.*, ¶ A.
460. *Id.*, art. 175, text modified according to Law No. 26357, Sept. 23, 1994, art. 1.
461. *Id.*
462. *Id.*, art. 177, modified according to Law No. 26293, art. 1.
463. *Id.*, art. 170, first ¶. Incorporated according to Law No. 26293, art. 2.
464. Law No. 26770, Apr. 7, 1997, art. 2.

465. *Id.*, art. 176-A.
466. *Id.*
467. *Id.*, last ¶.
468. DEMOGRAPHIC AND FAMILY HEALTH SURVEY, *supra* note 185, at 21.
469. *Id.*
470. PERU CONST., *supra* note 2, art. 13.
471. *Id.*, art. 16. Additionally, the Children and Adolescents' Code, art. 15, cl. f, provides that the State must ensure that basic education includes sexuality and family planning.
472. Population Law, *supra* note 105, art. 15, cl. c.
473. *Id.*, ¶ ¶ c and h.
474. *Id.*, ¶ k.
475. *La educación sexual en la escuela* [*Sex Education in Schools*], SHORT CUTS (Trimestral Bulletin of the Center for the Documentation of Women [CENDOC]) Year I, No. 1, at 3 (Sept. 1996).
476. *Id.*
477. *Id.*
478. *Id.* The preparation of these methodological guides originated from a debate between the state and the Catholic Church on the subject of sex education. The Episcopal Commission of Peru has already published a separate guide for parents and teachers, entitled *Formación y Orientación para el Amor y la Sexualidad* [*Training and Orientation for Love and Sexuality*], published in Mar. 1996.
479. Marino Costa Bauer, Minister of Health, Statement to the Congressional Commission on Women, at 44.

Regional Trends in Reproductive Rights

By identifying the trends in reproductive rights and women's empowerment that emerge from a review of nine Latin American and Caribbean nations, this chapter provides an invaluable guide for assessing the effort required to promote reproductive rights and to focus attention on the laws and policies that are necessary to achieve these rights. The analysis of regional trends identifies, where appropriate, laws that can serve as a basis for regional reform efforts. Draft bills and policies still under consideration are also mentioned. Finally, this chapter notes those instances where governments have not enacted regulations and where access to information is restricted.

The regional trends described in this chapter are based exclusively on an analysis of the content of national laws and policies. It does not take into account the procedures, if any, established to implement these laws and policies and the extent to which such laws and policies may be executed. While we regard such information as critical to securing reproductive rights, we also believe in the need to determine the legal and political framework before exploring other equally important factors that affect women's reproductive lives. We hope that the regional trends identified in this chapter serve not as a conclusion but as a preface to multiple and diverse initiatives for the promotion of women's reproductive rights by governments, international agencies, and nongovernmental organizations.

I. Setting the Stage: the Legal and Political Framework

All the Latin American countries covered in this report, with the exception of Brazil, achieved independence from the Spanish monarchy during the first half of the nineteenth century. Brazil gained its independence from the Portuguese crown toward the end of that century. A legacy of the Portuguese colonization of Brazil is the use of Portuguese as the national language. This fact sets Brazil apart from the remainder of the region, which has adopted Spanish as its primary language. Moreover, since slavery was not abolished until 1888, Brazil has the largest population of people of African descent in all of Latin America. Jamaica gained its independence from the British crown in 1962; it remains a member of the British Commonwealth and regards Queen Elizabeth II as its head of state.

Latin America's common cultural heritage, a consequence of Spanish and Portuguese colonization, has resulted in various shared characteristics between these nations. For the purposes of this report, the most relevant of these characteristics is the existence of a shared legal system, derived from ancient Rome, known as *Corpus Juris Civilis*, or the civil law system. In this legal system, the role of the courts is to interpret the written law for each case. Judicial precedent has no value except in rare cases and only when the law itself so determines. Jamaica, on the other hand, as a former English colony, inherited England's ancient legal system — the common law. The common-law system comprises the body of principles and rules of action that derive their authority solely from usage and customs of immemorial antiquity, particularly the ancient unwritten law of England as well as court judgments and decrees. In the common-law system, courts are able to formulate and develop legal doctrines.

In all the countries studied, as well as in the remainder of Latin America and the Caribbean, both these legal systems coexist alongside legal norms and justice systems derived from ancient rules and customs unique to the indigenous populations. Most of the regional constitutions recognize and protect ethnic diversity and the various customs of indigenous people within their territorial jurisdictions. However, not all nations recognize indigenous customary norms as valid legal systems, much less give equal status to these norms alongside the formal legal system. Only Bolivia and Peru recognize indigenous customary norms as a source of law. Bolivia considers the application of customary law and procedures to indigenous or peasant groups by their own authorities as an "alternative mechanism for conflict resolution." Peru recognizes customary law, and authorizes indigenous, native, and peasant authorities to

exercise "special jurisdiction." Nevertheless, in Peru, such jurisdiction is limited to those cases that the civil legal system fails to cover. Like Bolivia and Guatemala, Peru establishes that these customary laws and their enforcement must respect human rights. Colombia grants indigenous peoples the right to administer justice within their territories in accordance with their customary norms, without recognizing such norms as a source of law or their legal system as an alternative to the civil legal system. In Mexico, the Constitution protects the "legal practices" of the native population.

The social and political context of a particular country has a direct effect on its legislation, on the enforcement of laws and on the stability of its policies. Military and civil dictatorships, as well as lengthy periods of civil war, are two primary characteristics affecting the recent history of several Latin American countries. Each new dictatorship, as well as the ensuing return to democracy, and even the initiation of each new democratic government, has resulted in a traumatic readjustment of the political and legal landscape. The result is either a series of incongruent shifts in laws and policies or their fragmented or partial application. Most governments in the region, except for Jamaica and Mexico, are elected for a period ranging from four to five years. Thus, all policies, including those dealing with population, reproductive health, and family planning, are in effect for a similar period of time.

A. THE STRUCTURE OF NATIONAL GOVERNMENTS

The constitutions of each of the countries covered by this report define themselves as republics. Jamaica, a parliamentary monarchy, is the exception to this general trend. As republics, Latin American nations adhere to a political system known as "representative democracy," that is, the government and its authorities represent the people and derive their power from the people. Jamaica is a democratic parliamentary monarchy. The highest authority in that country is the British-appointed representative of the queen. However, members of the democratically elected House of Representatives form the executive branch of government.

In all of the nations covered by this report, the governments have three branches; the executive, the legislative, and the judicial. The administrative regime, however, varies in each country. Argentina, Brazil, and Mexico are federal governments and thus consist of a federation of states that are independent in terms of most executive, legislative and judicial functions. But, in such nations, local states are subject to a national constitution. Although Bolivia, Colombia, El Salvador, Guatemala, Jamaica, and Peru have centralized and unitary governments, each has numerous levels of decentralized administration. Each of the countries profiled in this report has a government bureau dedicated to the promotion of equal rights for women. In six of these countries — Argentina, Bolivia, Brazil, Colombia, El Salvador, and Peru — women's bureaus administer their own budgets and, to varying degrees, are important components of the executive branch of government. In the remaining three countries, women's bureaus have limited decision-making powers, and do not have their own budgets. In terms of women's participation in the political structure, Argentina and Brazil are the only two countries among the nine studied that have affirmative action legislation to promote women's participation in political parties. In Argentina, the Constitution contains an affirmative action provision that requires all political parties and the bodies and procedures that regulate elections to adopt measures that ensure real equality and political participation of women. In Brazil, the *Ley de Cuotas* (Law No. 9100) decrees that at least 20% of all candidates presented by each party or political group for municipal elections must be women. Statistics indicate that these measures have had a significant positive impact on the political participation of women.

Executive Branch

In Latin American nations, the executive branch of government is in charge of the economic and political administration of the country and foreign policy and foreign relations. In all of these countries, except Jamaica, the president is the head of the executive branch. In Jamaica, the queen of England is the head of the executive branch and is represented by her appointed governor general. In practice, however, the prime minister and his or her cabinet run the government. Cabinet ministers are in charge of the elaboration and implementation of public policy for a particular sector, including health and population. In every country, in accordance with its constitution, presidents and cabinet ministers are subject to varying degrees of control by the legislative and judicial branches of government.

Legislative Branch

In Latin American nations, the legislative branch is generally known as the *Congreso Nacional* (National Congress), *Asamblea Legislativa* (Legislative Assembly), or *Parlamento* (Parliament). The most important function of the legislative branch is to enact laws. With the exception of El Salvador, Guatemala, Jamaica, and Peru, the countries studied have a bicameral congress. The Jamaican Parliament is composed of the governor general, who represents the queen; the Senate; and the House of Representatives. El Salvador, Guatemala, and Peru have single-chamber congresses, each composed of more than 100 representatives.

The process by which most Latin American nations enact laws is similar. Once a bill is discussed, revised, and approved by

a majority, Congress forwards the bill to the president for final approval and publication. The publication of a new law is mandatory in all nations. The president has the right to veto and to amend a law, but final decisions regarding a bill rest with the Congress. If a law approved by Congress is vetoed by the president, the percentage of congressional votes required to override the veto increases significantly. For example, El Salvador and Guatemala require a two-thirds vote of Congress to override a presidential veto. It is important to note that in three countries — Brazil, Colombia, and Peru — citizens may propose legislation directly to the Congress so long as they follow the appropriate rules and regulations. In the remaining nations, citizens' proposals are indirect in that they must be presented through those persons or entities prescribed by the Constitution.

Most national legislatures have the ability to enact laws in almost all arenas. However, in the federal republics — Argentina, Brazil, and Mexico — the Constitution reserves only certain areas of legislation to the national legislative bodies and entrusts the remainder to each state's legislative body. For example, in Argentina, the Constitution specifically establishes which laws are within the purview of the national Congress, such as the civil, commercial, penal, mining, labor, and social security codes. In Mexico, certain areas of penal and civil law are regulated at the federal level, while others, such as marriage and sex crimes, are the province of state legislatures.

Judicial Branch

In all of the nations profiled in this report, with the exception of Jamaica, the Supreme Court is the highest tribunal in the judicial system. Jamaica has two high courts, each with jurisdiction over different arenas. Most Latin American nations have a lower court system comprised of *juzgados de paz* (peace courts), which are often presided over by lawyers. But anyone elected by a community to resolve its conflicts can be a justice of the peace. The law stipulates the issues over which justices of the peace have jurisdiction. In Bolivia, Colombia, Mexico, and Peru, peasant, native, and indigenous authorities may also function as courts of law.

B. SOURCES OF LAW

Domestic sources of law

The sources of law vary with the nature of the legal system. In Jamaica's common-law system, judicial decisions constitute one of the most important sources of law. In the civil law tradition of Latin American nations, the primary source of law is legislative norms, while judicial decisions constitute mandatory jurisprudence only when so stated in the written law.

In every country, the constitution is the most important domestic source of law. Formal sources of law constitute a pyramid in which the national or federal constitution — depending on the administrative regime — is at the top. In Argentina, Brazil, and Guatemala, the constitution shares its status as the highest law of the land with international human rights treaties, such as the Convention on the Elimination of All Forms of Discrimination Against Women and other regional human rights instruments, including those that protect women's rights. In Jamaica, the decisions of the courts and laws and regulations issued by the legislature are both subordinate to the Constitution.

Secondary sources of law also exist. In Colombia, the *fuentes auxiliares* (auxiliary sources) of domestic law are the principle of equality, the general principles of law, jurisprudence, and the well-established opinion of legal experts. Custom and usage — which is not the same as customary law of the indigenous peoples — constitute a valid source of law in El Salvador and Guatemala. In Guatemala and Peru, jurisprudence is also a source of law. In Peru, courts apply general principles of law when legislation does not address a specific issue, particularly in matters concerning health. In Mexico, such general principles apply only when there is no relevant legislation, and they then apply only in civil matters.

International sources of law

International treaties constitute the most important international source of law in all of the nine countries studied. All of the nine nations profiled in this report have adopted major international human rights treaties. The national constitutions almost always have superior status to international treaties, except in Argentina, Brazil, and Guatemala, where international human rights treaties are equal in status to the national constitution. Thus, in these three nations, the Convention on the Elimination of All Forms of Discrimination Against Women and the Inter-American Convention to Prevent, Sanction, and Eradicate Violence Against Women (the Convention of Belém do Pará), both ratified by all nine countries in this report, are equivalent to constitutional norms. The importance of the constitutional status of human rights treaties in these countries lies not only in their superiority over domestic law but also in the fact that courts may apply these treaties to protect women's rights, even in the absence of specific national laws. Courts may also apply international human rights norms in situations where national level laws are inconsistent with such norms. Nonetheless, Argentina, Brazil, and Guatemala continue to maintain domestic legislation that discriminates against women or hinders their reproductive rights.

There are two general regional trends regarding the relationship between international treaties and domestic law. First, there are those nations that accord treaties — other than human rights treaties in the case of Argentina — a status lower than the

constitution, but higher than that of domestic law. This is true of Argentina and Colombia. In the latter situation, however, only non-human rights treaties are accorded this status.

A second set of nations regard international treaties as being equivalent in status to domestic laws. This is the case in Bolivia, Brazil, El Salvador, Guatemala, and Peru. Mexico is an exception to these trends. While it does not explicitly bestow constitutional status on treaties, it regards treaties as "ley suprema" de la nación ("supreme law" of the nation) and places them alongside the Constitution. Some countries make the supremacy of the constitution over international treaties more explicit than others do. In El Salvador, for example, the government is barred from signing treaties that effect or limit the norms of the Constitution. The judicial system also has the power to declare these treaties null and void.

With the exception of Jamaica, the process by which nations adopt treaties is similar. The president generally signs the treaty, but the legislative branch must then approve it. This approval can occur either before or after the president signs it, depending on the subject of the treaty. Once the president and the legislature have approved the treaty, it becomes part of domestic law. In Jamaica, the signing or ratification of treaties is not subject to parliamentary debate and is a matter within the sole jurisdiction of the executive branch. Exceptions to this rule exist in special circumstances, such as when a treaty involves a limitation on the rights of citizens, increases the powers of the executive branch, or imposes an economic obligation upon the government.

II. Examining Health and Reproductive Rights

The nine Latin American and Caribbean nations that are the focus of this report have responded to reproductive health problems in varying degrees and with diverse strategies. As a result, there exists a significant array of relevant laws, policies, and programs. The intention of governments to promote reproductive health must be measured not only by the existence or absence of general laws and policies but also by the enforcement of specific programs and strategies. Most countries have constitutions that guarantee the right to health and a national health authority — a ministry or a secretariat — that is entrusted with the formulation and development of policies. However, very few mechanisms in the legal system guarantee this right. The Latin American and Caribbean region has also a considerable indigenous, native, and peasant population whose cultural and demographic characteristics differ from that of nonindigenous or urban populations. They are generally less able to access health care services. Yet laws regarding health and policy strategies rarely consider such differences. Some exceptions to this trend exist in the general health policies of Colombia and El Salvador and in the reproductive health policies of Mexico and Peru. In certain countries, policy documents indicate the existence of a direct relationship between poverty, lack of education, social alienation, discrimination, and neglect of reproductive health and maternal mortality. These studies also demonstrate that rural women are less able to exercise their rights under national laws and have more limited access to the services provided by the state.

A. HEALTH LAWS AND POLICIES

In all nine Latin American and Caribbean countries, the Ministry of Health, part of the executive branch, is responsible for the formulation of the health policy. In most cases, the ministry administers policies, but tends to decentralize services. However, "decentralization" of health care services does not have the same meaning in every country. For some governments, such as those of Bolivia, Brazil, Mexico, and Peru, decentralization means the legal independence of certain public offices, which enables them to have administrative autonomy and to control their own resources. There is no change in the ownership of the health care service infrastructure nor in responsibility for providing such services. In Bolivia, the municipal governments provide physical infrastructure, resources, and equipment; they also support health care services with municipal taxes. But the general laws and policies, as well as specialized health services, are all centralized in the capital. On the other hand, in countries such as Argentina, decentralization is a pseudonym for the privatization of health care services. Currently, all the governments in the countries profiled herein are directly involved in the provision of health care services. Nonetheless, they are in the process of transferring such responsibility either to the private sector or to health insurance services that depend upon the contributions of workers and others. Argentina is the most advanced in terms of the privatization of health care.

In all the countries, public health care systems coexist with health insurance systems supported by worker contributions. Although such insurance coverage varies, all nations face the shared challenge of expanding the coverage to those who are excluded from that system by not being formally employed.

Objectives of the health policies

The major objective of national health policy in all the countries examined is to meet the basic health needs of society's poorest segments. In all nine Latin American and Caribbean countries, policies focus, to differing degrees, on achieving better-quality health care services and on providing free or subsidized assistance to the poorest segments of society. In

Argentina, improvements in the quality of service are a priority, since, according to available statistics, this country has achieved optimal coverage levels. In Mexico and Peru, the quality and effectiveness of the health care sector are also essential government concerns, even though they have not yet succeeded in providing full coverage to their target groups. In the remaining countries — Bolivia, Colombia, El Salvador, and Guatemala — where a higher percentage of the population lacks access to basic health care, policies focus on enhancing access. In Colombia, for example, the national health policy is directed toward achieving free and compulsory basic health care. By the year 2000, the goal is to provide coverage to the whole population, including those groups that are unable to pay.

Brazil and Peru are regional models for health care because of their efforts to implement comprehensive health programs. The government of Brazil declared 1997 to be the Year for Health and has attempted to improve the population's health by involving federal, governmental, municipal, and private institutions in the achievement of these goals. Health and prevention programs developed by community-based health care workers focused on the provision of primary care and basic medical care, including women's and children's health and sexually transmissible infections ("STIs"). Peru is developing health policies and laws with special emphasis on reproductive health. This positive trend seeks to address women's reproductive health problems in the nation with the second-highest maternal mortality rate in South America. The Peruvian government has declared the present decade to be the decade for family planning and has established important objectives regarding women's reproductive health for the five-year period from 1995 to 2000.

Infrastructure of health services

In all nine Latin American and Caribbean countries, health care facilities belong mainly to the public health sector and are ultimately managed by ministries or secretariats of health. Even in countries like Argentina and Brazil, where an extensive network of private facilities are linked to those of the public health care system, the public sector's infrastructure continues to be more important than the private one. For example, in Brazil, there are 6,378 hospitals, of which only 2,877 are private.

In most countries where health services are centralized, there are varying degrees of sophistication between general medical facilities and basic health care centers or stations in rural areas. The latter provide only basic or primary care services. In Bolivia and Guatemala, as in other countries, the number of basic health stations is significantly higher than that of hospitals. In Bolivia, out of 1,651 health care establishments, 1,373 are basic health stations. In Guatemala, basic health stations constitute 68% of the total public health care infrastructure. Although the information collected for this report focuses on public services, it is important to note that, in some countries, nongovernmental organizations ("NGOs") play an important role in the provision of health care. In Bolivia, for example, in addition to public infrastructure, there are around 500 NGOs providing health care services, mainly in the rural areas.

Although the human resources available for health care differ considerably among the nine countries, they differ even more within each nation. Generally, there is a lack of health care providers in rural areas. Peru is a clear example of the marked difference between rural and urban areas in doctor-patient ratio. In 1992, there was one doctor for every 12,000 inhabitants in the most distant provinces, while the ratio for Lima, the capital, was of one doctor to 800 inhabitants. The Pan-American Health Organization recommends a doctor-patient ratio of one to 910 inhabitants. In Argentina, there is a doctor for every 376 inhabitants; in Brazil, one for every 486 inhabitants. Out of all nine Latin American and Caribbean countries profiled, the latter two countries appear to have more human resources within their health care system. Bolivia and Jamaica, on the other hand, have the most deficient global coverage levels, with a doctor-patient ratio of one to 2,941 and 1,700 inhabitants, respectively. Overall estimates indicate that in Colombia 97% of the population had access to primary health care in 1996, although such care was of low quality and was concentrated in urban areas. In Guatemala, the government recognizes that the low coverage of its health care services contributes to approximately 64% of all deaths.

Cost of Health Services

The World Health Organization ("WHO") recommends a minimum allocation of 10% of a country's total budget to its health system. In most countries that provide financial resources directly for health care, the trend has been to increase the investment in health. However, key information regarding the manner in which such funds are distributed is unavailable. For example, Guatemala spent 2.2% of its gross domestic product ("GDP") on health in 1996 but invested it mainly in the construction of hospital infrastructure rather than in the provision of health care. In 1996 El Salvador spent 7.3% of its national budget on health, Colombia spent 2.41% of its GDP, and Mexico 2% of its gross national product. From 1994 to the present, Peru increased its expenditures on health by more than 100%. Although the WHO standard is an important means by which to determine the priority a government has given to health, it must be considered in relation to each country's health system. For example, of all the nations discussed in this report, Argentina has the best coverage levels in health care

services. Yet, it spends only 3% of its national budget on health. In Argentina, private agents and other systems, such as workers' health insurance schemes, assume most of the costs related to health care.

The laws of all nine countries contain provisions that ensure free health care services in some or all cases. However, none of them clearly states which services are free, and most countries establish vague standards regarding exemptions from fees. Generally, these standards use terms such as "low income" and "lacking resources" to exempt persons from payment. In addition, countries such as Bolivia and Peru have introduced fees not through laws but either through administrative measures or directly in practice. In 1995, in Peru, resources derived from fees charged in public hospitals accounted for 65% of all hospitals' resources. In Mexico, fees cover up to 10% of total costs.

In most nations, governments continue to contribute to employee health insurance plans. However, governments are contributing fewer resources to such plans. In Mexico, the employer provides 70% of the contributions to work insurance, the employee 25%, and the government 5%. In Argentina, 80% of the social security budget comes from contributors to the social security system, but the government maintains a special fund for people with neither insurance nor resources. In Colombia, the Comprehensive Social Security System establishes subsidies for people who cannot pay their insurance contribution. In El Salvador, the Social Security Health Institute, financed by the state, provides services to insured workers and free care to people who cannot afford to pay.

Regulation of health care providers

All nine Latin American and Caribbean nations have laws that establish the requirements by which people qualify as medical professionals and that regulate the activities of health care providers. Although in all nine countries legal development in this arena has focused on physicians, Bolivia, Jamaica, and Peru have laws that regulate other health care professions more widely. In Bolivia, the Health Code requires doctors, dentists, nurses, nutritionists, and all others that provide health care to register with the government once they have complied with all legal requirements for training. In Peru, the General Health Act contains a chapter devoted to the regulation of the medical, dental, pharmaceutical, and other similar professions, as well as that of health care technicians and assistants. In Jamaica, there are three applicable statutes — the Medical Act, the Nurses and Midwives Act, and the Pharmacy Act — that create governing councils and establish their own judicial bodies. Of all nine countries, Bolivia, El Salvador, Mexico, and Peru have additional laws that regulate the health sector and establish official control mechanisms for health facilities and their professionals. These laws establish principles and obligations with which health care professionals, particularly doctors, must comply. Such obligations include confidentiality as well as civil and criminal liabilities stemming from negligence or from criminal offenses.

With the exception of Jamaica, registered medical professionals in all countries are also governed by a Medical Ethics Code and a professional council or tribunal that oversees the application of this code. These codes establish ethical obligations for health care providers, including respect for the life and dignity of patients, health care without discrimination, and patient confidentiality. Some of these codes, like those of Brazil and Guatemala, specifically refer to the doctor-patient relationship in reproductive health matters. The Brazilian Medical Ethics Code establishes a doctor's duty to respect the patient's right to freely choose a contraceptive or fertility method, as well as informing him or her about the consequences and risks of such methods. It also prohibits artificial insemination without the patient's consent. In Guatemala, the Ethics Code establishes that doctors must abstain, except during obstetric emergencies or with judicial approval, from examining the genitalia of female minors in the absence of parents, a guardian, or other legally responsible individual. Professional tribunals may punish medical providers by issuing official warnings, fines, suspensions, and expulsions from the relevant professional association. Although ethical codes establish rules of conduct for doctor-patient relationships, these codes generally do not have the force of law, unless explicitly provided by law. In Peru, for example, its General Health Act establishes that the punishment imposed upon health care providers for certain acts may be provided in the applicable Ethics Code. Guatemala provides an example of an instance in which an act or governmental policy is in conflict with the Ethics Code. The Ethics Code forbids doctors from performing sterilizations. Yet sterilization remains one of the most popular methods of contraception among married and cohabiting women and is mostly provided by public health care providers.

Except for Jamaica, the penal codes of all nations discussed herein punish a range of offenses that may be committed by health care providers. The most common offenses are injuries and death caused by negligence; the performance of abortions, which is generally illegal in all nine countries; infringement of patient confidentiality; crimes against public health; illegal trade of toxic substances; and unlawful prescription of drugs.

While the practice of alternative or traditional medicine is very common in the countries in the region, providers of such care are not regulated by the government. In Bolivia, although each traditional healer assists approximately 500 people per

year, legal regulations do not exist. In Peru, herbs and traditional medicine are used by 25% of the population. However, the General Health Act does not deal with traditional medical providers, except that there is a manual that establishes qualifications for traditional birth attendants.

Patients' rights

None of the nine Latin American and Caribbean nations described in this report has specific laws and effective regulations ensuring the protection of patients' rights. When the law grants such rights, the procedures by which to enforce such rights are practically nonexistent. In most cases, patients have rights that correlate to the duties imposed upon medical professionals and described in the previous section. Numerous health acts and ethics codes set forth patients' rights, which generally include assistance in case of emergency; informed consent; and the right to be treated with dignity and without discrimination. In all these countries, except Jamaica, the most effective mechanisms that patients may utilize when offenses are committed by health care personnel are those offered by the penal and civil judicial processes. In Jamaica, there are no legislative or regulatory provisions concerning damages and medical negligence, but common-law rules that regulate suspension of professional practice and civil liability are applicable. In Peru, health establishments have joint and several liability for crimes committed by medical practitioners.

Jamaica is the sole country out of the nine discussed in this report where the Medical Act empowers the relevant professional council to revoke the license of any medical practitioner that infringes the rules established by that law. It may also impose various disciplinary measures that may be appealed before a judicial body. Jamaica thus provides the only example of a nation where a law empowers a nonjudicial body to impose punishments. In all the other countries, professional tribunals may only impose disciplinary measures, including expulsion. No professional bodies are empowered to compensate victims for their claims.

B. POPULATION, REPRODUCTIVE HEALTH, AND FAMILY PLANNING

A review of population laws and policies in all nine Latin America and Caribbean countries indicates that their existing population policies mainly seek to balance population growth rates and an even distribution of the population with a rational use of available resources. The regional trend is toward abandoning the emphasis on population control in favor of such a balance. However, in four countries — El Salvador, Jamaica, Mexico, and Peru — limiting population growth remains a policy objective. There is also a trend to view population within the context of sustainable development. The 1994 Declaration of Principles on Population and Sustainable Development of Bolivia, reflecting this trend, states that population policies must not be regarded as instruments of demographic control. For example, the 1996 Family Planning Act of Brazil prohibits coercive family planning as a method of population control.

Population laws and policies

Not all the countries profiled in this publication have issued specific population laws and policies. Brazil, for example, deals with some population issues in its general social development plans or in social policies like those for employment and education. In addition, in Guatemala, population control is not a specific policy and is hardly mentioned in the government's national program. As discussed previously, the laws and policies of El Salvador, Jamaica, Mexico, and Peru place greater emphasis on the need to decrease population growth rates. El Salvador has a population growth rate of 2.5%, one of the highest in Latin America. The government has declared that it has an "overpopulation" problem and it has elaborated strategies by which to address this issue. These strategies include women's education, the incorporation of women within development plans, and family planning. In Peru, the national population policy seeks to decrease the current annual growth rate of 1.8%, stating that such a reduction will take place without coercing, manipulating, or biasing people in favor of family planning. In Peru, the family planning program aims to achieve an average total fertility rate of 2.5 children per woman, as opposed to the current rate of 3.5. In Mexico, the National Planning Council is responsible for establishing the country's demographic policy. The goal is presently set at achieving a 1.75% population growth rate for the year 2000 and of 1.45% for the year 2005; the current population growth rate is 2.05%. In Jamaica, the government seeks to limit population growth to an annual rate of 0.8% over the next three decades; the current growth rate is 0.9%. Argentina, which has a pronatalist population policy, is an exception in the region.

Reproductive health and family planning laws and policies

All the nine Latin American and Caribbean countries that are the subject of this report are characterized by laws and policies that recognize the right to family planning and respect individual choice regarding the number and spacing of children. Likewise, recent policies and legislation in Bolivia, Brazil, and Peru regard reproductive health and family planning as fundamental human rights. For example, the law regarding family planning in Brazil declares that the exercise of family planning ensures men and women equality of rights with regard to the number and spacing of children.

This recognition and protection of rights through laws and policies offers a stark contrast to women's status and

reproductive health. Women's general subordination, alienation, and inequality affects their reproductive life, decisions regarding spacing of children and their ability to access reproductive health services. Laws and policies in reproductive health and family planning, however, generally do not address this linkage. Only Colombia and Peru aim directly to empower women or to improve their social situation in their reproductive health and family planning policies. In Colombia, the Comprehensive Health Program for Women seeks primarily to integrate poor women into the subsidized health care system and to encourage family coverage by health care insurance. Thus, the benefits of health care insurance are extended to spouses and permanent partners and the children of those workers who belong to the insurance system. In Peru, the Reproductive Health and Family Planning Program ("RHFPP") refers to gender equality and considers socioeconomic status to be a determining factor in women's reproductive health. This policy seeks to begin to remedy the current situation by creating subprograms that address gender issues, including the eradication of violence against girls and women.

There are two important regional trends in the development of policies relating to reproductive health and family planning. A recent trend in all countries, except Jamaica, is the formulation of policies that integrate reproductive health and family planning services. For example, in Bolivia, the government has declared that family planning is an important part of reproductive health. In addition, Peru's RHFPP has established that family planning is a "priority action" in reproductive health. A second trend is to propose policies and programs on either reproductive health or family planning that are not part of the general national health policies directed toward women. In Bolivia, Mexico, and Peru, there are specific policies or strategies regarding reproductive health and family planning. In Brazil and Colombia, these services are part of comprehensive women's health programs; in El Salvador, they are a component of overall national plans such as the Women's National Plan. In Jamaica, there is no legislation or policy regarding reproductive health; the government addresses only family planning. Only Bolivia has a program, known as the Sexual and Reproductive Health Strategy, that refers directly to sexual health. This policy is focused on the implementation and provision of family planning services.

The central objectives of the reproductive health programs in the eight Latin American nations described herein are numerous. They include the provision of assistance to improve women's reproductive health in all the stages of their lives; reduction in the number of unwanted pregnancies and abortions; detection and treatment of cervical and breast cancer; improvements in pre- and postnatal care as well as the rate of births assisted by medical practitioners; reduction of pregnancy risks among adolescents; and prevention of HIV/AIDS and STIs. Although there is no national family planning program in Argentina, there are information and training programs on maternal reproductive health, with a special emphasis on mother-child health. One of its main activities is training women as preventive health agents. To date, 60,000 women have been trained throughout Argentina. Since 1995, Peru has issued the most regulations and specific policies relating to women's reproductive lives. Nevertheless, Peru's maternal mortality rate is second only to that of Bolivia.

In all nine countries, except Argentina, governmental institutions at the national level are responsible for promoting and enforcing family planning and reproductive health policies. Brazil, however, has established that both public and private organizations may be responsible for family planning programs. Although Argentina's government has restored the right to family planning as well as the state's responsibility for providing information on this matter, it has not yet established the state's responsibility for the provision of contraceptives. Currently, the federal government in Argentina has no family planning policy and undertakes no related activities related.

Government delivery of family planning services

In most countries, except Argentina, laws and policies establish that governments must play a central role in the provision of family planning services. They seek to achieve this goal through the provision of information, contraceptives, and contraceptive services. However, in Argentina, in 1986, the government stipulated that public health care services were responsible for disseminating information and for counseling people regarding their right to decide on the number of children that they want. However, the government's mandate does not include the provision of family planning services and the distribution of contraceptives. Hence, although there are no legal or policy barriers, the absence of family planning services hinders the right of people to plan the number of children they wish to have. In Argentina, the private sector is the main provider of contraceptive services, which are provided for a fee. Argentine public hospitals that obtain pills and intrauterine devices paid for by the state must specify that these items will be used for purposes other than contraception, because there are no explicit provisions that authorize these hospitals to acquire or distribute contraceptives.

Governments vary in terms of the fees they charge to provide services. In Jamaica, family planning services are available through the public health care services. But such services are not free. The fee charged amounts to 5% of the market price for contraceptives and services. The Jamaican Family Planning

Board, the government agency that implements family planning services, ensures access to such services. However, in recent years, there has been a decrease in the number of pregnant women assisted by the public health care service and in the number of people using contraceptives supplied by public services. Mexico and Peru have guaranteed access to all family planning services free of charge.

The great majority of government programs include the distribution of contraceptives and the provision of information and services necessary for such distribution. Mexico presents one of the most outstanding examples of a government program that provides information, counseling, prescription, and contraceptive services free of charge to a large number of people. In 1995, 72% of Mexican women who used contraceptives obtained them from the public health service system. In Peru, the state supplies all types of contraceptives free of charge. In 1996, the Peruvian government established free services and supplies for family planning. Moreover, the Ministry of Health and the Peruvian Institute of Social Security provide contraception coverage to 70% of all women users. In El Salvador, the Ministry of Public Health and Social Action and the Salvadoran Social Security Institute provide most family planning services. A private institution called the Salvadoran Demographic Association provides a significant portion of these services. Together, these three institutions provide contraceptive coverage to 78.7% of all women users in El Salvador. There is insufficient information in Bolivia, Brazil, and Guatemala regarding the percentage of women who use public family planning services. In Bolivia, while family planning is a recognized part of reproductive health and a fundamental human right, the national health agency does not provide free family planning services. In Brazil, the Single Health System is the government agency responsible for providing family planning services and contraception. In Guatemala, the Reproductive Health Unit is the official agency responsible for the provision of medical supplies and family planning methods and for training professionals in the delivery of contraceptives.

Private and nongovernmental organizations play an important role in the provision of contraceptive methods in all the countries described herein. In some nations, they distribute more contraceptives than the government. In 1993, the Colombian government provided only 20% of the population with contraceptives. Although this situation persists, the Colombian government continues to consider family planning to be an integral component of its social security system's primary health care plan. In other words, the government has shown the political will to provide family planning services for low-income users in each public health center and hospital.

C. CONTRACEPTION

Prevalence of contraceptives

The prevalence of contraceptive methods varies from one country to another, ranging from an average rate of 32% of married and cohabiting women in Guatemala to 76.6% of the same group of women in Brazil. Bolivia and El Salvador have, after Guatemala, the lowest rates of contraceptive usage with only 45% and 53.3%, respectively, of married and cohabiting women using contraception. In the five remaining countries, the average rate of contraceptive use is over 60% of all women living with partners. The particular rates are as follows: 72% in Colombia; 68.9% in Argentina; 67% in Jamaica; 66.5% in Mexico; and 64% in Peru. In five of the nine Latin American and Caribbean countries described in this report, sterilization is the most popular method of contraception among women, with rates that are considerably higher than those of the second-most popular method. In Mexico, 43.3% of women that use a modern contraceptive method are sterilized. In Brazil, this percentage is 40%, in El Salvador 31.5%, and in Guatemala, 14.3%. Although no official figures for sterilization were found for Colombia, it is believed that sterilization is also the most popular method of contraception in this nation.

It is important to note that, in some countries, traditional methods such as periodic abstinence are much more popular than modern methods. In Bolivia, 18.3% of women use traditional methods while 11.9% use modern methods. In Peru, this situation has been changing in recent years.

Legal status of contraceptives

In all nine Latin American and Caribbean countries, contraception is legal. All governments state that contraception is a means by which people can exercise the right to family planning. However, Argentina is the only country where sterilization is illegal and punished by law. While the performance of most abortions constitutes a criminal offense in all nine countries, several nations also expressly reaffirm their prohibition on abortion as a method of family planning.

All nine nations regulate modern contraceptive methods. In all nine countries, there are official institutions responsible for quality control and registration of contraceptive products. Peru, the most advanced country in terms of legislation relating to contraceptives, is the only country that regulates emergency contraception. The *Manual on Reproductive Health* recognizes its use within seventy-two hours of unprotected sex for cases of "nonconsensual carnal intercourse" — such as rape — or for failures resulting from barrier contraceptives.

Regulation of information on contraception

Although not prohibited in any nation, regulation of information on contraception differs considerably from one

country to another. In Argentina, Bolivia, Brazil, El Salvador, and Jamaica, there is no particular law that regulates such information. However, the governments of these nations have made a commitment to disseminate information on family planning methods. In Colombia and Mexico, laws permit mass distribution only of drugs that do not require medical prescription. In Peru, according to the recent General Health Act, access to information on all available modern and traditional methods of contraception is a right of all women users, and the provision of it a corresponding duty of health care providers.

Sterilization

Sterilization is a legal and popular contraceptive method in all countries studied, except Argentina. In four of these nations — Brazil, Colombia, Mexico, and Peru — sterilization is subject to legal regulations and requires the informed, conscious, and willing consent of the patient. Jamaica does not regulate the performance of sterilizations. However, in practice, Jamaican hospital providers tend to perform such a procedure only when a woman has more than two children.

Although Brazil currently has the second-highest rate of sterilization among the nine countries covered in this report, the 1996 Family Planning Act referring to sterilization was vetoed by the president in August 1997. The vetoed sections included some provisions that protected the rights of patients, established requirements such as a written record of consent, elaborated conditions for eligibility, including having had two children, and being over 25 years old, and established a waiting period of sixty or more days between consent and surgery. The president revoked his veto in August 1997, prompted primarily by action undertaken by the Brazilian feminist movement. In El Salvador, sterilization is the most popular contraceptive method, although there is no specific legislation on the matter.

D. ABORTION

Although not reflected in official statistics, abortion remains one of the main causes of maternal mortality in several of the countries covered herein. Abortion is illegal in all nine nations. Yet, the rate of clandestine abortions is high. Brazil and Mexico have the highest rate of clandestine abortions, amounting to between 800,000 and 2 million per year. More than 80% of the abortions performed in Latin America and the Caribbean are performed in eight of the countries discussed in this report. The current legislative trend is toward more stringent regulation and punishment of abortion. Reproductive health and family planning programs aim to decrease clandestine abortion and to provide care for women suffering from abortion-related complications. Even so, these same countries also penalize health care providers and their women patients for obtaining abortions. There is thus a contradiction between policies and laws regarding abortion.

Legal status of abortion

In all nine countries studied, abortion is a felony punished by penal law. In many nations, illegal abortions performed in inadequate conditions have become a major public health concern. Abortion is one of the main public health problems in Bolivia. It contributes to a high rate of maternal death and to the increase in public hospital costs that arise from treating women suffering from abortion complications. In Guatemala, abortion remains one of women's most serious health problems. In Colombia and Peru, abortion is the second cause of maternal death. In Peru, patients suffering from abortion-related complications occupy 30% of gynecological beds in all public hospitals. In Jamaica, women suffering abortion-related complications occupy 20% of gynecological beds in public hospitals.

Requirements for obtaining legal abortion

In all nine countries, abortion is illegal. However, seven of the nations discussed in this publication, except Colombia and El Salvador, establish exceptional situations under which a woman may obtain an abortion. Under some exceptions, the individual's actions are not regarded as criminal and he or she is excused of any wrongdoing; other exceptions exempt the individual from punishment. This means that, depending on the legislative provision, a judge may decide that criminal prosecution of a woman who obtains an abortion or of others involved in performing or obtaining the abortion is not warranted. It can also mean that even if the prosecution is legally permissible, the consequent penalty may not be imposed because an exception requires immunity from punishment. In either case, the practical effect is that, under such exceptional circumstances, the persons involved in an abortion cannot be punished.

In most nations, abortion is permissible only in limited circumstances. In Argentina, Bolivia, Brazil, Guatemala, Jamaica, Mexico, and Peru, an abortion performed to save the mother's life (known as therapeutic abortion) is not punished. In Argentina and Peru, an abortion is not punished if the pregnancy poses a serious risk to either the mother's health or her mental and physical health. Jamaica also permits an abortion in the latter circumstance. In addition, in Bolivia, Brazil, Jamaica, and Mexico, abortion is not punished when a pregnancy is the result of rape; in Argentina, an abortion is not punished when it results from rape or a sexual act with a mentally handicapped or insane woman. In all cases, it is required that the abortion be performed by a medical practitioner and that there is certifying evidence of the existence of an exceptional circumstance. In Bolivia, the rape victim must request authorization to obtain an abortion from the judge assigned to the rape trial. In Brazil, although not so

provided by the penal code, the judicial branch has used writs to extend the exceptional circumstances for legal abortion to include those situations in which the fetus has incurred serious and irreversible abnormalities. Nine Mexican states also do not penalize abortion performed under such conditions. Only one Mexican state, Yucatan, permits abortions on serious economic grounds when a woman already has three children.

Penalties for abortion

Penalties for performing an illegal abortion differ considerably in the nine nations. Penalties depend both on the criteria defining abortion in legislation and on provisions therein defining aggravating and alleviating circumstances. Punishment also depends on the extent of the person's involvement in the crime and on whether the performer is a medical practitioner. Jamaica is the only country among the nine discussed herein where the penalty for abortion is life imprisonment.

Generally, the same penalty is imposed upon the woman who obtains an abortion and on the person who performs it, unless the pregnant woman did not consent to the procedure. Penalties vary from two to ten years of imprisonment, depending on aggravating circumstances such as in the case of an abortion that results in death or injury. In Peru, a person who performs an abortion suffers a harsher penalty than the woman who consents to the abortion. Peru also has specific provisions in its recent General Health Act that establish the duty of health care providers to report women who seek treatment for post-abortion complications to the authorities.

Some laws establish alleviating circumstances for abortion similar to the exceptional circumstances that merit "impunity" or "exoneration." For example, in Peru and Colombia, an alleviating circumstance occurs when the pregnancy is the result of rape. In Colombia, a risk to the mother's life or health is also an alleviating circumstance. In Bolivia and Mexico, the pregnant woman's "good" behavior is an alleviating circumstance.

E. HIV/AIDS AND SEXUALLY TRANSMISSIBLE INFECTIONS (STIs)

Laws affecting HIV/AIDS and STIs

All the Latin American and Caribbean countries covered in this report, except El Salvador and Jamaica, have laws concerning HIV/AIDS and STIs. In Argentina, Bolivia, Brazil, Colombia, Guatemala, Mexico, and Peru, the deliberate transmission of HIV/AIDS is a crime. In some countries, laws seek to protect the rights of persons with HIV/AIDS. In others, the law imposes duties on health care providers regarding the precautions necessary to prevent the transmission of diseases by blood transfusions and other means.

Laws recognize a range of rights for persons with HIV/AIDS. In most countries, the rights of patients with HIV or AIDS include confidentiality of test results; the right not to be discriminated against by medical providers; protection from employment discrimination and discrimination in certain aspects of their social lives; protection against wrongful disclosure of their medical information; respect for their human dignity; and the right to receive medical treatment. In Bolivia, people with HIV/AIDS may not be refused access to their work premises. In Bolivia and Colombia, a person suffering from HIV/AIDS is not required to inform his or her employer of his or her illness. In Peru, the dismissal of an employee suffering HIV/AIDS is not legal. Bolivia, Colombia, and Guatemala forbid compulsory testing for HIV/AIDS. In Bolivia, Brazil, Guatemala, and Peru, institutions or persons that perform HIV/AIDS detection tests are required to notify the authorities of positive results. These reports are strictly confidential.

In two nations, El Salvador and Jamaica, laws are not explicit in their protection of persons with HIV/AIDS. In El Salvador, the Health Code contains very restrictive regulations on HIV/AIDS that regard AIDS, like other STIs, as a disease about which health care providers must notify the authorities. A person with HIV/AIDS may be forced to submit to isolation, observation, and surveillance in a manner determined by the authorities in the Ministry of Public Health and Social Action. This law also prescribes the sterilization of the premises and objects with which the infected person has had contact. In Jamaica, there exist neither laws regulating this issue nor a specific prohibition against discrimination toward persons with HIV/AIDS.

Of all the laws that protect the rights of patients with HIV/AIDS, the Peruvian law that renders invalid the dismissal of a worker with HIV or AIDS merely because of his or her condition is the most important legal mechanism developed by a nation to protect persons with HIV/AIDS against employment discrimination.

Sexually transmitted infection legislation in the region is scarce. In Argentina, Bolivia, Colombia, Guatemala, Mexico, and Peru, laws do not deal specifically with STIs and mention them only in laws relating to HIV/AIDS. In Brazil, legislation declares only that it is in the public interest to eradicate STIs. In El Salvador, the same norms that apply to HIV/AIDS are also applied to STIs. In Jamaica, no specific laws address STIs. The Public Health Act states that the Ministry of Health must do whatever is necessary to stop the spread of these diseases.

Policies on prevention and treatment of HIV/AIDS and STIs

Most of the countries reported have governmental institutions or bodies that address AIDS prevention. In all nine Latin American and Caribbean countries, ministries or secretariats of health are in charge of policy management and enforcement

either directly or through a dependent institution. El Salvador is the only country that does not have a specific HIV/AIDS and STI policy, though the Women's National Plan seeks to review laws and regulations to ensure HIV/AIDS prevention. Only Argentina, Bolivia, Brazil, and Mexico have policies regarding the treatment of AIDS. Except in Mexico, HIV/AIDS and STI services are not integrated within reproductive health and family planning programs.

In nations where public services are available for HIV/AIDS, there is considerable variance in the range of such services. In Argentina, health care officials must provide medical, psychological, and pharmaceutical treatment for HIV/AIDS. However, the service is deficient, especially with regard to the provision of drugs. In Bolivia, the HIV/AIDS Prevention and Surveillance Program seeks to improve care, provide information and education, and maintain a team of professionals to assist AIDS patients. Brazil, a nation with one of the highest HIV/AIDS prevalence rates in the world, has been slow and deficient in its response to this health problem. The country's budgetary crisis has hampered the government's ability to undertake policies for the prevention and treatment of AIDS. The Unit for Sexually Transmissible Infections in the Ministry of Health develops the National STI/AIDS Program, which envisages two strategies: first, the strengthening of diagnosis and care; and second, the dissemination of information through educational and counseling campaigns. These campaigns have been undertaken in surgical centers at a federal level, as well as in universities and hospitals that undertake research on HIV/AIDS at a national level. These institutions, financed either by the federal government and/or international institutions, have successfully distributed condoms free of charge.

Mexico is the only country among the nine profiled herein that integrates its AIDS prevention and control program with its Reproductive Health and Family Planning Plan. The government's policy aims at reducing morbidity and mortality resulting from this disease and increasing access to information, diagnosis, prevention, and control services through communication programs, preventive actions, and AIDS assistance in primary health care facilities. The government's goal is to provide care to 80% of all HIV positive patients, reduce STIs by 30%, and reduce prenatal transmission of AIDS by 50%. Mexico's HIV/AIDS policy is the most comprehensive of any nation profiled in this report.

As expected, the policy objectives of HIV/AIDS programs vary. In Argentina, the National Program Against HIV/AIDS develops prevention and information campaigns in schools. In Colombia, the National AIDS Council and the National Executive Committee for the Prevention and Control of HIV/AIDS encourage healthy sexuality, prevention, and the provision of laboratories for the diagnosis of such diseases. In Guatemala, the National Commission for the Surveillance of AIDS undertakes epidemiological surveys, health promotion and counseling, distribution of information, and other activities that seek to control AIDS. In Jamaica, the National Program for HIV/AIDS Control and the 1997–2000 Medium-Term Plan establish that the Ministry of Health must improve condom-distribution plans, elaborate a policy for prison inmates, develop an AIDS policy for the workplace, and provide STI services within primary health care facilities. In Brazil, the promotion of civil society's participation in the prevention of HIV/AIDS is one of the most relevant governmental initiatives in the region.

III. Understanding the Exercise of Reproductive Rights: Women's Legal Status

Women's health and reproductive rights cannot be fully understood without considering women's social and legal status. All nine countries, except Jamaica, include in their national Constitutions provisions relating to equal rights and nondiscrimination. In Jamaica, freedom from discrimination based on sex or gender is not constitutionally protected. Although the Jamaican Constitution establishes that any action "affording different treatment to different persons, … on the basis of race, place of origin, political opinions, color or creed" is discriminatory, this provision does not mention gender. Argentina and Brazil mandate affirmative action measures to promote women's political participation. Argentina's Constitution includes an affirmative action provision that seeks to achieve women's equality in political participation. Brazilian national law establishes that all political parties must ensure that at least 20% of the candidates they propose are women. Other countries have important constitutional provisions regarding the legal and social status of women. In Colombia, the Constitution establishes the state's responsibility for the promotion of equal participation of women in political power. In Peru, the Constitution establishes the right of persons not to suffer moral, physical, or mental violence, which includes all forms of violence against women.

Although all nine Latin American and Caribbean countries made progress in their legislation advancing women's rights, there remain obsolete discriminatory civil and penal provisions that indicate the lack of political will to fully implement constitutional principles that protect women. Take, for example, Bolivia, Brazil, and Guatemala. In the civil codes of Brazil

and Guatemala and in the Family Code of Bolivia, men have rights in marriage that discriminate against women. Yet all nine countries profiled in this report have signed or ratified two key international instruments regarding women's human rights — the Convention on the Elimination of All Forms of Discrimination Against Women and the Inter-American Convention on the Prevention, Punishment and Eradication of Violence Against Women (Convention of Belem do Pará). One of the main obstacles affecting all women is the enormous gap between the rights granted by law and women's exercise of such rights. This gap is partially attributable to the absence of efficient, direct, and simple mechanisms by which women can exercise their rights. This problem is exacerbated for women in vulnerable situations, especially those who are low-income, rural, and indigenous. Native and rural women generally suffer discrimination in their community lives because custom and usage work against them. In such communities, not only are men in leadership positions but women are also legally entitled to inherit less land than men. This form of legal discrimination hinders their access to credit and their ability to improve their general economic condition.

Violence against women is a serious problem in most of the nine Latin American and Caribbean nations discussed in this report. Yet the extent of the problem is also very hard to prove because of the lack of reliable documentation and statistics in most countries. Based upon available information, it was possible to identify the following as the main acts of violence: sexual violence, domestic violence, and other forms of physical and mental violence. In Bolivia, 76.3% of the acts of violence against women were regarded as physical violence and 12% as sexual violence. Most of these acts occurred within the home. In Peru, in Lima alone, 6,244 cases of violence against women were reported to a special police unit; rape and other sexual aggressions are the third-most common national crime. In Jamaica, in 1992, 1,108 cases of rape were reported to the police.

Sexual harassment also continues to be a problem that governments have not yet addressed effectively. None of the nine Latin American and Caribbean countries profiled herein have specific laws regarding sexual harassment that protect women in all areas of their lives, including their domestic ones. Illiteracy among women in these countries ranges between 4% in Argentina to 50.3% in El Salvador. In the remaining seven countries, women generally have higher illiteracy rates than men. Illiteracy is usually highest among women in rural areas. For example, in Guatemala, the illiteracy rates for urban women is 13%, compared to 49% for women in rural areas.

A. CIVIL RIGHTS WITHIN MARRIAGE

In all of the nine Latin American and Caribbean countries studied in this publication, the trend is toward legislative amendments that seek to guarantee equal rights within marriage. Yet some countries are still under the influence of their recent past when a married woman was subject to her husband's custody. In Argentina, Bolivia, Brazil, and Guatemala, the constitutions establish equality in marriage. But in spite of this declaration, their civil codes contain discriminatory rules against women that infringe upon their fundamental rights. Even in some countries where the law does not discriminate against women, the regional trend towards equal rights must to be understood within a regional context of continuing violence and inequality. In Peru, for example, 60% of women are poor and have little knowledge of their rights. And, in most of the countries studied, domestic violence is a problem that has serious effects on women's health, including their reproductive health.

Marriage laws

All nine Latin American and Caribbean countries have similar legal systems regulating marriage. Civil codes and other civil laws proclaim equal rights and obligations between spouses. Except when otherwise established by spouses, the law recognizes a community property system and joint parental custody over children. Laws in all nine countries establish a series of reciprocal obligations between spouses, such as fidelity, mutual assistance, maintenance, and cohabitation. According to the common community property system, all property acquired during marriage is held jointly by both spouses. The exception to this rule is provided either by the existence of an alternative settlement stipulated in the civil law or by a joint agreement regarding a different property settlement. The liquidation of joint property in cases of death, divorce, or separation results in property held jointly being divided equally between spouses, in the case of death, among their heirs. In Jamaica, despite the existence of three marriage laws — the Marriage Act, the Hindu Marriage Act, and the Muslim Marriage Act — all three establish the same rights and obligations for both spouses. Nonetheless, the marriage laws of many nations discriminate against women. Only Colombia, El Salvador, Jamaica, and Peru have norms that do not discriminate in favor of or against one of the spouses. The remaining countries in this report still have obsolete provisions in force.

In Argentina, although the regulations regarding marriage contained in the Civil Code have recently been amended to eliminate discriminatory provisions against women, some discriminatory provisions still exist. For example, the law entrusts the husband with the administration of property of uncertain

origin, denies the mother the right to dispute her child's paternity, and includes the concept of so-called reverential fear that women owe their husbands. In Latin American jurisprudence, reverential fear has been used to invalidate the need for a married woman's consent in most situations because it is presumed that such consent was granted on the basis of the reverential fear the wife owed her husband. The Bolivian Family Code also contains discriminatory provisions. For example, the husband may restrict his wife's practice of a profession or trade on the grounds of either morality or when the woman's role within the home is affected.

In Brazil, the Civil Code establishes that the husband is the holder of all property held jointly by the spouses. He legally represents the family and holds sole parental authority over the children during marriage. The husband may even request the annulment of the marriage up to ten days after its celebration if he discovers that his wife was not a virgin. Brazilian civil law establishes that the married woman becomes her husband's partner, spouse, and companion and is responsible for the material and moral direction of the family. A wife needs her husband's authorization, duly recorded as an authenticated public record, to sell or mortgage her own personal property, to transfer property rights to third parties, and to incur debts that restrict joint property. The law presumes that wives that exercise their profession outside the home more than six months have their husbands' permission to do so. Husbands are entitled to administer joint property as well as their wives' property.

In Guatemala, despite civil and constitutional laws declaring equality of rights between spouses, the Civil Code establishes that only the husband may legally represent the couple in the administration of jointly owned property. In addition, it establishes differing obligations between spouses. It is the husband's obligation to supply the wife with the means necessary to support the home; it is also the wife's obligation to care and tend for their children when they are minors and to conduct household chores. The wife may work outside the home provided these activities do not damage the welfare and interests of her children and her household duties. In any case, a husband may oppose his wife's working as long as he can support the home. Until recently, penal law in Guatemala contained discriminatory provisions against married women. In March 1996, a group of women reformed laws that regarded adultery as a crime only when committed by a married woman. In Mexico, each state regulates marriage in its territory. No federal regulation of marriage exists. In the Mexican capital, the Federal District, the civil code follows the principle of equality between the spouses.

Regulation of domestic partnerships

In all nine countries, couples frequently live together and raise families as if they were married. These situations are known as *uniones de hecho* or domestic partnerships in some countries and "concubinage" in others. However, not all countries recognize that such unions generate legal rights and obligations. In the countries that regulate domestic partnerships, laws are generally nondiscriminatory. The regional trend is toward increasing recognition of rights of these couples and their children and granting rights similar to those that exist within a legal marriage. Although laws generally confer upon women in domestic partnerships fewer rights than those conferred upon married women, the existence of legal standards in this regard benefit women. It is women who usually need to claim their property rights vis-a-vis their male partners and apply for social security benefits for themselves and their children when such benefits are provided only by their partner's employment.

Seven countries — Bolivia, Brazil, Colombia, El Salvador, Guatemala, Mexico, and Peru — regulate domestic partnerships. Of these nations, El Salvador, Guatemala, and Peru regulate domestic partnerships at the constitutional level. In El Salvador, the absence of a legal marriage does not affect the enjoyment of rights established in favor of families. In Guatemala, domestic partnerships are considered legal by the Constitution, and these unions have legal effect so long as the interested parties declare to a local authority. In Peru, the Constitution defines and guarantees domestic partnerships in a manner similar to that of legal marriages and the Civil Code regulates such unions. Bolivian law also protects domestic partnerships or "free marital unions" as well as other forms of premarital unions such as "*tatancú*" and "*sirvinacuy*." The latter exist in Andean and other communities and enjoy legal effects similar to those of legal marriage. Moreover, in Brazil, Colombia and Peru, laws establish minimum periods of stable cohabitation for the domestic partnership to be legally recognized. In Brazil, this period is five years; in Colombia and Peru, it is two years. In Brazil, in sharp contrast to laws that govern legal marriages, laws that govern domestic partnerships respect the principle of equality and nondiscrimination against women. In Colombia, a couple in domestic partnership has equal rights. In 1992, the Constitutional Court in Colombia set a relevant precedent at the regional level by recognizing the value of domestic work as a contribution to the property jointly held in domestic partnerships. In Mexico, each state regulates domestic partnerships within its territory.

Argentina and Jamaica are the only countries in which domestic partnerships or situations of cohabitation are not regulated. However, in both countries, children born out of wedlock are entitled to the same rights as children born within a

marriage. In Argentina, there is only one example of a law — a labor law that recognizes the right of a cohabiting partner to receive a pension when the other dies — that confers rights to women (called concubines) in these unions. The law confers this right to a pension only if the couple have lived together for at least five years before the death in question, or if they had acknowledged their children, or if the deceased did not have other legal ties. In Jamaica, there exist many "visiting unions" and "common-law unions." Couples sometimes raise children together before entering a legal union. However, these unions are not legally recognized and this situation often leads to lack of legal protection for women and their children.

Divorce and custody law

All nine countries permit divorce. In all of them, except El Salvador, there is a predivorce stage called separation in which jointly held property is liquidated and the marriage is not dissolved. Civil laws that regulate divorce do not establish, as a rule, discriminatory provisions against women. They are, generally speaking, egalitarian when regulating the requirements, procedures, and effects of divorce and separation.

In Argentina, Guatemala, Jamaica, and Peru, there are gender distinctions in the law regarding child custody and maintenance. In Argentina, the law grants women custody of children under the age of 5. In Peru, parents are under an obligation to support their single daughters over the age of 18 but not their sons. In addition, except when the judge decides otherwise, a mother assumes the custody of daughters and sons under the age of 7 when both spouses are deemed "guilty" — or at least at fault in — the divorce. In Jamaica, the husband is not under any obligation to support his wife if she is "guilty" of "adultery" or "desertion." The wife is only under an obligation to support her husband if he is destitute and she has property. A man is also required to maintain his children and any of his wife's minor children or the children of any woman with whom he lives. In Guatemala, maintenance/alimony is granted to a woman who has obtained a separation or divorce when the husband is "guilty" only if she "behaves well" and does not marry again.

B. ECONOMIC AND SOCIAL RIGHTS

Property rights

In all nine Latin American and Caribbean countries profiled herein, a woman is equal before the law with regards to the right to property. But this does not mean that she has equal opportunities to access it. The following examples indicate practical limitations on property rights. In Bolivia, women in rural communities where customary norms prevail are subject to restrictions related to the acquisition or maintenance of land if there is no male in the home who can ensure its productive use. In that country, a peasant woman is also unable to inherit land when there are living male relatives. In Colombia, only 37.5% of women who are heads of household are proprietors, as opposed to 53% of the homes in which a man is head of household. In El Salvador, only 10% of rural property is registered in the name of women, even though 26.23% of heads of households are women. In Brazil and Guatemala, existing discriminatory provisions in their civil laws that grant the administration of joint property to men constitutes an infringement of married women's right to property. In addition, in Brazil, the Civil Code permits a person to draft a will that disinherits a "dishonest" daughter living in the paternal house. In this case, the term "dishonesty" refers to sexual conduct.

Labor rights

Seven countries — Argentina, Brazil, Colombia, El Salvador, Guatemala, Mexico, and Peru — have laws to protect women's labor rights. The law in these countries forbids discrimination in employment, establishes the principle of equal pay for equal work and, by granting a minimum of seventy-five days of paid maternity leave, protects pregnant women and mothers. In El Salvador, pregnant women only receive 75% of their wages during maternity leave. Several countries also require employees to grant breaks so that female employees can breastfeed their children. Moreover, it is illegal to dismiss women on the grounds of pregnancy. In addition, in Brazil and Colombia, there are laws that protect the reproductive rights of women workers. Since 1994, it has been illegal in Colombia to require pregnancy certificates before hiring a female employee unless the job entails a high health risk. In 1995, Brazil enacted a law that forbids employers to request pregnancy or sterilization certificates when hiring women.

Bolivia and Jamaica are the exceptions to the regional trend toward protecting women's labor rights. In Bolivia, laws protect only pregnant employees. Bolivian law does not protect women against discrimination at work. In Jamaica, the Constitution does not forbid discrimination based on gender and does not forbid employment discrimination against women. The Jamaican Women's Labor Act provides that no woman shall be employed in night work and that women may not exceed a total number of ten hours of work per twenty-four hours, except in certain professions. Among other protective measures, the Ministry of Labor may limit or forbid the employment of women in industrial undertakings. However, a 1970 Jamaican law establishes criminal liabilities for an employer that pays employees differently for the same work.

Access to credit

Although none of the nine Latin American and Caribbean countries discussed in this report has laws that directly regulate

or limit women's access to credit, it is evident that men and women often do not have equal access to credit. In some nations, such as Brazil and Guatemala, marriage laws that either restrict the administration of joint property by women or their access to inheritances also limit their access to credit. In rural areas, the unequal distribution of property between men and women also limits women's access to credit. In addition, it is a common practice among banking institutions in some countries to request the husband's signature when granting credit to a married woman even when she has the resources necessary to obtain such credit. In Jamaica and Peru, banking institutions retain practices that discriminate against women. In Jamaica, a married woman who requests a loan is required to obtain written confirmation from a lawyer that she has received necessary legal advice even when a husband and wife apply together for such a loan.

Some nations — Argentina, Colombia, El Salvador, and Mexico — have implemented governmental policies to solve the difficulties associated with women's access to credit. In Argentina, the government is developing training programs for women involved in small businesses. The Colombian government has enacted legislation to support access to credit by women who are heads of family. In El Salvador, in 1990, the government created communal banks and small businesses to address women's credit needs. In 1994, these institutions granted loans to 6,372 women. The Mexican government has enacted legislation to support rural women's access to credit by establishing industrial agricultural units for women in agriculture and providing aid to rural women's income-generation projects.

Access to education

None of the nine Latin American and Caribbean nations profiled herein restricts women's access to education. The general trend is for Constitutions and other laws to include the universal right to education and to establish that it is the government's duty to provide such education. Although all nine countries have instituted the right to free basic education for all, some – Colombia, El Salvador, Guatemala, Mexico, and Peru – specifically provide for it. For example, in Jamaica, education is free, although the cost recovery program, recently introduced, allows the government to recover only a little over 5% of its budget from fees paid by students.

Many countries also provide policies and programs to ensure education under equal conditions. In general, government education policies in all nine countries focus on girls and young women and not on the adult population. However, most illiterate women in these countries tend to be adult women, particularly those in rural areas. In Mexico, despite the fact that access to education is not restricted and that enrollment rates have increased, two out of three illiterate adults are women, and women in rural areas have the lowest educational levels in the country. In Argentina, Bolivia, Colombia, El Salvador, Guatemala, and Peru, illiteracy primarily affects women and rural people. Some governments are undertaking plans and programs to address this situation. For example, Argentina is developing a national-level equal-opportunity program for women in education. This first stage of this program focuses on the elimination of discriminatory stereotypes in educational materials and on the institutionalization of nonsexist language in the Federal Education Act. There is also a department for women in the Argentinian Ministry of Education that seeks to ensure and strengthen gender equity.

Women's bureaus

Although governmental offices entrusted with the promotion of women's rights exist in all nine Latin American and Caribbean countries, their powers vary considerably. Peru is the only nation where the main government institution for women is of ministerial rank. In Argentina, Bolivia, Brazil, Colombia, and El Salvador, these institutions have their own budgets and decision-making powers. In Jamaica and Mexico, these bureaus have less power. In Guatemala, this division's budget is limited and dependent on a ministry, so it is not regarded as significant. The regional trend is toward the creation and strengthening of these kinds of institutions. Most women's bureaus are independent from ministries but depend upon the executive branch.

As stated above, Peru is the only nation of the nine described in this report that has a ministry focused on women. In Peru, the Ministry for the Promotion of Women and Human Development, created in 1996, is the main bureau for women. Its mission is to promote the development of women, family, and population and to ensure priority attention for minors at risk. The other important institutions for the promotion and defense of women's rights in Peru are the Women's Commission in the Parliament and an Ombudsman for Women's Rights in the national Ombudsman's Bureau.

In five nations, women's bureaus have their own budgets and exercise considerable decision-making powers. In 1992, Argentina created the National Council for Women, which seeks to implement the Convention for the Elimination of All Forms of Discrimination Against Women within the nation. In Argentina, this convention's legal status is equivalent to that of the Constitution. This bureau has its own budget and also seeks to achieve the maximum participation of women at all levels. In sixteen Argentine provinces, there are women's bureaus that aim to develop public policies that address women's problems. Since 1991, Bolivia has attempted to

implement a gender perspective in public policies. The Women's National Program, the key instrument for such social policies, is enforced by the National Solidarity Board, which is dependent on the National Secretary for Ethnic, Gender, and Generational Affairs. Furthermore, the Gender Affairs Undersecretary is responsible for institutionalizing a gender perspective in development policies. Brazil's National Women's Rights Council is responsible for formulating national-level policies and programs related to women's rights. In 1995, Colombia created the National Office for Women's Equality in the interest of promoting women's equality and participation. This institution is the main women's bureau responsible for national policy coordination. It is associated with the presidency and has its own economic resources. In El Salvador, the Salvadoran Institute for the Development of Women aims to design public policies to improve women's status and to establish gender equality. It was created in 1996 as an autonomous body with legal status and its own economic resources.

Women's bureaus in Jamaica and Mexico have limited status. In 1975, in Jamaica, the Bureau for Women's Affairs was created as a bureau of the Ministry of Labor, Social Security, and Sports. Its main function is to educate, train, and raise the national awareness of women's affairs and to promote women's integration into national development plans. In Mexico, a Women's National Program is enforced by a secretary of the government, which develops policies that seek to eliminate discrimination against women.

Of all nations described in this report, Guatemala has the weakest women's bureau. In Guatemala, the Women's National Bureau, which is part of the Labor Ministry, is the governmental institution responsible for designing policies for the promotion of women. Because its budget is scant and it has a low administrative rank, this institution is prevented from adequately achieving its aims. Other specialized women's institutions are the Women's Commission in the Human Rights Office and the Women's Attorney General. A proposal to create another institution awaits approval in Congress.

C. RIGHT TO PHYSICAL INTEGRITY

The available statistics on violence against women indicate the importance of this problem for many countries in the region. For instance, in Brazil, 70% of all the reported incidents of violence occurred at home. In almost every case, the abuser was the woman's spouse or partner. In Colombia, violent death is the main cause of death for women aged between 15 and 24; 5.3% of women of reproductive age have declared that they had been forced to have sex, and in 80% of the cases, the abusers were acquaintances or relatives. In Mexico City, 87% of the victims of all crimes reported to the Attorney General's Office were women. In Peru, rapes constitute 48.6% of all "crimes against freedom." In 1996, domestic violence increased by 50.53% compared with the previous year.

Rape

All nine Latin American and Caribbean countries described herein define rape as a crime against sexual freedom, honesty, or respectability. The most common legal description of rape includes vaginal, anal, or oral penetration and penetration with objects. Except for Guatemala and Jamaica, the laws of the remaining nations do not differentiate between male and female victims of this crime.

In Guatemala and Jamaica, the crime is defined as occurring only when the victim is a woman. Moreover, in Jamaica, rape is also defined as including only vaginal intercourse.

Penalties for the crime of rape vary by country. In general, penalties are aggravated in the following circumstances: the number of people committing the crime; the extent of injuries suffered by the victim; pregnancy and death resulting from rape; the relationship between the abuser and the victim; and when the victim is defenseless. Guatemala and Jamaica have the toughest penalties for rape. In Guatemala, punishment for rape varies from six to twelve years of imprisonment. If the victim is under the age of 10, the crime is punishable with the death penalty. If the victim dies as a result of the crime, the punishment ranges from twenty to fifty years. In Jamaica, the penalty for rape is life imprisonment. Bolivia, Mexico, and Peru impose the most lenient penalties for rape. For example, Bolivian law punishes rape with a prison term ranging from four to ten years. In Peru, rape results in a penalty that ranges from four to eight years. If the crime is aggravated, the penalty ranges from twenty to twenty-five years. In addition to prison sentences, some countries establish other punitive measures. In Peru, the perpetrator must also undergo therapeutic treatment and must support the children born as a result of the crime. This provision does not specify whether it is necessary to obtain the victim's consent to the perpetrator's role in supporting the child. Finally, three countries maintain legislative provisions that exempt abusers from punishment if the victim marries the rapist. In Argentina, Bolivia, and Guatemala, there is no penal punishment if the victim willingly agrees to marry the perpetrator of the crime. In Bolivia, Brazil, Guatemala, and Mexico, "abduction for a sexual purposes" is a specific crime that it is not punished if the victim and the abuser marry.

A regional model of legal protection from marital rape exists in Colombia. In all nations, except Colombia, marital rape is not regarded as a crime. In Colombia, the penalty for marital rape varies from six months to one year. Jamaica presents another example of a nation making an effort to

criminalize marital rape. In this country, common law protects women separated from their husbands by recognizing that a wife is not deemed to having consented to sexual intercourse with her husband when she is threatened with violence; her husband suffers from a sexually transmissible infection; or the couple is separated. Moreover, there is a bill pending that seeks to enable a woman to charge her husband with marital rape. As opposed to this trend, a regrettable precedent was set in Mexico in June 1997 by its Supreme Court of Justice. This decision established that coercive sexual intercourse between spouses does not constitute a crime. Rather, it is to be considered the "wrongful exercise of a right" by the husband. Given that, in 1995, a Mexican state (Queretaro) considered marital rape as a crime, this judicial opinion may represent a regressive trend toward protecting women against violence in the home.

Domestic violence

Between 1993 and 1996, seven out of nine countries described in this report enacted, for the first time, laws and policies against domestic violence. These laws seek to establish legal protections, to develop preventive measures for victims of domestic violence, and to eradicate such violence. They also establish provisional measures and punishment for abusers through penalties like fines, restraining orders, and exclusion of the abuser from the family home. Depending upon the degree of violence, abusers may also be imprisoned. The legal proceedings in these nations involve the police, prosecutors, and civil, penal, and family judges. Examples of these laws include those in Colombia, Peru, and Argentina. In Colombia, a 1996 law declares domestic violence to be a crime and establishes temporary and permanent protective measures for victims of such violence. Victims can turn to a unit of the police dedicated to domestic matters, the public prosecutor, or the police generally. However, when domestic violence results in physical injuries, criminal laws are applicable. In Peru, the 1993 Domestic Violence Act aims to eradicate domestic violence, establish legal proceedings for victims, provide police offices with specialized personnel, promote the establishment of temporary shelters, and create institutions to treat abusers. In such proceedings, complaints are brought either to the police or a prosecutor to undertake preliminary inquiries; their report is then sent to a justice of the peace or a prosecutor-in-charge to issue a series of immediate punitive measures that range from expelling the abuser from the home to the imposition of civil fines. If a crime has been committed, the inquiry is extended. In Argentina, the 1994 National Act for the Protection Against Domestic Violence allows the victim to request protective measures from a judge. However, the law forces the victim and the abuser to participate in a mediation hearing. The regulations implementing this law create information centers and counseling in cases of physical and psychological violence.

In two of the countries studied, domestic violence falls within the scope of two laws. In Jamaica, two statutes are applicable — the Domestic Violence Act and the Matrimonial Causes Act. The latter is applicable only to married couples while the former also protects those who live in common-law unions or other nonmarital unions. Recently, Jamaica created special units within the police force to address domestic violence. In El Salvador, both the Domestic Violence Act and the Penal Code regulate violence. These laws specify three types of violence: psychological, physical, and sexual. Since the Penal Code also establishes sanctions for domestic violence, it falls within the scope of both the penal and civil systems. There is a special division of the National Civil Police to investigate and undertake the necessary procedures.

The domestic violence laws of Bolivia and Guatemala enable a variety of entities to enforce the law. Bolivian laws provide an interesting mechanism for the eradication of domestic violence in indigenous and rural communities. In Bolivia, the Domestic Violence Act is similar to those in other nations, except that it establishes an important mechanism to make protection against violence more accessible to indigenous and rural women. Authorities of native and rural communities are deemed competent to resolve cases of domestic violence in accordance with their usage and custom, provided such regulations and procedures are not contrary to the Constitution or the spirit of the national law relating to domestic violence. In Guatemala, the Act for the Prevention, Punishment and Eradication of Domestic Violence establishes that a victim's relatives and doctors, as well as any witness to the attack, may request protective measures. National police and justices of the peace take part in the proceedings.

Brazil and Mexico do not have specific national-level laws that address domestic violence. In Mexico, there is no federal legislation that specifically criminalizes domestic violence. In 1996, the Federal District enacted a law — the Act for the Assistance and Prevention of Domestic Violence — to establish nonjudicial procedures for the protection of victims. Some states consider violence against spouses or domestic partners only as an aggravating circumstance in certain cases. In Brazil, the Constitution ensures protection against domestic violence. However, there are no laws regarding domestic violence. There are draft bills that have encountered great resistance from jurists who declare that penal laws already protect individuals from crimes against personal safety. In Brazil, police offices focused on the defense of women encourage women to report cases of domestic violence to them. There is no legal basis at

the federal level for the creation of such offices. Rather, they have been established at the state level.

Sexual harassment

Only four of the nine Latin American and Caribbean countries profiled in this report — Argentina, El Salvador, Mexico, and Peru — have laws or regulations regarding sexual harassment. El Salvador and Mexico deem sexual harassment a crime. In El Salvador, it is defined to include unwanted and unmistakable sexual acts such as "touching." Sexual harassment is punishable by six months to one year of imprisonment; additional fines may be imposed if the harasser is exploiting his supervisory authority. In Mexico, only some states view sexual harassment as a crime. In the Federal District, if the harasser is a civil servant, the penalty is a fine and loss of job. However, in order for a crime to be punishable, the victim must be injured and must file a complaint against the harasser. In Peru, sexual harassment is defined as an act of "hostility" by an employer that is, in accordance with labor laws, equivalent to dismissal without cause. Within thirty days of the incident involving sexual harassment, the victim may either take action to limit the hostility or terminate her contract and request compensation. In Argentina, the sole regulation relating to sexual harassment deals with situations in which a superior induces another person to agree to his sexual request. The scope of this law is also rather limited since it does not cover most civil servants.

In Guatemala, Brazil, and Peru, legislatures are considering draft bills to regulate sexual harassment. The regional trend is to continue to restrict punishment of sexual harassment in the workplace, except for in Guatemala and some bills pending in Brazil, where protection measures against harassment in educational facilities are also being considered. In general, the Inter-American Convention on the Prevention, Punishment and Eradication of Violence Against Women is the regional instrument that provides the best framework for protection against harassment. It considers sexual harassment an act of violence against women that occurs within the community and that may be perpetrated by anyone in educational institutions, health establishments, places of work, and in other places. All nine Latin American and Caribbean countries analyzed in this report have either signed or ratified this convention.

IV. Focusing on the Rights of a Special Group: Adolescents

Minors and adolescents account for almost half the population of each of the nine Latin American and Caribbean countries discussed in this publication. However, not all laws and policies define the term "adolescent." Only the national laws of Brazil and Peru define adolescents as persons between the ages of 12 and 18. Although Colombia has constitutional provisions that establish rights for young people and children, it does not establish any specific age limits. Generally, legislation in the remaining countries distinguishes minors from adults only in the context of marriage and sexual crimes. Even those countries that formulate policies addressing the reproductive health of adolescents do not define the term "adolescent." However, most demographic statistics refer to an "adolescent" as a person between the ages of 15 and 19. For the purposes of this report, whenever national-level laws and policies do not provide definitions, we follow the definition contained within Article 1 of the Convention of Children's Rights, which defines as a child anyone under the age of 18.

A. REPRODUCTIVE HEALTH AND ADOLESCENTS

Reproductive health statistics are not equally available among all the nine countries analyzed in this report. In several countries in the region, such as Colombia and El Salvador, international cooperation and NGOs have promoted the collection of demographic information and reproductive health indicators from all members of the population, including adolescents. The governments of Mexico and Peru have taken more initiatives in this area, unlike Argentina, which possesses limited general demographic information, particularly on adolescents.

Teenage pregnancy is a problem in every country profiled in this publication. In all nine countries, policies and laws that promote reproductive health among adolescents are very scarce. In these countries, higher rates of adolescent maternity correspond to lower rates of contraceptive usage. El Salvador and Bolivia have the highest rates of teenage pregnancy in Latin America — 20% and 18%, respectively, of all pregnancies. In these countries as well as in Jamaica, adolescent access to contraceptives is extremely limited. Hence these countries experience the highest rates of teenage pregnancy. In Jamaica, a third of all mothers who give birth are adolescent. Although this rate is very high when compared with that of other Latin American nations, it does not appear to be so in terms of the Caribbean region. In Peru, pregnancy among adolescent girls accounts for 15% of maternal deaths. The Ministry of Health has pointed out that a great number of adolescent pregnancies result in abortions because such pregnancies are unwanted. Mexico also provides a good example of the effect of contraceptive access on adolescent maternity. Statistics indicate that the use of contraceptives among adolescents during 1976 to 1992 has increased, and teenage pregnancy for the same period has decreased from 132 to 78 births for every 1,000 women. However, Mexico faces other challenges in the field of adolescent reproductive rights;

between 1990 and 1993, STIs among adolescents increased by 14%, and the maternal mortality rate of women under 20 is still 6% higher than that of older women.

Among the nations discussed in this report, there are only a few that utilize laws to promote adolescents' reproductive health. In four of them — Argentina, Bolivia, El Salvador, and Jamaica — there are no public policies or national programs to meet the reproductive needs of adolescents. In Argentina, very few provinces have initiated programs focused on the care of low-income teenage mothers. In Jamaica, the private sector assists with health needs and seeks to facilitate the return to school of adolescent parents. In the remaining six countries, there are some policies that address reproductive health and the family planning needs of adolescents. The common objectives of these policies include the prevention of unintended pregnancies and abortions among adolescents; the prevention of HIV/AIDS and STIs; the provision of information on family planning; and the eradication of sexual violence against minors. In these six countries, the trend is to formulate specific goals regarding adolescent reproductive health as part of either their general policies on these matters or of broader policies that relate to all adolescents. Peru, for instance, has a specific integrated health care program for adolescents; one of its components is reproductive health. One of the most important aims of the National STI/AIDS Program in Brazil is to fight child prostitution.

Although all countries except Argentina and Jamaica are characterized by common policy goals for adolescent reproductive health, they differ in terms of the strategies and activities undertaken to implement them. In Colombia, Mexico, and Peru, the main strategy to reduce unwanted pregnancies and abortions has been to initiate activities to provide family planning information. In Guatemala, educational campaigns on HIV/AIDS have focused on promoting chastity among young people. In Colombia, the national public policy on equality for women has as one of its goals the prevention of abortions and unwanted pregnancies, through the design and implementation of family planning activities that facilitate adolescent access to contraceptives. Mexico has opened special reproductive health units for adolescents in 102 health establishments across all thirty-two states. In Peru, the Comprehensive Health Program for Schoolchildren and Adolescents also services adolescents' reproductive health problems. It covers 40% of the adolescent population and, for the period from 1996 to 2000, has established a goal of achieving a contraceptive coverage rate for adolescents living with partners at not less than 60%.

National laws vary in terms of the legal protection they afford adolescent health. Where legal protection of adolescents exists, it is does not always cover their reproductive health. In some cases, instead of protecting adolescent health, the law seems to affect it negatively. For example in Mexico, the Federal Constitution establishes that parents have the obligation to preserve the physical and mental health of their children, and children are legally protected from violence in many states. However, these states also have obsolete norms in their penal laws, which grant parents the right to inflict corporal punishment on their children. On the other hand, in Bolivia, Brazil, and Peru, special national laws that regulate the rights of children and adolescents also guarantee certain reproductive rights. In Brazil, the Single Health System covers pregnant adolescents. In Peru, the state must provide special care for adolescents during pregnancy, birth, and subsequently, and adolescents also have the right to receive sex education and family planning information. The Bolivian Code for Minors establishes the state's obligation to provide specialized care to pregnant minors before and after birth.

Current laws do not take into consideration the rights of adolescents as users of health services. Some regulations that apply exclusively to professional health care providers contain special rules regarding the care of adolescent patients. For example, in Guatemala, the Medical Council's Ethics Code requires the presence of parents or guardians when a gynecological examination is performed on a minor, unless there is a gynecological/obstetric emergency or it is ordered by a court. This norm also establishes that patient confidentiality on pregnancy diagnosis or assistance at childbirth is not mandatory when the patients are minors.

Although the provisions contained in the legal codes of Bolivia, Brazil, and Peru that establish reproductive rights for children and adolescents are very limited, they are the best regional examples of such laws. In fact, Peru is the only country that has legally recognized the reproductive right of adolescents to sex education and family planning in its Minor and Adolescent Code. In addition, the situation in Guatemala serves to illustrate the role that ethical codes of health care providers could play in the regulation of adolescent rights as users of reproductive health care services.

B. MARRIAGE AND ADOLESCENTS

In the nine countries described herein, the average age of first marriage ranges from 18.5 to 23, with the lowest age prevailing in El Salvador and Mexico and the highest in Argentina. Civil laws in these countries establish the age when people may marry without obtaining authorization from a third party and the special circumstances under which minors may obtain judicial authorization to marry. In Argentina and Brazil, individuals can get married without authorization at the age of 21, while in the other seven nations, this age is 18. In Jamaica, the

minimum legal age of first marriage is 16; unlike other countries, there are no exceptions to this rule, and all marriages of persons under 16 are invalid. In El Salvador, parents, guardians, or judges can deny authorization to marry to individuals under 18 on grounds related to their behavior and their inability to support a family. In El Salvador, as in Colombia, if a minor has a child or is pregnant, she may be eligible to marry at below the minimum legal age of first marriage.

In seven Latin American countries, except El Salvador, national laws establish different minimum ages of first marriage for women and men who seek to marry without authorization from parents, guardians, or judges. However, the law does not provide a reason for this difference. Minimum ages of first marriage for women vary among 12, 14, and 16; for men, the corresponding ages are usually two years older.

C. SEXUAL OFFENSES AGAINST ADOLESCENTS AND MINORS

Although available only in a few nations, statistics regarding sexual violence against adolescents and minors indicate that this issue is a cause for great concern. Although all nine Latin American and Caribbean countries described herein punish such offenses severely and penalties may include life imprisonment, this legal harshness contrasts sharply with the lack of policies or programs directed at eradicating sexual violence both at home and in the streets. In Mexico, it is estimated that half of all rapes and other sexual crimes are committed against girls and adolescents; in 60% of the reported cases, the aggressors were relatives of the victim, including her parents. In Colombia, the average age for adolescent rape is 14, which represents 3.1% of all reported rapes. A similar pattern occurs in Mexico, where 39% of all aggressors were boyfriends, friends, or neighbors and 26% were relatives.

Penal laws that punish sexual crimes against minors and adolescents are similar in all nine nations profiled in this report. Legal protection extends to children between the ages of 7 and 18, and the range of crimes covered is broad. The most common crimes are rape (intercourse using physical violence); statutory rape (sexual acts using deceit); incest; abusive sexual acts (any sexual acts other than intercourse); abduction with sexual intentions; "corruption" of minors; encouragement of child prostitution or pornography; and sexual harassment of children and adolescents. The penalty for each of these crimes depends upon the age of the victim and increases in severity as the age of the minor decreases. The aggressor's relationship with the victim is the most important aggravating circumstance in these kinds of crimes; the closer the relationship with the victim, the more serious the crime.

In some of the countries studied, there are obsolete and discriminatory provisions against adolescents. For example, in Argentina, Bolivia, Guatemala, and several Mexican states, statutory rape is punished only when the adolescent victim is viewed as "honest." In Argentinian jurisprudence, the term "honesty" is synonymous with virginity. In other countries, "honesty" requires that the adolescent meet several criteria of good behavior. In certain countries, perpetrators of rape are exempted from any punishment if they marry the victim after committing the crime. Although Colombia, Mexico, and Peru have recently abolished such provisions, Bolivia and Peru have maintained them in cases of statutory rape and "seduction."

D. SEX EDUCATION

Sex education programs that are integrated into formal education are scarce in the region. In four of the nine Latin American and Caribbean countries analyzed herein, there are no sex education programs. In Jamaica, a program that has not yet been formalized is being implemented in schools. Bolivia, Colombia, and Peru have legislation and educational programs directed at students. In Bolivia, programs also train teachers and produce material regarding sex education that varies depending upon the age of the target audience. At the primary education level, the content of sex education is focused mainly on the development of sexuality and family life; at the secondary level, educational material is concerned with developing a responsible sexual life, HIV/AIDS prevention, and family planning. Colombia's national sex education plan seeks to change sex roles, make family relationships more egalitarian, and increase the knowledge of adolescents of their sexual and reproductive rights.

MICHIGAN STATE UNIVERSITY
LIBRARY

OCT 09 2025

WITHDRAWN

PLACE IN RETURN BOX to remove this checkout from your record.
TO AVOID FINES return on or before date due.
MAY BE RECALLED with earlier due date if requested.

DATE DUE	DATE DUE	DATE DUE
OCT 17 2001	MAR 0 5 2011	
	0 3 2 0 1 1	
APR 0 2 2002		
0 4 0 2 0 2		
0 5 0 1 0 3		
MAR 2 9 2003		
AUG 2 7 2005		
0 5 0 3 0 5		
OCT 3 1 2009		
0 1 0 4 1 0		

1/98 c:/CIRC/DateDue.p65-p.14